DAVID SYLVESTER

ABOUT MODERN ART

CRITICAL ESSAYS 1948–1997

A JOHN MACRAE BOOK

HENRY HOLT AND COMPANY NEW YORK

Henry Holt and Company, Inc.
Publishers since 1866
115 West 18th Street
New York, New York 10011

Henry Holt® is a registered trademark
of Henry Holt and Company, Inc.

First published in Great Britain by Chatto & Windus in 1996.
This edition with revised Preface, Curriculum Vitae, and Postcript
first published in the United States by Henry Holt and
in Great Britain by Pimlico in 1997.

Library of Congress Cataloging-in-Publication Data
About modern art: critical essays, 1948–1997 /
David Sylvester.—1st American ed.
 p. cm.
"A John Macrae book."
Originally published: London: Chatto & Windus, 1996.
Includes bibliographical references and index.
1. Art, Modern—20th century. I. Title.
N6490.S895 1997 97-17125
709'.04—dc21 CIP

ISBN 0-8050-4441-8

Henry Holt books are available for special promotions and
premiums. For details contact: Director, Special Markets.

First American Edition — 1997

A John Macrae Book

Printed in the United States of America
All first editions are printed on acid-free paper.∞

1 3 5 7 9 10 8 6 4 2

TO MY DAUGHTERS

with thanks for their tolerance and intolerance

CONTENTS

PREFACE

This book is an updated version of a volume initially published in 1996 and entitled *About Modern Art: Critical Essays 1948–96*. The present edition includes a 'Postscript' comprising five essays completed during the last twelve months. Also, the introductory 'Curriculum Vitae' has been revised, making it less detailed on some topics, more so on others.

The essays are mostly about art of the twentieth century; a few look back to the nineteenth. They have been selected and arranged as if the book were the equivalent of a retrospective exhibition. That is to say, they include a small fraction of the author's total output during the years they cover, they have been chosen for their intrinsic interest rather than the importance of their subjects, they are grouped in sections somewhat analogous to rooms in an exhibition, and their sequence is basically determined by the order in which the pieces were produced but is modified by taking account of their subject-matter.

Adherence to the principle that the book's essential purpose is to reprint things which look as if they may be interesting to read now has had the disappointing consequence that a number of the artists I most admire are absent or virtually absent because I have failed to write about them well enough. They include, alas, all artists born since 1945 (that is, more than twenty years after the author), a failing that can only be regretted as one regrets having become useless at tennis.

The analogy of the retrospective extends to the documentation of the chosen material. This is analogous to a catalogue in that it is introduced by an essay discussing the development and context of the work as a whole and then has a prefatory note on each piece which provides information about it and occasionally a comment on why it has been selected.

As to the side of editing that does not normally have a counterpart in curating an exhibition, the individual works have indeed been

subject to a fair amount of cutting and revising. The changes have been made to counter the risk of boredom, to improve syntax or to correct false or out-of-date information, rather than to alter the sense. Again, in order to help the reader scanning the list of contents, virtually all the texts have been given titles which differ from those under which they were originally published. The date attached to each item is that of the year in which its writing was completed. With a piece that was later radically revised, the relevant date is taken to be that of its original composition. The prefatory notes go into some detail about such matters.

In deciding on the selection and the sequence I have had crucial advice from Sarah Whitfield, Francis Wyndham, Richard Shone, Peter Campbell, who has also designed the book, and above all from its publishers, Jonathan Burnham of Chatto & Windus, Will Sulkin of Pimlico, and John Macrae.

Beyond that, there is a pile of debt in the background, built up over half a century, to colleagues, students and artists and also editors who have provided stimulus, information, ideas and advice. Were I to compile a long list of creditors, lapses of memory would still create omissions. So I shall mention just three colleagues with whom I was closely in touch during my formative years: Andrew Forge, Max Kozloff, Jacques Dupin.

London and New York
February 1997

CURRICULUM VITAE

I came to art through modern art – initially a black-and-white repro-
duction of Matisse's *La Danse*. I was seventeen, involved in music, and
had always thought of art as a means of telling a story. The Matisse
made me aware of the music of form – in the rhythm and sustained
tension of the series of curves forming the outline joining the ring of
figures and the counterpoint presented by the outlines of the pound-
ing legs.

Within days I was trying to paint. I painted in oils and drew,
almost always out of my head, eight or ten hours a day, with a constant
awareness that I had neither ability nor originality. I went on with this
for a year or so. In November 1942, shortly before I gave up, an exhi-
bition at a London dealer's gallery led me to write an article about
drawing: reading books about art had made me feel that writing about
it would be rather easy. I submitted the article to *Tribune*, the weekly
organ of the Labour left, and John Atkins, the Literary Editor, pub-
lished it and, shortly after, a long review of a major loan exhibition of
nineteenth-century French painting held at the National Gallery.

I feared for my new career when I learned that my young patron
was to be superseded by George Orwell, but the great man turned out
to be infinitely kind over giving me a variety of books to review. On
the other hand, I was warned that the Editor, Aneurin Bevan, found
my style heavy with Latinisms, and my charmed life with *Tribune*
came to an end early in 1945. My swan song was a full-page review of
a comprehensive picture-book on the work of Henry Moore. When I
received a cheque for it for two guineas and telephoned the payments
department to say that a piece of that length was surely worth three, I
was told that what a piece was worth depended on how good it was.

Actually, this was a better piece than usual. Most of what I wrote
was undermined by ignorance. Thus the French show at the National
Gallery was the first sizeable exhibition of first-rate art that I had ever

seen. It had not been by chance that the epiphany with the Matisse had come about through the medium of a black-and-white reproduction, for this was the way in which I saw most art until the latter part of 1945. During the war years in London access to major art was mainly confined to the National Gallery's monthly display of a single Old Master abstracted from the collection's underground hideaway plus the occasional sight at a dealer's gallery of an important modern French picture.

What one could see was good contemporary British art, mostly in dealer's galleries and in the continuous War Artists' exhibitions at the National Gallery – work by Moore, Epstein, Stanley Spencer, Matthew Smith, Paul Nash, Graham Sutherland, etc. I also saw work in studios, mostly of artists met in Soho pubs and clubs, among them Lucian Freud and Gerald Wilde, both of whom I wrote about in *Tribune*. I also started paying visits to Henry Moore's studio in Hertfordshire after he got in touch in the wake of the book review.

Moore, then, was the first artist of international renown whose work I was able to study seriously. This produced several results: publication in 1948 in the *Burlington Magazine* of a two-part article on the work's development; a few months as Moore's part-time secretary (this had to stop because we spent too much time arguing about art); the editing of a radically revised edition of the book I had reviewed and also of the second volume in the series of six (the remainder were edited by Alan Bowness at the insistence of the publishers, who found that I took too long to do things); above all, a first opportunity to curate and catalogue a major museum exhibition – Moore's retrospective at the Tate in 1951. Though subsequent articles I published included some that were sharply critical of certain of his new works, Moore asked that I undertake his next retrospective at the Tate, in 1968. I took this as an opportunity to isolate what I thought was his really creative output – a task made possible by his generous noninterference in the selection. The monograph that served as a catalogue seems to me the one thing among the many I have written on Moore in which I got things right (I have used a chapter from it as the piece about him here).

My first encounter with substantial bodies of work by individual foreign artists came with three exhibitions that opened in London in

December 1945: a small retrospective of Matisse and a selection of
Picasso paintings of 1939–45 at the Victoria and Albert Museum and
a large retrospective of Paul Klee at the National Gallery. Museums
were reopening and I was finally getting to see the great art of the
past, in London and abroad. Abroad was mostly Paris. I first went
there in July 1947, and found enough writing, translating and editor-
ial work to finance several lengthy periods there during the next three
years. Time spent in the studios of Brancusi, Léger, Laurens, Masson
and Giacometti was my compensation for having chosen to go to
Paris rather than up to Trinity College, Cambridge, to read Moral
Sciences.

Major retrospective exhibitions were another source of education
in twentieth-century art, notably the Bonnard at the Orangerie des
Tuileries in October 1947, nine months after his death, and the Klee
at the Musée National d'Art Moderne in February 1948. As at the
London exhibition in 1945, the Klees that touched me the most were
those of his last years, 1938 to 1940, perhaps because the appeal to me
in all his work lay, then as now, in its formal qualities rather than the
fantasy and the humour, which I have always found rather heavy. I
wrote a short piece calling attention to the all-overness of Klee's late
works and asking what this might mean. It was rejected by *Horizon*
and four other London periodicals, but was accepted by the avant-
garde New York review, *Tiger's Eye*, which absorbed it into a
symposium on the Sublime, sandwiched between contributions from
Robert Motherwell and Barnett Newman.

At the same time, *Les Temps Modernes*, the existentialist monthly
edited by Jean-Paul Sartre and Maurice Merleau-Ponty, offered to
publish it in French translation. Instead, I asked for and was given
leave to develop the ideas at greater length and in a more specific, less
poetic, fashion. During the next two years this piece went through
several drafts – helpfully criticised by Merleau-Ponty – which
included a good deal of discussion of how several living artists seemed
to have been aiming at an all-overness akin to Klee's, notably Miró,
beginning with the *Constellations* of 1940–41, and Masson, in much of
his current work; the discarded material included my invention of a
new movement called 'Afocalism'. And while the article was in
progress I published an introduction to the catalogue of a show at the

Hanover Gallery, London, in February 1950, pointing to this phenomenon in the recent sculpture of Eduardo Paolozzi and William Turnbull, two Scottish contemporaries of mine who were working in Paris. Sad to say, I managed for some years to miss the most important parallel to Klee's all-overness: certain current American painting, especially Pollock's. It took me until 1958 to perceive this. When I did, I surreptitiously slipped a long passage from the 1948 account of a late Klee into a description of a Pollock drip painting.

But it did occur to me in good time that Klee's approach might be on the point of finding embodiments in architecture. In the course of an article on 'Architecture in Modern Painting', published in February 1951 in the *Architectural Review*, I discussed the influence of modern painting on architecture, first recapitulating the usual points about the influence of Cubism and Mondrian, then putting the question whether any further modern painting already in existence might in the future influence developments in architecture, and proceeding to suggest, given the current desire among architects and theorists for a more organic style, that inspiration might now be found in Klee, especially in late Klee. I proposed a comparison with German Baroque churches, 'which provide the same stimulus of linear rhythm to keep the spectator on the move and the same refusal to reveal their structure until he has moved through them'. In 1960, when I was starting to put the present book together, I asked Reyner Banham whether the article was worth reprinting, and he replied that the part about Klee 'is now so much more true than when you wrote it that it needs at least a massive footnote on the optics of all glass walls and the planning of buildings like Ronchamp'. I have not in the end included it here, but the two pieces on Klee begin the book. I think they already exemplify the way I can't help writing about art, which is not unlike St Teresa of Avila's reports on her intercourse with the Deity.

It was through the good offices of Daniel-Henry Kahnweiler that the second of these pieces came to be commissioned by *Les Temps Modernes*. In Paris I used to have dinner every week with Hans Hartung, and when he read the manuscript of the first Klee piece he said he would like to show it to Kahnweiler, someone I venerated both as a dealer and for his monograph on Juan Gris. Hartung took me to meet him at the gallery and handed him my manuscript. Two or three

days later Kahnweiler telephoned asking if he could suggest to *Les Temps Modernes* that they publish a translation and also inviting me to coffee the following week at his apartment. There I was introduced to Michel and Louise Leiris, Jacques Lacan, Sylvia Bataille, André Masson and Alberto Giacometti.

Finding Giacometti there was a miraculous surprise. It had been very frustrating to see him, as I often had, sitting alone on the terrace of the Flore or the Deux Magots, for I badly needed to meet him. It was thirteen years since, renouncing Surrealism, he had started working in isolation making and destroying and making figures and heads: there had been a glimpse of this work in the amazing sixteen pages of reproductions which *Cahiers d'Art* had published in 1946, and then a good look at it in the catalogue of the momentous exhibition at Pierre Matisse's in New York early in 1948, but in Paris it was almost impossible to see any of this work in the original, beyond drawings at Pierre Loeb's gallery, without having an entrée to the studio. Looking continually at a borrowed copy of the New York catalogue, with its magical photographs by 'Patricia' of spectral beings rising from the chaotic studio's plaster rubble, its alluring evocation by Jean-Paul Sartre of the frenetic creation and destruction that went on there, its facsimile of a long illustrated letter from the artist to Pierre Matisse telling of his development, of his obsession with trapping his sensations and of all the effort and anguish this had entailed, I came to see Giacometti, not only as the creator of a number of sculptured figures and heads which inhabited space in a uniquely vertiginous, hallucinatory fashion, but also as the saintly knight without armour who had come to redeem art from facility and commercialism. Once we had met at Kahnweiler's I was allowed to visit him quite often.

Giacometti, then, seemed to me the key figure in the current art scene. At the same time, he belonged to an embattled minority. I accepted that the ruling tendency in contemporary art was abstraction, that abstraction was the *norm*. (Abstract artists I especially admired were Hartung, Schneider, Poliakoff, Bram van Velde and de Staël – still an abstractionist then – in France; Alan Davie, Gerald Wilde and Victor Pasmore in England.) At the same time, I believed that a figurative art was capable of going further, provided it could go anywhere at all. I

believed in those days that abstract art was an incomplete kind of art, that even at its best it did not achieve all that art could do, that figurative art could be more complex, more specific, richer in human content. But it seemed there was a very limited reason to be figurative if the artist – Derain, for example – was going to rehash old styles, was not going to make figurative art new. Giacometti gave serious substance to the hope that it could be made new.

At the turn of 1949–50 I perceived that there was a really important figurative painter working in England. I had been admiring and writing about Francis Bacon's work for three or four years but always perceiving it as a form of Expressionism. Suddenly, looking at a recent image of an ectoplasmic head with an open mouth and an ear that seemed attached by a cord to the ceiling, I recognised that it was a painting, not a cry of pain.

In the search for figurative art that was new and grand it was imperative not to be confused by all the retrogressive attempts which a host of painters and sculptors everywhere were making 'to go back to the figure'. Such efforts were insistently promoted by the most influential critic on the scene, John Berger, whose primary heroes were Guttuso, de Staël and Friso ten Holt. It was not surprising that Berger failed to recognise the value of Bacon: he was too much of a boy scout not to see Bacon as a monster of depravity. But it is difficult to forgive his dismissal of Giacometti at the time of the 1955 retrospective in London. Years later Berger beat his breast for that, but someone with the stance of a prophet has to be on the right side when the battle is at its height. When Giacometti's cause needed support, Berger wrote that 'everything he does seems only the seed or residue of an idea', that 'an unconventional form of bas-relief might be more suitable for his purposes', and that admirers of his sculpture 'are, I am convinced, only using it to confirm their own dessicated view of life in general'. Happily, Berger decided to continue his career as a fiction writer through the medium of the novel. But at the time he was writing criticism he was a serious distraction, because his rhetorical skills and his performing skills on T V won considerable support, financial as well as moral, for inferior artists. His dominance was all the more dispiriting in that there were seven or eight excellent London critics who were interpreting matters in a less simplified and schematised way.

The noisiest shot I fired in the campaign against the Berger line was an article satirically entitled 'The Kitchen Sink', published in *Encounter* for December 1954. This postulated a 'Kitchen Sink School', which included French painters such as Rebeyrolle and Minaux as well as English painters such as Bratby and Jack Smith, and concluded: 'It is as well to remember that the graveyard of artistic reputations is littered with the ruins of expressionistic painters whose youthful outpourings once took the world by storm.' But the term 'Kitchen Sink School' was hijacked by cultural journalists to serve as a designation for a supposed movement that encompassed novelists and dramatists.

A more positive contribution to the campaign was a lecture called 'Towards a New Realism', which I first gave at the Royal College of Art in 1951. Here I argued the desirability of a new art concerned with appearance and insisted that, if there was to be such an art, it would have to reflect the fact that modern man 'conceives of reality as the series of sensations and ideas that occur in the consciousness of each individual'. I went on: 'The private and subjective character of modern art clearly accords with this conception of reality. Thus Cubism does not represent objects but a series of perceptions of an object, a system of aspects. Thus Paul Klee does not represent a scene but an adventure, a succession of experiences: his pictures are maps of man's subjective world. And for the artist wanting to create not merely a map but an *image* of the world, it must still, to be valid now, be about that subjective world.' This meant that he 'must show that experiences are fleeting, that every experience dissolves into the next . . . must produce images which are not scenes, set up apart from the observer and seeming capable of existing when there is no observer present . . . but must be images in which the observer participates, images whose space makes sense only in relation to the position in it occupied by an observer.' As paradigms of such an art I showed slides of sculpture and paintings by Giacometti and paintings by Bacon.

During the first half of the 1950s my lecturing and writing on contemporary art was dominated by these two figures. I wrote only one substantial text entirely devoted to Giacometti, a catalogue introduction in 1955 (reprinted here). But I published at least a dozen eulogies of Bacon between 1950 and 1957, including the cata-

logue introduction for his show at the 1954 Venice Biennale. Though they include well-turned phrases – 'Paint that brings flesh into being and at the same time dissolves it away' – they are all somewhat spoilt by portentous rhetoric (which is why only one of them is reprinted here).

There was other figurative art being produced in England that moved me. There was Stanley Spencer above all, who as a man as well as an artist seemed to me a genius. I proposed a retrospective of his drawings to the Arts Council and curated it in 1954 – the first of many exhibitions I worked on with Joanna Drew – but his important work lay in the past. There were William Coldstream and Lucian Freud, but neither seemed radical enough in style to be relevant to the future of painting. However, in *The Listener* for 12 January 1956 I was able to say that Frank Auerbach's exhibition at the Beaux-Arts Gallery 'seems to me the most exciting and impressive first one-man show by an English painter since Francis Bacon's in 1949 . . . These paintings reveal the qualities that make for greatness in a painter – fearlessness; a profound originality; a total absorption in what obsesses him; and, above all, a certain authority and gravity in his forms and colours . . . The result is arrived at through the act of painting and painting and painting again, and its magic derives from the fact that in this clotted heap of muck there has somehow been preserved the precious fluency, the pliancy, proper to paint. Here at last is a young painter who has extended the power of paint to re-make reality.' It was not until many years later that I realised that Auerbach's friend Leon Kossoff, who was working along similar lines, was also an artist of consequence. Both had studied devotedly under David Bomberg, an outstanding painter from 1913 on, but a difficult man whom the art world had idly allowed to slide into obscurity. Following his death in dire poverty in 1957, an Arts Council memorial exhibition a year later renewed his fame. The review I wrote expressed doubt that we had seen paintings by a British artist of this century finer than the finest of those in this exhibition, except for some by Sickert, perhaps.

What, then, was I now making of Bacon? Earlier that year, 1958, his new paintings had seemed so shockingly bad that I felt totally disillusioned about him. Of course it was childish to let that disillusion spread to everything he had done before, but at that moment and for

nearly four years afterwards I felt his work to be incomprehensible and alienating: it seemed to me that it had become illustrational, caricatural, monstrous. For several years I remained silent about all of the work, sometimes studiously silent, as when I wrote in 1960 and again in early 1962 that there were currently three artists under sixty who were creating great images of the human figure, namely, Giacometti, de Kooning and Dubuffet, or as when I wrote in 1961 that the most interesting living painter in England was Auerbach. But Bacon's retrospective at the Tate in 1962 concluded with work which showed me that he was just emerging from what I now saw as a necessary period of transition, and I said this in a long review of the show (reprinted here). A few months later we recorded the interview that was to lead to our making a bookful of them.

But all this was marginal. In 1956 I had suddenly realised that I had previously been backing the wrong stable in believing that salvation was going to come primarily through the hard-won achievement of a particular sort of ambition – had failed to see, what Lawrence Alloway had seen, that it was going to issue from the natural fertility of a culture which in the domain of art had hitherto not produced a really significant crop but was now ready to yield one great vintage after another. But in 1956 I woke up to the value of American Abstract Expressionism. When exposed to the first-rate examples shown at the 1950 Venice Biennale, I had reacted in an utterly obtuse way, proudly exhibiting that blindness in a patronising notice in *The Nation*, a piece which ironically had been commissioned at the prompting of Clement Greenberg, who obviously wanted his own paper to publish a positive response from a European and who for some reason assumed that I was capable of that. I was incapable because I was blinded by an old fashioned anti-Americanism.

From about 1953 I had further exposure to work by Pollock and others which made me less unreceptive, but my response was still half-hearted when in 1955 I wrote an article called 'The End of the Streamlined Era' (reprinted here). I underwent my Damascene conversion one evening in January 1956 when the Museum of Modern Art's itinerant exhibition of *Modern Art in the United States* opened at the Tate Gallery. I wrote an article called 'Expressionism, German and American', inspired jointly by this show and another national

anthology recently shown at the Tate: it was published in *Twentieth Century* and was reprinted in *Arts*, the New York monthly edited by Hilton Kramer. It began with one of my routine diatribes against German Expressionism, qualified by enthusiasm for two early Kirchners and for a series of Beckmanns which I saw as 'expressions of one of the most profoundly personal imaginations of our time – paintings of an astonishing individuality of colour, and paintings which establish a mythology which, by virtue of its power and conviction, can almost be considered a Northern counterpart of the Mediterranean mythology of Picasso'. I then launched into a eulogy of American Abstract Expressionism, one of whose points was that much of this art achieved a 'curiously neutral and matter-of-fact' quality of paint that had been typical of previous American painters, such as Stuart Davis, from his beginnings: 'It is paint that contrives to be sensitive without being *aesthetic*. And this kind of sensitivity, not only in the handling of the paint, might be considered the keynote of the best modern American painting. What I wish to emphasise, above all, is that if this painting is not aesthetic, neither is it *anti-aesthetic*, as expressionist painting tends to be; it is anything but coarse or brutal. The Americans, indeed, seem to have solved as a matter of course one of the problems which most preoccupy painters everywhere today – the problem of avoiding a gratuitous beauty or charm without at once producing its opposite.'

All my writing so far had been dispersed in a wide variety of contexts, and I found this very frustrating: I wanted to be the accredited Art Critic of a particular publication. In 1953 I was appointed Art Advisor to the newly founded monthly *Encounter*, edited by Stephen Spender and Irving Kristol, and was also expected to be a contributor, so this meant that I finally belonged somewhere. But that did not solve the problem, which was that I had no platform from which I could continuously develop ideas set off by current exhibitions and publications. My comments on what was happening were scattered. There were essays in exhibition catalogues, there were articles in periodicals, both specialised and general, there were occasional reports on events in London for the *New York Times*, and above all there was work for the BBC – interviews, unscripted discussions, scripted talks for the

Third Programme, the Home Service and the French service and articles for *The Listener*. But I felt I lacked a pulpit.

There was one English newspaper for which I reviewed exhibitions regularly for a while, in tantalising circumstances. Around 1954–55 the position of Art Critic of *The Times*, a job with real standing in those days, was vacant, and the editor of the arts pages, W. A. J. Lawrence, was sharing out the exhibition reviewing, which was, of course, anonymous, among three or four critics. It seemed fairly certain that one of us would succeed to the job, which I wanted badly, mostly because I had a hunger for the respectability that seemed to come with a job on *The Times*, but also because, if I was going to write for that paper, I wanted my byline to read 'By Our Art Critic', which is a name, and not 'From a Correspondent', which is not. I threw my chance away through an excessive readiness to articulate critical judgements. After I had been reviewing in the paper for some time, writing the most avant-garde art criticism that had ever appeared in its columns, I received an invitation to one of its Thursday lunches, gatherings of pillars of the Establishment. I was seated between the Editor, William Hayley, and Lawrence Irving, a member of the Board and its expert on artistic matters, thanks to being a nephew of the actor and an amateur water-colourist. That morning an extremely laudatory piece of mine on a major Cézanne exhibition had appeared in *The Listener*, and Irving asked me if I really thought all that highly of Cézanne. I replied that I had no doubt that he was an artist of the very first rank and, by the way (as I spoke I sensed suicide), there had not been another since. A spy informed me later that *The Times* hadn't appointed me because they were looking for someone more in touch with the present.

In 1957 I was made Art Critic of the *New Statesman*, the weekly which I had read with almost unbroken regularity since I was sixteen, had appeared in very occasionally from 1947 and had always longed to join. I was now appointed for a year, as a stand-in for Berger, and then had to read him again for two years – though I did odd pieces for them on other subjects – before assuming his mantle at the start of 1960. Within three years I realised that, much as I liked having the job, it was by its nature using me up. I generally had to cover a subject in a thousand words or less, though I sometimes had up to two thou-

sand: I thus lacked the space to milk my ideas when they were worth it, and I didn't feel I was walking around with an inexhaustible mine of good ones, so in July 1962 I left. (The pieces from 1963 and 1964 which are reprinted here are two of three one-off contributions about American artists.) When I left it was on an impulse and with nowhere to go, but within a few days I was invited by Mark Boxer to do an undemanding editorial and occasionally writing job on the brand-new *Sunday Times Colour Magazine*, a job which later grew, under Godfrey Smith, into a demanding one, but not as demanding as regular writing, and much more diverting.

A high proportion of the pieces chosen for this book have turned out to be among those written for the *New Statesman*. The Literary Editor in 1960–62, Karl Miller – for whom I worked again long after on the *London Review of Books* – was the best sub-editor I have ever had. He invariably improved the writing, partly because he was himself a subtle writer, partly because he got the balance exactly right between intervention and non-intervention. Some editors are diffident to a fault. J. R. Ackerley, Literary Editor of *The Listener* as well as one of the most luminous prose stylists of our time, would send me an apologetic postcard if he added or removed a comma, whereas I always longed for him to iron out all my clumsiness. On the other hand, when typical American sub-editors argue the numerous changes they want, they make you feel like a good Catholic girl on a date. They probe you here, they grope you there, insinuate themselves elsewhere; when you protect yourself in one place, they paw you in another; when you protest, they tell you what to do to give them pleasure and use emotional blackmail till you do; it's all a long struggle to preserve a shred of your virginity. And yet they're somehow so endearing in their desire for logic and intelligibility that you feel quite guilty about your anger. The worst villainy occurs when they bypass consultation. It's like having been abused while asleep. You wake up and find sentences totally rewritten, missing the point and losing the rhythm. I suggest that the American culture respects idiosyncrasy and obscurity when it knows it is dealing with Poetry or Art but is reluctant to admit that such lower forms of life as critical prose or historical prose may also partake a little of the character of poetry and might therefore also be licensed not to conform. As things are, the insistence on

conformity is so demented that it includes making professional writers obey schoolroom rules such as always giving somebody's full name the first time they are mentioned in an essay, oblivious to the facts that 'Greta Garbo' or 'Pablo Picasso' don't sound the same as 'Garbo' or 'Picasso', don't mean the same as 'Garbo' or 'Picasso' and are rather an insult to Garbo and Picasso. Had Swift – sorry! Jonathan Swift – or Dante – oops! Dante Alighieri – been subjected to American editing, there would surely have been an additional island in *Gulliver's Travels*, a further circle in Hell.

I am fairly sure that the best thinking I did in the Fifties never got into print. It went into aborted writing and undeveloped notes, particularly in connection with a book to be called *The Eye and the I*; it went into seminars at the Slade School and the RCA at which Bacon or Sutherland as well as artists on the teaching staff would drop in; it went into private conversation with artists and writers, above all Rodrigo Moynihan and Andrew Forge. The talk was partly about contemporary art. It was partly about photography: indeed, it was predominantly about photography, I think, and one of my great sadnesses in regard to this book – and to everything else I have published – is that it contains virtually no traces of all that talk. The talk was also about French painting of the second half of the nineteenth century, which was posing many questions that seemed to be extremely urgent. The Courbet revival was a central issue, and I gave a carefully worked lecture at the Slade School in 1953 which sought, above all, to demonstrate that Courbet was much more indebted to art, even Italian art, than he liked to admit. Cézanne was a very constant preoccupation, because Cézanne sits there behind discourse on modern art as the Montagne Sainte-Victoire sits there behind the flat expanses of land in his pictures. But Monet was a still more obsessive subject, since he was in the process of being rediscovered and revalued.

My published work also failed, and goes on failing, to reflect the time spent in looking at old art – not only European old masters but also antiquities, classical and pre-classical, and tribal art and, since 1970, Islamic art and, since 1990, Hindu art – time which far exceeds the amount spent on looking at the subjects of my published work. During my first visit to Greece, in 1958, I filled notebooks with thoughts about architecture as well as art; I have not looked at them

since. My published writing about pre-nineteenth-century art has included only one substantial piece – a long essay 'On Western Attitudes to Eastern Carpets', written in 1972, and this was more a study in the history of nineteenth-century European taste than an investigation of the objects themselves. There have also been a few very short texts on artists such as Giotto, Michelangelo, Titian and Velázquez. I wish I had had the nerve to write more about old masters. But I feel a still greater disappointment over my silence since 1951 about modern architecture, especially as some of the best contemporary architecture has been needing all the polemical help it could get. I particularly regret my silence about Le Corbusier, the greatest visual genius of this century apart from Picasso.

While avoiding subjects of this seriousness I did in the course of the 1950s enlarge my scope by writing frequent, mostly short, pieces in two areas which had obsessed me from the time I was about eight. These were ball games and motion pictures. Alan Ross, the poet, who was both cricket and soccer correspondent of the *Observer*, at that time the best English Sunday paper, generously asked me if I would like to do some reporting on both these games (Michael Davie, the Sports Editor, liked to use surprising reporters, such as A.J. Ayer and John Sparrow), and for some years I spent my Saturdays doing this with great involvement. Apart from the pleasure of being present at splendid contests all around the country, the task of writing against the clock about highly formalised yet dramatically unpredictable activities while trying not to lapse into cliché was the most testing literary exercise I have undergone.

In contrast with sports writing, film criticism was more than just an opportunity to write about a domain that obsessed me; it was political. It is the one branch of writing I have embarked on with a sense of mission. My purpose, nursed since the mid-1940s, was to subvert the complacent standards of the caucus of highbrow and middlebrow writers on film. While happy to accept that films had been made which in intention and achievement were works of art – notably films by Eisenstein, Pabst, Dreyer, Buñuel, Renoir, Preston Sturges and Rossellini – I believed that apart from such rare exceptions films should be judged as entertainment, and that treating directors like Hitchcock, Ford and Carné as artists was putting a load upon them

that they were not meant to bear. I believed that the cult of the director among film critics was a distortion of the culture of the movies. Films were about stars: people went to the cinema to see stars, to be thrilled by their glamour and to involve themselves emotionally and intellectually in the evolving interplay between repetition, variation and aberration in the choice of the parts they played. In short, I believed that films were artefacts made in Hollywood and that other films, while they might be more intelligent and more moving, were not the real thing. I knew that this position was to some degree absurd, but it was forced upon me by the lamentable way in which film criticism was practised in publications read by the educated, and I was determined that, if I were ever to write film criticism, I would write it *as if* that position were entirely tenable.

I got my chance when Irving Kristol, knowing that I spent more time in cinemas than in art galleries, suggested in 1954 that I might try writing some film reviews for *Encounter*. Shortly after this, *Them!* was released – a frightening, imaginative, beautifully written B-movie-style S F film about giant ants, exactly the sort of film the professional critics could be guaranteed not to latch on to – and Kristol had the courage to publish a lengthy review. I went on writing pieces for *Encounter* about S F films and trashy social comedies and musicals, with the result that in 1955 it became, I think, the first highbrow magazine to publish an article devoted to Marilyn Monroe. I also took every possible opportunity to do film pieces elsewhere. I stopped in 1967 (except for recently writing a tribute to that great film critic David Thomson). I like being able to watch films, as I like being able to listen to music, without having to think of things to say.

Meanwhile my writing about art had become increasingly concerned with American art. Early in 1959 I finally saw a representative selection of abstract expressionist painting when an exhibition of seventeen artists circulated by the Museum of Modern Art came to the Tate. I wrote a long, totally committed text which I gave as a talk on the Third Programme but desisted from publishing because it seemed too provisional. Early in 1960 I visited the USA for two months as a guest of the State Department, which had been persuaded by their embassy in London that I was a 'Foreign Leader'. My main ambition was to see more of the work of the Abstract Expressionists

and to visit them in their studios. I was embarrassed by the prospect of being introduced to these high Bohemians through the mediation of government officials, but when I got there a miracle happened. I had insisted on being in New York for my first few days rather than following the normal routine for Foreign Leaders of beginning in Washington, and I was therefore able to spend my first evening in America with an old girlfriend who took me to a nightspot where Charlie Mingus was playing. For my second evening I had a dinner invitation from Irving Kirstol, now returned home. Irving had asked me whom I would like him to invite and I had said Harold Rosenberg. When I arrived I was presented to him and then to a tiny figure who suddenly emerged from behind his great frame – Willem de Kooning. After dinner, as we entered the elevator, de Kooning proposed we repair to the Cedar Bar. There he introduced me to Franz Kline, David Smith and Philip Guston among others. The night concluded at 7 a.m. after a Chinese meal and a drive round Manhattan Island with Guston. It had, of course, been like the evening *chez* Kahnweiler in transforming my life.

An immediate consequence was that during my stay I recorded interviews in the offices of the BBC on Fifth Avenue with de Kooning, Smith, Kline, Guston, Motherwell and Gottlieb. (Rothko always refused to make a tape with me even though he was the artist with whom I became friendliest; I didn't interview Newman till several years later, or even call on him, because I was too dense at first to appreciate his importance.) This satisfying coup was but a small part of what made the next two months the most exciting of my life. The State Department's invitation generously encouraged one to go anywhere and everywhere expenses paid, but, save for a couple of weeks divided between Washington, Los Angeles and San Francisco, I couldn't bear to leave New York.

Much of my New York experience wasn't really lived in the present. The streets, the elevators, the dolls, the delis, the cab-drivers (then mostly men of the Left), the jazz (especially Max Roach) and the Chelsea Hotel (where David Smith found me a huge dusty room) were actual. But the art I was involved in was in the past. Though Pollock was dead and most of his peers had already done their best work, I didn't just spend time with Abstract Expressionists, I identi-

fied with their standpoint, taking little interest in what my contemporaries were doing. This was partly because of an antipathy I felt towards most of those I happened to meet – chest-thumping second-generation Abstract Expressionists who were sickeningly mindless. But my lack of awareness can't be blamed on social circumstance. Though I did warm to the work of Ellsworth Kelly and Kenneth Noland, I managed to see a Rauschenberg show at Castelli's and like it without beginning to realise how good it was. I also lacked the curiosity to see works by the young artist whose name, Jasper Johns, was on everyone's lips and was whispered with trepidation by Abstract Expressionists.

I longed, of course, to settle in New York, and I let it be known that, as the current art critic of *Time* was soon to move on, I would love to succeed him. (My growing pro-Americanism had for some time even included a taste for *Time*'s house style.) A couple of years later I was approached about the possibility of becoming art critic of the *Washington Post* and said I would love that if I could spend about four days of every week in New York; I heard nothing more. It must have been through lack of funds – I had a wife and three children to support – that I didn't return to the USA until 1965. By then I had discovered, through work seen in Europe and in reproduction, Johns and Rauschenberg and Lichtenstein and Oldenburg. I hadn't got on to Warhol at that stage, but in 1967–68, when teaching at Swarthmore for a year, I was maintaining that the future was his.

Meanwhile I had had the luck in 1964 to meet both Rauschenberg and Johns in London and had been invited by Johns to come and stay at Edisto Beach in South Carolina and also to use his empty apartment at Riverside Drive. On later visits I stayed there with him. I don't think I have ever met anyone who was intellectually more exacting and more stimulating. And his is one of many extremely articulate minds among the New York artists of his generation and the next. Living in London, my heart and head have been in New York. The city itself is the most variedly beautiful place I know and feels more and more so. Still, I tend to look back with nostalgia to the days of Pop and Minimalism, outwardly different, closely related. I suppose that anyone at any time who has watched new art unfold throughout his adult life has had a feeling that among the passing movements there

was one which was made for him. For me it was Minimalism. I felt
at home with it, felt I might have invented it. Yet I have totally failed
to write about it. My only substantial article in the area has been the
one reprinted here about Robert Morris's *Box with the Sound of its
Own Making*, a work I was able to treat as a piece of Conceptual Art.
And the problem has continued with related phenomena that have
moved me, such as Walter de Maria's *Lightning Field* and the ultra-
Minimalist sculpture of Fred Sandback. Sandback can transfix and
subjugate me with a length of twine strung across a corner of a room,
but I have not found a way to write about the experience. But neither
have I succeeded with even more crucial experiences provided by
Beuys and Nam June Paik, say. Such failures could be either an effect
or a cause of the diminution in my published output of art criticism.
In the mid-1960s I started doing less of this and more teaching, edit-
ing, sitting on committees, curating exhibitions, interviewing artists,
making art films.

The attraction of teaching – both art history students and art
students – is partly the feedback of ideas and the constant stimulus of
other minds, partly that it involves discourse which requires tenta-
tiveness rather than encourages patness. The attraction of editing is
that it is much easier but equally gratifying at the time of a birth to be
a father than a mother. The attraction of serving on committees is
that one can influence events – the purchases of works, the choice of
artists for exhibitions – far more than one can by writing in the press.
The attraction of curating exhibitions is that it is more rewarding to
manipulate the works of art themselves than it is to try and talk about
them. The trouble with discourse is that one almost always either says
too little and goes nowhere or says too much and makes statements
that are beside the point. This is why since 1970 I have not written
substantial texts in the catalogues of most of the exhibitions I have
worked on: I have wanted to preserve my illusion that in curating I am
helping the artist's work to speak for itself. The attraction of inter-
viewing is that here one has the illusion that one is helping the artist
to speak for himself. The attraction of making art films is that it is
exhilarating to try and create a *Gesamtkunstwerk*; alas, the effort
usually ends in frustration because film-making tends to demand so
many compromises.

But all those activities do not explain why there is only one piece in this book – and that a short one – written between 1970 and 1986. From 1967 on, more than half my working life for more than a quarter of a century was taken over by René Magritte. I had first written in praise of Magritte in 1950 and 1954, had then done an exhibition review in 1961 (reproduced here) that identified him, prophetically, as the great popular artist of our time – which was, of course a double-edged tribute. But when I came to know Jasper Johns in 1965, I was impressed by his unaffected admiration for Magritte. Then, at the end of that year, when I was visiting Mark Rothko, he suddenly said: 'Magritte, of course, is a case apart, but there's a certain quality in his work which I find in all the abstract painting that I like. And I hope that my own painting has that quality.' Perhaps he said it then because a Magritte retrospective was just being hung at the Modern. I was let in to that show for a glimpse later that day, as I was leaving America on the morrow. The consequence was that a few weeks later I proposed to a relevant committee in London that a Magritte retrospective there was overdue. I was asked, to my surprise, to curate one myself for the Tate and to do the catalogue (an extract from which is reprinted here). I had started to work on the show and was about to go and talk to Magritte – whom I had never met save for a handshake at a party – when he died in the summer of 1967. The show, which opened early in 1969, was innovatory, firstly because the selection strongly favoured the early work, and secondly because I had small claustrophobic rooms constructed so that the pictures could be hung one or two to a wall instead of being strung out along the length of a gallery. I was also able to benefit from the presence of the pictures to make a half-hour film, photographed and produced by Bruce Beresford, scripted and directed by myself, *Magritte: The False Mirror*.

Later in the year I was persuaded by Jean and Dominique de Menil to undertake a *catalogue raisonné* accompanied by a critical-biographical study. While working on the project, I co-curated two major retrospectives. The monograph was published in 1992, and the five volumes of the *catalogue raisonné* in 1992–97. I was co-author with Sarah Whitfield of three volumes as well as editor of the set.

A reluctance I had felt strongly to take on this labour had been

cancelled out by a desire to contrive a *catalogue raisonné* that had a rational and serviceable structure. Whatever the structure, though, working in the genre is blighted by a built-in flaw which virtually guarantees extreme boredom – that the same scholarly care and triple-checking, the same amount of energy and patience, are demanded for the artist's mediocre works as for his inspired works, which in Magritte's case were about one work in ten.

A compensation for all the labour was that it did succeed in clarifying the muddle over datings. Another was reaching an original and satisfactory solution to the crucial problem of reconciling two conflicting requirements in users of a *catalogue raisonné*: the need to look up individual works without missing any relevant information; and the need to follow the unfolding of the artist's development without being held up by the repetition of information. And then compilation of the catalogue helped with the monograph – and this was a book made worthwhile by its argument that Magritte was more of a painter, less purely an image-maker, than his enemies and his friends supposed. And I still love the work; but the fact remains that I spent years of my life, like Swann, on someone who was not my type.

The Magritte years, then, divide the book into two eras. But both are dominated by the same question, the most banal and persistent question in art-critical debate for nearly a hundred years now. It is not even the question of Picasso versus Matisse, for even at those times when Matisse seems the greater, Picasso himself is still the question, probably because Matisse is a great artist in the same sort of way as many great artists of the past, whereas Picasso is a kind of artist who couldn't have existed before this century, since his art is a celebration of this century's introduction of a totally promiscuous eclecticism into the practice of art. In any event, Picasso *is* the issue, Picasso is the one to beat, Picasso is the fastest gun in the West, the one every budding gunfighter has to beat to the draw in order to prove himself. And for those of us who are not involved in the life-and-death struggle of the game of art but only in the sham heroics of the game of criticism, Picasso is again the one to beat. The young critic cuts his teeth on Picasso. He proves his manhood by putting down Picasso, which is

quite easy because he is so flawed an artist, is such a colossal figure that he has several parts that are clay, probably including his feet, but not his balls.

I started being hostile to Picasso in print in 1948, when I wrote that he was essentially a great sculptor and that as a painter he was not the equal of Klee or in some ways of Juan Gris. I left these judgements behind fairly soon, but in January 1953, reviewing a small Matisse exhibition at the Tate, I wrote: 'These drawings are precisely and penetratingly realistic . . . Each of them vibrates with the impact of a particular experience. Never do they lapse into generalisations and arty idealisations such as find their way into Picasso's drawings.' And I remember that while writing this review I made a resolve that my career as a critic was to be dedicated above all – even more than to promotion of a Giacometti–Bacon axis – to establishing that Matisse was a greater artist than Picasso.

Matisse's supremacy was challenged two years later by a small but intoxicating exhibition of Bonnard at the Maison de la Pensée Française in Paris. This happened to be running concurrently with a great Picasso retrospective, which included *Guernica*, at the Musée des Arts Décoratifs. 'Comparisons may be odious, but the presence of Bonnard does not so much allow as *force* us to see Picasso in perspective. And in this perspective Picasso appears a superficial draughtsman, a very limited colourist, and a painter whose handling of the medium may often be brilliant or delicate but has not got mystery. Yet there remains a radiant, a miraculous, a god-like, capacity to invent forms which ravish our senses, to create a new canon of ideal beauty. His most violent distortions, it seems to me, so far from having a grotesque or alarming effect – and this applies even to *Guernica* – strike one as highly desirable improvements on nature.' The odious comparisons were producing the same preference for Bonnard and Matisse when I wrote a long review of the Picasso retrospective at the Tate in 1960 (reprinted here). My standpoint was undoubtedly much influenced by devotion to Giacometti's work and approach. Picasso was a quintessential finder, Giacometti a quintessential seeker, and it seemed more virtuous to be the latter.

Pieces from throughout the 1960s reflect a continuing attachment to Matisse and Bonnard and also an increasing appreciation of

Mondrian. But I did publish an unbridled eulogy of Picasso's sculpture, occasioned by the great retrospective of it in 1967 shown in Paris, London and New York. The most interesting passage was on the bronze *Death's Head* of 1943: 'From most points of view the *Death's Head* is peaceful, resigned, lies there like a stone or lump of metal ore, makes death a fact like any other. Until one gets to the point where one is facing both its eyes. Suddenly it is alive and most horrible. It's the distance between the eyes that does it, the appalling unnatural width of the space between. It is as if the eyes had been wrenched apart and one feels one's own being wrenched apart in the effort to look each eye in the eye. One recalls those hallucinatory gas masks of the First World War. Is it these associations that make these as sinister as they seem or is it their design, the blank dislocated gaze of those round wide-apart goggles? The sockets of the *Death's Head* glare with a look of accusation. The face has something too of the aspect of those paralyzed faces in medical text-books. It is not a dead face, but a face struggling with death.'

I did not, however, write then about some Picasso paintings of the mid-Sixties that greatly impressed me, for I didn't see the late work in quantity until the exhibition at the Basle Kunstmuseum in the autumn of 1981. This made me long to do an exhibition myself of the late work, a hope that came to be realised largely because of the friendship with the Leirises that had been initiated on that momentous evening in 1948. I co-curated the exhibition in 1988 at both the Pompidou and the Tate. (What I wrote at the time is reprinted here.)

Working on a Picasso show was a help towards accepting his genius rather than resenting it. I began to understand how the great pieces redeemed the poor ones – how they needed the poor ones to clear the way for them. I began to see that, if the great pieces were not great enough – because, as I complained in 1960, they were not taken far enough – there was an interaction between pieces that added a further dimension to the work as a whole. Anyway, were they really not taken far enough? I finally came to my senses about how far they could be taken working rapidly when in 1992 I saw *Guernica* at the Museo Reina Sofia, saw it, not as one used to at MoMA, coming upon it sideways, casually – and treating it rather casually, almost patronis-

ingly, like the *Mona Lisa* – but slowly approaching it head on. 'The frenzied, helpless, agonized gestures of the figures, cutting through space in every direction, are locked together – like the pieces of a jigsaw – so that they are held in a terrible stillness which the explosive force in every inch of the design is endlessly trying to break through. It is only in responding to this tension between irresistible force and immovable structure that I have started to perceive the scale of the imaginative genius that underlies the iconography, its choice and placing of actors and props, each functioning both as phenomenon and as symbol – the bull, the dying horse, the bird, the flower, the light bulb, the fallen warrior with a broken sword, the woman mourning a dead child, the woman falling from a burning house, the woman rushing across the scene holding a lamp – worked out within a few weeks of the air raid with a conviction that gives it the air of inevitability of a classic religious iconography.'

Coming to see what was there in Picasso happened through realising that it may be more generous to find than it is to seek. I had been freed to accept this by a certain amount of disappointment in the major Giacometti retrospective at Saint Paul de Vence in 1978. The sculptures up to 1956 had retained all their magic, but in the subsequent works it seemed that there was not the previous perfect reconciliation between the demands of trapping appearance and those of achieving structural clarity; the pent-up violence and the power to dominate space were greatly diminished. And the paintings from the mid-1950s on seemed to have suffered a loss of mystery and luminosity. The drawings, on the other hand, seemed to have got more and more marvellous. Was it relevant that the drawings, unlike the sculptures and paintings, did not invariably take a frontal view of the subject, and in any case dealt with a wide variety of subjects? Perhaps the diminution of energy and mystery in the sculpture and paintings had been brought about by the repetitiveness of the interminable attempt to take a rigorously frontal view of the model and concentrate totally on getting a likeness to it. Seeking had become – what it never had with Cézanne, say, or with Mondrian – fetishistic.

One day (according to Maurice Jardot) Picasso told Michel Leiris that he felt that the work of their old friend Giacometti was becoming increasingly monotonous and repetitive. Trying to explain and

excuse this, Leiris spoke of Giacometti's consuming and intense desire 'to find a new solution to the problem of figuration'. Picasso answered: 'In the first place there isn't any solution, there never is a solution, and that's as it should be.'

LATE KLEE

Klee – I
<div align="right">1948</div>

Entitled 'Auguries of Experience', this piece about Paul Klee's late work – 1937–38 to his death in 1940 – was written in Paris during or just after the retrospective at the Musée National d'Art Moderne in February 1948. It was published in *Tiger's Eye: on Arts and Letters*, no. 6, December 1948, placed in a symposium on 'What is Sublime in Art?'. A few words have been changed.

The last works of Klee undermine your perceptual habits. Their motifs are germinal motifs of the physical world. A motif may be geometric, or it may be a diagram of an object, or it may be a telescoped image of diverse objects. But all become ideograms of movement in nature.

The movement of the motifs themselves defines the fluid space they inhabit.

Macrocosm in microcosm, the world in a grain of sand, the defeat of the anthropocentric.

These are pictures without a focal point. They cannot be seen by a static eye, for to look at the whole surface simultaneously, arranged about its centre – or any other point which at first seems a possible focal point – is to encounter an attractive chaos. The eye must not rest, it must allow itself to be forced away from the centre to find a point at which it can enter the composition – there are usually many such points, most of them near the edge – and so journey through the picture, 'taking a walk with a line'.

Even the most diffuse compositions in the Renaissance tradition lead the eye to a single, usually central, point of focus, a point at which

all formal and spatial relations are concentrated. If any points in a Klee are outstanding, they are not points of arrival but points of departure. Their predominance is therefore ephemeral. In the long run, all points are of equal importance. Indeed, they are of no individual importance because they are only stages, fixed by an arbitrary choice, in the journey which is the reality.

Tonal music always reverts to a home tonic; thus also, a painting in the tradition of the Renaissance returns to its point of arrival. Every note of the atonal scale is equally important; likewise each point in a Klee, whose point of departure corresponds to the first note of a tone-row.

In a late Klee, every point of arrival at once becomes a point of departure. The journey is unending.

Many of Klee's later paintings, like most of the earlier ones, have 'literary' titles. But the title is never a frame to the content, only its point of departure. As there are points of departure to the composition, from which the journey through the form begins, the title denotes a point of departure in your previous experience from which a journey through memory begins. As the physical point of departure is near the edge of the composition, the title's meaning is near the edge of the total significance of the picture. As the composition has no single point of focus, the content is never a single object or emotion or idea. Composition is distributed equably anywhere, content absorbs experience from everywhere – both as agglomeration of distinct memories and as elucidation of the common, germinal elements and movements of the remembered physical world.

In journeying through a Klee you cultivate it. It grows because it is an organism, not a constructed form. Klee's method of composition is diametrically opposed to that of the Renaissance, and therefore Picasso. For a Renaissance painting is a constructed form, it is architectural, that is: it is three-dimensional; it has a foundation of symmetry, affirmed or negated; it has a specific focal point, a point of arrival. Klee's affinities are with Mexican picture-writing, Egyptian hieroglyphics, Sumerian cuneiform signs, Chinese ideograms, and German Gothic illumination.

The order of an architecturally composed picture is apparent from

the start. The evident order of a Klee is only in the parts, as with a landscape, a forest, a hedge, a crowd of people. To find an overall order, you must look for it yourself by taking hints from the given sensation. It is useless to wait for the order to affect you. You must commune with the picture and its order will become manifest – not in space but in space-time.

A Renaissance picture is a building, an established and complete entity. A Klee is an organism in growth. A building cannot develop of itself; it can only be changed by outside forces. An organism has a future as well as a past. Likewise, a picture by Klee goes on becoming not only while he cultivated it but while you cultivate it. Obviously you need time to understand any picture, but when you have looked at a Renaissance painting for years it is only you and not the picture that has changed. To look at a Klee over a period of time is not to acquire a deeper understanding of the finished thing but to observe and assist in its growth.

A Renaissance picture is a scene set before your eyes. A Klee is a landscape through which you journey. Of the first you are a spectator, in the second you are a participant. One moves you to exaltation, the other to communion.

To speak of communion with and participation in a Klee is not to speak simply of empathy. You can 'feel-into' a scene of which you are the spectator; empathy occurs in every aesthetic experience. It is in a more particular sense that you commune with a Klee.

A Renaissance painting is a room with one wall eliminated, as on a stage, or a church the façade of which is missing. To 'feel-into' it is to explore those perspectives already visible from outside. A late Klee is the face of a cliff. To 'feel-into' it is to clamber over it. In the former case, you move about untouched; you can touch or caress the forms, but they remain as unyielding as statues. With a Klee, the relationship between the picture and yourself is reciprocal; you touch a loose rock with your foot, it falls from under you and you are left dangling in space. You are part of it as you are part of the sea when you go swimming; you plough your way through it and, in turn, are buffeted by the waves – lines continually changing in plane and direction. For the picture is always changing, always becoming. 'Character: movement.

Only the dead point is timeless. In the universe too movement is taken for granted. Stillness on earth is an accidental stopping of matter. It would be a deception to consider it primary.' In Klee's world motion is primary. It is a world of space-time.

A Renaissance picture has a beginning and an end. In a late Klee, the end is the beginning. The picture is limitless, like space and time. 'Art plays an unwitting game with ultimate things, yet reaches them nevertheless.'

Klee – II *1950*

This essay written for *Les Temps Modernes* was worked on from early 1949 to the autumn of 1950. It appeared in the issue for January 1951 in a version by Monique Roman entitled 'Paul Klee. La Période de Berne'. Not previously published in English, it is reproduced here with revisions made at some time in the 1950s or 1960s.

The majority of the pictures painted by Klee between his return from Germany to Berne in 1933 and his death in 1940 consist of bold linear signs of an ideogrammatic character scattered haphazardly – or so it seems – over a brightly coloured surface: this agglomeration of signs has neither a beginning and end, since it looks as though it could go on beyond the borders of the canvas or paper, nor an axis, a focal point on which the eye can come to rest so as to see the picture, disposed about that point, as an ordered whole. In short, such a picture could be an abritrarily isolated fragment of a decorative pattern. And, indeed, these late works of Klee's are thought by many of his admirers to be little more than decorative by comparison with his earlier work.

Let us consider, however, what can happen to this picture if the spectator looks into it more closely. Confronted by an incoherent maze, or in some cases a confusing dance of colours, dazzling as the rotating clubs and balls of a juggler, he tries to make sense of it by fixing his eye on a focal point towards which all the signs are orientated. He is prepared for difficulties, for he has had some experience of late

analytical cubist pictures, with their elusive focal points which have to be searched for before the image as a whole, grasped in relation to that point, becomes stable and legible. Nevertheless, in the case of the cubist pictures, a focal point had invariably emerged in the long run. Certainly, cubist paintings may have no focal point in the sense Giedion gives the term when he says they have none, for he speaks of 'lines of perspective which converge to a single focal point': he is using the term to mean a vanishing point. At the same time it has also been suggested that Cubist paintings have no focal point in the sense of a point around which the whole composition is disposed, as by Gertrude Stein when she wrote of an analytical cubist Picasso that 'the composition was not a composition in which there was one man in the centre surrounded by a lot of other men but a composition that had neither a beginning nor an end, a composition of which one corner was as important as another corner, in fact the composition of cubism'. Now, this may be all very true so long as the composition is looked at as if it were abstract, but, as soon as an attempt is made to read it, the need to find a focal point arises, and the need is always satisfied.

A late Klee, on the other hand, really is like the composition described by Gertrude Stein: every point is as crucial as every other, and there is never a point on which the spectator's eye is allowed finally to come to rest. Whatever sign it tries to come to rest upon, it is never able to take in the picture as a whole. And when it tries to grasp the part of the picture that eluded it, it is deflected towards some other sign and goes through the same process again. Soon the spectator finds that this movement of his eye from sign to sign is pulling him, in imagination, into the picture. He yields to this magnetic pull, enters the picture at some point and begins to move about within it. It is then that the picture begins to be legible and articulate. He encounters a sign and stops, then moves along it and finds that it indicates the direction he must take next, the sign he must next encounter. So he continues on his way, often returning to a sign already visited to find that it now means something other than what it meant when approached previously from a different direction. What forces him to go on circulating in the picture, constantly setting off in new directions, is that many of the marginal signs, though they point a way out

of the picture, so that the continuation of the structure beyond its actual borders is suggested, also indicate a direction back into the picture other than that by which they were reached.

What has been said so far could also apply, more or less, to certain decorative designs – say, the four large panels on Oceanic themes recently designed by Matisse, which bear a marked, but superficial, resemblance to many pictures of Klee's Berne period. If, however, the works by Klee were decorative designs in conception, they could be seen only part by part. Indeed, not only decorations but pictures without a focal point – such as friezes, certain Gothic tapestries and some of Miró's paintings – can usually be seen only as the sum of their parts, since the absence of a focal point precludes the spectator's confronting them as ordered wholes. This is not so with a Klee, as we shall see, and the reason why it is not so constitutes Klee's great contribution to the art of composition.

Although a late Klee has no focal point and is not enclosed by its frame, the composition is nevertheless integrated in so far as the elimination of any part would cause the whole to function differently. And the way in which it would function differently reveals by what principle it is unified. If one of the signs in a late Klee is concealed from view, one of the other signs becomes a focal point for what remains and the interplay of the movement of the signs is disrupted. It follows that the unity of the picture consists not in a balance of *masses* but in an equipoise of *forces*. It is the combinations and oppositions, tensions and relaxations between the directions in which the various signs give the illusion of moving that determine the very delicate unity of the whole. Now, the movement and direction of the signs are so regulated that the total equipoise can be apprehended from any point in the picture: the spectator, situated in imagination on one of these signs, can sense the convergence towards him or recession from him of each of the other signs – that is, the interplay of movement which surrounds him. In other words, wherever he is, the picture finds its focus in him. He becomes in a sense the focal point. And it is by this means that he apprehends the whole. All this implies that when the spectator explores a Klee, he does not merely get a close-up of an image which he had already seen as a whole, any more than he reads it bit by bit: he sees what was previously a decorative pattern as an articulate image. It

follows that, while the spectator *may* project himself into any picture, he *must* project himself into a late Klee.

To what extent is this imperative applicable to Klee's work prior to 1933? It applies to some works but not to the majority. In no work of the Berne period is a magnetic pull drawing the spectator into the picture exercised more strongly than in those drawings of the 1920s (often representing gardens) in which the paper is covered by hundreds of evenly-spaced lines, giving the effect of basketwork. The forms, when the spectator moves in imagination among them, become giantesque and menacing – an experience that makes nonsense of the current notion that Klee was a miniaturist. In general, however, Klee's pictures prior to the Berne period, whether or no they have a focal point, do not have to be seen 'from within' – though they do have to be read by a roving, not a static, eye.

As the spectator moves between the signs of the Berne pictures, he feels, not that he is travelling on a surface, but that he is suspended in space and that the structure of the picture is three-dimensional. This is in spite of the fact that it contains none of the devices – linear or serial perspective, plastic colour, overlapping of forms – normally used to give an illusion of depth and space. And, indeed, no space is signified so long as the spectator confronts the picture. Yet when he projects himself into it and moves about in it, the signs situate themselves at different depths, thereby implying space. The means with which this effect is produced are novel and remarkable. They can best be explained by first examining those pictures by Klee – painted both at Berne and earlier – which might be described as polychromatic chessboards with wavering lines instead of straight ones. Since the lines are not straight, the 'squares' are not rectilinear. Where one side of a 'square' is shorter than the opposite side, the operation of a perspectival effect makes it appear farther away in depth than the longer side, while the other two sides, which of course are converging, seem to be foreshortened. Thus each 'square' is now seen as an oblique plane, and since these planes slant into depth in different directions, the illusion is engendered of a warped surface, like an undulating façade. In these pictures, the unbroken succession of 'squares' combines in a single undulating surface when depth is suggested; in the pictures consisting of signs on a ground, the presence of intervals

between the signs situates them in space when depth is suggested by precisely the same means. The lines which compose the signs cease to lie flat upon the picture-plane and become oblique because, like the converging lines in the 'chessboard' pictures, they give an illusion of foreshortening, which, as before, is due to the fact that the relative lengths of the lines and the angles between them make it appear as though the lines lay at different angles of incidence – both horizontal and vertical – to the surface. As the lines of each 'square' pointed in different directions in depth, so now do the lines of each sign; and as each 'square' as a whole inclined in a different direction in depth from the next 'square', so now does the overall reaction of each sign differ from that of the next.

So far we have merely described an elementary optical effect which must inevitably operate to some extent whenever a surface is covered with lines other than the pure reticulation of a Mondrian. And this effect only gives the signs the illusion of existing in space. Something more is needed before the signs – and not only their extremities – seem to be located at a variety of depths. This comes about when the spectator journeys through the picture. We have seen that, when the spectator moves, he travels along a sign and then follows the direction it indicates until he reaches the next sign. But, since each sign signifies a foreshortened form, the spectator's movement along it takes him into depth. He therefore alights on one of the extremities of the next sign at more or less the same depth as the extremity he has just left of the preceding sign. When he reaches one of the other extremities of this new sign, he has travelled in a different direction in space and reached another depth. In this way, every sign becomes positioned in depth relative to the other signs. The spectator's movement does not always take him farther into the picture's depth; it frequently brings him back: if the point at which he alights on a sign is at its near end, then his movement along it will take him farther into depth; but if this point is at the far end, his movement will bring him back towards or even beyond the picture-plane. So, while some of the signs recede into the picture, others project from it and bring space with them. When planes seem to project from the surface of a synthetic cubist picture, the effect upon the spectator confronting it is like that of a relief. In the case of a Klee, on the other hand, the spectator is in

imagination situated within the picture, so that when he is advancing into the picture along a receding sign the projecting signs seem to be *behind* him, and when he is returning along a projecting sign the receding signs seem to be behind him. He constantly feels entirely surrounded by signs and by the space, behind and in front of the picture-plane, which they define. That the signs do indeed define that space is proved by the fact that there is no illusion of space beyond the illusory depth of the farthest sign. On the other hand, it must be said that, just as the 'squares' in the 'chessboard' pictures are helped to appear oblique by the variety of their colour and tone, the three-dimensional functioning of the signs on their flat monochromatic or duochromatic ground is assisted by the intrinsic luminosity of that ground: light helps to give them spatial life. But, ultimately, the realisation of this space is due to the spectator's inhabiting it.

When the spectator explores a late Klee, each point of view, as we have seen, provides him with a different view of the whole. That is to say, the perception of the picture in time produces changes in its structure; the image develops in time. There are two senses in which any picture can be said to develop in time. Firstly, the longer the spectator contemplates it the better he understands it, and this development applies not only to the picture's content but to its structure. But the structure does not change with time, it merely becomes elucidated. This is true even of a cubist picture, whose structure may at first be as elusive as that of a Klee: though that structure is not instantly legible, it is, when it emerges, instantaneously legible. Secondly, the successive perception of the details of any picture requires time and presents different views of the image. But these are not different views of the whole. The issue is somewhat complicated by the special case of the frieze, since here the whole cannot be instantaneously perceived, but is gradually revealed as the spectator's eye traverses it. But although the frieze needs time to unfold, the structure of the whole is static. The structure of a Klee of the Berne period is dynamic. It does not require time in order to unfold, for the spectator can always perceive the whole instantaneously. But that which he perceives at a given moment is only one of its possible structures. There is no moment at which the structure is more definitive than at any other. At whatever point in it the spectator finds himself, a new

total structure is established, and, since the composition of the picture impels him to move from point to point, several structures are successively established. If the picture's structure changes in time relative to the position of the spectator within it, it can be said to function in space-time. Klee's pictorial conception in a way reflects the Theory of Relativity.

There is, of course, a certain correspondence between Relativity and Analytical Cubism, for the overlapping and juxtaposition of a multiplicity of views of an object represents the perceptions of a spectator at different stages in a promenade around the object and therefore implies the notion of space-time. On the other hand, this telescoping of images experienced at different instants renders time timeless. The main philosophical implication of Cubism is Russell's conception, expounded in *Our Knowledge of the External World* (1914), that what we call a 'thing' is a 'system of aspects': what, indeed, is an analytical cubist picture but a 'logical construction' from a series of appearances? If in contrast there is a connection with Relativity, it is an oblique one. Klee, on the contrary, introduces motion and temporal succession, and the alterations of appearances consequent upon them, into the very contemplation of the picture, which does not merely – like Cubism – imply that time exists while bringing it to a stop, but re-creates time. In 1920, Klee wrote: ' . . . the activity of the spectator is essentially a temporal one. He brings part after part into his field of vision, and in order to attune himself to a new part he must leave the preceding one. Now he stops and goes away, like the artist. If he considers it worthwhile he returns, like the artist.' This is by no means a confirmation that Klee was trying to create a spatio-temporal art; what he says here is in itself true of the contemplation of the details of any picture. But it does show that he was consciously concerned with the problem of time in visual art, while his notion of the spectator's journeying through the picture like the artist journeying through nature implies that he thought it necessary for the spectator to project himself into the picture, to inhabit it.

The linear signs which Klee used during the Berne period were indispensable to his methods of composition and of signifying space, for reasons too obvious to need stating. The great danger of using emblems so elementary was that they might become diagrammatic,

but this was precluded by Klee's uncanny acuteness and subtlety of observation. It enabled him to grasp, and to communicate in even this most economical language, an attribute of objects whose expression guaranteed the evocation of both their vitality and their personality – namely, their movement. Klee crystallised every kind of movement with a miraculous precision – few artists have surpassed him in the rendering of the checked, the inhibited, gesture – and made all sorts and conditions of things and creatures live again in the form of their typical action.

But if Klee had a genius for creating signs which immediately establish the identity of the object they signify, he was also unsurpassed in the creation of signs with multiple significations, that is, signs which signify two or more species of objects by abstracting and exhibiting their common features. Among Klee's linear signs of this kind are one that is both flower and musical note, one that is boat and insect, one that is nipple and eye, one that is dying water lily and snail, one that is tree and archer, another that is tree and ostrich, another that is tree and antennae of a butterfly. No other artist has used the *multi-evocative sign* – and the device was not only one of the essential features of Surrealism, but has also been used at times by Picasso and Braque, among others – to establish associations so unconventional and unexpected or to make his associations appear so inevitable.

Klee also created signs which might be considered non-figurative but for their being so pregnant with a sense of nature and growth in general that they can be read as multi-evocative signs at so high a level of abstraction that they do not just signify two or three objects, but establish essential forms capable of elaboration into signs beyond number. Not all Klee's signs of this kind are superficially non-figurative: some of them signify a specific class of objects – for example, pronged twigs – and then their meaning beyond this level persuades us that this object is the basis of a host of more complex ones. The creation of such signs corresponds precisely with Klee's aspiration to 'approach the secret place where the primordial law nourishes all developments': they could therefore be called *primordial signs*. They should not, on this account, be confused with those products of automatism which have primeval significations, such as forms of Arp with plasmic associations and early pictures by Kandinsky which

evoke bacteria seen through the microscope. These are no more than evocations of actual primitive organisms, whereas the primordial signs of Klee are not at all evocative of primeval slime but infinitely suggestive of nature as a whole. The primordial signs usually appear in conjunction with simple and multi-evocative signs, but sometimes a whole picture is composed of them – for example, *Harmonised combat* (1937), in which quick black lines, some straight, some pronged, dancing on a red and yellow ground that is light itself, evoke the movement of all things that have ever moved concertedly in space, constantly threatening to collide and destroy one another, whether men, animals, fishes, birds, leaves, waves or comets. The splendour of this conception lies not so much in the breadth of suggestion of these forms, as in the fact that this breadth of suggestion conveys an idea of the universality of the forces which those forms manifest. Here Klee shows what he meant when, thirty years earlier, he wrote: 'I seek out a remote point, the origin of creation, at which I divine a kind of formula serving, at one and the same time, for man, animal, plant, earth, fire, water, air, and all the rotating forces.'

This statement not only confirms our interpretation of one element of Klee's pictorial vocabulary, but provides a key to the meaning and purpose of his language as a whole. What it suggests is that Klee was concerned not so much with objects as with the conditions under which they exist and the forces which act in and upon them. This, indeed, is the burthen of all Klee's writings. So it must surely have been because he was less concerned with the objects that man experiences than with the process of experiencing them that, in most of his works of the Berne period, Klee juxtaposed signs for a variety of objects which could never be juxtaposed within the field of vision but could certainly be met with in the course of a few hours in a normal day. The function in this system of the multi-evocative signs is to draw attention to resemblances between diverse objects, just as in life one kind of object frequently reminds us of another, seen some time beforehand, while that of the primordial signs is to reveal elements common to a wide range of experiences, just as in life we seek to generalise from particular events as to the nature of existence. Where primordial signs predominate in a picture, this, as we have seen in the case of *Harmonised combat*, tends to become a comment on the world

in general; where multi-evocative signs predominate, it may well be that Klee intended to depict the dream-world or memory, where the identity of objects is uncertain and things are frequently transformed into other things or in which an object is two objects telescoped into one. This interpretation seems applicable to *Intention* (1938). The canvas is divided by an irregular perpendicular into two sections, the right-hand section, which occupies two-thirds of the whole, having a light red ground and the left-hand section a dark red ground. At the top left corner of the lighter section a staring eye is depicted on a far larger scale than all the other signs in the picture: it is surely meant to be the eye which sees the multifarious objects around it. In the darker section, the linear signs are far more sinuous in drawing than the angular signs in the lighter section, and this makes them move slowly, as in a dream. Although signs with single significations are juxtaposed with multi-evocative signs in both sections, the meaning of the signs in the darker section is more mysterious than in the lighter. It can only be concluded that *Intention* represents the continuum of human experience, perhaps dreaming and waking, perhaps past and future.

Now it becomes clear why Klee composed his last pictures as he did. His iconography presents a succession of objects appearing in a period of the continuum of experience. Analogously, the spectator encounters the signs successively in journeying through a composition which, being unlimited by its frame, is like a period of a continuum; which changes in structure as the spectator moves through it in time; in which space is created by the movement of the spectator; and of which the spectator is always the focal point. The picture is a scheme of the stream of consciousness, and the spectator must project himself into it because reading it consists in identifying oneself with that stream of consciousness. Klee's last works are a crystallisation of human experience conceived as process and viewed from within.

POST-WAR

End of the Streamlined Era 1955

'End of the Streamlined Era in Painting and Sculpture', the nearest thing to a personal manifesto that I had so far published, appeared on 2 August 1955 in *The Times* under the by-line 'From a Correspondent'.

The most obvious difference between the art of today and the art of the inter-war period is that rough surfaces have taken the place of smooth ones. Two decades ago the current ideal was a streamlined finish, clean, precise, immaculate; the present age delights in texture and irregularity, exploits the accidental, courts imperfection. This difference obtains both in painting and in sculpture, and in styles ranging from the purely abstract to the naturalistic.

It is a difference that concerns superficies, but its implications and their import are profound. For this change in the treatment of the surface reflects a change in the whole orientation of art, and not only of art. Yesterday's taste for smooth surfaces was the outward sign of an aspiration to order and impersonality, today's taste for rough ones that of an aspiration to freedom and singularity.

Where the surface is smooth its function is to be no more than a transparent envelope for precisely defined forms and colours on which no trace remains of the gestures of the human hand that put them there. The suggestions of fallibility that accompany any trace of human action are excluded. Thus – to consider two entirely different types of painting which none the less are both highly characteristic of the inter-war period – the smoothness of the paint in M. Dali's pictures combines with their scrupulous rendering of minute detail to suggest that they are products of colour-photography, while the

smoothness of the paint in M. Léger's pictures combines with their highly schematic forms to suggest that the shapes have been drawn and the colour applied by the impersonal workings of a machine.

The geometric constructions of the Constructivist sculptors likewise rejoice in immaculate surfaces, and the fact that the actual materials are metals and plastics gives them the illusion of being entirely machine-made. This abnegation of individuality, as expressed in the idiosyncrasies of personal gestures, doubtless corresponded to the collectivist ideals of the advanced political thinking of the period. There is an affinity between the so-called machine aesthetic and Sidney Webb's belief that 'the perfect and fitting development of each individual is not necessarily the utmost and highest cultivation of his own personality, but the filling, in the best possible way, of his humble function in the great social machine'.

In the effort to surmount the disagreeable condition of being human, all too human, other artists have chosen to identify themselves, not with the robot, but with the great impersonal, elemental forces of nature. Thus the smoothness of the stone-carvings of M. Brancusi and Mr Henry Moore has been admired for implying that the forms were shaped by the blind forces of the wind and the sea. Whether machine-minded and materialistic, or pantheistic and mystical, the typical art of the inter-war period was a calculated rejection of individualism and individuality.

The presence of a rough surface does not, of course, guarantee that the artist has sought to leave the imprint of his hand upon the work of art. Here again he may only be simulating the workings of nature – the growth of moss or lichen which is suggested by the textures of certain English neo-Romantic painting, the wear and patination undergone by archaeological relics which is suggested by much contemporary Italian sculpture. Where the use of an uneven texture seems to be motivated along these lines, the current taste for roughness of surface must be interpreted merely as a taste for the picturesque. But there is also a use of rough, broken, or uneven surfaces in contemporary art which does not serve to produce an illusion of wear and tear so much as to affirm that the work of art is the reverse side of the artist's gestures. Here roughness of surface is the symptom and symbol of a revolt against the anti-humanism of the streamlined

surface, an assertion of the artist's humanity and of the value of the creative act, considered as an act.

There is no question here of adding an interesting and evocative texture as if it were icing on a cake, the cake being a formal configuration which might equally well have a smooth surface. Here the surface texture and the form are completely interdependent, so that the form would not exist without its particular surface. This kind of painting, to quote Mr Francis Bacon, 'tends towards a complete interlocking of image and paint, so that the image is the paint and *vice versa*. Here the brush-stroke creates the form and does not merely fill it in. Consequently, every movement of the brush on the canvas alters the shape and implications of the image.'

This is, of course, a resuscitation of the great *malerisch* tradition, which was rejected by those who thought they were following Cézanne, though Cézanne in fact was one of its supreme exponents. But it is much more than a mere revival, simply because the artist is much more conscious than before of the weight of meaning which can attend the reflection of his gestures in paint or plaster.

This increasing self-consciousness in regard to gesture has come about through the practice of Expressionism and Surrealism. The practice of Expressionism has shown the artist how his gestures can be the immediate projection of his states of feeling or emotions. The practice of Surrealism, with its various techniques of automatism, has shown the artist how his gestures can become a journey of exploration in which, conscious control being suspended, forms allowed to create themselves come to signify or suggest a complex of oblique allusions to reality, so that the artist's gestures become a means of discovering, transformed within his unconscious, a wealth of memories of human experience.

But if the contemporary artist has inherited his exploitation of the gesture from Expressionism and Surrealism, he has refused to comply with their doctrines. Nothing could be more symptomatic of the general shift of attitude from anti-individualism to individualism than that, whereas a quarter of a century ago it was easy to classify artists into groups or movements (if they had not so already classified themselves), today there are few clearly defined movements.

In non-figurative art, Abstract Expressionism and Abstract Sur-

realism have more or less coalesced. In figurative art there are painters and sculptors in whose style elements of Expressionism and Surrealism and Romanticism and Impressionism are perfectly synthesised. It is precisely his desire for freedom to find his way as he goes along, creating his own values as he goes, that impels the artist today to create works which are a complex of traces of his acts. The work itself renders visible his process of exploration. Outcome of a continuous experimental improvisation, the rough surface of the work does not overlay the form, but is the form.

There is a certain danger in the manifestation of this attitude in abstract art, aptly known as 'action painting' – namely, that the painter is so free of any discipline that this work is highly unlikely to achieve much tension: certainly, no action painting has a tension comparable to that of a Mondrian. In the domain of figurative art, however, painters like Mr Bacon and sculptors like M. Giacometti, have created styles in which an entirely free and autonomous treatment of the surface is reconciled with a profound concern with problems of representation, thereby achieving a mysterious interplay between the personal gesture and the extra-personal fact.

Giacometti *1955*

Written early in 1955, this was the catalogue introduction, 'Perpetuating the Transient', for the small retrospective which I curated at the Arts Council Gallery, London, from 4 June to 9 July 1955. Another introduction to a London retrospective, the one at the Tate in 1965, would also have been included in this book had they not both been reproduced in my recent monograph, *Looking at Giacometti*. The present text was somewhat revised for that book and appears here in its revised form.

Giacometti's standing figures suggest objects long buried underground and now unearthed to stand out in the light. Fossils perhaps, but also columns or caryatids – caryatids indeed, with their compact, frontal stance, except that they seem too tenuous to be that. But they are not ethereal: they have a density which calls to mind the shrunken

heads that cannibals preserve. They are figures without 'physical superfluousness', like Starbuck in *Moby-Dick*, their thinness a 'condensation'.

That image of a standing figure is always a standing woman. She has a counterpart, an image of a man which again is an upright figure, but here an active figure, walking or pointing. There are also busts of a man and these too are somehow active, the head attentive, watchful. The female is passive, a figure standing motionless, whether with others in a row, parading (as a point of fact) in a brothel, waiting to be chosen, or alone, as if waiting in the street.

But as they stand there, they are not quite still. Their surface, broken and agitated, flickers and the figures, rigid in their posture, perpetually tremble on the edge of movement.

> A blind man is feeling his way in the night.
> The days pass, and I delude myself that I am trapping,
> holding back, what's fleeting.

Transience is everywhere, nothing can ever be recaptured. Yet merely to think of a happening is to try and recapture it, as our very awareness of it pushes it into the past. The days pass and all awareness is nostalgia. The sense of the transitory in these sculptures is a sense of loss.

It is also a statement of fact. The slender proportions and agitated surfaces may be loaded with a mass of romantic evocations whose weight might be a compensation for lack of corporeal mass, but the conjunction of these properties also serves to suggest quite simply that our sensations, for subjective reasons or objective ones, are always shifting, would cease to be sensations if fixed like a butterfly by a pin. If they are to be trapped or fixed, it must be less rudely. Now Giacometti's aim, as he has put it, is 'to give the nearest possible sensation to that felt at the sight of the subject'. It is evident that for him this entails making it clear that the sensation is fugitive. And to make this clear, he uses forms whose appearance contradicts our notions about the appearance of things. Naturally, there are further attributes of our sensations which these forms are meant to convey. In order to find out what they may be, it is useful to look for a clue in the paintings and drawings, which, being less extravagant in their proportions

(they are generally done from life), are easier to read.

The most striking thing about the paintings, and to a lesser extent the drawings, is the density of their space. The atmosphere is not transparent: it is as visible as the solid forms it surrounds, almost as tangible. Furthermore, it is uncertain where solid form ends and space begins. Between mass and space there is a kind of interpenetration.

At the same time, the paintings and drawings lay great emphasis on the distance of the things in them from the beholder's eye. The perspective is often elongated, giving an effect like that of looking through the wrong end of a telescope, so keying-up the nearness or remoteness of a figure or an object. The near extremities of bodies tend to be enlarged, as they are in snapshots, that is, in images whose perspective is optical and not idealised. The scale of the forms in relation to the dimensions of the rectangle (which is generally defined somewhere inside the dimensions of the actual canvas or paper) is peculiarly expressive of their location in space.

Giacometti, then, is preoccupied with problems that concerned Cézanne – the elusiveness of the contour which separates volume and space, and the distance of things from the eye. The stylistic resemblance between his drawings (perhaps the most perfect aspect of his art) and those of Cézanne is not superficial. The attributes of sensation which obsess Giacometti therefore present no major problems which painting has not confronted hitherto. When it comes to sculpture, however, they might be thought to lie quite outside the scope of that medium. Giacometti's insistence that they should not is what has determined the form his sculptures take.

This long slender figure with its broken surface – sometimes as tall as ourselves and no thicker than our arm – clearly bears no relation to the real volume of a human body. There is a kind of core, and outside the core a suggestion of mass dissolving into space. The volume is confessedly an unknown quantity, by implication an unknowable quantity: the fact that in reality contours are elusive is conveyed by the fact that in the sculpture there simply is no contour.

Consider the elongation again. Is it not akin to the kind of elongation produced in painting by the device of anamorphosis? A sort of anamorphosis has distorted the sculptured figure or head, distorted it so that it embodies a perspective, implying that it was seen from a par-

ticular angle or distance, so that it belongs at a certain imaginary distance from us which is independent of its distance from us as an object. It is, in other words, like a figure in a painting, fixed once and for all in space, indifferent to our distance from the canvas. Again, the forms are sometimes placed in a kind of cage which defines a space around them like the space contained within a picture, or they are realised in relation to the base they stand on in such a way that the proportion of figures to base works like that between the figures and the foreground in a picture. At the same time, the surfaces have the vitality and autonomy of texture of the surface of a painting.

What matters most is not that the language of sculpture has been extended. What matters most is that, in arriving at proportions which give effects beyond the normal range of sculpture, Giacometti creates a mysterious and poignant image of the human head or figure, fragile, lost in space, yet dominating it.

Bacon – I *1954*

Written at the turn of 1953–54 for Britain To-day *and published under the title 'Francis Bacon' in February 1954. Here the two opening paragraphs, giving background information, are condensed into a single sentence. Later, there are two minor revisions.*

It is a long time since the London art scene sported a player as controversial as Francis Bacon. Nightmarish horror is what is generally felt to be uppermost in his art. Certainly this is an interpretation justified by the primacy in his iconography of the human scream. This scream appears everywhere: on the faces of prelates and of businessmen or politicians; in representations of the Crucifixion; and on mouths detached from a face. The horror often persists where no such extreme situation is presented. But there are other works, mainly recent ones, which depend not at all for their impact upon making our flesh creep and whose disturbing effect resides far less in its premonitions of disaster than in the sheer weight of its sense of reality.

The notorious scream, so often surmounted by a pair of pince-nez,

had its origin in one of the great images of the cinema – the close-up of the screaming bespectacled face of the nurse in the Odessa Steps sequence of Eisenstein's *Battleship Potemkin*. This screaming face often surmounts the seated figure of a prelate – a figure derived from Velázquez's portrait of Pope Innocent X. If it is a pope who screams, it is because a pope is a symbol of magnificence, and therefore lends that heroic stature to the screaming figure which is necessary to give it the weight of a tragic image. At the same time, Bacon has done many paintings after this Velázquez in which the Pope's countenance is not agape in anguish. To some extent this must be because the subject allows Bacon to indulge in luxurious harmonies of gold and violet – in which colour he always paints the cape, in contradistinction to the red of the Velázquez (which, in any case, Bacon has only seen in reproduction). Ultimately, however, the fascination which the Velázquez has for him probably resides in the almost archetypal attitude of the figure in his chair – at once so formal and so real.

But if Velázquez has haunted Bacon's imagery, it is Rembrandt who, of all masters, has taught him most about the handling of paint, the creation of volume, the representation of flesh and of the relation of clothes to the body within them. Nevertheless, he owes less to the influence of any painter than to that of the camera, as we shall see. No contemporary artistic influences are evident in his mature work – that is, his work of the last six years. Before that he owed much to Picasso's style of around 1930. The crowning work of this earlier period was the *Three Studies for Figures at the Base of a Crucifixion* in the Tate Gallery. These sculpturally modelled invented forms – showing twisted mouths at the end of long necks draped with a handkerchief – transmit a sense of physical anguish so powerfully that we cannot but squirm with pain. Subsequently, Bacon's treatment of form became more painterly, more atmospheric, but the practice of isolating chosen features of the head or body lingered until 1950.

No serious painter has owed so much to the photograph as Bacon. Many painters, such as Degas, have looked at photographs in order to discover instantaneous attitudes of the body or to learn to compose their pictures in an apparently haphazard fashion. Such painters, however, might be said only to have looked *through* the photograph. Bacon has looked *at* the photograph inasmuch as he has tried to find

a painterly equivalent for its actual physical attributes and its manner of presenting the image. He likes the sense of immediacy which it gives, and its implication of transience. He likes the almost grotesquely vivid and dramatic way in which a head or a figure confronts us in the newspapers or on the cinema screen.

He has also found ideas for presenting the figure in space from Muybridge's great photographic compendium – which served Degas in a quite different fashion – of human and animal locomotion. From these photographs of Muybridge, among others, he has also learned how the human figure can become transformed into abstract shapes fantastically removed from our usual concepts of it. Similarly, he has discovered in photographs the extraordinary extent to which forms can be distorted without losing an air of reality – and it is one of his main preoccupations as a painter to see how far it is possible to twist appearances out of shape without depriving them of conviction, and by this act of taking reality to the brink of unreality, to heighten our awareness of it.

Then Bacon is fascinated by the peculiar tonal unity of photographs, their 'all-overness' of texture. In this respect, he is particularly interested in big-game pictures, in which the forms of animals loom up out of a background of undergrowth or jungle. In the same way, he is attracted by the velvety consistency of images on newsprint, as well as by the way in which the forms in such images are blurred as if dissolving away. Bacon's interest in these quasi-atmospheric effects of the conjunction of the camera lens and the behaviour of printer's ink on the porous surface of cheap newsprint is the outcome of his desire to make the vibrations of the paint itself his means of communication (as it is in the paintings of Van Gogh).

The most remarkable example of the eloquence of paint in Bacon's work is to be found in the third of his *Three Studies of the Human Head*, a triptych reminiscent of a strip cartoon. In this image, the features of the face have been rubbed out by the brush. One does not know whether they are obscured because a hand has been raised to hide them in a gesture of agonised despair or because they have been literally shattered. One does not need to know. For the dissolution produced by the paint acts directly upon our nerves, suffices without further explanation to convey a sense of tragedy.

Bacon can, I think, be called a tragic painter because his figures – in his later works, at any rate – are not merely the victims of their anguished situation. They have an air of defiance in the face of destiny that is not only the product of the rather Edwardian sense of luxury with which he tends to surround them, but because of the breadth and grandeur with which they are realised. What is remarkable is that Bacon can achieve this grandeur, not only in his representations of the princely figure of a prelate, but when he has to reconcile it with the coarse features and vulgar posturings of personages who clearly belong to the breed of cheap politicians and big businessmen. But beyond this achievement of his in putting on to canvas the anguish of contemporary life, his art is remarkable enough for the electric brilliance with which it captures the quality of our sensations of corporeal things. Before the gloomy, claustrophobic, curtained backgrounds of his pictures there loom up in front of us beings whose presence is as disturbing, as unexpected, as fleeting, as commanding, as the presences of other people which in life confront and torment us with their portentous ambiguity.

Dubuffet *1958*

This untitled broadcast talk was given in March 1958 in an edition of the BBC Third Programme arts magazine, *Comment*; it has never appeared in print. It seems to me a better piece than longer texts published shortly after, such as 'Jean Dubuffet' in the *New Statesman* on 14 May 1960 and the untitled introduction to the catalogue of *Dubuffet: Recent Gouaches and Drawings* at the Robert Fraser Gallery in April–May 1962.

A Marxist critic wishing to lecture us upon the decadence of our culture would surely find no better proof of that decadence than the work of Jean Dubuffet. It would be bad enough that such infantile doodles and scrawls should be perpetuated in the name of art even if society were to ignore them: that they should also be exhibited, offered for sale at very high prices and actually sold, talked about on the Third Programme of the BBC, even if only to abuse them – here are signs as

conclusive as any of the hopeless decadence of Western culture.

The Marxist would nowadays probably be sufficiently sophisticated about art to admit that an artist who parodied, or at least drew inspiration from, the scribbles of children need not necessarily be a dolt or a charlatan. He might say that Paul Klee, using a pictorial language influenced by children's drawings, brought to bear on it such technical refinement and so exquisite a sensibility that, though he was clearly a decadent artist, he was still an artist. Dubuffet, on the other hand, is beyond the pale of art, does not refine this infantile sign-language – if anything, coarsens it. The thick brushwork with which his large childish scrawls are painted suggests that he doesn't only envy children their way of drawing but also their licence to spend their afternoons making mud-pies.

But let us assume that it is not necessarily a sign of decadence that a society can produce and take seriously an art with such affinities to the activities of infants. It still remains undeniable that Dubuffet's art could only be produced by a decadent society. For, needless to say, this highly innocent-seeming art is produced for the most highly sophisticated reasons. It is the result of the kind of extreme self-consciousness about style which is precisely the prerogative of decadent societies. But the preoccupation with style, the morbid preoccupation, which infects Dubuffet is not merely a symptom of decadence that we recognise in him and in his work. We could interpret, say, Picasso's work in this fashion: but with Dubuffet there is something more. He is not self-conscious about style because of a love of style but rather because of a hatred of style. His preoccupation with style arises in the first place out of *his* recognition of the decadence of our culture, his feeling that the styles we accept are all played out, his disgust at an art that feeds on art and feeds again on art fed upon art, and out of his desire to create an art that might rise above it all, above all the fancy nonsense, in spite of everything. There is something heroic in this enterprise of Dubuffet's, in his readiness not to shrug his shoulders and make an elaborate joke out of all the mess as the Dadaists did, but to return to certain basic essentials and see what he can make of them – the essentials being the simplest kind of schematic drawing, the plainest, earthiest colours, the stuff the work is made of. Let us, he says, take these, and think of what they are, and use them,

and see what happens. Let us see whether it is still possible to produce a pictorial image that has some truth, some authenticity, and isn't just another art-object serving to flatter the vanity of connoisseurs.

It has been the special mission of the serious artists of Dubuffet's generation, the generation born in the early years of this century, of artists like Giacometti and Jackson Pollock, to ask, in one way or another, the question: Is art still possible, or is it too late now? They are artists who are suspicious of art since art all too easily becomes art for art's sake. They feel that art has got to justify itself, and that to do this it has got to have some sort of very direct truth to reality, even if the only kind of truth to reality that they can manage is to make the painting a record of the gestures they committed in producing that painting. This has led in America to the development of a kind of art from which all consciousness of past styles has been rigorously excluded in order that the painting should faithfully reflect what the artist *does* when painting, how he acts, a kind of art too in which the end result is important mainly as the sum of the processes by which it was achieved. A recent exhibition at the ICA of paintings from the E. J. Power collection made it clear that, although Dubuffet has much in common with these painters, his position in these two respects is much more ambivalent and complex than theirs. By comparison with the works there by Pollock and Rothko and Kline, the Dubuffet had the air of a precious object, an art-object: the end result was not all that incidental. In the same way, Dubuffet does, in spite of everything, draw upon the art of the museums, even if he has to go back to very early art, to palaeolithic cave-paintings, to neolithic sculptures, and perhaps to Cycladic carvings, to find models that are not too much tainted by association with art for the sake of art, not to say art for the sake of snobbery.

It seems to me that the great merit of Dubuffet's work, the merit which makes him the finest European painter of his generation, is that it communicates a feeling for life which has something of the warmth and poignancy characteristic of this very early art. Dubuffet's vision of man combines marvellously – as they are combined in Cycladic figures – a sense of extreme vulnerability with a profound dignity and sense of being indestructible, in spite of everything (a phrase I've used three times now: it is constantly coming to mind when I think about

Dubuffet). His figures have a pathetic, clownish grandeur, like Rembrandt's drawing of the elephant. They are oafish and clumsy, and yet, and yet, fragile. They care about things. And on the other hand, they are roaring monsters who don't give a damn for anyone, they are reincarnations of Père Ubu. They are also creatures who might conceivably live in dustbins, as in *Fin de Partie*. They have connections too with Godot, who dreams, like Lucky, of stones and sky and games of tennis, and discovers, like Pozzo, that birth happens astride of a grave. Among the various thoughts and images that Dubuffet brings to mind, there is one which for me persists above all others. It is the sentence with which Van Gogh spoke of Millet's paintings of peasants: 'They seem painted with the earth they sow.'

Pollock

This untitled review of a retrospective at the Whitechapel Art Gallery was broadcast on 7 November 1958 in an edition of the BBC Third Programme arts magazine, *Comment*; it has never appeared in print. It is included here for having surreptitiously slipped into the description of a Pollock all-over painting a paragraph lifted almost unaltered from the description of a late Klee published in *Tiger's Eye* in 1948.

Sam Hunter's Introduction to the catalogue of the Pollock retrospective now at the Whitechapel says that 'Pollock always saw the painting field as an arena of conflict and strife' but that 'Time has taken some of the sting from Pollock's rage, and today we begin to see that his paintings seduce as readily as they bruise.'

I think it is their seductiveness that has been the big surprise for those of us who are seeing Pollock wholesale for the first time. Their *elegance* is the most striking thing about them. Probably it would be less striking, probably it would take its place along with their various other qualities, if it didn't run counter to the great Pollock legend, of Pollock the wild man, Pollock the anti-artist, the slapdash improviser, the cultivator of the accident, the iconoclast who showed his contempt for the art of painting by laying his canvas flat on the ground

and tramping over it while he dribbled paint out of a hole in the bottom of a tin: Pollock the frenzied doodler, Pollock the High Priest of chaos. Now, all this is precisely a legend, not a lie: like any legend it is based on half-truths whose oddities have been magnified out of all proportion. At the same time it must be said that it doesn't need the legend to create the impression that Pollock's paintings are chaotic; people get that impression just by looking at the paintings. The first time I saw some Pollocks – it was in 1950 – I thought they were incoherent nonsense, messy, uncontrollable daubs, pots of paint flung in the public's face. What could I have been using for eyes? Pollock's handling of paint and organisation of colour is in fact as sure, as subtle, as magisterial as Matisse's or Bonnard's.

Let me hasten to say that I didn't have to wait for this exhibition to realise what a beautiful painter Pollock was, though I didn't previously realise quite what a master of the medium he was. But I did tend to think of him until now as the creator of a frenzied beauty, an ecstatic Dionysian beauty. What the exhibition has made me see is the *serenity* of his art. Or rather, that was the main impact the first time, but the next time I was more conscious again of its drama, now that I was taking that serenity for granted. Because it now seduces as readily as it bruises, that doesn't mean it can no longer bruise. We see beyond the 'conflict and strife', the 'violent combat', to the elegance and calm and are delighted by them, but then we can see beyond the elegance and calm to the 'conflict and strife'. Our reactions to Pollock at the moment are in no state to be defined, because they are so heavily related to our own previous reactions. This applies not only to the question of whether they are primarily paintings that seduce or paintings that bruise but to the parallel problem of the interplay in them of improvisation and control. The element of control is far greater than many people thought. All the same, we must not forget the element of spontaneity, and the fact that, although the exploitation of accident is common to almost all painters in oil, Pollock did exploit it more than most. We are on a see-saw at the moment, so it's hardly the time to try and make positive statements about Pollock – except the statement that the fact that he has us on a see-saw can cause us, as soon as we begin to say anything about his paintings, to ask ourselves whether the opposite isn't equally true.

I think there's at least one thing about Pollock which can be affirmed with confidence, and that is the reason for his use of an 'all-over' composition, a composition without focal points, that is of axes around which the design as a whole firmly settles. Now, Pollock spoke of his desire when painting to feel that he was '*in* the painting'. I think that the absence of focal points is intended to make us get into the painting in imagination, not to try and see it over there, away from us, but to enter it and explore it. If a picture has a focal point or points, it at once becomes a scene laid out in front of us. It is true that we can imagine ourselves into a scenic painting, move about in its space, 'feel into' the figures in that space. Yet we can also withdraw from it, become a detached spectator. And when we move about in it, it is only to explore perspectives already visible from outside. With a Pollock we create the perspectives as we move about in the painting. We are not spectators but participants, participants in its creation. In a scenic painting we move about untouched: we can touch the forms, but they remain as unyielding as statues. In a Pollock, the relationship is reciprocal. We are as much a part of it as we are of the sea when we go swimming. We plough our way through it and in turn are buffeted by the waves lines continually changing in plane and direction. The picture is always changing, always becoming. And it changes by virtue of our imagined movement within it. Its space is a fluid space defined and redefined by our movement. It is a space that exists only in so far as it exists in time. The painting is like a living organism. As Pollock said: 'A painting has a life of its own.' This is old hat. But he added: 'I try to let it live.' It lives by continuing to grow and change not only while he was creating it but while we create it. Of course we need time to understand any picture, but when we've looked at it for years it's only ourselves that have changed, not the picture. To look at a Pollock over a period of time is not to acquire a deeper understanding of a finished thing but to observe and assist in its growth.

Rothko

Review of a retrospective at the Whitechapel Art Gallery published under the title 'Rothko' in the *New Statesman* for 20 October 1961.

Faced with Rothko's later paintings in the exhibition at Whitechapel one feels oneself unbearably hemmed in by forces buffeting one's every nerve, imagines the gravity of one's body to be multiplied as if some weight borne on one's shoulders were grinding one into the ground; one feels oneself rising against these pressures, riding them, carried away into exhilaration and release: pain and serenity become indistinguishable. This complex of feelings is familiar enough in the experience of tragic art, but tempered and complicated by other appeals to the senses and intellect and imagination – involvement in a specific type of human situation; the re-creation of familiar elements of reality in a way that makes them seem more real than in life; the benign equilibrium of a lucid architectonic structure; the poetic evocation of unexpected connections; the sensuous delight of beautiful colour or sound. There is nothing of all this in these paintings. Here emotion is unadulterated, isolated.

In retrospect, Rothko's image – a haunting image, I suspect, even for those who respond to its presence only mildly – provides its incidental satisfactions. It projects itself on to our vision of reality: looking along Park Avenue at the great glass-fronted slabs with their edges dissolving in the light, it is difficult not to be reminded of Rothko's looming, soft-edged stacks of rectangles. And it projects itself on to our taste: its combination of Indian red and brown and black can be rediscovered in fashionable ties and shirts of recent design.

But the evocative quality of the form, the seductive charm of the colour become irrelevant when the paintings are confronted. These paintings are beyond poetry as they are beyond picture-making. To fantasise about them (as the catalogue does), discover storm-clouds or deserts in them, or sarcophagi, or aftermaths of nuclear explosions, is as corny as looking at Gothic architecture and thinking of the noonday twilight of the forest. These paintings begin and end with an intense and utterly direct expression of feeling through the inter-

action of coloured areas of a certain size. They are the complete fulfilment of Van Gogh's notion of using colour to convey man's passions. They are the realisation of what abstract artists have dreamed for fifty years of doing – making painting as inherently expressive as music. More than this: for not even with music, where the inevitable sense of the performer's activity introduces more of the effects of personality, does isolated emotion touch the nervous system so directly.

The claims which Rothko has made for his work seem on the surface decidedly perverse. He says he is 'no colourist', which might well be thought affected in view of the dully glowing splendour of his harmonies. He denies the view common among his admirers that his work is Apollonian, quietist, maintains that on the contrary it is nothing if not violent, Dionysian – the perverseness of this claim being that it seems pretty extravagant to attribute violent passion to paintings whose means of expression – the hushed colour, the design in terms of horizontals – are traditionally associated with serenity and stillness. But the claims are not perverse: it is not when he talks that Rothko is paradoxical but when he paints. The value of his painting lies precisely in the paradox that he uses seductive colour so that we disregard its seductiveness, that he uses the apparatus of serenity in achieving violence. For of course the stillness is there as well, and that is just the point: violence and serenity are reconciled and fused – this is what makes Rothko's a tragic art.

The achievement is parallel to Mondrian's, who, using means the obvious potential of which was the creation of a perfectly static art, evolved a world of form in which stillness is locked with violent movement. Of this consummation in terms of the physical – to put it rather schematically – Rothko's art is the equivalent in terms of the emotional. Their work is as it were the Parthenon and the Chartres of abstract painting – a vulgar analogy, perhaps, but one whose relevant implications include the point that a Mondrian dominates us as a compact entity out there, beyond our reach, a Rothko incorporates us, envelops us in its light. The analogy also serves to emphasise that a Rothko is awe-inspiring as a cathedral is, not as a mountain is: the effect of its scale is not to make us feel puny and helpless beside a sublime vastness. It has a scale transcendent enough to command, accessible enough to reassure.

The strength of the great monomaniacs of modern art – who also include Giacometti, Rosso, Monet – in relation to their audience is that they are not distracted by success or by failure. Their vulnerability is that they are peculiarly subject to hazards of presentation, since their work pushes the medium to extreme limits where there is no margin between glory and absurdity, so that, shown in the wrong light or at the wrong height, it can so easily go the other way. At Whitechapel Bryan Robertson's exhibition is worthy of the exhibits.

Guston 1963

This is an uncut version of a review of a retrospective at the Whitechapel Art Gallery which appeared, entitled 'Luxurious', in the *New Statesman* for 15 February 1963.

In their pictures, as distinct from their ideas and attitudes, the differences between the American Abstract Expressionists – the ones who matter – are decidedly more striking than the similarities. No other movement in modern art has had less of a common style. There are, for all that, two characteristics which are pretty constant. One is a willed absence of charm and overt sensuousness in the handling of paint, a spare, tough matter-of-fact air (an air that masks, doesn't preclude, sensitivity). The other is a tendency towards a rigorously simple kind of configuration, so that at first impact only one thing seems to be happening on the canvas – for example, one rectangle is placed above another – though that one thing may work in several ways at once. Even the tangled web of the busiest Pollock has this simplicity of concept, because of the all-overness of the tangle: the painting includes no major variations in density, changes of tempo. These two characteristics are closely interconnected. They both reflect a reductive, a puritanical approach to painting, which seems concerned to find out how much of the traditional apparatus of art can be eliminated from painting without eliminating art: it's like a test of art's powers of survival in the face of a denial of its comforts.

Philip Guston is Abstract Expressionism's odd man out. He is

committed to luxury. His paint is exceedingly rich and luscious – in its texture, in its implications of high virtuosity. Again, by the standards of a century which values economy of means above almost everything, he is quite grossly self-indulgent in the comprehensiveness of his vocabulary: a calligraphic and a plastic approach are often freely combined on the same canvas; both colour contrasts and tonal contrast are used to create space, and the colour in some pictures embraces all the colours of the rainbow, while the tonal variation in some pictures encompasses both exquisite gradation and the violent juxtaposition of light and dark.

Complexity of means is linked to complexity of composition. The neo-Romantic figure-compositions which Guston painted before 'going abstract' never present isolated figures lost on illimitable sands. They are claustrophobic. Figures are packed together, overlapping, interweaving. The abstracts present an analogous complex of numerous parts. A Pollock, a Rothko, a de Kooning, a Motherwell, a Kline, a Gottlieb give us the feeling of being confronted with something in close-up looming up over us. A Guston has the look of a medium-shot of several events going on out there.

There is a superficial resemblance between many of Guston's pictures and Monet's late paintings of lily-ponds – something of the same diffuse, inchoate, swimmy look – though it doesn't extend to the range of colour, which in Guston's case varies from warm to hot. But the Monets are in close-up, and as we look at them they have the effect of entirely enveloping us. A Guston is a fragment of a world apart. It neither draws us in nor does it, as a Rothko does, seem to hem us in through the menace of its impact. Guston's paintings, indeed, have little immediate impact, apart from that of the sheer prettiness of those of 1947–55. They are intensely withdrawn and private, with the privacy of the dark not of the ivory tower. They are the acting-out of long uneasy meditations that have to end in doubt. At one level the uneasiness and doubt are obviously about painting itself, what it can do, should do, should not do, to be authentic. The very indulgence in the wealth of painting's possibilities serves to extend the area of doubt. In the later works there is doubt above all about the degree in which paint on canvas can allude to the reality of nature without loss of its own intrinsic reality, its own autonomy and vitality and eloquence

(and here it must be admitted that, on the evidence of his early figure-compositions, for Guston clear figuration is a dead loss).

Are the doubt and anguish related only to the responsibilities and trials of painting itself or do they embrace something more – are they 'about life' as well as about art? The question is unanswerable and beside the point. What matters is that these paintings are palpably about a man's struggle with himself and reflect its reality and urgency. What matters still more is that in their very doubt and desperation they become affirmative. They are intensely private and self-enclosed and yet they exist there on the wall as rather large canvases, statements on a public scale, and they fit that scale. Again, the more recent works (which seem to me the finest) are so packed with doubts and denials as to have gone far beyond the brink of what we think of as coherence and to be just about the messiest pieces of painting ever to be exhibited as works of art. And yet these muddy colours glow with something of the refulgence of the Venetians.

Reinhardt *1964*

This review of a showing of paintings at the ICA was published in the *New Statesman* for 12 June 1964, headed 'Blackish'. It was slightly revised and lengthened shortly after.

The extreme thing about Ad Reinhardt, by twentieth-century standards, is not that he's done paintings which are black all over; it's that for ten years all his paintings have been black all over. A single painting of *Black on Black* was exhibited in 1919 in Moscow, by Rodchenko, leader of the Non-Objectivist group, as his answer to the *White on White* of Malevich, leader of the Suprematists. Polemical art is all very well, but it seems to have become a nagging bore when you can go into a gallery, as at the ICA now, and see seven black rectangles five foot square. (By comparison, Yves Klein produced conventional decorative art: his paintings were blue all over.) After half a century of anti-art art, Reinhardt appears to have reached the ultimate. Besides the sheer denial of what art is supposed to be, per-

haps some symbolism is intended – art is dead and to be mourned? Or
are these objects of a kind – such as sculptures with movable parts –
which require the spectator's active participation? Are we perhaps
meant to ask an attendant for chalk with which to scrawl upon these
blackboards, or are we simply to use whatever implements we have?

Fatuous suppositions like these can spring readily from the
assumptions we bring to seeing new art now: an assumption that the
work is there to argue a standpoint, is a demonstration; an assumption
that the work is incomplete, needs to have something added, physi-
cally or mentally, by the spectator; an assumption that the work exists
as likely as not to discredit the idea of art – anything but the assump-
tion that the work is there in order to be looked at. (Thus the
Gulbenkian show, rich and exhilarating though it is, is laid out in a
way that encourages us to see works of art as signals of attitudes rather
than as objects to be contemplated. Even so, the signals are meant to
be read at walking pace; at the Guggenheim Museum, it's as if they
were to be read while riding a bicycle downhill.)

If we take the trouble to face one of these Reinhardts from a few
feet away, risk a few instants of our busy time on giving it a specula-
tive look, we perceive that it may not be a demonstration after all. The
matt black surface starts to sing: we recognise the vibrations given off
by the inexplicably living surfaces of all authentic works of art. As we
move in closer, look longer, the reason why this surface sings emerges
along with the emergence of infinitely subtle variations of tone and
colour – bluish blacks, reddish blacks, brownish blacks, purplish
blacks. There's no more variation than that. No mark of the brush is
visible. The faintly different areas are demarcated by straight lines.
What's more, every painting has been trisected vertically and hori-
zontally so that it has the same cruciform design as every other. All the
same, no two paintings are alike (they're reassuringly unequal in
quality). Yet there's nothing to look at but the contrast between, say,
a bluish black and a brownish black within a symmetrical rectangular
design. It turns out to be sufficient. Once involved in one of these
paintings, I find it difficult to tear my attention away: my entire capac-
ity for attention has been focused into gazing at a contrast of colours
that is scarcely perceptible and totally absorbing.

The sustained involvement in a contrast between large areas of

matt colour calls to mind the experience of looking at a Rothko, not least because the demarcations appear to oscillate, the divisions appear not to stay where they are. But it's not at all the same sort of experience. A Rothko has an enveloping effect; we feel we're immersed in it. It also has a violently opposite effect to that: the looming forms seem to bear down on us, almost to strike out at us. Either way, the painting *impinges*, provokes an illusion of one kind or another of direct physical relationship between it and us (a persistent characteristic of anti-classical art – Mannerist and Baroque and Romantic). A Reinhardt painting provokes no such contact. In gazing at it, we may lose ourselves in *gazing* at it, but we do not lose ourselves *in it*. Nor does it impinge on us by aggression. It remains an entity out there, something apart.

This apartness, while making for calm contemplation, is also what makes Reinhardt's paintings polemical. The fixes to his position are his work before 1954 and his spirited, witty theoretical writings. His early work is very varied by any standards, covers a wide range of abstract modes, uses them all with a strength and sensibility which are perfectly evident from the other side of a room. His theoretical writings are largely virulent, often lampooning attacks on the open-boat-on-an-open-sea-type theories of the Abstract Expressionists. These two combine to suggest three explanations for the apparently perverse and undoubtedly repetitive form of the work Reinhardt has done since reaching forty.

The first is that, taking a stand against the total freedom of recent romantic abstract art, he chooses to discipline himself by looking for variation within a strictly confined language. The second is that, by cultivating a style the absurdity of which smells of anti-art, he gives an edge to an art which is anti-anti-art. The third is that he forces the spectator to stop and concentrate in order to see anything at all in his work. Opposing the easygoing, free-for-all attitude of most recent abstract art, which acts as a stimulant to the spectator's fantasy, Reinhardt presents the spectator with an artefact from which he'll get nothing unless he's prepared to look really hard at something outside himself.

MASTERS

Art of an Aftermath

1957

This was a contribution, entitled 'What's Wrong with Twentieth-Century Art?', to a symposium, 'Eighty Years of Progress?', in *Twentieth Century*, March 1957. It has been slightly revised.

There is no denial that I can think of to the familiar middlebrow assertions that twentieth-century art is (a) the product of isolated individuals who fail to give expression to the consciousness and tastes of society as a whole; (b) over-specialised, lacking the breadth and complexity of what came before, too prone to sacrifice important attributes of art in order to be able to develop a narrow obsession to an extreme degree; (c) too self-consciously preoccupied with problems of style and with achieving originality. These things are the case, and all one can say about them is, firstly, that the art of our time may not be very good by comparison with the best, but that its very limitations have caused it to make a unique contribution to the corpus of art (this is to assume that uniqueness is a necessarily valuable quality), and, secondly, that the limitations of our art reflect certain weaknesses of our society, and that if our society were different our art might be better. This second proposition may be defeatist in its determinism, but all the evidence supports it. For there have been artists, serious artists of great talent, such as André Derain and Henry Moore, who have tried to give greater breadth and comprehensiveness to art in our time, but the results have never been entirely convincing. It is not enough to try, the time must be propitious. The artist cannot achieve what he feels it is desirable to achieve by willing himself to achieve it. Limitations that are common to the work of all the artists of a period

are unlikely to be the artists' fault. (As to what I have just said about the impotence of the will, this very belief may be a reflection of the passivity which caused the twentieth-century artist to do what comes naturally and leave out of his reckoning much of what his predecessors took into account as a matter of course. If the twentieth-century artist believes in doing what comes naturally, in not trying to force his work in a preconceived direction through an effort of will, he is only sharing in an attitude that is current in many fields, including that of education itself.)

I have been speaking of 'twentieth-century' art, but that is not what I have had in mind. What I have had in mind is the period since the 1914 war. For the early years of this century were, it seems to me, the culmination of one of the supreme periods in the history of art. What was astonishing about the years before the bombardment was that they brought out the best in any artist: those who were old men surpassed themselves; those who were young men reached a level which they subsequently failed to sustain (a sweeping generalisation that asks to be shot at, and of course exceptions can be found, but to think of the cases of Cézanne, Degas, Monet, Renoir, Rodin, and on the other hand of Matisse, Vuillard, Utrillo, Picasso, Braque, Derain, Vlaminck, Rouault, Munch, Chagall, Kokoschka, Chirico suggests that it is broadly true). The entire world of art had the kind of creative energy, in the years before 1914, which is often said to be the prerogative of the genius who is shortly to suffer an early death.

It was to be the death, as has often been said, of everything that Europe took for granted – of all kinds of values and beliefs and hopes that were now seen to be ill-founded, presumptuous, and naïve. The wisdom that comes from disenchantment is not a climate that suits the growth of art: art, it seems, thrives on innocence. In this it only follows the principle that the more one knows the less one tends to do.

The classic relationship between the art of a great creative period and that of its aftermath is that the latter develops to an extreme degree, in a narrow way, and at a lowered emotional temperature, certain discoveries made by the former, with a tendency to isolate those discoveries from their context and to exaggerate their peculiarities. This is essentially a kind of exploitation, and therefore tends to be richer in ingenuity than in energy. The art of the aftermath somehow

cannot liberate itself from the domination of the great period; it can neither make a radically new contribution, nor can it go right back to an earlier period to find a fresh point of departure.

Here are two current examples of this last point. Recent abstract painting has cultivated the amorphous, in opposition to the over-emphasis on shape of art which claimed descent from Cézanne. And it has found its inspiration in the late work of Monet. The conclusion is that, while fashions may change as to what aspect of the great period is the immediate stimulus, the great period retains its hold.

The second example concerns those young neo-realists who have noisily rebelled against the turn-of-the-century period and made their slogan 'Back to Courbet!' Yet their work, as it turns out, is less a derivation from Courbet than a vulgarisation of Van Gogh. The fixation on the turn of the century is not to be dispelled by slogans.

If it is the case that a tendency to specialisation is always operative in the art of an aftermath, because, as I said, ideas are taken out of context and developed to extremes, this tendency is especially strong in the art of our time, because of the particular character of the ideas which have been developed. The great discoveries of the turn-of-the-century period all relate to one central idea, that the work of art is virtually autonomous, that it can convey sensations of or feelings about the real world without requiring verisimilitude. The consequence is that the shapes, the colours, and the surface-textures of the work of art can be allowed an unprecedented freedom to go, so to speak, their own way. This exceptional liberation of the *means* of painting and sculpture is obviously conducive to an exceptional degree of specialisation, specialisation in the use of shape or colour or texture.

But if this is what is wrong with art now – if to be like this is to be wrong and not merely second-rate, which is not the same as to be wrong – is it a condition peculiar to fine art? It seems to me that the twenty-five years or thereabouts leading up to the 1914 war were a time of astonishing creative ferment in almost every field. It was not only fine art that made a great leap of the imagination during this time. The foundations of modern logic and analytical philosophy were laid at this time by Frege, Russell and others, as were the foundations of psychoanalytic investigation by Freud and his colleagues.

What has happened since in these fields might be just as aptly described as a specialised development of those initial discoveries as the art of the last forty years could be described as a specialised development of the discoveries of Cézanne and Monet and Gauguin and Rodin. And this even applies to the physical sciences. The invention or discovery of the aeroplane, of wireless telegraphy, of Röntgen rays, of the principles of atomic physics – these too belong to the time of Cézanne and the early Picasso, and these too remain the primordial ideas that science since 1918 has developed and investigated and exploited, through specialisation. If it is said that the new Viscount is a better aeroplane than Blériot's, while the latest Mark Rothko is not as good a painting as a Monet, this is not a condemnation of Rothko, but a definition of art.

Monet *1957*

This is the review, slightly revised, of an exhibition of Claude Monet at the Tate Gallery published in the *New York Times* at the end of September 1957 under the title 'London ponders Monet as a Modernist'. The review concentrated on the artist rather than the exhibition as there would have been little point in discussing this in an American newspaper. I published another review in the *New Statesman* for 5 October, entitled 'Monet, More or Less', which was entirely focused on the exhibition, selected by Douglas Cooper and John Richardson, and was very critical of its bias against the late work.

Of all the series of major exhibitions of modern French painters organised for the Edinburgh Festival and then shown in London at the Tate Gallery, none, surely, can have been more impatiently awaited than this year's offering, which opened at the Tate Gallery on Thursday. For the subject this year is Monet, the art world's most newly resurrected deity, the painter whose standing has risen more than that of any other as a result of post-war movements in taste – meaning post-war movements in art, since Monet's current high reputation is obviously a by-product of the growth of Abstract Expressionism and other current activities.

There are several nineteenth-century masters who since the war have become altogether respectable again – Courbet, Géricault, Millet, Rodin, among others. But Monet has become so eminently respectable that he has almost taken over from Cézanne as modern art's father-figure. It is of course, the late work that has won him this position, which is to say that his revival has been less of a rediscovery than a discovery, since much of the late work was never shown in his lifetime.

What is it that makes us find Monet so peculiarly sympathetic? It isn't only that he reminds us of Rothko and Still. It's that he shares a certain basic attitude with us, namely, a desire for complete freedom from the constraints of art, a dislike of the 'well-composed' picture, of an order imposed by convention, of the ideal – in a word, of tradition. The freedom and spontaneity with which an experience is captured – this is what matters above all, especially above artistic beauty. We see him as a liberating force in our revolution against Cubist aesthetics, which dismissed his work as deliquescent and unorganised, and which we now in our turn reject as being sterile in their preoccupation with formal discipline.

Now, there is one respect in which our attitude is profoundly different from Monet's and that is the thing which really does make it rather silly to call Monet an 'Abstract Impressionist' – how can one give this label to an artist wildly, passionately, pathologically in love with appearances? On the other hand, it could be said that Monet's attitude to appearances and ours are equally the outcome of the common wish for freedom. Monet, with centuries of ideal art behind him, could find in a complete surrender to nature a means of avoiding the conventions of art. We, on the other hand, have Monet behind us, and not only Monet, of course, but all who have copied him in the belief that they were copying nature.

Consequently, the conventions of art that we have to reject include the conventions of Impressionism. Hence 'Abstract Impressionism', which, crudely speaking, is Impressionist painting from which Argenteuil, Pontoise and Giverny have mysteriously disappeared, like the Cheshire cat. Abstract Impressionism is the grin without the cat.

But the difference is bigger than that. It is not just a question of subject-matter but of the marks on the canvas. The abstract paintings

done today which resemble the late works of Monet are palpably the reflections of personal gestures. They are the artist projecting himself, his impulses, his rhythms. The thing which has impressed me most vividly about the Monet exhibition is that throughout his career he was obsessed with paint, the stuff itself, but that, unlike other artists who have had this obsession, such as Rembrandt or Goya or Van Gogh or Pollock, he didn't use paint as the medium of a personal handwriting. He didn't use it to project himself, to impose his rhythms, upon the external world. He always seems to have tried to reflect in the movements of his brush upon the canvas the rhythms of the things he was painting – the rhythms proper to the sea, to the sky, to grass and trees and rocks and stones, and to the still, silent pools in his garden. The act of painting itself, as much as the act of being an eye, was a means of losing himself in nature.

Only, the garden at Giverny was not precisely nature. It was the product of considerable labour (there were six gardeners for an area of three acres) and prolonged labour, in accordance with Monet's design. Monet, who refused to redesign nature on canvas, was obliged to redesign it in the raw. He didn't reshape what he saw; he shaped what he was going to see. It was a confession of the absurdity, the impossibility, of one of the strangest enterprises in the history of art.

Kandinsky 1960

Review of an exhibition of *Der Blaue Reiter* at the Tate Gallery published in the *New Statesman* on 8 October 1960 under the title 'The Blue Rider'.

The *Blaue Reiter* painters were a chain of friends who worked in Munich around 1910, sometimes exhibited together (notably in two shows organised by the editors of the almanac, *Der Blaue Reiter*, Kandinsky and Marc) and shared certain attitudes of a rather vague kind – a belief in the primacy of the spiritual and a longing for the interpenetration of the arts combined with a crush on Science, which they thought of in purely romantic terms as a way to the heart of things. (For all their talk of science and philosophy, they were igno-

rant of current thought in the philosophy of science: their idea of a philosopher wasn't Mach or Poincaré but Rudolf Steiner or Madame Blavatsky.)

They hadn't much more than this in common. Though full of theories, they had no common theory, not even as to whether non-figuration was preferable to figuration or *vice versa*: Kandinsky, the main animator of the movement, is unusual, maybe unique, among the pioneers of non-figurative art in having felt no need to convert all his friends from figuration. And they had no common style: the nearest we can get to finding a unifying formula is to say that most of them followed the example of the Fauves in laying a strong emphasis on the primary colours. Some of them took more than this from the Fauves. Gabriele Münter was a Fauve painter pure and simple, and few painters have used the language of Fauvism more decoratively. Jawlensky was a sort of Fauve painter with a peculiarly intense romanticism and an iconic quality which brings the Byzantine background of Fauvism to the fore. Macke, Marc and Campendonck combined elements of Fauve drawing and design as well as colour with cubistic mannerisms picked up from Delaunay. An exhibition of these five painters would suggest that the *Blaue Reiter* was a group with a common style. The point is that this exhibition would exclude the three outstanding *Blaue Reiter* personalities – Klee, Kandinsky and Arnold Schoenberg.

The two heads by Schoenberg at the Tate are possibly the first of his paintings to have been shown here. Almost monochromatic and very fluidly painted, they are haunting images, weird and strained as *Pierrot Lunaire*, counterparts of all that is romantic in his music but not of its formal discipline, and closer in style and feeling to the *Brücke*, and especially Nolde, than to any *Blaue Reiter* painter, even Kubin.

Certainly the most problematical of the *Blaue Reiter* artists, perhaps of all modern artists, is Kandinsky. By any normal standards of good painting – *any* normal standards, German as well as French – Kandinsky makes it difficult for us to take him seriously as a painter. The want of presence and density in his shapes and colours gives them a slightly sickening effect. In the face of an inability to integrate forms into a continuous texture filling the surface of the canvas and of a

feebleness of structure which gives no coherence to strident relations of colour, we feel queasy. There is nothing tangible for us to hold on to; it is as if we were in a small boat out in a rocky sea. Kandinsky talked of creating a concrete art; concreteness is the thing his art lacks most of all. He talked of creating a musical painting which would communicate without reference to things; his paintings couldn't more readily call other things to mind. The works of the *Blaue Reiter* period call up grottoes, mountainous landscapes, the iconography of fairy tales, bacteria under a microscope; those of his middle period look like diagrams of golf courses or fairgrounds; the late ones are like bacteria again, only this time in sharper focus.

The isolation of the idea of musicality in painting was Kandinsky's; musicality in painting is a norm. When we look at a Titian or a Poussin from a distance, we are aware at first only of a configuration of shapes and a harmony of colours which, as Baudelaire said, is already meaningful and memorable before we've identified a subject. And Kandinsky is one painter with whom this doesn't happen. As soon as we look at the picture, it starts making faces at us. Paradoxically, it could be said that Kandinsky is the least abstract of painters. He was by nature an illustrator – as his earliest works make plain – and his abstract pictures are illustrations of the idea of painting an abstract picture. Seen from a distance, the only music they make is a jumbled noise.

But move closer to them, physically and sympathetically, close enough not to be disconcerted by the impression they make. Let their colours break over you like waves (as if you had got out of the rocking boat and decided to swim for it). Allow yourself to explore space with their tendril-like lines. In a word, give yourself to these paintings. You will feel that you are moving in concord with the movements of another mind, that the very movements of another mind and not only its conclusions have become yours. These paintings are not expressions, crystallisations of states of mind, of particular feeling-tones, they are gropings after states of mind, they are traces of the process itself of introspection. The very feeling-tone of these Kandinskys of the *Blaue Reiter* period is that of groping, of reaching out into the unknown. Some of them may be rather sad or rather gay or rather expressive of conflict, but their dominant feeling is always this uncer-

tain reaching forth – the *Sehnsucht*, the yearning, that is so familiar in German romantic art here related to the elusiveness of the artist's own feelings.

The incompleteness of these paintings – the way that passages are left unresolved – is something like the incompleteness of an unfinished Cézanne still life. The Cézanne is a record of a groping after the forms of external objects in which honesty compels that what cannot be said with certainty is better left unsaid: a Kandinsky of the *Blaue Reiter* period is its counterpart in terms of a groping after the forms of feelings. The difference is that a Cézanne, incomplete as it is as an investigation, is resolved as a painting, the Kandinsky remains a conglomeration of sensitive gropings in the dark. It is not resolved in the painting as a concrete thing, its resolution only comes about in and through our process of exploration of the painting. In this sense, it *is a form of music* – in that it needs time not merely to unfold its secrets but to begin to mean anything at all.

Picasso – I *1960*

I published three articles in the *New Statesman* occasioned by the great retrospective of Picasso paintings at the Tate Gallery in 1960. The first, 'Picasso at the Tate – I', published on 9 July, was merely a description of the show itself and there is no reason to reprint it. The others, 'Picasso at the Tate – II', published on 16 July, and 'Picasso and Analytical Cubism', published on 27 August, were written as one article, but for reasons of space the middle section had to be extracted and published separately. They are published here as written, with a few revisions made in the course of the 1960s.

There is a tendency in modern art towards the *isolation* of one aesthetic quality or another, say, linear tension, luminosity, weight or weightlessness or both of them contrasted, compositional geometry, contrasts of texture, the sense of movement, the flatness–depth duality. A modern work will often, rather than embrace and reconcile several such qualities, be concentrated towards possessing one or two of them to an extreme degree. The quality isolated doesn't merely

acquire an especial intensity; it is as it were placed there on exhibition, it is exposed. For it is not predicated of something but, rather, offered for our contemplation as if it were itself a thing. A picture is not about, say, the weight of the dead Christ but about weight, not about the surging movement of a Bacchanalian revel but surging movement.

Picasso's position among modern artists is connected with his genius for isolating particular aesthetic qualities with an unequalled ruthlessness and brilliance, and for doing it to an unequalled range and diversity of qualities. He does it, moreover, with no fear at all of being obvious. It would be difficult to think of a painting which made its point, I mean its formal point, not merely its emotional point, more clearly than the famous Pink Period picture of a beach scene in which a slim child, all grace and ethereality, balances on a ball near a seated man with shoulders and back of enormous breadth and mountainous density. Here, of course, the point is not only an obvious one but also an unsophisticated one. When the point becomes sophisticated, it is still obvious. What, for example, once the Cubist principle of synthesising different views of a thing is accepted, could be easier to grasp than the idea of the typical Picasso head of the 1930s combining a straightforward profile with a straightforward front view?

A need to do one thing at a time and make it perfectly clear what that thing is, coupled with a genius for doing a great many different things, would certainly account for many of the peculiarities of Picasso's methods and development. It explains his use of a diversity of styles. And also his indifference to disguising his sources. Indeed, if he did disguise them it would be to his disadvantage: if a figure intended to isolate monumentality and timelessness recalls classical structure or a head intended to isolate fearsomeness recalls Oceanic masks, so much the better. The need to isolate also links with the penchant for caricature which shows in the Blue Period drawings and often reappears. And it connects with Picasso's habit of working in series and with the extraordinary way the *Meniñas* developed with the most complex and complete version coming first, followed by a long succession of more partial statements – from the comprehensive to the fragmentary.

The need to isolate often governs Picasso's use of colour. At different times he isolates blue, pink, black-and-white, and so on. This

has both a positive and a negative aspect. The positive is the assertion of the chosen colour: it's often said that Velázquez and Goya made a colour of black; Picasso's black-and-white pictures isolate this strain in the Spanish tradition. The negative aspect is that absence of variety in the colour helps to isolate qualities of form. Thus black-and-white tends to be used in ambitious and complex compositions like *L'Atelier de la Modiste*, *Guernica*, *The Charnel House*, and the first *Meniñas*. It has been said that the absence of colour from *Guernica* and *The Charnel House* has to do with their tragic content, but this doesn't square with its absence from the other pictures. What all four pictures have in common is that they are larger canvases with more figures in them than most Picassos. Black-and-white, then, seems to have been used because managing a complicated composition was enough without having to organise contrasts of colour as well, just as the reduction of colour to grisaille in Analytical Cubism resulted from the pressure of its intricate problems of form: Braque and Picasso wanted at first to give objects their local colour, only to find that their concern with a new and difficult conception of form left no room for this. This isolating of grey also had its positive aspect: Cyril Connolly, in *Enemies of Promise*, pointed out how 'grey' was the favourite epithet of writers between 1900 and 1910.

In Analytical Cubism Picasso was using for once an exceedingly complex formal language – as distinct from the complex use of a basically simple if sophisticated language in *Guernica*. Certainly, by comparison with late Cézanne, Analytical Cubism partakes of the modern tendency to isolate particular qualities, but it is still the most complicated style of the last fifty years, apart, perhaps, from Braque's own late style. What is significant about Picasso's Analytical Cubism is that it stands apart from the rest of his career. There is no doubt that the style was created in the first place by Braque, in the Estaque landscapes of the summer of 1908. And it seems possible that, if Braque had not created it, it would never have been created. True, it is embryonic in the background of the *Demoiselles d'Avignon*, but this picture points in so many directions that there's no guarantee that this one would have been taken. It is conceivable that, in the absence of Braque, Picasso could have gone straight from the style of the so-called Negro Period to that of Synthetic Cubism. The idea of

simultaneously presenting several views of an object, though not fully carried out until Analytical Cubism, is certainly latent in the *Demoiselles* (in the two figures on the right) and in other works of the Negro Period, and the form it begins to take here is closer to the form it later took in Synthetic Cubism than is the form it meanwhile took in Analytical Cubism.

It is also significant that the transition from Analytical to Synthetic Cubism was much sharper, more sudden, in Picasso's development than in Braque's – though for Braque too it was, of course, a fresh start, no logical development but (with everything getting too impossibly involved) a matter of making the best of a bad job. Still, there is some overlapping of the two styles in all Braque's work right up to the time his career was interrupted by mobilisation in August 1914, whereas there are certain Picassos done before the end of 1912 in which there is no vestige of the earlier style, and before the end of 1913 there is no trace of it in any of his work.

Furthermore, in Braque's later work, though this is, of course, founded mainly on Synthetic Cubism, there are more frequent reminiscences than in Picasso's of Analytical Cubism; he often introduces a hint of it into a section of a painting, as in some of the *Ateliers*. Picasso, on the other hand, does no more than make a very occasional excursion into a style which calls it to mind: thus the *Reclining Nude* of 1952 from the Ganz collection seems a deliberate evocation, in colour and form, of such proto-analytical cubist paintings as the *Bather* of 1908 and the Tate's *Bust of a Woman* of 1909 – and the very fact that the reference is much more clear-cut than it ever is in the later work of Braque tends to confirm that for Picasso Analytical Cubism is something special, something apart.

What is more, whereas Analytical Cubism left hardly any visible trace on Picasso's subsequent work, the Negro Period brought to birth certain forms which became typical of a great deal of the work of his later years. Just as paintings of 1905–6 contain the seeds of much of his more or less naturalistic work after 1920 – notably the monumental nudes of the early Twenties – so are the seeds of much of his more or less cubist work after 1935 contained in paintings of 1907. Since the mid-Thirties Picasso's most characteristic shape has been a taut shallow curve, something like that of a scimitar, used in opposition to

straight lines, and the 1907 paintings are almost entirely made up of exactly the same curve together with straight lines. The anticipation is most evident in *Still Life with Skull* (Leningrad, now at the Tate), for the shallowness of its space emphasises the picture-plane more than in the figure-paintings of the period and to something like the same degree as in the later paintings, but the nudes and the dancers too are built up out of the selfsame shapes. The scimitar-like curve incidentally, is characteristic of medieval Catalan painting as well as of the bronze ancestral figures from the French Congo which Picasso saw at the Trocadéro. Another feature of these bronze figures which Picasso incorporates is the decorative use of hatching. He first employs it in the faces of the two figures on the right of the *Demoiselles d'Avignon*; a few months later, in the *Nu à la Draperie* in Moscow and the *Flowers from the Colin collection*, he fills up every shape with this hatching. And this kind of hatching reappears, along with the scimitar curve, in several paintings of the late Thirties and Forties.

The paintings of 1907, then, are remarkably akin to much of the most typical late work. The differences are that in the later work the shapes lie flatter on the picture-plane and there is a more constant and systematic use of multiple viewpoints. But these characteristics are typical of Synthetic Cubism. So, much of the work of Picasso's full maturity combines features of his work of 1907 and of his work of 1913–15: everything that came between is excluded, everything, that is, involved specifically in the growth of Analytical Cubism, from the block-like figures of 1908, through their gradual fragmentation, to the shimmering crystalline structures of 1911.

The significance of this, I believe, is that Analytical Cubism is a less simple, single-minded and direct style than those which preceded and followed it, styles which clearly isolate certain qualities at the expense of all others. Analytical Cubism made Picasso into a seeker rather than a finder. Though it produced some of his finest work, it was not entirely natural to him, because the complexity of its aim was inimical to the creation of an immediate telling image.

Picasso's compulsion to isolate particular aesthetic qualities is analogous to his habit of breaking down the human figure into fragments and building some of them up into a new construction within which the fragments retain their separate identities. He breaks down

art into its several elements and exhibits them separately. Sometimes they are put together into a construction which is a series whose different members exhibit different qualities so that the whole is the sum of a number of ways of dealing with a theme – the *Meniñas* copies, for example (as a set of variations they are akin, not to the Diabelli Variations, which grow out of one another, but to the Art of Fugue). But many of Picasso's series or periods don't attempt to do several different things but go on doing the same thing until he embarks on a different series or period. But these periods are each as a whole part of a construction – the pattern of Picasso's career, a pattern infinitely diverse but unified by a conception of pictorial beauty which is as utterly personal as it is strange and ravishing. It is because the pattern of his career in its entirety is so thrilling that he is magnified by an exhibition on the colossal scale of the Tate's, where most artists would be diminished by its size. One walks about in these rooms in a state of amazement, vastly excited, and vastly entertained.

But if one can bear to drag oneself away to take a look at Bonnard's *La Table* and Matisse's portrait of Derain downstairs and then return to the Picassos, they now look curiously inert. One had imagined, under the spell of Picasso seen whole, that modern painting just couldn't be better than this: one had forgotten how much an individual great modern painting could do, that it can offer a dimension beyond Picasso's scope (as one forgets when watching a first-rate film that the theatre can offer a further dimension than this). A dimension is missing as the result of a too urgent and all-embracing compulsion to isolate particular qualities. Picasso seems to decide what it is that he wants to abstract from his subject, and then to shut his eyes and mind to it until he has given form to his decision and can make a fresh start on something else. Not necessarily on a different canvas, perhaps only on a different image, but on a *different* image. The film *The Picasso Mystery* is illuminating about this. It shows the myriad transformations undergone by a big painting of a beach scene, and each transformation is a change of image, never, as with the successive states that were photographed of paintings by Matisse, a further stage in the evolution of an image. The transformations are like those in the pattern seen in a kaleidoscope, forever forming and re-forming as it is shaken up, but only changing, never growing, whereas transforma-

tions in Matisse belong to a process of growth. There is no growth because each change cancels rather than qualifies what was there before: Picasso doesn't allow the experience of a subject over a period of time, with every alteration of heart and mind and perception that occurs, to accrete in a single painting in which every successive layer of the experience is somehow still active. Because he doesn't let nature take him by surprise, but always has to take it by surprise, he doesn't allow the total experience of the subject in all its richness to flood in and carry him along with it. He maintains his omnipotence by keeping his separate experiences of the subject in separate compartments. The dialectical process is excluded by which a stage negates what has gone before, leads on to a synthesis of what was finest in all that had gone before, which is again negated and so forth, so that at the end of a series of contradictions we are left with a distillation of the sustained experience.

If one regrets that Picasso's individual pictures haven't in consequence the richness and depth of a Matisse or a Bonnard, it is not because of a nostalgia for the conclusive character of the comprehensive masterpieces of the past. It is because one wants a painting to be self-contradictory, not 'a sum of destructions' but a sum of contradictions. The tendency of modern art to isolate doesn't at all preclude this: look at the serenity and the violence locked together in a Mondrian. Picasso, however, except in his Analytical Cubist works, only contradicts himself as between one painting or period and another. And contradictory statements that are juxtaposed can't combine to mean as much as contradictory statements that are superimposed: the first can only mean an interplay, the second an interlocking; the first can only mean opposition, the second opposition and reconciliation. The greatest paintings don't need the context of a great one-man exhibition.

Gris

This untitled review of a retrospective at Marlborough Fine Art was a broadcast talk for the BBC Third Programme on 20 February 1958. It has never appeared in print. It was substantially revised at some time in the 1960s.

To think of Cubism is first of all to think of the two painters who, oddly enough, were both its first and its finest exponents, and after them of Léger and of Juan Gris: it has long been taken for granted that these four were the leading Cubist painters. But the artists who seem in retrospect to have been the best exponents of a style are not always those who were so considered at the time. It is remarkable therefore that the dealer who did most to sponsor Cubism, Daniel-Henry Kahnweiler, sponsored all four of these Cubist painters and not one of the countless others. Nevertheless, in his booklet *The Rise of Cubism*, Kahnweiler mentioned only three of the four by name; Gris was the odd man out. He was, of course, a younger man – six years younger than Picasso and Léger, five years younger than Braque – and was still in his twenties at the time Kahnweiler wrote his text in 1915, so that his omission might be explained by the assumption that, although Kahnweiler the dealer had Gris under contract, Kahnweiler the critic, writing under the pseudonym Daniel Henry, was not pre-pared to be as committed to Gris as to the other three. Five years passed between the writing of the essay and its publication, yet even in 1920 Kahnweiler did not see fit to interpolate a mention of Gris's name.

His reason is suggested by this passage from the booklet: 'Our sub-ject is the rise of Cubism. Therefore we cannot discuss here the numerous artists who later joined the movement, but only those who created it. One of these is Fernand Léger. It would be unjust and false not to name him among the pathfinders of Cubism, along with Braque and Picasso.' The implication that Gris was not one of the pathfinders of Cubism is significant in the light of the fact that Léger's first Cubist pictures only antedate Gris's by a year – 1910 as against 1911. So Gris was only one of 'the numerous artists who later joined the movement'. Nevertheless, he has been given a place along with the three 'pathfinders' as one of the movement's four masters. For

instance, in 1936 Alfred Barr wrote: 'During the years of Synthetic Cubism, Gris held his own even against Picasso and Braque.'

This is a point of view, and it's a generally accepted point of view, which I find it difficult to understand. In any mixed exhibition which includes first-rate paintings by the four leading Cubists, Gris seems to me a distinctly lesser artist than Braque, Picasso and Léger, while clearly superior to everyone else. His forms, by comparison with Picasso's and Braque's, seem rather stiff and thin, have neither their vibration nor their density. I feel that, if I were to touch the forms in a Synthetic Cubist painting or collage by Braque or Picasso, they would have the earthiness, the substance, the living quality, of wood or earthenware, whereas the forms of Gris would feel like cardboard or American cloth. His paintings have neither the subtlety of Braque's nor the astringency of Picasso's nor the majesty of Léger's. Their refinement is a little pedantic. And I'm led to wonder whether Gris's high reputation doesn't owe something to his premature death, at the age of forty, because artists who die young are never in danger of being underrated, only overrated, and Gris in particular has long been thought of as a sort of saint of Cubism.

To see Gris on his own, as in the present exhibition at the Marlborough, is another matter. Here he looks very convincing. He is a beautiful colourist – this is evident from the very earliest picture, a sort of Cézanne still life out of focus – and his colour imposes his mood, irresistibly. What rules in these pictures is silence. It is a silence that calls to mind the fact that Gris deeply admired Philippe de Champagne. Silence rules absolutely. The hush spreads through the gallery. One rarely hears such silence in a crowded gallery: any talk is in whispers. It's like being in church. The reverence we feel is an echo of Gris's reverence, his reverence for art, and his reverence for life. He is an artist whom it is difficult not to admire and like.

The special value of the present exhibition is that it includes a number of late works never exhibited till they were shown very recently in Paris and some which have never before been shown at all. Seeing these paintings has confirmed a suspicion I have long had that Gris's finest works are not, as is generally thought, the still lifes of 1913 to 1917, but the still lifes of 1926 and 1927, the last years of his life. There is no doubt that in the early 1920s his work suffered a

decline. In the effort which he made at this time to enrich his forms, he succeeded only in making them, somehow, like butter. The still lifes become disconcertingly squashy, and the attempts at monumental figure-painting, for all their earnest intentions, are as dated as old book jackets. But in 1925, beginning with works like the large still life with a classical bust, a change starts to come over Gris's style. The volume he had given his forms is now gradually squeezed out of them. And, indeed, when we look at them, the flat emblems-for-objects of 1926–27 differ from the flat emblems-for-objects of 1913–17 in that they are not mere tokens for real things but seem to have once had a richness and a juiciness that has now been refined out of them. Yet they do not look dessicated, nor even like phantoms. They are simply shapes that have come to live a most curious and compelling life of their own. They are shapes which somehow bend space to their will. Space seems to curl and stretch and throw out feelers, feelers into another dimension: it seems to expand and contract as in the successive transformations of a cat's cradle. Space becomes elastic. A world has been created which is completely fluid and yet in no danger at all of disintegration or collapse.

The last still lifes of Gris broke entirely new ground at a time when Picasso and Braque were mainly consolidating old gains, exploring certain romantic and decorative possibilities of Cubism. Gris may not initially have been one of the pathfinders of Cubism, but he became one at the end of his life. It was not until twenty years later that the new ground he had first explored was fully taken over – in Braque's late still lifes such as the series of paintings on the theme of *The Studio*. In these masterpieces, Braque manipulates space in a way foreshadowed by the last works of Gris.

To compare these works of Braque and Gris is to be aware once again of their unbridgeable difference in stature. Nor does it make any sense to say that if only Gris had lived he too . . . His last works are the supreme expression of his talent, such as it was. It was left to a greater talent to develop to the full what they contain. There is nothing fortuitous in the fact that Braque did not develop it until his own late period, because the last works of Gris have the quality that is peculiar to the last works of artists – that curious mingling of bareness and utter freedom. And it is just for this reason that I believe that Gris

himself could not have developed further what he achieved in them.

Gris, indeed, like many artists who die young, compressed a full and complete development into his short span of life. We often find that the work of artists cut off at forty or even thirty still contains an early, middle, and late period, telescoped into a shorter time than that in which they normally unfold, but each possessing the characteristics which we especially associate with early, middle-period, and late work. Their last works in particular acquire that special character which is commonly found in work produced when the artist is close to death. Keats's second *Hyperion*, for example, has the stark, broken form of late Shakespeare. Schubert's posthumous works pass beyond the ordinary frontiers of music in much the same fashion as the late works of Beethoven. And has it been remarked what uncanny affinities there are between Titian's last work, the *Pietà* in the Accademia, and the *Holy Trinity* in Santa Maria Novella, the last work of Masaccio, who died aged twenty-seven? I am not trying to propose any theory that the pattern of a man's life is preordained; I am not even trying to suggest that those who are going to die young have some premonition of this which provides a spur to an accelerated development. I am only pointing out the fact that surprisingly often the late work of those who die young has that strange transcendent note which is characteristic of the late work of those who die old. And I am saying that, when the late work of a man who dies young is of this kind, it is absurd to lament what he might have done if only he had lived.

Still Life: Cézanne, Braque, Bonnard *1961–62*

The BBC Home Service commissioned a series of talks entitled 'Painting of the Month' in which the chosen painting had to belong to a British public collection. Subscribers could obtain a brochure relating to each talk, which reproduced its subject in colour and also had various supplementary illustrations. The speakers had to assume that the Home Service audience would be less informed than the Third Programme audience to which the pieces reprinted above on Dubuffet, Pollock and Gris had been addressed. Each of the speakers gave three consecutive talks on paintings in a particular genre; I was assigned still life. The examples I chose were all painted in France by Frenchmen during the first quarter of this century. The rules created great difficulties with the second talk. Whereas a first-rate still life by Cézanne and one by Bonnard could be found in a public collection within these shores, a first-rate Analytical Cubist still life, whether by Braque or Picasso, could not at that time, yet it was imperative that an example be included in the series. The choice had to fall on a painting that was not only of indifferent quality but also fell short of typifying one or another of the phases in the development of Cubism. That is why my text had so little to say about its ostensible subject and focused mainly on cubist still life in general.

Written at the turn of 1961–2, '*Still Life with Teapot* by Cezanne', 'Braque's *Still Life with Fish*' and 'Bonnard's *The Table*' were published in *The Listener* for 18 January, 7th February and 15 March 1962, respectively. I conceived the talks as a single piece in three parts, and am reprinting it as such, slightly revised.

I

Max Ernst tells how his father, an honest man, painted a picture of his garden from which he left out a tree for the sake of the composition, and was afterwards so troubled by this untruth to reality that he went and cut down the tree. He did not become a famous painter like his son. But Monet did much the same sort of thing, though in reverse order. He too believed that he ought to paint nature exactly as he saw it, without rearranging it in the painting to make it conform with an ideal of art. However, it is said that he sometimes paid workmen to lop branches off a tree before he began his painting of it, and certainly, once he had money enough to buy land, he had gardens and lily-ponds laid out in accordance with his designs and then painted what was there.

Behaviour like this is eccentric because painters normally take it

for granted that nature is one thing and painting another, that nature is natural and painting artificial, and that in translating nature into art they have every right to use conventions of art. Only a fraction of the painters in the history of the world's art have in any case made it their habit to paint directly from nature, and they have mostly taken in their stride the need to select from and rearrange what they saw in order to turn it into art. In Cézanne's case, for one, comparisons that have been made between his landscape paintings and the landscapes from which they were painted show his readiness to eliminate things that were there in order to give coherence to the picture. He didn't have Monet's scruples about making the painting match the motif.

When Cézanne painted a still life, however, he prepared the way rather as Monet did with his garden. He arranged the objects, according to an eye-witness, with the greatest deliberation and care, choosing and placing the fruits with an eye to their contrasts of colour, draping the napkin very precisely, even using coins and wedges under the fruits in order to tip them up into exactly the position he required. He took every advantage of the fact that in painting still life, and still life alone, the painter has the opportunity, without going to Monet's extravagant lengths, to copy exactly what he sees before him and still achieve exactly the composition he desires, down to the pleats in a piece of cloth. Certainly, the painter can dispose the living model as he wishes, can tell her to stretch one leg out and bend the other, just so – but only within the limits of what is anatomically possible. True, with still life there are physical limits to what the painter can arrange. He can't balance three oranges on one, though he can, as Cézanne did, wedge an orange into a position it would not naturally hold. Certainly the limits are much more flexible than those of human anatomy. If the painter arranging a still life wants another small mass in the corner, he puts another orange there. If the painter arranging a nude wants the same, the model has no spare foot up her sleeve, and the painter will in fact use some object of still life to fill the gap unless someone has a pet of the right size.

The peculiarity of still-life painting, then, is that it allows the artist to work directly and scrupulously from nature and still have the same entire control over his composition as the artist who is working out of his head. Other than in still life the painter working on an elaborate

composition only comes to arrange it when actually painting it or at least drawing it. He composes his design only in terms of an illusion of what it represents – with one or two exceptions, who have built small models from which to paint or to draw their designs, such as Poussin, who worked out his compositions with wax models of figures on a miniature stage and drew from these scenes; or Gainsborough, whose later landscapes were contrived in miniature with 'broken stones, dried weeds and pieces of looking-glass'. But for the still-life painter it is normal to compose an elaborate design in terms of the actual objects to be represented. He begins to create his work of art before he picks up brush or pencil. The subject of the painting already belongs to the realm of art.

Cézanne therefore had every reason to paint still lifes as much as he did. He wanted to produce grand and elaborate compositions like those of Poussin and the Venetians. Yet at the same time he wanted to paint direct from nature, 'to do Poussin again entirely from nature'. By painting still life he could improve his chances of achieving so paradoxical an aim. He could design grand, complex formal composi-tions in terms, not of the heroes of mythology and Scripture, but of the things he saw around him, aiming at what he described to Gasquet as a 'heroism of the real'. He had inherited from Courbet's Realism the notion that, contrary to academic theory, there were no special, appropriate subjects for art, that all subjects were equal. In practice, Realism had functioned as if some subjects were more equal than others. It had a decided prejudice in favour of those subjects which idealism had rejected. It created an inverted idealism which main-tained that a workman was a more honourable subject than a nobleman – though in a sense it genuinely is a more realistic subject inasmuch as many more men are workmen than are noblemen.

This sort of inverted idealism tends inevitably to arise in the first stage of a reaction against an entrenched official idealism with its hier-archy of approved subjects. The obvious precedent is Caravaggio. In insisting that beggars, bandits, and whores could be vehicles of tragic emotion, Caravaggio may have implied that those better placed in society could not be so used, but he also opened the way for Rembrandt really to treat all men on the same terms, to see them all with the same comprehensive sympathy. And as Rembrandt stands to

Caravaggio, so in a sense does Cézanne to Courbet. For Cézanne, all nature is a source of excitement for the painter. As he wrote near the end of his life, 'The real and prodigious study to be ventured is that of the diversity of nature's picture.'

There was a sound intellectual basis for this enterprise. To quote him again: ' . . . a strong sensation of nature . . . is the necessary basis of all artistic conception, and the basis on which the grandeur and beauty of the future work reposes.' His *sensation* of nature – this was the absolute to which he always returned in discussing his theories and practice. If the painter's real subject is his sensation, not some thing-in-itself out there, it follows that anything which gives rise to this sensation provides a motif as good as any other. The practice of the Impressionists implied the same reasoning, of course, but in their theories they imagined that the subjective phenomena they were painting were the objective behaviour of light and spoke of light as the unifying element in experience. This confusion led naturally enough to Monet's posturings over the relation of art to reality. I am not trying to say that the Impressionists' muddled thinking had a detrimental effect on their art. But I would say that Cézanne's understanding of what he was about was a necessary basis of his own more ambitious art, with its declared aim of 'making of Impressionism something as solid and enduring as the art of the museums'.

It was a wildly ambitious aim. He was actually proposing to sit there in front of some everyday motif and translate his sensations of it on to the canvas in such a way that the resulting work would have the same sort of grandeur as the old masters gave to their monumental compositions of ideal forms representative of gods and goddesses, saints and martyrs. It only made sense if sensation was primary. And then an apple or an orange was perhaps the best possible subject he could have: firstly, because while working from nature, he could still dispose it as he wished; secondly, because it carried no strong emotional overtones to distract him from realising his sensations; thirdly, because such objects presented, far more readily than landscape, the possibility of finding those clear and regular forms, like orders of architecture, which are needed for the creation of a monumental art.

And as we look at the four spheres embraced by the ellipse of a plate in the centre of *Still Life with Teapot*, we don't really know if they

are and which of them are apples, oranges, apricots, and we don't care. What we know as we look at them, know it physically, in our bodies, is the feeling of having the shape of a sphere, a shape that is perfectly compact, a shape that can touch similar shapes at one point only, a shape which has a very precise centre of gravity. Perhaps the thing that makes us so deeply aware of this shape – which is of course no more a geometric sphere than the sides of a Doric column are straight lines – is above all the relation between the shapes of the four fruits on the plate and the two on the edge of the table and that of the teapot between them. The body of the teapot – the teapot apart from its handle and spout – is also a sphere, standing out against those of the fruits, about twice as large and white against their luminous yellows and oranges. Its shape rhymes with the shapes of the fruits and acts as rhyme does in verse – both connecting what is dispersed and heightening our awareness of the shapes of the words that rhyme.

The contrast of the larger white sphere with the smaller coloured spheres, at once a repetition and a variation, heightens our awareness of exactly what that shape is, what it is from within. And, as we look, this contrast and repetition, making us feel not only this common shape but precisely where each form is in relation to the others, leads us to imagine that what we are looking at is no arrangement of fruits and crockery but a sort of temple, like a temple made up of columns, only a temple made up of spheres. But it is not the same as if the painter had simply constructed an abstract design of these more or less regular shapes. The thrill of our recognition of them depends on our reliving the painter's discovery of this temple of spheres in a few commonplace objects. We are indifferent, as the painter was indifferent, to the names of these objects, to their particular practical use, but it does matter that they are real, that we can find their forms in the everyday world.

But they stand there now like a temple. Only, temples are not found on kitchen tables, but in landscapes. Yet isn't the scene presented by this painting more like a landscape than a kitchen table? It has the immensity of a landscape, and its feeling of permanence. We move in imagination among the objects in the foreground as if among great boulders at the foot of a mountain, a mountain formed by the drapery beyond. Cézanne's painting of drapery always tends to be

metaphorical of mountains and cliffs; and here the drapery is not only mountainous in feeling but has a shape exactly echoing that of Mont Sainte-Victoire, which rears up in the background of so many of Cézanne's paintings of landscape. Consciously or unconsciously, Cézanne habitually gives the patterned drapery on the table in his later still lifes the form of Mont Sainte-Victoire.

Consider the great still life of *Apples and Oranges* in the Jeu de Paume in Paris, probably painted just before the turn of the century, whereas the Cardiff picture was probably painted just after. In the Cardiff picture, the drapery sits there across the wall almost exactly as the mountain does against the sky in Cézanne's late landscapes. In the Jeu de Paume picture with its exuberant diagonals, drapery fills almost the whole background, except in the top right corner, where we get a glimpse of wall and there, outlined against it, is the familiar shape of Sainte-Victoire. When Cézanne painted ostensible landscapes, it was always out of doors, from the motif. He never painted them, as painters always had before the nineteenth century, in the studio, out of his head or from sketches. But in these still lifes, painted in the studio, from nature, he is also painting his memories of landscape. He is projecting on to his intimate little indoors motif something of the vastness of the world outside.

When Cézanne spoke to Gasquet of 'the heroism of the real', he went on to talk about 'the immensity, the torrent of the world in a little bit of matter'. The still life on the table in the studio becomes a metaphor of the immensity of the world; and also of the torrent. Because the still life is not still: it is alive with movement, shifting, disturbed.

In the *Apples and Oranges* especially, less vehemently in the *Still Life with Teapot*, the luminous spheres of fruit seem to be asserting a will to live – 'the torrent of the world' – by trying to jump about, to and fro, out of place, out of the picture. And still they are held there, in place, decidedly held there, but only just held, against the force of their will to move, to slip out of a grasp which is compressing them into and on to a flat surface bounded by a rectangle. But they *are* held, locked together by a tension which encompasses every inch of the canvas, a tension that imposes order and unity by containing the intractability of nature; yet not by diminishing its force. The sensa-

tion of these apples and oranges is an experience of 'the torrent of the world', and it is nothing less than this that must be brought under control by the painter's art, fixed in place in 'a harmony parallel to nature'. 'All that we see', Cézanne said to Gasquet, 'is dispersed, is transient, is it not? Nature is always the same, but nothing remains of what we see of her. It's for our art to give the feeling of her endurance, with the ingredients, the appearance of all her changes.'

Cézanne's art gives us both the sense of flux and the sense of endurance, and it gives us each of them to an extreme degree. It is no safe, comfortable compromise between these opposites. It pushes each of them to the limit, and somehow holds them in balance, reconciled, yet with neither diminished by the other's presence. The only other artist I can think of who succeeds in reconciling opposites pushed to the same extreme degree is Beethoven. Polarity is, in one way or another, and at one level or another, perhaps the dominant characteristic of Cézanne's art. It certainly is of his thought. Those who talked to him were impressed by his need to balance any affirmation by immediately asserting its opposite. His inconsistency was almost laughable – no, it was not laughable, it was the result of his recognition of the appalling complexity of what is. Perhaps this was why he, who loved to theorise, scorned theory – because in words he could only contradict himself in sequence, couldn't say two opposite things at once. For in his painting he could and did do this. Thus his painting lays extreme emphasis on the flatness of the picture surface, while at the same time it makes the solidity of the motif utterly tangible. It is intensely passionate, but also intensely reflective. It is deeply concerned with order, yet it deals in the muddle of the appearance of everyday things. It is revolutionary, yet rooted in the museums. It gazes persistently outwards at nature, yet imposes on what it sees certain insistent and compulsive rhythms expressive of personal obsessions.

In our lives nothing troubles us more than our inability to deal with those contradictions which we recognise in ourselves, in our feelings, our desires, our consciences – our inability to accept them and reconcile them. We tend to deal with such contradictions by closing our minds to the existence of one side or another or by evading them with some feeble compromise. Perhaps it is because Cézanne's art

accepts contradictions to the full and finds a means to reconcile them that we always feel instinctively that it means so infinitely more than its ostensible subject. What it means is a moral grandeur which we cannot find in ourselves.

Among the contradictions which his art presents there is none, perhaps, more profound than that between the sense of the transience of life and of its permanence. In the *Still Life with Teapot*, even more, even much more, in the great late paintings of Mont Saint-Victoire, we experience these contradictory feelings separately, and each as poignantly as the other. There is a hopeless sadness that all we see and rejoice in dies for us no sooner than it is seen; there is a serene affirmation that what we are now looking at will be there for ever. We are faced with our deepest concerns about life and our place in it, but exalted here by this total acceptance of the intolerable fact that mortality and immortality are only meaningful in relation to each other.

Perhaps it is because Cézanne's art is a confrontation with ultimate questions that still-life subjects served him so well: through their absence of ready-made emotional overtones. And the same can be said of Saint-Victoire, which has no obvious sublimity, no Alpine grandeur or Parnassian magic. Such motifs brought with them a minimum of publicly acknowledged emotional significance: the significance they were to have would be that which the artist found in them for himself. Cézanne had nothing outside his own purposes to distract him when he took these as texts for meditations on ultimate things, on all nature and the way we see it.

II

Whereas Cézanne's art perceives contradictions in reality and seeks to resolve them, Braque's tends to make a point of preserving contradictions, making ambiguity an end in itself. This may be why cubist paintings by Braque and Picasso done half a century ago still puzzle most people. They feel disorientated, can't get their bearings, can't pin them down. And they are right, in a way. For the point of such pictures is that they consist of questions rather than answers, and that the questions are of a kind to which there is no one answer.

To say what the elements are that make up their mystery, we cannot do better than to compare them with those paintings of the last

seven or eight years of Cézanne's life, such as the *Still Life with Teapot*, which were the point of departure of these works by Braque and Picasso. The peculiar faceting of the forms in works like the *Still Life with Fish* in the Tate Gallery is almost certainly inspired by a particular type of Negro sculpture from the Ivory Coast. But the one other influence discernible in them is that of Cézanne.

In Cubism everything that was traditional in Cézanne was discarded, and everything that was special was exaggerated. The Cubists took his tendency to look at objects from two or three different points of view and to synthesise on the canvas the resulting information, and exaggerated it to an extreme degree into the principle of combining in a single image things seen from different points all round the object. They exaggerated the shallowness of his space and his tendency to uptilt the objects in the picture so as to bring them closer to its surface. They exaggerated his use of his device known as *passage* by which the near end of a plane is clearly defined while the far end dissolves into space. They exaggerated the suppression of colour in the works of his last years, arriving at a palette confined to greys and browns, sometimes heightened with green, almost like grisaille. They exaggerated his use of regular forms such as the cone, the cylinder, and the sphere, and to these added the cube. Actually I suspect that their love of the cube and of straight lines in general was a reaction against Art Nouveau, the reigning style of the 1890s, which never used a straight line, on the grounds that there are none in nature.

Again, the Cubists exaggerated Cézanne's disregard of surface textures. They exaggerated his tendency to treat solid objects and space as if they were equally tangible. In 1897 Bernhard Berenson wrote that Cézanne 'gives the sky its tactile values as perfectly as Michelangelo has given them to the human figure'. And Braque has told us that one of his own main preoccupations was to paint space as if it was as tactile as the solids in it. Above all, the Cubists exaggerated to an extreme degree the ambiguities in Cézanne's art.

I spoke earlier of three types of ambiguity in Cézanne's later still lifes. First, there was the feeling they gave that the objects are trying to jump about and yet will stay where they are for ever. Cubist paintings like the *Still Life with Fish* give us still more immediately both a sense of restlessness and unease and equally a sense of stability and

quietude. And I said that with Cézanne there was an ambiguity about the identity of objects, and that in some such cases – like the patterned drapery which could be a mountain – this led to a third ambiguity, a doubt concerning the scale of objects. In Cubist paintings the identity of the objects is utterly obscure, because of the fragmentation which results from painting bits of them as if from completely different points of view. This obscurity was a cause of concern to Braque and Picasso, who feared that because of it their paintings might be read as having no reference to reality, and for this reason they often introduced into their Cubist works a piece of almost illusionistic painting intended to provide a key for reading the picture as a whole. The perfectly unambiguous fish's head in the foreground of the *Still Life with Fish* is an illusionistic detail of this kind. Less intelligible are the two other fish, the napkin, and, in the left background, the bottle and the hunk of bread. And to the right in the background there is clearly another object which I am at a loss to identify: I think it might be a jug.

Beyond this, the general impact of the painting is hardly that of a still life at all, but that of something much bigger and more romantic and picturesque. It looks rather like one of those cavernous prison interiors etched by Piranesi, looks still more like a precipitous landscape with buildings set among the rocks, grey and brown rocks touched with sparse green vegetation, hard, tense, angular, piling up steeply and lit by the misty light of northern coasts – something like Mont Saint-Michel (which, as a matter of fact, is not far from the place where Braque grew up, Le Havre). And yet it all seems to be within reach of our touch, there on a table, down there in front of us.

We have found this sort of landscape-still life duality in Cézanne's *Still Life with Teapot*. But as we look at the Cézanne, we are always sure, at any given moment, of whether we are at that moment interpreting it as still life or as landscape. Whereas with the Braque we find that in some extraordinary way it seems always to be both things at once, that we somehow cannot disentangle these different ways of seeing it. And I think it is precisely this above all that makes us feel disorientated in the face of it. We really do feel physically, not just intellectually, that we don't know where we stand. And of course we get the same feelings as a result of the fact that the image compiles

fragments of information gained from several different standpoints. And we get it from being completely uncertain just what is solid and what is space.

Every attempt to interpret this painting ends in a question to which there is no one answer. Yet really this is true of any work of art, is the very reason why art enlarges our consciousness of life, by fusing things which in life reveal no relationship to us. Only, in general, we tend to overlook the fact that a work of art means many different things by making our minds up that there are one or two definite things which it does mean. A painting like this, by refusing to give us anything very definite, makes it impossible for us to overlook the mysteriousness and ambiguity which are conditions of art. It tells us something about the nature of all art.

It comments upon the mystery of art and it also comments upon the duality, of which again we are generally less conscious than we should be, inherent in the whole idea of representational art. Is it not, after all, extraordinary that a painting, a static coloured design on a flat surface, which is meant to please and speak to us as such, should also attempt to be a representation of part of a world that exists in space and in time? The very difficulty of relating a cubist painting to reality stops us from taking this duality for granted, stops us from taking anything about art for granted. The thing that moves us above all about such a painting is its power to involve us in the artist's recognition of the mystery of the relationship of art to reality, and in the wonder and awe he feels in the face of this mystery.

I have been discussing Cubism generally in relation to a still-life painting, and this is appropriate because in the cubist period Picasso and Braque painted more still lifes than all other kinds of subject put together – this in spite of the fact that before the birth of Cubism they painted still life hardly at all: Picasso had mostly painted figures, Braque mostly landscapes. The dominance of still life was in fact less strong during the period to which the *Still Life with Fish* belongs, the period of so-called 'Analytical' Cubism, which lasted from 1908 to 1912, than it was in the period of 'Synthetic' Cubism which followed. In Synthetic Cubism the transparent faceted forms and grisaille palette gave way to larger, opaque shapes in a wide range of colours.

The transition came about as the result of a decision made by

Picasso and Braque to strengthen the connection of their pictures with reality by introducing actual bits of reality, such as newspaper cuttings, theatre tickets, wood veneers, etc., and sticking them to the surface of the picture. In using this technique of *papier collé* they were substituting fragments of reality itself for the earlier fragmented images of reality. There was, therefore, an eminently practical reason for depicting still lifes in their *papier collé* pictures: that, if they were going to incorporate fragments of reality, it was clearly more convenient to use fragments of still life than fragments of vegetation or fragments of human bodies. However, it remains a fact that even before this the Cubists, especially Braque, were painting still lifes much if not most of the time. They even made sculptures of still-life subjects; were the first artists to use still life as a subject for free-standing sculpture as distinct from carved ornament. And their followers, painters and sculptors, were equally preoccupied with still life. Indeed, we tend to associate the cubist movement with still life much as we associate the Italian Renaissance with the nude.

This addiction to still life seems natural enough in artists whose hero was Cézanne. Though still life did not figure numerically as high in Cézanne's work as it did in theirs, Cézanne's apple is proverbial; it is, as it were, the emblem of his art, and was considered so from a very early date. When in 1900 Maurice Denis painted a *Homage to Cézanne*, showing a group of young artists admiring a Cézanne picture on an easel, the picture was a still life with apples. We might expect, therefore, that the Cubists' motives for painting still life so much were similar to Cézanne's. Last month I spoke of the tangibility with which Cézanne invests the objects in his still lifes. It is obvious that an artist obsessed with tangibility would be helped by painting objects which are handled all the time and a knowledge of whose total shape is so immediately accessible to the sense of touch. And we know that Braque was very consciously concerned with painting reality in an intensely tactile way; he has indeed said that one of his reasons for painting musical instruments was that they 'have the advantage of being animated by one's touch'. Other things he habitually painted, such as glasses and bottles, are objects we habitually touch.

But the curious thing is that none of the other motives which I suggested were relevant to Cézanne's use of still life could have been

operative for the Cubists. I suggested that he painted still life because this enabled him to compose the motif from which he was painting precisely as he wanted it. But the Cubists did not paint from the motif, except at the very outset. They certainly had the objects they were painting knocking about in their studios. But they didn't stop and assemble them on a table before they began to paint.

I also suggested that Cézanne painted still-life subjects because they presented better than other subjects the possibility of finding regular forms, ready-made architectural forms. The Cubists needed no such help because they were not trying to find such forms in what they saw in front of them. They constructed such forms quite freely, regardless of what the subject was.

Finally I suggested that Cézanne liked to paint still life because it did not carry the strong ready-made emotional overtones of land-scapes and the human figure, but, oddly enough, the repertory of objects used in Cubist still life is not free of such overtones in the way that Cézanne's apples, oranges, napkins, and jugs are. Our *Still Life with Fish*, by the way, is altogether exceptional in its subject-matter. The usual subjects of Cubist still lifes were guitars, mandolins, violins, clarinets; glasses and bottles of wine, spirits and beer; pipes, news-papers, playing-cards and dice.

This is a collection of objects which adds up to a very definite pic-ture of a certain way of life. These are objects which form part of the bric-à-brac of an artist's studio or which are commonly used in cafés; this is a life spent between the studio and the café, a bohemian life. This collection of objects has a symbolic meaning almost as there was a symbolic meaning in the earliest still lifes in European painting, which, by presenting a profusion of luxurious consumer goods, were intended to symbolise the vanity of existence on earth.

I said before that still life in Cubism was like the nude in the Italian Renaissance. The depiction of the nude in the Renaissance symbolised a whole complex of attitudes to art and life. The nude was a symbol of antique art and of humanist values. It stood for man released from all forms of priestly or kingly raiment standing forth as man. And I believe that still life as used by the Cubists also sym-bolised a complex of moral attitudes. I have already suggested that there was a certain limited symbolism in its particular choice of still-

life objects. I am going to suggest now that the symbolism went further than this, though in a way related to its symbolism of the artistic life.

Still life had engaged scarcely any great painters, or painters with pretensions to greatness, before the middle of the nineteenth century. Till then, for the most part, it had been the province of humble specialists. It came into being in its own right in the sixteenth century, at about the same time as landscape painting. But whereas many of the great masters of figure-painting were prepared to do landscape, more or less pure landscape – Rubens, Velázquez, Rembrandt, Poussin, Vermeer – they clearly felt still life to be beneath them. There are paintings by the young Velázquez in which he was obviously more interested in the still-life objects than in the figures, but he still ostensibly used them as mere props for the actors. There are only a handful of still-life paintings by pukka painters before the middle of the nineteenth century, apart from those by Zurbarán and Chardin. And Chardin, the only painter before Courbet continually to make still life a vehicle of great painting, was not really a pukka painter, inasmuch as he was not concerned with achieving a fashionable reputation. He was essentially a painter's painter – a fact that links up with Maurice Denis's choice of a still life as the particular Cézanne picture to which a group of painters pays homage.

So long as painters were painting for a public which was not simply buying a painting *by* someone, but was buying a painting by someone *of* something in which they were interested – a scene from the Passion, a beautiful girl, inspiring scenery – so long as this went on, there had to be a hierarchy of subjects, and in this still life occupied the lowest place, for obvious reasons. The hierarchy began to lose its validity as and when painters began to feel that whom a picture was by mattered decidedly more than what it was of, and that the public ought to accept whatever subjects the artist chose to give it. This growing belief in the divine right of artists was taken to its logical conclusion by the Aesthetic Movement of the Nineties, which preached that any interest contributed by the subject of a work was, so to speak, no more than a grace-note in the music of form.

I think the Cubists were encouraged to paint still life by the fact that the great masters of the past had considered it beneath them, by

the fact that the public had no predisposition to be interested in it as a subject, by the fact that it could only be animated by the genius of the painter. When they got round to incorporating fragments of real still life into their pictures, they were affirming that any mean fragment of everyday life could be made beautiful and significant if handled creatively. And even while they were still using brushes and paint, they were affirming that the power of art to transmute whatever comes to hand is so marvellous that there was no need for it to deal in subjects with a lively human interest. It was enough to celebrate the wonder of the fact that man can metamorphose the things he sees around him into mysteriously beautiful crystalline structures.

III

Bonnard's *The Table* of 1925 in the Tate Gallery seems altogether more accessible and ingratiating than the Cézanne and the Braque which were the subjects of my other talks. There is nothing alarming or difficult about its style. It hasn't the ambiguities of the Braque. It hasn't the Cézanne's stiffness of manner, its awesome austerity. It is a gentle and straightforward piece of Impressionism. And the subject is as agreeable as the treatment, a pleasantly domestic scene – not a still life which has obviously been set up only in order that the painter can knuckle down to work from it, but a table set for dessert, with fruit and cake and wine. A cosy moment of a comfortable life, and one in which we can feel ourselves participating, for the up-tilted angle of the table suggests that we are standing at this end of it, looking down at it and about to draw up our chair to it. There is even an overt human interest to add to its charm, for at the far end a woman is seated preparing food for the little dog whose nose is just intruding into the picture, next to her. This, by the way, raises the question whether the picture can be classed as a still life, since a still-life painting is one that is all still life, not merely one in which still-life objects are conspicuous.

The distinction is not pedantic, nor is the question whether we can really call this Bonnard a still life. Once there is a human figure in a picture, this alters our whole way of looking at it, just as an empty stage set is transformed as soon as one of the actors walks on. We instinctively focus on the human figure, and the objects become

accessories, even if there are a hundred objects and a single human figure. Conversely, in a still-life painting, the absence of any human figure is something positive. A painting by Vermeer of an interior with a single woman among furniture and objects is a figure-subject, very much so. Is this Bonnard, then, in the same category as the Vermeer? I don't think it is, because the woman and the dog have no independent psychological presence, they are part of the scenery. They introduce, as I said, a note of human interest, but this only confirms the human implications of the arrangement of the objects, it doesn't qualify them. The objects alone would be enough to establish the picture's mood of cosy domesticity.

But *is* this the mood of the picture? We infer that this is its mood when we think about what it represents, when we *think* about it. But the mood of a painting comes across long before we start thinking about the subject, even before we identify the subject. And the mood that comes across from this painting doesn't lend itself to pat definition and, whatever it is, it is not cosy. As to identifying the subject, this happens rather slowly with this picture. Each time I see it I find that it first strikes me in one or the other of two ways, depending on the prevailing light and the distance I am from it as I catch sight of it, and neither of these ways shows me a table laid for dessert and a woman preparing food for a dog.

One way is as a tapestry of colour, flat patches of colour which have here a gorgeousness and density, there a smoky elusiveness, neither of which one feels any right to expect from a mere painting but only from a flower-garden. The other way of seeing it is less luxurious, more mysterious. I have to be some distance from the painting – say, about twenty feet away – to see it like this, and the light has to be natural, not artificial, and preferably just fading – a condition which isn't often fulfilled at the Tate Gallery, I'm afraid, because whoever is in charge there of the switching-on of the electric lights evidently has rather an itchy trigger-finger. But seen in this second way, the painting is the very opposite of a flat tapestry. It gives a quite hallucinatory feeling of recession, is more like a tunnel than a tapestry. When the picture looks like a tapestry the table-top rises steeply, almost sheer, in front of me. When the picture is seen in depth, the table-top makes a long gentle slope away from me, as if it were the next twenty yards of a hill I'm

climbing. The objects dotted about the table, instead of being splodges of colour, are almost drained of colour, neutralised by the phosphorescent bluish white of the tablecloth. Against this vivid white the objects are thrown into relief, become a sequence of compact volumes rising up one after the other along the slope of the table until they culminate in the single fruit on a plate at the centre of the far end.

Once I close in, this deep space is lost. I can now see the picture as a tapestry of colours. Or I can see it as a domestic scene, and make an inventory of the kinds of food laid out on the table. But the various ways in which I have been seeing it seem dissociated from one another. I want to make them function together, to see the picture all at once as a flat coloured design which is at the same time a structure of solid forms in space which is at the same time a table with plates of fruit and cakes laid out on it. I try to find a way to focus on it that will bring all this together. I begin by finding my own bearings. I seem to be standing two or three feet from the table looking down at it. This is about where I feel I'm standing when I look at the big Monet in the Jeu de Paume in Paris of a table where they've just been having lunch out in the garden under the trees. This Monet is certainly the prototype of this Bonnard and many others, its prototype in colour and in *mise-en-scène*. Standing in front of the Monet, I'm perfectly certain of my bearings and of the bearings in relation to me of all the objects laid out in front of me. And they do immediately involve me. For I feel that I could reach out and pick up an object off the table, that I could reach up and take the hat which has been hung over the end of a branch of a tree. I am as it were *in* the picture and everything is in place in front of me and to either side of me as it would be in reality.

But the Bonnard doesn't work like that. Things don't stay still, conveniently in place. They float around, and I can't bring them into focus. I'm not certain that I'm standing where I thought I was. I'm not certain what's in front of me and what's to the side of me. For instance, the basket of apricots towards the far end of the table seems nearer than the empty plates down at the near end, in spite of the fact that, when I was looking at the painting from farther back, everything was very firmly situated on the receding plane of the table-top. But now I find myself seeing the individual parts each as if in close-up, one at a time, regardless of their position on the table and as if they had

detached themselves from everything else. And, indeed, they are clearly designed to detach themselves. Each plate or dish or basket is an ellipse, a self-contained form, a form that is, so to speak, wrapped up in itself. There is very little overlapping or touching of these ellipses: most of them are isolated, framed by the tablecloth. And the brushstrokes follow the form of each ellipse, and this emphasis on their self-containment is reinforced by the fact that the brushstrokes of the tablecloth at the periphery of some of the ellipses also follow their form, making a sort of aura round them. Each element is carefully, lovingly, isolated as a compact unit.

If I accept their separateness, allow myself to be drawn now to one, now to another, I find I have lost the sense of disorientation which resulted from trying to take everything in at once. I find that a coherent composition forms itself around each of the units in turn. I don't see the whole of the composition related to each unit, only that part of it which is in my field of vision as I focus on a given unit. And that which I see falls beautifully into place, in space. I come to feel the composition of the whole picture as an accumulation of the compositions that take shape around each part in turn.

I think that the picture is able to work like this because of the peculiar way in which it is held together almost without the spectator's knowing it while he is actually looking. Normally a picture is held together by the relation of the forms to the rectangle of the canvas. But in looking at a Bonnard I'm not really aware of the edges of the picture. For example, the edge often cuts off an object or figure in the middle, like the dog in this picture, as it does in a Degas. When Degas uses this device, I'm immediately conscious of the sharpness of that edge slicing through the image like the guillotine which photographers use to crop their prints. The edge of a Bonnard doesn't have this sharpness. Instead, towards the edges things get muzzy, as they do in reality at the periphery of our field of vision, and I'm no more aware of exactly where the rectangle of the canvas is than I am of exactly where my field of vision ends.

What Bonnard does is this: instead of relating the forms in the picture to the vertical and horizontal straight lines at the limits of the picture, he relates the forms to vertical and horizontal straight lines in the middle of the picture. In almost all his paintings there is at least

one emphatic vertical line and at least one emphatic horizontal line meeting at right-angles like vertical and horizontal axes of a graph. In the present painting the main vertical axis is the line, just to the left of centre, of the edge of the door-jamb, and the main horizontal axis is the far edge of the table. These two axes do not actually meet, because the woman's shoulder cuts across the angle, but the angle is strongly implied. Incidentally, it seems almost certain that Bonnard derived his use of horizontals and verticals within the picture from Gauguin, who was certainly his main youthful influence and who had, I think, a more enduring influence on him than is generally recognised. By his use of these axes, Bonnard controls the design of the picture from the middle outwards. They form an armature around which the picture is held.

Around this stable centre, everything is fluid. The paint itself is like a living substance, and its vibrations always prevent the eye from focusing on any point once and for all. The eye wanders, and, as the focus changes, things suddenly swim into my view as if I hadn't known that they were there, so unaware was I a moment before of their presence. I have already suggested that the Monet still life set out in a garden seemed laid out around the spectator as things are in reality, meaning that the spectator isn't separated from the objects in the picture as if they were on a stage and he in a seat in the stalls, but feels himself to be in there among them. But it is only his spatial relationship to them that is like reality. For his relationship to them depends on his imagining himself in a fixed position and keeping his head still – in other words, making what is instantaneous eternal. The Bonnard picture, on the other hand, re-creates the process of perception, the extension of perception in time.

As I stand looking at a table in reality, I don't fix my eye straight ahead and keep it there. I let it wander, concentrating first on one thing, then on another, recognising different things in turn and ignoring others or vaguely noticing them without bothering to identify them. In the same way, as I look at this Bonnard I become aware of a form that I was unaware of just now, and once it has swum into my consciousness it grows: my awareness of what it is – both my awareness of its identity as a thing and my awareness of its shape and colour and texture – builds up, rather as when we wake up in the morning and see a vague shape over there which gradually acquires more and more

substance, more clarity of definition and more overtones of meaning. And my inability to fix my own bearings in space in relation to the whole scene in front of me corresponds to the fact that in reality I am not necessarily conscious of where I am standing as I look at something: my consciousness is what I am looking at and my thoughts about it and my thoughts about my thoughs (which could include thoughts about the distance). Bonnard, then, does not paint something seen as if seen in an instant of time. He causes the spectator to have the same kind of experience in front of the painting as he has in and of the real world.

Only, is Bonnard really re-creating the process of seeing? He is re-creating a mental process, the way in which experience is continuous and cumulative. And it is true that our awareness of what things are on a table in front of us and how they are related involves a process like this. But a similar process is involved when we build up a picture in our minds of something we remember seeing in the past. One by one the elements build up in our consciousness, and perhaps what happens in looking at a Bonnard is really rather more like the process of recalling than it is like the process of looking at something which is actually there. As a matter of fact, Bonnard always painted from memory. But this is true of many painters: other painters even in the Impressionist tradition, such as Degas and Sickert, preferred to work from memory. So this doesn't prove anything, though it could be a pointer.

But there are several qualities in the paintings themselves which suggest remembered rather than actual images. There is an atmosphere of withdrawal and reverie. There is a sense that the intensity of the experience – the passionate tenderness felt for objects – is not matched by the density of the objects themselves, which are wraith-like, weightless. There is a feeling that the scene laid out is infinitely precious as only cherished memories can be precious. All of this adds up to the interpretation that Bonnard was painting in order to recapture, to recover, moments of perfect pleasure lived a long time ago. And yet on the other hand he could be painting from memory something seen in the dining-room just before he came into the studio, and investing it with a feeling of the transience of pleasurable things and of the transience of life itself – a feeling that could account for the nos-

talgic and evanescent character of the work. Seen as a painter of remembrances of things past, he is certainly akin to Proust in that, in recalling experiences, he is at the same time analysing the processes of remembering. Perhaps the table laden with fruits and cakes is his counterpart to Proust's *madeleine* – that insignificant delicacy which could evoke a complex of feelings, could start a chain of recollections of a whole world now lost. But it is quite beside the point to try and decide whether the work is about remembering or about seeing things there now. What matters is that both interpretations are plausible, for the existence of this ambiguity says that the only reality is the flux of our experience.

Soutine *1963*

This is essentially the untitled introduction, written in the winter and spring of 1962–63, for the catalogue of a retrospective arranged by the Arts Council of Great Britain and shown at the Edinburgh Festival from August to September 1963 and at the Tate Gallery from 28 September to 3 November. A number of revisions to the text were completed in 1981 for publication of a second version, entitled 'The Mysteries of Nature within the Mysteries of Paint', made for inclusion in the catalogue of an exhibition first held at Münster and later at the Hayward Gallery, London, from 17 July to 22 August 1982. This is the version reprinted here.

Soutine had to have the thing he was painting out there in front of him. He wouldn't invent. He wouldn't paint from memory, even the memory of a motif he had worked from day after day. He wouldn't paint from drawings or from photographs or from an earlier painting of the subject. He had to have the real thing there.

He even needed it there when painting his paraphrases of old masters. He never copied from the picture, either the original or a reproduction; he reconstructed the motif of the picture, worked from a model or a still-life subject disposed in accordance with the prototype. The prototypes included the Chardin still life with a skate in the Louvre, the Rembrandt in the Louvre of the carcass of an ox, the

National Gallery Rembrandt of Hendrickje paddling, and several Courbets – paintings of a large fish and of a bull calf, and a study (in the collection of a patron of Soutine's) for one of the figures in *Les Demoiselles des Bords de la Seine*.

Reconstituting the motif rather than working from the picture was a curious procedure to adopt when transposing other men's images. After all, one of the reasons why painters make copies or transpositions is to save themselves the bother of employing a model or buying a lobster or taking a trip to the country. And as a matter of fact Soutine was often put to more trouble than usual when he tried to find the living equivalent of an image he had chosen to adapt. Some of the most grotesque stories in the Soutine legend tell of such occasions. There is the story behind the picture based on Courbet's reclining girl the days of motoring round the countryside before a suitable model was found; the jealousy of her husband, a railway gatekeeper, who, after one session, tried to stop her from posing; Soutine's rage and threats of legal action. There is the story behind the painting after the Rembrandt of Hendrickje paddling – the search for an appropriate peasant-woman; the business of persuading her that, in asking her to stand still in a brook up to her knees, with her dress hitched up, Soutine was neither a madman nor trying to use her for immoral purposes; the sequel about the day on which he forced her to go on posing through a rainstorm while he went on working almost in the dark. There is the story about the carcass of beef which he had hanging in the studio while painting four or more large canvases paraphrasing the Rembrandt carcass – the complaints of the neighbours at the stench of decaying flesh; the pail of blood used to freshen up the meat as it got dry; the model hired to fan away the flies so that the motif could be seen; the artist's growing rapture at the colours that emerged as the meat decomposed, and the neighbour's growing desperation; the calling in of the police; Soutine's incomprehension and rage. He seems to have been particularly ruthless when inspired by Rembrandt.

The most interesting thing about such stories (for all of which Monroe Wheeler's monograph is the immediate source, though Charles Douglas, in *Artist Quarter*, relates a variant on the last)[1] is not so much that Soutine was prepared to sacrifice everyone around him to his art, as that he couldn't bring himself to work in any other way

than from nature. However, 'Garde', his companion in the late 1930s, writes that when she accompanied him, as she often did, on painting trips to the countryside around Paris, he would generally stop work after two or three hours and finish the picture later in the studio.[2] Since it seems fairly easy to discern from these pictures which bits were added afterwards, while in earlier works there do not seem to be any such tell-tale signs, it is probable that the practice of finishing landscapes back in the studio was peculiar to Soutine's later years. But, of course, even when he insisted at all costs on the presence of the motif, there is no way of knowing how much he actually looked at it, how much he needed it there as a sort of talisman.

He was no less a creature of habit in his choice of subjects than in his method of working. The narrowness of his subject-matter is not at all that of the specialist in landscape or in portraiture or in still life. He worked in all these genres with near enough equal involvement, but within each genre his range of interests was exclusive.

The vast majority of his human images are single portraits, usually seated figures, half- or three-quarter-length. The male sitters, after 1920, are almost all young men or boys wearing some sort of uniform – pastry-cooks, page boys, choirboys, valets, waiters – though the women and little girls are not so stereotyped. For the rest, there is a single nude, several pictures of a mother and child, a few pictures of a woman reclining or paddling or feeding geese, and several pairs of children sitting or standing or walking (but no extant image of a pair of adults). There are also some small pictures of farm animals.

His still-life subjects were at first quite wide in scope: he did table-tops with a variety of objects, he did numerous flower-pieces. But by the time he was thirty he had defined his personal range of themes, and it was patently obsessive. Thereafter he could do practically all his shopping for his still lifes at the butcher's and the fishmonger's. Sometimes the fish, flesh or fowl would be set off by tomatoes, lemons, bread, cutlery, a napkin, a jug. But by and large he had little interest in greengroceries, less still in man-made objects. He painted what was literally *nature morte*. (Not, by the way, that he ever did a skull: here the process of death would have been complete, and his insistence on the process shows in those writhing fish and convulsed

fowl which whether dead or alive seem to be in the process of dying.) His concentration upon the dead creature intensified with time. It is only one of several elements, and can be absent from the scene, in the still lifes painted by 1919. In the period between 1922 and about 1926, during which the majority of the still lifes were done, the dead creature, taking the centre of the stage, is at first often set off by other elements like napkins and tomatoes. In the latter part of this period, and in the occasional subsequent still lifes, the corpse – of beef, rabbit, salmon, fowl – framed in close up, is wholly isolated.

Though landscapes form a high proportion of Soutine's works and though he spent more than half his working life in Paris, he never did landscapes there, after some early attempts. Unlike Vuillard, Bonnard, Matisse, Utrillo, Giacometti, he didn't continue the Impressionist tradition of painting Paris's streets and squares and public gardens or the views from its windows. His landscapes of the Twenties were painted in small towns in the South of France, those of the Thirties and Forties in the countryside at various spots within two or three hours of Paris. The first great series was done at Céret in the French Pyrenees, where he worked almost continuously from 1919 to 1922. (Some of the so-called 'Céret' landscapes might have been painted in other small hilltowns nearby; all look as if they are of the same place.) Trees and houses climb steep menacing hills with scarcely any sky in view; the colour is dense and dark. The next series was painted between then and 1925 at a town Soutine had visited occasionally during the Céret period, Cagnes-sur-Mer – which is to say that he was shifting the scene of his operations from the frowning Pyrenees to the Cote d'Azur. Here again houses and trees are set in steep hills, but the composition is more open and the tonality much lighter – white-walled houses now dominating the trees – and the general effect is one of airiness as against the claustrophobia of the Céret paintings. Later in the 1920s Soutine at various times painted several almost identical views of a square at Vence, another village in the Alpes-Maritimes; it is in effect a view of a single tree against a backdrop of buildings. In 1933 he painted a view of Chartres Cathedral, and during the following summer or two some pictures showing a country house set among trees (there seem to have been two different though similar houses). In the numerous landscapes he

painted between 1936 and his death in 1943, however, a building seldom appears. These landscapes, mostly done in the region of Chartres or at Civry or finally at Champigny-sur-Veuldre, are uniformly dominated by trees. Trunks and rich foliage – and at Champigny their reflections in water – fill out the picture-space. Here as often at Céret there is a sense of immersion in a dark dense vortex of leaves.

Soutine's work, then, shows a certain consistency in both subject-matter and method. Furthermore, the development of his style is not marked by the sharp switches of direction, dramatic as conversions, that are so typical of artists of this century. Broadly speaking, Soutine's style went through the sort of evolution which we associate with, say, Vuillard, with a shift around 1923 from flatter to airier paintings analogous to that which occurred in Vuillard's work around 1900. Soutine himself, however, came to look back upon this transition as momentous, and to regard the work he had done before it with a contemptuous hatred so overwhelming as to make it one of the ruling passions of his later life. He developed a mania for buying back works of the Céret period expressly in order to destroy them. His friend and patron Madeleine Castaing says that, whenever she and her husband wanted to buy a picture Soutine had just completed, he would insist that before a price could be discussed they must go out and find him a couple of *Cérets*. He himself was a heavy spender on *Cérets*, and there are stories from several sources about the violence with which he slaughtered them and his joy and relief in the act.

Certainly, Soutine always was a destroyer of his work, usually at or about the time he did it. (Ironically enough, a considerable proportion of the surviving pictures ascribed to him are canvases which he abandoned, slashed, only for them to be rescued from the dustbin by a concierge or cleaner and sold to some dealer who would have them repaired, relined and retouched – in some cases freely repainted.) All the same, he doesn't seem to have habitually destroyed his later works without discrimination, whereas no *Céret* that came within his reach was safe. It wasn't, therefore, a question of his trying to discriminate retrospectively among his earlier works through a feeling that, though he had destroyed many of them at the time, he had not been exacting

enough. He thought of virtually everything he had done before 1923 as worthless.

A possible reason for the force of his revulsion against his early work was its association with his early life. The misery and squalor he endured during his childhood and youth in Russia and then during his twenties, throughout his first ten years in France, are as harrowing to read about as anything in the pages of Maxim Gorky. In the winter of 1922–23, his thirtieth year, his life was magically transformed in an afternoon. Szittya relates that Soutine was sitting with a couple of painter friends on a bench in the street in Montparnasse – sitting on a bench because they couldn't afford the price of a coffee. At that moment Dr Albert C. Barnes, one of the greatest private collectors of modern times, was visiting the gallery of Soutine's dealer Zborowski in the hope of discovering some young genius in the line of succession to the great Post-Impressionists. Barnes took no interest in anything Zborowski showed him, but then discovered in a corner a torn and dirty canvas by Soutine, wanted to know who the painter was and asked to see more. This is according to Szittya;[3] other sources[4] maintain, probably rightly, that Barnes had previously been shown a Soutine by Paul Guillaume. What is sure is that Barnes now decided that Soutine was his man and sent someone off to fetch him. Soutine was found on his bench and delivered by car, dirty and unkempt, to Barnes, who had him take a bath, ordered him clothes from an English tailor, installed him in a comfortable studio, and bought a large number – the usual estimate is a hundred – of his pictures. Soutine, when leaving his friends that afternoon in Montparnasse, had promised that if he got hold of any money he would help them and would also try to push their work with Barnes. He never came back, and thereafter he avoided meeting all his former friends and would turn them away from his door. He didn't go near his old haunts in Montparnasse for nearly twenty years, he enjoyed at least some of his contacts with the bourgeoisie, he made a great point intermittently of being well washed and well dressed, and generally gave himself airs, as far as his extreme shyness and bad temper allowed him to. In short, he seems from the time of his first success to have tried to obliterate his past. It is, then, conceivable that his desire to obliterate work done before 1923 was part of his effort to obliterate his life

up to 1923. Still, there were good reasons of an entirely impersonal kind why he should have formed a revulsion against his Céret work.

Soutine's main formative influence is generally supposed to have been Van Gogh, but Cézanne seems still more crucial. (In the earliest work Bonnard, of course, often had a strong direct influence, as in the *Flowers on a Chair*, the *Flower Still Life* in the Collin collection and, even several years later, the strange refulgent *Still Life with Red Meat* in the Musée de Troyes.) Van Gogh's example is clearly evident in many of the early *Gladioli*, and it can remain so in certain pictures done several years later, such as the *Landscape with Road, Cagnes* of *c.* 1923. On the other hand, there is nothing of Van Gogh but much of Cézanne, combined with the dark mid-nineteenth-century realism taught at the academies, in the *Still Life with Lemons* of *c.* 1916 and the *Still Life with Soup Tureen* in the Colin collection: the disposition of the table within the canvas and that of the objects upon the table, the particular flattened elliptical form assumed by plates – these appear to derive very directly from Cézanne still lifes of the 1870s and 1880s. But the real nature of Soutine's relationship to Cézanne begins to show in the remarkably authoritative *Portrait of the Painter Richard* of *c.* 1916–17. The composition suggests that Soutine had in mind Van Gogh's portraits of the Arles period (the pattern on the wall too would seem to derive from these rather than any patterned background of Cézanne's). But the drawing and handling are Cézannesque. (And it is significant that the Cézannesque elements have not been transmitted via Modigliani, as we might easily have expected them to be in view of Soutine's regard for his friend and his friend's habit of parodying Cézanne; these elements have not previously been squeezed into the mould of Modigliani's stylisations – they come direct from the source.) The modelling of the face through the interaction of red and blue, and not through tone, is obviously inspired by Cézanne. So is the breaking up of the form into clearly articulated planes. And so too is the broadening of the head in the area of one ear, as if part of the lateral plane had been wrenched round towards the picture-surface in an effort akin to Cézanne's to take hold of volume in its full tactile reality and beat it, as it were, into the picture-plane.

The persistence of this influence is obvious in several portraits of

the Céret period, which have exactly the slope of forms towards the right found in many Cézanne portraits of the Nineties, in various *Page Boys* of the mid-1920s, which are Cézannesque in the modelling of the head and in harmonics of red, blue and brown, and even in the *Portrait of a Boy in Blue* of 1929 in the Colin collection, which recalls Cézanne both in composition and handling. Nor is this influence confined to the portraits. It is Cézanne rather than Van Gogh who points towards the Céret landscapes, though they are always said to be particularly indebted to Van Gogh, this presumably because of their surging, headlong diagonal movement. But, while there may be some similarity in the tempo and direction of the movement, there is no similarity at all in its action. Van Gogh is linear: the movement wriggling or streaking across the canvas is made by a system of serpentine or spiky lines which incorporate solid forms as a whirlpool sucks things in. Soutine's approach is plastic: the movement is made up of lurching, heaving *planes*. To look at a Van Gogh landscape after looking at a *Céret* is to be vividly reminded how Japanese it is. The flatness of the *Cérets* is not the flatness of a Van Gogh, it is the flatness of a Cézanne, a flatness into which solidity has been compressed.

The *Trees at Céret* formerly in the collection of the Ben Uri Art Gallery, London, one of a series which Maurice Tuchman convincingly ascribes to *c.* 1919, the outset of the Céret period, is, as he says, reminiscent of Van Gogh.[5] But is it not equally or more reminiscent of Cézanne's *sous-bois*? The reaching out of the branches towards the edge of the canvas: this recalls Van Gogh, certainly. But the intricate relationship between the surface-pattern and the varying distances from the eye of the *columns* of the tree-trunks (a movement in and out of the picture, rather than a movement across it punctuated by *outlines* of tree-trunks): here, surely, the example of Cézanne's *sous-bois* has been at work. The warm glowing colours too are closer to certain of the *sous-bois* than to any Van Gogh. As the Céret style develops, affinities with Van Gogh diminish, those with Cézanne multiply. Consider the two similar landscapes, one belonging to the Tate Gallery and the other in the Sirak collection, which Tuchman ascribes to *c.* 1920–1. The black tendrils of branches in the former echo those in the foreground of such landscapes as the Courtauld *Mont Sainte-Victoire au grand pin*; in the latter, the dark mass of foliage that seems to wing

across the sky like a great bird calls to mind the *Grand Pin* at São Paulo. But Cézanne is not echoed in matters of detail only. Surely the style of these pictures grows quite directly from such Cézannes of around 1880 as the Boston Museum's *La route tournante*? There is the uptilting of foreground horizontal planes and the pulling forward of the middle and far distance towards the picture-plane so that the contents of the scene are closely, densely, unnaturally packed together. There is the virtual exclusion of sky. There is the all-embracing dominance of the rich greens of leaves and grass offset by white houses with red roofs, their walls making planes parallel to the picture-plane. There is the counterpoint between movement into the picture, which is almost immediately checked and curtailed, and the sustained movement across the surface of the canvas. There is a light which radiates from within the forms, not a light like Van Gogh's, which is the impact of the sun upon forms.

Of course there is the surge and vehemence of the *Cérets* as against the slow measured movement of mature Cézanne. But the frenzy, unlike a Van Gogh's, is not like a great wind blowing across the scene and bending everything before it; it is more like an earthquake, it is a sense of upheaval. Soutine, one might say, is related to Cézanne rather as El Greco is related to Titian. (As a matter of fact, El Greco and Tintoretto were Soutine's preferred old masters during the Céret period.) And this sense of upheaval, though in a less extreme form, is not at all foreign to Cézanne. It is clearly manifest in the late paintings of the Bibémus quarry, but also present in much else of his work, as D. H. Lawrence was the first to point out, in 1929: 'When he makes Madame Cézanne most *still*, most appley, he starts making the universe slip uneasily about her. It was part of his desire: to make the human form, the *life* form, come to rest. Not static – on the contrary. Mobile but come to rest. And at the same time he set the unmoving material world into motion. Walls twitch and slide, chairs bend or rear up a little, cloths curl like burning paper. Cézanne did this partly to satisfy his intuitive feeling that nothing is really *statically* at rest – a feeling he seems to have had strongly – as when he watched the lemons shrivel or go mildewed, in his still-life group, which he left lying there so long so that he *could* see that gradual flux of change: and partly to fight the cliché, which says that the inanimate world *is* static,

and that walls *are* still. In his fight with the cliché he denied that walls are still and chairs are static. In his intuitive self he *felt* for their changes.

'And these two activities of his consciousness occupy his later landscapes. In the best landscapes we are fascinated by the mysterious *shiftiness* of the scene under our eyes; it shifts about as we watch it. And we realize with a sort of transport, how intuitively *true* this is of landscape. It is *not* still. It has its own weird anima, and to our wide-eyed perception it changes like a living animal under our gaze. This is a quality that Cézanne got marvellously.'[6]

Lawrence's message about Cézanne could be said to have been that he was not the Apollonian artist Roger Fry saw him as, but one whose greatness lay precisely in the intensity of his synthesis between the Apollonian and the Dionysian. In the Céret landscapes the Dionysian principle takes control. Soutine always was, of course, in his methods of working, a classic example of the Dionysian type of artist, 'inspirational' in approach (and often going through weeks or months of inactivity awaiting 'inspiration'), in gesture vehement to the point of frenzy ('One day, furiously at work,' writes Wheeler, 'he dislocated his thumb and could not explain how it happened'). And the Céret landscapes are some of the most Dionysian paintings in the history of art.

Looking at a *Céret* like the one in the Tate has nothing to do with the experience of *gazing* at a landscape. Here is a jungle of colour, layer upon impenetrable layer, not murky but of a luxurious darkness in which light is held as in porphyry or jasper. It is a light that belongs to the forms, not a light thrown upon them. The atmosphere, similarly, has nothing to do with how the weather is behaving in a given area at a certain time – and to give these landscapes, as some do, such titles as *Mistral* or *Storm at Céret* is like calling a cubist portrait a portrait of a robot; by the same token, even *Gnarled Trees* is a suspect title, since the fact that the forms in the painting are gnarled does not mean that the trees were. Whether it is noon or dusk, whether it is raining or the wind is blowing, is of no concern. Nor is it really a matter of importance what things the shapes stand for – that this is a hill or a house or a tree. We acknowledge that it is, but we get no feeling – such as we do before a Matisse, a Bonnard, a Picasso – that this par-

ticular transformation of an object is making us *see* this kind of object in a new way. We do not read this landscape in terms of objects and relations between objects. Our awareness cuts through objects. It responds to rhythms, to an interplay of forces. To the opposition, for example, on the left-hand side of the picture, between the hectic downward-rushing movement of the torpedo shape (the foliage of a tree) and the slow, straining, upward-mounting movement of the two pyramids (the house and the hill) one of which rises out of and above the other. As it reaches the upper apex, goes over the top, this striving motion suddenly explodes into a paroxysm of movement and counter-movement, into abandon and release. And the other experiences the painting evokes are of a kind that engage our whole bodies: swinging, diving, falling, staggering, skating, climbing, gliding, riding downhill, teetering on a cliff edge. It evokes them as if they were dissociated from any firm contact with external objects. We enact them as we act in a nightmare, in the void of a nightmare. They arouse panic: only this panic is resolved, for the opposing forces are all somehow contained and held in balance by the overriding rhythm of the picture as a whole – not a frantic but an easy rhythm, like the swinging of a pendulum – which resolves convulsion and conflict into an unexpected serenity.

The picture is about action. It is no more a painting of a mood than it is a visual painting: the emotions it expresses are the emotions that might accompany the actions it evokes. It is Dionysian not merely in its antagonism to Apollonian contemplation of an entity out there; Dionysian not merely in its freedom and in its frenzy: it is Dionysian in that it works upon us in imagination like an intoxicant. When drunk we act without intention, without purpose, gratuitously, from a desire to act; we act without first asking ourselves how we feel, we discover the way we feel through the way we act. Outside us everything merges, becomes fluid, fluid in its boundaries, fluid in identity. Fluid too as to the status of objects: inanimate objects twitch and awaken into life. Thomas B. Hess writes as follows of the *Hill at Céret*: 'I see the hill with a house on top, but below, and to the left, I find a hook-nosed witch, a handkerchief tied around her head, holding the collar of a squatting dragon. But the beast's right side is defined by a dark area which now appears to be a curling-horned steer, drastically fore-

shortened, rising up to the farmhouse, while below, guarding his eyes with his forearm, a man tumbles backward into the sea. A few minutes later, I might have difficulty in finding some of these forms again. Perhaps the landscape will return, with all its roads, banks of trees, coils of earth, and flying clouds. But the very manipulation of pigment has pried the subject from nature into the personal sensation of terror, violence – and paint. Such a picture repays hours of examination, for it is fitted together as deftly as any cubist portrait. Interweaving layers of hue, coiled lines that shoot and cage motion within the rectangle, the elaborate play of tonalities up and down the image, all suggest spontaneity, but also disclose the patience and the labor involved. That the landscape is filled with animal energy, at times sinister, at times benevolently pastoral, is a logical projection of Soutine's vision. Everything in the painting breathes and devours space and color.'[7]

The landscape 'has its own weird anima, and . . . changes like a living animal under our gaze'. Lawrence's words come to mind, and are given a new twist by the overtones of extravagant fantasy for which there is no place in the landscapes of Cézanne. Yet the animation alone can generate the metaphors, the allusions, the ambiguities of reference, in a work by Soutine. Forms with metamorphic implications are part of the stock-in-trade of modern art – of Picasso and Braque and Klee and Arp and Miró and Pollock and so on. They are generally the result either, as with Picasso and Braque, of distorting a form signifying something in such a way that it also suggests another, or of using peculiarly generalised forms like Arp's biomorphs – all-purpose forms, so to speak – which almost automatically generate a multiplicity of evocations. Where Soutine is metaphorical, or metamorphic, it is usually for another reason. Consider the still life *Fish and Tomatoes*, in which the forks resting on either side of the plate of fish immediately suggest someone's hands ripping his stomach apart and laying bare the entrails – an image reinforced by the red of the tomatoes against the white of the napkin. Did Soutine see this metaphor? There are paintings of a hare and of a dog with pairs of forks in which one feels that he must have been thinking of such a metaphor. But the shapes of the motif do not seem to have been transformed – as by Picasso – with an eye to giving them a double meaning.

It is rather that the shapes, especially those of the forks, are more ani-mated than they are in reality and therefore take on an anthropomorphic character: the forks could seem to be grasping hands only because they don't seem to be still life. In the same way, the imagery suggested by a picture like the *Hill at Céret* is possibly no more than a by-product of our recognition of the convulsive energy embodied in the forms and the terror and exhilaration this inspires.

And it is not only the metaphors, the allusions, that are subordi-nate to our response to the energy, the violence, the panic, the release, compressed in the paint. The landscape motif is secondary to the forces it has unleashed. We may give the forms such names as hill and house and tree, but in the last resort such names are more definitive only in degree, not in kind, than names like 'hook-nosed witch' and 'squatting dragon'. This is an art of pure sensation, an art in which the painter has bodied forth in paint his experience of the motif in front of him without giving thought to the names of the elements of the motif. The resultant forms on the canvas are ambiguous, can be inter-preted as having a variety of names, because the painter has given them no name.

The development of the Céret style, according to Tuchman's highly convincing chronology, led in the direction of bringing the contents of the scene ever closer to the picture-plane, until, in the *Village Square* and *Red Roofs, Céret*, everything rears straight up almost filling the rectangle of the canvas. The portraits can take on a similar conformation: the astonishing profile portrait, *Praying Man*, with its surprising and perhaps significant resemblance to the Giacometti bronze busts known as *Têtes tranchantes*, is scarcely differentiated in form or content from the landscapes. The forms mount up over us like a cliff, and as our eye moves over them we have the sensation of clambering up a cliff face. What we know about the density of these forms, about their stability and their instability, their resistance and their give, is what we know through our imagined contact with their surface. It is as if we were blind. We do not see the landscape, we see the paint: the paint conveys what we would know and would not know if we were in the landscape, blind. The paint does not refer to an expe-rience; the experience is precipitated in the paint. Soutine, wrote Hess, 'can seal the mysteries of nature within the mysteries of paint'.

Nowhere more so than in that astonishing image in which a knot of houses is seen through a barrier of bare trees that assume the shape of slim, sinuous, shining bodies reaching from the bottom of the foreground to the top, where they intertwine as in the canopy of a tabernacle. It is a dance – which we are part of, floating through it as if mildly drugged – of forms which, because they seem simultaneously both ascending and suspended, also seem at moments to become a still vessel for containing light. 'At the still point of the turning world. Neither flesh nor fleshless; / Neither from nor towards, at the still point, there the dance is, / But neither arrest nor movement.'

Soutine, however, evidently saw the high Céret style as an *impasse*. Thirty years later, in his *Woman* series of the early Fifties and the cityscapes that followed, de Kooning was to see how to profit from the example of the *Cérets* – their slashing brushwork, their freely overlapping reds and greens, their flat yet broken cliff-wall of paint rearing up parallel to the picture-plane – and, reciprocally, to realise a potential in them which Soutine did not tap, by using their kinds of mark on a larger scale. But the cliff-wall was what Soutine had to eliminate. In doing so and opening up his space, he virtually chose to become more of a traditional than a typically twentieth-century painter. Therefore, although in some ways the transition that occurred at this time was not much more violent than the analogous transition – from flatness to spaciousness – in Vuillard's style around 1900, in other ways this transition can be seen as representing a major decision, almost an act of abdication. Perhaps, it was, after all, a conversion, for all that it did not involve any such change of method or basically of subject-matter as often accompanies conversion. And inasmuch as it *was* a conversion, Soutine's later revulsion against the *Cérets* can be seen, not simply as a dislike taken to morbid lengths of supposedly immature work, nor even as manifesting a resentful suspicion that his earlier work had had more vitality than his current production, but also as an act of faith in the outlook on painting to which he had been converted.

In the period of transition from Céret to Cagnes style, Soutine produced at least two of his most mysterious and tragic landscapes, works in which there is a quite unearthly tension between surface shape and three-dimensional space – the Jerusalem Museum's *Hill at*

Céret and the *Landscape with Cypresses*, which the presence of the cypresses, also found in another picture, suggests was painted at Céret but which has the sort of layout associated with paintings of Cagnes. By 1923 Cagnes style was fully formed, in portraiture as well as landscape. 'Soutine distorted the pictures but not the people', said de Kooning. No longer.

Cagnes style differs from Céret style in that its rhythms are more curvilinear, less abrupt, and in that it opens, instead of asserts, the picture-plane. The houses in the *Cagnes* are not dirty-white patches of paint but solid volumes in space. They are solids mauled and twisted by the swirling spiral rhythms that shape them. These rhythms do not animate the painting – as the rhythms in the *Cérets* do – so much as the objects depicted in the painting do: as Tuchman puts it, 'the *houses* are now anthropomorphic, rather than the strokes'. The houses and trees take on a fairy-tale quality, reminiscent of Chagall or even of Disney, which is far removed from the unnerving fantastic overtones of the *Cérets*. This descent from the sublime to the whimsical is due to a failure of scale. The *Cérets* make us feel puny; the *Cagnes* seem composed of model houses and trees: the Cagnes houses might have been moulded by a pair of human hands; the *Cérets* are not moulded, they mould us.

I think that this failure of scale in the Cagnes paintings may occur because the drawing and the treatment of space are ill-matched. Soutine was to use a deep space in the series, painted in the mid-Thirties, of a house among trees – of which the finest is the *House at Oisème* in the Emerson collection – and here there is no failure of scale. The form of the house, with its slight rhythmic distortion, does not seem imposed from outside; it seems determined by a tension between its shell and the energy contained within it. Here Soutine achieves the sort of plastic realisation of form that gives conviction to volumes disposed in an illusory space – and along with conviction, scale. In the Cagnes landscapes, on the other hand, there is an illusion of space and an illusion of volume but the shapes of the individual volumes and the relations between them are determined by *linear* rhythms. They are linear rhythms similar to those of certain late landscapes of Van Gogh. But Van Gogh's calligraphy lies on the surface of the canvas; Soutine's goes swirling through his illusory space.

Consequently, the forms are neither held firm at the level of the pic-
ture-surface nor hold themselves firm as self-sufficient plastic entities
in space. They look as if someone had pushed and pulled them about
and left them there.

It seems to me that the major successes of the Cagnes period are
mostly among the portraits and still lifes, and that this is at least partly
because the motif imposes a shallow space that suits the continuous
flowing line. The skate rearing up behind the table in the still life for-
merly in the Miestchaninoff collection is a pretext for the undulating
all-embracing line to map one large flat shape parallel to and close to
the picture-plane. And it is not, perhaps, fortuitous that the Cagnes
landscape which is undoubtedly the finest of the series in every way is
the one that is flattest in conception. This is the example in the
Castaing collection. The marvellous lightness of the stroking, the
radiance of the whites veined with red and blue, give it a luminous
airiness, a purity, a serenity even, that astonishingly call to mind the
streets in the backgrounds of Central Italian pictures of the mid-
fifteenth century.

One can well imagine how, quite suddenly finding himself able to
paint with such command, above all with such *grace*, Soutine, the poor
boy from an Eastern shtetl who had come to the capital of the art
world to learn to be a great painter, must have supposed that he had
begun to be a painter only once he had acquired this sort of technical
mastery, must have been stricken by a deep shame at the sight of his
earlier turgid fumblings. There was a parvenu's anxiety to forget his
past plus a parvenu's worship of technical virtuosity behind Soutine's
revulsion against Céret. But there was also the choice he made about
1923 – made it virtually then, consciously rather later, perhaps – in
favour of a basically traditional as against a basically twentieth-
century style. There is, of course, a link between the taste for tradition
and the taste for virtuosity, for again and again an essential manifes-
tation of twentieth-century style has involved a deliberate negation of
'painterly' virtuosity. And the stand that Soutine came to assume
against modern art – his contempt not only for the cubist, especially,
and fauvist traditions but also for Van Gogh and Cézanne – can also
be seen in terms of a parvenu mentality.

This painter of genius came from a society in which there was not

simply no background of painting but a positive hostility to painting, so that painting for him was not just a luxury but a forbidden fruit. The act of painting was a magical activity, a weaving of spells, and, since it happened that he could weave spells which by any standards were unusually potent, he was bound to display the powers he had appropriated. He would want to find a style in which they would not be wasted but could be paraded in all their glory, and obviously the best opening would be a traditional sort of style, sonorous in colour, rich in impasto, and – this above all, perhaps, for a child of orthodox Jewry – providing the opportunity to show off his skill in producing recognisable representations. Moreover, he lacked the sophistication demanded by any artist who is to work easily in a twentieth-century idiom. In the first place, he couldn't see the theoretical problems that have troubled and exhilarated modern artists: thus in 1938 he told René Gimpel that Cubism was cerebral, incapable of giving joy, that Cézanne, in whom he had once believed, was too stiff, too recondite, too difficult, too mental.[8] Secondly, he lacked sophistication in the sense of bored over-familiarity with the masterpieces of the European tradition hanging in the museums, paid lip-service to by parents and other bourgeois, and providing criteria of artistic respectability which must be shot at. For Soutine, in his innocence, museum pictures were *real* pictures, and his own pictures ought to look like them.

In particular, they ought to look like Rembrandts. Rembrandt always seems to have an extraordinary attraction for Jewish painters – by which I don't mean all painters who are Jews but those who picture themselves as Jewish artists: painters or sculptors like Joseph Israels, Chagall, Pascin, Lipchitz, Bomberg, Ben Shahn, and many others, mostly from Eastern Europe. This could be partly because of a scarcely conscious response to the sympathy with which Rembrandt painted Jews. It could be partly because of his legend – the idea that as a result of his integrity he became a social outcast. These two things, indeed, seem to have made Rembrandt into a sort of honorary Jew. But there are other reasons, more to do with painting. Jewish painters tend to have an exuberant relish for the manipulation of oil paint; Rembrandt is unequalled in his mastery of paint. Jewish painters tend to adhere to a traditional conception of space, to side-step or reject cubist space and the flat space of Fauvism (this is the

essential difference between so-called Jewish Expressionism and Central European Expressionism, which often uses elements of Fauvism and sometimes of Cubism); Rembrandt's pictures look utterly unlike cubist pictures or fauve pictures. Jewish painters tend to affirm – no, Jewish painters unanimously and vociferously affirm – that art has no business to exist if it does not speak to the onlooker of the miseries and occasionally the triumphs of human existence (and thereby mitigate the breaking of the law against representation by assuming a high moral purpose): Rembrandt, above all the great masters, is unashamedly a painter with soul.

A late Soutine in the Castaing collection of a little girl wearing a red dress, late-Rembrandtesque in colour and impasto, achieves something of the peculiar tenderness we associate with *The Family* at Braunschweig and *The Jewish Bride* (the picture Soutine is said to have admired above all others). Soutine had the usual twentieth-century bias towards Rembrandt's late style, and his paraphrase of the National Gallery *Women Bathing* transforms this small painting of the mid-Fifties, much of it rather tightly painted, into a large canvas very broadly painted in a rough parody of Rembrandt's last manner. No other painter since Van Gogh has used a Rembrandtesque idiom with such command.

Rembrandt's influence on Soutine first became effective about 1924–25 and seems to have been what showed him the way to the more plastic and monumental style that deposed the style of the Cagnes period. The *Carcass of Beef* in the Louvre was probably the crucial exemplar. Thus, whereas the *Beef and Calf's Head* in the Musée de l'Orangerie, which probably dates from about the end of the Céret period, presents an angular *silhouette* – across which the form is drawn taut as a sail – the big *Carcass of Beef* paintings of *c.* 1925 possess, in direct tribute to the Rembrandt, a massive *bulk*. This new feeling for physical weight brings with it a more concentrated and stable kind of composition. From now on the still lifes are no longer diagonally swirling designs gathering up a variety of elements. They are centralised compositions in which a single carcass of an animal or a fowl – or, later, a fish – is realised as a compact mass in space. Where this new emphasis on weight gives way – as in some of the paintings of poultry – to violent movement, the movement is never from one side or corner of the can-

vas to the opposite side or corner; it is centrifugal. The same bias towards centralised composition is found in the portraits in an increasing preference for frontality of pose and symmetry of layout. It seems likely that Soutine had certain Rembrandt portraits, especially self-portraits, in mind. But perhaps he had simply come to have an instinctive preference for centralised composition; every one of the small number of landscapes he carried out from 1926 to 1933 – namely, the intermittently painted versions of the *Tree of Vence* and the *Chartres Cathedral* – are, unlike virtually all their predecessors, symmetrical designs. The point about Rembrandt's influence on Soutine is not how much it can be discerned in the layout of particular works, or even in the mood of particular works, as its impact upon his whole approach to painting from 1925 on: as to technique, an extremely broad, free handling of paint within the framework of a bourgeois representational manner; as to content, the desire to present an isolated creature, living or dead, in a way that would show it as noble, vulnerable, ordinary.

There were only two other painters for whom Soutine is reputed to have felt any warmth in his mature years: Courbet – him in particular – and Corot. And Courbet's influence upon him was probably greater than Rembrandt's, especially during the last ten years of his life. What Soutine liked about Courbet, he told René Gimpel, was that he was 'direct'; Corot gave him the 'same sensation of immediate contact with things'. It is significant that this feeling for Courbet and Corot was one that Soutine shared with André Derain, who also came to turn his back on 'modern' art – at about the same time as Soutine did – though by reasoning rather than by instinct, or one might say through an excess of sophistication rather than a lack of it. The point is that Courbet and Corot were the last great masters before the beginning of modern art. They are the nearest to us of the old masters. Courbet, certainly, has in many ways a sensibility which the twentieth century can easily make contact with, in a sense that Delacroix has not (I am talking about them as painters; as theorists it's probably the other way around). But his aesthetic is not modern: it's closer to Titian's and Rembrandt's than it is to Cézanne's. Impressionism is the great divide. In a sense there is a larger gulf between Courbet and Monet – even perhaps the Monet of the Seventies, certainly of the Eighties – than there is between Monet

and Jackson Pollock. That Courbet and Monet were alike concerned to paint what they could see while Pollock's marks were self-determined – even this difference, which is scarcely negligible, counts for little. What does count is that Courbet painted *things* and Monet painted *sensations*. And as soon as the painter starts to paint sensations, his canvas becomes an entity of quite another order than that of a painter of things. It ceases to be a sort of window; it becomes a sort of grid. It interposes between the painter and his motif an autonomous structure which, instead of effacing itself, asserts itself, because its rhythm and texture are meant to be the equivalents, embodiments, of the rhythm and texture, so to speak, of the painter's sensations. The marks on the canvas become opaque instead of transparent, and their internal homogeneity becomes more important than the heterogeneity of the different elements represented by the picture – and it is this internal homogeneity of the marks that makes a Monet more like a Pollock than a Courbet in aesthetic conception. In other words, in an Impressionist painting or a Post-Impressionist – in the broadest sense – painting, a tree and the sky behind it are meant to look more like each other than unlike each other. In a pre-Impressionist painting – Courbet being the last great pre-Impressionist – a tree is one sort of thing and the sky is another; the different things represented are disparate entities, not adjacent areas in the field of vision.

Soutine is one of the two important cases in twentieth-century painting of conversion to pre-Impressionism; the other is Derain. But Soutine has nothing of Derain's eclecticism, and a painter with whom he is more closely related is one who always was a pre-Impressionist: Utrillo; the affinity is obvious in any Soutine picture with buildings done after 1925 – the *Tree of Vence* series, the *House at Oisème*, the *Chartres Cathedral*. Utrillo, however, no more than Derain, does not use paint with a comparable freedom. In any event, Soutine's imagery is less often reminiscent of that of his contemporaries – leaving aside his imitators – than of Courbet and even of *his* contemporaries, the Barbizon School. The dark green has a lot to do with it. But, beyond the imagery inspired by Courbet – the girls dressed in white, the trees in dark green, and so forth – there is the shared feeling for fat impasto and for the way it can symbolise the density of matter.

Yet there remains that freedom in Soutine's handling, a boldness

and arbitrariness used even within the framework of a pre-Impressionist idiom, which belongs to this century and lay beyond the compass of Courbet's conception of what painting could be. And there is another thing that makes Soutine a modern painter: his instinct to paint the motif in close-up. (The exceptions are certain landscapes of *c.* 1923–25 and *c.* 1934–35.) It is not only that the distant areas of a scene are brought forward towards the picture-plane (which is what distinguishes the late Champigny landscapes from Courbet's forest scenes); it is also that what lies on the picture-plane tends to be at a minimal distance from the eye. Soutine's proclivity towards seeing things in close-up is most clearly evident – though in any case it is quite apparent enough for no such systematic proof to be needed – in his paraphrases of other painters' compositions. Courbet's girl reclining by the Seine is observed by someone seated several feet away; Soutine's is seen as if by someone bending to offer her a cigarette. Rembrandt's paddling woman is magnified by Soutine so as almost to fill out the whole canvas, as if she were looming up over the beholder like a mother about to pick up her child. Rembrandt shows the carcass of beef within a setting, an interior with a girl in the background peeping round a door; in Soutine's paraphrases, there is no room for anything but the carcass – the carcass *is* the setting.

Now, for one reason or another, close-up seems to be the natural viewpoint of the twentieth-century painter. It is not fortuitous that the famous long-shots of twentieth-century painting are the endless beaches of the type of Surrealism whose conception of space is a deliberate negation of the twentieth century's and is, moreover, a nostalgic symbol of history – space meaning time. The close-up view is an inevitable consequence of the twentieth century's predilection for flat and simple design. Its affective implications can vary. It can aggrandise. Most often it signifies a refusal to maintain 'a respectful distance', expresses a will to intimacy, whether that of sympathy or that of insolence: either way it is anti-heroic; it probes. In Soutine's work it seems to have another meaning. Close-up first becomes important to him in those Céret landscapes of *c.* 1920–21. The exaggeration in such works of Cézanne's practice of tilting forms upwards towards the picture-plane is also, of course, a key factor in Analytical Cubism. But in Analytical Cubism the forms are predominantly trans-

parent planes linked to an armature of lines, and their ethereality tends to counteract the bringing forward of the forms, so that their nearness to the surface does not endanger it, and the structure stays classically poised. But in the Céret paintings the forms are dense and congested and their nearness makes them loom up, dangerously close, threatening to burst through the picture-plane and having to be held at bay. As if fearing attacks from them, Soutine assaults them: the canvas becomes a battleground between the menacing force of whatever confronts the painter and the bending force of the painter's will.

And this becomes Soutine's pattern (one that is highly consistent with what we know of his personality): to put himself in a position from which he feels that something is threatening him, so that he must attack it, wrestle with it, twist it, wring its neck. It is as if he can only make contact with the external world through an act of violence and violation. It is painting as a form of in-fighting. The brush is a weapon, and the paint is a magical substance with which to obliterate and remould the contours of the object, and its identity. The object is not so much tortured as lovingly torn apart. It is no longer a hillside or a tree, a carcass of beef or a dead bird. It is changed by paint into a nameless organism writhing in the throes of love or death, heaving with life. The paint appears to act like a miraculous teeming substance that actually generates life under our eyes. It is as if matter and energy were being continually churned out, were forever being renewed by the paint.

NOTES

1 Monroe Wheeler, *Soutine*, New York, Museum of Modern Art, 1950; Charles Douglas, *Artist Quarter: Reminiscences of Montmartre and Montparnasse*, London, Faber and Faber, 1941, pp. 316 ff.
2 'Garde', *Mes années avec Soutine*, Paris, Denoël, 1973, p. 57.
3 Emile Szittya, *Soutine et son temps*, Paris, La Bibliothèque des Arts, 1955, pp. 91–2.
4 e.g. Henry Hart, *Dr Barnes of Merion*, New York, Farrar Straus, 1963, p. 72.
5 Maurice Tuchman, in *Chaim Soutine*, London, Arts Council of Great Britain, 1963, p. 18.
6 D. H. Lawrence, 'Introduction to His Paintings', 1929, collected in *Selected Essays*, Harmondsworth, Penguin Books, 1950, pp. 341–2.
7 Thomas B. Hess, *Abstract Art*, New York, Viking, 1950, pp. 69–70.
8 René Gimpel, *Diary of an Art Dealer*, New York and London, 1966, p. 437.

Mondrian – I

This appeared in *Studio International* in December 1966 as 'A Tulip with White Leaves'. It drew heavily on the script of a BBC television programme on Mondrian which I made in 1964 as one of a series of half-hour programmes on 'Ten Modern Artists'.

'Everything was spotless white, like a laboratory. In a light smock, with his clean-shaven face, taciturn, wearing his heavy glasses, Mondrian seemed more a scientist or priest than an artist. The only relief to all the white were large matboards, rectangles in yellow, red and blue, hung in asymmetric arrangements on all the walls. Peering at me through his glasses, he noticed my glance and said: "I've arranged these to make it more cheerful." '

Thus Charmion von Wiegand on Mondrian's New York studio. In his Paris studio he had used flowers to make it more cheerful. One tulip in a vase, an artificial one, its leaves painted white.

As Mondrian was probably incapable of irony, the tulip was unlikely to be a wry joke about his having had to produce flower-pieces between 1922 and 1925 when he no longer wanted to because there were no buyers for his abstracts. It could, of course, have been a revenge for the agony a compromise of that sort must have cost him. More likely, it was simply a part of the general revulsion against green and growth which made him, when seated at a table beside a window through which trees were visible to him, persuade someone to change places.

The artificial tulip fitted in, of course, with the legend of the studio as laboratory or cell, the artist as scientist or anchorite. Mondrian felt it mattered that an artist should present himself in a manner appropriate to his artistic aims. A photograph of him taken in 1908 shows a bearded floppy-haired Victorian man of sensibility. A photograph of 1911 shows a twentieth-century technologist, clean-shaven with centre parting and brilliantined hair; the spectacles were an inevitable accessory. Soft and hairy becomes hard and smooth; one of the great landscape-painters of his generation, one of the great flower-painters of his generation, comes to find trees monstrous, green fields intolerable.

The loneliness of the artificial tulip with its painted leaves might seem to suggest that flora were admitted grudgingly, one plant being the next best thing to none. But it probably meant the opposite of that – was probably a sign, not of Mondrian's having become a different person, but of his having remained the same. When Mondrian had painted flowers, he almost invariably painted one chrysanthemum, one amaryllis, one tiger lily. His most personal paintings of trees are paintings of one tree; of architecture, are paintings of a lighthouse or a single windmill or an isolated church – a solitary tower, often with its entrances as if blocked, like a fortress, refusing disruption of its monolithic intactness, its immaculate otherness, its self-sufficient singularity.

Likewise the early romantic landscapes are rarely at all panoramic: they usually take in something like a couple of cows and a tree, three or four trees in a row, a group of farmhouses. And the tendency to concentrate attention inwards persists into the paintings and drawings of the sea of 1914–15: half of them are of a *Pier and Ocean*. The ocean is not oceanic, consuming, illimitable: it radiates from a vertical motif representing a man-made projection – like the towers jutting into the sky. Only the composition is no longer centripetal. The pluses and minuses of the sea don't converge upon the pier: they do radiate outwards, are then checked by the containing oval within the rectangle of the page or canvas. These works are, of course, among the key transitional pieces between figuration and non-figuration in Mondrian. In the tensions they exhibit between centripetal and centrifugal, they are also representative of his transition from centripetal to centrifugal design. In Mondrian figuration is equated with the centripetal, non-figuration with the centrifugal. (It is interesting that an artist so exceptionally given to symmetry in his early days should so rigorously exclude it in his maturity.)

Focusing inwards is rejected by Mondrian when the object is rejected. Focusing inwards is involvement. Involvement with objects entails suffering. In the paintings of chrysanthemums – that most centripetal of flowers – there is a sense of concentration that is agonising. It is as if the artist were trying to hypnotise himself by gazing into this flower and as if he were trying to hypnotise the flower into suspending its process of growth, the process that will make the

petals fall away, the flowers wilt and die (as it is seen to do in two of the paintings in the series). The rapt quality of the image seems to embody a longing to deny time, the flower is held together with a sort of desperation. In the series of images of trees that followed, the forces of growth can no longer be held in. Growth is seen as an irresistible force moving through the tree – a river of life, spreading, demanding space into which it can expand. Pictures such as *The Red Tree* reflect not simply a tree seen now, but the way it has evolved, has lived, has been formed, is still in formation, will wither and die. In pictures such as *The Blue Tree* the urgency of the need to grow is such that it is as if the whole growth were telescoped into one explosive moment like a shellburst. Coursing with life, the trees are twisted images of torment and despair.

Intense involvement with living things is involvement with death. If you follow nature, wrote Mondrian in 1919–20, you have to accept 'whatever is capricious and twisted in nature'. If the capricious is beautiful, it is also tragic: 'If you follow nature you will not be able to vanquish the tragic to any real degree in your art. It is certainly true that naturalistic painting makes us feel a harmony which is beyond the tragic, but it does not express this in a clear and definite way, since it is not confined to expressing relations of equilibrium. Let us recognise the fact once and for all: the natural appearance, natural form, natural colour, natural rhythm, natural relations most often express the tragic . . . We must free ourselves from our attachment to the external, for only then do we transcend the tragic, and are enabled consciously to contemplate the repose which is within all things.'

Mondrian could find a repose to contemplate in natural things so long as he could see them with their energy held in check, as with the chrysanthemums. The object was tolerated so long as it seemed to contain its energy. Looking at the trees, he recognised the forces flowing out of them – so that the tendency towards the centrifugal first appears among these images – felt the need to release those forces from objects and objectify them in another way. Attachment had to be transferred from natural objects to things not subject to death. To an artificial tulip, which would be everlasting. To lines which were not lines tracing the growth in space of a tree but were lines not matched in nature, lines proper to art, lines echoing the bounding lines of the canvas itself.

The lines which had followed the lines of the boughs and branches and twigs of the trees gave way in 1912 to lines derived from the scaffolding in space of Analytical Cubism. Geometric abstraction by and large has its origin in the flat shapes of Synthetic Cubism, a mode completely foreign to Mondrian. One imagines, in the first place, that he must have disapproved of the fact that Picasso and Braque, having evolved with exquisite logic for four years from the Estaque and Horta landscapes to the shattered luminosity of the hermetic period, suddenly took a capricious sideways leap into the arbitrary improvisations of *papier collé*. It is known that he disapproved of the fact that, having attained a sublime level of abstraction from nature, they used *papier collé* to let reality – in all its banality and all its subjection to time – in through the back door – a recourse to nostalgia and materialism. It is evident that he could accept no form of assemblage as a solution. The assembled shapes of Synthetic Cubism ultimately derived from the flat separate shapes of Gauguin. Mondrian's allegiance belonged to Impressionism and Seurat, to their concern with translating a sensation into a mesh of brushmarks. Mondrian's neo-Impressionist brushmarks of 1908–10 were elongated into the short lines of the seascapes and façades of 1914–15 which in turn were elongated into lines extending from side to side of the canvas and seemingly beyond.

A painting by Malevich or Van Doesburg or Kupka is an assemblage of shapes. A Mondrian does not consist of blue rectangles and red rectangles and yellow rectangles and white rectangles. It is conceived – as is abundantly clear from the unfinished canvases – in terms of lines – lines that can move with the force of a thunderclap or the delicacy of a cat.

Mondrian wanted the infinite, and shape is finite. A straight line is infinitely extendable, and the open-ended space between two parallel straight lines is infinitely extendable. A Mondrian abstract is the most compact imaginable pictorial harmony, the most self-sufficient of painted surfaces (besides being as intimate as a Dutch interior). At the same time it stretches far beyond its borders so that it seems a fragment of a larger cosmos or so that, getting a kind of feedback from the space which it rules beyond its boundaries, it acquires a second, illusory, scale by which the distances between points on the canvas seem measurable in miles.

'The positive and the negative are the causes of all action . . . The positive and the negative break up oneness, they are the cause of all unhappiness. The union of the positive and the negative is happiness.' The palpable oneness of the solitary flower or tower, being subject to time and change, had to give way to the subliminal oneness of a vivid equilibrium.

Bonnard *1966*

Occasioned by a major Bonnard retrospective at the Royal Academy, this appeared in the *Sunday Times Colour Magazine* on 6 February, 1966 under the unfortunate title 'A Nude about the House'. The text has been slightly revised.

A nude by Bonnard is not an odalisque or a nymph or a goddess or a model but a woman observed in the bedroom or the bathroom, almost always self-absorbed, doing something to her body or looking at her reflection or brooding. Very occasionally she is looking towards the beholder, and then more often with an indifferent than a directed, provocative gaze; generally her face is averted or turned away and she has an air, moreover, of being unaware, or choosing to ignore, that she is under observation.

She is scarcely ever shown with someone in attendance, whether a maid or a mate. The rare exceptions include an early work in which she is sitting up on a bed next to which a naked man is standing holding a towel or a robe; and a late work in which only her legs are visible, stretched out in the bath and seen shooting up from the bottom of the canvas, while in the far corner are part of the dressing-gown and the foot of a man walking into the picture carrying a palette.

There are a few paintings in which a solitary nude woman is found out of doors, and a few, usually with mythological subjects, in which a couple or a group of nudes are seen among trees or by the sea. But in most of these the nudes are part of the landscape rather than nudes in a landscape: the outstanding exception is an almost Titianesque picture, painted about 1903, of a faun rudely embracing a nymph. For the most part the nudes in landscapes are ingredients in making a pic-

ture rather than bodies whose nudity seems to have involved Bonnard's feelings or curiosity. His book illustrations include several highly charged images of naked groups of girls and loving couples. As a painter his obsession with the nude was concentrated on a solitary, private, figure.

In this exclusiveness Bonnard is rare among the great painters of the nude. Most of them have done nudes in couples or in groups – lovers, bathers, dancers, athletes, noble or ignoble savages, women in harems or brothels, or just models posing together. Bonnard's neglect of these possibilities is all of a piece with his work as a whole. Whether painting people or still life or landscape, he painted what was near to him – his surroundings and his intimates. He painted whatever belonged to his personal life, and he painted it the way he saw it in the ordinary course of events: one cannot imagine him arranging a still life on a table in order to make a picture of it; he would have painted the still life that happened to be there, rearranging it on the canvas, perhaps, but not interfering with the actual things – just as, in fact, he didn't cultivate his garden but let it grow as it would.

There may well have been a connection between this passivity of his and his diffidence about painting from nature. He gave convincing reasons for preferring to paint from memory, helped by drawings; he felt in danger of being 'distracted by the effects of direct and immediate vision and losing the primary idea on the way'. Yet his deepest motive could have been an unwillingness to freeze the flow of life.

It was an attitude which in his treatment of the nude precluded his depicting her posed and returning his gaze; it demanded that she should not notice him. And then it precluded that will to organise and dominate which urged Cézanne and Renoir, Matisse and Picasso to emulate the great figure-compositions of tradition. And it precluded the quest for exotic models, for women apart, that led Degas and Lautrec to find subjects in the brothels. The brazen sexiness of many of Bonnard's paintings and lithography of the late Nineties clearly derived from the pleasures of a private and absorbing relationship – his involvement with Marie Boursin, known as Marthe, whom he met in 1894 and who lived with him until her death in 1942 (they got married in 1925). The majority of the nudes he painted were images of Marthe.

She was constantly the same woman in a rather special sense: as she got older, he went on painting her almost exactly as he had when she was younger. He views her with a complexity of feeling that has hardly been surpassed in art. There is idealisation: the ageing wife dreaming in her bath is dissolved into his daydream of their youth. There are intimations of her mortality in the way in which her form is in process of disintegrating in the light and in the colours which are the colours of overripe fruit or of flowers that have begun to die. There is compassion for her in her vulnerability. There is longing to possess her, a feverish and insatiable longing to merge with her as closely as she herself, when lying on a bed, seems to melt into the sheet beneath her. And there is irony, a rueful wit that is sharply aware of her absurdity: the absurd look of a woman – for all that she is as golden as if she were a goddess of the sun – when she is standing in front of a mirror perfectly naked but for her high-heeled shoes, powdering herself; the absurd affinities between women and their pets – as in the painting of a girl lying on her front in which the delectable undulations of the contour of her back are echoed in the contours of the little white dog lying by the bed, and again in the painting of a woman in the bath in which a small brown dog lying on the bathmat is framed by the mat as its mistress is framed by her tub.

There is an extreme ambivalence at work in all this, and perhaps the most poignant aspect of Bonnard's ambivalence towards his model concerns the desire to touch her. He conveys the promise and the memory of the delights of handling her flesh, of bringing his body into contact with her body. He conveys that it is too precious, too fragile for him to dare to take hold of it: he holds back, leaving the flesh to be caressed by the light that plays over it, invades it, infuses it as it infuses and floods the surrounding space. The woman remains apart. Her apartness seems symbolically expressed in the series of nudes reclining in their bath-tubs (especially in the greatest, the one owned by the Musée d'Art Moderne de la Ville de Paris). They lie there enclosed in their tubs as if enclosed in shells. They are the counterpart of Botticelli's Venus rising from her shell at the moment of love's coming. The nude enclosed in her shell is love's denial. She is self-immersed, she is indeed 'in a shell'.

She can be seen, I suspect, going into her shell in that picture I

mentioned of a man and woman in a bedroom, painted in 1900 and owned by the Musée d'Orsay. The woman is as self-enclosed as the two cats playing on the counterpane; in the foreground a folded screen appears between the couple, stands there like a barrier. It is an image of isolation, and the figures are surely Marthe and Bonnard.

Marthe was in fact an impossible companion – deeply neurotic, an invalid, unable to have children, devoid of understanding of Bonnard's work, unwilling to receive his friends in the house, endlessly nagging, wildly jealous. (Someone who knew Bonnard well has informed me that in 1920 he fell in love with a girl called Renée Monchiaté, that they met and went on trips together until 1925, when Bonnard married his sick rose and Renée killed herself. He had done numerous paintings of her, almost all destroyed at Marthe's insistence). He remained loyal to her in spite of all he suffered, or because of all he suffered. No doubt it served him as an artist, as for one thing it indubitably served him that Marthe happened to have a compulsion to spend several hours a day washing herself or taking baths. The monument to her obsession is a series of canvases which probably stand alongside certain Matisses as the greatest works of art of our time.

Except that they're about her only incidentally. He doesn't focus fully on her, doesn't focus fully on anything, tends to see everything as if seeing it out of the corner of his eye or when walking past it (so that his wife's familiar, for example, is not quite a small brown dog but rather Henry James's 'something dark, something canine'). All the things in the paintings are only incidentally what the paintings are about. What they are really about is seeing, the process itself of seeing. Which is why the principal actor in Bonnard's scenes is the light – the light that irradiates things, meaning possession, the light that disintegrates them, meaning loss.

Matisse

This is a version for the printed page, prepared for the present book, of the script of a BBC television film, *Matisse and His Model*, directed by Leslie Megahey and first transmitted on 13 August 1968. The opening section, a selection of passages from the artist's writings used as a voice-over to archival footage of him painting from a female model and drawing his grandson, is omitted, and changes have been made here and there.

Matisse's habit of using the confrontation between artist and model as a subject was one that he shared with Picasso. He also had a habit Picasso did not share of actually confronting the model when making art. Naturally, therefore, Picasso's images of the confrontation focus on its drama and its myth, whereas Matisse's are often about looking and about noticing. For instance, they present the artist's discovery of how he and his model occupy the space. He does a drawing of her front view, adds her back view reflected in the mirror and remarks that he too, or a chopped-off bit of him, is reflected in the mirror – as sometimes happens in paintings too (such as *Carmelina* of 1903). Or he looks at the model and then at his paper and discovers that his hands as they make the drawing are a part of his field of vision.

And then there are paintings in which he is wholly visible and working from the model. He made two of them around 1919–20, shortly after he started working in a hotel room at Nice: *The Painting Session*, in which the model is at a dressing-table looking down at what might be drawings, and *The Painter and His Model: Studio Interior*, in which the model, lolling deliciously in her armchair, is treated as a jewel for which all the other elements provide a setting. The window and curtains create a frame for her. The tables on either side of her provide diagonal lines directed to lead the eye towards her and her soft languid curves. The rest of the picture is packed with straight lines – the slats of the artist's chair and the stripes on his jacket, the stripes of the tablecloth, and the criss-cross pattern on the floor, the windows and shutters, the pleats of the curtains and the dressing-table apron, the long stalks of the flowers – all setting off the flowing curves of her body and of the chair she sits in. Whenever our eye alights within that busy interplay of straight lines, it is hustled along towards

her, allowed to rest only when it reaches her, and there it stays, lingering over her caressable flesh. The model becomes the serene unmoving source of life.

Seen through the window behind her is a palm tree. Lawrence Gowing pointed out that in bringing together a seductive woman with a palm tree, Matisse had unwittingly painted a traditional allegory of fertility. There is a further allusion which I suspect Matisse was making consciously through the palm tree among other things – a teasing allusion to Vermeer's *A painter in his studio*. The artist has his back to us, the model faces us, though without looking out at us. The canvas in progress is mostly bare. The tiled floor has a criss-cross pattern. Vermeer is wearing a doublet with vertical slashes of which the stripes on Matisse's jacket and the slats of his chair might easily be a parody. Perhaps, then, the palm tree is an upside-down version of the chandelier hanging in Vermeer's studio.

What is certain is that the palm here – which also appears at the centre of the related picture, but in reflection – can be read as a symbol that the scene is at Nice. It would be impossible for the manner and mood to present a more total contrast than it does with the stark, mysterious canvas, *The Painter in His Studio*, executed at the turn of 1916–17 in Paris, which is Matisse's biggest version of the artist and model theme. Here the painter is not seen in action; he is sitting back looking at his canvas. Here he is not interposed between the canvas and ourselves; the canvas is wholly visible. And it shows, not a picture barely started, but one that is more or less complete. The canvas has taken on an independent life, separate from the artist's, comparable to the model's. The painted figure looks back at the painter as the model looks back at us.

The model is centrally placed as in the Nice picture, but her scale is dwarfed by the painter's. Yet she still remains the dominant element in the scene – not this time through the help of conspicuous compositional machinery but through the nicest adjustment of design. Her mere positioning makes her imperious in her command of the painter, her humble servant, and one remembers the traditional phrase for the dais often used for models: the model's throne. At the same time, she is scarcely more real, in a sense, than her effigy on the canvas; she is almost equally flat, schematic, featureless.

The elements in the painting which do have their features clearly described are the artist's chair and the easel and the Baroque mirror on the wall and the wrought-iron balustrade and the view out of the window. The view is readily recognisable as the Pont Saint-Michel and part of the Palais de Justice on the opposite bank of the Seine. So the location is identified. And the painting on the easel is identifiable: it is a picture called *The Green Robe*, which Matisse painted in 1916–17. Again, the view, familiar as the view from Matisse's studio, informs us that the painter in the picture is Matisse – a fact not revealed in the figure of the painter himself. Elsewhere, Matisse clearly portrays himself, with his red hair and beard and his spectacles. Here he is perfectly anonymous – faceless, generalised, and apparently nude, and possibly looking less like a naked man than a lay figure, so that the palette, which has the same neutral colour as the figure, is like an extension to an automaton. Perhaps the figure wears no clothes because any clothes would have given him a more specific character, diminishing his anonymity. The anonymity clearly corresponds to Matisse's ideal of the artist as an impersonal being concerned not to project his personality but to disappear into the work, the self-sufficient entity with its own life which he leaves behind – rather as Matisse, when visiting a sick friend, went off after a while leaving behind one of his paintings to soothe and comfort the patient.

Beyond that, does the figure tend to suggest a lay figure in order to hint that the artist has less external vitality than either his model or his painting? Or simply to mirror the immobility of the model's pose? Or because Matisse needed an area of neutral colour in that part of the painting? Is the unclothed artist, in contrast with the clothed model, a conceit, a reversal of Manet's *Picnic* and other paintings famously juxtaposing nude women and clothed men, perhaps above all Courbet's allegorical picture of the painter's studio, where an artist's model is the only nude among a multitude of figures? The model is appropriately nude in the Courbet because in art the nude is more an artistic convention than a representation of nakedness, and Courbet's painting is an allegory of the artistic life: if the scene in the Courbet had been real, the model would have put on a dressing-gown on the arrival of the many visitors, but in art nudity is appropriate where in life it would offend against modesty.

Did Matisse, then, want to demonstrate that, if nudity in art is a convention, the artist-figure could as suitably be nude as the model-figure, just as the Greek god of an artist is nude in Picasso's artist-and-model confrontations? Or did he want to demonstrate that having actually used, if he did, a lay figure as the model for the artist, he had no need to disguise the fact? But then, is the figure meant to be seen as unclothed anyway? Since the figure and the palette are the same neutral colour all over, could this not mean that the colour of the figure is not meant to be read literally at all and has nothing to do with its being unclothed? After all, the silhouette of the leg is like that of a trousered leg. However, that may not mean that the leg is trousered, because the shapes in the picture are mostly no more literal than the colours. Then again, there are other paintings of the period by Matisse in which a centrally placed solid form – as in *The Rose Marble Table* of 1916 or 1917 – is treated as a blank silhouette with a similar neutral colour. It is rather as if the painting were analogous to a photographic negative, only not with light and dark reversed but with solid and void reversed.

For that matter, in rendering light as well, Matisse often did the precise opposite of the expected thing. The 1916–17 *Painter in His Studio* is a case in point. The wall and floor are arbitrarily divided into a dirty-white area and a black area. But the black is not shadow. The near-white and the black combine to generate light. And in *The Green Robe* the densely solid black of the ground is as vivid as the green and the violet. Light flares out of the blackness.

And volumes and space seem to switch roles with each other – above all in the design, made near the end of his life in cut and pasted paper, for a ceramic decoration representing figures in a swimming-pool. Sometimes the blue areas seem to be the swimming or diving figures. Sometimes the figure seems to be the white and bare canvas contained within an open blue shape. Sometimes the blue shapes seem to oscillate between being figures or limbs and the empty spaces around and between figures and limbs. So it is possible to interpret the colour of the painter-figure simply as a device creating formal ambiguity. But that scarcely seems sufficient in the face of a picture as charged and mysterious as this.

I suggested earlier that in 1919 Matisse parodied Vermeer's treat-

ment of the artist-and-model theme. This painting recalls the Vermeer for very different reasons – the quality of its stillness, its intentness, its silence, and the artist's insistence on his anonymity. The common qualities heighten the contrast between two very different views of the painter's world. Vermeer's painter resembles the painter-figure described by Leonardo da Vinci in order to show how much better off the painter is than the sculptor – like Michelangelo – who toils and sweats in noise and dirt, gets his face 'pasted and smeared all over with marble powder, making him look like a baker' and whose 'dwelling is dirty and filled with dirt and chips of stone'. 'How different', Leonardo goes on, 'is the painter's lot – we are speaking of first-rate painters and sculptors – for the painter sits in front of his work at perfect ease. He is well dressed and handles a light brush dipped in delightful colour. He is arrayed in the garments he fancies, and his home is clean and filled with delightful pictures, and he often enjoys the accompaniment of music or the company of men of letters, who read to him from various beautiful works to which he can listen with great pleasure without the interference of hammering and other noises.' Painting as Vermeer represents it lacks the visiting men of letters, demands a more rapt concentration, but is none the less a highly civilised activity fitted into an agreeable life.

Now, the world of Matisse's interiors is generally bourgeois and comfortable, and Matisse as a man often tried to present himself to the world as a normal bourgeois gentleman. For instance, in 1913 he said to an American lady journalist: 'Oh, do tell the American people that I am a normal man; that I am a devoted husband and father, that I have three fine children, that I go to the theatre, ride, have a comfortable home, a fine garden, and that I love flowers, etc., just like any man.' But that image is not sustained here. Certainly, the ornate mirror is a handsome worldly possession, but it only throws into relief the sombre starkness of the scene as a whole, the stark nakedness of the artist. The luminous world outside the window seems as remote as the tree seen through the barred window of a prison cell. Is the picture saying that, in order to paint what is beautiful and richly glowing, to renew this beauty on canvas, the painter has to give up everything? Is the studio meant to be seen as a cell, the painter's nakedness as a symbol of deprivation? Or is the painter's nakedness a symbol of apartness

from the daily commerce of urban life – is this figure a representative of a more primitive world, a world of totem and magic rites? Certainly, the mirror is treated in a way that makes it look rather like an African fetish, and the figure of the artist recalls Negro sculptures.

This figure also seems to have come indoors from certain Matisse figure-compositions in a landscape, seemingly mythological pictures, only with more or less unidentifiable stories, such as the *Bathers by a River*, worked on from 1909 to 1916, and the *Bathers with a Turtle* of 1908. There is something here of the same intent, brooding, ominous quality as in the studio painting. There is a feeling that we are in the presence of some ritual the meaning of which is hidden. There is a sense of drama for which there is certainly no visible reason. As the bathers look down at the turtle an extreme gravity seems to be attached to the act of looking. And it may be that the studio picture suggests that painting is some sort of primitive rite in which magical powers are exercised.

The sense of mystery and foreboding pervades a companion-piece completed shortly after, *The Studio, quai St Michel*. The same studio is seen from a point towards the centre of the room instead of near the window. The same model – an Italian girl called Lorette – is lying there alone, but the painter-and-model theme is implicit in the artist's empty chair. If the scene appears sombre in mood, it is not primarily because of its sombre tonality. Matisse's very early picture of an attic studio has a dark interior, but the darkness suggests calm and privacy, the feeling of having a refuge, whereas here the sombreness is given another meaning by the stark severity conveyed by the insistent straight lines. There are the rectangles of the divan, of the wall behind it, the drawings on the wall, the buildings outside; there are the trapezoids of the window-panes and of the chairs and the drawing and portfolio on one chair; there are the zig-zag lines on the floor; above all, there is that series of emphatic vertical lines along the window side of the room. Where the length of the lines of the window-frame was limited by the exigencies of perspective, Matisse painted in a stool in front of the window, so that its two near legs provided a pretext for extending the parallel verticals downwards till they run along almost the whole height of the canvas; he didn't bother to put in its far legs. The stool, incidentally, looks from the way it's painted to be a late

addition to a canvas which involved Matisse in a great many changes of mind. Visible alterations include a major change in the placing of the model, changes in the placing of the drawings on the wall, the elimination of the wrought-iron balustrade. The wrought iron would have introduced curves at this point. Matisse chose to limit his use of curves to the emphatic circle of the tray on the stool, the emphatic arch of the bridge, the much flatter curves of the curtain on the right, and the powerful curves in the figure of the model – a curvaceous bird in a rectilinear cage – plus the faint echoes of those curves in the lines of the drawings. So the curved shapes are restricted in number but are very strong, so that they contrast violently with the straight lines.

In the same way, positive colour is confined to a few areas but is emphatic enough to be thrown into violent contrast with the pervasive grey and dark brown. Almost all the strong colour is concentrated in the model and her divan, which is also where the design is compressed and energetic; elsewhere it is broad and open. Like the model in the other picture, the model has appropriated all the rich colour that is there. But instead of a wall schematically divided into black and white, the wall behind the reclining model is grey, an oppressive grey that weighs down upon her luminous body.

Just across the river from this studio on the Quai Saint-Michel is Notre Dame, the exterior of which Matisse painted at several different times in his career. Inside the cathedral, the piers of the nave and the aisles do not so much lead the eye upwards to the roof as lead it from each pier to the next: the eye does not soar; it moves along a majestic procession of verticals. The aisle is a cold grey: the tonality is sombre. Set in these grey walls are the richly glowing shapes of the stained glass. Is it possible that Matisse was thinking of the rose window at Notre Dame when he did the 1916 painting of a bowl of oranges on a grey ground, the top of the bowl cropped, the oranges bounded with heavy black lines like the leading of stained glass? In painting the model on her divan, here too using thick black lines like leading, and setting off the jewelled colour with a very dark grey wall, is it possible that, consciously or unconsciously, he was evoking the cathedral and its glass in this room where the ritual of art is enacted?

What is special about the two 1916–17 studios is not only that they are different in mood from all Matisse's other works with an artist-

and-model theme, and not only that they are larger, but that they alone refer to other actual paintings of his. Matisse often showed his own paintings hanging in interiors, and constantly included in them his early bronze sculpture of a reclining woman, sometimes making it look like a live woman – the reverse of what he did in the studio painting, making himself look like a sculpture. But he didn't show particular works in his artist-and-model pictures. Only, this studio is, as it were, a long-shot relating to this close-up of a concurrent work, a life-size picture called *Sleeping Nude* – with the difference that here the long-shot doesn't show the picture but only the model as she is seen in the picture.

Matisse evidently felt a need to step back and place the posing model in the context of his own life and surroundings, to examine the situation within which he would gaze at her, and make something out of her. On 1 June 1916, during the battle of Verdun, Matisse wrote to his friend Hans Purrmann in Germany about the work he had been doing, and went on: 'These are the important things of my life. I can't say that it is not a struggle – but it is not the real one, I know very well, and it is with special respect that I think of the army privates who say deprecatingly, "we are forced to it". This war will have its rewards – what a gravity it will have given to the lives even of those who did not participate in it if they can share the feelings of the simple soldier who gives his life without knowing too well why but who has an inkling that the gift is necessary. Waste no sympathy on the idle conversation of a man who is not at the front. Painters, and I in particular, are not clever at translating their feelings into words – and, besides, a man not at the front feels rather good for nothing . . .'

Perhaps it was this sense of guilt that induced Matisse to examine and depict the struggle in which he was engaged. Perhaps he invested these studio scenes with their austerity and solemnity because he wanted to affirm that, though painting wasn't the real struggle, neither was it frivolous or easy. Or perhaps, on the contrary, he portrayed himself like this because he felt that at this time he lacked substance as a man and, with that, identity. But again, perhaps he emphasised his anonymity because he wanted to be something more than just himself, wanted to be a symbol of the artist, the representative of all artists, since art itself was on trial. Probably he had absolutely none of these

intentions, but only a compelling depression and unease within himself. What is certain is that here he forgot his customary resolve 'to keep', as he put it, 'my anxieties and anguish to myself and record only the beauty of the world and the joy of painting'.

Georges Duthuit once wrote that he had seen Matisse meet with such resistance in front of the canvas that he had gone into a sort of trance, weeping, gasping, trembling. But Matisse always tried to cover up the pain. As he said: 'I have always tried to hide my own efforts and wished my works to have the lightness and joyousness of a springtime which never lets anyone suspect the labours it cost.' At the same time, he in fact worried continually that people wouldn't realise how much pain had gone into getting that effortless effect. It distressed him that he couldn't have it both ways. There's the story, for instance, about the portrait of his wife painted in 1913. When his friend, the American critic Walter Pach, first saw it, he said admiringly that it looked as if the painter must have brought it off rather easily. Matisse was quite cross and protested that, on the contrary, it had needed over a hundred sittings. But he went on making things look easy. He was a dandy among painters, one who takes infinite pains to get a casual look. He wanted the audience to be concerned, not with the agonised face of the artist, but with the radiant face of the work. For art was good, and was good because of its beauty, not because of whatever heroism went into making it. One might need heroism to create beauty, but the good was in the beauty, not in the heroism. Even in this wartime confession that art was deeply demanding there are no heroics in the presentation of the artist-figure, but a certain irony and a resolute self-effacement.

ENGLAND

English Abstract Art *1957*

This is a heavily abbreviated and slightly revised version of a review article pub-
lished in two parts in the *New Statesman* for 21 and 28 December 1957. The
occasion was a survey, entitled *Dimensions*, of British abstract art, 1948–57,
arranged by Lawrence Alloway with assistance from Toni del Renzio, and staged
at a large London dealer's gallery, the O'Hana.

It seems to me that the field of abstract art in which we really flourish
in this country is the relief construction. The reliefs in this survey
show by Pasmore, Nicholson, Mary Martin and Anthony Hill,
together with Kenneth Martin's mobiles, which are analogous, have a
command over the medium, a certainty of purpose, a freedom from
compromise, a directness, generally lacking in English art and espe-
cially English abstract art. Mary Martin's *Black Relief*, for instance,
goes to show what scope for imagination there is in the reputedly arid
art of geometric construction. The subtle openings, the jagged
shadows, have a mystery that is all the more poetic because it is not
smothered in picturesque sauce, pickle or schmaltz.

Conversely, it is precisely a dependence upon the picturesque that
is the flaw in British abstract painting of the free, painterly kind – its
dependence upon vague poetic allusion rather than the properties of
painting as such. If the specimens of 'painterly non-figuration' – to
use the neat term with which Alloway covers Tachism, Abstract
Expressionism and Abstract Impressionism in the catalogue – are
compared with the work of Americans such as Pollock, Rothko, Kline,
Motherwell, Tomlin, Still, they strike us as peculiarly lacking in
physical substance, physical presence, in a word, *concreteness*. They do

not hold the wall, they float, they melt away as we look at them, do not affirm their physical reality as canvases covered with paint. We have the impression that, whereas the Americans have improvised on their canvases with the positive and unafraid intention of turning those canvases into live *things*, for these British painters improvisation has meant playing about with paint on the assumption that if they go on long enough something is bound to turn up, the something being some vague poetic suggestion.

The difference is not between a poetic art and an art which has physical presence and no soul: it is the difference between an art which relies on evoking things outside itself, an art that is somehow *transparent*, and an art which evokes other things only when it has firmly and decisively established its own reality. By the same token, the difference is not between a subtle art of tenuous suggestion, a shifting, ambiguous art, and an art of simple positive statements: it is the difference between an art that is all ethereal echo and an art in which there is something there to shift, something to be ambiguous about. None of our English paintings are more subtly pale and evanescent than Mark Rothko's, but the Rothkos have the decisive reality of a rock-face: they could scarcely be more transparent in texture, or more opaque in effect. Sam Francis, on the other hand, gets Rothko's subtle paleness but not his concreteness, and this may explain why he is so much more highly esteemed in England than in America.

The only 'painterly' paintings in the show at the O'Hana which have something like the degree of physical presence that a Rothko has are by Roger Hilton (his two later and larger canvases). There are good paintings by Moynihan and Davie, among others, but they tend to lack the density that makes a painting, before it is anything else, a *painting*. But, of course, this transparency is not peculiar to British painters only of this type. Of all the 'geometric' paintings in the O'Hana show, only the large Adrian Heath seems unassailably there.

The flaw, indeed, runs through all British painting and has long done so. It seems to be the misfortune of British painters to be born with more in them of Shelley than of Keats. And I suggest that this flaw is what is responsible for the odd look, the strained uneasy look, that virtually all British attempts at modern painting have had,

because it is a flaw which runs absolutely counter to the central thesis of modern art, the thesis laid down in 1890 by Maurice Denis: 'It must be recalled that a picture – before it is a picture of a battle-horse, nude woman, or some anecdote – is essentially a plane surface covered by paints arranged in a certain order.' The basic assumption of modern art – I speak of the major trends, those related to Matisse, Bonnard, Braque, Picasso, Soutine, Klee, Mondrian – is that the first concern of a work of art is to present a configuration of shapes and colours and marks which in and of itself stimulates and satisfies, and that only after this condition has been fulfilled can the subtlety of observation, the depth of human feeling and insight, the moral grandeur, expressed in the work, have validity: before the work conveys reality it must achieve its own reality, before it can be a symbol it must rejoice in being a fact, and the more it affirms its autonomous reality the more will it contain the possibility of returning us to the reality of life.

American-type painting is simply the extreme logical conclusion of this doctrine: its credo is the Denis definition shorn of its last words, 'arranged in a certain order'. For the earlier consequences of the idea of art formulated by Denis were forms of art in which the order of the work was too obviously emphasised. In answer to the schematic rhythms of Cubism and its offshoots, American-type painting has shown that the picture can have a life and presence of its own without having to look like 'flat, coloured architecture' (to use an expression of Juan Gris's): it only has to look like paint on canvas. Furthermore, American-type painting implies that, just as a painting does not have to depend for its vitality on resembling pre-existing phenomena, neither does it have to depend on conforming with any pre-existing canon of order. Its order as well as its subject-matter can be evolved in the act of painting, for the ultimate reality of painting lies in painting.

And in this kind of abstract painting, it is only after the reality of the picture itself has been established that its evocations – of states of feeling, of sensations remembered and half-remembered – have meaning and point. British paintings of this kind are like coals in the fire or cloud-formation or damp-stains on the wall – they are not seen in themselves, they merely serve to stimulate the fantasy of the spectator. In a sense, they do not begin to be works of art, for the work of art must offer a *resistance* to the spectator's fantasy, a check as well as

a stimulus. In figurative art the reality, the presence, of the object represented has this dual function of firing and resisting our imagination so that our relationship with the work always remains reciprocal, does not become a one-way traffic into day-dreaming. In non-figurative art it is the reality, the presence, of the painting itself that has to fulfil this function.

Sickert *1960*

Written in May 1960 as a review of a Sickert retrospective at the Tate, it was cut for reasons of space when published in the *New Statesman* for 4 June 1960 as 'Shapes in a Murky Pond' but was published in full in *Artforum* for May 1967 under the title 'Walter Sickert'.

The tragic flaw in English painting is compromise, unwillingness to be committed to a point of view, a desire to have the best of two or more worlds (especially, in our time, a present and a past world). Steer tried a compromise between Impressionism, Constable and Gainsborough, Matthew Smith a compromise between Fauvism, Delacroix and the Venetians, Sutherland a compromise between Palmer and Picasso. It can have the most honourable causes – like excess of humility or excess of imagination. But it's always a drag on development, because it prevents that carrying of one idea to an extreme conclusion which is achieved by every great artist (as well as a type of bad artist).

Sickert, however un-English he was in his habit of looking straight at the visual facts and in his easy mastery of picture-making problems, was thoroughly English in his lack of single-mindedness. His paintings do too many things. They are highly visual, with a camera's indifferent reflection of fortuitous effects of light and a marvellous eye for the totally unexpected shapes which crop up in nature if only one can be mindless enough to see them; they are highly aesthetic, with their impeccable design and harmonisation of tone and colour, and their fastidious feathery touch, a moth's kiss of a touch; they are highly psychological, with a novelist's eye for specific human tensions. There has never been another painter who managed to combine these

particular qualities. And the point is that Sickert only combined them by having them exist side by side. They don't fuse as the disparate elements in the work of great artists fuse so that each is inconceivable without the others.

To begin with, although he is both a brilliant observer and a consummate designer, his recording of sensations doesn't fill out the whole design. To see what I mean, compare the Camden Town interiors in the exhibition at the Tate with Vuillard's *The Loaded Table* (*c.* 1908) in the permanent collection. Vuillard has grasped the entire space of the scene and everything in it as a comprehensive whole: sensation has become composition. The Sickert interiors are aesthetic arrangements within which there are passages of observation which are fresher and keener than Vuillard's; but only passages – only the nude on the bed, not the nude on the bed in the room. Vuillard translates what he has seen into a painting; Sickert sees like a draughtsman, and then builds a painting round his drawing.

There is the same dissociation between his eye and his handling of paint. The brushwork looks marvellous, only it's not a vehicle for his sensations but a way of covering a canvas with a lively and lovely surface. Compare those heads where the paint is at its freest and liveliest, like the Camden Town period *Portrait of a Man* or the latish *Signor Battistini Singing*, with those late Manet portraits of Berthe Morisot which make a similar use of broad abrupt diagonal strokes slashing across forms. In the Manets, the accumulation of marks corresponds (as it does in a Velázquez or a Rembrandt or a Goya) to an accumulation of observations: it's a pattern of assertions, qualifications, denials as to what was seen. In the Sickerts, the configurations of marks say nothing about the actual process of seeing: they are mosaics designed to give the paintings a surface vitality. This dissociation between the act of seeing and the act of painting becomes really obvious where the marks are less broad, as in the townscapes and interiors. The way light falls across a naked body on a bed or the façade of a house is registered with the greatest delicacy, but we can conceive of its being registered with marks other than those which are there, as we can't with a Vuillard, or with a Whistler. For instance, looking at *L'Affaire de Camden Town*, we can ask why it is that the modelling of the nude figure is achieved with black hatching, as if the painter had been free

to make an arbitrary choice as to how to put down his vision. And the positive proof that Sickert's handling was largely a matter of caprice, not the inevitable result of what he had to express, lies in the quite random differences between the kinds of marks he used in the different versions of those paintings which he did several times over. So seeing comes first, paint comes after – the draughtsman again. Sickert, for all his French training, painted as Legros accused all English artists of painting, by making a drawing and filling it in. And it's no answer to say that Sickert's actual method was like that – doing a drawing, transferring it to canvas, painting it without transforming the shapes. The point is that a visual painter is a kind of painter who can't afford to work like that, more especially if his handling is conspicuous: the way he paints needs to be as empirical as the way he sees, else he risks producing something like a piano sonata scored for symphony orchestra.

And just as the qualities of his handling and design stand apart from his grasp of visual realities, so do they stand apart from his equally accurate grasp of psychological realities. In looking at a Vuillard, we don't know where his peculiar kind of formal pattern ends and his peculiar kind of feeling-tone begins; in looking at a Vuillardesque Sickert, a really good one like *The Rehearsal, Brighton*, we begin by seeing it as marvellous coloured design and then proceed to disentangle what it is about in human terms – and I'm not talking about the common experience of responding to a picture's form-and-colour before we recognise its subject, because this normally means that the form-and-colour is conveying the artist's feelings about his subject: with the Sickert we go from form-and-colour to subject to feeling.

A painting ought to leave us in a state of doubt whether the subject was a pretext for putting down what is on the canvas or whether what is on the canvas is the outcome of an obsession with the subject. With Sickert this sense of necessity is absent. The subject always appears as a pretext for painting a picture: Whistler professed to treat his subjects in this way; Sickert really did so. So that when the subject has a human interest, this seems to be gratuitous. And yet the human interest is needed. The architectural paintings, the views of Dieppe and Venice, are, frankly, rather boring. They look precisely like stages

on which the actors have not yet appeared. In the Camden Town paintings the actors are brought on. But the human interest they acquire doesn't go beyond interest: Sickert is intensely curious about them and extremely shrewd about them, but he has no emotional involvement with them or moral point of view about them, which is why the analogy that has been drawn with Lautrec doesn't go very far. So extreme is his detachment that he sees them as if he were not so much a psychologist as a zoologist – though one fancies that zoologists tend to feel more empathy and more wonder. He knows it all, and he enjoys hearing himself telling us about it. And we for our parts can feel, yes, people are like that, but recognising this doesn't make us love or hate them any better.

The greatest interest, in fact, in Sickert's handling of human themes is in that it makes him show his own hand more and is therefore revealing about himself, his attitude to life. It is an attitude of sophisticated, indifferent curiosity which, when applied to themes like the Camden Town murder, is like watching to see what fascinating and bizarre shapes present themselves when a couple of creatures in a murky pond fight it out to the death. The human element as such merely provides him with a pretext for displaying how much he knows about life: the one thing that passionately obsesses *him*, that involves *his* feelings, is the unexpected shapes which forms of life assume. A liking for strange shapes, queer, misshapen shapes, either abstracted or invented, is a very English taste: we find it in painters as different as Stanley Spencer, Francis Bacon, William Scott, as we find it in Fuseli and Blake and Stubbs's baboon and even Turner. Sickert's particular genius consists in the fact that his feeling for such shapes is completely unromantic. This is the essence of his uniqueness. The other elements in his art are seasoning.

This is why I believe that the portraits are, throughout his career, the most consistently successful aspect of his work, because in these he tends to indulge his taste for curious shapes without confusing the issue by telling a story and because he allows the shapes seen in a particular head to be the design rather than mounting the shapes he has discovered for himself in the setting of a received type of design. And it is why I believe that his finest works are the best of his late works – the ones made from squared-up photographs in raw scrubbed colour

with their dry graceless paint sinking into the coarse-grained canvas, works which are nothing but the strangeness of the shapes that the eye sees in nature when the mind, with its knowledge of anatomy and its memories of tactile experience, is not allowed to intervene. Here Sickert accepts himself as he is, declines to dress up his central obsession. And in so doing he achieves images of the most startling and brutal originality and modernity. The portrait of Hugh Walpole, with its one bespectacled eye looking out uncannily from a full-face two-thirds of which is a flat pale brown shadow, is in its way hardly less astonishing and hallucinatory than a double head by Picasso.

More remarkable still are the portraits of Sir Alec and Lady Martin, which belong to the Tate but have been left out of the exhibition. Here there is nothing very weird about the shapes. Here Sickert goes beyond a sense of the unexpectedness of the shapes we see to a sense of the very unexpectedness of a human presence. These figures are no more than presences: they haven't been built up into characters; there is no more of them there on the canvas than they would manifest of themselves if we came into a room and saw them sitting there. No more but also no less: they are very much there – solidly there, and yet they are mere shades of figures, have none of the corporeal substance which we know human figures to have. Degas, when using photographs, was still too much the classic artist not to impose upon the visual image his knowledge of tactile experience; Sickert, painting the Martins from photographs, had the boldness to leave unexplained and make no pretence of explaining those forms which did not explain themselves to the camera's eye, added nothing not given to the eye. The portraits simply reflect back at us a sensation of the sitters sitting there, a sensation of their *there*-ness.

The greys and pale dirty browns which are the colours appropriate for translating a camera's vision into paint are relieved by flat areas of turquoise – that turquoise which is the very symbol of *fin-de-siècle* aestheticism, the turquoise of Whistler, of the background of the caricatures of *Vanity Fair*, of the background of Sickert's portrait of George Moore. But here the turquoise only serves to accentuate by contrast the chalky pallor of the overall harmony. It is rare for painting to match the pallor of reality. Painting is generally either darker or more colourful, and the mature Velázquez remains almost the only

painter whose tones are the tones of nature. The Sickert of the Martin portraits has a Velázquez-like acceptance of what appears to the eye. The figures look as they look in northern daylight coming through a window. This is life as one would see it if one had no feelings, no thoughts, no moral or aesthetic prejudices. And these portraits are like demonstrations that life seen like this is life as it is. They have an empiricism as ruthless, as disenchanted, as raw, as absolute, as the empiricism of Hume. Sickert was only an eye, but what an eye!

Coldstream *1962*

This was a review, 'Grey Eminence', and a postscript to it, 'Fences', of a retro-spective at the South London Art Gallery. They appeared in the *New Statesman* on 27 April and 25 May 1962.

I

The fifty-seven paintings in the William Coldstream retrospective at the South London Art Gallery add up to about three-quarters of all the paintings that have come out of his studio in more than thirty years. This remains a tiny output even when every allowance has been made for the fact that most of the canvases have been worked on for an exceptionally long time by modern standards and for the likelihood that there must have been a number of canvases started and aban-doned. Coldstream has been prepared to take elaborate precautions against painting.

His decision in 1934 (he was then twenty-six) to stop painting and join the GPO Film Unit was not in itself significant of this: pictures were difficult to sell and he had to earn a living. And working in docu-mentaries helped to bring him back to painting – part-time in 1936, full-time the following year – with a new sense of purpose. It devel-oped his concern with the look of the everyday world around him and showed him how much the camera could and could not do – and so encouraged both an interest in and a belief in the value of realistic painting in which the subject was no mere pretext but mattered, and was a subject taken from ordinary life. He came back to painting full

of very definite ideas of what he ought to do as a painter – and not only
of what *he* ought to do but of what others ought to do, for he almost
immediately helped to found a private art school where the teaching
was extremely dogmatic, wholly committed not only to working
relentlessly from nature but to doing so by means of a particular and
rigid method.

After painting hard for three years, he anticipated call-up and vol-
unteered for the army in 1940. This stopped him painting until he was
appointed an Official War Artist in 1943. The fruits of this appoint-
ment are illuminating. Being obliged to paint, being deprived of the
choice whether to paint or not, he painted busily. Again, having to
paint subjects relevant to the war, and thus having the range of his
choice of subjects narrowed, he painted them with no less engage-
ment than usual, not at all as if he was doing a chore. Certainly, the
Italian landscapes he found pretexts for painting in 1944-45 were sub-
jects he might have chosen at any time, given the opportunity, and he
has done nothing to surpass them in tenderness and dignity. But the
series of portraits of Indian soldiers which preceded them were paint-
ings of models who happened to be readily available, and these
paintings also are among his finest things. What he needed, as always,
was an unsentimental, an impartial interest.

The most illuminating thing of all about these pictures is how dif-
ferent they are in style from those Coldstream was doing when he had
last painted: the overall hatching which is the characteristic brush-
mark of his pictures of the late Thirties gave way to a combination of
broad transparent washes and nervous spiky lines. He was using this
new and subtler style with complete conviction virtually from the start
(only the first of the portraits – the one belonging to the Tate – seems
to me a failure, with its embarrassing look of an attempt to ennoble
the subject). It is as if his work had been developing while he wasn't
painting just as much as it could have been expected to develop had he
never stopped, and perhaps more.

Since ceasing in 1945 to be employed as a painter, Coldstream has
had no sustained spell of intensive painting. He has managed to find
employment enough of other kinds to leave little time to paint. Most
artists have no other choice than to teach as a means of earning a living.
Coldstream is one who could have done otherwise, since portrait-

painting is a kind of painting in which there is a livelihood and Coldstream would paint portraits if he had to pay to do it, let alone be paid. Perhaps he felt, in choosing not to become dependent on portrait-painting, that to do so might hamper his independence: he has never been one to try and please the customer: it was hardly surprising that, after he painted his portrait of the Bishop of Chichester in 1954, the subscribers expressed the view that it was 'not a happy likeness'.

But Coldstream hasn't confined his activities to teaching (at Camberwell till 1949, since than as head of the Slade). He has sat on, in many cases chaired, advisory committees and boards of trustees – so many of them that the list of the honorary official positions he has held reads like something out of Gilbert and Sullivan. As some people are accident-prone, so is he prone to attract official handles. Before he became Sir William, before he became Professor, he was unaccountably known as Captain Coldstream – for no real reason: he hadn't been a regular (shades, perhaps, of Major Attlee). No doubt the surname encouraged the usage, but there must have been something about him which made it difficult for others to think of him as Mister.

And so he has become, not merely a pillar, but a veritable colonnade of the Establishment. What with quietly running, besides the Slade, practically the whole art world in this country, he has had little time for the practice of art. Remembering the results of his being made an Official War Artist, one wonders whether it isn't time a grateful government employed him again to paint, appointed him an Official Cold War Artist. His portrait of Lord Avon shows that he can paint even politicians, Garter fancy-dress, moustache and all, as human beings with a private dignity, human beings on a human scale, neither larger than life nor smaller. It takes a deeply private artist (somebody like Velázquez) to do this, one of the kind who establishes his privacy by not isolating himself, since isolation is a form of self-assertion.

Looking at what has been done in odd hours between committee meetings, one is at a loss to know whether, had he painted more, the gain would have been more than quantitative. During his first years at the Slade, he painted hardly at all. When he produced a series of nudes in 1953–54, they were a new departure in his work and the highest fulfilment yet of his dream of a kind of painting in which the

subject would be starkly itself. Then for a long time he was engaged on a portrait which he felt unable to resolve and has refused to show. But in the last three years he has come up with the most complex and extraordinary things he has done, the pictures of Lord Avon and Sir Ifor Evans and the nude of 1960–61, portraits with a rare intensity of presence, enigmatic as living beings. One asks whether he could not have gone still further if he had spent more time putting marks on canvas. But one also has to ask whether the quality of what he has done doesn't owe something to the feeling of urgency accumulated while not painting. For the self-denial, the holding back, that this entails is closely bound up with his particular qualities as a painter, qualities manifested with a concentration which makes him one of the two or three finest painters working in this country today and which has produced that unusual phenomenon, a retrospective exhibition of a British artist which increases his stature more than it exposes his limitations.

Holding back, a positive self-effacement – this is the very main-spring of his work. It was bound up in the first place with the decision he made in the Thirties about the kind of painting he must do. His motives were of course multiple. There was, as he admits, an element of snobbism in setting out to do something so unfashionable as to paint banal subjects greyly from nature: so dowdy an activity must have appealed to his particular kind of dandyism (he is the very type of the Baudelairean dandy, with his 'air froid qui vient de l'inébran-lable résolution de ne pas être ému': Auden, in *Letters from Iceland*, addressed him as 'you, whose tongue is the most malicious I know'). But he was also more earnestly motivated by a need to justify the activity of painting at a moment in history when it must have seemed frivolous and gratuitous. By painting the ordinary world and making it look ordinary, the painter could prove that he wasn't someone sit-ting up there in an Ivory Tower; by painting subjects with a common interest, he could hope to speak to those who did not belong to a priv-ileged class of aesthetes. It was a position analogous to and influenced by the cults of objective reporting and the documentary film.

The desire for self-effacement, all-seeing self-effacement – I am a camera – and the pre-eminence of conscience are already manifest in this position, which he shared with others. But there were purely per-

sonal motives at work, which must have functioned regardless of the current situation. 'I lose interest', he wrote in 1937, 'unless I let myself be ruled by what I see.' Recently he has spoken in a broadcast interview of the dislike he has of the marks he makes when drawing out of his head, when doodling for example – 'it always seems other people's doodles look so much nicer than mine'. On the other hand, he also said of the marks he nowadays makes and leaves visible when painting from nature: 'I do, I must say, get great pleasure in actually touching the canvas and in the sort of configurations I'm making under the cloak of representing what I see.' While he can't abide his own handwriting so long as it seems to be issuing entirely from within, so long as it is entirely *his* product, he takes pleasure in it as soon as it is occasioned by an external pretext, as soon as it is justified by the fact that while leaving his mark he is directing a scrupulous attention to something in the world outside.

The same reluctance to indulge himself, to impose himself, seems the main motivation for his compulsive unrelenting use of measurement as a means of getting a likeness to what is in front of him. He knows that measuring (the traditional practice of holding a brush or pencil out vertically at arm's length and, with one eye shut, using it to gauge distances between points in the motif) is an arbitrary way of ascertaining what is there. He knows it is only 'a kind of process for getting something going'. But it is a process which gives the initiative to something outside himself, a means of removing from himself the onus of getting things going. What he is to make on the canvas is to be derived in the first place from an outside authority, from an impersonal computation of some supposedly objective fact out there. 'It seems less willed if you're measuring.' What is imperative is not to impose one's own will on things.

But measurement is not only a means to get things going, but a passion in itself. He speaks of the 'intense pleasure' measuring gives him when painting, admits that when walking down a street he likes to try and guess his distance from a lamp-post, then pace it out. And this again is symptomatic of a concern that a respectful distance must be maintained between himself and things outside, of a need to know precisely where they stand in relation to him, so that he can be sure of their apartness from him. And this apartness is perhaps the theme of

his art, this unremitting insistence on the otherness of other beings and things.

This rigorous refusal to impose himself governs what strikes me as the most peculiar characteristic of his work – a deficiency by normal standards which he turns to positive account. In virtually any figurative art you can think of, there is an element of ambiguity: a human figure, say, is also a metaphor of a tree, a rock, a landscape, an animal, a creature of the opposite sex, a god – some thing or things beside itself. The metaphor is generally not consciously intended – if it were, it probably wouldn't work – but it is the result of the artist's allowing himself to impose upon the subject he is ostensibly representing some obsessional form which carries a symbolic weight. Coldstream's subjects are presented as what they are and nothing else. They are presented without overtones, indeed without adjectives.

These paintings are utterly literal. There is no poetry in their imagery, there is poetry only in their act of acceptance. Their beauty is the precise opposite of a beauty that is skin-deep. That is to say, it is a beauty that comes up from within, barely penetrates the surface, is to be discerned only in so far as one is prepared to try and match the artist's own attentive gaze.

II

I revert to the Coldstream exhibition, which has looked more and more impressive each time I have seen it. When I wrote about it here before I mentioned the lack of ambiguity in Coldstream's imagery – its exclusion of metaphorical overtones – but I failed to bring out the point that there's another kind of ambiguity at work, very much so, an ambiguity in the attitude towards the subject. In the first place, the sense of the subject's apartness from the artist is no simple matter of detachment. It can include an acutely painful awareness of the promise of sensuous pleasure implicit in the subject – Italian space and light no less than naked girl. The separateness may signify a holding back from pleasure (which is, after all, exactly what the continued act of painting is). Or it may signify the artist's recognition that something of the pleasure which the subject has to offer always eludes him (in the painting of the dome in the Capua landscape he seems to be straining to see more and more, enjoy more and more, of that infi-

nitely subtle gradation of the curve as it disappears from sight). Desire and remoteness are there together.

The pleasure taken 'in the sort of configurations I'm making under the guise of representing what I see' brings a further ambiguity. That is to say, there is a tension between the subject's domination of the picture – the proportions which measurement of the subject yields are rigorously adhered to, are not distorted or idealised – and the picture's domination of the subject – the stars, barbs and lines with which those very measurements are registered become an elaborate abstract design in red and blue which overlays the image and in the later work is quite the most striking feature of the picture. Consequently, despite the painter's refusal to shape the subject according to his will, his distinctive mark, his handwriting, intervenes conspicuously between the image and the spectator: the painter may not *impose* himself; he does *interpose* himself. He doesn't, as Cézanne does, for instance, or Giacometti, master, even maul, the subject in order to reconstitute it. He leaves it intact and at the same time uses that web of spiky marks to fence it off from the outside world.

Andrews
<div align="right">*1958*</div>

Published as 'Michael Andrews' in *The Listener* for 16 January 1958, it is slightly altered.

The idea of a first one-man show at the Beaux Arts Gallery calls to mind the image of walls thickly covered with canvases thickly covered with paint and bursting with conviction. The latest of the series, however, that of Michael Andrews, bears as much resemblance to this archetype as a daisy chain to a rhododendron bush. The pictures are sparely hung, for all that they are a selection from the work of seven years. The paint has been put on diffidently: even where it has become physically thick through prolonged overworking, it does not give an impression of thickness. And the overall impact, so far from being one of blazing certitude, is of works that are unsure of themselves.

Their tentativeness, all the same, is very far from giving them a

tenuousness. On the contrary, every one of them has a substance and a presence, the substance and presence of a *necessary* utterance. Each seems the result of a particular obsession, nothing seems painted for the sake of painting another canvas. We suspect that many a talented painter would produce an exhibition out of the thought Andrews puts into one picture, for we sense that each of his pictures embodies a period of life, an accumulation of experience.

But in spite of all that has gone into them – or more likely because of it – these paintings all look unresolved, with that endearingly unprofessional uneasy look that is so common in English paintings of figure-subjects: it is most frequently found in the work of minor artists of the eighteenth century, but even at the highest level, most Stubbses have it, as do Turner's portraits. It is as if the artist had had to learn the language of his painting as he painted it, learn it more or less from scratch.

But Andrews's awkwardness is not only an aspect of his pronounced Englishness. It is also the awkwardness of almost every modern painter who has not been content to solve his problems by simplifying them. Modern art, since Monet, has been a series of extreme statements, which is to say partial statements: its glory has been its demonstration of how much can be eliminated of the traditional apparatus of art without eliminating art. The modern artist who aims at the *inclusiveness* of traditional European art runs up against the difficulty of recovering that inclusiveness without embracing what have become the clichés of the tradition, and the awkwardness arises from trying to have one without the other.

Andrews, in his delicately bungling fashion, has in some ways gone remarkably far towards surmounting this dilemma. In the first place, he has succeeded in making every picture tell a story, as pictures used to do, without employing expressionistic deformations to drive home the point and without lapsing into illustration (the result of the painter taking his eyes off the characters in the story in order to concentrate on making them tell it, and so having to use clichés to represent them). The story is always some sort of reverie about life in our time, rather as early Bonnards are reveries about contemporary life. And one feels that the future will find in them that intense period flavour which we find in Bonnards of the Nineties. Yet, in spite of the

acute feeling for life now, Andrews's mood often is one most rarely found in art now, a mood of pleasure. And this ties up with another of his peculiarities – that his paintings have a kind of beauty, or sometimes prettiness, that tends to conform, above all in colour, with the conventional idea of beauty, or prettiness, which is to say the discredited idea. They conform without ever quite falling into cliché.

Linked with this acceptance of a traditional canon of beauty is Andrews's treatment of space. At a time when pictorial space is generally either rigorously shallow or else has the hallucinatory steepness of Mannerist space, Andrews presents us, as scarcely any painters have since Seurat, with the serene order, the cool radiance, of classical space-composition. Seurat, in fact, surely inspired the earliest work here, the Slade competition-piece *August for the People* (wrongly catalogued as *Sunday for the People*). But in *Lorenza Mazzetti in Italy*, painted in Rome in 1954, the source itself has been approached: it would be difficult to think of a twentieth-century painting closer to Piero (as one might expect, the unfinished portions of *The Nativity* are what are called to mind). The coupling of a Pieroesque space with the homage to Coldstream implied in the brushstrokes with which the face is painted makes this picture, by the way, an illuminating piece of art criticism.

With *Some People Sunbathing*, painted in 1955, Andrews moved away from a tonal method and also attempted a more complex and diffuse type of design. The over-schematic treatment of the figures (which contrasts with the consummate control of space) suggests that he was uncertain how to distort the forms in order to achieve those echoes, those rhymes between one shape and another which are needed to give unity in this more colouristic and also less centralised kind of picture. He appears since to have sought the answer in Bonnard, an influence discernible in most of his recent paintings – in *A Garden Party*, in *A Girl on a Balcony*, and in the very large work in progress, *Late evening on a Summer Day*, a most subtly luxurious representation of a necking party. The influence of Bonnard has involved a certain compression of space: this is not so deep as hitherto; planes are uptilted, the distant distances are shortened. But this is not Bonnard's space, which is flat Art Nouveau pattern given a certain depth. These paintings begin with the idea of depth and then contest

it till the elusive point is reached at which space seems to have a radiant amplitude and yet be destructible. So it becomes infinitely precious.

David Bomberg *1963*

Under the title 'The Discovering of a Structure', this was one of the essays in the catalogue of the retrospective organised by the Arts Council at the Tate Gallery from 2 March to 9 April 1967. It is a revised version of the preface, written at the end of 1963, to the catalogue of a one-man show at the Marlborough New London Gallery in March 1964. The later version omits the opening two paragraphs, which are purely rhetorical, and has a different and more interesting final paragraph. However, as only that one paragraph was written in 1967, the piece is dated 1963 here. In fact, it is a complicated piece to date because it contains so much recycled material: one passage appeared in *The Listener* for 18 September 1958, in a review of the memorial exhibition organised by the Arts Council of Great Britain, and another in the *New Statesman* for 17 September 1960.

In Bomberg's late paintings and drawings of landscape, where massive forms and skies pulsate as if they breathed, the firm, dense structure is not conceived as some immutable essence fixed once and for all. The structure is not presented pat; it unravels as the spectator looks at the painting, and he relives the process of discovering it. For the painting is not a painting of a structure, but a painting of the discovering of a structure. The discovering process seems to have relied on empathy more than on vision. It is as if the painter, in contemplating the landscape out there, had felt he was feeling his way over it with hands and feet and knees – here climbing laboriously up a steep rock-face, there zooming into a valley with the slope in control of his limbs. It is as if the contact were so close and so sustained that the painter had gone beyond being in the landscape and become the landscape. Looking at his picture I scarcely know if I am facing the scene or facing outwards from it.

Bomberg's brushmarks play a beautifully ambiguous role in all this. At times I see those long dragged trails of paint as traces of

Bomberg's self-projection into the scene before him. On the other hand, while Bomberg always re-creates a landscape in terms of its depth and mass, often the trails of paint are not directed into the scene; they traverse it horizontally and firmly adhere to the picture surface: they declare themselves as the painter's handwriting on his flat canvas. One might say that it's like counterpoint – that some marks work with the form and some against it and that, as in musical counterpoint, the more the opposing strands work against each other, the more they work with each other. But it's not as simple as that, because here there's no clear demarcation: a brushstroke can work in different senses and directions at different moments.

The colour has a similar ambiguity as well as a similar eloquence. It's impossible to pin down how colour is being used. It isn't local colour; it isn't atmospheric colour; it isn't plastic colour; it isn't decorative colour; it isn't poetic colour: it partakes of all of these, but it's not exactly any of them. Its primary function is to give the whole image density and life. It does so because there seems to be so much of it there: every inch of the canvas is charged with colour, teeming with colour. Layer upon layer seems to have got there with each layer preserving its own identity and virtue. The underlying layers somehow have as much presence as those which are visible. And the layers act upon one another exactly as visible areas of colour in different parts of a picture-surface act upon one another, singing against each other and together. The colour works in depth: concords and discords vibrate not only between the colours spread across the canvas, but between the colours superimposed on one another. This is not the result of conscious planning, of the deliberate execution of premeditated effects. It is something that has happened because Bomberg habitually worked over and over a painting, rapidly changing the shape and scale of the forms, and did this without losing the freshness of his colour as it grew more dense. No doubt this was because he could achieve the sort of rapport with his motif that allowed him to gain in understanding of it without losing sharpness of response to its impact.

'He wanted to touch the world of substance once more with the intuitive touch, to be aware of it with the intuitive awareness, and to express it in intuitive terms. That is, he wished to displace our present mode of mental-visual consciousness, the consciousness of mental

concepts, and substitute a mode of consciousness that was predominantly intuitive, the awareness of touch . . .

'. . . The eye sees only fronts, and the mind, on the whole, is satisfied with fronts. But intuition needs all-roundedness, and instinct needs insideness. The true imagination is for ever curving round to the other side, to the back of presented appearance.

'. . . In the best landscapes we are fascinated by the mysterious *shiftiness* of the scene under our eyes; it shifts about as we watch it. And we realize, with a sort of transport, how intuitively *true* this is of landscape. It is *not* still. It has its own weird anima, and to our wide-eyed perception it changes like a living animal under our gaze . . .'

Bomberg could easily have been the subject of those sentences. They were written by D. H. Lawrence and in fact are about Cézanne. Bomberg looked to Cézanne as his master, but so have modern painters of all kinds: Bomberg evidently saw a Cézanne in the same mould as Lawrence's – a Cézanne groping to realise a structure on canvas that would re-create the intensity of his tactile sensations before nature rather than one who wanted to abstract from nature classical compositions as perfect in their geometry as Poussin's (of course he is both). Elsewhere, in writing on Soutine, I have quoted a passage from Lawrence on Cézanne for the sake of its aptness to the Céret landscapes, and there is an overlap between the sentences I borrowed there and those which I've used here. Bomberg once referred to Soutine in a letter as 'our colleague', and I think that Soutine provides a point in reference to which he can be situated. On the other hand, the work of Soutine's which relates to Bomberg's – the work done before he came under the spell of Courbet – is both much more convulsive in feeling than Bomberg's and less scenic in conception. Though it may be tempting to bracket Bomberg with a fellow-Jew of his own generation to whom in many ways he was akin in temperament, closer affinities to his work can be found in Matisse's paintings of around 1900, just before the fauvist style began to emerge. There are striking similarities of handling and composition and a very similar kind of indebtedness to Cézanne. I can see no need to look further afield to situate Bomberg's later work (except that he must sometimes have had Turner in mind).

Stylistically, then, Bomberg's late work was backward-looking,

adding little or nothing to the language of art that had not been there fifty years before. If it is, as I believe, the finest English painting of its time, only its intrinsic qualities make it so: in terms of the history of art it's a footnote. Forty years earlier, Bomberg, in his early twenties, was not only producing the finest, by a long way the finest, English painting of its time; he was producing some of the most original painting being done anywhere, even then. The significant difference was a matter of confidence. The paintings of 1913–14 are filled with an imperious conviction that the artist can dominate nature – as in the superbly bold, free way in which, in *In the Hold*, the all-over check pattern – an inspired pictorial invention – is imposed upon the figures. Art was the master, nature had to conform. Then came three years of war service and then the humiliating compromise of the Canadian War Memorial commission, when Bomberg wanted to do a painting in his usual manner but had to conform with official preconceptions as to what sort of style was suitable. By the time Bomberg was thirty, in 1920, that early creative arrogance was gone, never to be recovered. And perhaps with never a likelihood of being recovered by one who, after winning considerable early recognition, was sickeningly neglected and rejected throughout the rest of his life, and desperately cared.

From the 1920s on, he allowed nature to dominate him. At first in Palestine, he was a humble servant, content to alternate between conscientious topography and the charming sketch. Gradually he won his stature as an artist back, not through dominance but through a devotion that brought deepening insight, a profound communion. What his early and his late achievements have in common is the bigness of their form, the energy it encloses.

Auerbach

This review of Auerbach's third one-man show was the first occasion on which I wrote about him at any length. It was published under the title 'Nameless Structures' in the *New Statesman* for 21 April 1961; a few lines have been cut. The reasons why it made no specific mention of the works in the exhibition were that I wanted to write about Auerbach's work as a whole, and also that the new works, strong as they were, seemed less marvellous than those in the previous shows.

Paint laid on so thickly that the picture resembles a low relief is a common characteristic of European painting today, and to this extent Frank Auerbach's landscapes and heads at the Beaux Arts conform with a widespread tendency, more especially as their colours are the earth colours which are so generally – and by no means fortuitously – a concomitant of this thick paint. Only, with Auerbach the connection with relief is no more than a resemblance, whereas the work of Dubuffet or Fautrier or Tàpies really is more a form of painted relief sculpture than of painting proper. For the material they use is some kind of cement which is built up and perhaps incised and then has colour added (whether or not the original paste had a distinctive colour). With Auerbach there is no such separation between material and colour.

His paintings are oil paintings and their thickness is simply the outcome of a gradual accumulation of layer upon layer of impasto. I mention this difference of technique because its import is far from being merely technical and because its consequences are perfectly visible: we don't require inside information or chemical analysis in order to recognise that the substance of a Dubuffet seems rigid and opaque as lava, that of an Auerbach fluid and, for all its density, somehow transparent.

Implied among other things by this technical difference is whatever is implied by the difference between getting an effect quickly and getting a similar effect slowly (in the one case in the course of a few hours, in the other over a period of months). But the essential implication is that with Dubuffet – and the other exponents of what Lawrence Alloway has aptly called 'matter painting' – the thickness of the material has a decided purpose of its own, whereas, with

Auerbach, the thickness is no more than a by-product of another purpose.

The matter in 'matter painting' is symbolic. It symbolises the idea of the massive materiality of the physical world. It symbolises the relationship between man and the raw materials with which he builds, the inchoate matter which is at once responsive and resistant to his will to impose a form upon it and which both submits to his manipulation of it and inspires that manipulation. ('My connection with the material I use', says Dubuffet, 'is like the bond of the dancer with his partner, the rider with his horse, the fortune-teller with her cards.') And, having this life of its own as a concrete substance (and not merely as a vehicle for the act of painting), the material in 'matter painting' gives the illusion of being subject to the same natural hazards as is the material of a building: observing fissures in its surface, contrasts between rough and smooth in its texture, we spontaneously associate these with natural phenomena, with wear and tear above all, but also the growth of moss or lichen and so on. Thus the thick opaque matter of these paintings seems not only to have a life but to have lived, to have been weathered and ravaged by time.

There is a symbolism of time which can be read into Auerbach's paintings too – not of the time that has passed since a thing was built, but of the time taken to build a thing. It may well be a part of Auerbach's purpose that we should put this interpretation upon the thickness of his paint, that we should recognise his paintings to be accumulations of statements, a sum of denials and qualifications. But it is not primordial in our experience of his paintings. The thickness of his paint and its variety of texture don't hold the attention as such. The paint engages us, not as symbolic substance, but as the vehicle of a vision of reality.

I take this self-effacing character of Auerbach's paint as a mark of extraordinary accomplishment. It is a sure sign of quality in art that the effect of the chosen means is the opposite of what we would expect it to be – as when an almost monochromatic painting seems to be richly coloured, as when a string quartet seems as sonorous as an orchestra, as when a tightly organised play seems as haphazard as life. Auerbach's paint is thick, needs to be thick because he needs time to bring his image to fruition, but when we look at the painting, it isn't

the paint that we notice: the image is what imposes its presence.

It imposes itself from the start, but it needs time to gain clarity (as it did for the painter). Auerbach's pictures don't sing out feeling or emotion. They impress us as having tremendous strength of design, and this strength gives them an authority which commands our continued attention rather than seduces or disturbs us into giving it. The image that emerges is an image of structure, of firmly articulated masses of great density in a space that is equally taut and architectural. It has the degree of architectural resolution that we normally associate with kinds of art that are concerned with constructing ideal forms; only we feel that these forms have been arrived at empirically – the fluidity of the paint suggests the very process of their evolution – and that their firmness is an attribute of the degree of certainty that comes from profound and intimate knowledge of the subject, from which every guess and every illusion has been pushed away.

These structures seem to be known as if from the inside, as if the painter had become each object, had become the space, had become the light, and had painted them from the inside out. Structure and volume are not described, they are remade, projected on to a flat surface; in the movement of the paint over this surface their stresses and their density are reconstructed. The painting is not a scene presented; that is to say, it is a process of discovery given tangible and simultaneous existence.

But what are these things whose structure has been so firmly realised, what are their names? We sometimes need the catalogue to tell us: the paintings of building sites, for example, might easily be read as studio interiors. But is the name of a thing relevant to its structure? On the contrary, as soon as we name a thing, we tend to form preconceptions about its structure, blind ourselves to the structure it really has. It is not a question of ambiguity: ambiguity means that a form has several possible names. These forms have no name at all. They have their physical reality, and our sense of their reality as objects in space is heightened by this concentration upon what they are rather than what they are used for or how they behave outside the painting.

It's often lamented that there isn't enough of nature in the art of today, that paintings have become ends in themselves. It seems to me

that there's too much of nature in the art of today, that most painting is packed with allusions to the physical world, is a ragbag of memories of things, and bits and pieces of things. I believe that what is wanting is not reference to nature but a more firmly focused reference; that instead of treating reality as a sort of lucky dip, the painter might commit himself to achieve real penetration into clearly defined areas of reality; and that his work might acquire imaginative breadth, not by claiming the freedom to hint at a rich variety of things, but by concentrating together all the richness and variety of his perceptions of some particular thing – his visual perceptions, his tactile perceptions, his perceptions from close to and from far away, his perceptions when he is standing still and when he is on the move, the changes in his perceptions and the play of memory upon them, in short the total experience of an object. It is because of the subtle and profound way in which Auerbach's work gives expression and coherence to the complexity of our perceptions of simple things that he is for me the most interesting painter in this country.

Bacon – II

1962

A review of Bacon's first major retrospective held at the Tate, published under the title 'Francis Bacon' in the *New Statesman* for 22 June 1962.

Every clown wants to play Hamlet; no Hamlet would prefer to be a clown. Any painter would rather be a tragic artist than a comic artist, if he can make it. It's not out of a desire to be chic that so many painters of the human image today play it cool, do it satirically. They know how nearly impossible it has become to paint solemn images of man's fate when newsreels and news photos are constantly bombarding us with pictures of tribulation and disaster hot from the hells of the world, making the calamitous image an inflationary currency – in much the same way as the ubiquity of the pin-up has made it embarrassing to paint a beautiful girl beautifully.

In this situation, the artist who tries to picture the sufferings of mankind risks producing something which, however authentic his

feelings, seems to dramatise *him* rather than his subject; it is as if he were congratulating himself on his compassion. A few weeks ago Ted Hughes, in the catalogue of an exhibition of graphic art of the American Leonard Baskin, had a fiery outburst against 'the ferocious virus of abstraction', pleading that 'the particular misery and disaster of our time are, uniquely, the perfect conditions for the purest and most intense manifestation of the spirit, the Angel, the ghost of ashes, the survivor of the Creation, which has chosen to reveal itself in the works of Leonard Baskin.' In the face of Baskin's works, I for my part had the perhaps unfair feeling that it was as if the artist was *exploiting* his eminently serious themes. The trouble was that the images were too general: the artist was representing Suffering Humanity rather than human beings suffering.

It is one of Francis Bacon's strengths that he keeps clear of high-minded generalisation while making a statement about the plight of man. One sign perhaps that he consciously aims to avoid generalisation is the way in which his images are distortions, corruptions, of familiar images: a Velázquez portrait of a pope, Grünewald's battered Christ, the life-mask of Blake, self-portraits by Van Gogh, a still from *Potemkin* – surely the most famous still in the history of cinema. The allusion, instantly recognisable, restricts the happening – it is happening, we see, to Van Gogh, to a pope, not to Everyman. The method and its purpose are those of *The Waste Land*, a poem that has long obsessed Bacon, who speaks of how it is 'packed with memories'. Allusion makes for concreteness. And Bacon, like Eliot, keeps his allusions alive and kicking by mingling them, with that combination of surprise and inevitability which is the mark of a real imagination – as when he puts the Eisenstein head on the Velázquez shoulders.

But beyond the conscious will to make the thing particular, he has a knack of finding images that unite the vitality of a particular form with the resonance of a general import. Bacon, everyone feels (whether they like the work or not), is saying something that matters about the times in which we live – perhaps about the vulnerability that dangerously qualifies the arrogance of those in power. Yet nothing is more improbable than that he is setting out to moralise or enlighten. He is obviously an artist in whom compulsion is far stronger than intention, an artist ruled by private obsessions. It is simply that these

obsessions, whatever their personal origin, somehow correspond for us with certain elements in the public domain – perhaps with our ambivalent feelings towards those ruling monsters we see as father-figures, our fear and envy of their potency, our longing for their downfall, our relief and pity and shame and exhilaration when it is consummated.

Certainly, Bacon's force as a maker of images resides in the ambivalence of the feelings he induces at the sight of his fallen heroes. They present, as truly tragic heroes do, massive contradictions. Even as they are struck down by their calamity, they inspire awe. They rage in the face of their doom, yet they still seem to have some power in reserve which they choose not to utilise, so that finally they have an air, not of defeat, but of triumph and a certain serenity. Yet they are rather like puppets, filled with straw. On the other hand, they can seem acutely conscious and to be watching us (it's rather like looking through a chink at someone facing you, and having the conviction that they can see you and are pretending they don't).

They are also like caged animals. Bacon speaks of wanting 'to make the animal thing come through the human'. In his tendency to emphasise the affinities between men and animals, Bacon is very close to Eisenstein. Bacon hasn't necessarily got much in common with those on whose imagery he draws, but between his imagination and Eisenstein's there does seem to be a profound kinship. Images from *Strike* are recalled by several pictures in the Tate retrospective painted before Bacon saw the film or could have seen it or stills from it. *Man in Blue IV* of 1954 is reminiscent of the managing director of the factory leaning forward across his desk. The canvas entitled *Head IV* of 1949 shows a man with a monkey perched on his shoulder and there is this image in the film. *Head II* of 1949 and the similar *Head I* of the same year, which is not in the exhibition, show a head twisted upside down with the mouth open in a scream, and this image occurs in close-up in the film when one of the workers is crushed in a door during the riot. *Head VI* of 1949 is one of the paintings based on the still of the shrieking nurse from the Odessa Steps sequence of *Potemkin*. In using it here, Bacon has dissolved away the top half of the head in order to focus on the wide-open mouth. And in *Strike* the fantastic non-narrative montage sequence which forms a coda to the film

has as a clinching shot a close-up of the lower half of a face with the mouth open wide.

Besides the affinities with apes and dogs in Bacon's figures, there is an affinity which I did not consciously recognise until it was pointed out by Adrian Stokes. These lonely figures, imprisoned in boxes, their feeble perfunctory limbs hardly able to respond to their will, their mouths open to scream, are (but of course) like infants howling in their cots – and this is a very good reason why we instinctively feel the figures to be intensely exposed. The infantile connotations are present again in those nude crouching males, bunched like embryos. What is remarkable is Bacon's ability to express such feelings of helplessness along with a sense of animal vitality and a sense of superhuman grandeur. And with all this there is the nagging threat of death. One of the qualities that is always present in great art is that while abounding with life, it is an intimation of death. Bacon's art has this.

Whether Bacon's paintings are great art (as de Kooning's figure-paintings, with which they can most closely be compared, are great art) is another matter. It seems to me that, so far, the intensity which Bacon achieves in certain passages of a large number of the canvases has not been sustained throughout the whole area of any of them. And in painting in which the intensity is not sustained, the result isn't just that some parts are better than others: everything suffers, because the spectator's concentration is not totally gripped. For the grip depends upon the illusion that energy is flowing outwards from every part of the canvas to the edges and flowing from the edges into every part of the canvas.

Bacon's flaw is his difficulty in relating masses to what is outside them – firstly to the surrounding space, and then to the edges of the canvas. The paint that composes a head or a figure is marvellously alive: it seems to be generating form under our eyes. Where the volume ends the paint goes dead. The surrounding space is a vacuum. And there is no tension between the figure or head in the middle of the canvas and the four edges – the tension that should seem to hold a mass in place, as if it were locked there, incapable of being anywhere else.

Bacon seems to be trying to get round this problem when he draws – as he so often does – a rectangle or space-frame around the figure.

The spectator tends automatically to read this as a glass box like Eichmann's (for all that Bacon himself says that this is not generally his intention), and thus thinks of the figure as being imprisoned, and so perhaps feels that it is held in place. But it's only concepts that hold it there, not the architecture of the painting. What is lacking is the tension which makes the scale of a canvas look exactly right for the scale of the forms it contains. One feels that the canvas might equally well be much bigger or smaller. The result is that in the smoky tonal paintings on black or Prussian blue grounds of 1949 to 1956, the head or figure floats like ectoplasm in a void. Yet this only begins to disconcert when one tries to concentrate on the individual paintings and finds them diffuse. The general effect of the pictures in the first three rooms is marvellous, with that quality of late Titian which Iris Murdoch has exactly evoked: 'full of great melancholy shattered forms'.

Bacon, however, must clearly have been aware of what was lacking. In 1957 his work took a new departure which involved discarding the glamour and poetry of those muted, greyish presences and which must almost certainly have related to a search for a more coherent pictorial structure. He started to use vivid colour, to outline his forms with sinuous Art Nouveau arabesques that assert their presence as shapes, to divide the canvas into a pattern of coloured areas: he began, in short, to treat the canvas as a surface, not as a tank.

But the masses still don't link up with the surrounding space: they look now like silhouettes cut out and stuck to the canvas. The flesh is still painted in terms of tone shot with streaks of colour, but now, instead of swimming evocatively in a dark sea, it is thrown into harsh relief by the brilliant adjacent colour. This gives the distortions an air of wilful grotesqueness. And the backgrounds, still detaching themselves, look too resolutely designed.

Yet it all begins to make sense in relation to the exhibition's culminating work, the *Crucifixion* triptych. It looks here as if Bacon has been trying to reconcile the compact sculptural character of the forms of his 1944 triptych – with its biomorphic forms deriving from the Picasso of about 1930 – with the more painterly and 'realistic' handling of the subsequent work. The space still doesn't entirely convince, but the impact is electrifying all the same. The new triptych is

probably Bacon's most remarkable achievement to date, and it has shown me what this superbly ambitious artist was talking about when he said, seven or eight years ago: 'What I've always wanted to do is to make things that are very formal yet coming to bits.'

Bridget Riley *1963*

Untitled catalogue essay for a one-woman show at Gallery One from 9 to 28 September 1963.

Bridget Riley's central obsession seems to be the relationship on the picture-surface between repose and disturbance – the possibilities of establishing a certain obvious regularity which must then be denied. A rhythmic pattern is proposed and then modulated in space in much the same way as the rhythmic pattern and the density of texture in a work by Boulez or Stockhausen are modulated in time. If Riley's work is, as I believe, among the finest of its kind being done anywhere, it is because this obsession is not something cerebral but is the means of rendering visible tensions in our affective lives between feelings of composure and feelings of uncertainty, anxiety, vertigo.

This tension is embodied in her new paintings in a decidedly different way from its embodiment in the works in her previous exhibition at Gallery One eighteen months ago. In the earlier paintings a field of forms has the character of something going on 'out there', at a distance. Often (as with *Horizontal Vibration* or *Movement in Squares*) these paintings are like landscapes, or seascapes, not in the sense that they evoke the imagery of landscapes but in that the sensations they provoke are analogous to sensations provoked by landscapes. In the present works there is neither the diffuseness nor the distance of landscapes. The forms are more compact, more centripetal, and also appear to be within reach – claustrophobically so; it would often be more apt to say we were in reach of them. There is one series of pictures with such titles as *Disfigured Circle* and *Broken Circle* that consist of a number of concentric circles whose immaculate continuity is violently interrupted by a sort of dislocation. The

disturbance of regularity seems somehow more strenuous, more physical, than in the earlier works, and as we look at the picture we feel that we are twisting the circles out of shape with our hands as we might bend a piece of metal. This sensation that our bodies are involved in the process of disruption leads on to an identification of our bodies with the forms themselves, so that we no longer know whether we are twisting something out of shape or being twisted out of shape.

This emphasis on motor rather than visual sensations tends to give the recent paintings a greater intensity than the earlier ones had. A side-effect of this new development is that it has diminished the eye-hurting tendency of Riley's work – a tendency that can make her pictures impossible to hang at eye-level in a room in constant use (short of putting curtains in front of them). The painting called *Fall*, for example, would be intolerably painful to look at if we did not find that we don't seem to be at our actual physical distance from it but have felt ourselves into the forms, are enveloped by them. There is thus no time, so to speak, for the eyes to be hurt by the illusory action of the forms, because this is not going on 'out there' but as if in our own muscles.

SURREALISTS

Arp

1962

This broadcast talk occasioned by a retrospective at the Tate and entitled 'On Arp and Nature' was given on the BBC Third Programme on 1 December 1962. It has never appeared in print I have eliminated the opening three paragraphs and made a few minor revisions.

Arp has made one of the most conscious attempts in modern art to be playful for a seriously subversive purpose. He says that his art 'aims to save man from the most dangerous folly· vanity'. He says too: 'The Renaissance puffed up human reason with pride. Modern times with their science and technology have made man a megalomaniac. The atrocious confusion of our epoch is the consequence of this overestimation of reason.' There are three dragons, then, to be fought with: Vanity, Reason, Confusion. Arp's weapon against all of them is the pun – the visual pun made by a shape that means two or three different and incongruous things at once and hints, moreover, at referring to further things that can't quite be identified. There is scarcely a shape of Arp's that hasn't a multiplicity of obvious referents, whether in his sculptures in the round or in his works on the flat, the reliefs and tapestries and so forth.

Now, the multiple meanings are witty in effect only in the works on the flat. One reason for this is that, since the sculptures in the round are more or less monolithic, the range of their referents is restricted, so that there is not enough room for incongruity. So the multiple meanings don't go much further than suggesting that different parts of the human anatomy are interchangeable – buttocks and breasts, breasts and phalluses – and that they can resemble pears and eggs and snowdrifts and

mountains of the moon – all of which may be very lyrical and symbolic but isn't funny. In the reliefs, a number of shapes are related to one another, and the ways they relate lend these shapes a larger and wider range of referents. So in the reliefs the imagery of the sculptures is supplemented by suggestions of plates and forks and tables and hands and anchors and shirtfronts and mushrooms and masks and helmets and baleful eyes and that marvellous pair of Blimpish moustaches gliding through space like a gull in flight. Here Arp's ubiquitous navel becomes as versatile as in the famous recitation of Yvette Guilbert's, 'Elle avait le nombril en forme de cinq', with its great incantation, 'nombrils correctes, nombrils à la renverse . . . nombrils gras et béats des curés de campagnes, nombrils séparés de timides épouses, nombrils rusés, nombrils malins qui avaient l'air américain . . .'

How, then, does Arp see this versatility of forms as serving to undermine Vanity, Confusion, and the overestimation of Reason? In confronting us with a world in which everything has a shifting identity he challenges our worship of Reason by questioning the basic principles of logic: the principles of identity, contradiction and excluded middle which hold that if anything is A it is A; nothing can be both A and not A; anything must be either A or not A. He combats what he calls 'the atrocious confusion of our epoch' by creating an intentional confusion in the face of which we may perhaps be purged of the confusion that browbeats us in our daily lives, so that, being so purged, as he puts it, 'melancholy departs, dragging with it its suitcases full of black sighs'. And he seeks to show up human vanity by revealing that man cannot be clearly distinguished from nature's other myriad forms, and therefore has no right to assume special status. The aim, as Arp says, is 'to identify man with nature' and so to arrive at 'a negation of man's egotism'.

The message wouldn't come across as it does if Arp's puns were merely amusing, merely little jokes illustrating a viewpoint. What gives them conviction is that the shapes and relationships that embody these puns seem themselves to have organic life, to breathe, to pulsate, to grow, to move. As beings in their own right, they caress the sight and enchant our senses. They radiate the sort of erotic quality which in nature we attribute to flowers and fruits as much as to naked bodies.

But it is only the reliefs which have this wonderful interplay of wit

and organic life. The sculptures in the round don't have it, and, what's more, strangely enough, besides lacking the wit, they have, I feel, much less life: their pulse is altogether weaker, their sensuousness is flaccid, almost embarrassingly languorous and soft. I am not trying to suggest that Arp's work is efficacious only when it is, among other things, amusing. None of his reliefs is finer than the elegiac *Architecture florale pour une morte*, made in 1943, shortly after the death of his first wife, Sophie Taueber. But its solemnity is made taut by a sharpness of sensibility akin to wit. It is this sharpness that is lacking in the sculptures.

Perhaps there is no further reason for this than that Arp has more native talent for working on the flat than in the round. Certainly, he came late to working in the round. There are only two free-standing sculptures in the retrospective exhibition at the Tate which were done before 1930, by which time Arp was forty-three. Yet his talent on the flat showed itself early. The figure-compositions of 1912–13 are able paintings in the fauve spirit (black-and-white fauve pictures, by the way). While still not yet thirty Arp made in 1916 the collages which are among the most original and sensitive examples of early non-figurative art. It was at about the same time that he began to make his painted reliefs, and within a couple of years he had arrived in this medium at his characteristic and perennial forms. By the time he made the *Planche à oeufs* in 1922, he was a master of arabesque and of design in flat colour – and it shouldn't be forgotten that as a colourist Arp is at least the equal of Miró.

As a sculptor in the round he didn't get going seriously, as I said, till 1930. And the sculptures have a degree of derivativeness which, while it doesn't stop any Arp sculpture from being unmistakably his own, could be significant in view of the very exceptional originality of his reliefs and collages. One obvious source is Brancusi. Another would seem to be Picasso's so-called metamorphic works of the late Twenties, notably the series of sculpturesque charcoal drawings of bathers made at Cannes in 1927 and the related bronze figure carried out the following year. Another possible influence which could in some ways have been still more crucial – while perhaps involving some cross-fertilisation – was that of Tanguy. When Tanguy first started to paint pictures, about 1926, of an imaginary world under the sea, he peopled it with a variety of identifiable objects. In 1929 he

replaced these figures and plants with ambiguous little shiny bio-morphs. He probably got the way he grouped them from Hieronymus Bosch, but their actual forms look as if they had been derived from Arp's reliefs. It is as if he had envisaged the sort of sculpture that Arp would have made if he'd worked in the round, and then depicted them illusionistically. Arp would certainly have seen these paintings almost as soon as they were done. And it might have occurred to him that here he was faced with what were virtually colour photographs of the sculptures he would have made if he had ever made sculptures in space. The following year he began to work intensively at sculpture in the round, and his first important sculpture, the *Torse* of 1931, certainly looks as if it had been fished out of Tanguy's sea.

Yet, when all is said and done, the fact that Arp came late to making free-standing sculpture doesn't really prove anything about his comparative lack of talent for it. After all, Chekhov wrote short stories for many years before turning seriously to writing plays. The real point is that Arp's tendency to think naturally in terms of flat shapes shows, it seems to me, in the sculptures themselves. The *Torse* of 1931 which I mentioned just now is essentially two-sided. There is an evident will to be three-dimensional in the way in which the small of the back is used as a pretext for making a deep hollow in the block. Nevertheless, the work is essentially a front view and a back view, rather than a form fully formed from all round. Now, this is one of the earliest sculptures. But a variant of it done in 1959, the *Torse dit des Pyrénées*, is no different in this respect. In all the sculptures of the last thirty years – with perhaps a handful of exceptions like the large *Coupes superposées* of 1960 – Arp seems to have conceived the forms, not as if he were holding them in imagination in his hands, but as if he were looking at their silhouettes from one or two viewpoints. Compare them, for example, with the sculptures of a contemporary of his who also tends to see the forms of the female body as fruits and gives the outlines of his figures the same sort of flowing arabesques – Henri Laurens. As we look at a Laurens, the flow of the line always takes us round the corner towards what is happening at a point invis-ible to us from where we are standing now: it insists that we move round the sculpture. A sculpture by Arp explains itself as we stand still in front of it, once we have found one of its 'good' viewpoints.

Yet there is, of course, great sculpture – Romanesque sculpture, for example – that is essentially frontal and seems not at all insufficient on that account. But its frontality is part of its purpose. It is sculpture with which we are meant to stand face to face, held by the compulsion of its gaze. Were it not frontal, this would be a distraction. But we are not arrested in this way by Arp's faceless biomorphs. There is therefore no particular viewpoint we are meant to find for reasons to do with its potency as an image. We feel we are meant to see it from all sides. Yet on the other hand we aren't taken compulsively round it, as we are by a Laurens. We can see it from a single angle, once we've found an angle from which it looks good. In consequence, we're reduced either to finding a view that's decided by nothing more than taste, or to wandering around the thing rather aimlessly. In short, there is something too arbitrary in our relation to a sculpture by Arp. And this matter of arbitrariness also comes up in considering Arp's theory of sculpture. I believe there is a flaw in this that could explain, as much as or more than the nature of his gifts, why the free-standing works are so much less fine than the collages and reliefs.

Arp's theory of art has a purely Germanic basis. He is, of course, an Alsatian by birth, and has worked in both Germany and France. Stylistically his work is rather French – broad and sensuous yet dry. Ideologically it is entirely German. His theories stem from ideas which made their appearance in the writings of Goethe and Schiller and Novalis and a hundred years later inspired the painters of the *Blaue Reiter*, Klee and Kandinsky and Franz Marc – ideas to the effect that artistic genius consists in arriving at a special understanding of and harmony with the secret laws underlying nature. Thus Klee likens the artistic process to a tree, of which nature is the roots, the artist the trunk, the work of art the crown. Klee says of the artist: 'He surveys with penetrating eye the finished forms which nature places before him. The deeper he looks, the more readily he can extend his view from the present to the past, the more deeply he is impressed by the one essential image of creation itself, as Genesis, rather than by the image of nature, the finished product.' Compare Arp: 'We yearned for the swan-white tide, the divine affinity which unobtrusively permeates the differences of matter, of conditions, of events.'

Now, it seems to me that Klee sought a harmony with natural

processes through the way in which he interrelated the forms in his paintings, and especially the paintings of his last years. In his late paintings the signs are distributed over the surface in such a way that none appears more important, more central, than any other. There is no obvious balance of forms, no 'composition' in any traditional meaning of the term. We only know how closely the signs are held together when we cover one of them up and find that the picture falls apart. Its balance is like the ecological balance of nature, a balance whose workings we cannot divine so long as it is maintained, but which becomes clear to us once we eliminate one of the elements – a species of animal or insect or plant – and find the balance disrupted. Furthermore, a late painting of Klee's compels the spectator to enter into a relationship with it that is analogous to his relationship with nature. For, since the spectator cannot find a focal point in the picture around which he can see it all as an ordered whole, out there, he is drawn in imagination into the picture so that he moves among its signs as if in a labyrinth – or as if walking through nature, where things are all around him, not in front of him. In this way, it seems to me, Klee's paintings become analogies of nature's mode of being.

Now, Arp has said: 'We do not want to copy nature, we do not want to reproduce, we want to produce, we want to produce like a plant that produces a fruit and not to reproduce, we want to produce directly and not through interpretation.' And the forms Arp produces are like further creations of nature, 'finished products' which nature doesn't happen to have produced but which, working as she does, she might be supposed to have produced, if the artist is, as he aspires to, working in harmony with nature's processes. Arp's forms, then, are not, as Klee's are, structures analogous to nature carried out in terms of art, in terms of a script. They are simply variants on existing forms, additions to nature. They are *like* living growths. Except that they're not alive. Which means that they're analogous to snapshots, as distinct from paintings, in that snapshots freeze movement without making adjustments in the shapes to allow for the fact that the movement is now frozen. They don't have an appropriate distance from nature – the distance which acknowledges the undeniable fact that art is not on the same plane as nature. The reliefs, however, get their distance from the convention of the medium. If they are finer than the

sculptures in the round, it could be because they fulfil the need of art to create structures which in some remarkable way are at one and the same time close to reality and rigorously apart from it.

Again, Arp's sculptures are *like* living growths. Except that living growths have the forms they need for survival, and those forms are not arbitrary. Whereas Arp's sculptures haven't a discipline of this kind. They can be anything formally, just as they can be anything as images. Now, Brancusi's sculptures – a fair enough touchstone by which to judge Arp's – are never just anything: they are very specifically birds or cockerels or fish, whatever other things they might also evoke. And though, while we look at them, we may think less of their specific referent than of their magical qualities as shapes, it could be that it was the will to differentiation that went into their making that gives those shapes their vitality and their inevitability. A further contradiction necessary to art is that it should be rich in analogy and ambiguity yet sharply differentiated.

Moore *1968*

This is extracted from a book completed early in 1968 which served as the catalogue of *Henry Moore*, a retrospective curated by myself which was organised by the Arts Council of Great Britain at the Tate Gallery from 17 July to 22 September 1968. The publication was an autonomous monograph with a list of exhibits added, and an edition shorn of that paraphernalia and with a few revisions suggested by the sight of the exhibition was published as a straightforward book later the same year by Frederick A. Praeger, New York and Washington. Its structure bore no relation to that of the exhibition: the exhibits were arranged according to size and medium and period; the book's fourteen chapters dealt with various aspects of the work, such as 'Square Form', 'Divided Figures', 'Fitting Together'. The extract reprinted here is the chapter entitled 'Correspondences'.

Early in 1931 Moore carved a *Composition* in blue Hornton stone, a tentative piece, which was his first sculpture in a more or less abstract idiom. For two years he produced work of this kind concurrently with figurative work, then almost exclusively work of an abstract kind from

1933 till 1940. Whereas the figurative pieces of the early Thirties tend to retain something of that squareness of form inspired by Mexican art – though they do become increasingly curvilinear between 1930 and 1932 – the early abstract pieces have the serpentine forms characteristic of the language of ambiguous biomorphic shapes which was current in the work of such artists as Arp, Picasso, Miró, Tanguy. (Basically this language was a continuation of Art Nouveau, except that there it had mainly suggested plant forms; now, mainly animal forms. Indeed, the plant forms persist in Arp's imagery, even dominate it till about 1920. If there is one key work in the evolution of the common language, it is probably Brancusi's *The Princess* of 1916.) From 1934, however, Moore's abstract pieces were becoming less sinuous, tending to revert to a squarer kind of form.

Going abstract was primarily a consequence of the Brancusi revolution. Brancusi's 'special mission', as Moore saw it, had been to eliminate an overgrowth in European sculpture since the Gothic of 'all sorts of surface excrescences which completely concealed shape'.[1] If shape were to be asserted, it could be more conspicuous if not immediately associated with a reclining woman, a mother and child, a girl with clasped hands – if the sculpture presented itself as a more autonomous entity. Furthermore, this entity could be given a form that would evoke a multiplicity of associations and so imply the notion of metamorphosis – a possibility with which Brancusi was concerned only intermittently, but which became central for Arp and Miró and Tanguy, for Picasso at moments, and for Moore. But, if Moore's forms were those of a common language, there is no need to look beyond Picasso's work alone for his specific sources. A pair of abstract low reliefs, mixing biomorphic and geometric shapes, which he made in 1931 are curiously reminiscent in composition of certain Picasso *papiers collés* of 1912–14. The initial *Composition* of 1931 looks as if it must have been based on a Picasso sculpture variously known as *Figure* and *Metamorphosis*, made in 1928 in plaster and immediately reproduced in *Cahiers d'Art*,[2] which Moore saw regularly. Like the Picasso, the Moore is a full-length standing, though squat, figure with a tiny head which looks like some grotesque animal; its shapes are similar; it makes a similar use of linear signs incised in the surface; it has a similar open space near the top which is similarly surmounted by

a form like a handle – though in the Picasso this seems to represent a long neck, in the Moore it is an arm held up to the head. Picasso made no other sculpture quite like this, but he produced a quantity of drawings and paintings in 1927–29 which have similar forms and in many cases are sculptural in conception, so that if it so happened that Moore missed seeing the sculpture reproduced he could still have deduced a sculpture like it from the related paintings and drawings.[3] These undoubtedly influenced further works by Moore in the next two or three years and via these the mainstream of his work thereafter.

Some carvings of 1932–34 resemble Arp more closely than Picasso. This happens when Moore's forms are more compact than usual: his general tendency, like Picasso's and unlike Arp's, is to penetrate volumes with voids. Again, his actual shapes are usually much more like those of Picasso than of Arp – tense and muscular where Arp's are gentle and fleshy. Moreover, the conformation of Moore's images almost always has a specific model in the human body. While he was doing his most abstract sculptures, he was still constantly drawing from life and teaching drawing and modelling from life, and these activities were not something apart. Even his most ambiguous pieces were usually conceived as full-length figures or half lengths or heads-and-shoulders or heads. Though many of Arp's sculptures are torsos or half-lengths, others of his 'human concretions' are totally free compositions of anatomical allusions, while many pieces relate to plants much more than to the body. Moore, like Picasso, is an anthropocentric artist, which Arp, like Brancusi, is expressly not.

Where Moore's art is totally unlike Picasso's is in its absence of wit, of the sharply incongruous image. Moore's metamorphic forms reveal marvellous and unsuspected likenesses between disparate things, but the revelation is like that of some elemental truth: once recognised, it seems inevitable; it may not lose its mystery, but it does lose its surprise; it seems right and natural, reasonable, not outlandish and questionable. Compare two characteristic sets of variations on the human figure, each realised as drawings as if of sculptures assembled from a mixture of organic and man-made parts; Picasso's several pages of standing figures called *An Anatomy*, dating from 1933,[4] and Moore's sheet of reclining figures, *Ideas for Sculpture in Metal*, 1939. In the Picasso series, the parts include chairs, planks, fruit, vegetables,

sand-trays, beakers, balls on strings, a pillow, a hoop, a cog-wheel, a flower-pot, a bladder, a bench, a wedge, a sausage, a fruit dish, bread, piping, nails, door handles and a string of sausages. Anything can be anything. Altogether more homogeneous, the Moore variations look like curious implements, also look as if they might be made of bones. Now, Picasso himself had composed several 'bone-figures' in paintings and drawings of around 1930, but Moore reduces the figure to what might be an assemblage of just three or four bones – perhaps developing a conceit advanced in a lead statuette of a *Reclining Figure* of 1938 wherein the two legs are transformed into a single bone. And the form of these bones is that of bones which can be held in one hand. So the figure becomes an object on that scale – a hand-held articulated structure, perhaps with movable parts: something to be picked up and handled like a tool. Yet, like the human figure, an articulated assemblage of bones. The transformation has a kind of logic.

Free association produces significant results when congruity of structure is discovered in things or situations which are incongruous in their character or context. Art which discovers unexpected correspondences will tend to emphasise either the incongruity which makes them remarkable or the congruity which makes them viable, and with Moore the focus is generally on the structural affinity. If we fail to recognise that the head of Picasso's sculpture of a baboon consists of two toy motor cars, we are not getting the message. With Moore what went on in the artist's mind is not so central to the message. If told, for example, that the *Three Points* of 1939 had been inspired by a painting, one might hazard a guess that this was one of those Picassos of the *Guernica* period with a woman's or a horse's mouth open in agony and a thrusting tongue with the form of a conical spike: Moore's adaptation would have been to close the jaws so that they are impinged more on the tip of the spike. And, considering Moore's relationship to Picasso plus the *réclame* of those particular Picassos at the time the sculpture was made, it is possible that Moore unconsciously derived the spike from Picasso. Furthermore, images of threatening mouths are not uncommon in Moore's work, and no doubt such an image is part of the latent content of this particular work. Nevertheless, the painting which was in fact Moore's source of inspiration was the School of Fontainebleau double-portrait of

Gabrielle d'Estrées and her sister in the bathtub. The fastidious pinching of Gabrielle's nipple between her sister's pointed forefinger and thumb gave Moore the idea of making a sculpture in which three points would converge so that they were only just not touching.[5] The sheet of studies (made in 1939 though signed 1940) in which the idea for *Three Points* crystallised contains a wide range of variations on the theme of points meeting. Mostly they resemble shells, but four of them are figures which have sharply pointed breasts matched by a second pair of pointed forms, like their reflection, coming up to meet them. In the *Reclining Figure* of the previous year which has a bone in place of legs, there are two similar pairs of pointed forms, but the upward-thrusting pair are directed like pincers at one of the breasts, as if this were about to be bitten by the mouth of a fish-like creature incorporated in the figure of the reclining woman. However, when Moore came to adapt the similar image of the plucking fingers in the double-portrait, he reversed the direction of the pincers: instead of their coming from the opposite direction to the point they converge on, all three points stem from the same source. This change brings in a different range of evocations – such as the tongue nipped by the teeth, such as a sting within a sheath, such as a membrane on the point of being pierced – but it seems certain that the conscious motivation for the change was to create a compact and cohesive structure.

In this case Moore began from a specific image which he saw as the paradigm of a type of physical situation. That situation is embodied in the resultant sculpture along with suggestions of other, quite different situations; the particular image which started him off has disappeared. *Three Rings*, of which he carved two versions in 1966–67, was another conception, like *Three Points*, unlike anything he had tried before. Only, this time the stimulus was not something seen, but a formal problem to which he set out to discover a solution. He wanted to make, as a present for his daughter, a ring with three openings which could be fitted on a finger in three different ways. His first two attempts failed to come off: as he worked on a third, he noticed how the three rings, rolling up against one another on the bench, tended to fit together. He decided to make a carving of three such rings, and went on to make a medium-sized version in rosa aurora marble and then a very large version in red Soraya marble. While he

was carving the first, the delicate pale pink colour of the stone gave him the idea that the curves of the outer surfaces should be like the cheeks of a girl's bottom. He was not conscious that he was also making forms whose inner shapes and surfaces suggest her internal anatomy. The red Soraya version is an almost unaltered enlargement yet an altogether different image. The dominating scale, the harsh red-brown colour of the marble, its look of density and hardness, exclude the erotic implications of the earlier version, with its intimate scale, the soft translucent blush of the marble, its pliable, yielding look. Obviously the forms retain their uterine association, but this now serves to suggest something like giant eggs from which large reptiles might have hatched.

The associations which Moore's sculptures evoke recurrently divide into four categories: parts of the human body; parts of animals; landscape; natural objects. Occasionally there is a suggestion of a man-made object: some that have occurred to Moore himself while working on a sculpture are a pipe, a bridge, a shoe, a toy 'bomb',[6] a spark-plug.

Natural objects come frequently to mind, though their range is limited. Very occasionally there is a suggestion of fruits, flowers, fungi, but for the most part the objects evoked are hard: bones, shells, pebbles, flints, boulders, fossils; also, in a number of bronzes of the last ten years, tree-trunks and jagged rocks. Such images overlap, of course, with the suggestion of landscape that is almost ever-present in Moore's more complex pieces. The idea that a figure could be a range of mountains was a conscious factor at least as far back as 1930, when Moore wrote of mountains as a sculptural idea[7] and carved the *Reclining Woman* in green Hornton stone.[8] In the second half of the 1930s he was carving his first figures penetrated with holes and writing of 'the mysterious fascination of caves in hillsides and cliffs'.[9] Hillsides was the more appropriate thought for the works of the period; cliffs came into their own in the rough-hewn bronzes of the late Fifties and Sixties. In these later pieces the landscape imagery is more deliberately cultivated than before. It is even based at times on landscape paintings – Monet's Etretat pictures, Seurat's *Bec du Hoc* – as well as, less consciously, on memories of particular places seen in reality: Adel Crag in Yorkshire, which he visited as a boy, is an

acknowledged model,[10] as are the slag heaps which were ubiquitous where he grew up; another model might be the Old Harry Rocks off-shore near Bournemouth, where he frequently spent summer holidays in the Fifties. In some of these later pieces – the *Two-piece Reclining Figure No. 2* of 1960, for example – the landscape feeling tends to overwhelm the figure: the tension between human image and land-scape image is lost; the sculpture looks like a sculpture of a rock-formation which – as rocks do or clouds do or burning coals do – happens to suggest a figure.

Animals have been explicit subjects for several clearly representa-tional sculptures: dog, horse, goat, snake, bird. Among the abstract sculptures, several are more related to animal than to human forms: the *Bird Basket* is indeed a bird; one of the key images in the *Locking Piece*, for Moore, is an elephant's foot; there is a small bronze called *Slow Form: Tortoise*. Other sculptures are almost equally suggestive of animal and of human forms: the first of his abstract pieces is a sort of standing figure, but his own nickname for it is 'Elephant in an arm-chair'; the next such piece, the *Composition* of 1931 in Cumberland alabaster, is a human half-length resembling some such creature as an octopus; the *Composition* of 1932 in African wonderstone is a human head-and-shoulders and something like a seal. In several sculptures of whole human figures, a part of a woman's body is also a part of an animal: for example, the head of a fish or reptile forms the abdomen of one reclining figure, one breast of another; in one of the late divided figures, the throat is a bird's throat and the middle section evokes the protruding head and forelegs of a giant tortoise.

The parts of the human body which are most often isolated as unidentified forms or appear, magnified, in whole figures or half-figures in places where they are not in reality, are not structural elements: these – it is a matter of that reasonableness which distin-guishes Moore from Picasso – tend to stay in their normal relationship to one another. The parts which are subject to being irra-tionally isolated, magnified, displaced – and this, almost invariably without conscious knowledge – are the mouth and the genitals. *Three Points* suggests lips and a tongue; in the Pynkado wood *Two Forms* the larger form is a predatory mouth, as well as a grasping hand and a pro-tective shell; in the *Two-piece Reclining Figure No. 1* the legs appear

from certain angles to be huge open jaws; in a small *Stringed Figure* of 1939 which is intended as the top half of a reclining figure, the thorax is a gaping mouth with fangs. The female genitals are imaged frequently, in abstractions such as the rosa aurora *Three Rings* and the Pynkado wood *Two Forms*, and in the tunnelled forms of reclining figures: they are precisely imaged; it is not at all a matter of indiscriminately seeing holes as sexual symbols. Phallic imagery occurs mostly in sculptures of the last ten years. The phallus never appears as an isolated image – unless one indiscriminately sees tall upright shapes as sexual symbols – but only in conjunction with forms that signify the female. It rears up in front of her, burrows into her, is enclosed within her. But there is no more powerful embodiment of sexual confrontation in Moore's work than one presenting no such specific imagery – the *Two Forms* of 1966–67 in red Soraya marble, which are like two thrusting pelvises facing each other.

But they are also two heads facing each other, one menacing, the other somewhat recoiling. And they are also two rocks in the desert. To isolate, as one has been doing, some of Moore's recurrent associative images is beside the point. The point is, of course, that the forms are several images, are metamorphic, suggest correspondences between different things. If there is one constant which distinguishes Moore's language of ambiguous biomorphic forms from those of his contemporaries, it probably lies in the coincidence of landscape with oral and genital references. The human body becomes at the same time its own most secret parts and a part of its elementary environment.

NOTES

1 *The Listener*, 18 August 1937, p. 338.
2 *Cahiers d'Art*, 3rd year no. 7, Paris, 1928, p. 289. Photographs of two views are reproduced.
3 Several were reproduced in a Picasso number of *Documents*, vol. II, no. 3, Paris, 1930, of which there is a copy in Moore's library.
4 Reproduced in *Minotaure*, no. 1, Paris, 1933, pp. 33–7.
5 In fact the points are not separated in some of the casts (there are unique casts in lead and in iron, and an edition of bronzes).
6 This toy, which Moore knew as a child, consists of two interlocking pieces of cast metal between which is placed a cap that goes off when the bomb is dropped.

7 *Architectural Association Journal*, May 1930, p. 408.
8 This work was given the title *Mountains* when illustrated in R. H. Wilenski, *The Meaning of Modern Sculpture*, London, Faber, 1932, pl. 24.
9 *The Listener*, 8 August 1937, p. 339.
10 See Donald Hall, *Henry Moore*, New York, Harper & Row, 1965, pp. 158–60. Adel Crag is illustrated.

Miró

<div style="text-align: right">*1967*</div>

Introduction entitled 'Fowl of Venus' in the catalogue of *Miró: Oiseau Solaire, Oiseau Lunaire, Etincelles* at the Pierre Matisse Gallery, New York, November 1967.

Miró's *Solar Bird* got its name from the circle inscribed on its behind. I asked the artist whether the languages he speaks have any equivalent for 'She thinks the sun shines out of her ass', but the expression was new to him. During this conversation I learned that the longer and lower of the two birds was the *Solar Bird*, the taller, fatter one the *Lunar Bird*. I had previously spent two afternoons admiring them while believing that each was the other and thinking how aptly each was playing its role. However, they had been playing several other roles besides.

The *Solar Bird* changes identity most markedly as one's viewpoint changes, but also suggests at least two or three identities from any single angle. From one position or another, it is a charging elephant, a seal, a boat, a horse, a motor bike, a turtle swimming, a beast of burden, a sort of crucified figure, and a woman on her back. The crescent on top that stands for wings can be breasts as well as handlebars to be held by the man in the riding position. The knobs at the sides – the bird's eyes – can be the woman's stumps of arms – but also her breasts, and when they are these the wings are her arms stretched out to clutch or embrace. But these wings like a pair of horns are, of course, phallic too. The *Solar Bird*, indeed, might be a prototype for the third human sex which a sated world seems to be longing to discover.

The multiple evocations are probably richer and wider than in

sculptures by Arp or Moore in the same tradition. But the Miró is also different in kind. What it evokes is not so much entities, or fragments of entities, as actions – on the one hand the various actions of which it seems capable (flying, swimming, running, clutching, bouncing, etc.), on the other the will to action it inspires in the beholder, especially the desire to ride. Thus the scale, which seems puzzlingly small given that this is a piece on an ambitious scale, is probably explained by its need to relate to ours in a useful way. Again, formally, the piece seems to derive from certain Picasso sculptures and sculptural pictures of 1928 to 1932 which present anatomical fragments piled together – in particular a modelled *Woman's head* of 1932 composed of soft phallic shapes. But these Picassos propose a static situation, in the same way as a house of cards, since their equilibrium is so wilfully precarious. The *Solar Bird*, on the contrary, and the *Lunar Bird* as well, so far from suggesting something holding itself together, seem the embodiments of flowing, sweeping gestures.

The *Lunar Bird* rises, all rampant libido, looming up over humankind. Arrogant and hostile, it is crowned by a large crescent like the one on the back of the other bird, only, whereas in *Solar* this is there as if to be handled, here, inaccessible, it becomes a teasing emblem of domination. This seems a bird that might throw a stone at a personage. It is cocky, bullying, tumescent, and one can imagine avid women urging themselves on to the great spike that sticks out in front of it. So long as one stands facing it. From the side, that big thrusting thing is a pathetic bird's tongue, and the monstrous eyes and threatening wings are sad, like a hungry fledgeling's. Another, almost equally ludicrous transformation happens round at the back. Especially from close to, the figure is gently female, in the manner of a matron. If one rode this woman, it would be as a baby on its peasant mother's back. From here the horns belong to a placid, benevolent cow. The *Lunar Bird*, then, has three quite separate personalities – rampant man, feeble fledgling and fond mum – according to where one is standing; the *Solar Bird*'s different roles elide into one another, overlap, intermingle.

Lately, Miró has made another large bird sculpture, as yet without a specific title. About all it has in common with the others is that marvellous combination of tautness and give in its surface, rather as in

Rodin, which makes one feel – as does so little sculpture of any time and place – that touching it would be like touching flesh. But it offers no visual puns to speak of, doesn't evoke gesture, doesn't exhibit personality, let alone multiple personalities. It is a single seal-like form as compact almost as a Brancusi. And it is also, like a Brancusi, devoid – or one might say it is free – of the surrealist attribute of stimulating a diversity of associations in the beholder. Its surface – unlike the immaculate surface of a Brancusi – is disturbed by a long, curving, incised line and by a deep, circular hollow. The hollow especially might have been richly evocative of emotionally charged images. But in effect the hollow and the incised line focus attention on themselves and their sharp contrast with the smooth gentle convexity of the total form. One's awareness is heightened of the nature of the relation between hollow and mound – of what Rodin said sculpture was about.

This recent piece is the equivalent in sculpture of those large late canvases of Miró's called *Blue, Red, Green*, and so on, in which a few blobs or a single line are isolated in an immense field and which seem to be a series of meditations upon the elements of painting. Influenced, one imagines, by some of the American abstract painters on whom he himself had been a prime, if not the prime, formative influence, these works constitute a distinctly post-surrealist phase in Miró's development. The *Solar Bird* and *Lunar Bird*, in contrast, are utterly surrealist in spirit.

They are, indeed, based upon sketch-models made as long ago as the mid-1940s. Their enlargement many years after was a gradual process. They were magnified in two or three stages, and at each stage considerably modified. Presumably Miró was prepared to go back on his tracks in this way and carefully elaborate old ideas because he was out to produce a pair of masterpieces. He succeeded in creating objects which, for all his labours, feign a superb spontaneity. And in creating what probably are two of the masterpieces of Surrealism.

Ernst

This review of a retrospective at the Tate was published in two instalments in the *New Statesman* for 15 and 22 September 1961, entitled respectively 'Teases' and 'Art as Conspiracy'. One sentence has been revised.

Max Ernst's famous portrait group, *Aux Rendezvous des Amis* (included, like most of his major works, in the retrospective exhibition at the Tate), is probably the supreme expression of that teasing affection for Victorian imagery which appears in the work of many revolutionary artists born in the 1880s and 1890s. It is found, for example, in Léger's group of cyclists and circus performers. It is seen at its wickedest in the sepia-and-rose colouring of Duchamp's *La Mariée*. There is even, perhaps, a suspicion of it in the oval format of certain cubist still lifes. Above all, it occurs constantly in Ernst's work, as in that of lesser Surrealists. But it is *Aux Rendezvous des Amis* which, besides being the most comprehensive parody of such imagery, maintains the nicest balance between irony and nostalgia.

Now, the sort of group portrait that *Aux Rendezvous des Amis* debunks is not so much that of the bourgeois group, the composed family or members of an institution, as that of the artistic group. And its relation to Fantin-Latour's pantheons of artists and writers is precisely symptomatic of the difference in mystique between the *avant-garde* groups of the Eighties and those of the Twenties. Fantin's assembly of poets could easily be mistaken for a view of the Masters' Common Room at Rugby. The significance of this does not relate, I hasten to say, to Verlaine's pedagogic career, but to the longing of the great revolutionary writers and artists of that time to be accepted as useful members of society. Feeling themselves to be part of a group brought consolation for the hostility of the public, but not satisfaction. They wanted the world at large to see the truth as they saw it. At the very least they wanted general recognition of the seriousness of their intentions. So Fantin portrays them as men of probity, men of a worth as solid as that of Rembrandt's syndics.

The Dadaists, on the other hand, had no such hopes. They took it for granted they would be misunderstood. (Their desire to administer sharp shocks came out of their recognition that they were bound to

shock anyway. Hence the emphasis they laid in their propaganda on the anti-art element in their work rather than on the art that was there despite their iconoclasm: it was like the immoral posture which often has to be assumed defensively by those who are trying to establish a new morality.) They saw themselves as a group, therefore, not simply, as the Impressionists did, as producers, but as consumers: they were their own audience. The Impressionists dealt in the stuff of common human experience, the Sunday pleasures of the people. Dada art was for initiates. If the surrealist movement failed to sustain the same creative intensity as the dada movement, I think it was because its necessary esotericism was weakened by a pull in the opposite direction inspired by social commitment and democratic instincts.

Dada, however, was uninhibitedly conspiratorial. One consequence is that its products are loaded with private jokes and allusions. So with *Aux Rendezvous des Amis*, painted in Paris in 1922, when Dadaism was dissolving into Surrealism. Ernst and a number of his friends posed together in company with a marble bust of Chirico and the live figures of Dostoevsky and Raphael. Ernst's attitude to these interlopers is mysterious to such innocent beholders as ourselves. Is Raphael's presence a tribute or a sneer? Or simply an allusion to the fact that in Raphael's own *Parnassus* there appear familiar faces from the past such as Dante's? Again, Ernst portrays himself seated on Dostoevsky's knee and tweaking his beard. Why is it Dostoevsky in particular who is used here as a surrogate for Ernst's perennial father-figure? Moreover, would we in any case recognise Dostoevsky's role and the nature of Ernst's ambivalence towards him if we did not know our Freud, which the people in the picture did but the art public in 1922 did not?

These in-group allusions persist throughout Ernst's career. In the large painting of 1941–42 called *Day and Night*, a number of paintings-within-the-painting are hung or propped up in a desert. The paintings-within-the-painting are typical Ernsts, but the composition as a whole is clearly a parody of certain Chiricos of 1917, and Chirico of course was the acknowledged father-figure of the Surrealists and in particular of Ernst himself. This is one of many such allusions to Chirico in Ernst's work: the girl running in *Two Children are Threatened by a Nightingale* is clearly meant to be read as

the front view of the running girl seen from the back in Chirico's *Mystery and Melancholy of a Street*. But, as we go on looking at *Day and Night*, we realise that the luminous, light-toned pictures within the nocturnal landscape are in fact framed areas of the landscape itself as it is seen by day, and we remember those paintings by a younger Surrealist, Magritte, in which a painting-within-a-painting seems to represent that part of the surrounding landscape which it is concealing from us. Once we have seen this, the Ernst becomes a refinement of Magritte.

This sort of competitive kidding is, of course, a classic in-group gambit and would be rather a bore, in spite of the paintings' intrinsic beauty and mystery, if it were not combined with a wealth of allusion to imagery other than that of the group itself. And Ernst's work has the same kind of echoing allusiveness as *The Waste Land*. When Ernst borrows, his audience is clearly meant to recognise the source. With Picasso our pleasure in front of the work depends not at all on our knowing what showcase in the bowels of the Louvre gave him his inspiration. It is later, when we ourselves discover in the Louvre something that Picasso has parodied, that we gain something – in seeing the prototype with a fresh eye. With Ernst, if the allusion is missed at the time we look at the work, so is some of the point of the work. We have to be party to the conspiracy. To take the most obvious example, his series of engravings put together from bits and pieces of Victorian magazine illustrations would lose their unnerving impact did we not know that they had been so put together and were we not familiar with the sort of material they are composed of.

Even popular derivatives of the Dada-Surrealist tradition show how artists in that tradition tend to make a virtue of the necessary fact that they are addressing an exclusive group. *ITMA* had an exclusive radio audience of millions, who were always given the feeling of belonging to an in-group. Dada had its 'Rrose Sélavy', *ITMA* its 'Don't forget the diver!' 'Can I do you now, sir?' and 'I'll 'ave to ask me dad' (and it was, of course, just in these catchphrases, with their Freudian overtones, that the surrealist element in the programme was at its strongest). The catchphrases heightened the habitual audience's awareness of being initiates. And I suspect that, with regard to the allusiveness of Max

Ernst's work and the necessity of picking up the allusions, the point is not only that we need to have inner knowledge in order to get the allusions, but that the allusions are there in order to entail the exercise of inner knowledge and provoke a sense of complicity.

The allusions in Ernst are of several kinds. There are those where he has actually incorporated by means of collage fragments of popular or practical art, such as illustrations to Victorian magazines or old medical textbooks, and we have to know the normal context of these bits and pieces to appreciate his use of them. There are the teasing references to the work of other members of the in-group. There are the quotes from the art of the past, among the more obvious of which are references to a number of German painters of the sixteenth century such as Grünewald, Altdorfer and Schoengauer, to Archimboldo and de Momper, to Boecklin and Caspar David Friedrich, to Redon and Dulac, to Baroque high reliefs with ivory figures in wooden grottoes, to Bavarian Rococo, to Piranesi, and – in the Dada drawings, annotated in copious manuscripts, of mad machines which will never be constructed in his lifetime – to the notebooks of Leonardo da Vinci.

Then there are allusions in the titles: for example, *The Polish Rider*, a painting which resembles the Rembrandt not at all but rather a Chagall. Again, it may be that, in calling a wildly gesticulating and menacing scarecrow *L'Ange du Foyer*, Ernst is not simply indulging in a too obvious piece of irony but is also referring to the angel fish (*ange de mer*), which might just as easily as Grünewald's Risen Christ have inspired the tattered semi-transparent shapes of his figure. And if one sometimes sees allusions that were not intended, that is all part of the game, a game which Ernst plays so wholeheartedly that he even, in *Vox Angelica*, gets up to the old medieval trick of making emblems of his trade spell out his proper name.

But all of this is the gravy – and maybe its flavour of erudition is even meant to disguise the strong taste of the meat. If the allusions that really matter in Ernst were picked up by the uninitiated, the mothers one sees at the Tate earnestly taking their schoolboy sons round would be covered in blushes if not dashing hysterically into the street in search of a policeman. Admittedly, they do not improve their chances of seeing what's going on by, as the majority of visitors to the

exhibition do, burying their noses in the catalogue rather than point-
ing them at the pictures: the catalogue's author, Roland Penrose,
shows his deep loyalty to the cult in resolutely declining, except in two
or three deliciously oblique comments, to divulge what the pictures
really are about. Most of them are about the one type of human
activity the depiction of which is rigorously forbidden in our society –
honest genital sex. It is pictured by Ernst in the most intimate close-
up, but in symbols which, it is evident, only initiates can read. And this
esotericism is certainly apt when dealing with the sacred mysteries of
the earthly paradise.

It might, however, be argued that the losers are not those who can-
not read the symbolism but those who can. These symbols are not a
set of arbitrary conventional signs, they are forms that really do
express what they stand for. They are therefore capable of speaking
directly to the spectator's unconscious and moving him aesthetically
without his knowing why. Conversely, it can be said that those who
can say what the symbols mean are, because of this intervention of
intellectual recognition, less subject to their magic. I believe that in
fact this is not the case.

There certainly exist symbolic forms in art and indeed in architec-
ture the meaning of which arouses emotion in the spectator without
his discovering what that meaning is, but I do not think that Ernst's
forms have the kind of intrinsic eloquence which brings this about.
On the other hand, I am certain that the intellectual interpretation of
Ernst's symbols at their most potent does nothing to dissolve their
magic: we are pleased and entertained by our recognition at a con-
scious level of those facts of life the direct representation of which is
taboo, but the mystery and imaginative resonance of their presenta-
tion still persists. Indeed, our comprehension and our wonder serve to
enhance each other.

The functioning of Ernst's symbols seems to me to imply a notion
of esoteric visual symbolism similar to that current in the sixteenth
century. That the meaning of symbolic images was a matter of agree-
ment among initiates did not, it was held, deprive them of their
mystery, because there was an inherent virtue, a transcendental force,
in those images, deriving from their correspondence with the work-
ings of the universe, which would always ensure the preservation of

their total meaning from the grasp of human intellect.

Now, Professor Gombrich ('Icones Symbolicae', *Warburg Journal*, Vol. XI, 1948), in discussing the close link between this view of visual symbolism and the general trend of Neo-Platonist thought, has argued that the Neo-Platonist 'idea of intuition as the highest form of knowledge can easily merge with the doctrine of revelation through visual symbols'. This idea of the primacy of intuitive knowledge, as against rational knowledge and the knowledge of the senses, holds, as Gombrich puts it, that 'we can only hope to achieve this true knowledge in the rare moments when the soul leaves the body in a state of ek-stasis, such as may be granted us through divine frenzy'.

The mind, then, is open to the highest knowledge when it ceases to be an agent and becomes a kind of medium. And it is just this state of attention that Ernst has said he has sought to achieve through the use of certain automatic mechanical techniques as a means to artistic creation. He has described his technique of *frottage* as 'a process which rests solely upon the intensification of the mind's powers of irritability', saying of his own use of it that, 'by enlarging the active part of the mind's hallucinatory faculties, he succeeded in attending, simply as a spectator, the birth of his works'.

This affinity with Neo-Platonist thinking is one that Ernst shares with other Germanic artists of his period. It is found in Klee's doctrine that the artist is one who does not create but 'transmits', and that his concern is not with 'the finished product of nature', but with 'the one essential image of creation itself, as Genesis'. It is found in Arp's statement that 'we yearned for the swan-white tide, the divine affinity which unobtrusively permeates the differences of matter, of conditions, of events'.

The link between these artists and Renaissance Neo-Platonism is not hard to guess at: it is almost certainly Goethe's *Faust* – though at some later stage Ernst's circle is known to have read in Pico della Mirandola (whose doctrine of correspondences they would obviously have found sympathetic). The point I wish to emphasise is that in Ernst we rediscover the merging discussed by Gombrich between the Neo-Platonist sanctification of intuition and the doctrine of revelation through symbolic images.

The need for an inspired passivity as the proper condition for artistic creation acquires further emphasis for Ernst because of the extreme degree of self-consciousness in the conscious thinking about symbols of anyone versed, as Ernst was from his very early days, in Freudian thought. Whether Parmigianino was or was not aware of the meaning an Ernst would see in the tapering column in the background of the *Madonna della colla Lunga*, whether Michelangelo perceived a similar significance in the outstretched neck of Leda's swan, is something we cannot know (on the one hand, it seems unlikely that artists so sophisticated would have missed it, on the other, Parmigianino and his contemporaries had no hesitation whatever in putting an unmistakable priapus where they wanted it).

But whether or not sixteenth-century artists recognised a phallic symbol when they saw it, they did not think about their unconscious motivation for putting it there. An artist like Ernst, however, not only knows a great deal about what he is putting in his pictures but also a great deal about why, and he knows that the audiences of initiates to which his work is addressed will also get the motivation along with the allusion – he knows that, if he calls a picture *Garden Aeroplane Trap*, his fellow-conspirators are going to babble of fears of castration.

Now, the artist is supposed to be one who differs from other men in being able to communicate, not what he thinks he feels, and not what he would like to feel, but what he really does feel. The whole problem of an artist like Ernst is the difficulty of being honest where his self-consciousness is so comprehensive, more especially when he is an artist of strongly romantic inclination, a lover of the mystery and wonder of the forest, the kind of artist whose strength has always resided in the total conviction with which he submits to his own feelings and fantasies. Alas, some of the pieces in the show suggest that with practice in using mechanical techniques the artist tends to start calculating his effects and pushing things around rather than going on working with the receptiveness that he aspires to.

Magritte – I *1961*

Occasioned by two concurrent London dealers' exhibitions, this review appeared in the *New Statesman* for 6 October 1961, entitled 'Magritte'. Two small changes have been made here.

The *TV Times* has a page of cartoons each week most of which have something to do with TV. In about half of them, the joke requires getting the image on the screen mixed up with the world outside. For example, a game of darts in a pub is interrupted by an arrow fired at the board by an Injun on the television. Thus the kind of joke typical of Magritte's paintings has already become a cliché of popular art, in much the same way as Pirandello's juggling with the worlds of theatre and reality has been inherited by every comedian who gags about the joke he has just told.

Actually, the typical Magritte joke goes a stage further than the one about the arrow and the dartboard. It presents a landscape with a painting on an easel in the foreground, and the painting apparently depicts the piece of landscape which it is obscuring, as if it weren't a painting but a pane of glass. Or does it? Maybe the missing portion of the landscape is quite different? Or maybe it's much the same but the painter has added or subtracted something, as painters do? But even the doubts get into the *TV Times*. In the current issue there's a drawing of a TV set with the screen showing a man asleep in bed; the set has doors, over one of which are neatly hung the sleeper's clothes. But are the clothes his?

It's the hardest test an artist can face: when the sort of thing he does has passed into popular art, do his own works still have striking-power? Magritte's do, I think, on the basis of the eight or ten of his major works included in two current retrospective shows at London galleries – the Obelisk and the Grosvenor. They stay out ahead of the *TV Times* jokes simply because the logic which they use to reach absurdity is more forceful and far-seeing – comparable, indeed, with the logic which Lewis Carroll brings to problems of semantics in the conversations with Humpty Dumpty and the White Knight.

Carroll, of course, figures large in the pantheon of those the Surrealists have claimed as precursors, but Magritte is the one

Surrealist who has a real kinship with him. This is seen most obviously in their common preoccupation with semantic problems and in their way of handling them – the way they push the conventions of the language to absurd yet plausible conclusions. We are used to the convention that in fairy stories animals and plants speak English, yet it startles us when Alice is addressed by the plum pudding. We are used to the convention that artists design their paintings in such a way that formal echoes are established between unlike things, but it startles us when one of the balls on the dumb-bells held up by Magritte's strong man is itself his head.

But it is the air of innocence, as if nothing untoward were happening, with which Carroll and Magritte present their fantasy in all its forms that is perhaps the most important quality they share. Most surrealist fantasy – that of Dali or Tanguy or Ernst – is presented in a wondrous atmosphere like that of a gothic novel; Magritte's is set down with the matter-of-factness with which children speak of marvels. Magritte is completely open about his fantasies. With such rare exceptions as *Les Pipes Amoureuses de la Lune* they are not primarily symbolic. They are what they are, so that when he paints a woman's head whose face is her torso (unshaven), the image really is shocking.

There is nothing, then, in Magritte of the esotericism of Ernst or Tanguy, and I think it is just this utter explicitness of his which resolves the dilemma of the Surrealists – an in-group which nevertheless wanted to transform the consciousness of the multitudes and convert them to the faith.

With an artist like Dalì, this contradiction led to his presenting more or less esoteric symbols in a sensational, rabble-rousing manner. With Magritte the idea is accessible to all, the presentation perfectly casual – and, in its simplicity and purity, grand. It seems to me that Magritte, more than any other artist of our time, is a genuine popular artist, in that he speaks in a strong, clear voice of wonders and enigmas which matter to everybody. His paintings are the icons of an Age of Doubt.

Magritte – II

This is an extract from the catalogue of the retrospective exhibition organised by the Arts Council at the Tate Gallery from 14 February to 2 April 1969, of which I was curator. A revised version was published by Praeger in the USA as a book in its own right. Whereas in the exhibition I hung the pictures more or less chronologically, I arranged them iconographically in the book, aiming to compose a sort of tragicomic strip. A few text pages interspersed among the pictures reproduce translated passages from the writings of the artist and his poet friends. All this is preceded by a long essay of my own in seventeen sections, the first three of which are reprinted here.

It wasn't enough for Pharaoh that he had seen seven fat kine being eaten up by seven lean-fleshed kine. He had to find a meaning. The meaning as interpreted turned out to be the same as that of the dream about ears of corn. Symbols are interchangeable.

Magritte resented any tendency to read his images as symbols. 'If one looks at a thing with the intention of trying to discover what it means, one ends up no longer seeing the thing itself, but thinking of the question that has been raised.' The interpretation of an image was the denial of its mystery, the mystery of the visible. 'One cannot speak about mystery, one must be seized by it.' His images are to be looked at, not looked into.

Pharaoh's dreams were interpreted because they were messages from God; ours because they are messages from ourselves. Magritte presents dreamlike images as experiences not messages. He evokes extreme or impossible physiological states or events which have an intense affective import – being crowded, being trapped, being immobilised, defying gravity, etc. – with great immediacy but no sensuous correlative, just as in dreams the action is all in one's head. And he depicts this action with a conspicuous absence of distortion, so that the artist seems to have no attitude towards the phenomenon, and the spectator is not distracted by speculation as to what is meant, is left free to concentrate on what is there.

What is there can induce a dread as compelling, as consuming, as dread felt in a dream. It is not surprising when we feel this dread in the face of the great violent images of human helplessness – say, of

Caravaggio's *Martyrdom of St Matthew* or Goya's *Third of May*. But Magritte is not a painter of martyrdoms or massacres. He can provoke disquiet and mounting panic by, say, coolly fixing in mid-air something normally earthbound: orderly ranks of ordinary men; everyday objects floating in front of faces; or simply – excluding the affective charge of a human presence – a featureless sphere in an empty room. The drama is impersonal: the suspension of gravity; the suspension of time. It induces a nameless terror like the instinctive dread felt during a total eclipse.

Magritte produces aberrations in the behaviour of things that seem at once matter-of-fact and momentous. When arguing in a lecture that the displacement of objects could have its maximum effect only when these were 'very familiar objects', he went on to illustrate his point by saying that a 'child on fire will surely move us more than a distant planet burning itself out'. Of course. But Magritte never painted a child on fire: he painted, say, tubas on fire. He could make a burning tuba sufficiently disturbing.

I live on the ground floor of an old house divided into flats. The room I work in has large sash windows overlooking the front garden. A new tenant took to parking his large cream-coloured car in the garden, offside wheels on a footpath, nearside wheels in a shrubbery. All I felt I could see through the window was this cream hulk wedged in and trampling on growth. Every time I looked out, the cream monster might as well have been thrusting itself through the window into the room. What was happening outside seemed to be happening in my head. I felt the car was stuffed inside my brain.

This excessive reaction was conditioned by a whole complex of relevant and irrelevant factors involving my habits, my tastes, my sense of property, my prejudices about people, and a mass of feelings about my work, my family, my home and my inadequacies. If this displaced inanimate object was a persecutor, it was because it engaged this complex of facts and affects that were not manifest in its mere presence. But Magritte's displaced inanimate objects need nothing more than their appearance on the scene to have an equally exaggerated and upsetting effect. When he paints a village among whose houses geometric solids the size of houses have crammed themselves in, or when he paints loaves of bread floating in mid-air outside a win-

dow, these abnormalities instantly become my disequilibrium and my disorientation.

Magritte's avowed master was Chirico. But Chirico's eye invariably gravitates, like an Expressionist movie director's, towards the spectacular, picturesque, vertiginous viewpoint. A Chirico composition is a kind of collage in which every element has been seen from a different position and each position provides an 'interesting' angle: a steep, high or low angle, or an acutely oblique angle, or an extreme close-up or extreme long-shot. A picture by Magritte may be a kind of collage or may be a continuous space, but either way the viewpoint is straightforward, in terms of angle and in terms of distance: a safe medium-shot. The composition is often symmetrical, is almost always blandly frontal, with figures posed perfectly full-faced or profiled and with receding planes placed parallel to the picture-plane in a shallow, clearly delimited space with no room for evocative perspectives.

When a child asking 'Why aren't there cracks in the sky?' made me think of Magritte, it wasn't because any such painting of his came to mind or because I recalled his own, less resonant, statement, 'The cracks we see in our houses and on our faces seemed to me more eloquent in the sky.' It was because the question wasn't a question with the logical form, 'Why aren't there pigs/two-headed/birds/angels/spaceships from Mars in the sky?' It wasn't a question about the existence or non-existence of certain possible phenomena within a given situation. It was a question which defined a situation by proposing the possibility of its being otherwise in a way that was by definition impossible. The child was using an implicit double-negative to clarify its awareness of the identity of sky. Magritte dealt in the absurd, not the fabulous. He didn't paint two-headed birds; he painted birds made of sky and made of stone.

His image embraces the sense of what a thing is by making it what it is not. His large rock floating in the sky heightens awareness of the weight of rock. Conversely, the weight of his stone bird in flight heightens awareness of the marvellous buoyancy of a bird. The sight of his alternatives renders reality more mysterious.

His art is anything but freely fantastic. It is as rigorous as logic. It

denies fact but not reason. It is argumentative in method, not associative. For example, a door exists so that people can walk through it: Magritte painted a door which looks as though someone had walked through it when it was shut. A man with his back to us facing a mirror can see his reflection in it: in *La reproduction interdite*, Magritte made the reflection duplicate the back view. A mermaid is half-human and half-fish: Magritte painted a mermaid in which the human and the fish parts have changed ends. The dominant feature of a torso is the rib-cage: Magritte painted a figure whose torso is a bird-cage. Where a fireplace normally has a stove-pipe jutting out, Magritte put a locomotive with its chimney smoking.

In a lecture given in London in February 1937, he said: 'There is a secret affinity between certain images; it is equally valid for the objects which those images represent . . . We are familiar with birds in cages; interest is awakened more readily if the bird is replaced by a fish or a shoe; but though these images are strange they are unhappily accidental, arbitrary. It is possible to obtain a new image which will stand up to examination through having something final, something right, about it: it's the image showing an egg in the cage.' Lecturing in Antwerp the following year he had more to say about this insistence of his that it wasn't enough to indulge in free association, that he was involved in an 'investigation' of reality directed towards the discovery of images which would have a certain inevitability: any object he dealt with presented a problem to which there was 'only one correct answer', an answer that was 'strictly predestined' – something already known but lost in the depths of the mind.

He said that this search for affinities had only begun in 1936, and that until then his method had been to bring together totally unrelated objects. He was in error as to the date, not for the only time in writings about himself: he proceeded to mention as examples of his method since 1936 several images which first appeared in 1933–34. Furthermore, at least one painting done in 1931, *Le calcul mental*, presents a clear affinity between the two kinds of object juxtaposed: the houses, hollow constructions with openings in their walls, and the cubic and spherical blocks, solid and impenetrable masses which are also caricatures of buildings in another style. Before this, it *was* a matter of combining unrelated elements. On the other hand, the main

emphasis in his earlier work was not so much on the juxtaposition of objects as on the analysis of pictorial language – the relation between images and words, the relation between images of the body and images of objects, the relation between the parts of a polyptych, the relation between a framed image in a room and the space of the room, the relation between images of natural and of man-made objects. The particular feeling for paradox which Magritte later brought to bear on his investigation of objects was first brought to bear on an investigation of pictorial semantics. There always was argument.

AMERICANS

Art of the Coke Culture 1963

This is a version of an article written in 1963 which appeared in the *Sunday Times Colour Magazine* of 26 January 1964 under the unwanted title 'Art in a Coke Climate'. It has been much altered, partly by cuts, especially of passages dealing with individual artists, partly by additions, mostly of passages in the original manuscript that were not published in the magazine, partly by minor revisions. The piece still labours under the misapprehension, quite common at that time, that Jasper Johns was an exponent of Pop Art.

'There's as much culture in a bottle of Coca-Cola as there is in a bottle of wine.' Thus an American painter friend in Paris in 1948. He looked hard at me as he said it and I rose to the bait, manifesting outrage. It wasn't that I personally didn't like Coca-Cola as well as Cognac, Buicks as well as Bugattis. It was that I couldn't accept the juxtaposition of Coca-Cola and culture. But of course there's a Coke culture, a set of tribal tastes and customs implying certain values and attitudes and a conception of what life could ideally be.

Wine culture means techniques which have been learned through centuries of trial and error. Accepting the idea that nature is unpredictable and irresistible. Believing that stability is the prime source of good, as in the saying that the way to produce an English lawn was to roll it every day for four hundred years. It means living with flies and bedbugs. Fruit which tastes as if it was grown, not made, and is bought, much handled, off a barrow. Scope and necessity for the individual to choose. It means that you can't judge the quality of a shop or restaurant from its appearance. It means buildings with surfaces weathered and crumbled by time. Containers of food and drink that

are awkward to open. The sanctity of the unique object. It means durability; it means inequality.

Coke culture means added chemicals. Boarding a plane as if you were boarding a bus. Going into any drugstore knowing that when you order a tuna salad sandwich you can predict its taste and edibility. Endless exhilarating freeways along which drivers fall asleep. Sanitary, precooked, prepacked food. Sanitary girls like canapés bought ready-made with a gelatine varnish. It means that midtown New York is awesomely beautiful only because its proportions are, and not because of anything it gains from surface-textures. It means caring less about the taste that flavours your alcohol intake. It means using machines and self-service counters, rather than being served or serving. More people having a good time than have ever had a good time before. A taste for vicarious pleasure as well as vicarious cooking. Brand advertising everywhere. Muzak. A Promethean faith that nature is conquerable. It means expendability; it means standardisation.

The suspension of American motor cars insulates passengers from any sense of contact with the road. They feel they are floating along weightless, beyond the reach of gravity. There is a strong allusion to spaceships in the appearance of these cars, an allusion underlined in advertisements current a few years ago in which automobiles were divested of their wheels. But the image of the flying car is more than a day-dream: it corresponds to the way we actually feel when travel-ling in these cars. The spaceship fantasy is appropriate to the reality – is only larger than life and faster.

There's as much fantasy in a Rolls-Royce as in a Cadillac, but it doesn't ring so true. The design of the Rolls-Royce radiator is intended to evoke the pediment and columns of the Parthenon and also those of all the banks and museums that already evoked the Parthenon. The radiator thereby symbolises permanence, dignity, silence and wealth. In all this it does not lie, for these are indeed attributes of the Rolls or its owners. Nevertheless, the Parthenon was never a machine for riding in. The spaceship look of the Cadillac may give it a glamour that a car hasn't got, but at least a spaceship is a mechanically propelled vehicle, not a place of worship or an ancient monument. The Rolls-Royce, a masterpiece of technological achieve-ment, plays down the idea of technology where the Cadillac bolsters

it up. The Rolls pretends that technology can be integrated into a wine culture: it tries to establish a respectable continuity with the ancient world. Its image relates to an ideal past, the Cadillac's to an ideal future of moon-bound men. One harks back to a Golden Age, the other says the Golden Age is now.

The prominence of brand advertising in Coke culture doesn't only lie in the ubiquity of actual ads; sales talk, sales imagery are built into the commodity itself. Modern design may look functional but it is loaded with symbols – functional components shaped in a way that gives them a more glamorous meaning as well as decorative components which are there for the glamour of their symbolism alone. Reyner Banham has lately enumerated practically every external feature of a common transistor set and interpreted it as a status symbol: for example, the pull-out aerial as a science-fiction symbol, the massive buckle as an army-surplus symbol, the magic-eye tuning as a miracle-of-electronics symbol, the black leather as a virility symbol, the waveband selector as a racing gear-change symbol, the optimistic register of stations as a romance-of-communications symbol.

In our society – though not yet in Western Europe as entirely as in the USA – the things we use and consume form part of the same total fantasy as the world of brand advertising and the world inhabited by the stars of popular entertainment. The perfect embodiment of this fantasy is to be found in the last frontier of the West, Los Angeles and its suburbs – Mount Olympus itself. Here, where dreams are fabricated, is where you can be arrested as a vagrant if you don't use a car to move around after dark. And here is where the supermarket started, the shop where you serve yourself and the commodity sells itself, through flaunting its identity. The self-celebration of branded goods on the scale of the billboard is, of course, the most conspicuous feature of the modern urban scene, but in Los Angeles celebration of identity on a large scale is not only pictorial but architectural: here is the place, not only where every large house is styled to symbolise a private fantasy, but commercial buildings often have a form as symbolic as churches – restaurants shaped like potatoes and so on. It's like a fairground, with shops like booths each of which assaults you with images of what you dream of finding within. The city seems to be made up of a number of main streets from Westerns casually strung

together. Nothing looks built to last. Expendability is everywhere, novelty is everything.

And yet, at a party at Romanoff's, it was frightening actually to see, what one of course knew, how long the stars had been around. A picture of the scene could have been called *An Allegory of the Race between Fame and Time*. But the interesting thing was not the intimation that the stars are not immortal gods. The interesting thing was that these embalmed faces were those of still current stars. We talk about the fickleness of fashion, the call for new gimmicks and new faces in the entertainment world. But this is balanced by a need for enduring images. The minor stars can come and go, must come and go: it is part of our fantasy of them that they should be expendable, seasonally sacrificed. The major stars endure – Wayne, Gable, Cooper, Grant, Crawford, Dietrich, etc. There is a longing that the stars should be immortal, and the public tries to ensure that they are. Still, they are not immortal, and we want some more interesting relic of them than their footprints at Grauman's Chinese Theater. We want them preserved in a form that will renew them for us continually, as art does.

When we come across a picture of thirteen mostly bearded men in robes and sandals seated over a meal at a long table, we do not have to stop and wonder who they are and what they're celebrating: we see the scene at once as the Last Supper. We recognise it as that because we have learned to interpret this image; we know the iconography of Christian art. Now, the art of this century, when it is representational, generally has subject-matter which we need no such special knowledge to identify – jugs on tables, nudes in bedrooms and so on. There are not many important modern paintings like *Guernica* the significance of which cannot be found through looking at the picture but only through possession of information gained from sources outside the picture. It is not surprising that most modern representational painting has used subject-matter of the kind which Panofsky calls 'natural' or 'primary', inasmuch as it is the product of the age that invented abstract art. For in a certain sense representational painting of 'natural' subjects is closer to non-representational painting than it is to representational painting of subjects which are intelligible only if we understand their iconographic conventions. A straight painting of

the nude and an abstract are alike in requiring no special knowledge for the interpretation of the forms and colours on the canvas, only a general fund of human experience, whereas a painting of a nude rising from a large scallop shell on the seashore will only make complete sense to someone who knows the story of the birth of Venus. Subject-matter of this kind is not simply there; it calls attention to itself.

In recent years a high proportion of artists have been feeling a certain boredom with making types of painting which have no iconography. That boredom has provoked a number of young painters and sculptors in England and America to find subjects in the mythology of Coke culture, drawing on material such as posters for movies, posters for commodities, brand labels and packaging for cigarettes, food and drink, record sleeves, strip cartoons, jukeboxes, slot-machines, hamburgers, cars. In 1954 Lawrence Alloway, then of London, now of New York, gave this new trend the name of 'Pop Art'. This label has caught on, although its inventor is among those who are wary of using it. Its danger is that it may suggest that Pop Art is analogous to pop music, pop imagery, pop culture – that a Roy Lichtenstein is trying to be an Elvis Presley of painting. Still, most of the labels attached to art movements have been liable to mislead: 'Cubism', for example, seems to suggest that cubist paintings have to be all straight lines.

Forms of popular imagery and culture were enjoyed by avant-garde artists (unlike the middlebrows who see themselves as the guardians of high culture) long before Coke culture came in. Sometimes this enjoyment got into their art, sometimes not. Seurat painted the circus; the cubist painters also loved the circus (much preferring it to the theatre) but had no occasion to paint it until Léger did so in the latter part of his life. Again, in 1917, the cubist ballet *Parade*, on which Picasso worked with Cocteau, Massine and Satie, introduced 'a little American girl' who (in Cocteau's words) 'quivers like movies . . . dances a rag-time . . . buys a Kodak' by way of representing Coke culture in the bud.

Pop Art, however, is more often a form of still-life painting than of figure-painting. It doesn't depict fairground barkers and buskers, but fairground equipment, like targets and slot-machines; it doesn't depict men drinking, but the can of beer; it doesn't depict families out

for a Sunday drive, but the car they drive in. When Pop Art brings figures in, it doesn't depict stars as they appear in the flesh, but the posters announcing their appearance; it doesn't depict the rites of teenage romance, but strip cartoons about them published for teenage readers. And I mean precisely that it depicts the poster or strip – doesn't merely use it as a source for an image, but evokes the poster or strip as such. So that even a painting of figures becomes a kind of still life.

In general, Pop Art's preoccupation is not so much with cult-heroes and cult-objects as with the means of communication by which they are popularised. There are at least two explanations for this. In the first place, modern artists have a strong tendency to use art as a form of meditation about art and about its relation to reality. Secondly, visual communications bombard the eye today as never before in human history. Wherever we turn, someone is trying to tell us something or sell us something through the media of pictures and lettering. And an emphasis on the label or package and its enlargements is a key characteristic of Pop Art. But labels, or bits of them, and stencilled names, or parts of them, are common in cubist paintings and collages from 1911 onwards. They refer to types or brands of drink ('Marc', 'Bass', 'Ennes'), to popular songs ('Ma Jolie'), to newspaper mastheads ('Le Jou'), and so forth. Only here they come in as useful elements in design and as an aid to identifying objects within the wilfully fragmented and confusing figuration of the cubist idiom. The Cubist uses the brand name to indicate that a certain shape refers to a bottle, a traditional component of still life. The Pop artist uses it to affirm that a work of art can be made of subject-matter as commercial as a beer-bottle label.

In 1921 the American post-Cubist Stuart Davis painted *Lucky Strike*, a work close in style to Picasso's collages, except for two things. First the meaning behind the lettering ('Lucky Strike', 'Roll Cut Toba', '1910', 'The American Tobacco Co') is clearly meant to arrest the attention in its own right. Second, the composition appears to be a single emblem – perhaps one side of an enamelled cigarette lighter issued for publicity purposes. It might be adapted from an existing emblem or might be the artist's invention, but either way it reads as a brand emblem. This, I take it, is the first Pop painting. It is not sur-

prising that its author is a painter whose subsequent work has been a dazzling jazzy glorification of the American urban scene, a commitment of the cubist idiom to Coke culture. What Davis revealed in *Lucky Strike* is that the essence of the Coke culture scene lies in the ubiquitous and compelling presence of emblems.

And I think that this presence of emblems is the real subject of Pop Art. Jasper Johns, the finest of Pop painters and the most original, intelligent and interesting artist under forty now working anywhere, has a sense of this presence of emblems in all their beauty and banality that is rivalled only by Roy Lichtenstein's. But whereas Lichtenstein's subject-matter is the commercial art – strip cartoon or ad – that typifies Coke culture at its brashest, Johns, untypically of Pop artists, paints emblems and objects which are almost invariably left over from an earlier age and, being still in use, belong to no one culture, but are neutral.

He paints targets, the American flag, a map of the USA, stencilled lettering of a kind long used on packing-cases and the like. And he makes bronze casts of objects such as an electric torch and a light bulb: strip lighting spells Coke; a bulb or a torch is neutral. These emblems and objects are all things in constant use, so much so that their form is unnoticed, unquestioned, a matter of indifference – or was until Johns set them up so that they could be seen again. Leo Steinberg, in his brilliant monograph on Johns, has pointed out that each of his motifs is 'a Universal': 'What Johns loves in his objects is that they are nobody's preference; not even his own.'

Pop Art uses pop imagery as a source in the same sorts of ways as Renaissance and neo-classical art used antique sculpture. That is, as a source of motifs and as a model for style. Now, there are forms of borrowing in art where the original is simply something the artist wanted to use for his own purposes. But when Renaissance artists and neo-classical artists used antique models, and when Pop artists use commercial-art models, it is central to their intention that we should recognise what sort of art was their model and that we should think about the way they have transformed it.

And allusion to style matters more than allusion to motif, as with the use of antique art. Any subject treated in the manner of Greek sculpture makes us think of classical antiquity, whereas a *Venus* in the

manner of African sculpture does not. In the same way, Willem de Kooning's *Marilyn Monroe* is not Pop Art, because its style has little to do with the style in which Monroe would be depicted on a hoarding or the cover of a magazine. De Kooning came nearer to being a Pop artist when he cut out the mouth from a Camel 'T-Zone' ad for incorporation into the first of his *Woman* series of the early 1950s. What makes an artist Pop is not that he alludes to popular culture or that he borrows from the mass media, as Francis Bacon and Michael Andrews, say, have done, but that he parodies styles of the mass media.

So David Hockney cannot validly be claimed, as he often is, for Pop Art, mainly, it seems, on the grounds that he once did a picture around a billboard-sized packet of Typhoo tea: for what his style relates to is graffiti – which are as different from the mass-produced images which inspire Pop Art as birds are from Thunderbirds. Again, Peter Blake should not be classed as a Pop artist whatever the intensity of his preoccupation with the heroes and heroines of Pop culture. Though Blake has painted his portraits of stars from photos in fan magazines and on record sleeves, it is not from preference. 'The Beatles aren't available. Ideally I'd paint their portraits.' So he has to use available images, but he paints the stars as if he were looking at them, not at an image of them. And the style in which he paints them is a folk-art style – that of inn signs and circus signs (the lettering as well as the pictures). The finished product can thereby give the impression that Blake is a *naif* painter. To see his paintings in progress, however, before they get their painstakingly detailed finish, is to realise that Blake is well aware of what contemporary fine-art painters such as Francis Bacon are doing. He uses a folk-art style from choice, not because he has to. By depicting the stars and the goodies of the immediate present in a style which has a history yet is not linked to any one moment in history, he translates them into a timeless world. It is a way of making them subjects of instant nostalgia.

Roy Lichtenstein has said that Pop Art means 'an involvement with what I think to be the most brazen and threatening characteristics of our culture, things we hate, but which are also powerful in their impingement on us'. Can these go-getting characteristics of a materialistic culture possibly provide a springboard for art in the way it has

been provided in the past by religions which had transcendental aspirations and a tragic sense of life and could command an artist's respect when they didn't get his allegiance? How far can an artist be on the side of Coke culture's myths? It seems to me that the British artists by and large take a far more romantic view of Coke culture than the Americans do. If this is so, the reason would clearly be that Coke culture has not yet completely taken Britain over and so exerts a more exotic fascination for us. Most of British Pop Art is a dream, a wistful dream of far-off Californian glamour as sensitive and tender as the pre-Raphaelite dream of far-off medieval pageantry.

The Americans see the imagery in a cooler way. Roy Lichtenstein has lately said, when interviewed by G. R. Swenson: 'Pop Art looks out into the world: it appears to accept its environment, which is not good or bad, but different – another state of mind . . . We like to think of industrialisation as being despicable. I don't really know what to make of it. There's something terribly brittle about it. I suppose I would still prefer to sit under a tree with a picnic basket rather than under a gas pump, but signs and comic strips are interesting as subject matter. There are certain things that are usable, forceful and vital about commercial art.'

In the ways they use images and styles taken over from current mass communications, Lichtenstein and Johns, it seems to me, have aligned themselves to the great traditions of French classicism, the tradition within which Chardin and Seurat and Léger conferred dignity on simple, ignoble, everyday objects and events. Lichtenstein takes a frame from a comic strip, makes a few adjustments to it, thinning or thickening a line here, slightly shifting the position of a line there, and a vulgar journalistic image is transformed into a design that has a grandeur and expansiveness and radiance which recall Léger, but with an irony in place of Léger's optimism. Johns places the American flag on a monochrome background and its placing has the mysterious rightness of the proportions of classical architecture. His control of tone evokes Chardin. The dabbed brushmarks, delicate and firm and somehow vibrating with a silent attentiveness, bring to my mind the hitherto unique magic of the brushmarks of Seurat's oil sketches.

Almost nothing of these qualities is apparent in colour reproductions. Here we can only see the audacity and absurdity of the

enterprise. And this is the most reassuring thing of all about the work of Johns and Lichtenstein – that it only has meaning when seen in its proper scale. Which is to say that these artists are using the most mass-produced of emblems as subjects for paintings which emphasise above all the value of the unique object. A reverence for the unique object is, I take it, the basic moral assumption of a wine culture, which is the kind of culture to which art can't help belonging.

Johns – I *1964*

This is the text, cut and slightly altered, of 'Jasper Johns at the Whitechapel', a broadcast talk occasioned by a retrospective exhibition and given on the BBC Third Programme on 12 December 1964; it has not previously appeared in print.

'Using the design of the American flag took care of a great deal for me because I didn't have to design it. So I went on to similar things like the targets – things the mind already knows. That gave me room to work on other levels.' Jasper Johns's strategy is reminiscent of that of another American painter of works which firmly refrain from flourishing their meaning and intention: Ad Reinhardt. Reinhardt nowadays restricts his range of colour to shades of black, a range that is licentious by comparison with his range of form. Painting after painting is made on a square canvas, five feet by five, which is trisected vertically and horizontally to give a design like that of an empty noughts-and-crosses frame, only with blackish squares instead of white ones. The proportions of the canvas make it, says Reinhardt, 'neutral, shapeless'; the dimensions of the canvas make it, he says, 'not large, not small, sizeless'; the design of the canvas gives it, he says, 'no composition'. So he might easily have gone on to say, with Johns, that using this design takes care of a great deal for him and gives him room to work on other levels. One thing Reinhardt does say is this: 'The painting leaves the studio as a purist, abstract, non-objective object of art, returns as a record of everyday (surrealist, expressionist) experience ("chance" spots, defacements, hand-markings, accidents, "happenings", scratches) and is repainted, restored into a new paint-

ing painted in the same old way (negating the negation of art), again and again, over and over again, until it is just "right" again.' It might be said that when a Johns *Flag* or *Target* is exposed to the public, it goes through a *psychological* process which is analogous to the physical process a Reinhardt goes through when exhibited. The *Flag* or *Target* is 'purist' both in its self-denying acceptance of a ready-made and unglamorous design and in its wilful inexpressiveness. The 'deface-ments . . . accidents . . . scratches' are the interpretations we put upon it. It is 'restored into a new painting' in that, as we go on looking at it, our guesses about it cancel one another out until it gazes back at us in its deadpan way as if it were an object entirely fresh and unknown − 'just "right" again'.

Here are some defacements of the *Target with Four Faces* of 1955. The canvas is a target, like an archery target; above it is a wooden con-struction with four boxes each containing a plaster cast of part of a human face, truncated above across the bridge of the nose and below across the chin. I am reminded of Egyptian block statuettes, their body a geometric and standardised form upon which a portrait head of an individual is mounted. But the target is not a body; we speak of a target as a 'face': this is a conventionalised face surmounted by real faces. But are these 'real' faces so very much more like faces in reality than the targets are? We know they are individual portraits because we can see that they are casts of someone's face, yet they divulge very little about the particular appearance of that individual − not even what sex he or she is. (The model was in fact a woman). The plaster faces have no more identity than masked faces. So that in effect they are faces no less conventionalised than the target face. Again, although the plaster faces are more solid, the target face is at least complete. It has to be complete: it would be intolerable if the position were reversed and the casts were complete and the target incomplete: a part of a face still signifies a face; what price a part of a target? Being complete, the target in a sense has more of the attributes of a real face than the plaster casts: the casts are sightless, the target seems to be gazing at us with its bull's eye − only a single Cyclops eye, but that makes one more than the casts have between them. The casts, how-ever, have mouths − but the target's eye is also a round O of an open mouth. The target and the plaster casts alike are impassive, expres-

sionless faces. We could put an expression on the target's face by firing several arrows at it. If the target is there to be shot at, maybe the casts are there to be shot at: their absent eyes give them the look of men blindfold before a firing squad.

Does the work refer to the relation between the psychological subject and other people? The target would stand for the subject: it is a complete entity looking outwards; it does not represent a person's external appearance – we never see our own appearance. The casts would stand for other people, known to us through their appearance but impossible to know more than partially. On the other hand, there are moments when the target loses its gaze, becomes an inert object, but one that draws the focus of the eye and holds it there compellingly. With the thought of looking made vivid, we may project the act of looking on to the plaster faces and have the sensation that they do see. In which case the faces now become the subject, the target the object.

Is the work intended to raise the question posed by all figurative art as to whether art can ever match life? If it is, it would seem to give the answer that art had best do what it can – create a schema, a design – and that, in order to capture the presence of a living being, it is better to bypass art and take a cast from life. But the brushmarks which make up the schema have far more life in them than the inert surfaces of the casts.

Target with Four Faces can also be read as an allegory – an unwitting one, naturally – of this artist himself and his work, the relation between them, the face each presents to the world. The target equals the work, of course, the faces the man. The target is a closed, self-contained form, one of the most classically perfect of forms, but the clarity of its design is contradicted by the very free handling of the paint, when the expected thing would have been to paint such a form smoothly, immaculately. The target is banal, but is used so unexpectedly that it becomes outlandish. It is mocking, of us and itself. It is inscrutable, provides no easy clues for understanding its intentions. At the same time, it is bold and forthright, not intimate, retiring. The plaster faces are impassive, unforthcoming, self-effacing. But there are four of them and they are not identical: they are casts of the same woman's face taken at different times. As an artist Johns presents

several somewhat different faces simultaneously. His language is variable – not by any standards, to be sure, but very much so for an artist who is so evidently certain where his interests lie. But he doesn't operate as if he felt he *owned* a style. He doesn't proceed from one packaged stylistic period to the next. It is rarely easy and often impossible to date a work by Johns on internal evidence. The aggregate presents no clear narrative sequence. When the four plaster casts were placed in the boxes in the order in which they had been taken, it became too obvious for Johns's liking how the model's mouth had progressively relaxed with each successive take, and to eliminate the narrative sequence he shuffled the casts round into an arbitrary sequence. For him, the art-work has to be separated from personal history. The relation between the target and the casts says as much. The art is isolated from the man, stands apart from him, does not lean on his myth or his explanations, reveals nothing about his personal life and as little as possible about his personal tastes.

About Johns's disregard of his own tastes, Leo Steinberg quotes a short dialogue he had with Johns in which he 'asked him about the type of numbers and letters he uses – coarse, standardised, unartistic – the type you associate with grocery signs, packing cases, and crates.' Steinberg asked and Johns answered as follows:-

'You nearly always use this same type. Any particular reason?'

'That's how the stencils come.'

'But if you preferred another type face, would you think it improper to cut your own stencils?'

'Of course not.'

'Then you really do like these best?'

'Yes.'

Steinberg addresses the reader: 'This answer is so self-evident that I wonder why I asked the question at all; ah yes – because Johns would not see the obvious distinction between free choice and external necessity. Let me try again:

"Do you use these letter types because you like them or because that's how the stencils come?"

"But that's what I like about them, that they come that way."'

This sort of fatalism, which runs all through Johns's choice of themes, says a good deal about the mentality behind the posing of

those semantic paradoxes and puzzles and the provocation to make wild guesses as to his intentions, past, present and future. Johns is too much of an ironist not to enjoy the spectacle of our confusion. But isn't it possible that he himself doesn't know the answers, is not concerned with answers but only with questions of a kind that have to lead through a dialectic process to further questions. Total curiosity: that, I take it, is Johns's ideal of an attitude of mind. The measure of his own curiosity is the persistence with which he nags away at a question, letting it take him where it leads him. I think that this is where he is profoundly different from Marcel Duchamp, his affinity to whom may have been exaggerated. Duchamp is much more ready to impose himself on the situation, to decide where he's going next, to make an intuitive leap to a certain position, gather himself and make another leap. By the same token, he is also much more the performer. Johns will take pleasure in the public's confusion; Duchamp seeks to promote it. Duchamp is like a boy coming into a room full of people, pointing a pistol and saying: 'Your money or your life!' His victims don't know whether he's seriously holding them up with a loaded gun, merely having a joke with a loaded gun, having a joke with an unloaded gun, or holding them up with an unloaded gun. Duchamp likes to play for effect. I don't mean that he's a clown, but he is a rhetorician. Even his celebrated silence over the last forty years is a rhetorical silence.

Do you know the story of the sadist and the masochist? The masochist said: 'Hurt me!' The sadist answered: 'No'. When Diaghileff said: 'Étonne-moi, Jean!', Cocteau tried to oblige. When the art world expected Duchamp to astonish it yet again, Duchamp said No – like the sadist. The refusal to surprise was the surprise. I don't believe that Johns has this direct relationship to his audience. I imagine that, if he gave up producing art, he wouldn't especially want the art world to bear it in mind that there he was in a state of having given up producing art. He'd renounce it like Rimbaud, whereas Duchamp does so like Tolstoy. Certainly Johns is well aware of how the world reacts to his work – is extremely curious about it. But in an almost clinical spirit. He doesn't do something in order to provoke a certain effect. He does something, then waits to observe the reaction it gets. The reaction may have an influence on what he does next, but

this in turn is done experimentally, not rhetorically. When de Kooning made his comment about Johns's dealer, 'Give that sonofabitch Leo Castelli two beer cans and he could sell them!', Johns manufactured a *trompe l'oeil* bronze of two beer cans, or, rather, ale cans. Castelli sold them, of course. But I fancy that Johns would have been equally pleased if Castelli had failed to sell them, whereas I don't believe Duchamp felt impartial when in 1917 he submitted a urinal for exhibition as a piece of sculpture: he would have felt very frustrated if the jury had not rejected it.

One of the strongest impressions I get from Johns's retrospective show is of looking in on a highly obsessional *private* game. Its problems nag at him: he can't leave them alone. He has to formulate them, break them down, re-formulate them again and again. The form of the questions, the terms in which they are posed, changes continually. Their content remains the same.

The content always has to do with an aspect of the relation between reality and art. The early *Flags* and *Targets* emphasised questions of design and format. But in most of the work since then the focus has been on the relation between reality and the stuff out of which the work of art is made. This applies both to the bronzes, with their smooth surfaces and unambiguous figuration, and to the paintings, with their broken painterly handling and their elusive, indefinable reference to our visual experience of the real world. Johns's paint is poignantly beautiful, carries that inexplicable density and weight of feeling which spells nothing less than greatness in a painter. And it is always more than beautiful and emotionally charged paint. A field consisting of brushmarks in slightly varying tones of medium grey somehow gives the conviction that it is relevant to our vision of reality – a conviction that can't be explained or justified in rational terms. The only hint or guess that I can hazard is that it evokes a sense of reality through its evocation of a process of disintegration and re-integration.

One painting in which it does this quite obviously is the *Map* from the Heller collection, the most recent of his three large paintings of the map of North America. Johns doesn't paint landscapes, he paints a diagram of the American landscape: and the diagram becomes a landscape. The flat areas denoting the states rear up off the picture

surface to become massive rocks. I find myself in front of a structure reminiscent of Cézanne's late landscapes of the Bibémus Quarry and the Mont Sainte-Victoire – an image of immense solidity and at the same time of trembling and slow upheaval – an opposition that resolves itself, when I retreat a few paces, into a mood of sublime yet threatening calm. Paint disintegrates the complacent flatness of the map, re-forms it as a solid structure in space but a structure assailed by the energy within; the painting seems to embody a continuous process of simultaneous disintegration and re-integration.

Mostly the image is less specifically evocative of things than that. In works such as *Periscope, By the Sea, Out of the Window*, it compares with the *Maps* in rather the same way as late analytical cubist paintings compare with the Cézannes which were their prime inspiration. I believe that the key to what Johns is concerned with is to be found above all in the Cubism of Picasso and Braque in the last phase of Analytical Cubism and the phase of transition towards Synthetic Cubism. I am not merely talking about by-products such as the predilection for greys, the use of lettering, the introduction of collage elements. I am talking about common preoccupations concerning the relation of art to reality. Firstly, at the level of semantic puzzles and paradoxes. In Picasso's first collage painting, for example, the *Still life with chair caning* of 1912, there is a piece of oilcloth upon which is printed a *trompe l'oeil* representation of chair caning. The oilcloth is a fragment of the real world incorporated into the artificial world of a work of art. Looking at the oilcloth we may be deceived that it is an actual fragment of chair caning. But it's not chair caning, it's oilcloth. The 'real' element in the picture is in fact its most artificial element in that it's intended to deceive. And so on. Is this not precisely the kind of semantic paradox with which Johns has been concerned?

At a deeper level lies the fact that, like a Johns, an analytical cubist painting somehow gives us the feeling that it is about visual experience, however difficult it may be to name things to which it refers. It is concerned with re-creating the *process* of perception rather than the objects perceived. It is very evidently concerned with disintegration and re-integration. It operates, as a Johns does, in the area between question and assertion. It fuses lyricism with intellectual investigation. (My main criticism of Johns would be that in his work these

elements are less totally fused.) Analytical Cubism, in carrying an aspect of Cézanne to an extreme point, concentrated on the structural elements of his language, neglected its painterly elements. The paint is a *vehicle* of form and colour, its substance is not affirmed. With Johns, the material element dominates the structural. His art can be seen as a kind of Cubism in painterly terms. I mean that that is one of the ways in which it can be seen. And that alone is a major contribution to the history of modern painting.

It may be relevant to recall that, when Picasso and Braque were producing those miraculous works, they were about the age Johns was when he painted the *Maps*. At 30 one *can* be a master. I believe Johns is one.

Lichtenstein *1969*

This is a shortened version of an article published in American *Vogue* for September 1969 under the title 'The ironic Lichtenstein who takes soulful subjects and paints them with cool'. The cuts, amounting to nearly 40 per cent of the piece, consist of interview material and other quotations. There are also a few minor revisions.

Some artists like to think they are working in the dark, others that they are firmly in control. The preference seems almost more a matter of generation than of individual temperament. Most of the artists whose styles were formed in the 1940s subscribed to the idea that making art meant feeling one's way through unknown territory. Robert Motherwell spoke – as if wearing Whitman's beard – of the painting process as 'a voyaging into the night, one knows not where, on an unknown vessel'; Giacometti began a poem with the line, 'Un aveugle avance la main dans la nuit', and the blind man groping in the dark was clearly the artist's image of himself. Art was the lonely journey of existentialist man, whether it resulted in large bold abstracts or in nervous, compressed human effigies, and this ideal of the journey was shared by a multitude of artists, abstract and figurative. This common ethical ideal led to a generally shared attribute of style: the

way in which the work was made was more or less visible in the end-product.

The typical art of the Sixties is as different from this as Colonel Borman's journey to the moon is from Lévi-Strauss's journey into the tropics. It is carefully planned, tightly organised, precise in execution. It is technological (as in its use of silk-screen and spray-gun or as in sculpture ordered from the factory by telephone). It is also hand-somely financed; and this is not incidental. The art of the Forties was an art of outsiders, its audience other outsiders. The art of the Sixties has a public and a publicity machine: it is soundly professional and socially acceptable. It is sure of itself and has an air of certainty and decision. The artist, like a good executive, makes up his mind what he will do and does it, or gets it done to his specifications.

Lichtenstein is one of those who make a point of painting in a quasi-machine-like way, following a predetermined course. At the same time, his images are based on mass-produced images which repeat certain standardised symbols or designs: ads and strip cartoons and manufactured ornaments. (They are mass-produced in two senses: millions of copies of a cartoon frame are printed; also, the way something is drawn in one frame repeats the way it is drawn in innu-merable others.) Lichtenstein pointed out to me this connection between his way of working and his choice of image: 'I'm interested in what would normally be considered the worst aspects of commer-cial art. I think it's the tension between what seems to be so rigid and cliché and the fact that art really can't be this way. I think it's maybe the same kind of thing you find in Stella or in Noland where the image is very restricted. And I think that is what's interesting people these days: that, before you start painting the painting, you know exactly what it's going to look like – this kind of an image which is completely different from what we've been schooled in, where we just let our-selves interact with the elements as they happen. This high restrictive quality in art is what I'm interested in. And the cliché – the fact that an eye, an eyebrow, a nose is drawn a certain way – is really the same kind of restriction which adds a tension to the painting.'

He evidently relishes the element of certainty, the knowing 'exactly what it's going to look like'. And the pictures themselves, hard and precise and cool, look as if they were about certainty. But they

aren't about certainty – rather the opposite, as we shall see – and it's largely the interplay in them between certainty and uncertainty that makes them go on as they do being surprising though they have the look of an art that is not going to sustain its impact.

At a purely formal level, Lichtenstein is perfectly clear about his aims. He knows what he can add to the cartoon images that they haven't got. 'There's a sense of order which is lacking. There is a kind of order in them, there's a sort of composition, but it's a kind of a learned composition. It's a composition more to make it clear, to make it read and communicate, rather than it is a composition for the sake of unifying the elements. In other words, the normal aesthetic sensibility is usually lacking, and I think many people would think it was also lacking in my work. But this is a quality, of course, that I want to get into it.'

When I asked him in what ways he might alter the clichés to this end, one of his answers was: 'Sometimes I try to make it appear to be more of a cliché, to emphasise the cliché aspect of it, but at the same time to get a sense of its size, position, brightness and so forth as an aesthetic element in the painting. And they can both be done at once, as you can certainly do a portrait of someone and also make it art. In other words, you can be doing something besides pure art as you work.'

Along with this conviction that art doesn't have to be pure goes a belief that the artist may gain by not always indulging his own tastes, but by accepting certain norms that have not been created by himself. The thing that first attracted him to cartoon images was 'the fact that an eye would be drawn a certain way and that one would learn how to draw this eye and would draw it that way regardless of the consequences'.

The certainty evaporates as soon as Lichtenstein starts talking about the cliché's relevance to life, as against its usefulness to art. When I asked him, not too seriously, whether he liked girls who looked like the cliché girls he painted, he threw the ball back by saying – and this wasn't sophistry – that the kind he painted were 'really made up of black lines and red dots. I see it that abstractly, that it's very hard to fall for one of these creatures, to me, because they're not really reality to me. However, that doesn't mean that I don't have a

clichéd ideal, a fantasy ideal, of a woman that I would be interested in. But I think I have in mind what they should look like for other people.'

'Are you, by using subject-matter which is absurd, making your work say: "I am using subject-matter, I am not painting abstract pictures; at the same time, the subject-matter is absurd, so it doesn't really count"?'

'No. I think I'm really interested in what kind of an image the thing has and what it really looks like as well as the formal aspect of it. Let it go at that. I'll just do it anyway. I'm interested in this kind of image in the same way as one would develop a classical form – an ideal head for instance.'

I've been concentrating on Lichtenstein's ladies and their gentlemen friends, although they were mostly painted five to eight years ago, because among all his images these are the ones that come closest to the bone in the matter of our response to his subjects: these clichés have the same marvellous blend of kitsch and allure as Hollywood musicals. And certainly the crucial problem in talking about Lichtenstein is the problem of how he deals with his subject-matter and how it deals with us. His formal qualities are pretty obvious and scarcely need to be dwelt on.

But there is one of these that I would tend to single out, which is his mastery of scale. He will, say, take a school exercise-book, with marbled cardboard cover and stuck-on label, and blow it up to a height of nearly five feet, and by the nicest choice of scale in this enlargement will give us almost hallucinatory feelings about the relationship of our scale to that of a supposedly familiar object.

His most dramatic use of enlargement occurs in the blown-up brushstrokes of 1965–66 which constitute, I think, his finest series. To draw what may be a crude distinction, Lichtenstein operates on two kinds of clichés: on the one hand, those in the field of mass communications, advertising, strip cartoons, travel posters and the decorative style of the Jazz Age; on the other hand, those in the field of fine art, beginning with Picasso's and Mondrian's. The brushstroke paintings evoke, of course, Abstract Expressionism – but with the difference that they don't actually resemble the work of any particular Abstract Expressionist, whereas the others are unmistakable parodies, 'like a

five-and-dime store Picasso or Mondrian . . . a way of saying that Picasso is really a cartoonist and Mondrian is too, maybe'. The brush-strokes, as he says, aren't 'really so much of a parody of anyone's paintings, more an epitome or codifying of the brushstroke in itself'. The brushstrokes represented, indeed, look less like anything done by Kline or de Kooning or Motherwell than like the marks which any-one might make in daubing a wall with a house-painter's brush.

So it may be that we wouldn't relate Lichtenstein's pictures of brushstrokes to Abstract Expressionism if we hadn't already seen his take-offs of Picasso and Mondrian. Because we know his ironic glosses on other art, we see his meticulous imitations of slashing brushmarks as a joke about the Abstract Expressionist cult of heroic spontaneity – maybe remembering Rauschenberg's joke of doing a free gestural painting in the Abstract Expressionist manner and then producing a duplicate. But the basic irony is simply the notion of representing the appearance of *any* spontaneous daub with obvious deliberation and care.

What is marvellous about the irony is that Lichtenstein's carefully conceived and executed reconstruction of an explosively violent brushmark looks much more explosively violent than the real thing. Though ironical, this is not paradoxical. The explosiveness derives from the way the harsh colours are edged with black and by the sharp-ness of the shapes. But, as to sharpness, I personally feel that the violence derives above all from a metaphor which I always see in the shapes: teeth and other jagged tearing instruments. I asked Lichtenstein whether he meant to put them there. He answered that he didn't. 'I did notice that some of the edges of the brushstrokes looked like explosions and things, but I really wasn't thinking of any other imagery except the obvious.' Here for a change he is utterly decisive about what the paintings mean to him. And it turns out that something which for me is the most impressive feature of his most impressive paintings is something with which he is flatly uncon-cerned.

In the brushstrokes series, as in the cartoon images of love and war, Lichtenstein takes subjects with a high emotional charge and deals with them as commercial art would 'by a very removed method', as he puts it. 'It's really not so much that I really use that method but that

it appears as though I've used it and as though the thing had been done by a committee.'

I feel that his best work is generally work in which there is this contradiction between cool in the treatment and soul in the subject-matter – as against the still lifes, the landscapes and the parodies of Jazz Age ornament. It is a contradiction that corresponds to one of our most needed mechanisms of defence: to joke about what we mind most about.

Lichtenstein's method of doing this is the inverse of Jasper Johns's, the artist whose ironic use of common emblems showed the way to Lichtenstein and the other creators of Pop. Johns takes cool subjects and paints them with soul, or what looks like soul. Lichtenstein takes soulful subjects and paints them with cool, or what looks like cool.

Rosenquist *1974*

Untitled preface to the catalogue of *James Rosenquist: an Exhibition of Paintings, 1961–1973* at the Mayor Gallery, London, from 3 December 1974 to 18 January 1975.

Rosenquist's career as a painter of billboards, which reached its dizzy climax in the heights above Times Square, was formative as well as expedient: 'the style I use was gained by doing outdoor commercial work as hard and as fast as I could'.

Working in Time Square, he would have been one of the Western world's more public painters. Not only was he making vastly public images in a densely public place of matters of public concern, but in the act of making them was giving a public performance: painting the stars on the front of the Astor Victoria Theater meant being in as well as dealing with show business.

Yet what man is more an island than one mixing colours on a swaying plank twenty-two storeys up above the teeming city?

Rosenquist's art is public in that its formal elements are largely derived from the brashest kinds of commercial art, public in that its iconographic elements are generally taken over from the imagery of

conspicuous mass-consumption and its attendant communal fan-
tasies; in sensibility, it is beautifully private. It doesn't make its
meaning plain, doesn't strike resounding chords of easily nameable
feeling. Where other Pop Art often plays off emphatic irony against
emphatic sensuousness or emphatic nostalgia or emphatic violence or
emphatic melancholy, Rosenquist's feelings about his imagery seem
so inextricably mixed that one is left not puzzled but clueless as to his
motivations; one simply senses a certain complex wonderment. He
paints like a man absorbed in bringing back to mind for no particular
reason an especially interesting dream. Some artists seem to have the
attitude towards their imagery of a man flaunting his intimacy with an
enviable companion; others the attitude of someone allowing you to
view his collection of fetishes; others that of someone exposing his
scars. Others seem to be persuading themselves how fervently they're
on the side of life, others to be confiding that the material was admit-
tedly unpromising but look what they've managed to make of it.
Rosenquist's art is free of salesmanship. It radiates – I can't say why,
but the quality is as unmistakable as it is rare an artist's total cer-
tainty, untouched by inhibition or affectation, as to his tastes. To be
in the company of his work is like being in that of one who is acute,
relaxed, entertaining, enigmatic.

The wonderment whether it involves putting together disparate
fragments of the world, as in, say, *Smoke*, or whether it involves tak-
ing over something ready-made, as in, say, *TV Boat* – is conveyed
through the handling of the paint itself, which vibrates with an elat-
ing redolence of sensations. It's this paint, subtly direct, that is telling,
not symbolism or allusion. In *Study for Marilyn*, for example the lower
lip of the open mouth is touched by a small stick of gradated greys.
The conjunction of opened lips and a stick of something has become
one of the most sickeningly calculated devices in the repertory of per-
missive advertising, and several Pop artists have not been beyond
utilising this sort of facile erotic signal. That Rosenquist can appear to
be flirting with such synthetic eroticism and can do so without taint-
ing his intrinsic eroticism is one demonstration of the way in which
the narrative implications of his paintings are altogether subsidiary to
their formal qualities. All that intriguing interplay of images –
intriguing above all because of the variations in the degree of their

identifiability – is subordinate to the effect in calling back sensations of the interplay of warm and cool tones, of thick and thin paint, of variations in the pace of the brushmarks. In a way, paint is the substance of the dream.

Oldenburg *1967*

Written late in 1967 and published as 'The Soft Machines of Claes Oldenburg' in American *Vogue*, February 1, 1968. Slightly revised here.

I was brought a cup of tea in bed one morning which was the nastiest cup of tea I had ever tasted until I realised it was coffee (good coffee). My taste-buds were on edge for hours after. All such denials of expectation give an unpleasant jolt to the nervous system – the surface that's surprisingly sticky or shiny, the heavy-looking object that is weightless when picked up – but there is one which is peculiarly traumatic. A clown hands his mate an object which seems firm and hard; trustingly accepted, it suddenly sags and droops. Ugh. It is far more upsetting than any soft-looking object which when kicked turns out to be brutally hard: its connotations are more humiliating.

Slackness, besides repelling, provokes moral opprobrium, spells weakness of will, absence of energy. Attributes of art deemed to be desirable correspond to approved moral attributes: art is asked to be, for example, pure, strong, disciplined, generous. So form, in sculpture especially, is supposed to seem taut and muscular. No two sculptors of the same generation could be more different than Moore and Giacometti, yet this they have in common: Moore's stated ideal of form is 'pent-up energy', Giacometti's 'contained violence'. From ancient Egypt to the Romanesque, the African to Michelangelo, the Parthenon to Brancusi, sculpture offers a tumescent presence. Except for bad sculpture. Claes Oldenburg, therefore, is arguably among the most revolutionary artists of all time, in that his sculpture glories in a detumescent presence – doesn't only *seem* soft, it *is* soft.

'I did study tradition as much as I could in my way but I reached a point finally where I relied on my own experience, and this experience

had a lot to do with my sense of myself as a physical object, and I felt that it was natural for a sculptor or painter to create a body image of himself. I find when I'm written up in papers people very often compare my work to myself. I suppose they're trying to insult me. But it seems to me a very logical thing. I don't think I'm drawn very much as a body image to rigid sculpture. I am drawn to something which is more like me, more soft and flabby.'

Oldenburg's soft and flabby images are not ostensibly images of the human body. Like other twentieth-century sculptors – notably Picasso, Boccioni, Laurens – but more exclusively, he makes sculptures of still-life subjects, mostly food: hamburgers, ice-cream, pastries, bananas; and common equipment: typewriters, telephones, plumbing, cars. The sculptures are generally larger than the thing they represent – when this is food, they may be many times the size – possibly following the lead of advertising art: Oldenburg's giant version of an ice-cream cone is no larger than the representation of a cone standing outside the ice-cream shop. Only, his version is not firm and upstanding but flaccid and reclining.

The transformation is never of man, always of man-made things. Oldenburg says that, if he tried to make a human figure, it would have to come out as a doll, a typical doll, and that he did in fact once make a sculpture like a Barbie doll. Even the images of food are not representations of nature. Except in early work where he made cuts of meat that are as lyrical as if painted by Bonnard, they are always of food that has been processed, is to some extent man-made: the potato crisp, not the potato, the hamburger, not the side of beef, beans as bought in a package, not as picked. The subjects are never more than obliquely organic; they are standardised products. And Oldenburg's deformations of common equipment disturb *because* it is standardised, constant in shape, and constantly used, with confidence in its constancy. We are as certain as we are of gravity how the telephone will feel when we lift the receiver, how the bathtub will shield and sustain us when we get in, how the bathroom scales will react when we step on them, how the typewriter will respond to our touch. To be confronted with soft versions of these rigid objects is like going to sleep at night in our own beds and waking up in a ship on a rolling sea.

A flatiron with nails sticking out of its flat side; a cup, saucer and

spoon entirely covered with fur: the strategy of the classic surrealist objects is to add something intolerable to objects in common use. It corresponds to the incongruous juxtapositions in surrealist painting. Oldenburg's treatment of his subjects corresponds somewhat to an alternative strategy of surrealist painting – to show objects behaving contrary to their nature, as when Magritte paints a cloud from which rain is falling upwards, or a still life turned to stone, or, indeed, as when Dali paints watches that are soft as tongues.

Oldenburg's brand of derangement, naturally enough, concentrates on the tactile. The objects he deforms are tools we constantly handle, never bother to contemplate, are familiar with through our sense of touch. They are virtually extensions of our bodies. At the same time, we trust them. Rather than doubt them we doubt ourselves. Their misdemeanour not only wrecks our poise but seems to reflect some weakness in ourselves. So these soft sculptures become a sort of insult to our *amour propre*.

'I found that a great many people objected to the fact that my sculptures were soft, you know. I think it must be some sort of sexual thing. Perhaps sculpture is involved with erections and so on.' Yet, if softness in sculpture evokes failure and inadequacy, the implications are not localised. Rigid form implies a flexing of all the muscles, slackness a general inertia. Tautness as a sculptural ideal refers to every virile activity, is valued at least partly because of sculpture's traditional concern with the heroic – with depicting Hercules performing his labours, not Hercules resting between them. But the normal state of man is the relaxed state enjoyed between performances. Consequently, while Oldenburg's soft sculptures might be about failure and collapse, they might equally well be about nothing more dramatic than a state of rest, waking or sleeping. Instead of being, or besides being, metaphors for pathetic situations, they might be manifestations of the modern doctrine – common to Realism, Impressionism, Intimism, Cubism, Dadaism – that art should not deal with the heroic and the exceptional but with the most ordinary behaviour and things.

Oldenburg himself plays down the pathos. Talking about his squishy typewriter with its tumbled, jumbled keys, I said that it seemed to be a metaphor for collapse and disintegration, and asked him whether it was this for him. He said: 'I never thought of the type-

writer as having a sense of the pathetic. I think what I worked with is a contrast of form. If something is hard I'm very simply led to believe that it could be soft, or I want it to be soft. Or if something is soft, I want it to be hard. I don't think so much of the interpretation of this. It's just a natural possibility. I'm concerned more with forces and states of matter rather than the emotions attached to the particular piece. If you want pathos from my typewriter, you can get it. But that's how nature is. The sun goes down and really all that's happening is the sun going down. But a lot of people are standing around feeling very sad the sun is going down.'

But is a collapsed typewriter like the setting sun? Is it how nature is? A relaxed typewriter is not a typewriter by night, it is a useless typewriter. On the other hand, why should it, when soft, be called useless? It is a sculpture, not a typewriter, and unlike a typewriter is not rendered ineffectual by being soft. On the contrary, its pliability gives it ways in which it can be used which it could not have if it were rigid. It can be pressed, caressed, squeezed, like a woman's body: it has the springy softness of a woman's body to the touch. Or rather, it has the springy softness which is sought in a woman's body. That is to say, it is not soft merely by default of being hard: its softness is positive, proposes an alternative norm. If tautness in sculpture corresponds to an ideal of male desirability, perhaps the softness of Oldenburg's sculptures corresponds to an ideal of female desirability?

Come to think of it, these sculptures are made in materials which belong to the world of women. They are executed in fabrics stuffed with kapok, the technique is none other than sewing, and the work is done by the artist's wife and other seamstresses. Identification with the female lies as much in the choice of materials as in the choice of forms, and one cannot say which came first, because, as in any sculpture, materials and form are interdependent. If at times the image Oldenburg has a mind to make demands a particular material for its realisation, at others the material suggests the image, as a carving can be inspired by the size and shape and colour of a piece of stone the sculptor acquired without knowing quite what he would do with it. When Oldenburg was working in California in 1964 he found a remnant store which often had pieces of special plastic materials not available elsewhere. 'So I made a practice of going in there every week

and seeing what had arrived, and many times the material that had arrived suggested the piece to be made. I got a very strange green kind of sticky plastic which made a great impression on me and resulted in a series of beans that I had made.'

Now, this ideal female softness is resilient, has resistance, and Oldenburg's soft sculpture is not baggy, not inert. His problem is to imbue fluid, relaxed form with a tension which, without becoming conspicuous, is sufficient to animate the image (it is a problem akin to that of Bonnard as a painter). 'It places much more responsibility on the artist who deals with slack form. I mean he really has to prove himself, you know. Most of my slack form, if it's set up in the right way, you can see that the basis for it is a very rigid basis. It's just like the human body, which has in effect a very rigid structure. But the body can do the most amazing things. It can bend and it can change in space and it can be pressed and so on.' The heart of the matter is not that these sculptures are soft but that they are pliable. And variable.

Their shapes can be altered casually, accidentally, or by the most careful manipulation. A larger piece – such as the six-foot-long *Soft Engine with Fan and Transmission* from the series celebrating the Chrysler Airflow – can be two radically different pieces, according to whether it is suspended from the ceiling or laid out, collapsed, on the floor. The variability alone, indeed, would be a sufficient reason for making the sculptures soft. For one thing, the spectator can enjoy altering their form as he pleases. Modern art often encourages the spectator's active participation, and a number of sculptors have created objects with movable parts, but Oldenburg is the first to have found a means to give us a hand in determining, not simply the relations between the shapes, but the shapes themselves. More important, the variability gives each piece a whole range of expressions: by comparison with other sculptures, these are like plays as against *tableaux vivants* (Oldenburg, by the way, is the author of several Happenings). Certainly there is any amount of kinetic sculpture being made nowadays, but mostly all that happens, it seems to me, is that it works: it is like a busy office, humming with action, where no romance or catastrophe breaks the routine. Whereas the mutations of, say, the *Ghost Typewriter* present a series of metaphors. In one state the soft machine is the face of a predatory beast, in another of a dirty old woman, in

another of a beaten-up boxer.

Oldenburg's images generally suggest more than one thing at a time. Aside from the equation with the body or its parts, which is pervasive, and the equation with the face, which is recurrent: drainpipe = crucifix; electric fan = spider; engine with fan and transmission = elephant; Dormeyer Mixers = tropical fruits; half-peeled banana = plane in flight; etcetera. Such visual puns relate him to the whole Surrealist movement, the Arp/Miró wing as well as the Magritte/Dali wing. Now, the typical Arp or Miró biomorph, with its multiple meanings and its sense of endless metamorphosis, seems to have been derived from the amoeba. Oldenburg's soft sculptures actually change like the amoeba, given help from outside. His images are both metamorphic and protean. This, of course, means that a variety of meanings come easier and cheaper than for Arp and Miró, who set themselves the task of making static forms imply variety and change. But Oldenburg is an altogether less austere, more extravagant kind of artist. If the history of Surrealism were cast in terms of the past, one might say that Arp represents its primitive phase, 1930s Miró its classic phase, Gorky its mannerism, Oldenburg its baroque.

And being a baroque kind of artist, he is not content to make mere objects but contrives preposterous environments and dreams of over-weening monuments in city squares. *Bedroom Ensemble* includes some of his most compelling hard artefacts, both of the kind which are soft objects transformed – the leopardskin coat – and of the kind – the dressing table – which make hard objects hardest. As Max Kozloff summed up this environment when it was shown at the Janis Gallery in 1964: 'These ersatzes and synthetics, congealed movements and claptrap modernities, electrify the cheapness and madness of American hotel and suburban décor.'

As to Oldenburg's most hilarious inventions, the projects for colossal monuments, the drawings (like his uninhibited, unexhibited, pornographic drawings) were done in a truly baroque manner. 'The first suggestion of a monument came some years ago as I was riding in from the airport. I thought: how nice it would be to have a large rabbit about the size of a skyscraper in midtown. It would cheer people up seeing its ears from the suburbs. The spot I had in mind

was the space in front of the Plaza Hotel (where there is already a fountain). However, the Playboy Club later made its headquarters nearby, which made construction of the giant rabbit at that particular spot impossible. I substituted the baked potato, in either of two versions: upright or thrown against the wall of the hotel.' Other projects include a colossal ironing-board for the Lower East Side, a colossal peeled banana for Times Square, a colossal teddy bear for the north end of Central Park which 'stares down from black New York at white New York somewhat accusingly but glassy-eyed too from helplessness (handless)'. While staying in London in 1966 Oldenburg learned that the Thames rises and falls a considerable distance with the tide. He therefore invented a monument to ride the river near Waterloo Bridge: a (hard) version of the ball cock in a lavatory cistern.

'Everything I do is completely original – I made it up when I was a little kid.' This is to be believed. It is consistent with the average degree to which the sculptures magnify household utensils and fittings and also clothes. Their size in the sculptures relates to ours roughly as their size in reality relates to that of a child. These are Mummy's and Daddy's things, a constant anxious-making reminder of one's smallness and inadequacy. The sink is too big for the plug to be reached, the w.c. too high for feet to touch the ground, the vacuum cleaner too heavy to push, and Daddy's clothes swallow one up when one tries to act his part. There are big Mummy and Daddy lying in bed, what can they be thinking about? The telephone, the toaster, the typewriter: impossible to use; hands are too small, too clumsy, they slip away. This is Mummy's body: how nice to cuddle her, make a dent in her. This is Daddy's big thing: hope it stays soft.

The real joke of the padlocked cabinet is, I take it, not the mild paradox about the key but a move in an extended joke that Morris seems to play upon his audience. The message about the key might have been scrawled realistically on a scrap of paper that might have been stuck on the face of a cheap wooden cabinet that might have been picked up ready-made, but its absurdity could gain a further dimension through its assuming the style of a monumental inscription beautifully embossed. From this it was an inevitable step to the Johnsian tactic of re-creating a common object in bronze. A pleasant little conceit about the nature of boxes is thus rendered as enduring as the art of the museums, and something can be looked at forever which offers almost nothing to look at. In the meantime, certain other pieces by Morris which could give prolonged aesthetic satisfaction are expressly built not to last or have kinds of variable form which frustrate the longing to recover some lost state in order to see it again. The moral seems to be this: making makes, say, boxes and the boxes may be good to look at, but it doesn't matter whether boxes good to look at last; but making always matters; so, if anything is to be made to last, it might as well be the making as the box.

The *Box with the Sound of its Own Making* is closely related, no less than to the boxes with pictures, words or signs, to another and very different series of polyhedrons, pieces made before and concurrently with and after the informative boxes and more central to Morris's work. The *Box with the Sound* relates to these by virtue of being a cube – a minimal, a primary, structure. These large, plain, strictly geometric and brutally simple presences are, so to speak, uninformative boxes, except that, as Michael Compton points out, 'Every piece is, in a sense, a box with the sound of its own making (this contrasts with many works of art which carry the "sound" of their own motivation), but the sound is replaced by one's sense of every aspect or level of the artist making, perceived only through the nature and presence of the object made.'

The early primary structures were all made in wood, but some with sawn planks, their surfaces rough in places, their joints and screws left visible, the others in plywood, usually painted grey. The *Box with the Sound of its Own Making* was the paradigm of the first small group, which included the *Pine Portal* and the untitled box like

a lidless coffin standing on its end or like a sentry box, pieces which to some extent recall Brancusi's oak *Arch* and *Bench*. The paradigm of the other group, which covered several years, was a piece made at about the same time as the *Box with the Sound*, a square *Column* eight feet tall in plywood painted a matt pale grey. It was made in response to an invitation to create a stage piece lasting seven minutes. Morris had composed and performed a number of dance pieces and was later to do more, but on this occasion he chose to exhibit this object on the bare stage, placed upright for half the allotted time, horizontally for the other half.

Column embodied essential features of the aesthetic which was later to be called Minimalist – notably the idea that a minimal unit might be capable of being presented in more than one position, and the insistence on a blank, deadpan exterior. This neutral, anonymous surface suggests that anyone could have made the piece as it stands, once given the specifications, that it might have been ordered by telephone and that it might as well have been executed in painted metal or fibreglass as in plywood. To have put a tape of the sound of its making inside the *Column* would have been as beside the point as to type one's signature on a cheque. The sound of the *Box with the Sound* is relevant because the box is explicitly a piece of carpentry, is palpably hand-made. The preservation within the completed work of traces of the process of its making could be a point of honour according to the ethic of Abstract Expressionism or, for that matter, of Brancusi's treatment of wood (Morris had been doing Abstract Expressionist pictures till a year or two before and during the next couple of years was to write a dissertation on Brancusi). The new twist is that the traces of the making of the visible thing are audible (a combination of media appropriate to an artist who is a dancer) and that the preservation of the traces is dependent on technology (a resort appropriate to an artist of the Minimal/Pop generation).

There is another sculpture which bridges the gap between the Minimalist side and the Neo-Dada/Mixed Media side of Morris's early work. This is the set of four mirrored cubes, which is somewhat Neo-Dada in the games it plays with visual ambiguities and notions about levels of reality through having reflecting surfaces where blank ones would be expected. The cubes are laid out as if at the four

corners of a square. The units and their arrangement are models of perfection and stability. Yet what is seen in looking at them is fugitive, circumstantial and unpredictable – whatever happens to be around, whoever happens to be passing. Thus the same conjunction of opposites is presented as in the *Box with the Sound*: on the one hand, form of a Euclidean finality; on the other, the Heraclitean flux of events. The timeless form of the cube as gestalt is opposed to the existence in time of the cube as thing – in the case of the *Box with the Sound*, what happened to the cube before the time of its completion as a cube; in the case of the mirrored boxes, what happens to the cube after the time of its completion as a cube.

These two works spell out patterns of behaviour one or the other of which is followed to some degree by many or most of the sculptures: a piece will show forth the process of its making by Morris or will demand that the process of its making be continued by others. The process of its making by Morris is shown, for example, through the deliberate visibility of the components which hold it together, such as bolts or clips; by progressive incorporation into a work of progressive photographs of its preceding states; by having the public witness the making of a piece, bringing the execution into the exhibition. Active participation by others in extending the process of making is induced, for example, by forms that are variable in orientation; by sculptures consisting of several units of which there are numerous possible arrangements; by limp, protean sculptures in felt to be freely disposed on the floor or hung from the wall; by conceptual works such as the *Fuel piece*, for which the artist provided only a set of instructions on collecting samples of given materials and performing certain operations on them.

At the time he was making the series of felt sculptures Morris wrote an article entitled 'Anti-Form' totally committed to process and indeterminacy. Obviously the felts are a calculated assault on the superstition of enduring form. But they are also a denial of anti-form. For all the wide range of variation, for all the frustration endured in trying unsuccessfully to re-create some past configuration whose impact has become fixed in the memory, repeated experience of arranging one of the felt pieces leads to consciousness not of its variability but of the constancy with which it insists on falling in some

ways rather than others. The felts impose firm restrictions on what one can do with them. Their behaviour is obviously very much subject to decisions as to the height they are hung from and the way they are put up, but, once those decisions are made, their structure always provides a resistance to the will to make what one wants of them. The most satisfying arrangements of a piece tend to be those which follow from putting it up and letting it fall its own way. And when one has arranged a piece and stands back, one has the strange feeling that one isn't looking at something pliable which has just assumed its present shape but at something carved in stone which has always had its present shape. Some soft sculpture rejoices in being flaccid. With Morris's felts it's not the softness of the material that one is conscious of but the planes and the edges of the ribbons, as if these were planks, only more than if they were planks. It is as if the sculpture were soft in order to enhance awareness of hardness through focusing on the hardness in softness. And it is as if the form were indeterminate in order to enhance awareness of the inevitability with which a given material determines what can be done with it. The felts are a lesson about making.

Behind all the phases of Morris's work there has been no interruption in the sound of the *Box with the Sound of its Own Making*.

FORERUNNERS

Daumier *1961*

Review of an exhibition of paintings and drawings at the Tate Gallery published
in the *New Statesman* on 23 June 1961 and slightly revised later in the 1960s.

In Daumier's paintings as in Michelangelo's the figures inhabit no
place. The token rocks and vegetation are not a setting which looks as
though it had been there before the figures; they seem to be present
only because the figures are – as in the sort of expressionist play in
which the actors bring the bits of scenery with them on to an empty
stage. There is only as much scenery as is needed to explain the action.

Daumier was in most things obviously much involved in his time –
a commentator on current events and personalities and conditions, and
an artist who drew widely upon current pictorial devices. But he did
not share the preoccupation of his time with the relation between man
and his surroundings. It could well be argued that man's place in
nature – precisely *in* nature and not against a backcloth of nature, and,
again, precisely nature as a setting for man and not as a world apart –
is the central theme of painting in the last three-quarters of the nine-
teenth century. Daumier's world begins and ends with man. Man is
wholly self-contained, the limits of his world are the limits of his ges-
tures. When there are groups of figures, they jostle one another as if
blind, only seem aware of one another through the involuntary contact
of their bodies; their heads seek one another out like puppies' heads.
Hence that strange poignancy we feel in all Daumier's gatherings of
figures huddled together, at once menacingly and comfortingly. In the
close-up paintings of individual heads there is often a bleariness or
blankness in the sockets of the eyes which calls to mind the unseeing

look of Michelangelo's later carvings. And then there is Daumier's obsession with Don Quixote, he who is unable to see what things are: the revolving arms of windmills are those of hostile men; gesture is what signifies. Blind gesture responds to blind gesture.

Nineteenth-century painting generally, besides seeing the figure within the context of nature, sees everything within the context of a field of vision, relates what is seen to a point of view – by which I do not mean the ideal viewpoint of Renaissance perspective, which is impersonal, but the viewpoint of an implied beholder whose particular attitude to the subject is conveyed as well as his particular position in space. This sense of a particular relation between the thing seen and an implied beholder, a beholder with whom we are made to identify ourselves, first occurs in European art around 1600. Caravaggio's moments of sudden drama are visualised as if seen by someone on the spot – seen, perhaps, or so both the angle of vision and the peculiar sense of amazement suggest, by a wondering or terrified small boy, mirroring the evident emotion of the boy actually present in each of the pair of facing pictures in San Luigi dei Francesi. Even in sculpture, Bernini makes the presence of an implied beholder an integral part of the work. These and the many other possible examples from the age of Baroque tend to involve an implied beholder for reasons which have to do with rhetoric rather than with ideas about vision – Velázquez is something of an exception, with those games with mirrors which imply a spectator in the midst of the scene, a spectator invited to observe but not to express a reaction. In the nineteenth century, ideas about seeing become the general motive for implying the eyes of a beholder. The very meaning of a Degas resides in the implication that the beholder is a sort of peeping Tom, that of an Ingres in the implication that the women under survey are aware of being looked over, that of a Monet in the implication that the beholder feels as if enveloped by what he is contemplating, that of a Cézanne in the implication that the beholder is compulsively measuring his distance from each successive plane in the scene before him, and so on.

But in Daumier's paintings there is no implied beholder. Our efforts to re-establish the artist's attitude with regard to the subject out there in front of him always end in failure. As we bring our concentration to bear on the forms confronting us, we suddenly find that

we are no longer looking at them but have been as it were spun round so that we have become them. What was out there is all that is there, contained within itself and accessible to us only through our total identification with its actions and in no other way. The artist has not looked at these figures, he has drawn them as if he were inside them. In the drawing of *Don Quixote in the Mountains*, from the collection of M. Maurice Loncle, Paris, there is a horse lying flat on its side, and what we are aware of is not so much the swell of its visible flank but the feel of the contact of the hidden flank with the bare flat rock. In the chiaroscuro painting of *Don Quixote and Sancho Panza* from a private collection in Zurich, the bizarre black and white shapes formed by Don Quixote and his horse are not of the order of those unexpected shapes which the camera's eye often gives us: the total form is not a man on a horse rushing headlong seen in strong light and shadow; it is the embodiment of rushing headlong. Daumier has not asked what his subjects *look* like when behaving in a given way, but what they *feel* like, within themselves.

It goes without saying that empathy plays an essential part in almost any aesthetic experience, both that of the artist in regard to his subject and that of the spectator in regard to the work. Only not, as it does here, to such a point that no room is left for anything else. The unfinished look of Daumier's painting was therefore inevitable: when we thrust out an arm into space and feel the muscular tension along it, we aren't mindful of the length of our fingernails. This total absorption in empathy explains the unfinished look of Daumier's paintings as it explains the unfinished look of the Rondanini *pietà*. Not even in Michelangelo's late paintings, but only in his late sculpture, do we find empathy as total as that of Daumier's later paintings and, of course, of his sculpture.

To be an artist like Michelangelo was one of the most commonplace dreams of the Romantic tradition. Paradoxically, the artist who came closest to its realisation was (as Balzac and Daubigny were so quick to recognise) one who earned his living as a cartoonist and who, even as painter, draughtsman and sculptor, took most of his subjects from the banalities of everyday life. There is no affinity whatever in their range of feeling to explain how Daumier got close to Michelangelo: Daumier is neither morbid nor sublime. What he

shares with Michelangelo is a capacity for absolute empathy. And it was this that enabled him to bring the art of sculpture to life again (though there are intimations of this revival in the two sculptures by Géricault which have survived). The Michelangelesque aspirations of a Rude or an Alfred Stevens were strangled at birth by their instinctive adherence to Bernini's pictorial approach to sculpture. Daumier, without thought of impersonating the Grand Manner, instinctively worked in the same terms as Michelangelo – in terms of empathy. Several of his sculptures were included in his big Paris exhibitions of both 1878 and 1901: it is difficult not to infer that the sudden conspicuous broadening of Rodin's style which occurred about 1880 was due to Daumier's influence, and that, as a result of the second exhibition, Matisse's development as a sculptor was affected.

Daumier's habit of expressing what it feels like to do something, not what somebody looks like doing it, connects with his invariable practice of working out of his head, but not at all as a necessary consequence of it: a preference for working from memory has been held by many essentially visual painters, such as Goya, Degas, Bonnard. The vital factor is that he was instinctively more a sculptor than a painter, more so, perhaps, than any other great painter one can think of. So that as a painter he absolutely had to be an innovator. Daumier, more than anyone but Turner, perhaps, did most to break down the traditional distinction between the sketch and the complete work of art, a distinction still strong in Delacroix and Constable. He also made flat shapes speak of form in space in a way that was later to be of use, one suspects, to Munch, Matisse, Rouault, Picasso.

He began with an amateur's ragbag of pictorial ideas filched from everywhere – Géricault, Delacroix, Millet, Goya, Rembrandt, Fragonard, etc. His experience as a lithographer combined with his instincts as a sculptor to forge these ideas into a new language of painting. In the *Don Quixote and Sancho Panza*, the black and white shapes simulate the effect of hard contrasts of light and shadow, but they are not about light and shadow, they are about the thing that lithography is about – the use of shapes in black and white to give an illusion of form in the round. These shapes, being not descriptions of visual sensations but visual projections of motor sensations, come to acquire a degree of autonomous life which gives them both the imme-

diacy and the ambiguity of impact which are characteristic of the shapes of twentieth-century painting.

Goya

1965

This review-article occasioned by Tomás Harris's *catalogue raisonné* of the prints and a coffee-table book on the black paintings was published in the *New Statesman* for 2 April 1965 as 'Here Comes the Bogeyman'. One small cut has been made.

Goya's portrait of himself being nursed by his physician is inscribed: 'Goya in gratitude to his friend Arrieta for the skill and care with which he saved his life in his acute and dangerous illness suffered at the end of the year 1819 at the age of 73. He painted it in 1820.'[1] Goya otherwise celebrated his rescue from the jaws of death by decorating the walls of his villa, the Quinta del Sordo, with the fourteen 'black paintings'[2] which by and large are the most sickening images he ever painted. Having survived, he not only gave himself to realising hellish visions, but chose to do so in a form that left him surrounded by them (and without the freedom canvases would have offered to turn their faces to the wall).

All sense of relief was reserved for the *Self-Portrait with Dr Arrieta*. It almost resembles a *Pietà*. Goya is seen sitting up in bed, more dead than alive, leaning back against the doctor, who supports the patient's weight with one arm and with the other raises a glass of medicine towards his lips. Portrayals such as this of love or warmth between human beings are rare among Goya's mature works. Others have created images as terrible as his of man's inhumanity to man, but no other major artist has conceived of a world so comprehensively consumed by hate.

Goya seems to have come to take it for granted that a human being with power or authority over another will abuse it to ruin the other – to dismember, deprave, despoil, relentlessly, gratuitously. Maybe the scenes in *The Disasters of War* of the pointless butchery which the victors inflict on the vanquished tell us no more about Goya himself than

that, like any humane and rational being, he loathed the excesses of war. Maybe the scenes in the *Caprices* in which the old sell or corrupt their charges tell us no more about him than that he was a sharp social satirist. His witches' sabbaths where babies and foetuses are roasted are not proof that he assumed, even unconsciously, that all women would rather eat than feed children. But there can be no doubt as to the depth of his despair in the face of his guarded inscription on a drawing in the Prado of an attractive young woman seated cuddling a small child: 'She seems to be a good woman.' Love is exceptional. Depictions of tenderness and compassion are found among the famine scenes of the *Disasters*: love flowers in the context of deprivation. A loving care is portrayed in the painting made in 1819 of *The Last Communion of San José de Calasanz*. It is curiously prophetic of the *Self-Portrait with Dr Arrieta* – both are images of a suffering man sustained by a man who is feeding him.

The mouth plays a role in Goya's art more prominent than in that of any other major artist. Mouths leer, grin, gape, gasp, moan, shriek, belch. A hanged man's mouth lies open and a woman reaches up to filch his teeth. Grown men stick fingers in their mouths like sucking infants. Mouths vomit, the sick gushing out of them, and a great furry beast sicks up a pile of human bodies. Mouths guzzle: they guzzle avidly, ferociously, living flesh as well as dead. Saturn grips one of his children in his fists and with his mouth tears him limb from limb.

In Rubens's version (which Goya would have seen in Madrid), Saturn bends his head over the body, sinks his teeth in the flesh and sucks the spurting blood of his kicking, screaming child. Goya's version shows a bleeding remnant of a body, one of its stumps entering the hoary giant's gaping mouth. Goya's painting of an episode from the sixteenth-century novel *El Lazarillo de Tormes* is its comic counterpart. The blind old man, wanting to smell out whether his supper has been eaten by the youth Lazarillo, 'forced open my mouth with his hand, and thrust in his nose, which was long and thin, and at the same time had grown another few inches with rage'. 'Those who reach eighty,' reads one of the *Caprices* commentaries, 'suck little children; those under eighteen suck grown ups. It seems that man is born and lives to have the substance sucked out of him.'

And mouths are focal points in many scenes other than those actu-

ally depicting oral aggression or symbolising oral sexuality. For Goya, to a degree unknown in any European artist before him, habitually relies on the mouth to convey the passion possessing a figure. With other artists facial expression is conveyed by the face as a whole, and by the eyes to more or less the same degree as the mouth. With Goya the mouth dominates the face – and not only the face but the whole body. For, after all, in general painters and sculptors of figure-subjects do not depend primarily on facial expressions to convey the passions animating their actors. Their actors, like actors on a stage who know that their facial expressions are hardly visible beyond the front rows of the stalls, must convey their passions through the gestures of their whole bodies. Goya, however, tends to restrict the body's expressive role.

His figures have the jerky movements of puppets, not the expansive actions of heroes. After the eloquent decisive gestures of that long chain of great European figure-painters from Giotto to Tiepolo and David, Goya's gestures, suddenly – apart from the gestures of his mouths – are ambiguous. Here gesture loses the clarity of a language, and the language of flat shape takes over the main burden of conveying meaning. In a Goya drawing of, say, two men fighting, the drama lies less in how they are seen to act in relation to each other than in the expressiveness of the configuration which their combined forms establish on the page.

And Goya uses every pretext to present his figures, not as articulated bodies, but as looming shapes, which are as eloquent in their silhouettes as they are mysterious in their identity and often their actions. There are those menacing silhouettes of shadowy figures which – especially in the prints – loom up in his backgrounds. There are his crowds, which are not a multiplicity of individuals but – even when near to the eye – a sea of faces and bodies in which separate identities are submerged. Above all, there is his use of cloak and cowl. Goya uses drapery, not as other artists use it, as a foil to the free action of the limbs and to the texture of flesh, but to disguise, to submerge, to depersonalise.

The prototype of the recurrent cloaked and cowled figure appears in Plate Three of the *Caprices*, looming up, its back to us, over a mother and a pair of terrified children. The caption is 'Here comes the bogeyman', and Goya's gloss reads: 'Lamentable abuse of early education. To cause a child to fear the bogeyman more than his father

and so make it afraid of something that does not exist.' The nameless draped apparition is more potent in the children's eyes, more real, than their father, a mere person, could be. And so it seems to have been for Goya: again and again he embodies menace or aggression in a nameless looming hulk – and this in realistic as much as in fantastic scenes, so that in *The Executions of the Third of May, 1808*, the firing-squad, their backs to us, are not men but massive threatening shapes, and the face and pose – the outflung arms – of the next victim precisely echo the face and pose of the child nearest the apparition.

The Renaissance-Baroque tradition in painting is essentially about the human figure acting in space. Not only is man the summit of natural beauty; he is the vehicle of all life. So the human figure is shown *enacting* the feelings and emotions the image is intended to convey, and representations of it acting are sufficient to embody – as the Olympian gods do – abstractions such as love and war and folly and fear, whereas in many artistic traditions passions and ideas are transmitted through a language of symbolic forms. Goya finds ways to deny the human figure that heroic role. The one area of his mature work in which the most eloquent thing about his figures is their actions in space is the bull-fighting prints – the most commercial of his subject-pictures – and here, by way of compensation, he makes it fairly plain that for him the hero is the bull.

In spite of all he owes to Rembrandt and Velázquez, and in spite of his being a highly visual painter, the dramatically telling attributes of his subject-pictures tend to be attributes characteristic of primitive and archaic art-forms – the suggestive eloquence of impersonal shapes and the vivid representation of an isolated organ of the body; and also the creation of hybrids of man and beast. Goya here has an intense obsession and a fertility of invention which set him apart from other European painters.

Yet there is still, surely, *The Naked Maja* as an affirmation of the Renaissance tradition's cult of the human body? It celebrates the sexiest skin, the most resilient flesh, the most exquisite suggestion of a line of hair running from the navel down. But the incoherent articulation – the inexplicable incompetence of the drawing of the arms, the impossible position of the breasts, the unconvincing conjunction of the head with the neck – is a virtual denial of the Renaissance

tradition's feeling for the body as a functioning whole, not an assemblage of delicious parts. Goya sees his nude as he sees the women in his portraits – as a doll.

His space, moreover, has nothing of the plenitude of Renaissance and Baroque space. It is airless, depthless, cramping, oppressive: it precludes the very possibility of heroic action. It is full of flying figures. Titian's figures in flight are solid bodies borne up by the marvellous buoyancy of the space, a space invested with an energy which counteracts gravity. Goya's space is a lifeless void, the figures float because they have no density. All his figures are weightless: their feet placed on the ground, they do not so much stand on it as brush it, like marionettes. The space is like space in dreams, the figures like figures in dreams. The fantastic scenes become nightmarish because they have the quality, the atmosphere, of dreams. And the royal portrait group, say, no less than the witches' sabbaths, appears to be happening in a dream.

But there is one area of our waking experience which gives us similar sensations – silent films. Renaissance space is the space of the proscenium stage. Goya's shallow, shut-in space, the weightlessness of his figures, his habit of compelling our gaze to zoom in on a mouth, his reliance on the expressive effect of dark flat shapes against the light or light flat shapes against the dark – all this foreshadows the shadows on the screen.

I suspect that this link with the Film Age has a good deal to do with the widespread intuitive feeling that Goya has a special relationship to our time – a feeling that tends to be rationalised with arguments that quite ignore his roots in the eighteenth century. The question of his modernity has become the *pons asinorum* of recent writers on Goya. Some seem unable to speak of him without babbling of Picasso: Sánchez Cantón, Director of the Prado, is one Spanish scholar who has a tendency that way (perhaps it's partly a gesture of conciliation from Franco Spain). On the other hand, there are those Don Quixotes of art history who, still reeling from the traumatic shock of Malraux's essay, want to see Goya as a sort of Hogarth. The late Tomás Harris rather took this position; the most extreme exponent is Professor Nigel Glendinning, who appears to perceive Goya as an illustrator of old saws and chronicler of folkways.

This view of Goya involves the notion that he was always anxious to communicate. Thus Harris expresses surprise that he never published the *Proverbs*, forgetting that the contemporaneous 'black paintings' were made for the artist's private consumption. Above all, he is anxious to establish that the *Proverbs* – the name given to the series, which Goya himself left untitled, by the posthumous publishers – are indeed illustrations of proverbs and not simply *Follies* (*Disparates*), the other name by which the series has been known on the grounds that Goya inscribed some of the individual proofs '*Disparate Feminino*', '*Disparate Ridiculo*', etc. Harris therefore expended great labour and ingenuity on discovering a Spanish proverb which Goya might have had in mind for each plate. But even allowing that Goya envisaged the series as *Proverbs*, this still does not mean that they are didactic expositions rather than irrational imaginings, since Goya would have been free to choose whatever sayings provided a pretext for making the images which his obsessions compelled him to make.

Interpretation, however, was not Harris's main intention in compiling his catalogue of the prints. His purpose was to analyse Goya's techniques, which he has done with an extremely acute eye, and to enable us 'to identify any engraving as a proof of a particular state, or as an impression of a particular edition'. In the matter of particular editions he has failed, because the task is impossible. When every distinguishing feature has been taken into account, it often happens that the crucial datum is the size of the sheet, and this criterion is often useless because sheets have commonly been trimmed (indeed, I have found instances where it seems Harris's own measurements were taken from trimmed sheets). As to the production, although these volumes contain superb illustrations of chosen engravings and details and drawings, the reproductions in the full catalogue are so small as to be illegible. No. 251 is printed in reverse.

NOTES

1 This translation, like most of those quoted here, is taken from Tomás Harris, *Goya: Engravings and Lithographs*, 2 vols, Cassirer, distributed by Faber, 1960.
2 F. J. Sánchez Cantón, *Goya and the Black Paintings*, with an appendix by X. de Salas, London, Faber, 1960.

Constable
1991

This review, entitled 'Constable's Weather', of an exhibition at the Tate Gallery, was published in the *London Review of Books* for 29 August 1991. Two phrases have been inserted.

Perhaps our weather is the main ingredient in our education as well as our conversation. Could it not be that the origin of the Englishman's phlegm is a childhood of wreckings or last-minute cancellations because of rain of long-awaited treats, inuring him for ever to disappointment? The great English painters of weather, though, did not have to submit to the weather's domination. While they recorded it with closer fidelity than any painters before or since, they were free to put it where they wanted it.

Consider the genesis of Constable's full-size sketch of Hadleigh Castle, the work described by the selector-cataloguers of his panoramic exhibition at the Tate, Leslie Parris and Ian Fleming-Williams, as 'for later generations the very epitome of Romantic landscape painting'. It was the most derelict, most desolate scene Constable ever pictured, with its ruined pair of towers set beside an endless flat expanse of land and sea and land, and, with its ferociously tempestuous sky, the most violent, strident painting he ever did. It was realised in the wake of the death in November 1828 of his wife, Maria, a death that devastated him: 'I shall never feel again as I have felt – the face of the World is totally changed to me.' He had seen Hadleigh Castle and made a tiny pencil drawing of it in a sketchbook while on a tour of south Essex in the company of a friend in June 1814, two years before his marriage. 'At Hadleigh,' he told Maria, 'there is a ruin of a castle which from its situation is really a fine place – it commands a view of the Kent hills, the Nore and North Foreland and looking many miles to sea.' There is no reason to believe that he ever saw the place again, and for nearly fifteen years there was no further sign in his work of his ever having seen it.

When he came back to the subject, he began with a small oil sketch based on the sketchbook drawing but adding a shepherd and his flock. The next development was a pen-and-ink drawing in which he articulated the shape of the definitive image: he brought the two towers

closer to each other and put a small tree between them, and, with the help of another of the memoranda in the sketchbook of the 1814 tour, tripled what he made visible of the width of the shores and sea, so balancing the presence of the ruined towers with that of a long stretch of poisonously dank, God-forsaken flatness.

In these two versions of the image and in the full-size oil sketch and again in the finished exhibition painting, he repeated the precise positions of the birds flying around the foreground tower in the 1814 memorandum: whatever changes he made, those birds, which in reality were of all the incidents on the scene the most ephemeral in their placing, remained immovable. Only in the two final oils did he introduce the gulls driven inshore which underline the turbulence of the sky common to all the versions done after his wife's death. The drawing which had been made on the spot suggests cloudy, blowy conditions (the only time I visited the site was also in midsummer, and it was fairly wet and windy and overcast). Whatever weather happened to have been found there was irrelevant when it came to composing a picture. Feeling was what determined that weather. In 1834 he told a friend: 'Every gleam of sunshine is blighted to me in the art at least. Can it therefore be wondered at that I paint continual storms? Tempest on tempest rolls – still the "darkness" is majestic.'

Constable sometimes associated his most menacing imagery with that of Wordsworth. For instance, he sent a friend a proof of his mezzotint of *Weymouth Bay* and (mis)quoted 'This sea in anger, and that dismal shore'. And certainly he could have said of himself, as Wordsworth did, that he had 'sought that beauty which, as Milton sings, / Hath terror in it'. Drawing links and parallels between Constable and Wordsworth has become one of the easy options of art scholarship. But of course there is no similarity between the experience of looking at a picture by the one and reading a poem by the other, as there is, perhaps, between looking at a picture by Turner and reading a poem by Shelley. Wordsworth is limpid, reflective, precisely evocative of the joy or panic the poet has experienced in the face of given phenomena and of the mark this has left upon him; he essentially talks *about* the phenomena, does not re-create their substance, does not make them immediate. Constable's paintings are congested,

packed with sensation, are among the most physically immediate pictures ever painted: they take us *there*.

In the finished painting, the painting prepared for exhibition as *Hadleigh Castle. The mouth of the Thames – morning after a stormy night* (one of the few major works missing from the Tate show), the weather was moderated, neutered. Here it was no longer determined by a purely personal need, but, to an extent, by an economic need. The finished pictures could fetch high prices, the full-size sketches had no commercial value, and some at least of the clientele insisted that it was not enough for him to clarify the detail: he also had to clarify the weather. As his uncle told him, in 1811, 'cheerfulness is wanted in your landscapes. They are tinctured with a sombre darkness.'

From the time around 1820 when Constable started making full-size or near full-size sketches for his set pieces, the weather was almost invariably improved in the course of translation from sketch to finished picture. This seems rather immoral from our puritanical point of view: we have been brought up to prefer the sketches and have not yet reacted against that preference, which is rooted in a belief in self-expression, a love of the ambiguities that arise from an unfinished surface, a taste for spontaneity and a prejudice that cheerfulness is less interesting than a sombre darkness. But even as we go on judging the full-size sketch of Hadleigh Castle to be a distinctly greater work of art than the exhibition version, we still have to ask whether it was entirely because of external pressures that Constable improved the weather. Could it not be that he was trying to reassure himself that painting the sketch in all its *terribilità* had had a cathartic effect upon him? Or could it not be that there had indeed *been* a cathartic effect? What is certain is that he accepted with all his heart the idea that the greatest landscape paintings he knew presented a form of earthly paradise.

Claude, he said, in one of his lectures, given in the 1830s, 'has been deemed the most perfect landscape painter the world ever saw, and he fully merits the distinction. The characteristics of his pictures are always those of serene beauty. Sweetness and amenity reign through every creation of his pencil, but his chief power consisted in uniting splendour with repose, warmth with freshness, and dark with light . . . In Claude's landscape all is lovely – all amiable – all is amenity and repose; the calm sunshine of the heart.'

While Claude was as surely the ideal and model for the great English landscapists as classical sculpture for the Italian Renaissance, there was an unruliness in Turner and Constable, as against Wilson, say, which made them radically transform rather than imitate their model. They took Claude's compositions as theatres within which to work out their personal obsessions. Turner bombarded scenes out of Claude with brilliant light, at once decomposing and transfiguring them. Turner made Claude's scenes more ethereal, Constable made them more factual. He did this in three very different ways, two of them for the land, another for the sky.

On the land he insisted that between the eye of the beholder and the serene prospect of the distances there be a close-up view, warts and all, of a messy tangle of vegetation, nettles and spikes and thorns and rotted wood, with slime and mud and murky water. Only after the eye has traversed this organic equivalent of a ditchful of barbed wire may it enter the paradise beyond.

The other way in which Constable's land is more factual than Claude's is that the human action which goes on there in the open has to do with horny-handed toil rather than the pursuit of love or war. So the reigning calm and order has manifestly been achieved through ages of human and equine labour that has kept rampageous nature – whose untidy invasiveness has been put on display in the foreground – under control. That the figures are shown performing routine daily tasks – driving wagons, fishing, opening lock gates – enhances the sense of order and well-being, the intimation that things have long been going on like this and it would be as well that they continue to do so. It is the Suffolk in which Constable grew up as the son of a miller who prospered enough to live, it was said, 'in the style of a country squire'; nor was he unaware that his pictures were testaments to his 'careless boyhood'. And he could hope that the system would go on working in his favour. 'The husbandman, after his useful labours,' said an article in the *East Anglian Magazine* in 1814, 'rejoices to see his house adorned with the work of the fine arts' (the article, admittedly, was written by a friend). At that blessed time the everyday world was itself an ideal world; by the time in the mid-1820s when Constable achieved his finest depictions of it, that harmonious world had become harshly discordant. 'From 1821,' writes Michael Rosenthal in

one of his invaluable accounts of Constable's social and ideological context, 'the East Anglian proletariat expressed its dissatisfactions by assembling riotously, breaking the threshing machines it blamed for its lack of winter employment, and firing stacks and property.' And nobody was more angry than Constable that the lower orders didn't welcome hardship.

But, then, Constable was no realist. The proof of this is that in his big pictures of home it's eternally summer, and around midday. It seems quite probable that the remark in a current publisher's blurb that Constable is 'best known for his sun-dappled landscapes of the English countryside' is not a cynical attempt to cash in on the popularity of Renoir but a slip which occurred because the writer had noticed that the landscapes were summery but not that this didn't mean they were sunny. The way in which Constable made his skies factual was, first, to make them as temperamental as skies are in England, and second, to make them as dominant as they are in Suffolk through consuming so much of the field of vision. His art is a celebration of the experience that, standing on the bank of the Stour by Flatford Mill, you can see sky everywhere around you, and the sky you see is a number of different skies, many of them threatening, and ten minutes later those skies have changed position and several new ones have appeared, and ten minutes after that they have all changed. (And there are skies to be seen there which are never seen in his pictures – for instance, a silver-gilded sky that Tiepolo might have painted.)

Constable's landscapes, then, often present a contrast between a terrestrial nature that is benign and ordered and on a human scale and a celestial nature that is ungovernable and hostile as well as vast. In speaking of Claude he said that the master's 'chief power consisted in uniting splendour with repose, warmth with freshness, and dark with light'; he gave himself the task in most of his major paintings of uniting antitheses which were far more emphatic in their opposition.

I think it was through this epic duality between land and sky that he achieved his avowed aim of endowing landscape painting with the moral significance and weight which were traditionally the prerogative of history painting. Through that duality the paintings become sermons about the antithesis between the earth, where man has some say at least in ordaining its destiny, and the skies, where man has no

control at all; they remind us that the god of the sky and of atmospheric phenomena was Zeus himself and that the skies are the playgrounds of the gods, to be used in killing us for their sport (or they remind us of the Christian equivalent, in which Constable believed, of all that bullying). Furthermore, the skies have the power to rule our feelings, in life (leaving us to turn the tables in art).

Out of doors in Suffolk or in Wiltshire menacing summer skies are a commonplace. On the small flat surface that is a picture the contrast risks producing the effect of playing the *Apassionata* during a recitation of Gray's 'Elegy'. Claude resolves his oppositions by endowing everything in the painting with the same marvellous radiance; in the sketches Constable resolves his, more testing, oppositions by endowing everything with the same mysterious opaqueness, the opaqueness of a wall of oil paint. The contradictions are dissolved because the painting is so insistent that images are not made of fields or trees or clouds, but of paint on canvas, a vibrant massing of paint with a life of its own: for instance, where there are trees, a complex of surging upward movement in the paint becomes an equivalent for the process of growth. The sketch for *The Leaping Horse* is the most marvellous of them, as everybody knows. Another which has the same miraculous combination of flickering aliveness and brooding gravity – so that at one moment it can call to mind the density of Courbet, at another the dark energy of Goya – is the sketch for *Salisbury Cathedral from the Meadows*, a work of chequered reputation often said to be badly drawn in places (which it probably is, if one is looking at pictures as if they were dogs at Cruft's).

The magnificent finished version of the same motif was the work which Constable felt was going to be considered his greatest. Here indeed is a piece that might be rated higher than its sketch – as one longs for all of them to be, in refutation of a view which has been in vogue too long – what with the spectacular way in which Constable adds a rainbow and uses the geometry of its arc as a foil to that of the cathedral's spire (their interplay, one suspects, could have given as much pleasure to Kandinsky as that of the index fingers of God and Adam). Nevertheless, by comparison with the sketch's transformation of the life of nature into the life of paint, the exhibition picture is only wonderful theatre, a Tintoretto as against a Titian.

Like virtually all the other finished set pieces, it doesn't begin to have the utter togetherness, the organic quality, of the sketches. This seems the deepest of the reasons why it was generally necessary to temper the weather in the exhibition pieces: the characteristic duality in its extreme form could not be reconciled in pictures painted as these are; instead of the opposition's being harmonised through the unifying power of paint, the scene itself had to be made more harmonious. So the opposition which could not be convincingly reconciled was the contradiction between the all too evidently laborious way with which the paint was applied in realising these pictures and Constable's ambition that his landscapes should have the freshness and brightness of the outdoors.

Moreover, the loss incurred through finishing was not only one of painterly, colouristic qualities, but also a loss of architectural qualities. In the sketch for *The Leaping Horse* the series of figures across the middle distance seems to form a frieze which evokes antique reliefs as a Poussin does. The finished picture loses the breadth of handling which imbues the image with the monumentality that engenders those associations. It goes to show how trying to please the Royal Academy could make an artist lose contact with the grand tradition.

Perhaps there are a handful of great Constables among the finished set pieces – and if there are, one of them is *A Boat Passing a Dock*, his Diploma work – but by and large this exhibition seems to me to be saying that we have been right about the superiority of the sketches and that when the finished versions are rehabilitated – as they are bound to be, since art historians are paid for being perverse – it will be for reasons not altogether remote from those for which Cabanel and Couture are nowadays considered presentable.

The exhibition is timely, given that fifteen years ago the Tate staged a Constable show which has been needing obliteration from the memory, a show which was a prime example of that contemporary phenomenon, the exhibition as life-size art book. The new exhibition is very intelligently and sensitively conceived and is well presented, though I find the background colour a bit tasteful, and, of course, the lighting in that suite of galleries is notoriously unfair to painterly pictures; its computerised machinery must have been invented in Laputa.

It is a large and demanding exhibition: one way of dealing with that

is to begin every visit with Rooms 8, 9 and 12, which cover the paintings from about 1823 onwards, and then look at some other things. There are about 200 paintings and 150 drawings and mezzotints. At least half the paintings are uninteresting other than historically, or for the way in which they are bad. The range of quality is very wide. It is scarcely believable as one stands in Room 4 that works as nervously alive as the *Weymouth Bay* from the Louvre and the intense little related sketch, No. 84, are by the same hand at about the same time as the nearby views of *Dedham Lock and Mill*, Nos 95 and 96, which are pictorial equivalents for waxworks: they look like colour reproductions. Again, in the circuit of Room 9, the picture which follows the *Hadleigh Castle* sketch, the larger version of *The Glebe Farm*, looks like a framed tin tray, hand-painted by a local artist, from Ye Olde Tea Shoppe. Yet again, the end wall of the final room is shared by *The Valley Farm* and the *Stoke-by-Nayland* from Chicago, and the juxtaposition demonstrates how a great artist nearing his end can produce, in the first case, something that looks utterly dead – because as the cataloguers put it, 'he is almost desperately adhering to earlier values, trying to preserve a basically naturalistic image in which he no longer has much faith, obsessively polishing the life out of it' – and, in the other case, a picture which, while clumsy and mucky and perhaps unresolved, movingly combines, as late works can do, evidence in its daring execution of sustained vitality with evidence in its feeling-tone of a sense of the nearness of death.

Measured, as artists should be, on the basis of his best, not his average performances, Constable got better and better, which is rare. The platitude that painting is an old man's art is only valid, when you stop and think about it, for a small minority of painters: painters are more like writers than composers in that few of them do their greatest work in their last years. And the few who do so normally reach that state through ups and downs. Constable had 'the slowest start,' as Kenneth Clark put it, 'of any painter before the time of Grandma Moses'. He moved fairly steadily towards a peak reached around 1824 and then stayed at about that level until not long before he died, at sixty-one, in 1837.

And he was pushing things further towards the end, in manifestations of 'late style' as typical as Titian's *Marsyas*. In the

Stoke-by-Nayland and the altogether luminous and perfect *Farmhouse near the Water's Edge* from the Phillips Collection, the freedom and autonomy and the wealth of metaphor in the spun and smudged and spattered paint are reaching in the directions of Soutine and Pollock and Leon Kossoff. Here is a fulfilment of the imperative which Constable had set down in 1824: 'It is the business of a painter not to contend with nature . . . but to make something out of nothing, in attempting which he must also of necessity become poetical.' The cataloguers, in the role of fuddy-duddies, ask: 'On the Phillips canvas did he, as it were, lose rather than find himself in paint?' No, he bloody didn't.

ENGLAND

Epstein *1992*

This is a revised version of a review of *Jacob Epstein: Artist Against the Establishment* by Stephen Gardiner which appeared in the *Daily Telegraph* on 19 September 1992 under the title 'Epstein. Living Like an Old Testament King'. Cuts made in the original text for reasons of space have been restored; the discussion of the book reviewed has been omitted.

Why was it that Epstein, a Polish-Jewish New Yorker, chose to make his career in England? Certainly it was not the thing for serious and ambitious American artists of his generation to stay at home; what is curious is that, having gone to Paris to study, he didn't stay on there along with immigrant contemporaries he knew and admired such as Brancusi, Modigliani and Picasso.

The explanation may be very simple. His command of French was limited; perhaps he felt that it was never going to get much better and that, being a man who enjoyed using words, he didn't want to live where he couldn't express himself with ease. There may have been no more to it than that. But other possibilities are worth considering, though not the one that he saw himself as an American in England following in the footsteps of Copley, West and Whistler: this was a role for WASPs.

Perhaps he came because he had an instinct that powerful people here were nicer and kinder than in France. Stephen Gardiner's authorised biography is subtitled 'Artist Against the Establishment', but the Establishment was not against this artist. Of course he suffered at their hands, but what is significant is not how much they opposed him but how much they supported him.

Take his first big commission and public outcry. It was remarkable that a foreigner aged twenty-six was given the demanding and prestigious job of making eighteen over-life-size stone figures for the façades of the new headquarters in the Strand of the British Medical Association. And, while the results provoked heavy controversy, it was the *Evening Standard* and its ilk that attacked him; *The Times* came to his defence. Before long the big guns of the Establishment had silenced the snipers. Nearly thirty years later, in 1935, the building was acquired by the Southern Rhodesian government, which announced its intention to remove the sculptures. Sickert wrote to the *Daily Telegraph*; the Director of the V&A, Sir Eric Maclagan, organised a letter to *The Times* the eminent signatories to which also included Kenneth Clark, Lord Crawford, J. B. Manson and H. S. Goodhart-Rendel, and the colonials gave way. (Two years later, when the stone partly crumbled so as to become dangerous to passers-by, the threat was countered in a mindless fashion which left the sculptures in place but badly mutilated.)

By and large Epstein won more battles with officialdom than he lost. His victories could be expensive for the authorities: having sanctioned his memorial to W. H. Hudson in Hyde Park, they were forever having to clean it after it had been vandalised with paints or chemicals or tar and feathers. It was the public that was against Epstein, egged on by the gutter press. As an old lady said of his *Christ*: 'I can never forgive Mr Epstein for his representation of Our Lord – so un-*English*.'

Even in his most serious losing battle he had a measure of Establishment support. This was when he fought hard to be appointed an Official War Artist rather than be called up (he had been naturalised in 1911). Though he lost, it had been touch and go. In France there would have been no argument: Braque and Léger were dispatched without question to the front. And it was French functionaries who gave Epstein the roughest ride he ever had professionally with their objections to his tomb for Oscar Wilde in the Père Lachaise cemetery. Perhaps he chose England rather than France because of an intuition not only that the authorities here were less rigid and bigoted but also that this mattered because it was going to be his fate to have more troubles with authority than most artists

do, that he was going to be one of those artists, like D. H. Lawrence, who need to take society on.

If England was the preferable alternative, there were still times when he got fed up with it. 'Here all is pettiness and prejudice. If I produced babes' heads to the end of my days I would be thought wonderful, but anything large, grand and terrible, fit for our times, is timidly shrunk away from in the timid and tepid atmosphere of our art world here . . .' This was in 1918, in a letter to an American friend. And when he was in New York in 1927 he wrote home: 'I think I will find a generous acceptance here and not the niggardly and grudging patronage I've had in England.' But not long after he was saying: 'I'm getting to hate this country and all its crude ways . . .'

With America excluded, there was a further kind of motivation for working in England rather than in France – that he had to earn a living as a sculptor, that it might not be easy to sell pieces with subjects of his own choice, that he had a gift for making likenesses in bronze, and that France offered less of a market than England for commissioned portrait sculptures. So he made portraits of many of the most remarkable individuals of our time: Conrad, Russell, Einstein, Churchill, etc. Now, ancient Egypt and Rome showed how possible it was to make very specific portraits of the great which are also sculptures of the highest order. Epstein's are interesting records but are rarely worthy of the name of sculpture: they tend to deal with features, not with forms; they present characteristic facial expressions frozen in shiny lumps of bronze which look uncouth and *de trop* (as bronze is wont to do)

The subjects which consistently provoked him to create form were babies and children, beginning with the marvellous two heads of a new-born baby which he made around 1903. He himself found this sort of work peculiarly satisfying. About the fifteen portraits he made of his daughter Peggy-Jean he said: 'I never tired of watching her, and to watch her was, for me, to work from her . . . To work from a child seemed to me to be the only work worth doing, and I was prepared to go on for the rest of my life looking at Peggy-Jean and making new studies of her . . .' And: 'I regret that I have not done more children, and I plan some day to do only children. I think I would be quite content with that, and not bother about grown-ups at

all.' However, his mastery in portraits of the young often extended to nubile women. The mastery lay in his recreation of young flesh and smooth skin, in the way he could invest those soft round shapes with life.

But Epstein's main concern was to produce imaginative compositions, mostly carved in stone, on Great Themes such as *Genesis*, *Ecce Homo*, *Consummatum est* and *Adam*. 'I have portrayed him searching, seeking, questioning, yearning – the appetites, aspirations and evolution of mankind . . . Adam is not to be regarded as primitive man, but as man in general, something of the earth, the air, the sea, the sky.' But Modernism in France rejected Great Themes. Rodin, who had handled them so superbly, was completely out of favour; Brancusi could certainly permit himself to *imply* a Great Theme in his *Endless columns*, but not to embrace it.

Epstein was completely out of tune with much of Paris-based Modernism – especially Surrealism and abstraction – and made no secret of the fact. Nor did he carry the discernment, the unrivalled discernment he showed as a collector of tribal art, art so crucial to the modern movement, into his judgements of modern artists: thus he greatly admired Modigliani while finding Braque and Léger 'dull and uninteresting'. It was his apartness from the mainstream that was to create the big divide which grew between him and Henry Moore despite his having bought some of Moore's early pieces and written a very committed catalogue preface for him in 1931. He was extremely hurt by Moore's subsequent manifestations of what he took to be disloyalty, but the gap between them had already been indicated in a comparison made in 1929 by a critic, Howard Hannay – who was totally on Epstein's side – between the carvings each contributed to façades of the new headquarters of the London Underground – Epstein *Day* and *Night*, Moore *North Wind*: 'Mr Moore represents formalism empty of meaning, while Mr Epstein has employed a very profound acquaintance with the Eastern Sculpture admired by the modern formalists and also an understanding of the modern aesthetic principles to express a meaning . . .'

It was precisely Epstein's emphasis on meaning that was an embarrassment to his protégé. The difference in their priorities is implicit in a statement about his aims which Moore published in 1937: 'It

might seem from what I have said of shape and form that I regard them as ends in themselves. Far from it. I am very much aware that associational, psychological factors play a large part in sculpture. The meaning and significance of form itself probably depends on the countless associations of man's history . . .' Moore tended to want meaning to come of its own accord; what made him feel uncomfortable with Epstein's sculptures on Great Themes was that they seemed to bang the drum about their meaning. Here Moore's ideology rooted in Picasso and Brancusi combined with his English fear of unseemliness to make him see those sculptures in a rather priggish light. It was this that lay behind his misguided putdown of Epstein as 'only a modeller' ('I am a carver'). And it was this that lay behind his participation in 1963, as a member of the Royal Fine Art Commission, in the undermining of a plan to site *Ecce Homo* in the vicinity of St Paul's. That rejection of Epstein seems pardonable, even sensible, given the great size of the carving. What does not seem pardonable is Moore's refusal in 1937 to sign Maclagan's letter to *The Times* about preserving the sculptures in the Strand.

England's unsophisticated lovers of art, however, were still literary enough in their approach to it to provide an audience for Great Themes. It was an audience that tended to be disturbed and enraged by the way they were handled, but then this whetted its appetite for more. So Epstein, as an exponent of Great Themes, became one of the great English eccentrics, an innocent visionary in the tradition of Blake. This was what made him at home here; this was the mode in which he was an artist against the Establishment.

And some of his carvings on Great Themes, such as *Elemental* and *Jacob and the Angel*, have certain strengths that complement Moore's strengths and are as fine as anything done by sculptors of his generation outside France. But they are outclassed by the best of those working inside France: Brancusi, Matisse, Picasso, Lipchitz, Laurens. Thinking of Laurens and the subdued, modest, uncelebrated life he led suddenly makes me realise to what an extent Epstein lived like a king, with his wives and his concubines and his numerous progeny, his courtiers, his scribes, his protégés, his traitors, his love of fame, his multiple residences, his voracious acquisitions of art from far away, making for heavy debts and fabulous possessions, and, of course, his

troubles, troubles often sparked by racial hatreds: an Old Testament king.

Stokes *1988*

This piece about the paintings of the great art writer was written for a number devoted to him of *Les Cahiers du Musée National d'Art Moderne* issued in Autumn 1988. It was published there in a translation by Jeanne Bouniort as 'Note à propos de Stokes Peintre'. The long penultimate paragraph is a slightly revised version of a contribution to the catalogue of *Adrian Stokes, 1902–1972: A Retrospective* at the Serpentine Gallery from 8 June to 4 July 1982.

Almost all of the great writers on art have been artists. Some have been great artists. Others have given most of their time and commitment to being artists, but more or less undistinguished ones. Some have been writers primarily who have produced art that is interesting only for those interested in them personally or in their writings. Others have been writers primarily who have produced art which could be interesting for those knowing nothing of them or of their writings. Ruskin is a clear case of this latter category, as is Artaud. And Stokes seems to be of their number.

He did not begin painting until about 1935, when he was in his mid-thirties and had some of his finest books behind him. For the first twenty years his pictures were the work of a sensitive amateur. But then a way of painting crystallised, above all in his still lifes, which produced some of the most beautiful and personal paintings of appearance done in England in the twentieth century. That is not a vast claim to make in a French publication; it is a claim that Stokes is decidedly a minor artist, but also an authentic one, an exquisite one and a poetic one. The poetry was that of painting whose manner and matter overlapped with those of both Bonnard and Giacometti but was as English as that of, say, Ben Nicholson (with whom Stokes regularly played tennis – good tennis).

However authentic it gets to be, however moving for others, performance on a *violon d'Ingres* inevitably embodies less of the

performer's being than finds its way into his primary means of expression. The qualities in Stokes's writings that do not appear in his paintings include some of the most potent. Take this passage from the chapter called 'Gasometer and Tower' in *The Invitation in Art* (1965):

'To put the matter the other way round: how Gothic is the female genital. Think of the pointed arches, fold within fold, of a cathedral door, of turret slits and narrow apertures. We pass into vaulted chambers of a foliate if chastened exuberance. But more than plants the animal, animal function, sustains this soaring, religious style. The Gothic female nude with low-sloping shoulders is a chastened animal, weasel-like, of an indomitable bestiality at the behest of God. Gothic iconography juxtaposes the sublime and the very bad: angel and gargoyle attend entry into the mother's body; even the Virgin is a dimpled weasel.'

There is nothing in the paintings of the spirited metaphor, the mordant wit, the shockingness (which, like the rudeness of Oscar Wilde's gentleman, is never unintentional), the celebration of unconscious fantasy, the constant awareness of the drama of bodily functions, the Pateresque preciosity of language, the rich variety of intricate rhythm.

What the paintings do have that is deeply characteristic of the man is a search for truth that is patient and brave, a pervasive fastidiousness of style, an unceasing sense of the transience of things and the threat of their loss, a profound respect for silence, and an attitude to art which made Beethoven intolerable, Schubert a touchstone. In painting, Stokes said, he had always been something of a conscientious objector. He amplified that remark in a statement about his painting which he wrote in 1968:

'It would be ridiculous to pretend that my fuzzy paintings of bottles, olive trees and nudes, dim as blotting paper, project an armature of the architectural effects that mean everything to me, that seem to me to express everything, all shades of the relationships in which our feelings are involved. But I have to confess that my interest as a painter – only as a painter, mind you, not as a spectator – is in an interpretation of volume that is without menace in slow and flattened progression as of the lowest relief, in which any section is as prominent or important, or is as little so, as any other section. I am interested in a status of mutual recognition, as it were, between

objects and their spaces wherein there is nothing monumental, no movement, no rigidity, no flourish, no acuteness, no pointedness, no drama. What's left? It seems a fluidity, but this too I find anathema, I mean for me. I fully admire all these qualities, but in the act of painting I don't aspire to them.'

In an attempt to say something about what the paintings do do, I shall focus on the typical still lifes. In these arrangements of glass jars, bottles, decanters and so on, the forms of the vessels echo each other mutedly, not in the way a gathering of terracotta pots in actual space will do, sonorously, roundly, the form of one celebrating the form of another, one separately apprehended for a time but soon absorbed again into the play between one and others, voices in imitation, mingling and companionably reverberating. It is as if Stokes, this full-throated choir in mind, looked, with a need for fastidious obliqueness, for a way to reduce the song, to distill it, to a whisper – or rather to something less portentous, say a discreet murmur. To this end, as it were, he diminished substantiality and space and shape. There, the excessively sonorous reverberations of the pots depends on the reaction to light of terracotta's opaqueness, thickness, dryness, earthiness; here, in Stokes, is a presence of transparent forms that look weightless, belong with water and air. Again, there, the sonority of the pots depends upon the positioning of those substantial forms in a space generous enough in depth to give room for an echo to be picked up from one by another; here the illusory space is rigorously shallow, the forms in it given a minimum of breathing-space. Again, there, the sonority depends on the affirmation of shape, on the observer's grasping the form of a form as surely as if he were firmly holding it; here the forms have a symmetry and a simplicity signifying clarity, only the clarity is contested and dispersed by the vaporous atmosphere in which the forms are poised, a luminously murky greyish-bluish-greenish-yellowish space that seems rather denser than the things it envelops.

The space becomes still more dense, more palpable, in the paintings done in the last three months of his life – when a tumour on the brain was wrecking his physical and mental co-ordination – and the objects still more luminous, regardless now of whether they are made of glass or earthenware, and the perception of volume fragmentary

and unpredictable, and the thrill of the interplay between volume and space heightened as awareness of a flower may be heightened as it begins to wilt. The arrangement of the objects now had to be left to a friend, and Stokes tended to convey dissatisfaction with it, but this did not stop him from painting: acceptance of the sight presented to the mind is precisely what the paintings are about. Two or three weeks before the end he told his wife that he felt able to paint without any restraint and exactly as he wanted. 'This is how I should have painted.'

Hamilton *1991*

Revised version of 'Seven Studies for a Picture of Richard Hamilton', written in the spring of 1991 as the catalogue introduction for a one-man exhibition at the Anthony d'Offay Gallery, London, from 20 June to 10 August. Two changes have been made: the opening paragraph of section 6 has been removed; and a new section has been inserted as section 7 of this version, so that it now consists of eight 'studies'.

I

Given Hamilton's fame as a prospector of resonant images in the day's mass media, it was fitting that he should have been the first painter to be invited by the National Gallery to choose an exhibition of pictures from its collection of old high art.

Like the other selectors for this series, *The Artist's Eye*, he was asked to complete his anthology with a work of his own, to install the exhibition and to defend it in a catalogue essay. In choosing the work of his own he resisted, typically, the temptation to which most artists succumb to select a recent work. He chose one painted thirteen years before, in 1965. It was *My Marilyn*, a piece in which a dance in paint is performed on the surface of a photographic collage. The component photographs, which are by George Barris, depict the star in various poses, and the prints which Hamilton reproduces include markings which she herself had made on them. 'Marilyn Monroe', he has explained, 'demanded that the results of photographic sessions be submitted to her for vetting before publication. She made indications,

brutally and beautifully in conflict with the image, on proofs or trans-parencies to give approval or reject; or suggestions for retouching that might make it acceptable . . . *My Marilyn* starts with her signs and elaborates the graphic possibilities these suggest.'

The model's superimpositions on images of herself, signs made with lipstick, the end of a nail file or something of the sort, and so forth, are complemented, then, by Hamilton's superimpositions of marks made with a brush skilfully manipulating oil-paint, marks made to look as spontaneous and urgent as the star's but in reality achieved through high artifice, through inheritance of the great tradition of oil-painting which filled the rest of the exhibition and most of the rooms to every side of it. On top of the raw photographs are the subject's critical comments, both elements being concerned with marketing, regardless of whatever else they communicate unwittingly, such as the photographer's personal attitude to the model or what her marks con-vey of her personality. On top of the photographs and the model's marks are the marks laid there by the artist, lovingly but also self-con-sciously. And his intervention brings in another kind of marketing: its manifest rootedness in the great tradition of 'painterly' painting con-fers artistic respectability upon these documents pilfered from mass culture and its infrastructure. Adorned with beautifully crafted oil-paint, Marilyn was on show in one of the great shrines of art. The interplay here, typical of Hamilton, between contrasting and often opposing modes of communication leads, then, to among other things a reconciliation between demotic and mandarin. Once he has a paint brush or pencil in his hand, Hamilton does have an irresistible ten-dency to civilise his brash source-material. 'I've always been an old-style artist, a fine-artist in the commonly accepted sense; that was my student training and that's what I've remained,' he wrote in 1967. Last year, in the course of a public interview by Michael Craig-Martin at the ICA, he reiterated the point: 'I have a feeling that I'm an old-fashioned artist.'

But Hamilton is still subversive enough to have found pretexts for importing into that temple of fine art bits of mass culture in a raw form. The exhibition included a television set switched permanently on. There were several further items of domestic furniture: four of Marcel Breuer's 'Wassily' chairs, an antique mirror and a plain carpet.

A well-used ironing-board with a singed cover was erected in front of a Rembrandt self-portrait as an evocation of Duchamp's epigram about using a Rembrandt as an ironing-board.

II

Defining Hamilton as the founder or father or grandfather of British Pop diminishes him inasmuch as it focuses on a secondary element in his work. His preoccupation with mass culture is only an aspect of his consuming obsession with the modern – modern living, modern technology, modern equipment, modern communications, modern materials, modern processes, modern attitudes. He has a passionate involvement in the modern for the sake of its newness. It is a realistic involvement, not a romantic fantasy like that of the Futurists, and it is manifest in his work in two distinct ways. Firstly, it shows in his marvellous eye for the contemporary scene, as in *Lobby* (which he describes as 'a kind of purgatory') – and, by the way, he is more exclusively concerned with what is precisely contemporary than the Pop artists tend to be: in Warhol and Lichtenstein there is a good deal of nostalgia for the recent past. Secondly, his commitment to the new gives rise to a dedicated use of specifically modern materials and techniques which makes one think of, say, Moholy-Nagy. (Hamilton, like Moholy-Nagy, would have been known as a typographer if he had done nothing else.)

In that interview by Michael Craig-Martin, Hamilton talked about the impact upon him of American Pop Art and how it had made him feel that in his own treatment of mass-culture material he had not had the strength to 'resist making the lyrical passage'. But then Hamilton without that lyricism – the lyricism of the English water-colourists – would be like a bird without wings. His art is naturally rarefied, luminous, ethereal. Its mass imagery does not belong to the billboard, the soup can, the Brillo box, the strip cartoon; it is imagery transmitted through a TV set. It is an art of the electronic age.

As early as 1952 Hamilton used the opportunity to occupy an entire house by moving into a brand-new one partly of his own design in a green suburban area more than half an hour away from the centre of London. He had already perceived what everyone is now realising, that in an age of electronics one can be of the city without being in the

city. He has remained of the city since his further movement out into the shires in 1978: no hint of rusticity has been allowed to penetrate his work.

It seems as inevitable that he should end up by painting with the help of a computer as that Monet should end up painting lily-ponds.

He 'fell in love', he says, with a computer dedicated to the job of image-processing, the Quantel 'Paint-box', when he became aware in 1987 of 'its ability to combine the manipulative method of the painter with the instant creativity of photography'. It fulfilled a desire which seems to have been present in the way he has used collage since the late 1950s. Works of that time, such as the *Hommage à Chrysler Corp.* series, appeared, while making it clear that they were collages, to be moving towards a seamless integration of the elements (such as Ernst came to in his collage novels). And that tendency gradually increased so that in *The citizen* of 1982–83 seamlessness was virtually achieved. In the BBC TV series, *Painting with Light*, made in 1987, Hamilton spoke of how much better it was to use the paint-box than to use scissors; his way of doing so was demonstrated as he was filmed working towards *The Orangeman* of 1988–90. The computer's capacity 'to retouch and invisibly-mend' has been used extensively in the recent self-portraits in Cibachrome and paint, in which enlargements of colour Polaroids are overlaid with Abstract Expressionist brushmarks in heavy impasto – paint which is sometimes part of the camera's subject, sometimes applied to the Polaroid and then again manipulated on the Cibachrome enlargements in an array of variations. In *Northend I* of 1990–91 and *Northend II* of 1991 there is simply no knowing where the photograph ends and the painting begins. It's as immaculate as Vermeer (who also, of course, made use of the latest technology, the camera obscura).

III

We met in 1941, when I was seventeen and he was nineteen and, having done two years at the Royal Academy Schools, was working as a jig and tool draughtsman – a further key instalment in his particular education as an artist. The place where we met was not one of those Soho pubs – known as the Swiss and the French – which a lot of artists used at the time but a nearby club, the Nightlight, located in a base-

ment in Little Newport Street, which stocked sloe gin and had cabaret in which performers such as Vida Hope and Peter Ustinov appeared. Richard was often there, accompanied by an older woman called Inge who looked every inch an Inge. They invited me one evening to a flat off Baker Street and Richard showed me a portfolio of etchings – elaborate figure-compositions, nudes done in line in which volume was conveyed by linear oval shapes within the forms, like contours on a map, which delineated the areas that would have been highlighted in a tonal drawing.

In other words, two of the key characteristics of Hamilton's work were already clearly visible: its transparency and its love of system.

Six years later he was doing those drawings inspired by Joyce's *Ulysses* which crystallised his artistic personality in a way beautifully expounded by Anne Seymour in 1980:

'The *Ulysses* drawings are Hamilton's first concerted exploration of a subject in multiple ways. They are subject pictures in the traditional sense. What is particularly important about them is that they take as parallel subject the language of which they are constructed. Hamilton conceived each illustration in a different style in order to create a visual equivalent to the changing verbal fabric of the story. Most literate of artists, he has followed Joyce's many-layered analytical approach to language to initiate something similar in his own work, instituting the principle that media and messages have equal rights and that everything has to give some sort of logical account for its presence.'

IV

In his *Artist's Eye* exhibition the eighteen works by other artists were as follows. There were religious, mythological or Shakespearian subjects by Pisanello, the Pollaiuoli, Mantegna, Bosch and Redon. There were genre subjects by Velázquez and Chardin. There were portraits by Bouts, Rembrandt, Gainsborough and Goya, and a horse by Géricault. The landscapes were the mountainous picture that used to be ascribed to Patenier, a Poussin, a Turner and a Cézanne. There was an interior by Saenredam and a still life by Courbet. But the work which had come first on Hamilton's list was van Eyck's *Arnolfini Marriage*, omitted from the actual exhibition because it had lately

been prominent in another special exhibition at the gallery and present instead in Hamilton's poster, the design for which doubled as the cover for his catalogue. 'The *Marriage* does embody', he wrote therein, 'all that I most admire in art: incredible technical mastery (in a medium that van Eyck was himself inventing) set to the service of an arcane symbolism that moves its audience with profound simplicity. It is an epiphany, a crystallisation of thought that gives us an instant awareness of life's meaning. No other art has this capacity to be entirely there, totally existent like a phenomenon of nature. When this enduring presence is charged with the spirit of one such as van Eyck, God himself can look a little hamfisted.'

Hamilton's poster for *The Artist's Eye* presents a head-on view of the *Arnolfini Marriage* partly concealed behind an angled view of an easel with a canvas bearing another treatment of the subject. 'My idea', says Hamilton, 'was that it should be as if we were looking over the shoulder of any artist confronted by the bridal couple.' And, indeed, the painting on the easel has the look of a work in progress. But perhaps it is not merely in progress. It is in a manner associated with late Cézanne, especially the water-colours, and often imitated and exaggerated by Hamilton since as far back as 1950, a manner in which the paint is so transparent and so sparely applied, by contrast with the wide areas of bare white, that there is no sense at all of certainty as to whether the painting before us is finished or unfinished. Thus there is an acute feeling of doubt as to whether the work on the easel here is supposed to be an unfinished Cézanne, a finished Cézanne, an unfinished Hamilton or a finished Hamilton. What is not in doubt is that the style of the work on the easel relates in some way to Cézanne's famous doubt and that van Eyck's original is gloriously free of doubt, is a quietly assured response to the appalling problem – all of whose difficulties are concealed – of depicting the visible, tangible world so that solid forms in space are consummately translated into coloured shapes on a flat surface with every minuscule detail taking its place in the representation of the scene as a whole. Not even in antiquity had the task been attempted with such ambition to master it totally, but it was taken for granted that, with enough loving care and attention, that ambition could be fulfilled. The painting on the easel, on the other hand, is a symbol of the doubt which is the

pain and the spur of modern art.

So Hamilton's poster commemorating the invitation to him to play a game with the art of the masters of the past is a confrontation of an image of their confidence with one of the modern artist's doubt. Beyond it lies doubt whether Hamilton's love of using this spectral late Cézannesque language derives from his sharing the widespread belief that it is the language ideally suited to conveying the modern artist's doubting approach to the questionable task of representing reality or whether it simply derives from having a fastidious nature, being miserly with paint, wanting to keep one's fingers clean. After all, Duchamp, who has long been Hamilton's idol, also made use of a late-Cézannesque manner, and Duchamp was an artist who, while troubled by doubt, was above all concerned to induce it. Among the questions that recur when thinking about Hamilton is how much he resembles Duchamp. I think that one respect in which he *is* like him is that he chooses his idioms rather than lets them choose him.

V

Hamilton's works are perhaps above all *exercises de style*. For me, study of his development – for instance, of how *My Marilyn* was immediately followed by the *Whitely Bay* series – leads to a belief that he first gets interested in some form or other of visual communication and that he then finds the sorts of subject-matter which suit that language or technique or method. In this he is the opposite of Duchamp. My belief here accords with the belief he has avowed, in regard to those remarkable exhibitions he created in the 1950s (*Growth and Form* and *Man, Machine and Motion*, among others), that the method of an exhibition could be more important than the things in it. Process precedes, images emerge.

VI

One of Hamilton's most fruitful strategies has been his particular way of following Duchamp's example in maintaining a rule of contrariness, moving along parallel tracks of activity, parallel tracks taking opposition directions, with the artist freely alternating between one and the other. The opposing aim which Hamilton chose was to try and defy Duchamp's own precept that 'retinal' painting was finished.

He decided, as he said in that ICA interview, to try and answer the question: 'How do you make retinal paintings again?'

Some of the paintings of heads and figures and interiors and land-scapes which Hamilton has made as a result of that decision have been very precise in handling. Others, such as the *Mother and Child* of 1984–85 have been very painterly. With their snapshot-like composi-tion and their air of detachment, these have been very much in the tradition of the later Degas. To be more specific, I feel that they have a particular affinity with the late paintings of Sickert. Certainly, the apparent free, open handling of paint in these Hamiltons is more the result of contrivance than it appears to be, whereas the free, open handling in late Sickert can be almost indolently casual. But the two of them are decidedly alike in their relationship to the photographs they use as models: in the brilliant way they exploit the chancy things that can happen in photographs; in the brilliant way in which they come up with just those particular photos – the one Sickert used, for example, for his full-length portrait of Edward VIII in guardsman's uniform – which somehow have an iconic potential. Another key respect in which the two of them are alike is their reticence about their personal feelings towards the subject. They seem to take life as it comes. They leave us wondering what they are thinking.

The *Mother and Child* is based on a snapshot taken by the husband and father, a snapshot the framing of which, in order to place the child firmly in the centre of the image, almost entirely cuts off the wife's face. As Hamilton said to me: 'it is the archetypal image of a child as recorded by his father'. Now, this toddler, plump and complacent and clad in white wool, is something of a monster. It looks so pleased with itself that I could kill it. Thinking about it I became obsessed for a time with the idea that somewhere in my memory there was an image of a similarly odious child, an image from a film. After two or three days of agonising I dredged it up. It was the plump smiling schoolboy in a beret and a tight suit in Buñuel's *L'Age d'Or*, the boy who suddenly appears in the grounds of the country house where a party is in progress and is fondly greeted by a gamekeeper. The boy starts getting playful, goes too far with his teasing and runs off. The gamekeeper raises his gun to his shoulder, takes careful aim and shoots him dead.

This extravagant act occurs in a context of unequivocal satire

against clerics, aristocrats and dignitaries. Hamilton never makes it clear how far he is being satirical, how far he is rather in love with the subject, and this equivocation is an aspect of the message. When he turns parts of motor cars into parts of the body in ecstasy, when he turns Lloyd Wright's Guggenheim Museum into a streamlined wedding cake, his personal feelings about what is absurd and what delightful are as unrevealed as those of the makers of those late-1930s Hollywood light comedies – with directors such as Gregory La Cava – about the antics of gilded families in Manhattan. Or as unrevealed as what Duchamp personally felt about the bride and the bachelors when he mounted a grandiose celebration of their unconsummated union.

VII

Luminosity, the radiance coming from within the image that is analogous to the light contained in carved marble, is a quality that was already evident in the *Ulysses* drawings of the late 1940s, was the very point of the quasi-abstract paintings of the early 1950s inspired by Cézanne's late water-colours, and was probably what gave their erotic shiver to the 1957–62 metamorphoses of parts of motor cars into parts of human bodies. It is the quality which makes *The citizen* of 1982–83 transcend political reportage and protest: the way the excrement is smeared over the wall is pleasingly calligraphic, but what really gives the wall its subversive poetry is its warm easeful luminosity. The corresponding panel of the pendant diptych of 1988–90, *The Orangeman*, is also an abstract composition in light, this time the light of moving headlights in a street, which is in total contrast – cold and glaring. This is a new kind of light in Hamilton. So the light that fills *Mother and child* has a brightness uncomfortable enough to have one almost reaching for one's sunglasses. And the light bouncing off the planes and mirrors of *Lobby* has a hard brilliance which rocks one back on one's heels in self-defence. In these recent paintings light becomes a medium of aggression.

Hamilton has always been a painter able to set up a satisfying interplay within a picture between an illusion of space and the affirmation of the flatness and continuity of the picture-plane. But in certain recent works the tension between the opposites has become electrifying. In *Mother and Child* the aerial perspective and shimmering light

could easily cause everything to lurch; its stability remains intact. In *Lobby* an exceedingly intricate game with reflections and duplicitous perspectives creates a complex, disorientating, vertiginous set of spaces; the sense of the picture-plane's integrity rests immaculate – yet as if everything might explode if the pent-up energy ceased to be contained.

VIII

Hamilton is a maddeningly difficult artist to place. If I keep making comparisons with film directors it is probably because he shares the film director's appetite for technology, and it has just occurred to me that the artist he has most in common with may be Godard. This despite the fact that Godard is much more spontaneous and prodigal and volatile, so that, while both produce work which rejoices in looking provisional, with Hamilton such work is usually followed at some stage by something more definitive, whereas with Godard one provisional work is followed by another.

These are qualities or obsessions which I have so far managed to identify as ones which they have in common:

A clinical clarity. A passion for white backgrounds. Especially white backgrounds running parallel to the picture-plane. And for other planes running parallel to the picture-plane, especially planes belonging to pieces of technological equipment.

An even more pronounced addiction to quotation and parody – including self-quotation and self-parody – than is fairly general among modern artists, writers, composers, etc.

A delight, in their early years, in Americana. And in the devices of advertising.

An obsession with relations between human beings and machines.

Cropping images of people provocatively. And framing isolated parts of bodies.

Quietly enjoying the steady observation of naked girls.

Showing the dramatis personae doing nothing much and investing the scene with an inexplicable sense of portent.

In their development as artists, an unpredictability which never smothers a highly personal identity. Taking a sudden leap into political commitment.

Irony in their attitude to their subject-matter, however much they are charmed with it. Basically they appear to be neutral. Even in their politically-minded works, they retain an air of detachment. Where they seem to feel passionately is in their fascination with the process involved in making their artefacts.

The constant use within the work of devices which call attention to its artificiality. We are not to forget that it's a picture. (As Godard told a critic who did forget and complained that there was too much blood in *Pierrot le fou*: It's not blood, it's red.)

Caro *1986*

Entitled 'Bits of the Cat', it was published as the introduction to the catalogue of *Anthony Caro: Recent Sculpture*, which was split between the Knoedler Gallery and the Waddington Galleries from 1 to 25 October 1986. The first article I had devoted to the artist whom I had rightly described in *The Listener* for 1 September 1955 as the best British sculptor since Moore, it was occasioned by an exhibition that was interesting rather than momentous.

A sculpture by Caro was the cause of the most unpleasant, most depressing row I ever had with a group of students. The sculpture was the large yellow steel construction called *Midday* which was one of the first embodiments of Caro's shift in 1960 from modelling to finding, cutting and welding. Being generally thought of as a key piece (thus it was to be purchased in 1974 by the Museum of Modern Art), it was chosen to represent the artist in the 1963 open-air exhibition at Battersea Park, which was where the row occurred. The students, seven or eight in number, were picked from among the sculptors at the Royal College of Art – were therefore, in principle, the *crème de la crème* of Britain's sculpture students. We used to meet one afternoon a week to talk together, and we went to that exhibition so as to talk about some specimens of new art while they were there before us. When we got to *Midday*, one of the group – one of the brightest of them – declared that he wasn't prepared to discuss the piece, as it wasn't a work of art (or maybe he said it wasn't sculpture). Only one

of the others – the most diffident of them normally – strongly opposed that posture.

Now, I myself was not strongly opposed to the disparagement of the actual work. Two years earlier at the Marlborough, a closely related work, *The Horse*, of 1961, had been the dominant piece in the second *Situation* group show organised by Lawrence Alloway. I had visited the exhibition on a Saturday morning with my two-year-old daughter, and when I encouraged her, in the presence of other visitors I knew, to climb on to the Caro and walk up and down the slope, it had not only been to show the pretty child off and keep her entertained; it had been a deliberate act of provocation directed against my friend and enemy Alloway: I had treated the piece as a piece of playground apparatus in order to imply that it was an object rather than a sculpture. This response was curious given that not only was I a keen admirer of Caro's previous work but I was also a fervent admirer of David Smith's, which had done so much to inspire Caro's change of direction. What my negativeness really meant was that Caro, in addition to turning his back on his own past, was doing something more radical than anything so far done by Smith, whose sculpture had been a wonderful but essentially comfortable extension of cubist and cubo-surrealist sculpture, the tradition of the *personnage*.

Two years later, on that distressing afternoon in Battersea Park, I had still to come to terms with Caro's newness. I shared my students' inability to accept the work, but I insisted that, since Caro's previous work had established him as an outstanding talent – nobody there denied that – any new departure in his work, however misguided it might seem, was entitled to be considered seriously, and that our duty to do this was a duty not so much to Caro as to ourselves. Uproar. They accused me of being a bully; I accused them of being like burners of books. I can't remember how it ended, but think it was with a perfunctory and embarrassed discussion of *Midday* during which at least half of the class sulked.

I have told that long story here partly because I have been waiting for two decades for a pretext to set down this instance of how aesthetic conservatism can manifest itself where we would least expect it but mainly because it has ramifications that are relevant to Caro's activity now. When Caro stopped being a modeller in mid-1959 to be reborn

early in 1960 as a welder, the metamorphosis was comprehensive – from soft, pulpy, weighty-looking forms with rough surfaces and earthy colours into hard, flat, weightless-looking forms with smooth surfaces and jazzy colours. It was like a caterpillar turning into a butterfly. And the pupal stage, given the length of a man's life, was decidedly short. It seems quite likely therefore *a priori* that the interruption could have left a residue of unfinished business, to take a phrase from psychoanalytic parlance. That unfinished business would not have been the general need to express feelings about the human body: that did not disappear from Caro's work merely because he turned from the 'figurative' to the 'abstract' (any more than the human voice disappeared from Mozart's work when he turned from writing an opera to writing a piano concerto). For instance, *Midday* can be perceived as a reclining figure (one that any self-respecting art historian would spot as the work of someone who had worked in the studio of Henry Moore).

No, the unfinished business would be more specialised. It would be an obsession with those characteristics of human bodies which have found their supreme modern expression in Dubuffet's *Corps de Dames* series, a crucial influence on Caro's work of 1954–59: the body as earth mother, soft pocket, blowsy tart, lumpy survivor, enveloping mate. Dubuffet was a key artist in Peter Selz's theme exhibition at MoMA in 1959, *New Images of Man*; others were Appel, Bacon, Giacometti, Golub, de Kooning, Richier. A review of the show in *Art News* by Manny Farber was entitled 'New Images of (ugh) man'. Caro's modelled work was loaded with *ugh*; working in steel eliminated *ugh*: if there was unfinished business, it must have had to do with *ugh*.

There was and it did. That has become clear from a number of recent works in which Caro has resumed modelling – first the female nudes in a variety of poses done from life, some of which were shown this spring at Acquavella's in New York, and then a series, shown in the present exhibition, of high reliefs – in which the modelled images of the body are framed by welded parts – which are a set of variations on an Indian sandstone carving of two flying female warriors made in the eleventh century in Madya Pradesh. However, Caro has not simply picked up where he left off. The form is fleshy and soft and

sensual again, but no longer ponderous, no longer slumped: the grunts have departed. The element of macho thumping of one's young male chest when confronted with a naked female has given way to a more tender sexiness in which Caro shows himself to be one of those rare artists who can create erotic images that are not kinky.

But while such straightforwardness of human feeling may be a plus, straightforwardness in works of art is not. The figures done from life have the fidelity to things observed of studies, and I suspect that, when the work at Acquavella's which touched me most was that in which two of the figures had been placed together, it was because the artist, merely in arranging this composition, had intervened more, imposed his temperament. By the same token, in the variations on the Indian relief, the most powerful pieces are among those in which the theme is most distorted, most transcended. The ones that are close to the theme are a joy to behold, sinuous, sensual, graceful, but in ways that echo the qualities of the prototype. Echoes lack force, and the forceful pieces in this series are to be found, it seems to me, in the works wherein the forms of the prototypes are transformed by abstraction into metaphors, mostly metaphors in which the external forms of the human creature become interchangeable with its internal landscape. Those supple bodies and lithe limbs, remoulded, become images of our entrails. The subject is 'the human clay', to borrow Auden's phrase, only not, as in the early work, through having our noses rubbed in it but through the sculpture's poetic allusiveness to elementary matters.

Yet if the best of these reliefs are those which achieve a synthesis between that direct preoccupation with the substance of the human body which was characteristic of Caro's modelled sculptures of the Fifties and the abstraction that entered his work when he started working in steel in the Sixties, this is not to say that such a synthesis has appeared only with his return to modelling – is not to say that his evocation through metaphor of a sense of 'the human clay' depends on working in clay. It started appearing in his welded sculptures around 1973 – in works such as *Durham Purse, Curtain Road, Bow, The Barrens Flat* and *Tundra* – and it is there in most of the steel pieces in this exhibition, above all, perhaps, in *Scamander, Angel Hair, Solar Wind* and *Myth*. Caro's steel sculptures of the Sixties are very much about human

gestures and stances, but they are disembodied gestures, almost dia-
grams of gestures, certainly the grin without the cat. What has been
happening since 1973 is typified by one simple technical specification
– that usually the steel has no longer been painted but has been allowed
to rust and then been varnished. To make a steel sculpture and paint it
with an overall flat colour is to confirm that it is an artificial construc-
tion made out of industrial material, is to affirm that it is an entity in
opposition to nature, is to ensure that it will resist the depredations of
natural forces; to make a steel sculpture and let it rust is to modify its
man-made look by inviting nature to play a part in its making, is to
ensure that something other than human choices and human uncon-
scious needs will determine what it is, is to affirm that art and nature
are not opposite sides of a coin but opposite ends of a line. And all this
is not just a question of method or ideology. its consequences are very
concrete and crudely palpable. Put a painted sculpture in a field and it
stands out like a pillar box; put a rusted sculpture in a field and it har-
monises like a lizard with its surroundings.

At the same time, what really mattered was that the introduction
of nature into the process of making the surface of the sculpture was
paralleled by developments in the vocabulary and syntax of its forms.
The cat's grin was enriched with reminiscences of its material being.
Only, not of the cat the whole cat and nothing but the cat, but of bits
of the cat, which, being bits, were suggestive of many and diverse
things. The surfaces, now being tonal, took on a softer look, and the
forms started giving an illusion of varying degrees of slackness and
tension. Furled, folded, tattered, curled, curving, undulating,
stretched, suspended, elastic, the forms suggest flesh, muscle, tendon,
membrane, viscera; they are especially redolent of the mysterious soft
hardness of tumescence. They present visual equivalents for our tac-
tile experiences of bodies, both their outsides and their insides, both
experiences of contact with bodies and of having bodies. And, of
course, male and female images are marvellously scrambled, espe-
cially in *Scamander*, which is at once a tunnel and a projectile. And
then a lot of art history has been absorbed: Caro could well say of
himself, what Bacon has said about himself, that he is like a pulveris-
ing-machine for existing images. There are frequent reminders, for
instance, of Picasso and of Boccioni. And both of the biggest pieces in

this exhibition have evolved from archaic Greek reliefs – *Scamander* from various lions, *The Rape of the Sabines* from the pedimental fragments from Aegina in the Glyptothek at Munich. At the same time I have a feeling that there is one mythological image which has never been a conscious starting-point for Caro, yet which makes recurrent appearances in his work: the river god. (*Scamander* had its title conferred on it after it had been cited as an example.)

When Caro, in starting to work in steel, made large pieces of sculpture that were designed to be placed on the ground and emphatically not on pedestals, there were ample formal reasons for that choice, but the basic reason was surely one of moral attitude: it symbolised a rejection of sculpture's traditional ceremoniousness. And perhaps the casual, laid-back look of Caro's art is what gives it its charm and uniqueness and even its potency. It is a look which has survived the transition from the brilliant shorthand of his early steel pieces to the more complex language and richer content of his later work. Indeed, that ease of manner has become still more telling as the sculptural form has become more dense, more baroque, more wrought.

Kossoff *1995*

The main part of the text, entitled 'Against the Odds', was written in January–March 1995, for the catalogue of the exhibition, which I co-curated with Andrea Rose, of *Leon Kossoff: Recent Paintings, 1987–94* in the British Pavilion of the Venice Biennale, 11 June to 15 October 1995, and was simultaneously published in the issue for Summer 1995 of *Modern Painters*. The 'Afterthoughts' were written in July and published, under the title 'Afterthoughts on Kossoff in Venice', in the Autumn 1995 issue of *Modern Painters*.

It is remarkable that any artists at all in our time have succeeded in trapping appearance in a way that is convincing and moving and new. Giacometti, who worked indefatigably, as Kossoff does, from the model, was plagued by the feeling that other people's art kept interposing itself between him and the sitter, so that the more he looked, the more did a screen between reality and himself thicken. I suppose

this must always have been a problem for artists concerned with appearance who were not prepared to settle for being derivative. But never as much as it is now, when the practice of art is surrounded, in museums and publications, by an unprecedented wealth of different representations of reality. It has become almost impossible to find 'a cool place on the pillow', to borrow Stravinsky's phrase. A second major inhibition for the figurative painter has been the overwhelming presence of photography and its appropriation of some of the central purposes of representational art. A third has been the legacy of Cézanne, who within the bounds of this century was taking the exploration of the problem of remaking appearance in paint to a deeper level than anyone had taken it before. The door he opened on to an enticing unknown land is one that many have felt bound to go through, only to find the terrain beyond to be crammed with potholes and bogs.

Moreover, if art is to be asked to 'return us to reality', as Francis Bacon used to put it, there is a wide range of current painting, from Brice Marden to Frank Stella, from Ellsworth Kelly to Jasper Johns, which succeeds in doing that without having to pick up the threads, broken by Cubism, of the European representational tradition. At the same time, despite the odds against them, there are artists such as Kossoff who persist in trying, as Bacon and as Giacometti did, to pick those threads up, setting out to realise the immemorial ambition to re-create, directly and wholly, the sensation of looking at a head or a figure or a tree.

Kossoff attempts to re-create his perceptions of reality on a flat surface through the application with conspicuous marks of a substantial material used in abundance and evocative of mud or clay (a splendidly obvious instance of the handling of paint as an unconscious equivalent for infantile play and fantasy). In looking at Kossoff's paintings we are constantly aware of the presence of that material. And this awareness brings recognition of the fertile contradiction in the work between the unmelting thereness of the paint's existence and the insubstantiality of what it is made to convey – visual perceptions that go flitting through the mind. The often monochromatic palette can contribute to our sense of the paint's materiality: undistracted by variety of colour, we focus on the movement of the paint as matter,

respond to its density, to its pliability, to how it has been manipulated in ways that animate the surface. I am myself especially addicted to those Kossoffs in which the resolved contradiction between image and paint is made especially evident by the inclusion among the marks of long trails of paint that do nothing to form the image but only assert the paint's presence and also that of the picture-plane – in short, the physical reality of the painting as a living thing, as against its existence as a medium through which to convey perceptions of reality – and I find that that coexistence of referential and purely gestural paint creates a heady counterpoint. But the most wonderful of the resolved contradictions in Kossoff's paintings is that between the sense of heaviness in the paint itself and the sense of light in the image, whether the palette is pale or quite dark. I have spoken of mud and clay. Mud and clay are opaque; Kossoff's paintings are luminous. It is perhaps this act of transformation above all – with its connotation of turning low into high – that makes these paintings compelling and exhilarating.

It's not only in creating light obliquely, unexpectedly, that Kossoff can be said to be among Rembrandt's descendants, with a lineage that passes through the young Van Gogh. That heritage is also present in the character of his chosen models and motifs and in his attitude to them. 'Making something out of nothing' is an aspiration that Kossoff frequently avows. His subjects tend to be everyday, down-to-earth, homely. First, family and close friends. Then nudes, female nudes, in some cases paid to pose. 'He chose no Greek Venus as his model', said a poem written against Rembrandt shortly after his death, 'But rather a washerwoman or a treader of peat from a barn . . .' Being a satire the poem translated an inclusive, a representative choice of models into a tendentious choice. Kossoff has a Rembrandtesque acceptance of the human clay. And it is an acceptance: his nudes often have a superficial resemblance to certain German Expressionist nudes, but these are there to play roles which the artist has assigned to them; Kossoff's nudes are not characters, they are beings who are there to be looked at. The paintings are not about the meaning of these women in the artist's mind, they are about the presence of these women in the artist's space.

Out of the studio there are places, always in London, where Kossoff was born and has lived most of his life. 'The pictures', he says,

'are about specific places, changing seasons and special times. But mostly . . . they are about how the human figure, passing through the streets, transforms the space by its presence.' The places are building sites; railway bridges; public swimming-baths; a parish church; the forecourts or booking halls of Underground stations; railways with the trains running along lines bordered by trees and shrubs and grassed banks. There is no equivocation in the treatment, despite the possibilities for ambiguity presented by the mystery of impasto: the images are literal, very rarely metaphorical. (One of the exceptions is *Outside Kilburn Underground (Nuclear Spring)* of 1987, translating a banal local venue into Chernobyl.) These, then, are genre paintings, but with an atmosphere that is not lowly and anecdotal but grand. The grandeur does not seem to have been imposed upon them by the artist; the artist convinces us that he has merely drawn out a quality that was inherent in the figures or the places.

Obviously, a painter's attitude to his subject mirrors and defines himself: it cannot be willed, it cannot be learned. But Kossoff's attitude certainly overlapped with that of a teacher who greatly affected him, David Bomberg. Both in fact were children of immigrants from Eastern Europe who had grown up in the East End of London. Bomberg was not on the staff of either of the leading art schools which Kossoff, born in 1926, attended between 1949 and 1956 – St Martin's and the Royal College of Art – but ran a class at the Borough Polytechnic. Kossoff's great friend Frank Auerbach, five years younger than himself, who had come to Britain when a child as a refugee from Nazi Germany, was a fellow student at both schools and also in Bomberg's class.

This now legendary class was humbly situated because Bomberg was the forgotten man of British painting. Born in 1890, he was always, from his student days until his death in 1957, among the very finest British painters of his time, but he found it extremely difficult to show or sell his work, partly because those who ran galleries, private and public, were blind to its qualities, partly because he was an uncompromising and quarrelsome human being. Driven by poverty to teach from 1944 on, this difficult and frustrated man turned out to be an inspiring teacher. Kossoff has described his class to Richard Cork: 'Bomberg was an intent teacher, showing respect for each indi-

vidual student's work; and though he was objective and concerned when talking about the emerging drawing, he always kept something of himself in reserve. I admired this. Once I watched him draw over a student's drawing. I saw the flow of form, I saw the likeness to the sitter appear. It seemed an encounter with what was already there . . . Though his deep experience of life somehow guided me, I did not have a personal relationship with him. I hardly knew him as a man . . . Although I had painted most of my life, it was through my contact with Bomberg that I felt I might actually function as a painter. Coming to Bomberg's class was like coming home.'

Bomberg's approach is epitomised by some phrases torn from one of the many theoretical statements found among his papers: 'The hand works at high tension and organises as it simplifies, reducing to barest essentials . . . Drawing flows from beginning to end with one sustained impulse . . . The approach is through feeling and touch and less by sight . . . Drawing is sculpturally conceived in the full like architecture . . . Drawing . . . reveals the unknown things . . . Style is ephemeral – Form is eternal.'

That final dictum could well have been a motto guiding Kossoff and Auerbach, for one of the strengths they share is a fine disregard for fashion. The feeling that drawing – drawing done from nature – is primary has been the basis of their way of working. But as painters they are both more extreme, more abstract, than Bomberg. Bomberg's painting is beautifully free with the brush, shows that the paint on the canvas has to have a life of its own if it is to convey life. But Kossoff and Auerbach have fulfilled that demand with more assertiveness than their mentor did, and with more daring. The time was ripe for them – Bacon, de Staël, de Kooning had led the way – to give the paint an extreme degree of autonomy. For them, this turned out to involve an extreme degree of thickness. Their daring lay above all, perhaps, in the risk that their piled-up paint, with all its associations, could induce revulsion – but one of the supreme purposes of art is to confront what is felt to be revolting and redeem it.

There were clear differences of artistic personality from the start – for example, Auerbach's tendency to create firm, clear shapes where Kossoff's forms are more fluid. Again, for some years there was a total contrast in the ways their paint thickened. Auerbach's paint – until

about 1967, when the facture began to get freer and the paint lighter
– used to be built up over a period of time. Though he did scrape it
off as well as put it on, ultimately it was an accumulation of repeated
reworkings. Kossoff has always been given to scraping the paint off
with a knife or blotting it with sheets of newspaper to leave only a
ghost of the image on the board – always a board, not a canvas – cer-
tainly at the end of each day and often several times in the course of a
day, and then beginning again. All that extremely thick paint is laid on
within a few hours: the physical execution of the final state of a paint-
ing worked on for many months has been completed in no time. The
method is analogous to Giacometti's – not in his painting but in his
sculpture, where time and again the clay or plaster was stripped down
to the armature and then completely rebuilt.

The result is a dialectic between rapid realisation of the image and
sustained involvement with a subject. And that sustained involvement
goes beyond the moment of decision that one particular image of a
subject can be left alone. For with Kossoff as with Giacometti
repeated rapid realisations of an image are followed by repeated rapid
realisations of another image of the same subject, perhaps on a differ-
ent scale, perhaps on the same scale. 'I can go on for years before the
presence of the sitter animates the painting,' says Kossoff. He stops
work on a particular landscape painting 'when I can't go on or when
the painting begins to look like the drawing made on that day or when
the image opens up a dialogue with the possibility of starting another
version'.

In recent years Kossoff's most repeated image has been – if it is not
his brother Chaim – a building, Christ Church, Spitalfields. His use
of it is rather a special case. Most of the things he has depicted in the
course of his career have been places or people that were part of his
surroundings at the time. But the neighbourhood church he has been
painting again and again was in his neighbourhood only when he was
a child, a fact perhaps reflected in the paintings – in the low viewpoint
from which the church is usually seen there. Nevertheless, they are
not painted from old memories. They are painted, as always with
Kossoff, from drawings done now, which means that the artist is com-
pelled to make frequent pilgrimages half-way or more across London.
The pilgrimage takes him into his distant past. It also takes him to an

architectural masterpiece, perhaps the greatest exterior designed by Nicholas Hawksmoor (1661–1736), perhaps the greatest of English architects.

I have said that Kossoff makes, for instance, a booking hall look grand; Christ Church, Spitalfields, a perfect marriage of power and proportion, is already as grand as any building could be. It has a wonderful density, compactness, sense of self-containment, and a rather Egyptian feeling that mysteries are enacted and protected there. A church with those qualities would have had a momentous meaning for a small boy who was Jewish. This nearby church was utterly foreign territory. In those days he would have been scared to go in for fear of being recognised as a trespasser and also for fear, if his family found out, of their seeing him as an apostate. Christ Church, that proud, severe edifice, was a forbidden place. For Kossoff to paint it again and again is not at all the same as Monet's repeated painting of Rouen Cathedral; or as Cézanne's of his childhood backcloth, Mont Sainte-Victoire. For Kossoff it means the assimilation of a hostile culture that was the norm in the place where he grew up, the culture whose normality made him an outsider. It is not surprising that there's an awe in these paintings, and a sense of vertigo.

Long before this there had been another kind of assimilation into Kossoff's psyche of a crucial aspect of English life. He had spent his first twelve years in a family of immigrants living in streets and buildings full of immigrants in a busy, crowded, impoverished area of a metropolis. When war broke out in 1939 he was one of the multitude of children of that city who were evacuated to safer parts, which in Kossoff's case meant not only a move from town to country but also being fostered by a very different sort of family from his own – one that was at home in England. The refuge where he was set down was King's Lynn in East Anglia, the great nursery of English water-colour painting and of John Constable, surely the quintessential English landscapist. Kossoff had been teaching himself to draw since he was nine, but it was when he got to East Anglia that he started to paint, and much of the painting he did was copying of the works of East Anglian painters found in the local museum. These were mostly minor artists, but he also began to discover Constable.

Kossoff's love of Constable has not brought into his work those

vast Suffolk skies, those masses of green, but it *has* brought in a handling of paint that is often akin to that of Constable's full-scale sketches. A host of English landscape painters have sought to imitate Constable's manner; Kossoff is one of a handful who have been possessed by something of Constable's spirit. Lawrence Gowing evoked that kinship when writing in 1988 of the *Here Comes the Diesel* pictures, which depict a familiar sight from a vantage-point near Kossoff's present house in north-west London:

'Catching the light and perhaps a breath of wind, this landscape shines with the freshness of the real country . . . One could more easily believe that the light shone so coolly beside the old London North Eastern, if not on the bank of the Suffolk Stour itself, the river that freshened painting for the whole of modern art . . .

'. . . The loaded brush must have passed repeatedly up and down the picture . . . On the way back from the sky as often as not a trail of white of sky colour has trickled behind the brush. Wherever it falls it leaves light, a lucent commentary on the graphic movement, an involuntary deposit of the brightness that makes the picture . . .

'I know nothing quite like this in current painting, this confessional network of the chances that betray how a painter gave himself to his image. In this picture of the Diesel, the random yet rapturous traces have some of the character of what Constable called his dew . . .'

Much of Constable's uniqueness seems to me to reside in a very particular experience often induced by his large landscapes, whether sketches or finished pictures. As I go up to the painting, its space seems suddenly to expand, the frame and the edges of the canvas seem to move outwards and virtually disappear from view, and I feel that I am standing on the brink of the actual expanse of land and sky. It may be that this effect is brought about by the force of the contrasts between areas of a radiant brightness and areas of a resonant darkness, contrasts reinforced by the sparkle that heightens both the brightness and the darkness. The consequence is an illusion of a deep three-dimensional space, a miraculous illusion inasmuch as the integrity of the picture-plane remains inviolate. The sense of freedom to enjoy that space fills me with a marvellous feeling of release. At the same time it makes me feel exposed to that space, to be vulnerable to its energy, to its weather.

Looking at Kossoff's landscapes, with their sudden contrasts of light and dark and the electric charge generated by the vitality of their paint, gives me a similar intoxicating sense of release despite the fact that here the space is uptilted so that everything is brought close. And here it is this very closeness that engenders the complementary sense that something threatens: the trees and buildings pulled towards us have the looming, menacing presence of cliffs. These paintings embody a fierce interaction between feelings of imprisonment and of liberation. It can almost be seen as a symbol of the interaction in Kossoff's work between unrelenting doubt and surging energy.

AFTERTHOUGHTS

When the final selection for the show was made on site from the thirty-three paintings reproduced in the catalogue, twenty-five works were hung, including six of the ten views of Christ Church, all big or biggish versions, two of them dated 1987, one 1990, one 1993 and two 1994, and these showed a very marked stylistic progression, over-looked in my catalogue essay. The progression has been towards a greater clarity of image, a diminution of ambiguous brushmarks.

Kossoff's typical way of handling a motif over a period of time brings to mind the sculptor's dream of releasing the image imprisoned in the block. At a certain stage in this process the work has qualities analogous to those often possessed by carvings in progress, with their irregular, broken surfaces resulting from an inconsistent degree of finish: unexpected, contradictory evocations; uneven, contradictory rhythms – whatever engenders mystery and vertigo.

With the Christ Church paintings this stage was reached in 1987 and was beginning to come to an end in 1990 in pictures such as the very large piece acquired by the Tate. Subsequent versions are generally rid of the ambiguities, the muddy, swirling waters: the ego has clearly played a larger part in their facture than the id. And in some of them, as so often happens in art when the ego takes over, there is not only a greater clarity but a pushier dexterity: in the two 1994 pictures the brushstrokes are positively feathery.

One of the habitual complications that Kossoff has eliminated is a feature to which my catalogue text avowed a particular addiction – 'long trails of paint that do nothing to form the image but only assert the paint's presence and also that of the picture-plane'. Now, Martin Gayford's essay in *Modern Painters* (summer 1995) is explicit about the origin of these 'skeins and whiskers and whipping strands that sometimes overlay the surfaces of his paintings like abstract-expressionist lace'. Gayford takes them to be 'quite simply a by-product of Kossoff's method . . . Their beauty and elegance comes accidentally as the paint flies off the brush in the artist's sweeping hand. It is mistaken to imagine him as a combination of abstract, gestural Expressionist painter, and the figurative – Jackson Pollock plus William Coldstream, as Peter Fuller once hazarded. He is an artist seriously – one might even say solemnly – committed to painting the world in which he lives.' If Gayford has got Kossoff right, which I think he has, it follows that the elimination of those delightful skeins is a desirable purification inasmuch as it helps to make Kossoff's intentions more manifest. That I am decidedly more moved by the more impure paintings is a typical instance of a consumer's preference for work in which the producer's intentions are frustrated.

Kossoff's handling of his latest outdoor motif, the crowded forecourt of the Embankment Underground station, is at the stage where image and marks are suggestively confused, especially in the big upright painting, *Embankment Station and Hungerford Bridge, Winter*, 1993–94, where the figures are adumbrated rather than delineated. Incidentally, this motif is nicely complementary to Christ Church, which presents an imposing mass in the middle of a space; Embankment Station presents a dipping void in the middle of architecture. It is a development from the theme of the train pictures, for the trains are seen at the bottom of a cutting. Only, the cutting is largely made of organic materials and the entities that move through this space are manufactured things, compact and unseeing; in the station forecourt the surrounding framework is constructed of metal and stone while the entities that move through the space are human, with an intense, nervous energy.

When Andrea Rose suggests (in her catalogue text) that Kossoff's figures hurrying through London have 'an almost Dantesque

rhythm', it seems to me that she is on the mark. This Dantesque quality may not be voluntary, but Kossoff does for me evoke one of the passages in which Eliot paraphrases the *Inferno*:

> Under the brown fog of a winter dawn,
> A crowd flowed over London Bridge, so many,
> I had not thought death had undone so many.

I feel that those intimations of hell in Kossoff's work are not confined to his crowds. Kossoff's nude women – no, naked women – have a marked and curious unease. They convey to an unusual degree some of the tensions that can exist between a sitter and the artist who is making his relentless demands on her endurance. They also seem to me to convey curious anxieties in the painter. I said in the catalogue text that these paintings are not about the meaning of these women in the artist's mind but about the presence of these women in the artist's space. That was too glib. It underestimated the degree to which the presence of someone in one's space can be disturbing at many levels. There is something in the atmosphere of these paintings that calls to my mind the unease that filled the room from which exit was impossible in Sartre's *Huis Clos*. As the play put it: 'Hell is other people.' Kossoff the man *is* something of a soul in torment.

Tension and disquiet between artist and model are mere overtones in these recent nudes; they are absolutely central to the *Two Seated Figures* of 1962 and the *Nude on a Red Bed* of November–December 1972, the large paintings which represent Kossoff in the Biennale's anthological exhibition compiled by Jean Clair, *Identità e Alterità*. With the extreme drama of their mood and the extreme violence of their facture, these have the look of expressionist pictures. They make a superb foil to the paintings in the British Pavilion, which bask there in the Venetian light looking almost serene.

The impact of the earlier pictures was so strong that some Europeans who were new to Kossoff felt that they made more *sense* than those in the one-man show. When the forthcoming retrospective at the Tate brings together the current and the earlier work, it's going to be interesting to see if the public shows a marked preference for one or the other. In the meantime it's to be hoped that the selectors will arrive at a better balance between periods than those for

the Kitaj retrospective did. It won't be easy for them, because there's such a mass of good work jostling for position.

Malcolm Morley *1990*

Entitled 'A Dance of Paint, a Dance of Death', this was the introduction to the catalogue of a one-man show at the Anthony d'Offay Gallery, London, from 11 September to 12 October 1990. The opening paragraph has been revised. Although Morley has been part of the New York scene since 1958, he is included in the present section rather than the next on the grounds that England is a state of mind.

You can turn away from the canvas to look at something else and still be assailed by the paint. The violence of its vibrations hurts, as if particles of it were being propelled in every direction. Yet, even as the picture's energy seems to fill the room, the picture-plane remains immaculate. Moreover, the image presents vertiginous spaces which behave like vortices, yet the surface still seems flat and solid as a slab of marble. The work is a paradigm of contained violence. It always has been with Morley, but the polarity becomes increasingly assertive.

Morley is very much an international artist, perhaps in rather the same way as de Kooning. Any self-respecting professional observer coming to the work for the first time would expect to be able to tell that it was painted in New York and by a European hand; he would hope to be able to tell that the hand in the one case was Dutch, English in the other. At the same time, Morley's language is peculiarly inclusive. His handling of paint seems full of quotations from or reminders of a wide variety of twentieth-century painterly painters – Pollock, de Kooning, Nolde, Kokoschka, Matisse, early Rouault, mid-Twenties Soutine (those large red areas in the recent work which seem to be Madeleine Castaing's dress).

The packing-in of masses of figurative detail means that the brushwork often evokes that of past masters: Constable's large oil-sketches come to mind; so, in all his flashiness, does Lawrence. The

other day, in the Metropolitan Museum, I was made to think of Morley by Frans Hals's picture of a Mardi Gras revel. I remembered having long ago compared this work with de Kooning's Women pictures, but that had largely been to prove a point about de Kooning's rootedness in a Dutch tradition; Morley's affinity is more comprehensive. A rearing mass of faces, lewd looks, grimacing mouths, bawdy gestures, diverse genital metaphors, thrusting movement in all directions, white impasto for the lace and the parallel pleats along the arms in a reddish dress, a mood – save in the character at top right, who has everything under control – of Dionysian fever, a Falstaff at the centre of the action, at the periphery an assortment of fleshy faces, ubiquitous ambiguities in the performance and the roles including the likelihood that the girl is a boy, pleasure pursued frantically, chaos come again.

Like the work of, say, Magritte or Jasper Johns, Morley's has been haunted by objects belonging to his boyhood. With Magritte such objects include reading primers, stereoscopic images, paper cut-outs, masks, metal puzzles, printed puzzles, comic strips, adventure books; with Johns, targets, flags, numbers, lettering, rulers, balls, maps; with Morley, tin soldiers, toy weapons, model aeroplanes, model ships, books about warfare (picture books but also things like the Biggles books) and the coronation mug which was handed out to schoolchildren at the time of the crowning of King George VI. Morley was six, and he says that the decoration of this mug has been the source of his idea of colour.

His Rosebud, lost to him when destroyed in an air raid on London, was a painted balsawood model he made of a famous warship, his favourite among several such models. It has come back, it appears, in one of the sculptures he has lately started making – a grey model of a battle cruiser mounted on a tall grey oval plinth which stands for the ocean and succeeds in evoking its depth and somehow in suggesting its perils. Like most of the eight sculptures Morley has made so far, it strongly relates in its sense of deliquescence and concomitant threat of loss to Medardo Rosso and to Giacometti. These sculptures also relate to Giacometti's, of course, in the ways in which image and base are inseparable.

Giacometti told me that he found tin soldiers in shop windows more relevant to reality than most contemporary figurative sculpture. Morley's sculptures mostly recall toy soldiers or their tanks or guns. They deal, it seems to me, with two sets of feelings experienced in boyhood. There is the feeling of attachment to certain objects which is stronger than any admitted feeling about human beings and which therefore produces acute anxiety or desolation about the fear or reality of their loss. And there is the feeling as puberty comes of the frightening force of one's growing virility together with its antidote, the identification of objects which resemble the irrepressible member in an entertaining way. Morley's two images of machine-gunners are splendidly potent symbols of this sort. The sculptures are reminders that toys are our education in the facts of death and life.

'What is fascinating now', Francis Bacon said in 1962, 'is that it's going to become much more difficult for the artist, because he must really deepen the game to be any good at all.' Morley is one of the few who seem to be deepening the game, which means, of course, always playing for high stakes. He invests exceptional technical resources in pushing pictorial languages to ridiculous extremes. Above all, his involvement in a pursuit to their limits of the drama and desperation of existence drives him as if without fear to explore the frontiers of madness.

He is not light-hearted in his use of ancient myths. Most modern artists, including Picasso, seem to be using the myths, as, say, Boucher did, as a pretext for making art of a certain sort. Morley seems to be using his art to brood upon the myths. He gives them both weight and immediacy, in a fashion which I find very reminiscent of Max Beckmann. He conveys a feeling that those were titanic days. He seems to have some urgent inner involvement with the stories which inspires the iconography he invents for them, full of new ironic conceits – for example, in that tremendous dance of death, *Black Rainbow over Oedipus at Thebes*, the way the letters in the Greek inscription across the base of the image are spaced so that they look like letters in a card for testing eyesight.

That was done knowingly. Other things done unknowingly are

even more relevant to my point. I was looking for the first time at another picture on the same scale painted a year earlier and called *Aegean Crime*. I recognised the characters from other works as being based on sculptures from which Morley had made drawings in various museums, the figure on the left being, he said, a French Romanesque Christ, the head at top right Minoan and the bust at bottom right a Roman copy of a bust of Alexander the Great. After looking at the picture for some time, awed by its atmosphere of tragedy, menace and revenge, I thought about the title and started asking myself what the subject could be. The clue seemed to be in the head at top right, its eyes veiled by a venomous green and therefore perhaps the blinded eyes of another Oedipus image. But there was too much going on that suggested a different interpretation. That dominant figure must be Clytemnestra with a baleful gaze, and the bearded head below her of a man largely submerged in water must be Agamemnon slaughtered in his bath; the Christ-like figure would be a symbol of sacrifice, while the two boats in the picture would represent, first, Agamemnon's fleet becalmed until he offered his daughter up for sacrifice, second, the vessel which brought him back to his bloody end. It was all as obvious and inevitable as the solution to a crossword clue once it is found. When I next saw Morley I congratulated him on his portrayal of Agamemnon and Clytemnestra. Politely he told me that he could not remember having heard of them. Three cheers for the collective unconscious.

Long *1994*

Entitled 'Doing Almost Nothing', this was written in the summer of 1994 as the introduction to the catalogue of an exhibition of Richard Long at the São Paulo Bienal of 1994. It was accepted for publication by the British Council, which with the artist's agreement had commissioned it, but was not found acceptable by the artist. It was therefore published in the *London Review of Books* on 20 October 1994 under the heading 'David Sylvester wrote this preface to the catalogue of the Richard Long exhibition at the São Paulo Bienal: Richard Long asked that it be left out'.

A catalogue preface, whether rhapsodic, investigative, polemical or explicative, is also meant to be a piece of advocacy. This creates a problem over writing a preface about Richard Long. He has too many admirers. A quarter of a century has passed since he began to gain an international reputation at about the time he left art school, and this reputation has steadily grown upwards and outwards. Mounting stacks of books, catalogues and articles have ensured that his very particular, ascetic, ritualistic methods and their mystique have become common knowledge. His solitary walks through the deserts of the world have come to have a scriptural resonance. To start singing his praises now is like taking a food parcel to someone who is in the middle of eating his dinner at the Ritz, or his manna in the desert.

The strength of Long's reputation, indeed, is such that he has even been spared the customary critical division of his career into good and bad periods. He might well have suffered the unkindest form of that division – the one which prizes the earlier work at the expense of the later – given that his work has been frankly limited and repetitive. But then it is quite remarkable how he can do the same things again and again without becoming mechanical: the inspiration has not flagged at all.

There is perhaps one disturbing feature that has appeared in certain of his works during the last decade. Some of these have been floor-pieces which seem – there *is* an element of subjectivity in identifying them – to be like aerial views of rocky landscapes. This gives them the look of models of something they are not, rather than assemblages of pieces of slate or sandstone or flint or marble or wood

arranged to fill a circle or a path – something that is just what it is and where it is. These illusionistic miniatures of other things in other places seem to me to strike a false note.

And then there have been wall-pieces which included arrangements of imprints of the palms of hands. The hands say that a maker has been there and has left his traces. Now, all of Long's works make it manifest that someone has been responsible for performing certain actions on that spot, either placing solids or pouring liquids or finger-painting – it is even more manifest than in works by, say, Pollock or Giacometti – that someone has been carrying out a series of moves that might well have gone on for longer and that he has desisted from making any more and has moved away, letting the work alone. But the artist's removal of himself is denied when he leaves his hands behind. There is something out of place about these signifiers, about the work's allusion to objects that are not actually present in it.

In short, there is an element of illustration in those two groups of works that is out of tune with the nature of Long's art. 'It is enough', he has said, 'to use stones as stones, for what they are.' And: 'I think all my works, my actions, have no meaning outside what they are.' The beauty of Long's work is that it is what you see, and that what you see is all that is needed to bring you to a stop and as you look to make you feel that time has stopped, and to fill you with a sense of well-being and completeness.

That sense of completeness, of inner peace, is surely bound up with an attitude of acceptance of nature that is rare in art. Western art normally colonises nature. When its tendency is romantic it takes nature over by inflicting the pathetic fallacy on it. When its tendency is classical it insists on improving nature by replacing its actual forms with ideal forms. Long's art works *with* things as they are. In the tradition of Zen.

He can occasionally be un-Zen-like, though, when talking about his relationship to nature, exhibiting a certain earnestness which I think is a part of our northern romantic heritage that Long has not discarded. Another, more significant, part of that heritage is the habit typical of English Surrealists such as Paul Nash and Henry Moore of discovering and fondling and cherishing *objets trouvés* in the form of stones. Another part is the style of the spectacular photographs Long

takes and publishes of his arrangements of those found objects within the landscapes where they were found: whether the view is mountainous or flat, these images often have a striking resemblance to compositions by Caspar David Friedrich.

Working out there in nature, then, Long is a performer in the open-air theatre of the sublime. But is this aspect of his work its main distinction? There are two possible extreme interpretations of the relationship between Long's outdoor and his indoor work. One would be that the former is the authentic work and that the latter is a pale shadow of it. The other would be that the outdoor work corresponds to the study and practice – exercises and rehearsals – carried out by a musician and that the indoor work is the actual performance. Both views are, of course, caricatures, but it seems likely that, while the outdoor work is the more physically demanding on the artist, the indoor work must be the more mentally demanding. Here, so far from having the back-up of marvellous settings or ravishing photographs of them, the material from which the work is to be made is wrenched from its natural habitat and transported to the hostile environment of a harsh, mechanical, white walled, neon-lit art gallery. Out of doors the works are like animals in the wild, indoors like animals in a city zoo, not only caged but surrounded by gawping or chattering faces. And yet it is asked of them that they create a compelling presence, a resonant silence and stillness. And they do.

And they do so without needing to evoke the transcendental, though they may. Their relatedness to the northern Romantic tradition suggests that they might well be a counterpart to the Abstract Sublime in painting. But they do not aspire to the cosmic grandeur of Newman or the cosmic energy of Pollock or the cosmic pathos of Rothko. The glory of Long's works lies in their being down to earth, in having 'no meaning outside what they are'. Meaning in those works can be defined, perhaps, in a paraphrase of a particularly elegant logical-positivist definition of verbal meaning, Moritz Schlick's 'the meaning of a proposition is the method of its verification': the meaning of a work by Long is the method of its fabrication.

Newman and Rothko exemplified the precept that 'less is more' as Mies and Malevich and Brancusi had done, through economy in the work's form. Long exemplifies that precept – and herein lies his pro-

found originality – through economy in the process of the work's making. 'I like the idea', he told Hugh Davies, 'of making art almost from nothing or by doing almost nothing. It doesn't take a lot to turn ordinary things into art.'

Turning anything into art, or any idea into art, entails, I take it, setting up a dialectic in which the interplay between the poles is vigorous enough to generate a powerful electricity. Long has spoken of a hope that his work will reconcile opposites. 'The planet', he said to Anne Seymour, 'is full of unbelievably permanent things, like rock strata and tides, and yet full of impermanences like butterflies or the seaweed on the beach, which is in a new pattern every day for thousands of years. I would like to think that my work reflects that beautiful complexity and reality.' Again, he told Richard Cork: 'You could say that my work is also a balance between the patterns of nature and the formalism of human abstract ideas like lines and circles. It is where my human characteristics meet the natural forces and patterns of the world, and that is really the kind of subject of my work.'

Within that subject he deals with such antitheses as order and chance, acceptance and control, complexity and simplicity, wholeness and fragmentation, stasis and movement. His indefatigable use of the circle and the path or line is, of course, integral to his way of generating these oppositions. For the circle and the straight line are not only paradigms of regularity but also of universality and impersonality. 'I think the very fact that they are images that don't belong to me and, in fact, are shared by everyone because they have existed throughout history, actually makes them more powerful than if I was inventing my own idiosyncratic, particular Richard Long-type images. I think it cuts out a lot of personal unwanted aesthetic paraphernalia.'

He was saying virtually the same thing as another master of concentric circles, Jasper Johns, said to explain his continual use of forms that belonged to the world at large: 'Using the design of the American flag took care of a great deal for me because I didn't have to design it. So I went on to similar things like the targets – things the mind already knows. That gave me room to work on other levels.'

Long's use of circles to work on other levels produces large-scale images on the wall and on the ground that call to mind some of the supreme portable artefacts of early antiquity. Thus the circles on walls

recall the type of Chinese ritual jade known as *bi* (a term transliterated until recently as *pi*). The *bi* is a paradigm of serenity, its immaculate form gently pulsating as the light passes over and through the jade; the opposition between stillness and movement is much more violent in most of the Long wall-works, where the hectic scrawlings and spatterings and splashings of liquid mud make the circle a blazing Catherine wheel.

Again, the circles on the floor recall the type of pre-dynastic Egyptian vessels in diorite or other hard stones in which the circular opening is set in a flat circle that is like a disc surmounting the bowl. The relationship between the random markings, in the form of white speckles on a black field, markings which agitate the surface, and the precise perfection and stillness of the surrounding circles is rather like the relationship between the units of stone or wood in a floor-piece by Long and the circle formed by their arrangement. In the vessel, of course, the irregular pattern created by the speckles is both the result of chance and beyond human control. In the floor-piece the artist has arranged things to set up a visual and perhaps philosophical confrontation and reconciliation of opposing principles wherein his placing of the sticks and stones has simulated the haphazard, while in fact establishing both the notional outline of the enclosing circle and within it a clear, distinctive rhythm, disturbing or soothing or aggressive or whatever. This sounds as if Long were far from doing almost nothing. But surely the rhythm he establishes in each work is already implicit in his choice of material? 'It doesn't take a lot to turn ordinary things into art.' It does take a lot of art.

Gilbert and George *1995*

An initial version was written for the *Guardian* as a review article about the exhibition of *The Naked Shit Pictures* at the South London Gallery in September–October 1995 and published on 8 September under the title 'Two Just Men'. During the course of the exhibition, the piece was revised and augmented.

Gilbert and George met in 1967 while they were students at St Martin's School of Art. They were as sharply differentiated in appearance and manner as, say, Morecambe and Wise: George, tall, fair, bespectacled, clerkly and manifestly Anglo-Saxon; Gilbert small, dark, dapper, handsome and presumably Southern European. The decision they made to merge was no mere entry into an alliance: their separate identities as artists were completely dissolved and fused, their *modus operandi* presented as inextricably collaborative. They were not unlike the Holy Trinity – two persons but one creator.

Their mystery was enhanced by the subversion of the traditional linguistic distinctions between painting and sculpture, painting and painter, painter and sculptor, sculptor and sculpture produced by their calling *themselves* 'living sculpture'. That the pictures they exhibited were thereby the products of a sculpture was an early example of their knack of devising preposterous statements or teasing questions that seem facetious but might be significant. It was clearly a salient feature of their work that it was double-edged.

The mysteriousness of their intentions and their double-edged effectiveness and their workaholism and their self-discipline and their readiness to take punishment in the cause of art all came together in their first widely known work, the repeated performances, beginning in 1969, of *The Singing Sculpture*. Dressed in suits and collars and ties and with hands and faces covered in metallic paint, they repeatedly mimed, all day long, day after day, 'Underneath the Arches', the music-hall song originally performed by Flanagan and Allen in the guise of a pair of Cockney tramps. It was nostalgic; it was quietly funny; it was hypnotic; it offered the fascination, as with a juggling display, of waiting on whether a slip would ever disrupt the immaculate routine; and it was very poignant.

Much of its effect was due to the remoteness, the impersonality, of the performers. Gilbert and George looked impeccably impassive, moved like automatons, were dressed like each other and like average citizens in their best suits, to become tailors' dummies, standardised objects. They managed to retain that look when they came to do performances that were energetic and expressive. In their dance to the music of 'Bend It' in their 1980 film, *The World of Gilbert and George*, the louche aroma of the taverna generated by the music, the contained violence and scarcely contained sexiness of the piston-like movements of the stiff forearms and trunks, the crescendo of stepping lightly, are all reconciled with that look of tailors' dummies in sober suitings.

And this disguise has persisted not only in G & G's performances but in the image of themselves presented in both their pictorial work and their daily conduct as living sculptures. Thus their telephone-answering machine announces, with clear, concise elocution, as if you had rung your local draper: 'Good morning. You have telephoned Gilbert and George. We are not available at present. Therefore, kindly leave a message after the tone.' The sense of mystery engendered by such affectations was such that a national newspaper became obsessed with trying to substantiate the rumour that one of them went home every evening to a wife and children in Essex.

The same sort of confusion was engendered by Magritte, who assumed a similar sort of disguise in his paintings and his performances for the media. With his impassive expression, his bowler hat and his Pomeranian on a leash, this subversive artist made himself look like a *petit bourgeois* citizen and a standardised object and a living sculpture. He did it so successfully that some writers have treated him, not as a dyed-in-the-wool Surrealist assuming a disguise, but as a Belgian man-in-the-street who happened to produce bizarre pictures.

The affinity does not end there. There are several respects in which G & G's pictorial art resembles that of Magritte. It can be witty and comical while being dramatic and erotic. It constantly deals with uncomfortable situations. It rejoices in establishing unexpected analogies. It tends to be emblematic, depicting its subjects head-on and assembling them symmetrically. And it's essentially a form of collage – seamless collage, as it doesn't technically stick its components together with paste. Above all, it's an art that is

straightforward in its mode of representation, deliberately free of aesthetic conceits, meaningful to ordinary people who do not frequent art galleries. It is concerned to achieve telling and compelling images, using painting or drawing in order to put those images there, not for art's sake. It is not about making artefacts that are good to look at; it is about making images that will change people's views of the world. 'We want to grab their souls,' said Gilbert in a recent interview by Dave Stewart.

Obviously it was the desire to communicate and dominate rather than to charm that induced G&G in the early 1970s to give up making murals drawn in charcoal, such as those dreamy panoramic landscapes including themselves, *The Shrubberies* Nos 1 and 2 of 1972, and to use photography instead (though in 1982–83 they made a group of works in which they drew parts of the body in a highly formalised adaptation of lavatory graffiti). They say they would have used photography to realise *The Shrubberies* had they been able to do so at the time, and that they did the next best thing by dirtying up the drawings in order to conceal the artist's hand. They do not want an art that shows the traces of its facture. Gilbert: 'We want to take the surface away and just have the message.'

When they turned to the camera, they used it lyrically at first, taking black-and-white snapshots – often of themselves getting drunk – that were to be grouped irregularly on the wall. They went on to use the camera more and more epically, in large monochromatic or polychromatic photo-pieces composed within a grid. The complicated technique basically consists in exposing, with the help of masking, two or more different photographic negatives on to the print, which, when stained here and there with photographic dyes and then glazed, is the work; the heavy black or white outlines which often surround the photographic images look as if they could have been made by drawing. These works are good to look at for their technical mastery alone (not the sort of compliment one can often pay to modern pictures).

While their art is like Magritte's in having a surface that is flat and uninteresting, it is very different in that the shock of the image is not cushioned by a wilfully pedestrian naturalistic style: the images are made to sing and to carry across a room. Their language varies but always exemplifies the eternal synthesis of story-telling figuration and

emphatic abstract rhythms or colours. Sometimes it recalls Léger, with areas of bright, flat, arbitrary hues. Sometimes medieval stained-glass windows come to mind, what with the thick black outlines surrounding the high colours and with the presence of the grid (not to mention that of glazing). Sometimes there is a rapid repetition of rhyming forms that evokes archaic Greek vase paintings or – given the scale – the low reliefs of the royal lion-hunt from Nineveh. Speaking of which, G & G's work is more diminished than most when seen in reproduction and not on its own scale.

One final comparison with Magritte: on the question of pictures in which the artist appears in a role. Responding to a commission for a self-portrait, Magritte painted himself in a bowler hat with most of his face hidden behind an apple; he also painted himself at table endowed with as many arms as an Indian god with which to eat and drink: his personal appearances are occasional ones in the role of a mystery man or a magician. Gilbert and George appear in almost every one of their pictures, sometimes more than once, full-length here, face-only there, or doing different things at different points. No previous artist, not even Picasso, not even Spencer, has been so ubiquitous in his work. Sometimes G & G appear as observers of the main action, sometimes in leading roles, where they perform in various histrionic ways. Normally their faces face us, but in *Bum Holes*, one of the series made in 1994 entitled *The Naked Shit Pictures*, we are confronted by back views of two undressed men, a short one who is kneeling and a tall one bending over. As George told Dave Stewart: 'One man naked is a male study; more than one, well . . . that's quite serious – two men naked are more naked than one.'

G & G's ubiquity in their work makes them like the stars of a repertory company whom we are able to follow in their assumption of a variety of different roles – in a range including kitchen-sink plays and Victorian melodrama – but of course they are more than that in that we know that these actors are also the authors. Given the mystery surrounding their partnership, we are thus kept constantly reminded that the work we are looking at has things about it that are enigmatic and problematic. Not the least problematic element is the question whether G & G's 'real' work is the corpus of their artefacts or is the living sculpture.

It was surely Marcel Duchamp who first invented that problem of where the real work lay, so that its ambiguities made him a continually fascinating artist even during those periods when he was not known to be producing any actual artefacts. And Duchamp – having started in the 1950s to be deeply influential on young artists – has been the veritable patron saint of the most conspicuous art made since the mid-1960s (Damien Hirst is an obvious example). I suspect that, if Gilbert and George have a patron saint it would have to be Duchamp. In their handling of the issue of identity even their initial coup, their merger, can be seen as a riposte to Duchamp. For at the time when a large part of Duchamp's output consisted of photographs of himself in various guises, he split himself into two identities, masculine and feminine, 'Marcel' and 'Rrose Sélavy'; Gilbert and George began with two identities and merged them into one.

And then there is the common element of mystification within the artefacts. First, the technical secrets of manufacture. More important, the question of how, conceptually, we are meant to take the work. G & G's big photo-pieces, like Duchamp's *Large Glass* and *Etant donnés*, are not simply big works of art designed to provoke big aesthetic responses: there is something deeply equivocal about what is expected of us. However forthright, however shockingly forthright, they both are in some areas, insufficient information is furnished to tell us in what spirit we are meant to react. The work may be meaningful to ordinary people, but this does not mean that the meaning is clear. Gilbert and George, like Duchamp, never forget the importance of keeping us guessing. And whenever we come up with an answer it's exactly like what Milan Kundera has said of the questions provoked by the wild situations set up by Rabelais: 'Every answer is a booby trap.'

It is as well to bring in an artist as generous as Rabelais because of the risk that I have been making G & G and Duchamp himself sound like smart alecs rather than seriously subversive artists who take serious chances. And Rabelais is particularly relevant to *The Naked Shit Pictures*, G & G's most daring series. They have made pictures about shit before, but not on this scale. Shit remains a taboo subject even now, when people have become quite difficult to shock. I am old

enough to be amazed when comedians on the BBC joke coolly about masturbation, menstruation and fellatio, but they don't come out with the jokes about excretion that were part of my prep school culture – and not, presumably, because those jokes are childish or old-fashioned but because they might give offence. We have no Pujol, Le Pétomane, the great farter-figure of French music hall.

But Gilbert and George are inveterate troubleshooters. They seem to have made it a point of honour to take on subjects from daily life that other artists have found too hot to handle. This time they have faced up to a process which, besides mattering as much as breathing and besides causing intense anxiety when it isn't working smoothly, is also, unlike eating or sleeping, a notorious source of embarrassment. G & G, as is their wont, have taken the difficult subject in their stride. The faeces they present us with are perfectly formed compact units. At the same time they are not presented on their scale in life but vastly enlarged. Blown up, they look like rocks, things that neither have an offensive odour nor leave unpleasant smears under the fingernails. These rocks are put to excellent use for the construction of totem poles, crosses and the like. Employed as building material for monuments, human excrement becomes as sociable as cowdung. And as sacred as lingams.

There is one picture in which it *is* threatening: *World*. Oddly enough, the excrement is not instantly recognisable here. The turd is seen completely foreshortened, so that it appears to be a disc, like a ginger biscuit. And it is placed right in the middle of the canvas in front of a close-up of George's face, so that his nostrils and his mouth are just behind it. Here for once we sense a whiff of ordure. This spontaneous response may be followed after a while by thoughts of the temptations of coprophagia. These in turn, given that we are looking at a round biscuit, may lead to speculation about a blasphemous version of Holy Communion. It might be called a Brown Mass. But that poor pun could equally well be inspired by the use of magnified shit to make crosses. However, since this enlargement acts as a deodorant, it can be interpreted as sanitising the subject – as, indeed, does the fact that in no less than half of the pictures in the series there is no shit on view in any form. I take it that this is because G & G felt that, while we needed to be made to face up to shit, this did not mean

that we had to have our noses rubbed in it. I also suspect that, in playing down the shockingness of shit rather than playing it up, they have wanted to leave our attention free to take it in that shit is not the central theme of the series. What brings us nearer to that theme is the thought that a man is never so far from being the master of his fate as when he is defecating, and that both excessive and insufficient movement of the bowels are the most obvious symptoms of being possessed by some kind of fear. So shit is linked in our minds with notions of our vulnerability.

But we are delving into meanings without even having taken account either of the most conspicuous visible feature of the works or of the adjective in the title of the series. Shit appears in half of the pictures; Gilbert and George appear naked in all of the pictures. In their previous work they had been naked occasionally as there had occasionally been shit. In *The Naked Shit Pictures* they are seen here and there in their sober suitings, but everywhere stark naked. And in *The Naked Shit Pictures* they are seen here and there looking cool and detached as usual, but everywhere in a state of apprehension or sorrow or panic; the famously laid-back pair cling together in desperation with a poignancy enhanced by a measure of middle-aged spread. *The Naked Shit Pictures* are about man's fate and about his nakedness in the eternal silence of infinite spaces.

In *Naked Flats* the foreground is filled by four naked men flying through the air like the rebel angels being dispatched to hell. And all the pictures are full as Renaissance pictures of male nudes posturing, gesturing, parading. And this affects the tonality: there are far fewer areas of strident colour than in recent series; flesh tints and greys are dominant. This series, dated 1994, is not reminiscent of stained glass but of Italian frescoes. It is having its first London showing, after delays in finding a venue, within the single handsomely proportioned space of the South London Gallery; hung there in two tiers, the pictures fit as if they had been designed to go there, designed to turn that space into a frescoed chapel. And at every visit I have found it difficult to drag myself away from that chapel, have felt compelled to remain in the presence of a disturbingly weighty vision of the world. This is the finest work, perhaps along with the *For AIDS* picture shown at D'Offay's in

1989, that G & G have achieved since they started in the early 1980s to make multicoloured compositions up to fifteen feet high by twenty long and thereby to bite off all sorts of difficulties which were not there when they made their marvellous smaller and less complex, crisper and less garish, black-and-white and black-and-white-and-red pieces of the 1970s.

They are outstanding artists in every context in which they might be assessed. Among their contemporaries – Nauman, Kiefer, Boltanski, Long, Cragg – they are probably supreme. Among exponents of photo-based art, going back to Hartfield, they come second only to Warhol. Among English artists, they are the successors to the line of visionary painters that runs from Fuseli and Blake and Palmer to Watts to Spencer and Bacon and Morley. They are, incidentally, perhaps the only artists who have succeeded in profiting from Bacon's large triptychs.

It was the sight of a dog's turd on a pavement that first aroused in Bacon the sense of the immanence of mortality that is so crucial in his work. Martin Gayford has lately written that Lucian Freud was dealing, like Bacon, with mortality and 'the brutality of fact'. But Bacon hit upon that phrase when trying to define a key quality which he found in Picasso and found wanting in Matisse, a quality that clearly involves a sense of the human condition, which in turn demands a measure of universality. Freud seems to see the world at close range through his own eyes only, painting attractive or repulsive sights according to his personal whim. Gilbert and George, in contrast, for all their camping it up, look at humanity at large with an instinct for the typical and a mature compassion. It is not a matter of camp when they take it upon themselves to pose together in what look like paraphrases of Masaccio's *Expulsion from Eden* (in *Naked Eye*) and Michelangelo's Rondanini *pietà* (in *Ill World*). At the same time, the compassion does not need scenes of high drama through which to express itself, let alone scenes enhanced by their evocation of classic images. It is just as poignant in the images of banal everyday acts like a man pulling his underpants up or down.

These pictures are a vision of the human race as lost souls, to borrow a phrase I have heard G & G use. They are glimpses of the emptiness of existence after the death of God. G & G are heirs of

Beckett as well as of Bacon, but more especially of Bacon because despair has a particular force in a body of images where the only acts of love are between males, are therefore acts which partake of a tragic finality. G&G's art acknowledges this disaster but at the same time grants the consolation that through deep partnership our solitude can be repaired.

AMERICANS

Newman – I

1986

This was written in 1986 under the title 'The Ugly Duckling', as one of the essays for *Abstract Expressionism: The Critical Developments*, organised by Michael Auping, the catalogue of an exhibition at the Albright-Knox Art Gallery, Buffalo, from 19 September to 29 November 1987. It was published with numerous editorial changes over which there was no consultation. The reprint is made from the original typescript with some recent revisions of my own.

Newman was born in January 1905; his earliest recorded drawing dates from 1944, his earliest recorded painting from 1945; the painting in which by his own reckoning he found himself, *Onement I*[1] dates from January 1948; the paintings in which his art reached its fullest maturity, *The Voice, Vir Heroicus Sublimis* and *Cathedra*, from 1950 to 1951. That is to say, he was forty when he produced his first known painting, around forty-five when he produced what seem the most indispensable paintings of this half of the twentieth century. Newman, then – given the resemblance of artists, not to mountaineers, with their finite ambition to scale particular peaks, but to jumpers and vaulters, with their infinite ambition to reach as far as they can (and their recognition that, whatever their success by comparison with others, they are bound to fall short in the end) – Newman was like those champion high-jumpers who delay coming into a competition till the bar is nearing its ultimate level.

His greatness was first manifest in some of the 1946 series of black-and-white brush and ink drawings with zips, beams or discs,[2] but no painting done before 1949 prepares us for the achievement during that year of *Concord, Covenant, Abraham, Yellow Painting* and *Be I* –

prepares us for either their mastery or their variety. As Athena sprang fully armed from the brow of Zeus, so Newman the artist sprang fully armed from the brow of Newman the dreamer. Such sudden realisation following prolonged meditation is not an occidental pattern of behaviour. Perhaps the resemblance to Zen art of some of those 1946 brush and ink drawings is more than skin deep.

Newman, of course, did more than meditate during his years of preparation; he wrote. He wrote, it appears, in order to define for himself what had to be done. The foremost imperative was the need to deal with ultimate things. 'The purpose of man's first speech', he wrote in 1947, 'was an address to the unknowable.'[3] And the following year: 'we are reasserting man's natural desire for the exalted, for a concern with our relationship to the absolute emotions.'[4] The next imperative was the need to be revolutionary, resolutely and unashamedly so: 'It can now be seen that the art critics who maligned Cézanne during his lifetime had a better understanding of the revolutionary implications of his art than his English and American defenders who hailed him as the father of modern art on the grounds that he was the great proponent of the art of Poussin.' The strength of modern art, its establishment of a 'basis for a continued creativeness', lay 'in its revolutionary differences, in its radicalism, in its "modernism" . . . not in the elaborate and erudite "affinities" with "tradition" that have been read into it by its apologists'.[5]

In the search for the absolute and commitment to the new, it was advantageous not to be a European, not to be steeped in a tired culture: 'I believe that here in America, some of us, free from the weight of European culture . . . are creating images whose reality is self-evident and which are devoid of the props and crutches that evoke associations with outmoded images, both sublime and beautiful. We are freeing ourselves of the impediments of memory, association, nostalgia, legend, myth, or what have you, that have been the devices of Western European painting. Instead of making 'cathedrals' out of Christ, man, or 'life', we are making it out of ourselves, out of our own feelings'.[6]

That was truly prophetic talk, talk of dreams that then come true. Newman did not say so, but it may have helped to be a Jew as well as an American, for painting was one of the delights of European culture

from which the Jews had cut themselves off, so that, when he picked up a paintbrush, the Jew, far more even than the American, was doing something uncorrupted by the boredom of ancestral habit.

But then Newman himself, at the time he was making those statements, had done little enough with his paintbrush. He simply had a compelling sense that something had to be done which was different from what artists in his culture had been doing, had an abstract intuition of what needed to be done, had an instinct that certain friends of his were doing something relevant, had an awareness of what he must actually do that was as vague as his awareness of what he must not do was exact.

'Not space cutting nor space building, not construction nor fauvist destruction; not the pure line, straight and narrow, nor the tortured line, distorted and humiliating; not the accurate eye, all fingers, nor the wild eye of dream, winking; but the idea-complex that makes contact with mystery − of life, of men, of nature, of the hard, black chaos that is death, or the grayer softer chaos that is tragedy.'[7]

Artists in that sort of situation, of knowing what their direction but not what their vehicle is to be, have traditionally found solutions with the help of art from remote times or places − Japanese prints, Byzantine mosaics, African carvings, Islamic textiles and so forth. Newman wrote about pre-Columbian sculpture, Oceanic art, Northwest Coast painting, but these did little or nothing to form his style. What does seem by common consent to have helped to do so was work by two living European artists, figurative artists: paintings by Matisse such as the *Piano Lesson* of 1916 and *Red Studio* of 1911, acquired by the Museum of Modern Art, New York, in 1946 and 1949 respectively, and the *Bathers by a River*, completed in 1917, which was exhibited in New York during the Forties; and the standing female figures of Giacometti, which made their first public appearance in a one-man show at the Pierre Matisse Gallery, New York, which opened on 19 January 1948, ten days before Newman painted *Onement I* (on his birthday) − and, if he hadn't seen the show by then, he would certainly have seen the catalogue. Hess discusses the resemblance to those figures of the 'rough hand-brushed character' of the vertical in that painting;[8] and Sandler is clearly evoking them when he writes that Newman's stripes 'can also be perceived as figures, ravaged by space'.[9]

It was not so much ironic as appropriate that Newman, while writing that 'here in America, some of us, free from the weight of European culture, are finding the answer', found his answer with the aid of European artists as steeped in European culture as Matisse and Giacometti. The point is that it was they who had had to deal with 'the weight of European culture' and that it was because Newman was free of that weight that he could deal with Matisse and Giacometti and go on from there. This, of course, was wholly characteristic of the Abstract Expressionists, who suddenly gave America its leadership of world art by seizing opportunities presented by an elaborate configuration of cultural, political and economic circumstances to achieve happy and glorious marriages between American innocence and European experience.

In the famous photograph of 'The Irascibles' published in *Life* magazine on 15 January 1951 Newman is seated at the very centre of the group. This could well have been for compositional reasons: the three most richly mustachioed men present are made to form a central isosceles triangle in which the brigand-like figures of Stamos and Rothko are on the flanks while the colonel-like figure of Newman is at the apex, while the two baldest men, Newman and Pollock, are placed one just in front of the other so that their domes hold the centre of the stage. Another, less likely, possible reason for Newman's position was that he was the neophyte of the group, having had his first one-man show only months before, whereas all the others were seasoned exhibitors; another was that his published writings had given him the role of the group's spokesman or guru or Fool. One thing is certain: he was not put in the centre because he was thought to have a central position as an artist. As an artist he was deemed by his peers – Pollock apart – to be a dud.

We tend to flatter ourselves that we are altogether better talent-spotters than our predecessors were in the days of the Impressionists and the Cubists – or even as late as the 1940s, when Mondrian died hungry. Yet Newman, who since the mid-1960s has come to be widely thought of as the greatest painter to have emerged since the Second World War, was generally ridiculed or ignored until the end of the 1950s. For instance, as late as 1959 a book as intelligent and informed

and broad in its sympathies as Sam Hunter's *Modern American Painting and Sculpture*[10] could have a chapter about Abstract Expressionist painting entitled 'Search for the Absolute' which did not include Newman among the fourteen exponents it mentioned. A discussion of events in the year 1950 – when Newman had his first one-man show – concluded: 'With Philip Guston's show of the same year, Kline's exhibition announced the last significant *new* extension of the radical abstract styles of the decade.' And the whole chapter ended: 'The paintings of Pollock and De Kooning on the one hand, and Rothko and Still on the other, continue to define the antipodes of the most vital American painting.' (Besides getting the future wrong through ignoring Newman's key position, that statement incidentally got the past wrong as well in the way it coupled Pollock and de Kooning. If the stylistic range of Abstract Expressionism is taken to cover an arc of 180°, then the relative average positions of its leading exponents might be something like this: de Kooning, 0°; Gorky, 40°; Pollock, 75°; Still, 120°; Rothko, 135°; Newman, 180°. I do not know where to put Kline.)

The rejection of Newman was, of course, the traditional fate of The Ugly Duckling, the character who appears on the scene when a member of a different species is expected. His role in the context of the Abstract Expressionists is similar to Cézanne's in the context of the Impressionists: to create a more rigorous idiom than that of his comrades while remaining involved in their kind of subject-matter. But Cézanne's art, while rejected by the world at large, was enormously admired by the artists who were close to him.

'One thing that I am involved in about painting', Newman told me, 'is that the painting should give man a sense of place: that he knows he's there, so he's aware of himself. In that sense he relates to me when I made the painting because in that sense I was there. And one of the nicest things that anybody ever said about my work is when you yourself said that standing in front of my paintings you had a sense of your own scale. This is what I think you meant, and this is what I have tried to do. That the onlooker in front of my painting knows that he's there. To me, the sense of place has not only a mystery but has that sense of metaphysical fact. I have come to distrust the episodic, and I

hope that my painting has the impact of giving someone, as it did me, the feeling of his own totality, of his own separateness, of his own individuality, and at the same time of his connection to others, who are also separate.'[10] The intention sounds abstract, moralistic. In reality it sums up exactly what the impact is of a painting such as *Vir Heroicus* or – to name a masterpiece of the following decade – *Shining Forth (to George)* (1961).

The painting's vibration alternates between its holding itself in, a totally resistant and opaque yet luminous surface, and advancing into the space between it and us as if it were reaching out to us. But only advancing towards us, not engulfing us. It is immaculately flat; at the same time it becomes three-dimensional through its animation of the space in front of it.

As against the compressed violence pervading the whole surface of a Mondrian, a Newman presents static areas interrupted by areas of explosive tension whose isolation makes them all the more aggressive: a zip can go through us from our own scalp down as if a sword were cleaving us in two. The term 'zip' is nicely chosen in that a zip is something which essentially has to do with touching: it brings out the way in which Newman is never purely visual, always tactile. Berenson wrote how Cézanne 'gives the sky its tactile values as perfectly as Michelangelo has given them to the human figure'.[12] Newman too makes every mark on his canvas – and the parts left bare – resonant with tactile values.

However large the canvas, the scale is not dominating. It is rigorously related to human scale. Thus we mentally measure the distances between its verticals in terms of the span of our own reach – by stretching out our arms in imagination, in judging how far they have to be stretched out in order to span that interval. Again, with, say, *Day One* (1951–52), the narrow tallness calls our height in question, measures our height against its greater height, makes us perceive through this shortfall our height as it is. Yet again, with the triangular canvas, *Jericho* (1968–69), the relationship of the sloping sides to a single vertical band – placed as if to mirror our asymmetry – arouses consciousness of the relationship of our arms to our flanks as we stand upright and suggests a rhythmic movement that seems to embody our breathing. In ways like this the canvas we are faced with makes us

experience a sustained heightened awareness of what and where we are.

The similar emphatic frontality of a Rothko creates a related kind of confrontation. Here we are faced with a highly ambiguous presence which seems, on the one hand, ethereal, empty, on the other solid and imposing, like a megalith. It is a presence that alternates between seeming to be receptive, intimate, enveloping, and seeming to be menacing, repelling. It plays with us as the weather does, for it is a landscape, looming up over us, evoking the elements, recalling the imagery of the first verses of the Book of Genesis – the darkness upon the face of the deep, the dividing of the light from the darkness, the creation of the firmament, the dividing of the waters from the waters. 'Often, towards nightfall', Rothko once said to me, 'there's a feeling in the air of mystery, threat, frustration – all of these at once. I would like my painting to have the quality of such moments.' And of course it does have that quality; it belongs to the great Romantic tradition of sublime landscape. Newman's art does not have to do with man's feelings when threatened by something in the air; it has to do with man's sense of himself. The painting gives us a sense of being where we are which somehow makes us rejoice in being there. It heightens, through the intensity of the presence of its verticals, our sense of standing there. With its blank surface somehow mysteriously returning our glance, it confronts us in a way that recalls confrontation with a Giacometti standing figure, that separate presence which mirrors us while it insists upon its separateness from us – and thereby sanctifies our separateness.

The *First Station* (1958), of *The Stations of the Cross*, is a variant on that confrontation. The freely brushed marks surrounding the zip make this a supreme example of Sandler's stripe like a figure 'ravaged by space', but the form adumbrated by those marks also evokes a more specific image – that of the Crucifixion, especially as it is realised in Cimabue's great Crucifix from Santa Croce, with the figure that Francis Bacon sees as 'a worm crawling down the cross . . . moving, undulating down the cross'.[13] The *First Station* is not explicitly said to be a Crucifixion, but the words spoken from the cross are the source of Newman's subtitle for the series, *Lema sabachtani*, and, according to Annalee Newman, that phrase was his first

choice for the main title, rejected because of a fear that it was too arcane. And *pace* Lawrence Alloway's statement in his authoritative catalogue preface that 'it would be a serious misreading of the work to consider it in formal terms as a theme and variations',[14] it seems to be rather perverse not to consider it as just that and as a work which might more fittingly have been entitled *Variations on the Cross*. For *The Stations of the Cross* is a title appropriated from a traditional iconography which deals with a succession of various events involving various characters and happening at various places, whereas the series Newman painted consists of a set of variations which, according to its appearance and its subtitle, relate to one event involving one protagonist and one place.

Whatever the suggestions that may arise in a Newman of the presence of a figure, the essential presence is that of the place in which the beholder feels his own presence. Our participation in a Newman is never the envelopment which a Pollock and a Rothko both create in their different ways; a Newman creates a space in which we feel ourselves fixed, but always as separate from the painting. Hess persistently equated this thought of a place where a man stands with the cabbalistic concept of *Makom*.[15] Rosenberg riposted that, for Newman 'the Kabbalistic "makom", central as it is in his conception of meaning, is synonymous with such other privileged "places" as Indian burial mounds in Ohio and the pitcher's mound at Yankee Stadium.'[16] His rejection of his friend's desire to turn Newman into a traditional Jewish mystic leads Rosenberg on into a neat summation of his way of thinking: 'Newman's enthusiasm for Jewish mystics and their sayings was a matter of poetic delight in their eloquent symbolism, as if they were a tribe of East European Mallarmés to which he could feel himself akin, rather than a matter of religious or philosophical solidarity – a facet of his childlike response to wonders and to illuminating phrases, whatever their source. As with other artists of our time, Newman's readings and concepts produced not an organised outlook but a kind of metaphysical hum that resonates in his paintings and indicates their mental character.'[17]

'For Newman', Rosenberg continues, 'painting was a way of *practicing* the sublime, not of finding symbols for it.' Practicing the

sublime meant making paintings capable 'of giving someone, as it did me, the feeling of his own totality . . .' And the paintings do indeed make one feel whole. They restore, they induce a sense of integration. They have the therapeutic action that Matisse said he wanted his work to have, and believed it did have, as in the famous story of how, when he and Francis Carco were staying at the same hotel and Carco went down with flu, Matisse brought in several of his paintings and hung them on the wall before going off for the day.[18]

Matisse's most elaborate attempt to make an art that would heal and exalt was the Chapelle du Rosaire at Vence.[19] Standing or seated there in the light of its coloured windows, we can feel cleansed of disquiet and depression, restored to ourselves. But we are not transported into a stratum that has 'a kind of metaphysical hum': the imagery is too specific, too close to nature. In both of the windows along the north wall the overall shape suggests that of a chasuble stretched out in performance of the liturgy; at the same time, the repeated rows of repeated shapes within clearly present a series of pairs of parted thighs: it is a nice counterpoint of images of sacred and profane love. But it does not go beyond being an exhilarating play of idealised natural forms; it involves no communion with 'the unknowable'. Newman, on the contrary, does evoke something of the mystery of being. His imagery, as I've said, does not give us the *landscape* of the first chapter of the Book of Genesis; his art does give us the primal *command* of the Book of Genesis. 'In the beginning . . . the earth was without form, and void . . . And God said, Let there be light: and there was light.' Earth could be given form, according to that book, only when there was light. Now, to say that Newman's fields of colour are always emanations of light is to speak of something he has in common with Matisse and all Matisse's valid heirs; but Newman's light has something more, something that provokes thoughts of primordial light. That something is a violence. Newman's zip, as I said before, can seem to go clean through us. In French a zip is *une fermeture éclair*, 'a lightning fastener'. The zip in Newman's paintings is a bolt of lightning, with the speed and violence of a *revelation* of light. That is one aspect of his evocation of the mystery of being. The other is that intense awareness of our bodies and where they are which he induces through confronting us with

perpendicular forms as unspecific and as resonant as the columns of a Doric temple.

In front of *Vir Heroicus Sublimis* Le Corbusier's words keep coming back to mind: 'Remember the clear, clean, intense, economical, violent Parthenon – that cry hurled into a landscape made of grace and terror. That monument to strength and purity.'[20] And the searing quality of the white zip frequently brings back another image of a temple: 'And, behold, the veil of the temple was rent in twain from the top to the bottom . . .' In checking whether I had remembered the wording correctly, I rediscovered the wording of the context: 'Now from the sixth hour there was darkness over all the land unto the ninth hour. And about the ninth hour Jesus cried with a loud voice, saying, Eli, Eli, lama sabachthani? That is to say, My God, my God, why hast thou forsaken me? . . . Jesus, when he had cried again with a loud voice, yielded up the ghost. And, behold, the veil of the temple was rent in twain from the top to the bottom . . .'[21] The sublimity of Newman's art follows from how its order and wholeness include disruption and destruction, and contain them.

NOTES

1 ' . . . the painting where I had only the one symmetrical line in the centre of the canvas – with no atmosphere or anything that could be conceived as natural atmosphere – I did in 1948 on my birthday . . . I don't paint in terms of preconceived systems, and what happened there was that I'd done this painting and stopped in order to find out what I had done, and I actually lived with that painting for almost a year trying to understand it. I realised that I'd made a statement which was affecting me and which was, I suppose, the beginning of my present life, because from then on I had to give up any relation to nature, as seen . . . That painting called *Onement I*: what it made me realise is that I was confronted for the first time with the thing that I did, whereas up until that moment I was able to remove myself from the act of painting, or from the painting itself . . . The painting was something that I was making, whereas somehow for the first time with this painting the painting itself had a life of its own in a way that I don't think the others did, as much.'
From an interview with Newman by David Sylverster recorded in New York, Easter 1965, and included in *Barnett Newman: Selected Writings and Interviews*, ed. John P. O'Neill, New York, Knopf, 1990.

2 Cat. nos 30–46 in Brenda Richardson, *Barnett Newman, The Complete Drawings, 1944–1969*, Baltimore Museum of Art, 1979.

3 'The First Man Was an Artist', *Tiger's Eye*, no. 1, New York, October 1947.

4 'The Sublime is Now', *Tiger's Eye*, no. 6, New York, December 1948.

5 'The Problem of Subject Matter', written *c.* 1944 but unpublished until incorporated into Thomas B. Hess's catalogue introduction in *Barnett Newman*, New York, Museum of Modern Art, 1071, pp. 39–41.

6 'The Sublime is Now'.

7 Catalogue foreword in *The Ideographic Picture*, Betty Parsons Gallery, New York, January 1947.

8 Hess, op. cit., p. 57.

9 Irving Sandler, *The Triumph of American Painting: A History of Abstract Expressionism*, New York/Washington, Praeger, 1970, p. 190.

10 New York, Dell, 1959.

11 From the interview quoted in note 1 above.

12 Bernard Berenson, *Italian Painters of the Renaissance*, Book III, chapter XII.

13 David Sylvester, *Interviews with Francis Bacon*, 1975, p. 14.

14 Lawrence Alloway, 'The Stations of the Cross and the Subjects of the Artist', in *Barnett Newman: The Stations of the Cross: lema sabachthani*, New York, Guggenheim Museum, 1966, p. 13.

15 E.g., Hess, op. cit., p. 73.

16 Harold Rosenberg, *Barnett Newman*, New York, Abrams, 1978, p. 79.

17 Ibid., pp. 81–3. This and the previous quotation are extracted from concluding pages which redeem a generally disappointing text, too much given to peevish tickings-off of critics such as Clement Greenberg who recognised Newman's qualities as a painter long before Rosenberg did. Hess, of course, was another late convert. So was the present writer – who might have come to Newman later still without Alex Lieberman's prompting.

18 Francis Carco, 'Souvenir d'Atelier: conversation avec Matisse', *Die Kunst-Zeitung*, Anjou, 8, 1943.

19 Statement in La Chapelle du Rosaire des Dominicians de Vence, 1951.

20 Translated thus in Peter Blake, *Le Corbusier: Architecture and Form*, Maryland, 1964, p. 124.

21 Matthew 27: 45–6, 50–1 (Authorised Version).

De Kooning – I 1993

Entitled 'Flesh was the Reason', this was initially written in 1993 as one of the catalogue essays for *Willem de Kooning: Paintings*, of which I was a co-curator, at the National Gallery, Washington, from 8 May to 5 September 1994; the Metropolitan Museum of Art, New York, from 11 October 1994 to 8 January 1995; and the Tate Gallery, London, from 15 February to 7 May 1995. The text given here incorporates some small additions, deletions and changes made in March 1995.

I

The Dutch masters of the seventeenth century worked at home, the Dutch masters of modern times worked abroad. Van Gogh first left Holland when he was twenty and was elsewhere for all but five of his remaining seventeen years; Mondrian first left at forty, was elsewhere for all but five of his remaining thirty-two years; de Kooning first left at twenty, has been elsewhere for all but one of seventy years.

There is nothing remarkable about their emigration: it has been the lot of leading modern artists born in Spain and Germany, Mexico, Russia, Korea, and everywhere else. Artists have always emigrated, because artists, for economic and for psychological reasons, are impelled to congregate. What is significant is that the artists of the first great age of Dutch painting congregated at home. The cream of their Flemish and French contemporaries worked abroad, the Dutch mainly stayed where they were – and stayed isolated from foreign painters, other than immigrants from Flanders. None came from farther abroad: painters were poorly paid, especially the best painters. So this small country, full of keen but often naïve and penny-pinching collectors, had a dozen great native painters working there in the course of half a century, whereas each of that trio of great painters born there in the half-century between 1853 and 1904 left, and left for good, each to become one of the most influential painters of his time. Being abroad did nothing for them financially, until de Kooning started making money in his mid-fifties, but it did enrich their work with an exceptionally fruitful interplay between their background and their foreground.

Thus the evolution of Mondrian's distinctive style between 1910

and 1921, an evolution the mere thought of which suffices to give aesthetic pleasure, was utterly bound up with his spending two years in Paris at the time he did and five in Holland at the time he did before returning to Paris. And when in his old age he took that style with him to New York, a style in which Holland's endless uninterrupted horizon can be apprehended in infinitely extendable straight lines, he broke up those lines into short staccato units in response to that city's hectic pace and current possession by a musical idiom that insisted relentlessly on its eight beats to a bar. In total contrast, the achievement de Kooning took with him to America in 1926 was no more than his training, which he remained very conscious of and talked about for as long as he talked about art, his daughter Lisa has told me. 'When I went to the Academy . . .' was a frequent opening to a sentence, as when he said in 1960: 'It's not so much that I'm an American: I'm a New Yorker. I think we have gone back to the cities and I feel much more in common with artists in London or Paris. It is a certain burden, this American-ness. If you come from a small nation, you don't have that. When I went to the Academy and I was drawing from the nude, I was making the drawing, not Holland. I feel sometimes an American artist must feel like a baseball player or something – a member of a team writing American history.'[1]

Three years later de Kooning left the city and moved to Springs, by East Hampton, Long Island, painting there for a quarter of a century till he stopped working four or five years ago. Now, it is true that this is an area where a lot of artists have lived, but few with such immersion in the place. And the place, as everyone recognises, is remarkably akin, in its light and the lie of its land and water, to Holland. Visiting Louse Point, one of the spots there that was most crucial for de Kooning's painting, I had the feeling that I'd been projected into a landscape by Van Goyen and realised that the emigrant was still at home.

II

'You are with a group or movement', he said in 1949, 'because you cannot help it.'[2] The group or movement he was with was one of those that have in common a certain stance, not a certain style. It was not a movement like Impressionism or Fauvism or Cubism or Futurism

where a work by one of its leading members can easily be thought to
be by another. Abstract Expressionism was a movement in the same
sense as *Der Blaue Reiter* or Dada or Surrealism. Even the artistic per-
sonality of Pollock, superficially de Kooning's nearest neighbour
stylistically among the founding members, is as different from de
Kooning's as, say, basketball, with its continuous movement flowing
all over the court, is from gridiron football, with its convulsive, inter-
rupted action. Or, we might say that one is like pasta, the other like
pizza. A Pollock presents an intricate entanglement of long strands in
the interstices of which we can discern a sauce, so to speak, and
various fragments of flora and fauna. A de Kooning presents a melted
mix in which some of the widely contrasting ingredients remain dis-
tinguishable while others have been smeared out of recognition. And
it has a sort of outline usually – nothing so clear as that of a disc or a
slice but still a shape containing the composition as against the inde-
terminate edges of a Pollock composition.

Whatever the energising effect of de Kooning's whiplash line, his
primary ingredient is the paint. 'I get the paint right on the surface,'
he'd say to his friend Emilie Kilgore. 'Nobody else can do that.' The
paint occupies that surface like a living and life-generating and decom-
posing substance within which there abound forms some of which are
recognisable, most are ambiguous and some are unidentifiable.

Confronted with a work in the Surrealist tradition that is full of
ambiguous references – and this, of course, can mean a work by
Gorky, de Kooning's mentor, as well as by Miró or Masson – the
spectator separates and savours the elements in the metamorphic
image one by one. But the impact of a de Kooning lies in a more direct
and physical response to the paint itself, so that the sense of external
reality this conveys – say, of the immediate, enveloping presence of
pink flesh ('Flesh was the reason why oil painting was invented'[3]) or
the insidious ubiquity of mouths with menacing teeth (human female
smiles, sharks' mouths, *vaginae dentatae*) – is not so much a consecu-
tive recognition of the elements in the flotsam and jetsam of
perceptions as a general awareness of reality as an all-absorbing
Heraclitean flux.

What typically happens is something like what Braque describes as
happening in paintings of his own. Given how deeply de Kooning's

art is rooted in Cubism, it was not by chance that the speaker was one
of the founders of Cubism; nor was it by chance that Braque was talk-
ing primarily about his current work in the 1950s, not far from the
time of de Kooning's black and white paintings:

'No object can be tied down to any one sort of reality: a stone may
be part of a wall, a piece of sculpture, a lethal weapon, a pebble on a
beach, or anything else you like, just as this file in my hand can be
metamorphosed into a shoe-horn or a spoon, according to the way in
which I use it . . . So when you ask me whether a particular form in
one of my paintings depicts a woman's head, a fish, a vase, a bird, or
all four at once, I can't give you a categorical answer, for this "meta-
morphic" confusion is fundamental to what I am out to express . . .
And then I occasionally introduce forms which have no literal mean-
ing whatsoever. Sometimes these are accidents which happen to suit
my purpose, sometimes "rhymes" which echo other forms, and some-
times rhythmical motifs which help to integrate a composition and
give it movement . . . Objects don't exist for me except insofar as a *rap-
port* exists between them or between them and myself.'[4]

Differences are that the pace of the flux in Braque tends to range
from adagio to andante, in de Kooning from allegretto to presto, and
that the things in Braque's flux tend to be things that can be held in
the hand, seen indoors, or taken indoors, whereas the imagery in de
Kooning's flux is wider, more elemental, wilder.

III

De Kooning hated modernist movements for being reductive, for
being categorical about what artists must not do, for being dictatorial
as to what they had to eliminate: 'Of all movements, I like Cubism
most. It had that wonderful unsure atmosphere of reflection – a poetic
frame where something could be possible, where an artist could prac-
tice his intuition. It didn't want to get rid of what went before. Instead
it added something to it. The parts that I can appreciate in other
movements came out of cubism. Cubism became a movement, it
didn't set out to be one.'[5]

The relationship to Cubism of de Kooning's own work lies in the
very general indebtedness manifest, say, in how the black paintings of
the late 1940s (notably the one in the Museum of Modern Art) use the

Cubist lingua franca of planes cut out into irregular shapes and put together in a low-relief-like space. Beyond that de Kooning's work was quite specifically influenced at one time or another by each of Cubism's main aspects: Analytical Cubism; the Synthetic Cubism of the *papiers collés* of 1912–14; and the kind of Synthetic Cubism making great play with biomorphic forms that Picasso invented in 1914 at Avignon and later developed between the middle 1920s and the late 1930s, which is a sort of Cubo-Surrealism. The last of them was the first to affect de Kooning's style. There are intimations of its influence in some compositions of 1942, though in these it seems filtered through Gorky. Where it really takes hold is in a work that was probably the single most decisive turning-point in a career unusually full of twists and turns: *Pink Angels* of *c.* 1945. This was obviously inspired by Picassos of the late 1920s. One work in particular could well, I suggest, have inspired the composition. It is the *Large Nude in a Red Armchair*, dated 5 May 1929, which de Kooning must have seen in Alfred Barr's exhibition, *Picasso: Forty Years of His Art*, at the Museum of Modern Art in 1939 and would surely have seen again and again in full-page reproduction in that exhibition's catalogue, probably the best-thumbed publication of its time in artists' studios. There is, of course, a huge difference in mood between Picasso's sadistic and disgusted image of a depressed and alienated wife and the elated atmosphere of *Pink Angels*. But that airy, linear aspect of *Pink Angels* could easily have been indebted to a very different Picasso of the same period, *Figure*, 1927–28, which also was included in *Picasso: Forty Years of His Art*.

At the same time, there are hints in *Pink Angels* of painterly qualities that are not to be found in Picassos of that period, and the painterliness became increasingly manifest in a succession of works that followed, such as *Fire Island* of *c.* 1946, *Mailbox* of 1948, *Sail Cloth* of *c.* 1949. The small *Black Untitled* painting of 1948 belonging to the Metropolitan Museum of Art is a painterly version of a somewhat later stage in Picasso's biomorphism: it is de Kooning's paraphrase, I take it, of *Guernica*.

The influence of classic Synthetic Cubism came much later – in the 'highway' and related landscapes of the late 1950s. Here it was not at all a question of taking over certain forms and configurations and

adding painterliness. Here the painterliness was primary: the broad, slashing strokes, the accompanying spatterings and drippings and tricklings of paint. The paint works as an equivalent for daylight: dazzlement is the sensation induced by that seminal masterpiece *February* of 1957, plus the suggestion of Turnerish storms at sea. But all the explosive energy is wonderfully, tensely, contained and held in equilibrium. And it seems to me that what holds it is an inheritance which is hinted at there (half-way between the central point of the canvas and the top right corner) in the sudden encrusted shape like a paint tube or a penis or a very large bird-dropping, a shape made of paint but looking as if superimposed, like an element in an assemblage, an inheritance clearly revealed in slightly later canvases such as *Ruth's Zowie* of 1957 and *Souvenir of Toulouse* of 1958. The inheritance is the body of *papiers collés* by Braque and Picasso, the paradigm of construction in twentieth-century art. In these de Kooning landscapes large, loaded brushmarks echo with massive resonance those beautifully flimsy pieces of paper cut out in triangles and quadrilaterals and polygons and stuck down on a sheet of paper in dynamic balance

Now, Synthetic Cubism is, of course, the aspect of Cubism that has been most widely influential: when we speak of a post-cubist painter, we almost invariably mean that he has come out of Synthetic Cubism. De Kooning in unusual in that he was crucially influenced by Analytical Cubism – not surprisingly, though, given that he was a naturally painterly painter and that Analytical Cubism is the painterly face of Cubism. A clear line of historical development runs from late Cézanne to the Analytical Cubism of Braque and Picasso to Mondrian's version of Analytical Cubism – in paintings such as *Composition VII* of 1913 in the Guggenheim – to de Kooning's *Excavation* of 1950. What the development meant was using the language with increasingly thick paint and therefore moving from near-transparency to near-opaqueness, a very luminous opaqueness. The plays of greys in Braque and Picasso becomes a play of blacks and whites, marvellous in that it is indeed, at its best, a play of black and white and not of black on white or white on black. An exquisite small canvas of 1949 called *Zot*, painted with the subtlest gradations between thick and thin, epitomises that equality of black and white. It dances as vigorously as a Mondrian dances and is as tightly structured.

And when the paint got still more opaque in the early 1950s and the flashes of red and green and yellow and blue got bigger, Analytical Cubism was still there. Can we not see in bug-eyed *Woman I* a paraphrase of the portrait of Kahnweiler? Not the least of their similarities is that the figuration in the head is much more legible than it is in the body – and this obtains in the other Women through 1953, as it does in the other Picasso portraits of 1910. With the last of those Women, *Woman VI*, the differentiation is diminishing, and just as it tends to disappear in the Picasso portraits of 1911, so it is almost absent from *Woman as a Landscape*, 1954–55, where, at the same time, the paint is thinner and the palette closer to the grisaille of Analytical Cubism. Of course, all of de Kooning's large oil-paintings of Women from as far back as 1948 tend to be women as landscapes, just as Picasso's 1910 portraits tend to be dealers as landscapes – a fairly similar landscape, indeed, steeply rising and seen from below, though with Picasso it is a hillside packed with houses, like Cézanne's Gardanne, in the de Koonings it is stark, looming rock, like Cézanne's Bibémus.

Thirty years before those Women were painted, Soutine, in the landscapes of his Céret period, had used broad strokes of thick, juicy paint to put flesh on the bones of analytical cubist compositions, or of the Cézannes that had inspired these. And there is no doubt that those paintings had a crucial influence on de Kooning. Shortly after I wrote in 1959 that Soutines such as *Village Square, Céret*, and *Red Roofs, Céret*, included in the one-man show at the Museum of Modern Art in 1950, could well have influenced the Woman paintings and later paintings such as *February*, 1957,[6] I made the acquaintance of de Kooning and learned that he concurred with what I'd said. I mention this because de Kooning did not explicitly single out the Céret paintings when in 1976–77 he improvised a remarkable eulogy on Soutine inspired by a request to identify his key influences: 'I think I would choose Soutine . . . I've always been crazy about Soutine – all of his paintings. Maybe it's the lushness of the paint. He builds up a surface that looks like a material, like a substance. There's a kind of transfiguration, a certain fleshiness, in his work . . . I remember when I first saw the Soutines in the Barnes Collection . . . the Matisses had a light of their own, but the Soutines had a glow that came from within the paintings – it was another kind of light.'[7]

Other Soutines not at the Barnes which may have influenced him – all of them works included in the 1950 exhibition – are: first, the famous Cagnes period portrait, *Woman in Red*, which seems to be echoed in *Woman in a Garden*, 1971; second, the version which Soutine made in 1931 of the Rembrandt in the National Gallery of a woman standing in a stream, which seems to be echoed in *Woman III*, 1952–53; third the half-length nude of *c.* 1933, Soutine's only known nude, which seems to be echoed in an untitled nude of 1970. And then it seems to me that the several mid-1920s paintings of a carcass of beef hanging up could well have triggered off the big red *Composition* of 1955 in the Guggenheim. But that clear memory of seeing the pictures at the Barnes does imply a particular admiration for the Céret paintings, since the Soutines at the Barnes are mainly of that period.

What de Kooning made of them fulfilled, it seems to me, the potential of the language of the Céret paintings in a way its inventor did not. Because Soutine invariably worked, whether at landscape, still life or figure, with the motif in front of him, his landscape paintings were limited in their size by the problems of getting canvases to the site and setting them up out-of-doors. So the Céret landscapes are rather small, and while this can give a great concentration to the energy of the brushmarks, it can also cramp that energy. De Kooning perceived the potential for enlargement of such marks and, working as he did in the studio, explored it increasingly *February* became the masterpiece of Soutine's Céret period.

The development of de Kooning's painterliness, then, was very much tied up with using lush paint to enrich Cubism. And if that consummation was certainly helped by the example of Soutine, it was also possibly helped by that of Matisse. A type of brushwork conspicuous from 1948 on that de Kooning was to make decidedly his own, a technique in which paint has been slapped on and scraped leaving streaks of different colours, is present in one of the key works in Matisse's development of his personal quasi-synthetic Cubism, the *Goldfish and Palette* of 1914–15 – in the area just below the palette – and that work must have been known to de Kooning. It was on loan to the Museum of Modern Art from 1939 to 1947, and the following year it was shown again in New York at the Pierre Matisse Gallery. Two or three other major Matisses of that period have similar brushwork – the

Yvonne Landsberg, for example – but there is not the same virtual certainty that de Kooning would have seen them.

De Kooning may also have learned something from the most painterly of all the great twentieth-century painters: Bonnard. Harold Rosenberg, in his 1952 essay on 'The American Action Painters', spoke of Americans with styles 'which the painter could have acquired by putting a square inch of a Soutine or a Bonnard under a microscope'.[8] Beyond that, some de Koonings were influenced by looking at a whole Soutine, and others may have been influenced by looking at a whole Bonnard. I am thinking of *Pastorale*, 1963, and certain works of around 1970, for example, the *Untitled* painting in the Eastman collection ascribed to *c.* 1969–72 and *Flowers, Mary's Table*, of 1971. Equivocal forms are found in a space with a slow rolling movement and a resemblance to Bonnard's uptilted table-tops. Their mutability and ambiguity are not those described by Braque, which have to do essentially with tactile experiences. They are purely visual and relate to the fleeting quality of sensations, the rapidity of the play between actuality and memory, uncertainty as to the identity of something seen, uncertainty even as to whether something tangible is there where that area of a different colour is. The parallel suggests that Bonnard too was 'a slipping glimpser'.[9]

IV

As a theorist – except that he is deliberately not so much a theorist as a diarist – de Kooning is independent and cutting. For instance: 'The attitude that nature is chaotic and that the artist puts order into it is a very absurd point of view, I think. All that we can hope for is to put some order into ourselves.'[10]

The great charm of his utterances is twofold. They have the rare merit among artists' statements of not being a means to sell his work to himself: they do not seek to give it an ideal shape. And they have a highly sophisticated way of subverting received ideas as if from simple-mindedness: 'At one time it was very daring to make a figure red or blue. I think now that it is just as daring to make it flesh-colored.'[11]

There is a strong central message in his utterances. It's that all theoretical prescriptions entailing exclusiveness are absurd: 'Art should

not have to be a certain way';[12] and, on painting a figure, 'I really think it's sort of silly to do it. But the moment you take this attitude it's just as silly not to do it.'[13] The commitment to non-intervention and to relativism call to mind Taoism and Zen. Indeed, de Kooning often said, Emilie Kilgore has told me, that he wanted his painting process to work like Zen archery. Of course, a sympathy with Far Eastern mystical thought was common to the whole Abstract Expressionist movement. At the same time, paradoxically, de Kooning's allegiances as a *painter* were exclusively Western. For as a painter he is a humanist where Pollock and Still are pantheists and Newman and Rothko mystics.

'. . . when I think of painting today, I find myself always thinking of that part which is connected with the Renaissance. It is the vulgarity and fleshy part of it which seems to make it particularly Western. Well, you could say, 'Why should it be Western?' Well, I'm not saying it should.

'But, it is because of Western civilization that we can travel now all over the world and I, myself, am completely grateful for being able to sit in this ever-moving observation car, able to look in so many directions . . .

'I admit I know little of Oriental art. But that is because I cannot find in it what I am looking for or what I am talking about. To me the Oriental idea of beauty is that "it isn't here". It is in a state of not being here. It is absent, that is why it is so good. It is the same thing I don't like in Suprematism, Purism, and non-objectivity.

'And, although I, myself, don't care for all the pots and pans in the painting of the burghers – the genre scenes of goodly living which developed into the kind sun of Impressionism later on – I do like the idea that they – the pots and pans, I mean – are always in relation to man. They have no soul of their own, like they seem to have in the Orient.'[14]

De Kooning's capacity for acceptance, then, includes acceptance of his European heritage – and I mean the European *and* the heritage: '. . . when I think of painting today, I find myself always thinking of that part which is connected with the Renaissance.' To affirm such admiration for the most conventionally revered aspect of the European past was a very daring line – a consciously, doubtless self-

consciously, daring line – to take for a vanguard American painter inspired by Cubism. For the Cubists anathematised the Renaissance. Braque at the end of his life was still saying: 'You see, the whole Renaissance tradition is antipathetic to me. The hard-and-fast rules of perspective which it succeeded in imposing on art were a ghastly mistake which it has taken four centuries to redress. Cézanne and, after him, Picasso and myself can take a lot of the credit for this.'[15]

In the same decade that Braque thus reiterated his fidelity to classic modernist tenets, de Kooning, walking around the Metropolitan in 1958 with Thomas Hess, said: 'I don't think any modern artist – Cézanne, Matisse, Picasso, and the rest – has been as great as the great of the past – Rubens or Velázquez or Rembrandt.'[16]

v

If de Kooning is the supreme painterly painter of the second half of the century and the greatest painter of the human figure since Picasso, it is not least through his absorption of so much of the finest painterly figurative painting of the first half of the century, all of it European. That is to say, he is a great consolidator. But he is also a great initiator. He and Newman have been the outstanding individual influences on subsequent art. In this as in other respects they have played complementary roles, at the poles of the movement. Newman's role is monistic: he has one predecessor, Matisse, and his heirs descend directly from him. De Kooning is pluralistic: his origins are extremely mixed and his heirs have all sorts of direct and indirect relationships to him. To change the metaphor, de Kooning sits there in the middle of the map of this century's art like a great railway junction: lines arriving from various points above converge there; lines depart from there to spread out in various directions below.

Half of the young painters in America in the 1950s and 1960s used brushmarks and often a palette that derived from de Kooning, whether they were straightforward second-generation Abstract Expressionists, like Joan Mitchell and Alfred Leslie, or artists who were doing something radically different, like Rauschenberg, Rivers, Johns and Twombly. It is difficult to see how Rauschenberg especially could have done what he did without the example of de Kooning's handling of paint, and it was surely that example which enabled him

to compose collage operas where Schwitters had composed collage
lieder.

But there was more to de Kooning's influence than that. His work
has something of both the elements, generally foreign to Abstract
Expressionism, that gave its novelty to the whole approach of
Rauschenberg et al. − artists whom I propose to call 'post-Abstract
Expressionists' as I don't know what else to call them. (To call
Rauschenberg and Johns 'Pop artists' seems to me like calling
Cézanne a 'Cubist'; 'neo-Dada' suits them better, but it doesn't fit
Rivers or Twombly at all, and there is so much overlap among these
four artists that one wants some sort of umbrella term to cover them
all somehow. 'Post-Abstract Expressionists' suggests that they relate
to Abstract Expressionism rather as the Post-Impressionists relate to
Impressionism, and that is near enough the case.)

One of the elements in common between de Kooning and the
post-Abstract Expressionists is the presence of comedy. De Kooning's
art does not have room for the cultivated wit and irony that is central
to the art of Rauschenberg et al. But it does embrace the droll and the
absurd. In life Newman was hilariously funny and Rothko fitfully so;
in art they were totally solemn, as relentlessly dedicated to high seri-
ousness as the tragedies of Aeschylus, whereas it was as integral to de
Kooning's art as to Shakespeare's that drollery should be woven into
the menace and desire and despair. It was there from early on. The
Woman of *c.* 1944 in the Metropolitan makes me think of Eliot's

> Grishkin is nice: her Russian eye
> Is underlined for emphasis;
> Uncorseted, her friendly bust
> Gives promise of pneumatic bliss.[17]

And the intermingling, in her multitudinous sisters and daughters, of
the absurd with one or another natural or supernatural quality, has
probably been the most heavily exploited topic in de Kooning studies.

The other common element is the presence of conventional
subject-matter (which requires recognition that something has an
agreed or established meaning) as against natural subject-matter, to
use Panofsky's terminology.[18] Vanguard art from the 1860s to the
1960s tended to confine itself to natural subject-matter, with such

strikingly obvious exceptions as Picasso's mythological and political images. By and large a still life, say, was a conglomeration of objects, not a Vanitas, and even an artist such as Magritte, whose images look as if they are full of conventional subject-matter, was at pains to insist that his forms, whatever anyone might think, were exactly what they seemed to be, had no symbolism, no underlying meaning. By the early 1960s all that had changed. A Warhol still life of wasp-waisted bottles containing brown liquid was no conglomeration of objects but an icon celebrating a sacramental elixir.

For twenty years before that, however, there had been a continuing crisis about subject-matter, exemplified by the letter to the *New York Times* in 1943 signed by Rothko and Adolph Gottlieb but written with help from Newman: 'There is no such thing as good painting about nothing. We assert that the subject is crucial and only that subject matter is valid which is tragic and timeless.'[19] And at this time most of the future Abstract Expressionists were trying their hand at mythological subjects. But the work in which they were to find their artistic identity is work in which all that really matters for the spectator – whatever fun we may have in looking for meanings in it – is the direct impact of its forms and colours upon the nervous system.

The crisis took another form in the work of Francis Bacon, a contemporary not irrelevant to this discussion if for no other reason than that his *Painting* of 1946, purchased by the Museum of Modern Art in 1948, may well, according to Judith Zilczer, have had an influence on the Women.[20] That very work exemplified precisely the introduction of conventional subject-matter of the most common kind. It confronts us with a butcher's shop with sides of beef, a totally mysterious figure under an umbrella, and in the background a looming mass of flesh and blood and bone, which might be read as a carcass of meat but which we do not hesitate at all to read as a detail of the Crucifixion, and without that interpretation the intended meaning of the work would be lost. Now, in 1965 Bacon painted a triptych entitled *Crucifixion* that included a figure with a red armband bearing a swastika – a very explicit case, we might suppose, of conventional subject-matter. Bacon, however, avowed that he 'wanted to put an armband to break the continuity of the arm . . . it was done entirely as part of trying to make the figure work – not work on the

level of interpretation of its being a Nazi, but on the level of its work-ing formally'.[21]

Such inhibitions about letting in elements that worked on a level that was not merely formal certainly didn't trouble the post-Abstract Expressionists, who, by half-way through the 1950s, had firmly estab-lished that conventional subject-matter was back. Whereas Kenneth Noland's paintings of coloured concentric circles were read as just that, Jasper Johns's paintings of coloured concentric circles were read as targets, and perception of the work was constantly determined by that recognition.

De Kooning was the one Abstract Expressionist who anticipated this development, mainly in images of the American female. He did a *Marilyn Monroe* in 1954, leaving us looking for recapitulations of her lineaments in later paintings and sometimes thinking we have found one. Earlier, his introduction into *Woman I* of the smile derived from the Camel 'T-zone' advertisement, instantly recognisable, guaranteed that she would acquire mythological status, paving the way for Thomas Hess to be able to say of one of her numerous toothy daughters – the *Woman and Bicycle* that she was 'a Michelangelo sibyl who has read *Moon Mullins*'.[22] Certainly, the element of conventional subject-matter in de Kooning's work does not loom anything near as large as in post-Abstract Expressionism, but it is there, and while ally-ing him to the next generation and the next and, it seems, the next, it also speaks of his nostalgia for the Renaissance.

VI

'Abstract Expressionism' is a disappointing name for a great art move-ment, a name that manages to be ponderous without being really accurate (except, perhaps, when applied to Rothko). 'Fauvism', 'Cubism', and 'Futurism' are more or less inaccurate, but they do have pizzazz. At the same time, aspects of the abstract expressionist move-ment have given rise to two quite brilliant labels, Robert Rosenblum's 'Abstract Sublime'[23] and Harold Rosenberg's 'Action Painting'.[24] The former is perhaps the most perfect label ever applied to a type of modern art; the latter is imperfect but relatively apt and extremely resonant. This resonance derives, of course, from the evocation, cer-tainly deliberate, of the existentialist act.

'Art as action rests on the enormous assumption that the artist accepts as real only that which he is in the process of creating . . . The artist works in a condition of open possibility, risking, to follow Kierkegaard, the anguish of the aesthetic, which accompanies possibility lacking in reality . . .

'Each stroke had to be a decision, and was answered by a new question. By its very nature, action painting is painting in the medium of difficulties.'[25]

Rosenberg's concept of Action Painting was surely inspired less by the sight of Pollock dripping and pouring paint over a horizontal canvas with sweeping, gracefully athletic gestures that belied his inner anguish than by the sight of de Kooning face to face with a canvas, intermittently making an abrupt decisive movement in the midst of his anxious questioning. Nevertheless, Pollock and de Kooning both seem to be exemplary cases of existentialist man, hardly less than Sartre's friend and hero Giacometti. Giacometti was the central figure in an exhibition staged in 1993 of *Paris Post War: Art and Existentialism, 1945–1955*.[26] It was an unconvincing show but gave rise to the thought that a great exhibition could be assembled of Art and Existentialism, 1945–1955, which would be international in scope. The central artists – or, alternatively, the only artists – would be Giacometti, de Kooning, Pollock, and Bacon (whose several common qualities include the fact that all of them were exiles, a long way away from the places, mainly country places, where they grew up). That de Kooning for his part had a feeling of closeness to the work of both Giacometti and Bacon is suggested by his frequent admiring and sympathetic allusions to them in public statements and in private (as when he chided me for writing in 1962 that, while his own greatness as a painter was certain, Bacon's was open to question[27]). De Kooning's work would be more at home in their company than it was with that of the other outstanding contemporary European figure painter, Dubuffet, when Women by the two of them were shown together.[28] For the element of comedy they share is much less significant than the concern that makes Dubuffet a radically different kind of artist – his search for an earthy tangibility that harks back to Courbet, whereas de Kooning and Bacon and Giacometti are all somewhat in the line of Degas.

In terms of working methods, de Kooning, Giacometti, and Bacon were improvisers whose gestures tended to be rapid but who worked repeatedly on pieces in an attempt to take them further and were still rarely satisfied with what they did. They had tremendous problems about knowing when a work was finished and often remained uncertain after it had left the studio, and photographic records of successive states of certain pieces often show that they had been better in an earlier state or states. In consequence, a great deal of work was destroyed. I am not talking here of Giacometti's repeated destruction of his sculptures as he brought them into being in plaster or clay: there were some sculptures he did destroy once and for all, but mostly he was simply beginning again, as all three artists did with their paintings, sometimes after removing existing paint, sometimes obliterating paint with paint. The effective destruction was what happened to paintings by all of them as a result of repeating those processes too often. This could mean totally losing precisely those paintings in which they got most involved. As Bacon put it, 'I think I tend to destroy the better paintings, or those that have been better to a certain extent. I try and take them further, and they lose all their qualities, and they lose everything.'[29]

Bacon's deliberate courting of risk was, of course, close to the mystique of the action painters, as was his cult of openness, the idea that anything could happen, anything could result from the interaction between the artist's behaviour with the paint, in all its unexpectedness, and the behaviour of the paint itself, in all its unexpectedness. As Franz Kline put it: 'Paint never seems to behave the same – even the same paint, you know.'[30] Each situation in the duet between painter and paint was to be met and dealt with as it came along, and the painters' hope was that they would not impose their will upon the situation but collaborate in the emergence of something with a life of its own. In Bacon's case, however, as in de Kooning's, there was an insistence that life must also be an equivalent for sensory experience of reality:

'Surely this is the cause of the difficulty of painting today – that it will only catch the mystery of reality if the painter doesn't know how to do it . . .

'If anything ever does work in my case, it works from that moment when consciously I don't know what I'm doing . . .

'You see, you don't know how the hopelessness in one's working will make one just take paint and just do almost anything to get out of the formula of making a kind of illustrative image – I mean, I just wipe it all over with a rag or use a brush or rub it with something or anything or throw turpentine and paint and everything else onto the thing to try to break the willed articulation of the image, so that the image will grow, as it were, spontaneously and within its own structure, and not my structure. Afterwards, your sense of what you want comes into play, so that you begin to work on the hazard that has been left to you on the canvas. And out of all that, possibly, a more organic image arises than if it was a willed image.'[31]

The wide overlap with de Kooning includes a central ambition to do 'a kind of tightrope walk between what is called figurative painting and abstraction'.[32] Except that de Kooning tried harder than Bacon to achieve this. His work reflects a total commitment to an ongoing dialectic between figuration and abstraction. Bacon, even as he speaks of that ideal tightrope walk, proceeds in his next sentence to enunciate his gut ambition. 'It will go right out from abstraction but will really have nothing to do with it. It's an attempt to bring the figurative thing up onto the nervous system more violently and more poignantly.' That was said in 1962 and he stood by it in practice. He was more prepared to fall into 'illustration' than into 'decoration'. He would risk the former because he wanted an image that, however ambiguous, should be readily identifiable; in conversation he always criticised de Kooning's art for being too equivocal in reference. In 1979 he defined his direction when saying: 'Really, I think of myself as a maker of images. The image matters more than the beauty of the paint.'[33]

Perhaps because of his more wholehearted commitment to the image, perhaps because he was more prepared to wear his heart upon his sleeve, Bacon's art carries a dramatic charge, an uninhibitedly tragic weight – in contrast with de Kooning's laid-back tragicomedy – that seems to make it meaningful to a wider international public than de Kooning deeply moves.

One Sunday in 1977 I had a day with de Kooning at Springs, after not seeing him for some years, and found him in marvellous form. He asked me to come again the following Sunday, but on the Friday or Saturday a mutual friend called to put me off. There was no need for him to say why. De Kooning had been drinking, maybe was violent, was certainly unapproachable. This happened often during that year, perhaps the *annus mirabilis* of de Kooning's career after 1950.

Its works do not even begin to recover the concentration of those of 1948–50. Nor do they often match the best of those of the mid-Fifties (say, *February* and the Guggenheim *Composition*). But they do combine de Kooning's usual nervous energy with a feeling of rapturous joy that is quite new in his art. They came, with the artist in his mid-seventies, as the climax of a period in which the paintings – most of them landscapes of the body, some, purely macrocosmic landscapes and seas – with their massively congested, deeply luminous colour, their contrasts between flowing and broken forms, attain at their best a total painterliness in which marks and image coalesce completely and every inch of the canvas quivers with teeming energy. They belong with the paintings made at the same age by artists such as Monet and Renoir and Bonnard. The paint is freely, loosely, messily handled, sometimes with fingers rather than a brush or knife. Blurred forms loom up, often in extreme close-up, simultaneously adumbrated and dissolved by the paint. In terms of technique, there's a reversion to infantile habits of smearing muck. In terms of attitude, there's an infantile easy certainty that others have seen the world as they have.

The incandescence in these products of ripe wisdom and second childhood, of this marvellous marriage of experience and innocence, is not only an incandescence of matter but often of erotic feeling. It is no secret that throughout this decade de Kooning was involved in a love affair that brought him happiness. The paintings of this time that have to do with the figure – I mean, with flesh, with skin and membrane of paler and darker shades of pink – blaze with desire and fulfilment. Comparison with Picasso's great expressions of erotic rapture – images of Marie-Thérèse Walter – is irresistible. And rather irrelevant. Because Picasso is an *observer* of rapture. He is a voyeur

even of scenes of coupling in which he is a participant. Even in works with those wonderful equivalents for how a face looks from as near as it is when making love, Picasso always puts a psychological distance between himself and his loved object. De Kooning's paintings of the Seventies are an annihilation of distance. The close-ups are about closeness, a consuming closeness. These paintings are crystallisations of the experience and amazement of having body and mind dissolve into an other who is all delight.

They are the sort of transcendental paintings that might fittingly have concluded one of the most glorious and sustained careers in twentieth-century art. But de Kooning, with his extraordinary capacity for self-renewal, still had something to give: flowing compositions that could be described as coloured and large-scale equivalents of his black-and-white linear quasi-automatic ink drawings, with forms that tend to echo those of the later Forties and early Fifties. These works have been called classic examples of 'late style', but it seems to me that, whereas this can justly be said of the paintings of the Seventies, the only late style to which those of the Eighties are really comparable is the highly specialised style of Matisse's *papiers collés*.

Airy, feathery, rhythmical, the best of the paintings from 1981 to 1984 induce an elation like that of dancing a Viennese waltz when one has not yet had too much champagne. Those made in 1985 are less vibrant, are the lull before a change that happens in those of 1986 and 1987. Here the tempo slows, often becomes eerily halting. Among these works are strange and poignant traces of searchings within a mind that is now isolated, paintings which have the poetry of utterances from a far distance.

NOTES

1 Willem de Kooning, 'Content is a Glimpse . . .' excerpts from an interview with David Sylvester in *Location* 1 (Spring 1963), 46. The complete interview, 'Painting as Self-Discovery', was conducted in March 1960 in New York for broadcast on the BBC Third Programme, 3 December 1960. 'Content is a Glimpse . . .' appears as an artist's statement without my questions in numerous publications, including Thomas B. Hess, *Willem de Kooning* (exh. cat., Museum of Modern Art), New York, 1968, 146–50, and Harold

Rosenberg, *Willem de Kooning*, New York, 1974, 203–8. Unless otherwise noted, all citations of this interview will refer to the 1963 publication. An overlapping extract from the broadcast, including the questions, was published in my article, 'De Kooning's Women', in the *Sunday Times Magazine* (London), 8 December 1968, 51–2, 57. The most nearly complete publication of the broadcast occurs in a French translation in *Willem de Kooning: Ecrits et propos*, ed. Marie-Anne Sichère, Paris, 1992, 99–112.

2 Willem de Kooning, 'A Desperate View', delivered 18 February 1949 at the 'Subjects of the Artist' school, was first published in Hess, 1968, 15–16, 138.

3 Willem de Kooning, 'The Renaissance and Order', in Hess 1968, 142, was written in 1950 for a lecture series at Studio 35 and first published in *trans/formation* 1, no. 2 (1951), 85–7.

4 From a synthesised interview by John Richardson first published as 'The Power of Mystery' by Georges Braque in the *Observer* (London), 1 December 1957, 16. I have reproduced the revised version of the passage, however, from John Richardson, *Georges Braque*, London, 1959, 26–7.

5 Willem de Kooning, 'What Abstract Art Means to Me', *Museum of Modern Art Bulletin* 18 (Spring 1951), 7.

6 First in 'The New American Painting and Ourselves', a broadcast talk on the BBC Third Programme, 15 March 1959; second in 'Soutine Reconsidered in Paris Exhibition', *New York Times*, 6 September 1959, 16.

7 Margaret Staats and Lucas Matthiessen, 'The Genetics of Art,' quoting a statement by Willem de Kooning, in *Quest* 77 (March/April 1977), 70.

8 Harold Rosenberg, 'The American Action Painters', *Art News* 51 (December 1952), 22.

9 De Kooning's description of himself in a 1959 interview. This appeared in Robert Snyder's film *Sketchbook No. 1: Three Americans: Willem de Kooning, Buckminster Fuller, Igor Stravinsky* (New York: Time Inc., 1960).

10 De Kooning, in Hess 1968, 143.

11 De Kooning, 1963, 47.

12 De Kooning, in Hess 1968, 15.

13 De Kooning, 1963, 47.

14 De Kooning, in Hess 1968, 142–3.

15 Braque 1957, 16.

16 'Is Today's Artist with or against the Past', *Art News* 57 (Summer 1958), 56; an enquiry of several artists conducted by the editors of *Art News*.

17 T. S. Eliot, 'Whispers of Immortality', in *T. S. Eliot: Complete Poems and Plays*, New York, 1952, 33.

18 Erwin Panofsky, *Studies in Iconology: Humanistic Themes in the Art of the Renaissance*, Harper Torchbooks ed., New York and Evanston, 1962, 3–17.

19 Adolph Gottlieb and Marcus Rothko, 'Letter to Edward Alden Jewell, Art Editor', *New York Times*, 13 June 1943, sec. 10, p. 9. This well-known letter,

dated 7 June 1943 and written with the assistance of Barnett Newman, was prompted by Jewell's avowed lack of comprehension before modern art.

20 Judith Zilczer, 'De Kooning and the Urban Experience', in *Willem de Kooning from the Hirshhorn Museum Collection* (exh. cat., Hirshhorn Museum and Sculpture Garden), Washington and New York, 1993, 52.

21 David Sylvester, *The Brutality of Fact: Interviews with Francis Bacon*, London, 1987, 65.

22 Thomas B. Hess, 'Mixed Pickings from Ten Fat Years', *Art News* 54 (Summer 1955), 78.

23 Robert Rosenblum, 'The Abstract Sublime', *Art News* 59 (February 1961), 38–41, 56–8.

24 Rosenberg 1952, 22.

25 Rosenberg 1952, 48–9.

26 *Paris Post War: Art and Existentialism*, 1945–1955, ed. Frances Morris (exh. cat. Tate Gallery), London, 1993.

27 David Sylvester, 'Francis Bacon', *New Statesman*, 22 June 1962, 915.

28 *Willem de Kooning/Jean Dubuffet: The Women* (exh. cat., Pace Gallery), New York, 1990.

29 Sylvester 1987, 17.

30 Franz Kline in a recorded interview by David Sylvester, first published in *Living Art* 1, no. 1 (Spring 1963).

31 Sylvester 1987, 100, 102, 53–4, 160.

32 Sylvester 1987, 12.

33 Sylvester 1987, 166.

De Kooning – II

This piece on the theme of *Woman I* was originally written in the summer of 1994 as a lecture that was delivered in October at the Metropolitan Museum of Art, New York. It was then revised before being given at the Tate Gallery, London, in February 1995 (see introductory note to 'De Kooning – I'). Further revisions were made for its publication as 'The Birth of *Woman I*' in the *Burlington Magazine* in April 1995, where it was also slightly cut for reasons of space. It was further revised shortly after.

What are the things that go to make a legend of a work of art? It can help if the work is a watershed in the history of the art, but that is neither sufficient nor essential. One factor that can be effective is a remarkable genesis, which could mean, for example, a magically easy birth or one that was prolonged and difficult or one that was shrouded in mystery. A second factor is the work's initial reception by the public and critics – an especially wild success or hostile rejection, either of which is usually provoked by daring and newness in style and/or subject-matter. This factor overlaps with a third, a remarkable subject, one that is either intriguing, as with *The Naked Maja* or the *Mona Lisa*, or disturbing, whether seriously shocking, as with *The Raft of the Medusa*, or offending against modesty, as with *Le Déjeuner sur l'Herbe*.

This century's most practised creators of legendary works have, of course, been Picasso and Duchamp, not only in big machines such as *Guernica* and the *Demoiselles d'Avignon*, the *Large Glass* and *Etant donnés*, not only in other major engagements such as the *Portrait of Gertrude Stein* and the *Nude descending a Staircase*, but also in throwaway pieces like the urinal and the bull's head made from bicycle parts. Perhaps *Etant donnés*, with its wondrous emergence from its secret germination and its sensational yet obscure subject, will be the most legendary of all of these, and among works of art produced in America the most legendary since Mount Rushmore. But what of American Abstract Expressionism, a movement steeped in legend? – legendary hopes, legendary deeds, legendary battles, legendary rags to riches, legendary drinking and, alas, legendary deaths. It did not produce many legendary masterpiece, for it flourished at a moment in art history when the masterpiece had given way to the series (the

series as against the cycle), though *Woman I*, which is of course a legend, is also a member of a series.

It became a legend before it was exhibited, a legend for those close to the artist while it was in progress, and a legend disseminated to the world outside shortly before it was exhibited – through a long article by Thomas B. Hess in *Art News* for March 1953. Entitled 'De Kooning paints a picture',[1] it was one of a regular series in *Art News* documenting the process of creating a particular painting or sculpture or print, a series for which Hess himself was editorially responsible. He had joined this influential monthly review as Associate Editor in the spring of 1947 and by the end of the year was its Managing Editor, second-in-command to Alfred Frankfurter, who left him in charge of contemporary art. The series was initiated in May 1949.

Hess himself was the author of the first two articles, their subjects Ben Shahn[2] and Feininger[3], and the series was continued in virtually every issue with an eclectic choice of artists: during the first four years it included, in order of publication, Edwin Dickinson, George Grosz, Hyman Bloom, Hans Hoffman, Andrew Wyeth, Lipchitz, Ivan Albright, Wifredo Lam, Jackson Pollock, David Smith, Tamayo, Dubuffet and Franz Kline. The most regular writer was Elaine de Kooning. Hess himself, after those initial pieces, waited for nearly two years before contributing again, perhaps because he wanted to take a back seat, perhaps because he was working on the book he published in 1951, *Abstract Painting: Background and American Phase*.[4] When he wrote again for the series it was on Dubuffet, the first European artist working in Europe to be included,[5] and then, nearly a year later, on de Kooning. Had de Kooning made his appearance in the series a couple of years earlier, at about the time Pollock did, the chosen picture could have been *Excavation*, the biggest canvas he had ever painted – or ever painted thereafter – which won first prize at the Chicago Art Institute Annual for 1951 and went on to become generally regarded as his supreme masterpiece. But Hess waited and chose a work that was not the summation of a period but a new departure.

In looking back at the history of a journal, it's often difficult to know whether crucial editorial decisions were conspiratorial or merely circumstantial. In this case the conspiratorial decision would

have been that de Kooning could benefit if the chosen work were a difficult picture, one that had a need to be defended. And the circumstantial decision would have been that Hess waited because he himself was busy with his book and didn't want anyone else to write the piece about the artist who was his hero. The decision here looks as if it were probably conspiratorial, given the following sequence of events. There was a danger lurking in the background that in Hess's lately published book his worship of de Kooning was palpable to the point of being a provocation and that this might diminish his credibility as a proponent of a controversial work in the context of his own magazine. It could therefore have been helpful if Hess could soften up doubters by using his editorial position to lay on a prior bombardment by heavy artillery. This is precisely what was done.

'De Kooning paints a picture' appeared a couple of weeks before the opening of the one-man show in which the picture was to be unveiled. Now, three issues before this, the magazine ran Robert Goodnough on 'Kline paints a picture',[6] a picture that was a fine orthodox example of Abstract Expressionism, and also carried a momentous article on that movement in general, Harold Rosenberg's 'The American Action Painters'.[7] Rosenberg had not yet embarked on his career as an art critic; at that stage he was well known as a poet and a man of letters, and the editorial foreword to his piece announced: 'A poet gives his answers to the increasingly difficult and important questions . . .' His speculative, provocative, epigrammatic essay, discovering an existentialist ethic, a Kierkegaardian anguish and a Melvillean spirit of adventure in the aspirations and practice of the artists, was primarily a sermon addressed to the unconverted world at large, meaning the literary as well as the artistic community. But it also contained some sentences which look like a political message addressed to the artists themselves. The message was a warning of the danger of losing all that splendid openness and fearlessness by allowing themselves to drop into new orthodoxies, to arrive at complacent identifications of the spirit of their movement with certain stylistic characteristics or technical procedures. I take it that this was what Rosenberg was driving at in the passage in which he quoted a point made by one of the artists against another of them and proceeded to demolish it.

'"B– is not modern," one of the leaders of this mode said to me. "He works from sketches. That makes him Renaissance."

'Here the principle, and the difference from the old painting, is made into a formula. A sketch is the preliminary form of an image the *mind* is trying to grasp. To work from sketches arouses the suspicion that the artist still regards the canvas as a place where the mind records its contents – rather than itself the "mind" through which the painter thinks by changing a surface with paint.

'If a painting is an action the sketch is one action, the painting that follows it another. The second cannot be 'better' or more complete than the first. There is just as much in what one lacks as in what the other has.

'Of course, the painter who spoke had no right to assume that his friend had the old mental conception of a sketch. There is no reason why an act cannot be prolonged from a piece of paper to a canvas. Or repeated on another scale and with more control. A sketch can have the function of a skirmish.'[8]

The sketch-addicted painter 'B–' could only have been Bill de Kooning. And Rosenberg's telling denunciation of the way his accuser was thinking in formulae would have been a very effective preparation of the ground before Hess set out to inform the world about de Kooning's extensive and complicated use of sketches in painting *Woman I*. Hess and Rosenberg were clearly beginning to work hard at earning the label that came to be attached to them by the New York art world: 'de Kooning's Mafia'.

'De Kooning paints a picture' begins with a sort of overture resuming the whole story:

'In the first days of June, 1950, Willem de Kooning tacked a 7-foot-high canvas to his painting frame and began intensive work on *Woman* – a picture of a seated figure, and a theme which had preoccupied him for over two decades. He decided to concentrate on this single major effort until it was finished to his satisfaction.

'The picture nearly complied to his requirements several times in the months that followed, but never wholly. Finally, after a year and a half of continuous struggle, it was almost completed; then followed a few hours of violent disaffection; the canvas was pulled off the frame and discarded. After that three other related pictures were begun (and these have since been finished).

'A few weeks later, the art historian Meyer Schapiro visited De Kooning's Greenwich Village studio and asked to see the abandoned painting. It was brought out and re-examined. Later it was put back on the frame and after some additional changes was declared finished – i.e. not to be destroyed. This was mid-June, 1952.

'When the canvas was mounted on a permanent stretcher prior to being taken to the Janis Gallery (where De Kooning is having a one man show this month, which includes *Woman*), another alteration was made. Then *Woman* escaped by truck from its creator.

'The painting's energetic and lucid surfaces, its resoundingly affirmative presence, give little indication of a vacillating, Hamlet-like history. *Woman* appears inevitable, like a myth that needed but a quick name to become universally applicable. But like any myth, its emergence was long, difficult and (to use one of the artist's favorite adjectives) mysterious.'[9]

Hess clearly shows, then, that this was one of those cases – there have, of course, been many of them – where it was obvious while a work was being created that it was going to become legendary. And *Woman I* fulfilled all the criteria for that. It had a long-protracted, self-doubting genesis the mythic import of which was enhanced by the inspiring intervention of the saintly rabbi who was the most revered sage on the American art scene. The work was given, along with its companions, a dramatic reception, to be summarised by Hess in his 1959 monograph: 'The Women made a traumatic impression on the public – to date they have been the last modern paintings to do so. The Museum of Modern Art, New York, bought *Woman I*, which has since become the most widely reproduced painting of the 1950's in the world.'[10]

And that traumatic impression was, of course, induced by the third of the attributes conducive to legend: a shocking subject. But here *Woman I* was a very special case: its subject was found shocking for two altogether different reasons. They need to be considered separately. One of them was that this image of a seated woman with bug eyes and buck teeth was taken to manifest an extremely hostile view of the human female. It was generally perceived by critics, according to Marla Prather's summary, as 'predatory and rapacious, a harridan, a frightening goddess, an evil muse . . . an "exposition of hate and bru-

tality"';[11] and those who saw it as such were mostly offended rather than titillated by what they saw. Or as Richard Shiff has put it: 'From its first public appearance de Kooning's *Woman I* raised questions of the artist's personal attitude towards women because it seemed to render its subject as aggressively unappealing or to treat it with violence so that detached aesthetic analysis became impossible.'[12] Shiff here underlines the disturbing double-sidedness of the presumed misogynistic aggression – the artist's perception of the female as a monster and his infliction of violence upon her.

It is curious that the misogynistic content attributed to the Women made such a heavy impression, given that this century has produced any number of images that are more decisively antagonistic towards women – images, for instance, by various Northern and Central European Expressionists or by Picasso in the late 1920s when he was almost systematically using his art to give vent to his hatred of his wife. It is very much open to question whether the Women do express hostility to their subject. The content of modern art is often less specific than it is thought to be by people – some of them writers on art – who do not read the language in the way that artists read it. Confronted with palpable distortions in the form of free brushmarks disrupting the form, distortions or marks that have been made in order to give the form a heightened vitality or presence or to give it a different and unexpected structure, such viewers often assume that these are acts of grievous bodily harm performed against the subject represented in the work. An artist like de Kooning, because of the freedom and energy of his marks, is very prone to have his cursive signs for faces read as real faces that have been assaulted or that are wearing grimaces, rather as if a multicoloured face in a painting by Matisse were taken to be a portrait of a brave in warpaint. It is, of course, possible that certain moves a painter makes on the canvas for conscious motives that are entirely formal could in reality be manifestations of unconscious aggression – and this may possibly apply to de Kooning – but in that case the aggression might tend to be directed against objects in general rather than specific classes of object, whether women or stovepipes.

The other aspect that was found shocking was the basic subject, a single woman seated in the open air. This subject gave as much

offence in the 1950s as was given in the 1860s by the woman seated in the open air in *Le Déjeuner sur l'Herbe*. But in Paris in the 1860s it was the bourgeoisie that was shocked; in New York in the 1950s it was the avant garde that was shocked. They took it as an act of gross betrayal of principles and of comrades that a leading member of the abstract expressionist movement, that movement which had been struggling so desperately to get a foothold in the world of acceptable art, should do a set of paintings of a subject so readily identifiable and so utterly traditional. It was an act of personal disloyalty; it was an act of aesthetic impropriety. The puritan strain in American art has been a great source of strength and a great source of silliness. A great source of strength for de Kooning has been his deep distrust of purity and dogmatism, his relaxed commitment to his instincts.

His open-mindedness both in this regard and in regard to how *Woman I* and its companions might be interpreted is manifest in the answers he gave to questions that I put to him early in 1960 in the course of a taped interview. This interview has been published again and again in a form – that of a monologue – which was imposed upon it by the de Kooning Mafia[13] and which I, as a newcomer to their territory, felt too scared to reject. Furthermore, not only have the questions been edited out but so have de Kooning's own verbal nervous tics, phrases like 'you know' and 'do you see what I mean?' Their elimination makes his statements sound less hesitant, less tentative than they were – makes them sound glib.

Raising the subject of the Women, I immediately asked him whether in painting them he had felt he was out on a limb.

'Yes, they attacked me for that – certain artists and critics. But I felt this was their problem, not mine. I don't really feel like a non-objective painter at all. I just visited in San Francisco, and Diebenkorn and Bischoff and fellows like that who paint now, they feel they have to go *back* to the figure, and that word "figure", it becomes such a ridiculous omen – the figure, you know. In a way, if you pick up some paint with your brush and make somebody's nose with it, this is rather ridiculous, when you think of it, theoretically or philosophically. It's really absurd to make an image, like a human image, with paint, you know what I mean, today, when you think about it, since we have this problem of doing or not doing it. But then

all of a sudden it was even more absurd not to do it. So I fear that I'll have to follow my desires.'

'So it was a simple desire, then', I asked, 'doing the Women. It wasn't a moral decision, it wasn't a theoretical decision, it was just a desire?'

'Yes. It had to do with the female painted through all the ages, all those idols. And maybe I was struck to a certain extent, that I couldn't go on, and it did one thing for me: it eliminated composition, arrangement, relationships, light – I mean, all this silly talk about light, colour and form, you know. Because there was this thing I wanted to get hold of. I put it in the centre of the canvas, you know, because there was no reason to put it a bit on the side – do you see what I mean? So I thought I might as well stick to the idea that it's got two eyes, a nose and mouth and neck, you know. So I go to the anatomy and I felt myself almost getting flustered. I really could never get hold of it. I mean, it kind of almost petered out. I never could complete it. And, when I think of it now, it wasn't such a bright idea, but well, I don't think artists have particularly bright ideas. Matisse's *Woman in Blue – Woman in a Red Blouse*, or something, you know – what an idea that is! Or the Cubists: when you think about it now, it is so silly to look at an object from many angles. It's very silly. It's good that they got those ideas for it is enough for some of them to become good artists.'

'And why', I asked, 'do you think it especially silly to paint the Women?'

'It is a thing in art that has been done over and over, you know, the idol, the Venus, the nude.'

'Were you troubled while you were actually painting them by the absurdity of doing this thing again which had been done so many times before?'

'Oh yes. It became compulsive in the sense of not being able to get hold of it and the idea that it really is very funny, you know, to get stuck with a woman's knees for instance. You say, what the hell am I going to do with that now, you know what I mean, it's really ridiculous, and it may be that it fascinates me, you know, that it isn't supposed to be done. I knew there were a lot of people, they paint a figure because they feel it ought to be done, because since they're a

human being themselves, they feel they ought to make another one, you know, a substitute. I haven't got that interest at all. I really think it's sort of silly to do it. But, like I said before, at the moment you take this attitude, it's just as silly not to do it.'

A little later he said: 'Perhaps I am more of a novelist than a poet; I don't know; but I always like the word in painting, you know.'

'You mean', I asked, 'that you like the forms to be identifiable?'

'Well, they ought to have an emotion of a concrete experience. I mean, like I am very happy to see that grass is green – you see what I mean? Like at one time, it was very daring to make a figure red or blue. I think now it is just as daring to make it flesh-coloured. I found that out for myself; content, if you want to say, is a glimpse of something, an encounter, you know, like a flash – it's very tiny, very tiny, content. When I was painting those figures, I was thinking about Gertrude Stein, like they were ladies of Gertrude Stein – like one of them would say, How do you like me? Then I could sustain this thing all the time because it could change all the time. She could almost get upside down, or not be there, or come back again, you know; she could be any size. Do you understand? Because this content could take care of almost anything that could happen, you know; and I still have it now from some fleeting thing – like when one passes something, you know, and it makes an impression.'

'But the impact?' I asked. 'You weren't concerned to get a particular kind of drama or a particular kind of feeling?'

'No. I look at them now: they look vociferous and ferocious, and I think it had to do with the idea of the idol, you know, the oracle, and above all the hilariousness of it. I do think that if I don't look upon life that way, I won't know how to keep on being around.'

'So there was no question of any sort of attempt to make a comment on the time . . .?'

'No. Oh, it maybe turned out that way, and maybe subconsciously when I'm doing it. But I couldn't be that corny.'

'It has been said that to some extent', I said, 'these paintings have a relation to current popular mythology. You remember Tom Hess's phrase about *Woman with Bicycle*: "a Michelangelo sibyl who has read *Moon Mullins*"? Were you conscious of this in painting them?'

'A little, yes.'

'In one of the first studies for *Woman I* you put on that mouth from a T-zone ad in collage?'

'Yes. That helped me. I cut out a lot of mouths. First of all, I felt everything ought to have a mouth. Maybe it was like a pun, you know what I mean, but maybe it's even sexual or whatever it is, I don't know. But anyhow I used to cut out a lot of mouths and then I painted those figures and then I put the mouth more or less in the place where it was supposed to be. It always turned out to be very beautiful and it helped me immensely to have this real thing. I don't know why I did it with the mouth. Maybe the grin. It's rather like the Mesopotamian idols, you know. They always stand up straight looking to the sky with this smile, like they were just astonished about the forces of nature, you feel, not about problems they had with one another. That I was very conscious of; and it was something to hang on to.'

Clearly these remarks made in 1960 about *Woman I* and the Women related to it were a mixture of thoughts that had occurred to de Kooning while he was painting them, between 1950 and 1955, and of thoughts that had come to him since and were surely not untouched by the heated public debate about them that had been going on since some of them were first shown in 1953. De Kooning had been vilified and interrogated to the point of persecution, he had been cornered, he had been reduced to avowing that he was not a closet queen, to protesting that he *liked* beautiful women and to confessing that he sometimes found women irritating.

After all that, it may be that some of the things de Kooning said to me were a smokescreen – notably his insistence that his content was 'tiny'. That notion goes very well with his distaste for the pretentious and the pompous. But is the idea that the content is tiny compatible with talking about goddesses and idols? His statement that content was 'very tiny' followed his saying that content was 'a glimpse of something, an encounter, you know, like a flash'. But the fact that a glimpse is fast doesn't mean that the experience is slight. Would the content be tiny if the glimpse were of a secret part of the body that is normally hidden? Or if it were a glimpse of something as momentous as a gathering of idols which 'stand up straight looking to the sky with this smile, like they were just astonished about the forces of nature'? On the other hand, if de Kooning found these figures 'vociferous and

ferocious', he also found them 'hilarious', and the retreat into hilarity was a strategy which, as he said, he found necessary to his survival. And, if you like, comedy probably *is* tinier than tragedy.

Throughout our discussion of what I was calling 'the Women' de Kooning was too courteous to correct the howler implicit in that usage. Study of his responses makes it clear that he recognised, when I brought up the subject of 'the Women', that I had in mind the series initiated by *Woman I*, which I should, of course, have been designating as, say, 'the 1950s Women'. Hess had made it clear in the opening sentence of his account of the genesis of *Woman I* that its subject was not a new departure, saying that the theme had preoccupied de Kooning for over two decades. He had refrained from adding that even lately, while he was realising the black paintings and *Attic* and *Excavation*, de Kooning had still been preoccupied enough with the Woman theme to have produced works as major and as excellent as the *Woman* of 1948 in the Hirshhorn Museum, the *Woman* of 1949 in the Leavitt collection and the *Woman* of 1949–50 at the University of North Carolina at Greensboro. Jackson Pollock was close to the bone when he attacked de Kooning at the party following the opening of the 1953 show by saying: 'You're doing the figure, you're still doing the same goddamn thing. You know you never got out of being a figure painter.'[14] Yet in their reviews of the show, two of the most established New York critics, Howard Devree of the *Times*[15] and Robert M. Coates of the *New Yorker*,[16] wrote as if the subject were something new for de Kooning. This ignorance was not all that surprising. There was no monograph on the artist, of course, and for his last one-man show, in April 1951, his dealer, Charles Egan, had sensibly sought consistency of style for a hang in a small gallery and had completely left out figures in order to concentrate on abstractions – or, to put it more accurately, had left out images of standing or seated figures in order to concentrate on images assembling fragments or hints of figures.

In the latter works the key influences were, of course, Gorky and Picasso, but there were further affinities, both cubist and surrealist. The black paintings executed in 1948 and 1949 include works in two radically different styles. In *Black Friday* and the *Painting* belonging to MoMA it is as if black cut-out shapes were put together with some

overlaps in low relief on a ground that is mainly black, partly white; the flatness of the forms is strongly emphasised, along with a sense of the movement of masses. In *Night Square* and the Art Institute of Chicago's *Untitled* the white lines of different thicknesses moving over a totally black ground may tentatively form shapes here and there but they are essentially linear and fluid, and the space they inhabit is a space that is limitless in its depth. The idiom of the first group derives from Cubism, is a sort of cubist *lingua franca* reconciling elements of both Analytical and Synthetic Cubism and very insistent on the shallowness of its space. The idiom of the second group recalls the infinitely deep background of certain mid-1920s Mirós such as *The Birth of the World* and of other surrealist visions and, going back further, to Kandinskys of 1911–14. The composition is very close indeed to that of certain Gorkys typical of 1944, such as *How My Mother's Embroidered Apron Unfolds in My Life*, which are, of course, inspired by both Miró and Kandinsky.

The mainly white paintings too are often clearly related to 1944 Gorkys: indeed, it was an influence that could still be clearly manifest in de Kooning's finest paintings of the Eighties – *Pirate* of 1981 and *Morning, the Springs* of 1983. Among paintings of 1948 *Asheville* is particularly close to *My Mother's Embroidered Apron*; *Attic*, of 1949, is more reminiscent of *One Year the Milkweed*. But *Attic* is also the perfect demonstration of how de Kooning differentiated himself from Gorky. Its insistence on low relief, incisively carved low relief, reflects the degree to which de Kooning's attachment to the tension and rigour of Cubist pictorial architecture outweighed the temptations of the hothouse of Surrealist eroticism. *Attic* is very typical of the balance of stylistic forces in de Kooning's white paintings. Not so *Zot*, another white masterpiece – but this time purely white – of the same year – a tiny canvas, about 18 inches by 20, painted with an exquisite touch. As against *Attic*'s insistently shallow space and all the vigorous pulling and stretching that goes on across it, *Zot* has a slightly misty atmosphere that makes for a certain amount of spatial depth, and its movement is haltingly spiral. There is cubist iconography here, where the word that gives the work its title is inscribed in large capital letters in the bottom left-hand corner; there is surrealist iconography too, in the sexy bodily parts. Except that here those allusions are not up front

but buried in the mists of the paint, rather as in a Twombly. Perhaps this is why the feel of the picture is not surrealist. The feel is distinctly analytical cubist, recalling the transparency and the ethereality of a 1911 still life by Braque.

The following year, in *Excavation*, the coming together of cubist and surrealist elements produced a remarkable affinity to Massons of the mid-1920s such as *The Wing* of 1925, with its cubistic Surrealism or surrealistic Post-Cubism. Beyond the resemblances in colours and shapes, there is the same crucial fixing of biomorphic forms in a grid, with all that this implies of an interplay between fantasy and formalism. Nevertheless, the de Kooning operates in a much more abstract way. It's an intensely dramatic work, and there is no doubt that a good deal of the drama is generated by all those menacing sharks' teeth, by that maelstrom of *vaginae dentatae*. However, this drama is less electrifying than the formal drama. Here is the old battle between the immovable object and the irresistible force – to be specific, between insistence on the flatness of the picture-plane and the infliction of a relentless assault upon it, here by slashing it, there by twisting it into three-dimensional shapes The artist is setting his ability to maintain the hallowed stability of the plane against his impulse to subvert and fracture it. The spectacle of his daring release of violent forces and of his power ultimately to control them resembles that of a car careering round a mountain track as if it were going to fly out over the edge but somehow continuing to hold the road (as a painter is sometimes said to 'hold the surface'). What all good painting is essentially about is the creation of a tension and a reconciliation between intimating nature's volume and depth and preserving the flatness of the picture-plane, in the same way as verse is essentially about the opposition between the natural flow of language and the constraints of rhyme and metre. In most painting that opposition is clothed in other concerns, but there are times when it is laid naked. *Excavation* is an especially highly charged unveiling.

When *Excavation* and *Attic* and smaller related pieces such as *Mailbox* and *Asheville* and *Sail Cloth* are compared at all attentively with the contemporaneous *Woman* at the Hirshhorn and *Woman* at Greensboro, the comparison makes a nonsense of the conventional perception of de Kooning's art as presenting a dichotomy between

abstractions and figures. It is not simply that the so-called figures are figures and the so-called abstractions are jumbled fragments of figures: this still leaves us positing a radical distinction between the works that show bodies with heads on and the works made up of bits of bodies and bits of heads. But either way sky and land and gravity are always present; furthermore, those jumbled fragments of figures are found *within* the works depicting seated figures or standing figures. All the works of a period are made of the same stuff. The dichotomy exists only to the same degree as we might say that there was a dichotomy between a classical marble torso and a classical marble statue. It is true that, when any image is topped off by a head, the head becomes a magnet to the viewer and it is really this simple fact that underlies the old obsession with dichotomy in discussions of de Kooning's art. In other words, there is no more of a dichotomy in de Kooning's art than there is between an analytical cubist still life and an analytical cubist portrait.

When de Kooning includes a whole head it usually has very much the same sort of relation to the rest of the picture as the head in an analytical cubist portrait. I have suggested in the catalogue of the current exhibition that *Woman I* is a paraphrase of the portrait of Kahnweiler.[17] The Women of the time of *Attic* and *Excavation* are even more reminiscent of such analytical cubist portraits, decidedly more when their palette is close to grisaille, as in the paintings at the Hirshhorn and Greensboro. At the exhibition of *Picasso: Forty Years of His Art* at M o M A in the winter of 1939–40 de Kooning would have seen, as well as the Kahnweiler portrait, the *Woman with a Mandolin* painted six months earlier. And if by the end of the 1940s he had lost his copy of the catalogue, in which both works were reproduced full page, he would certainly have acquired a copy of its expanded version, *Picasso: Fifty Years of His Art*, published in 1946, in which the reproductions of *Woman with a Mandolin* and the *Portrait of Kahnweiler* are on facing pages. It does seem likely that he could have been looking at the *Woman with a Mandolin*, the left side of it, when painting the *Woman* of 1949–50: the neck, the shoulder, the breast, the arm; there is even a suggestion of the mandolin. The head is another matter. It is a head that recurs in several de Kooning Women of the second half of the 1940s, after making a first appearance in the *Pink Lady* of *c.* 1944.

It is reminiscent of Picasso heads of the ten years before that, some of them heads with anguished faces.

There is a widespread critical consensus that de Kooning never did anything better than the black paintings and the white paintings. Perhaps it's a response to the fact that in de Kooning's career there was always an ebb and flow between two opposing attributes, the high precision of the whiplash line and the wildness or apparent wildness in the sloshing of paint, and that this antithesis achieved its perfect resolution in the works of 1948–50. Among the masterpieces of that time the Greensboro *Woman* is scarcely less momentous than *Attic* and *Excavation*. It is a poignant and mysterious piece, painted with a great variety of marks in a marvellous balance of freedom and control. The colour is a siren song, the brushwork has a rich sensuousness and an electric energy. The painting sets up rhythms of an amazing complexity but locks them all together on the picture-plane. It is explosive and it is dense. It contains fleshy forms and bony forms and landscape forms – say, water splashing among rocks. As a painting pure and simple it is possibly a finer work than *Woman I* as well as being a more resolved work.

But then *Woman I* is not meant to be a resolved work, as Mark Stevens has emphasised: 'Modernists had long appreciated the open-ended quality of unfinished art. The purposefully not-finished, however, is not the same thing as the unfinished. *Woman I* was not unresolved out of indecision or weakness, but out of strength: it was left to its imperfections by the aggressive decision of a great artist, in order to increase the work's disruptive, expressive power. In the rapid succession of Woman paintings that followed, de Kooning was becoming more interested in loosening the compositional joints of painting than in bringing them together.'[18]

But even if that eschewal of resolution became the *raison d'être* of *Woman I*, this still does not explain why its execution was so prolonged, so problematic, so tormented, given that it came in the wake of a procession of increasingly successful paintings of single women. I think that the answer is that *Woman I* was a new and radically different enterprise. The newness was that *Woman I* is a frontal image. It is true that the frontality is not sustained in the legs, which are violently – from a naturalistic point of view, impossibly – twisted to one side,

perhaps in order to intensify the tension in the figure, perhaps only in order to preclude difficulties in preserving the flatness of the picture-plane. But the first impression is decidedly frontal. And there is every reason to suppose that its frontality was essential to its intention, in view of the fact that virtually all the images of women realised over the next few years were completely frontal, whether presented singly or in pairs. The paired standing figures, incidentally, first appeared in minor works in 1949, perhaps because the artist felt that two women side by side seemed an easier way into making a frontal image than attempting a head-to-head confrontation.

And it surely *was* a problem, because de Kooning had not previously completed and preserved frontal paintings of women. He had achieved frontal paintings of men, such as the *Two Men Standing* of 1938, and there's a curious confirmation that for him painting a woman head-on was not like painting a man head-on. This is to be found in two frontal half-length portraits of around 1942 which give the impression as we glance at them that they are images of men; each is entitled *Woman* and each was destroyed by the artist. In all the extant paintings of women before *Woman I* the head is shown in a three-quarter view, even when the body is frontal, as in the Hirshhorn and the Leavitt and the Greensboro pictures. Above all it is a kind of three-quarter view in which the gaze seems to be avoiding eye contact with the beholder, whereas in *Woman I* and its successors their direct gaze is their most conspicuous feature.

When de Kooning did finally produce in *Woman I* a largely frontal image of a single woman, he inserted, consciously or unconsciously, a corrective that is inconspicuously present but indubitably so. (I do not think that this has previously been pointed out in print and am much indebted to Sam Sylvester for pointing it out to me.) All down the left-hand side of the picture is a profile image of a seated female with a head right next to the frontal head, a clearly delineated shoulder and waist which are also the right arm of the frontal figure, and a right leg which is also the right leg of the frontal figure. De Kooning (consciously or unconsciously, I repeat) has juxtaposed a rigorously frontal image with a rigorously profile image, a device that is characteristic of much archaic art and of police records. Here it has also produced an image that calls to mind Leonardo's picture of the Virgin seated in St Anne's lap.

The reason why de Kooning suddenly involved himself so pas-sionately in painting a frontal image of a woman seems to me to be contained in his answer to my question whether he started painting that series simply because he had a desire to do so: 'Yes. It had to do with the female painted through all the ages, all those idols.' And when he talked about them looking 'vociferous and ferocious' he added: 'I think it had to do with the idea of the idol, you know.' And when he talked about the mouth and the grin, he said: 'It's rather like the Mesopotamian idols, you know. They always stand up straight . . .' Now, I did suggest earlier that some of those things he said to me in 1960 about the ideas underlying the 1950s Women could have been thought up after the paintings were done. For example, maybe the reference to Gertrude Stein's ladies was a case in point, and maybe the mention of Gertrude Stein came in as a free association provoked by Picasso's portrait of her in the Metropolitan, since her head suggests the head of an idol. But in spite of the need for caution in making inferences from that interview, its constant iteration of the idea of the idol really does seem to be the clue to why de Kooning embarked on the frontal image of *Woman I*.

And the point of *Woman I* is the force as an image that derives from its frontality, the emotional weight it gains from the way this frontal-ity engages us. *Woman* of 1949–50 is a great painting; *Woman I* is an icon. Icons have prototypes and the prototype for *Woman I*, accord-ing to the artist, was a type of sculpture rather than a picture. But there was certainly a picture that was a predecessor, as everyone has said – not itself an icon but an altarpiece, the *Demoiselles d'Avignon*, notably the two women surging up in the centre.

Now, the primary identity among the various identities of the Demoiselles is that they are prostitutes in a brothel in Barcelona. They are classic examples of the tradition of representing whores not as enticing but as unapproachable. And the 1950s Women loom up over us in the same forbidding way. One could say that they are much more than forbidding – that they are positively destructive, that they are figures like the Indian goddess Kali. But I have already suggested the dangers of that sort of interpretation. What is sure, based on phys-ical effect, not psychological guesswork, is that they are figures that stop us in our tracks, figures as impregnable as fortresses. Thus the

face and the hands of *Woman III* suggest that she is a far more amiable, charming, available character than the others, but her physical presence is still resistant rather than compliant.

In this way of confronting us the 1950s Women but above all *Woman I* could be compared to certain of Monet's façades of Rouen Cathedral. (I am not bringing in Monet because I think he has any special relevance to de Kooning but to exemplify a way of handling pictorial space.) The rectangle of the canvas is filled with highly charged brushmarks presenting a certain amount of tonal variation but little emphatic contrast; the rectangle of the image is almost entirely filled by the mass of the compact motif. Between this and ourselves there is a very limited space into which we can move before we come up against the looming wall which has certain shallow recesses but nonetheless confronts us with an impenetrable barrier which there is no way through and no way round.

In a typical Monet of the following decade, one of the *Water Gardens*, with the motif, a pond and the sky reflected in it, inevitably filling the rectangle of the canvas, the space before us offers no resistance. It invites us into it, yields itself up, envelops us, makes us part of it. An analogous enveloping space appears in de Kooning's Women of the decade after that of *Woman I*. In, for example, *Woman in Landscape III* of 1968 we too are in the landscape, *in* it, not looking *at* it, and we are enveloped, moreover, not only by the landscape but by the figure of the woman. (This receptivity of the space, as with the Monet, is achieved without any sacrifice of the integrity of the picture-plane.) All this is typical of de Kooning's later paintings of Women, paintings which, by the way, are usually much warmer in palette, as in, say, *Amityville* of 1971. There was a vivid sentence about them by Marla Prather in a wall notice at the Washington showing of the current exhibition. 'At times the figure seems virtually formless, engulfed by the wet, slippery medium of oil paint de Kooning has developed.'

I take this to be a metaphor as well as a description. These close-ups of the female body are marvellous in their evocation of soft surfaces and entrances and liquid desires, their intimation of fusion, tender and violent, with another body. Their meaning is not at all elusive or ambiguous, and what they so palpably signify throws light on

the problem of the unconscious meanings of *Woman I*. Seen in that light, *Woman I* can only be what Elaine de Kooning famously said it was. 'That ferocious woman he painted didn't come from living with me. It began when he was three years old.'[19]

NOTES

1 Thomas B. Hess, 'De Kooning paints a picture', *Art News*, March 1953, pp. 30–2, 64–7.
2 Thomas B. Hess, 'Ben Shahn paints a picture', *Art News*, May 1949, pp. 20–2, 55–6.
3 Thomas B. Hess, 'Feininger paints a picture', *Art News*, June 1949, pp. 48–50, 60–1.
4 New York, Viking Press, 1951.
5 Thomas B. Hess, 'Dubuffet paints a picture', *Art News*, May 1952, pp. 30–3, 66–7.
6 *Art News*, December 1952, pp. 36–9, 63–4.
7 *Art News*, December 1952, pp. 22–3, 48–50.
8 *Ibid.*, pp. 22–3.
9 *Loc. cit.*, p. 30.
10 *Willem de Kooning*, New York, George Braziller, 1959, p. 117.
11 Catalogue of the current exhibition: *Willem de Kooning: Paintings*, Washington, National Gallery of Art, Newhaven and London, Yale University Press, p. 131.
12 *Ibid.*, p. 49.
13 It appeared in *Location*, No. 1, Spring 1963, edited by Thomas B. Hess and Harold Rosenberg, 'Content is a Glimpse . . .' by Willem de Kooning, the by-line footnoted 'Excerpts from an interview with David Sylvester (BBC)', pp. 45–8.
14 Quoted by Marla Prather in *Willem de Kooning: Paintings*, p. 31, giving multiple sources.
15 'De Kooning', *New York Times*, 22 March 1953, sec. 2, p. 8.
16 'The Art Galleries', *New Yorker*, 4 April 1953, p. 96.
17 *Willem De Kooning: Paintings*, p. 21.
18 'The Master of Imperfection', *New Republic*, 4 July 1994, p. 30.
19 Quoted by Curtis Bill Pepper, 'The Indomitable de Kooning', *New York Times Magazine*, 20 November 1983, p. 70.

Twombly 1995

Written in April–July 1995 and published in *Tate: The Art Magazine* for Autumn 1995, entitled 'Cy Twombly's Theatre of Operations'.

'Philosophy is not a theory but an activity' (Wittgenstein, 1918). 'At a certain moment the canvas began to appear to one American painter after another as an arena in which to act . . . What was to go on the canvas was not a picture but an event' (Harold Rosenberg, 1952). 'If there's no picture that's too bad. So long as I've learned something about why' (Giacometti, 1957). 'It could be argued that Bacon's essential aim is not so much to produce a picture that will be an object worth looking at, as to use the canvas as a theatre of operations for the assertion of certain values' (Michel Leiris, 1987). 'I'm not in this because I need or want to make another billion; that would have no value. It's all in the doing' (David Geffen, 1955).

Twombly is a clear case of the doer, perhaps a clearer case than Rosenberg's Action Painters. Pollock by comparison seems to have brought his paintings into being as steadily and soberly as if they were brick walls. In a painting by Twombly the traces of the scribbling and spattering seem the marks of an irrepressibly urgent need to spill pent-up energy and to leave something of oneself behind. Such a painting is surely the paradigm of an 'arena in which to act'. The action over, the canvas is like a soiled sheet after a wild night.

It is emphatically a hands-on art. It is deeply dependent for its effect upon our sense of the very varied pressure of the artist upon the canvas – from a brush, from fingers steeped in paint, from a pencil gouging lines through wet paint, from a pencil delicately touching the surface here and there. It is wholly antithetic to those typical parts of Pollock's technique by which he puts paint on the canvas from a distance – poured through a hole in a can, flicked from the end of a stick. Whatever Twombly's debt to Pollock's inspiration, in terms of his handling he is much more related to de Kooning. His personal style crystallised in the white-on-black paintings of 1954 – from which *Panorama* alone has survived, in a damaged state – and in the black-on-white paintings of 1955, such as *The Geeks* and *Criticism*, and of 1957, such as *Olympia* and *Blue Room*. Those works are manifestly a

response to de Kooning's black paintings and white paintings of 1948–50, as surely as Braque's Analytical Cubism is a response to late Cézanne.

Attic and *Excavation*, then, were the mature Twombly's point of departure, and in departing from them he immediately dropped, like a plane fighting to gain height, a quantity of what he saw as expendable baggage. Having demonstrated in his previous work a precocious mastery of picture-making in current European styles, Twombly presents a de Kooning shorn of his substantial inheritance from European pictorial culture. Firstly, he discards what de Kooning has taken from Cubism. By eliminating the cubist grid, he allows his scrawl to go where it will. (The wispy threads in *Blue Room* suggest leisurely levitation; the hectic tangle in *Criticism* recalls speeded-up scenes in silent slapstick movies.) Secondly he dilutes what had been handed on to de Kooning – mainly by Gorky – from Surrealism: he dampens down the evocations – whether punning or straightforward – of bodies or parts of bodies and other natural objects or fragments.

In Twombly's sculptures such evocations are extremely evident. Indeed, one of the most charming things about the sculptures is that when they bring Giacometti to mind – as most of them do – they simultaneously recall both his post-war sculpture and his surrealist sculpture. Twombly, then, is not averse to surrealist-type evocations. Such evocations are there in the paintings in very much the same way as they are in *Attic* and *Excavation*. Except that in de Kooning they thrust themselves at us; in Twombly they are subdued.

We discern phalluses and orifices, we interpret the splatters and spots as bodily secretions, we notice in *Olympia* that, where the title word is inscribed in block letters, the initial 'O' is also one of a pair of testicles at the base of an erection. But the suggestions are conveyed *sotto voce*: they are not on the surface but embedded in paint. By the same token, the resonant proper names from Greek and Roman mythology and geography tend not to be clearly spelt out but to be half-buried by clouding or distortion. The classical world is evoked not as it is by Keats but rather, as Kirk Varnedoe has suggested, as it is by Joyce, 'in the effort to fuse antiquity's epic spirit with the slang, raw data, and fragmented time of modern experience', in particular, in 'the headlong run of *Finnegans Wake*'.

The allusions and evocations, then, are not trumpeted, they are only partially communicated. It is as if they were there for the artist's private entertainment. There is a message in this: where a full-size de Kooning is a public statement, a full-size Twombly of 1955–61 is a page from a notepad. Indeed, the entire configuration of a work often makes it like a notepad page in that it seems to juxtapose different kinds of things that need recording: a name, a shopping list, a diagram, a phrase.

A notepad page has no rules to obey, arouses no expectations of inevitable order, and this of course gives savour to its turning out to be rigorously organised. Consider the great series of large white untitled paintings made in 1959 at Lexington, in which there is nothing on the canvas but some pale pencilled notations dotted here and there on a white painted field that suggests mist, atmosphere, space. Now, the natural tendency of those scattered marks would be to give an illusion of being situated at a variety of depths in the space. But Twombly controls this drift to here and there. Every one of the notations gives the illusion of being located at the same depth in the space, a depth that is rather near. A high tension is set up between the marks, making the space full of energy and full of stillness; mysteriously the space has hardly any depth while seeming empty and open.

By all accounts of Twombly's often feverish working methods, this control of depth could not have been achieved through cautious calculation. Twombly is endowed with the gifts that mark true painters of automatically sustaining flatness over the whole extent of the canvas and of imparting a certain stillness to the canvas regardless of how *mouvementé* the composition is. This last is one of the marvellous qualities of the series of paintings of 1961 in which bits of bright colour are deliriously – it seems – scattered and spattered and dripped and dribbled – works such as *Triumph of Galatea, Empire of Flora, Bay of Naples* and the untitled piece illustrated in Plate 59 of Varnedoe's catalogue.

I have spoken of the way Twombly diminished the Gorkyesque component in late-1940s de Kooning. Now, the key influence on Gorky's own mature work was certain Kandinsky paintings of around 1911–14: Gorky took these products of an inspired folk-artist and refined them. And in that 1961 series Twombly seems to have taken

the same raw prototype and worked out a different way of refining it
– a way that emphasised impasto rather than line. Whereas
Kandinsky's use of colour is that of an innocent peasant's liking for
bright things, Twombly's is in the tradition of the Venetians. The
colour we feel we are seeing is not made of the bits of colour applied
to the surface of the canvas; it is the mist of intangible colour that
these generate out there between the canvas and ourselves.

With the *Ferragosto* series of the same year, the areas of the canvas
filled by coloured impasto – hotly coloured – become larger. After
that, the figuration sometimes becomes more explicit, notably in *Leda
and the Swan* of 1962. It is as if within a space of three years Scarlatti
had been transformed into Wagner. This heated phase concludes
with the *Commodus* series of December 1965. Within months, it was
succeeded by a total reaction against it – the 'grey' paintings of
1966–71.

They look like blackboards written on with chalk. The blackboard
calls to mind lectures by Twombly's friend Beuys, but it also evokes
the schoolroom, and that image calls to mind the art of Twombly's
rival, Johns, with its apparatus of letters, numbers, rulers, targets,
flags, maps. But Twombly's art itself has long involved a harking back
to childhood: the scribbling and scrawling are a clear reversion to
that. Where Johns recalls childhood mainly through its objects,
Twombly recalls it through its processes, though also with certain
objects in that the scribbling incorporates the names of classical
heroes and places. The crucial difference is that for Johns reliving
childhood is a depressive meditation, with Twombly a manic recapit-
ulation. Nowhere is it more manic than in the 1954 predecessor of the
blackboard pictures, *Panorama*, with its all-over scratchy, tangled,
staccato scribble. There is no resemblance at all to this in the grey
paintings of 1966–71, where the writing is generally bold, broad,
flowing, repetitious and calmly confident. At the same time, the works
of 1966–71 do have some resemblance to still earlier Twomblys,
namely, the European-influenced work of 1951–53, in their use of
large curving forms and in their repetition of forms many times over.

The grey paintings mostly present several horizontal rows of a
repeated figure, usually a loop, each overlapping with the next. In
some, all the rows have figures of about the same size, in others they

vary in size; in some the figures are drawn on a clean ground, in others they lie on top of earlier layers. Sometimes the rows of loops have the grandiose impact of tiers of Baroque clouds. When the figures are not loops they are sometimes schemata whose repetition evokes an easily identifiable futurist composition such as Boccioni's *States of Mind: Those Who Stay* (these provide Twombly with a pretext for notable graphic virtuosity). The examples which do not consist of rows of figures tend, as in *Night Watch* of 1966, to present some sort of diagram which might have served to illustrate a lesson in geometry or mechanics. But then all the grey paintings return us to that schoolroom. Only, the artist is playing a different role. He is no longer the boy covertly scribbling erotica in an exercise book but the agent of authority beside the blackboard.

This iconographic sleuthing may be of marginal interest, but the distinction it draws symbolises an essential difference. The grey paintings, especially those bearing very few marks or – when more elaborate – precise, schematic structures, have the suave, relaxed look of confident artefacts from the Old World, a smooth look in contrast to the raw look of earlier Twombly, a glorious rawness in the line of Pollock, de Kooning and Kline. These grey paintings, especially when the paint on the canvas is manifestly thin, have an affinity to those large late Miró canvases with a few signs on a monochromatic (blue, red, green) field.

There are few more entertaining games to be played with contemporary art than that of carving up the career of the handsome Virginian who settled in Italy, carving it into American and European bits. After all, when he started painting, at various places along the Eastern seaboard, he was mainly producing European-style pictures, like a latter-day young Robert Motherwell. A lot of his work since 1981, when he started painting *Hero and Leander*, has looked like a continuation sometimes of late Turner, sometimes of late Monet. His masterpiece, perhaps, of the last ten years, the painting in three parts of 1985, *Analysis of the Rose as Sentimental Despair*, a marvellous investigation of certain possibilities of thick pink paint, deeply and inexplicably poignant in the relations between the clotted, weeping matter on the canvases, the rectilinear formality of the plaque above each canvas and the casual rapid scrawl of the inscriptions on the

plaques, has a very European perfume, though on the other hand one could also say that that was similar to, if much more pungent than, the scent of early-1950s Gustons, thereby raising further questions. The giant *Untitled Painting* of 1994, 13 feet high by 52 long, could be a conscious attempt at a marriage of Twombly's European and American strains. Perhaps one looks for plays of antitheses in Twombly's work because its greatness is so bound up with its basic antithesis between an uninhibitedly elemental idiom and a wealth of teasing allusion.

Cage
1989

Written in the summer of 1989 and published as 'Points in Space' in the catalogue of *Dancers on a Plane: Cage, Cunningham, Johns* at the Anthony d'Offay Gallery from 31 October to 2 December 1989 and the Tate Gallery, Liverpool, from 23 January to 25 March 1990.

I

This exhibition of the holograph of the sixty-three pages forming the piano part of Cage's Concert for Piano and Orchestra (1957–58) is more or less the equivalent of an exhibition of a set of architectural plans for a particular building and its grounds. However beautiful and interesting it may be to look at, it was not made as something to be looked at. It was made as a set of instructions for a construction to be realised by someone (the performer, the builder): the forms it presents and their relative placings are determined by the composer's desire to communicate his requirements to the performer as effectively as possible. There are, of course, when writing music, often alternative ways of communicating something to the performer, and it is not inconceivable that, where such alternatives presented themselves here, even Cage, with his attachment to the principle of rejecting opportunities to indulge personal aesthetic preferences, was not beyond instinctively choosing those he liked the look of.

The simple reason why, in the first place, I have compared these pages to architectural plans, rather than to some other kind of dia-

gram which conveys instructions for making or assembling something, is the way they mix the rectilinear and the curvilinear, with biomorphic lines or figures, like plans for winding paths or lakes or areas of parkland, placed here and there among the dominant sets of parallel straight lines. But there is a far deeper similarity than that. In an architectural drawing the relative magnitude of the lines is in proportion to the relative magnitude of the things they represent: if the east and west walls in the plan of a building are two-thirds the length of the north and south walls, so will they be in the building. But where, in a traditional musical score, three consecutive pages are packed with runs of demisemiquavers and are followed, with no change of tempo, by three consecutive pages of minims and crotchets, the first three pages are going to be played in a small fraction of the time it takes to play the second three. This is because the notation uses the position of a note on the stave only to indicate its pitch, not its duration; the duration is indicated by a semiotic convention. Cage, however, has invented a notation in which the duration of notes is not indicated by a code; the notes are all tailless and their duration is indicated by their relative placing within the page. Thus a page that is blank (e.g., page 15) is manifestly one of those infamous periods of silence. Manifestly. The measure here of time is space.

What is not manifest in the pages of the Concert for Piano and Orchestra is how the performer is supposed to deal with a given configuration. This is where a code is used, a code that is explained in the prefatory pages. It consists of eighty-four letters or combinations of letters one of which is placed before each configuration of notes. For instance, the letter A (e.g., pages 1, 5–6) means: 'Following the perimeter, from any note on it, play in opposite directions in the proportion given. Here and elsewhere, the absence of indications of any kind means freedom for the performer in that regard.' Or, again, the letter G (e.g., pages 4, 9, 11–12) means: 'Of notes written play number given in any manner (keys, harp) beginning and ending as indicated by arrow: Dynamic indications accompany each circle on the circumference of which the notes are placed. (Scale ppp-fff)' A large part of the instructions has to do with telling the performer where he is free to act according to his own choice. In Cage's mature music a performer is not an 'interpreter', someone trying to convey what

someone else wants to say; he is a co-composer, sharing the decisions on what to say. And along with that constant interaction between the composer's decisions and the performer's, the music also crucially involves interaction with decisions provided by chance operations, such as throwing dice.

For any performance of the Concert the variables to be determined by the performers and/or chance include how much of the music is to be performed, the length of time in which each configuration is to be performed, and which of the possible performers is actually going to perform. The maximum instrumentation consists of piano, three violins, two violas, cello, double bass, flute, clarinet, bassoon (or baritone saxophone), trumpet, trombone, tuba and a voice, plus a conductor who is no less optional (and whose role, when present, is not to mark beats but to use his arms like a clock, to measure the length of time within which a certain sequence of notes is to be played). There was at least one occasion when the freedom of choice served a high humanitarian purpose. At the first rehearsal of a full orchestral performance in the South of France, the excellent trombonist, a Japanese, fluffed a difficult top F. His sense of shame was distressing to behold. And then at the second rehearsal he fluffed the note again. He vowed that, if this happened in the performance, he was going to commit hara-kiri, and his colleagues knew him well enough to be alarmed. Cage, however, who was conducting, cooled matters by saying decisively that, while the trombonist was to perform in the other works to be played that evening, the Concert for Piano and Orchestra would have its trombone part omitted. It became clear that the trombonist took this as a well-meaning insult to his honour when, shortly after the rehearsal ended, it was found that he had disappeared, together with his instrument, and that a long-bladed knife was also missing. His colleagues hurried out to the woods to look for him. There was no sign of him until they heard the note, coming through the trees, perfectly formed. The trombone part was still left out of the performance.

'The Concert for Piano and Orchestra is without a master score, but each part is written in detail in a notation where space is relative to time determined by the performer and later altered by a conductor. Both specific directives and specific freedoms are given to each player

including the conductor. Notes are of three sizes referring ambiguously to duration or amplitude. As many various uses of the instruments as could be discovered were subjected to the composing means which involved chance operations and the observation of imperfections in the paper upon which the music was written. The pianist's part is a 'book' containing 84 different kinds of composition, some, varieties of the same species, others, altogether different. The pianist is free to play any element of his choice, wholly or in part and in any sequence.'

That summary description of the work by the composer reveals, directly or by analogy, a good deal about what Cage stands for and is. But then there are few things more revealing about anyone than clues as to where and how they impose demands upon others and where and how they let others pursue their own course. And as to when and where they stop trying to control things and let chance take over.

II

Three years ago, when an exhibition of contemporary music manuscripts was on at the Serpentine Gallery, I went to see it with my friend Diego Masson. I took advantage of his having conducted a high percentage of the works by questioning him as to whether the scores which appeared to me to be the likeliest for a conductor to find difficult actually were. But we also talked about scores as objects for looking at, and he remarked, making it clear that he was thinking of past as much as present music, 'A score which is beautiful to look at usually sounds better than one which is not.'

The chances of a Cage score's being beautiful to look at are presumably increased by his having had a history as a painter. After dropping out of Pomona College at the age of seventeen, he went to Paris and stayed for six months, long enough to see a good deal of modern art and hear some modern music. 'The impression I gained was that, if that was the way things were, I could do it too.' Then, in the course of a year's wandering around Europe and North Africa, he started painting and writing and composing, and he went on with them all when he moved back to Los Angeles. He painted landscapes from the motif, in a way somewhat influenced by Van Gogh, and then he painted what he saw in reflections in spherical surfaces such as the

chromium part of car headlights – reflections in them of architecture, yielding simple forms transformed by the optical distortion. This led to his painting invented abstract shapes. 'And what was interesting to me then was to make a very thin application of the oil on canvas, and to make it by using, not a brush, but steel wool, so that I was rubbing the paint on to the surface of the canvas.' From the start, then, Cage was fascinated by the use of new or uncommon procedures. The great innovators in the arts can be divided into those who are primarily inventors of new forms and those who like Cage are primarily inventors of new procedures. Primarily. New forms lead to new procedures and vice versa.

Cage's versatile youth came to an abrupt end when he was twenty-two and asked Schoenberg to give him lessons. Schoenberg did not mind his not being able to pay but did insist that he promise to devote his life to music. (Schoenberg, of course, knew what he was talking about, having himself been a considerable painter.) Cage, ever mindful of that promise, produced no further work of visual art till 1969. In the meantime, though, music of his had been exhibited as visual art. It was, indeed, the music exhibited here. The time was May 1958, when a retrospective concert of Cage's music was staged at the New York Town Hall and concluded (ultimately in uproar) with the first performance, conducted by Merce Cunningham, of the Concert for Piano and Orchestra. In celebration, the pages of the piano part were exhibited in the upstairs room at the Stable Gallery (while Rauschenberg was having a show downstairs). Several of the pages were sold; Cage wrote them out again to keep the set complete.

It was because of seeing some manuscript of Cage's that Alice Weston was moved to ask him to produce a graphic work in memory of Marcel Duchamp. This was what finally made him break the promise to Schoenberg; he produced a series of plexigrams. Three years later he made ten lithographs for a mycological book of which he was co-author. He was becoming increasingly mindful now of Margaret Mead's view that, living much longer as we do, we have the opportunity to live, not just one life, but several. In 1978 he decided to accept an invitation from Kathan Brown of the Crown Point Press in Oakland to come out there and experiment with making prints. Since taking that decision he has published about twenty albums of

etchings or monotypes and has also produced a quantity of drawings, made in 1984 and 1987. They are works whose interest is independent of Cage's greatness as a composer and importance as a writer; indeed, it seems to me that the best of them – for instance, the series of four drypoints, *Where R = Ryoanji*, of 1983 – are among the most beautiful prints and drawings made anywhere in the Eighties.

Now that that material exists, the piano part of the Concert for Piano and Orchestra is seen in an art gallery very differently from how it was in 1958. It is now the equivalent of a set of architectural plans by an architect who is also established as an artist. Cage himself has elected to show it, rather than recent prints or drawings, for his first exhibition in London, perhaps because of the exhibition's context. A reason for welcoming his decision is that pages of music represent his central activity. And they do certainly present, if with less immediacy, the qualities which radiate from the drawings and prints. 'Radiate' is exact, because the supreme quality of these works is how they contain light. That a drawing should do this is, of course, a criterion of its quality. At the same time, Cage's music as I listen seems to be peculiarly analogous to light. All that Cage does seems filled with light. Light and also lightness – for one thing, because of his way of making everything he does look effortless.

The immediate satisfaction I get from the piano part of the Concert is a sense of the grace with which the configurations sit or lie here and there upon the page. They do so, incidentally, in a way that reflects Cage's love of using collage – 'the bringing together of things that wouldn't be together unless you brought them together' – whatever the medium he is working in. In this manuscript he was not physically using collage, but he was thinking in collage terms, it seems to me, inasmuch as I have a feeling in looking at the page that each of the configurations there existed independently of all the others before being placed upon it. This feeling is accompanied by a concentrated awareness of the exact dimensions of the page, a pleasure in the finality of its edges. Till suddenly the sheet of yellowing paper disappears, ceases to be a surface and becomes a space, a space for the enactment of a dance – a dance which arises for the simple reason that in these pages space means time, distances mark beats.

The dance that unfolds is a vivid interaction between movements

that are regular, formal, rigorous, and movements that are fluid and meandering. It makes me think of morris dancing and its intense contrast between the disciplined, compact, frontal movements in a rectilinear framework – an extreme order, a violent order – of the six (or eight) dancers forming what is called the set and, winding in and out of that order, the wayward, unpredictable movements of the Hobby-horse and the Fool (or the transvestite figure called the Betsy). That dance, it seems to me, is a paradigm of the dialectic which underlies how all art operates. In Cage's work – and in the work of Cunningham and of Johns – this is not merely there below the surface. It is the overt guiding principle, the subject-matter almost, this play between the given and the indeterminate.

Warhol

1994

Entitled 'Factory to Warehouse', this was a report on the opening of the Andy Warhol Museum in Pittsburgh published in the *Independent on Sunday Review* for 22 May 1994. The present version is slightly different in that the opening paragraph is given as submitted, not as published, and then in a couple of small alterations.

The setting up of an Andy Warhol Museum prompts the alarming thought that one-man museums are about to proliferate, largely because artists for some decades now have been tending to work on a large scale. This means that their output doesn't get absorbed into private houses and apartments as the work of successful artists used to be. All the unwieldy pieces which have not been acquired by museums, or by private collectors whose habitations virtually are museums, stay on the artist's hands, hopefully awaiting posthumous consignment to a personal museum. The inevitable fear for potential visitors to such a museum is that there will be an awful lot of the artist's work there but very little of his best work.

The Andy Warhol Museum in Pittsburgh owns about nine hundred paintings and numerous sculptures, drawings, prints, photographs, films, videos and so on, and great piles of documentary

material: it is claimed to be 'the most comprehensive single-artist museum in the United States, if not the world'. The initial selection (by its English curator, Mark Francis) allays fears that the quality is not going to match the quantity. Some aspects of the work are not very well represented, but by and large there are first-class examples of all periods, and some are not well-known pieces. Quite a number date from the second half of the 1970s, a period that was scarcely evident in the big retrospective at the Hayward Gallery, London, in 1989.

For example, on the top floor there's a room given over to the *Shadows* series, and in another room, a small group of pictures of torsos – single torsos which are variously male or female, frontal or dorsal, and one work which presents a row of five repeated profile views of the same torso.

Each of these canvases was achieved through the typical Warhol combination of silk-screening a photograph and putting on synthetic polymer paint. The theme of the torso is one of the great themes that the art of our millennium has retrieved from the art of ancient Greece and Rome. This fact is less significant here than the fact that the images are photographic. And all of Warhol's mature work is as if inspired by a revelation that a modern painter could and should exploit the photograph as Renaissance painters exploited classical antiquities. For the photograph has come to assume the credibility which the Renaissance found in Graeco-Roman images and forms, though hardly for the same reasons: those antiquities got their authority from their beauty, photographs from their truth.

The art of ancient Greece and Rome had, furthermore, a certain moral authority: the artist who modelled his forms on its forms was imitating the relics of a golden age of human history. But the photograph, too, has a sort of moral authority. We say that the camera cannot lie, and this implies that it's a trustworthy, honourable instrument. We know that in fact there are ways in which the camera *can* lie, but we act as if we didn't believe that. The powers-that-be insist that the picture in our passport – a picture that's a matter of life and death – has to be a photograph (provoking David Hockney to protest that a drawing ought to be an equally acceptable portrait). And the powers-that-be know, as we all do, that passport photographs often look very

unlike the person. But these are still treated as uniquely authentic documents, such is the prestige that adheres to the photograph.

Painters have been exploiting photography for well over a hundred years, borrowing forms from the work of professional photographers and also taking photographs of their own as an aid to painting. The resultant paintings have rarely disguised the fact, and some have stressed it – works by Balla and Bacon, for instance. Warhol went much further. He created an art which would be utterly meaningless to anyone who didn't realise that it was made from photographs and was about photographs.

But truthfulness or supposed truthfulness clearly didn't top the list of what fascinated Warhol about photographs. Indeed, he altogether overturned the idea that photography filled a need for truthful recording while antiquities filled a need for an ideal beauty. Warhol used photographs to achieve glamour rather than for truth. The faces that appear most repeatedly in his work are those of Elizabeth Taylor, Marilyn Monroe, Jackie Kennedy, Elvis Presley and others of their ilk. He turned to photographs of stars, as the Renaissance turned to antiquities, to find images of gods. Elvis mostly appears full-length as a cowboy with drawn gun (a publicity still for the film *Flaming Star*). There are usually three or four of him in a row; but at the Warhol Museum there's a previously unknown version, *Elvis (Eleven Times)*. Nobody knows whether Warhol actually intended to show a row of this length or to cut the number down. They pose side by side in a lake of silver paint, some standing out from it distinctly, others almost dissolved in it, the rest in various degrees of clarity. Repeated again and again in this silver setting, his glance ominous, his face and hair smoothly sculptured, his body lithe and springy and balletic, Elvis is a reincarnation of Apollo. When Lautrec made monuments to the stars of the day, it was apt that he drew them, because they were live performers and drawing is a live art. Warhol's photographic images of the stars reflected the fact that the world knew them largely through the photographic image.

Another attribute of the photograph that Warhol exploited brilliantly was ambiguity. The glorious thing about the camera is that it's brainless and doesn't organise what it records, doesn't clarify it or limit it. All the photographs of disasters that Warhol used – mostly car

crashes – contain passages in which it's wonderfully unclear what is happening. Because the familiar forms have been smashed up, we can't fill in so as to conceptualise what we're looking at. The uncertainty gives rise in our minds to one phantasmagorical scene after another.

A magnificent little-known example is hanging in the Warhol Museum. Dating from 1963 and entitled *1947-White*, it is a variant on the more familiar *Suicide (Fallen Body)* of that year, one of the works in which the photograph is repeated in a grid, with variations achieved through the silk-screening, consisting in *Suicide* of four rows of four images each. In *1947-White* the grid is less regular, is somewhat telescoped in the second and third rows, and in the bottom row is telescoped enough for there to be five images. Down the centre of the image is a woman lying on her back, seen head downwards. The smashed forms of the automobile behind and around her give no clear sense of what has happened, but it looks as if she is lying cradled in a hammock, which gives her a poignant serenity. Only the title *Suicide (Fallen Body)* tells us that her comforting couch is the dented roof of the car on to which she has thrown herself. That knowledge does nothing to diminish the mystery of the work, which goes far beyond the question now answered. The light reflected from the twisted car creates flickering tongues of flame or water or flesh. In *1947-White* the middle rows are very luminous and the bottom row very dark, and the overall effect is one of writhing forms, rising or falling, in an Apocalyptic scene that might be a Last Judgement by Tintoretto or El Greco.

Repetition is everywhere in Warhol. Even when the individual work doesn't present the same shot five or eleven or seventeen times, even when the work presents a single photograph, we know that this is a repetition because photographs are *sui generis* repeatable, and even the Polaroids Warhol perpetually took of people could be multiplied through silk-screening. The repetitiveness bound up with photography could have been what attracted Warhol to it most of all. He made a fetish of repetition. Works of his that bypass photography are still a celebration of repetitiveness. The *Brillo Boxes*, for example, and the *Heinz Boxes* and *Campbell's Boxes*. All of these, by the way, are particularly well shown at the Warhol Museum: they are not arranged aesthetically, tastefully, as they were at the Hayward and the Royal

Academy's *Pop Art* exhibition, but are piled up as if in a warehouse, bringing to mind Warhol's remark, 'When you think about it, department stores are kind of like museums.'

Perhaps his most perfect game of repetition was played in *Silver Clouds*, the crowd of helium-filled cushions of metallised plastic film. They looked very beautiful at the Hayward retrospective, clinging to the curves of the concrete staircase like Baroque *putti* up there adorning a column. But at the museum they are presented as they were when originally shown in 1966 at the Leo Castelli Gallery in New York – filling a smallish room in which they float up and down and around in response to electric fans and the heat emanating from people's bodies, moving at differing speeds, here huddling together, there bumping into one another, and into us. Their blindness is as appealing as their sameness. It is difficult not to see them as living creatures. They seem to have the vulnerability and will to live of maggots. Above all, I was told by a colleague brought up in Australia, they are like sheep. 'I think it would be terrific', said Warhol, 'if everybody was alike.'

Warhol's love of repetition was also manifest in his life. 'I used to have the same lunch every day, for twenty years, I guess, the same thing over and over again.' The question is to what extent he simply had an addictive nature and echoed in his art his need to live obsessively, to what extent his faith in repetition was a conscious philosophy. The staggering size and variety of his creative output, and the readiness to delegate that this demanded, suggest a relaxed personality who could make his energy go a long way, not get knotted up in involvement with compulsive patterns. The love of repetition was tied up with a cult of standardisation which seems to have been more than a mere taste for experiencing the same thing over and over again.

Nan Rosenthal has even argued, in a remarkable lecture, 'Let us now praise famous men: Warhol as art director', that while he was at Carnegie Tech, Warhol was influenced by Bauhaus ideas about the virtues of standardisation, ideas which involved a rejection of the prejudice that hand-made artefacts were *a priori* morally superior to manufactured artefacts. The earnest tradition of the Bauhaus backed up Warhol's flip remark, 'The reason I'm painting this way is that I want to be a machine.'

So an old-fashioned modernist approval of standardisation tied in with a personal liking for popular culture. There is irony in this statement of Warhol's, but it's not unserious: 'What's great about this country is that America started the tradition where the richest consumers buy essentially the same thing as the poorest. You can be watching TV and see Coca-Cola, and you can know that the President drinks Coke, Liz Taylor drinks Coke, and just think, you can drink Coke, too. A Coke is a Coke and no amount of money can get you a better Coke than the one the bum on the corner is drinking.'

At the same time, the love of mass culture was radically different from that of the masses. 'I could never stand to watch all the most popular action shows on T V, because they're essentially the same plots and the same shots and the same cuts over and over again. Apparently, most people love watching the same basic thing, as long as the details are different. But I'm just the opposite: if I'm going to sit and watch the same thing I saw the night before, I don't want it to be essentially the same – I want it to be exactly the same, because the more you look at the same exact thing, the more the meaning goes away, and the better and emptier you feel.' From Pop to Zen.

If there is any doubt that Warhol's art is ample or deep or interesting enough or likely to be enduring enough to keep a one-man museum alive, it has to be remembered that the museum is also going to house and show his output as a film-maker. (The museum, a handsome 1911 warehouse, has been admirably renovated by Richard Gluckman in ways that make it serve its purposes, rather than call attention to the architect.) I think that film is where Warhol's supreme achievement lies. Whatever his genius – and his shattering originality demands that word – his output as an artist is probably not quite as distinguished as that of Johns or Twombly or Rauschenberg or Beuys. In the far more competitive, and culturally more important, domain of the cinema, he seems to me to stand to the fore among his generation throughout the world, along with Godard and perhaps Pasolini and Oshima.

That peerless writer on cinema, David Thomson, places him in a still more select pantheon: 'Warhol's films do have the sort of stylistic minimalism and dislike of expressiveness to be found in Ozu, Hawks, Bergman, Dreyer, Rossellini, Godard and Renoir; the style, I

would argue, that is most elevated in cinema . . . They shared
Warhol's reluctance to urge meaning into the action through the
ingenious placing of the camera. Like him, they tried to serve their
actors.' Or, as Warhol put it: 'I only wanted to find great people and
let them be themselves and talk about what they usually talked about
and I'd film them for a certain length of time and that would be the
movie . . . To play the poor little rich girl in the movie, Edie
[Sedgwick] didn't need a script – if she'd needed a script, she would-
n't have been right for the part.'

 One of the strengths of artists in all media in the first half of the
twentieth century came from a readiness to follow Mies van de Rohe's
precept, 'less is more': they simplified and purified their forms, rid
them of excrescences. One of the strengths of artists in all media in the
second half of the twentieth century has been that they seem to have
believed that less *intervention* is more: they set things in motion and
then let them alone, not trying to control them, but allowing them to
take their course and their chances. Warhol was supreme in achieving
that.

Serra *1992*

Written in November 1992, this review of Richard Serra's installation, *Weight
and Measure*, at the Tate Gallery from September 1992 to January 1993, was pub-
lished under the title 'Solid and Fleeting' in the *London Review of Books* for 17
December 1992.

It is interesting that Richard Serra, who is not short of offers of highly
promising locations for which to make site-specific sculptures,
accepted the Tate's invitation to do something in their domineering
central hall – a space ostensibly built for showing sculpture but serv-
ing that purpose rather badly, partly because it makes the things put
into it look as if they were lost at the bottom of a well, partly because
its huge Ionic columns dwarf other forms in the same field of vision.
For that matter, it is interesting that Nicholas Serota has ignored the
space's bad reputation in restoring it to its original purpose and shape,

this at some expense because of the need to strip away various accretions which had been added out of despair at the difficulty of showing sculpture there, as against certain kinds of painting – Picasso's *Meniñas* series, for example – that have looked quite good on the walls.

Its flaws as a setting for sculpture are the consequences of a single-minded pursuit by its main architect, John Russell Pope, of its underlying purpose, which was to provide a famous dealer in need of respectability, Lord Duveen, with a chance to display his munificence on a colossal scale. So the space seems designed to diminish any person or thing that enters it. Completed in 1937, it also has something of the bullying pomposity characteristic of official buildings erected in countries under totalitarian rule. Meanwhile at the British Museum Duveen was employing Pope to execute a takeover of our greatest artistic possession, or ward, the Parthenon Marbles. Before they could be installed in the house he had built for them the Luftwaffe mercifully destroyed it. Blindly the British Museum Trustees rebuilt it and in 1962 moved the sculptures in. Till then they had, of course, been one of the seven wonders of the world. Since then any pleasure still to be had from looking at them has been mixed with a good deal of pain.

There has been no blindness, though there has been risk, in Serota's decision to put sculpture and only sculpture in Pope's tripartite hall at the Tate, the South Duveen Gallery, the Octagon and the North Duveen Gallery. He has managed to choose and place and light various combinations of pieces from the permanent collection – and related borrowed items – in viable ways, works by Rodin and by Epstein especially. And he has initiated a highly interesting series of exhibitions 'which demonstrate a sculptor's response to the space'. Serra is the third sculptor invited to respond: his answer, *Weight and Measure*, will remain there until 15 January and will then be dismantled, doubtless for good.

The initial guest, Richard Long, followed his usual bent by focusing attention on the floor and so bypassed the problem normally posed by these galleries – that the space up above crushes sculptures and visitors alike. The three volumes were turned into three areas, thanks to the visual magnetism of three compositions which were not only beautiful in themselves and cleverly contrasted but related nicely to the shapes of their respective areas. The work was a triumph, but

one achieved by slipping through Duveen's gargantuan legs rather than by standing up to him. The next guest, Anthony Caro, took Duveen on. But Caro is an artist whose rich creativeness is not matched by his critical intelligence, and this has never been more evident than it was in his contest with Duveen. He appears in his naïvety to have made two strategic errors: to be too easy-going; to be too greedy. He seems to have supposed that he could dump a selection of existing works in this rebarbative space and move them around till they looked all right; and he seems to have supposed that the way to handle an enormous space was simply to fill it up, possess it, stuff it. The consequence was that the sculptures got in one another's way in the field of vision, so that a piece more than 10 feet high and 75 feet long became invisible. Caro's folly betrayed his own art and betrayed the Tate's act of faith that the space could be redeemed.

Serra typically took the problem seriously. How he did so is well documented, firstly in an interview with him recorded on 27 May and published in the exhibition catalogue, secondly in a lecture given at the Tate on 1 October and published in the current issue of the *Art Newspaper*. I quote from the interview. 'The architecture as a whole is overblown, authoritarian and a bit heavy-handed. It is a little bit "Thou shalt walk this way and then take the side aisles." What I wanted to do, and what I hope I am doing, is to bring another relevance to that space . . . I want to explose it by placing two volumes in the Duveen Galleries, leaving the octagon empty . . . The forged blocks will be centred on line with the main axis, placed 130–140 feet apart. They are approximately nine feet (exact measure 108½ in) wide, scaled to the distance between the central columns in the Sackler Octagon. One element is 68 inches high, the other is 60 inches high. The lower element is placed in the south gallery, the higher element in the north gallery, so that when you enter the hall, they will appear level due to perspective. Both elements will be 41 inches thick. I wanted a physical scale and mass which would act as counterweight to the columns and the weight of the stone . . .

'I started out considering five elements. We stood people at various locations over the distance to establish a scale reference . . .

'I did not reach a conclusion until after I had reduced the elements to four and three and at three I still had one in the centre. At that point

it became clear to us that we had to remove the work from the centre and see if we could hold the space with two elements. Only then did we feel that we were moving in the right direction. (I say we because Clara [Weyergraf-Serra] is part of the dialogue, always and continuously) . . .

'I started with circles, I started with the ideas of using forged rounds, taking the scale of the rounds from the scale of the columns. I dropped the idea. Conceptually it falls right into the post-modernist trap of contextualisation . . .

'I had recently installed a large forged octagon in front of a Romanesque church in Burgundy. To work with octagons was on my mind. And for a while I thought I would use them, but the active shape of the octagon draws too much attention to itself. It is too busy for this space. It can be too easily read as an interesting object . . .

'I dismissed the idea of using cubes as quickly as I dismissed the idea of using octagons and for the same reason. They would have been read as objects in the galleries. I've only forged one large cube. It is very absolute to forge a cube . . .

'We dropped the idea of using five parts because the seriality of their placement would have imposed a formal composition on the hall, isolating the installation from the conditions of the place. We only concluded the final number of elements after we started to work with full-scale models . . .'

The solid steel blocks have not come from the forge as regular, perfectly geometric cuboids. As the surfaces differ from those of minimal sculpture in being, through the workings of industrial processes, variegated and random, the forms are palpably imperfect: the top plane of the nearer cuboid has a definite slope; everywhere edges that look as if they might have been sharp and hard – as they are when Serra is working, as he mostly has, with steel plates – are here blunt and soft. Though these irregularities have again come about in the course of the manufacturing process, not through gestures of the artist's hand, the effect is analogous to that of Mondrian's brush-marks, palpable brushmarks which break up surfaces that would otherwise have been immaculate and predictable, giving them relief and animation. As those brushstrokes are an echo of the free painterly handling in Mondrian's early romantic landscapes, the roughness of

Serra's blocks relates to his early sculptures made by splashing molten lead on to a wall and floor. Obviously, Serra's untidiness is still more akin to the cultivated imperfections in Newman's straight lines.

Perhaps the first impression on coming into the south gallery is one of surprise at the daring of the work's absolute austerity. Perhaps the next, on approaching the first block, is that there's a deep solemnity about it which counters any feeling of surprise by conferring a sense of inevitability on the work. At the same time, the initial illusion that the blocks are the same height, followed by doubts on getting nearer as to whether this is so, engage the mind in the question of height, so that, when you get to the first block, you find – if you're between, say, five foot five and six foot tall – that its height is a tease. You can more or less see over it – certainly you can see the top plane, especially as the slope rises away from you – but you are still slightly bemused as to how its height relates to your own: it's a bit like dancing with an unfamiliar partner who isn't ridiculously taller or shorter than yourself. (I imagine that the short and the tall cannot respond to this work as others do: this applies to a lot of minimal art, the impact of which is so often bound up with its height in relation to ours.) As you leave that block behind and approach the other, there is a point at which you realise that this one is going to be higher. When you reach it you find – unless you are inordinately tall – that its top is above the level of your line of sight. Nothing teasing here; it is so decidedly something high that it might as well be as high as a house. This makes it more menacing than the first block. So does the fact that its edges look relatively sharp where those of the other are softened for the eye (as my colleague Marla Prather pointed out) by the way light falls on that visible top plane.

Everything about *Weight and Measure* – how the blocks relate to each other, how they relate to the space, how they relate to yourself – is a function of that difference between a barrier that is like a garden fence across which you can chat with a neighbour and a barrier that might as well be Gordale Scar. The blocks are utterly different entities though they are identical in their dimensions but for a difference of 13 per cent in their height. I am reminded of something said to me by Giacometti about the way in which the crucial differences in how art operates are physically very small: 'It's always extremely limited.

Like the fact that you can only survive with a temperature of – what –
between 36 and 39 degrees – and that's already very very bad. So you
can only really live with a temperature between 36.8 and 37.8. And
everything's like that.'

Contemplation of the blocks triggers a variety of visceral
responses. Their massive sense of solidity weighs me down, making
me feel that my own body is very firmly planted on the ground. The
energy emanating from them transfers itself to my body, so that it
feels lifted by that energy. The taller block gives off an energy which
has more intensity and speed than the other's: as I stand looking at it
from its far side, my body is assailed not only by the force emanating
directly from it but by waves of force which seem to have bounced
back from the surrounding walls so that they bombard me, like hail-
stones, from all sides and above. Turning away from the block and
looking towards the end of the gallery, I'm amazed to find that that
academic, bombastic architecture suddenly looks beautiful: the sculp-
ture has diminished its theatricality, and in looking more sober it also
looks finely proportioned. Turning around and walking back to the
smaller block, I invariably find on getting there that it's a soothing,
calming presence. It is (as Serota said to me) like coming home. It
seems to be hospitable, like a tomb in which I can imagine myself at
rest. The measurements which in reality would be relevant in a prac-
tical sense to its becoming that are no different from what they are in
the other block, which – here again the relative height is everything –
seemed forbiddingly impenetrable.

The relationship between the two blocks is not experienced as a
relationship between two objects set up in a space. It does not present
an interaction between forms perceived together from various points
in that space, as did, for example, that marvellous installation which
Serra created two years ago at the Kunsthaus in Zurich, *The Hours of
the Day*. The forms in that space were like actors seen in their places
on a stage; the forms in the Tate are like shots of single actors alter-
nating to build up a scene in a film. The relationship is one that is
constructed in the spectator's mind through successive – and inter-
acting – experience of the separate blocks. This is why I think Serra
was right in principle when he answered a question after his lecture
with the assertion that it didn't matter if people were drifting around

and getting in the way. But in practice it is true, I'm afraid, that the work looks at its most impressive when there are no people around. Their absence is especially helpful in regard to the crucial experience of walking from one block to the other. The space between the blocks is not a space contemplated but a space traversed. Every step taken in walking from the first to the second across the empty floor of the octagon seems momentous: how much distance has still to be covered seems a matter of great significance, because of the gradual heightening of tension and expectation. Hence the crucial importance of Serra's realisation that he had to have two units, not three: there had to be room left for a sizeable area of emptiness.

Walking from the second block back to the first is more an experience in visual ambiguity, as the sense changes with every step as to how the height of the one now ahead relates to that of the one now behind. Here again the work has to do with generating a succession of experiences unfolding in time. In the interview, Serra came to talk at length about Barnett Newman and one of his themes was this: 'In Newman's paintings space and mass which are formed between the vertical divisions are experienced as you walk or scan the field. It is an experience that unfolds in time ... When you reflect upon a Newman, you recall your experience, you don't recall the picture.' All the same, there are aspects of *Weight and Measure* which are less relevant to Newman than to Rothko. Given that there are two complementary modes in our relationship to works of art, the sense of envelopment and the sense of confrontation, Newman's paintings tend to induce the latter sensation to such a degree as virtually or entirely to exclude its counterpart, whereas Rothko's paintings tend to induce the two sensations alternately. And I think that *Weight and Measure* functions in these terms – I haven't yet worked out how – in ways analogous to the Tate's series of Rothkos of 1958–59.

Weight and Measure confirms with exceptional power certain familiar laws pertaining to the functioning of the energy which seems to be contained in great sculpture. First, that the energy emanating from certain forms, while not measurable by any instrument, has effects on an observer's nervous system which appear as real to that observer as physical pain or pleasure. Second, that this energy functions in a way analogous to light, seeming to fill a space as light

objectively bathes it. Third, that a form too many in a space can inter-
fere with the waves of energy so as to prevent them from totally filling
the space. Fourth, that when the waves of energy completely fill a
space, that space, in becoming altogether vibrant, becomes altogether
beautiful, regardless of its proportions and of the quality of its archi-
tectural detail.

Weight and Measure consists of two elementary forms made on an
unassuming scale, the scale of human beings, set up in a space
designed to make man feel small. It masters that vast space, matching
inordinate size with the force of its energy. None of the precepts that
has guided the modern movement has had more resonance than 'Less
is more.' *Weight and Measure* has turned out to be one of the supreme
manifestations of that principle, a milestone in the art of this century.
It's true that 'less is more' can apply to time as well as space, but it's
sad that *Weight and Measure* will stay – which means, being site-
specific, exist – for so short a time. Ironically, it has the look of a great
'timeless' monument.

Newman – II *1994*

Commissioned by *Artforum* as one of an ongoing series of short essays in which
'writers are invited to discuss a contemporary work that has special significance
for them', it was published in the issue for November 1994, entitled 'Barnett
Newman: *Untitled*, 1961'.

Usually the works that are going to matter most to one, like the
people who are going to matter most, start doing so as one first sets
eyes on them. The work I've chosen to write about is a piece I man-
aged to live with for many years without seeing anything very special
in it, and this despite the fact that it's by a painter whose art I normally
respond to so immediately that when I'm in museums I use it like a
drug. I would not, though, have bothered to go on living with this par-
ticular example had it not been for the circumstances in which I
acquired it.

It is a lithograph from an edition of thirty printed in 1961, one of

three untitled lithographs of that year which were Barnett Newman's first attempt at print-making. Two years after he died, in 1970, his widow, Annalee Newman, whom I had not seen since his death, came to London at the time of his retrospective at the Tate and brought the print with her as a present for me. (It is a print she has given to several friends, as the artist had done.) I was very touched by her gesture and was glad to have a copy of one of Newman's three first prints to go with the copy I already had of one of his two last prints, *Untitled Etching No. 1* of 1969, also in monochrome, which I had bought from Newman's dealer shortly after it was pulled. But I wasn't so moved by the lithograph itself, and though I kept it on the wall, twenty years passed before I began to see it.

This happened when I finally started responding to the richness of the black, its simultaneous flatness and depth, hardness and softness. Black was a sacred colour for the Abstract Expressionists, it was their lapis lazuli; they made a mystique of it, partly perhaps because of its austerity, partly perhaps because there was something splendidly macho in being able to produce a good strong black. If it took me so long to respond to the obvious beauty and depth, soft depth, of the black in the Newman print, it must have been because I was somehow thrown by the adjacent grey, with its rubbed texture – thrown, I think, by a scratchiness that made it seem awkward. But then that awkwardness suddenly became interesting, the rubbed grey suddenly took on a strange, elusive colour, and everything was singing.

And now it was stopping me in my tracks every day, several times a day. It was not only gripping but incredibly sufficient. The more I looked at it, the more it made me wonder why painters since time immemorial had bothered to put in all those arms and legs and heads. (And I'm no Modernist by persuasion: Michelangelo and Poussin are my cup of tea.) The print's elementary scope seemed to encompass everything a picture needed, yet I couldn't explain to myself why it was so absorbing and compelling. This mystery only added to its stature.

Nevertheless, I kept on asking myself what it was in the work that could give it such a hold. One possible answer was that the print is a wonderfully condensed embodiment of two opposing and basic forms of existence in modern painting – that the adjacent rectangles juxta-

pose the essence of Bonnard with the essence of Matisse. Another was the thought that in making this piece Newman was beginning even more than was his custom with a *tabula rasa*. It was one of his great strengths that his work asked fundamental questions about whatever medium he worked in, asked what were its first principles and requirements. So it was as if, making prints for the first time, working for the first time on a surface that was not going to be the surface of the actual work, he started thinking about the first principles of filling a surface, and proceeded to do exercises exemplifying them upon this unfamiliar surface, the lithographic stone.

Perhaps he started with the thought that it would be a good idea to separate the dimensions of the image from the dimensions of the surface. Why not do the obvious and draw a rectangle within that of the sheet? Next, why not articulate this inner rectangle by simply dividing it into two with a line, which might as well be a vertical line? Ought the line to bisect the rectangle? It would be more interesting if it didn't, but the asymmetry should be close enough to symmetry to suggest that that had been a possibility. Next, how to distinguish between the two halves? Since the sheet was going to be white, why not begin with its opposite, black? And then why not use the other half to mediate between white and black – not just to mediate but to show the transition between them by having them intermingle, in such a way as to leave no doubt that the white had been the ground, the black the additive? And so as to convey the sense of a process?

Perhaps the attribution to the work of such a programme helps to explain its air of improvised inevitability. Perhaps, too, the thought of that programme gives a meaning to its minimalism, implying that it is not only an exemplar but a sort of allegory of the principle of less is more. That is speculation. What I know is that when I stand and look at it the whole of art is there.

MASTERS

Picasso – II *1988*

The first section appeared, dated October 1987, in a translation by Jeanne Bouniort entitled 'Fin de partie', in the catalogue of *Le dernier Picasso* at the Centre Georges Pompidou, Paris, from February to May 1988. It appeared in English together with the second section, which was dated April 1988, under the title 'End Game', in the catalogue of *Late Picasso* at the Tate Gallery from June to September 1988. The third section, written in August 1988, appeared, entitled 'Late Picasso at the Tate', in the *London Review of Books* for 1 September 1988. The serial form came out of the perennial frustration of sitting down to write an essay for an exhibition catalogue with the feeling that one could be doing much better if one had seen the exhibition first. When I was co-curator of a major exhibition of late Picasso, I decided to compose an essay in three instalments, the first to be written for the Paris catalogue, the second to be written during the Paris showing and added to the first for the London catalogue, the third to be written during the London showing and published in a periodical. One fine day all the instalments would appear as a single piece that would give a sense of developing experience of the work. Putting the whole thing together seven years later, I have felt it would be as well to make several revisions.

I

The dignity of an old man's acceptance of approaching death is touched by absurdity in so far as he is already dead as a man. For a woman, the horror of ageing resides in no longer attracting; for a man, in no longer acting. In Oshima's *Ai no corrida*, when the heroine decides to offer herself to an old tramp his opportunity turns out to be useless and an occasion for shame; when the hero decides to pleasure an ageing geisha her opportunity is clearly and poignantly the first for years but is still an occasion for delight. An old woman is the ruin of a woman; an old man is a non-man.

That conclusion and the long shadow it casts before it has always been a favourite theme of stand-up comics. It is a great theme, and Picasso's late work is the first known body of work in the visual arts to realise its potential, through a remarkable conjunction of events. From the start Picasso had produced a diary of an artist's erotic life, a record of obsessions with particular satisfactions and frustrations and fantasies and partners; he happened to survive into his nineties and he went on producing that diary almost to the end. At the same time, during his last years it became admissible to exhibit and publish images of a degree of erotic frankness previously forbidden: indeed, it is worth remembering that, as late as 1968–69, when the '347' series was first shown, at Louise Leiris's, the most extreme images were on view in a private room and illustrated in a supplement to the catalogue; today they can be openly shown and reproduced by national museums (and no doubt the time will return when images much less extreme are not permitted to be shown or reproduced anywhere).

So a splendid conspiracy of the Fates brought about an extraordinary mass of work on the subject of loss of manhood, loss of face, loss of everything but the ambivalent pleasures of voyeurism and the will and force to go on making art. One of the great themes of this tragicomedy is that, while the young painter, even in the course of enjoying the model, is able to portray her, to transform her, to manage her likeness as well as her person, the old painter's incapacity to enjoy her makes him appear ridiculous even in trying to portray her, but he goes on all the same. He has the consolation that the young painter, when he assumes as he often does the form of Raphael, is due to die before he reaches forty; and the deeper consolation – the theme of one of the very last drawings, in which a woman lies there complacently displaying herself for the devouring gaze of an old man – that he still has eyes with which to exercise his inexhaustible obsession with the marvels of a paradise which his body can no longer enter.

There was an *Ur*-version of the tragicomedy in the series of 180 drawings which Picasso made in the winter of 1953–54 after Françoise Gilot left him. The iconography is an impressive demonstration of putting a brave face on despair. But as drawings they have nothing of the toughness of the prints of the last years. Picasso portrays himself as a ridiculous old man, but he renders doing so

bearable by using a style that puts the tragicomic subject-matter into soft focus. But then the whole Françoise period was near enough the least vigorous artistically of Picasso's career – one of those periods of repose that happen in the work of any long-lived artist. It doesn't do to make easy correlations between an artist's life and his work, but that period was surely the time when Picasso got his life together as never before: he was living with a young woman who was very beautiful and very intelligent and who quickly presented him with an enchanting son and daughter (the birth of his son Paolo in 1921 had been followed by a rather weak two or three years in the middle of an intensely creative time); he had as many loving and admiring friends as even an artist could need; he was as rich, as famous and as photographed as a film star; he was a lighthouse of the Left and a popular cultural hero (as an enquiry in *Réalités* in 1960 revealed) who might in passing make incomprehensible art but was all right because he had fathered a photogenic family when nearing seventy. Our exhibition begins with the ending of that earthly paradise, centred on an archetypal example of the theme of the model in the studio, perhaps the most obsessive of the various obsessive themes of the remaining almost twenty years.

A major factor in Picasso's persistent artistic renewal in those years seems to have been the intensely competitive game he played, more than ever and more systematically than hitherto, of making para phrases – of Delacroix, Ingres, Velázquez, Manet, and of Poussin combined with David. Doing whole series of them must have been like performing in a very heady jam session, where a player is inspired to improvise variation upon variation both by the lift the others' playing gives him and by the wish to outplay them. In the series on Velázquez's *Las Meniñas* (1957), he was not only taking on his motherland's greatest master but also, I suggest, his old ally and enemy, Braque. Now, Braque had been in tremendous form during the previous ten years, surely in better form than at any time since the heyday of Cubism. And his major works of those years had been a series of paintings on a theme which Picasso had long been making his own: the theme of the studio. When Picasso came to make his paraphrases of the most celebrated of all studio pictures, he began with a large grisaille which turned out to be a major masterpiece and a work

altogether unmatched in quality by any of the subsequent variations. In that initial piece there are stylistic elements which seem rather new, and these look very precisely as if they had been inspired by Braque's *Studio* series, in particular the grisaille *Studio II*.

The prototypes for paraphrases are not confined to great machines. Images of Jacqueline singly can be based, or seem to be based, on famous old masters: for example, as has long been suggested, the large reclining nudes with or without a cat painted in the spring of 1964 seem to be versions both of Goya's *Maja* and of Manet's *Olympia*, while the *Woman Pissing* of April 1965 seems a version of Rembrandt's *Woman Bathing* in the National Gallery, London. She is also, of course, as the head's stylistic allusion to Greek vase-painting tends to confirm, a version of the birth of Venus, she who rose from the froth of the sea after the severed genitals of Uranus had been thrown there by his son Saturn.

This monstrous leering goddess, adorably shameless, thrilled by her prodigality, belongs to a different world from the reclining nudes done only a year before. These are still classic works, fluently drawn and succulently painted. The interval between them and the *Woman Pissing* is scarcely represented in this exhibition: it was a period of transition which produced few pictures of great worth. Picasso emerged from it in the autumn of 1964 as an artist who had found his late style – if by 'late style' we mean a style that is all pithiness and abandon.

'Now it seems to me', wrote Adrian Stokes, 'that modern art, the art typical of our day, is the slang, so to speak, of art as a whole, standing in relation to the Old Masters as does slang to ordinary language.' Slang is elliptical, punning, subversive, abusive, casual, witty, unexpected, insolent, abrupt, throwaway and rich in teasing allusions to mandarin matters. If modern art is the slang of art, it has never been as extremely and gloriously so as in Picasso's last works.

They are works which lay utterly naked the horror of growing old. But Picasso was never an Expressionist, never one to wear his bleeding heart upon his sleeve. He was a Spaniard, like Don Juan, who joked in the teeth of death and shouted defiance when they dragged him to hell. Picasso's art affirmed until the end that, even when it is a diary, art is not meant to be a confession but a game.

II

Seen across the spaces of Beaubourg, the paintings radiated an explosive vitality that outshone their every other quality. The poignancy and the irony and the ribald or terrible truthfulness which they share with the drawings and prints were made rather marginal by the sheer energy with which the paint summarises form. These paintings' most telling answer to the closing-in of death was their simple demonstration of a gargantuan aliveness. I have rarely, if ever, seen an exhibition in which the presence of the paintings so overwhelmed that of the visitors. Paintings generally, when hemmed in by visitors, seem to retire into their shells; these reach out and consume their public.

The exhibition ran concurrently with one at the Musée Picasso of and around *Les Demoiselles d'Avignon*. That concurrence was due to chance, not to someone's having come up with the bright idea that the *Demoiselles* had some sort of special affinity with the late works. But once they were shown virtually together, students of Picasso were struck by the notion that there was in fact a remarkable affinity – that this was a classic instance of the way Picasso had of picking things up, consciously or unconsciously, where he had left them long before. It would also be an instance of our habit in old age of looking at our early days: *Les Demoiselles d'Avignon* was the giant step of Picasso's early days – he knew it at the time and so did his friends, and his enemies – and in retrospect it went on being the most crucial single work in his entire development. So, given Picasso's perennial habit of self-quotation and given that this became more addictive as he got older, it is not inconceivable that his late works sometimes quote the *Demoiselles* – that, for example, the head of the *Woman with a Pillow* (1969) is a conscious allusion to the head of the seated figure in the bottom right corner and not simply a typical Picasso head. However, the real interest does not lie in possible quotations but in the general attributes the *Demoiselles* and the late works seem to have in common.

Sometimes it is the glance. Often the glance of the late figures resembles one or another of the ways in which caged animals look at us, but quite often it resembles the bold and brazen look of the inmates of the brothel in Avignon Street, a look which is to be expected there. Above all, there is the over-life-size scale of the figures and the insistence placed on this by their confronting us so directly

and challengingly – a scale made significant by the fact that the figures are not gods or demi-gods – pantocrators or madonnas, for instance – but people – some importunate, some indifferent – people we might find ourselves confronted by in a street market, a bar, a station, a brothel, a studio or a fancy-dress party, but who loom up over us here so that they bring us to a sudden and apprehensive stop. The confrontation calls to mind a moment at a Notting Hill carnival when, in a side-street where there was space to move, I suddenly heard, above the sounds of the steel bands and the heavy metal, a booming voice call out my name. I perceived that the summons emanated from the figure, standing across the street, of a masked tribal dancer eight or nine feet tall. I found myself walking up to it and standing before it, wondering and afraid. 'You used to come to the Copacabana Club when I was a barman there,' it said. 'My name's Cyril. Don't you remember me?'

The resemblance of figures in the *Demoiselles* and in late Picasso to masked tribal dancers is as crucial as their scale in giving them a threatening force. It is irrelevant whether or not particular faces or bodies are based on particular tribal models: what matters is the air these personages have of coming from a world more primitive, possibly more cannibalistic and certainly more elemental than ours. At the same time the pictorial space also belongs to a less developed culture. Despite the rich assortment of allusions to paintings in the Renaissance tradition, the treatment of space rejects that tradition in favour of an earlier one, the flat unperspectival space of, say, medieval Catalan frescoes. All this involves the assimilation of an unprecedented variety of sources, but not so that the work becomes ponderous with erudition. At twenty-five, Picasso's raw vitality was already being enriched by the beginnings of an encyclopaedic awareness of art; at ninety, his encyclopaedic awareness of art was still being enlivened by a raw vitality.

It has to be admitted, all the same, that even at its best the late work does not possess the awesome intensity of the *Demoiselles*, that the period 1965–72 is not quite the equal of Picasso's supreme periods, which I take to be 1907–14 and 1925–33: for one thing, there is not the same impression that the artist is continually surprising himself. But it is one of his great periods, and it produced a number

(most of which reproduce badly) of his masterpieces, such as the *Woman Pissing* (1965), the *Woman with a Pillow* (1969), the *Seated Musketeer with Sword* (1969), the *Kiss* dated 24 October 1969, *The Embrace* dated 19 November 1969, and the one dated 26 September 1970, *Reclining Nude* dated 7 September 1971 and the one dated 14–15 November 1971, the *Landscape* dated 31 March 1972, the *Reclining Nude and Head* (1972).

That persistence of a raw vitality may be what makes for a crucial difference between Picasso's late style and the late styles which have tended to form our idea of 'late style' – those of Titian and Rembrandt and Michelangelo and also Beethoven and Shakespeare. Late Picasso does not conjoin as they do the trance-like, the blurred, the abruptly abrupt, 'Ripeness is all,' said Lear, and perhaps quintessential 'late style' has to be reached through a ripeness precluded by eternal youth.

Yet it seems to me that there are a very few very late pieces which come much closer to the familiar ideal of late style. For one, there is the *Landscape* dated 31 March 1972. I am sure it is the greatest painting Picasso ever did in the genre – a genre he scarcely touched in his last years – and unsure of everything else about it. I suspect that it is a landscape seen in rainy, windy weather, that it is painted from indoors, that it is a metaphor for a reclining female figure, and also that, despite its wholly modern technique, the way it is painted has something in common with late Titian.

And then there are three paintings all measuring 130 x 195 cm, the standard format called 120F, with its unusual proportions of two to three: the *Reclining Nude* dated 7 September 1971, the *Reclining Nude and Head* dated 25 May 1972 and *The Embrace* dated 1 June 1972. The last is clearly an *alla prima* painting and perhaps one that Picasso would have liked to go on with; the second was undoubtedly, as John Richardson points out, worked on over a period of time. These two are among Picasso's three or four last known paintings; the other was painted nearly nine months earlier but is very close to them in feeling and in idiom. It is an idiom which looks back, not to that of the *Demoiselles*, but – despite the difference in scale – to that of certain synthetic cubist collages, constructions and paintings of 1913–14, especially some of those in which Picasso became a Surrealist *avant la lettre*: for example, the *Reclining Nude and Head* (besides calling to

mind the sculpture of a bull's head made in 1943 from a bicycle saddle and handlebars) is strongly reminiscent of one of the relief constructions made in 1913, the one with a guitar and a bottle of Bass, in its first state – and the painting also has the quasi-pointillist dots highly characteristic of this phase. It is interesting that Picasso's very last paintings relate to the phase in his past which surely has a more plausible claim than any other to being the embodiment of the essential Picasso.

In these late late paintings the synthetic cubist structures exist in that uncanny, swimmy sort of atmosphere which is typical of late style and seems to have to do with loss and departure and floating away (as well as with fading sight and the insouciance of old age). The structures too are mysterious, indecipherable, full of uncertainties. They suggest images of barges bearing dead heroes to their resting places; suddenly Picasso's element seems to be water, after always being fire or air. Such speculation apart, there are intimations of both serenity and menace which together seem to speak of a will to embrace death. It is a will which under the torture of extreme longevity is seen to break down in certain drawings done after the final paintings, drawings possessed by horror. Here it can no longer be said that Picasso was never an Expressionist. Here he lets go, in those staring heads done at the end of June and the drawing dated 3 October of a naked woman lying back in an armchair. She is masturbating, using both her hands, and all around her there are hands, hands without explanation. They might be instruments of forces which are mauling her and threatening to tear her apart; they might be holding her together. They certainly serve in their multiplicity to emphasise her aloneness. They might, in spite of all that and along with all that, be about the fact that, when an artist is past almost everything, he can still watch his beloved, or think of her, using her hand to pleasure herself and can still, perhaps, use his hand to draw. The image seems a statement that that much consolation is not enough.

III

At the Tate Picasso's late paintings seem almost to be different paintings from those they seemed to be at Beaubourg. There they looked, by common consent, more aggressive and explosive and electric, here

more luminous, more beautiful, more grand. The differences in the selection, the hang and the ground-plan have not been crucial enough to account for so extreme a difference of effect. Clearly the Tate's having daylight, a light that is soft and diffuse, must be relevant, but the difference has also been there, though not as extreme, at times when the lighting has been mixed or purely electric. It must, therefore, mainly be due to the architecture. In Paris the spaces were not enclosed by the walls; above the tops of the manifestly temporary partitions you could see those hyperactive Beaubourg ceilings. Here, the movable walls reach the ceilings and these are vaulted, so that the paintings are surmounted by an amplitude of space in which to breathe. Those vaulted spaces do not suit every sort of art, and there are some paintings in the show which look less telling than they did in Paris. But others look greater than I have seen them look before, and the list of outstanding late paintings which I proposed previously demands the addition of the *Reclining Man and Woman with a Fruit Bowl* of 29 December 1969 and *The Embrace* of 1 June 1972. And by and large the paintings do look very much at home in these vaulted spaces, spaces like those of medieval churches, so that they tend to look as if they were medieval wall-paintings. Since everything they are contradicts the aesthetics of the easel-painting tradition, to say that they look like frescoes here – indeed, Catalonian frescoes – is to say that here they come into their own. That consummation, by the way, has nothing to impede it when they are framed by nothing more than a baguette or by nothing at all.

I have been focusing on the main body of an exhibition which has a misleading title because an accurate one would have been too cumbersome. An oversimplified title, 'Late Picasso', is complemented by a subtitle, 'Paintings, Sculpture, Drawings, Prints 1953–1972', which in fact contradicts it, because *late* Picasso surely begins in 1964 (the starting-point of Christian Geelhaar's pioneering show at Basle in 1981 of *Pablo Picasso: Das Spaetwerk*). And the exhibition is essentially one of paintings, drawings and prints of 1964–72, prefaced by a selection of paintings and sculptures with a starting-point at the turn of 1953–54. It is a point which marks both the arrival in Picasso's life of Jacqueline, his last love, and the death of Matisse, his lifelong cherished rival.

The opening rooms are haunted by Matisse. What Picasso meant by his famous statement that Matisse had bequeathed him his odalisque is illustrated by a painting as great as any he did in the course of the Fifties, the *Nude in front of a Garden* of 29 and 31 August 1956. This joyful, grateful hymn to Jacqueline, this celebration of 'the lineaments of gratified desire', is composed in a language that is joyfully, gratefully taken over from that of Matisses done in Nice between 1919 and 1924: we are reminded of the *Odalisque with Magnolias*, for instance, even by the way in which the garden in the background is turned into a decorative screen, while the flanking shutters, not at all a Picassian device, are an evocation of any number of Matisses of that period, as is the ideogram for a palm tree in the top left corner of *Nude in a Rocking-Chair* of 26 March 1956. And the first two works in the exhibition, *The Shadow* of 29 December 1953 and the *Nude in the Studio* of 30 December, painted while Matisse was still alive, are no less redolent of his reclining nudes in interiors. Nor is the imitation confined to what might be called Matisse's decorative side. For one thing, it also embraces his stark, sculptural aspect. The exhibition's biggest painting, the *Nude under a Pine Tree* of 20 January 1959, obviously alludes to Cézanne, but its palette, its stylisations, its atmosphere, make it closely akin to the monumental *Bathers by a River* which Matisse completed in 1917. The reclining nude in the foreground, and the table-top just behind her in the grisaille version, dated 11 February 1955, of the *Women of Algiers, after Delacroix*, are another evocation of Matisse the cutter-out of forms. And then there are the imitations of Matisse as draughtsman in line. The most intriguing of these is not in the exhibition. It is the set of twenty-one portrait heads of Artur Rubinstein made on 19 July 1958 – a forgery, almost, not only in the character of the line but in the particular way each image evolves from the last, and above all in the choice of concluding image. That degree of competitive identification with Matisse is found again in one of the most consummate pieces of virtuosity in the exhibition, the pencil drawing of a *Reclining Nude* dated 11 August 1969.

Evocation of previous art, including his own, is of course a constantly conspicuous feature of Picasso's last twenty years. (With his love of allusion added to his conscientious dating of works, he might have been aiming to ensure full employment for posterity's art histo-

rians.) From December 1954 till February 1963 his painting was all but taken over by the making of variations – mostly sets of them – on complex compositions by the masters, often compositions with a size-able cast of characters; during those years he did remarkably few other paintings of much interest (a notable exception is a series of small paintings of reclining nudes – one of them is in the show – done in April 1960). After that, while the work remains full of references to old masters, those references, in the paintings as against the prints, are always to pictures of one or two figures or to one or two figures from a picture – for the simple reason that the latter paintings generally confine themselves to an archaic simplicity of composition. In the preceding years Picasso was testing himself against post-Renaissance European painting at its most ambitious – the realisation of complex human dramas more often than not in a style that exploited the expressive potential of the free handling of oil paint. The apogee of both the complexity and painterliness came in 1961–63 in the *Déjeuner sur l'Herbe* and *Rape of the Sabines* series. Interestingly, the painterliness was at its maximum in the later series – above all, in the large grisaille which can be seen as a sort of compressed version of *Guernica* – whose dual models in Poussin and David are not painterly in style. Having gone further here than ever before into the post-Renaissance tradition, Picasso soon turned his back on it to work, more characteristically, in a pre-Giottesque tradition.

If his painting of the period preceding his late style is its antithesis, his sculpture of that period can be seen as something of a preparation for it, in so far as it was dealing – both in the mainly wood constructions of 1954–58 and in what evolved from them, the sheet-metal pieces of 1961–62, his final sculptures – in forms that are at once large and dynamic, at once grand and comic: in other words, they anticipate paintings such as the *Woman Pissing*. Which is to speak as if they were not in themselves a body of work which is one of Picasso's greatest post-war achievements. Indeed, the absence from the exhibition of the over-life-size group of *Bathers* made from bits of wood in 1956 is surely its most serious deficiency. And yet, they might have been redundant, given the commanding, enigmatic presence and the sculptural virtuosity of the light-hearted little *Head of Woman*, a project for a monument realised in polychromed wood in 1957. It is an

object lesson in what it is to be an unassuming masterpiece and in what it is to be a totally three-dimensional sculpture. It is a head in the round composed of a succession of profiles. It consists of two squarish boards intersecting at right angles and stuck into a cylinder representing the neck; behind the point of intersection, one board is deflected by thirty degrees; the colours are black, white, touches of grey, and the natural colour of the wood. It must be one of the few sculptures in the world every aspect of which – there are essentially eight aspects, each at a point of the compass – presents a view which works and a view which is totally unexpected, with a power to surprise that does not diminish after a hundred encounters.

The late style surely emerges in October 1964 with works such as the two large paintings of *The Artist and his Model* dated 25 October and 26 October/3 November, two of the numerous pictures in a series on that theme which had started early in 1963, and two of many in which painting the model means just that rather than doing a painting of her. The new style did not come as a clean break with the past: the large and highly complex *Artist and His Model* dated 16 November and 9 December 1964 is retrospective in style. But the decisiveness of the break is very clear when *The Sleepers* of 13 April 1965 – naked woman and black-suited bearded gent napping together on the grass – is compared with the *Déjeuner sur l'Herbe* series of which iconographically it is an obvious extension. Partly the difference lies in being more bold in facture, more slangy in idiom. But there's a more particular ingredient, one that is very evident indeed in *The Sleepers*.

It is known that around this time Picasso acquired a number of Japanese prints, and it looks as if books of erotic prints such as Utamaro's *Utamakura* profoundly influenced the late style, for example in the ways in which forms are flattened, and in the ways in which curves in the outlines of reclining or coupled figures are contrasted with straight lines and angles introduced into the mass of a body to disrupt it and animate it and mix it up with the body next to it; also in the actual stylisations of genitalia. There is even a plate in the *Utamakura* in which a half-naked elderly Dutch couple, the man wearing a tricorne, are copulating, and the man's hat and eyebrows and nose seem a veritable prototype for Picasso's musketeers. The *Utamakura* or books like it also seem to have influenced many of the

plates in the *347 gravures* of 1968, especially the couplings, hetero-sexual and lesbian, and the orgies realised in August and September.

The late paintings seem to me to be divisible into three phases of unequal length – a head, a body and a short tail. The first phase lasted until the illness which in November 1965 compelled Picasso to undergo major surgery. The paintings are mostly of nude women, nude couples, artist and model. They are painted like enormous water-colours, with their areas of transparent colour and areas of emptiness. They have an astonishing radiance and elation and sense of release. But that sense of release seems to have to do with painting itself, with being able to let go, with no longer caring. It is not like the gaiety about life of the 1956 *Nude in front of a Garden*; it is not relaxed, not even in the hymn to that goddess of irrigation, the *Woman Pissing*. Every important picture of the period is comical and is rather frantic in its comedy and sometimes rather bitter.

Picasso's resumption of painting in 1967 initiated the second phase. Suddenly, the iconography is dominated by the fancy dress of musketeers, dwarfs, smokers of pipes and so forth, though that is not evident in the present exhibition because the curators have exercised a marked bias away from these pieces and in favour of female nudes and of couples supping, kissing or fucking. The eroticism is forthright and violent. The sense of doing it is there, vividly, electrically, but not much sense of touch. The sensuousness of flesh which is so intensely present, for all the summariness of the style, in the nudes of April 1960 and survives in the *Woman Pissing*, has evaporated, except on rare occasions, above all, in the *Woman with a Pillow* of 1969.

Around the middle of 1970 the range of mood seems to narrow, becomes more consistently uneasy, menacing, feverish, melancholic, brooding upon the imminence of death. Sometimes this is symbolised by the intrusion of skull-like forms, as in *The Embrace* of 26 September 1970, or nightmarish forms, as in the *Reclining Nude* of 14 and 15 November 1971; sometimes it is directly illustrated, as in the *Nude Man and Woman* of 18 August 1971. The composition, with the old man filling the centre foreground and staring out of the picture, strongly recalls – and it is difficult to believe that Picasso was not recalling it – the *First Steps* of 21 May 1943, with the toddler where the man is and the woman again placed to one side of the background.

But in the old man's face fear of the unknown has been replaced by the blankness of acceptance, while here the woman is no longer using her hands to help but only to try and comfort as she reaches out to touch the man on the shoulder and he seems oblivious to this contact. A friend recently widowed told me that the woman's gesture reminded her of how, when she herself made a similar gesture some days before her husband's death, he responded in a way that made it clear he was beyond wanting any human contact. It was as if he was with the dead.

Death's nearness nonetheless brought no radical change of language in Picasso's painting until it had only a few months to go. I have suggested previously that he had a very brief final phase whose most distinguishing feature is an uncanny, swimmy sort of atmosphere which seems to have to do with loss and departure and floating away. I cite four examples – three very late works, *Landscape* of 31 March 1972, *Reclining Nude and Head* of 25 May 1972, *The Embrace* of 1 June 1972, and one painted six months earlier, *Reclining Nude* of 7 September 1971 – and at the Tate these were brought together in the final room in the hope that they would make sense visually as a group. They clearly did, and the next step was to see whether there were any other paintings that seemed to belong with them. It turned out that there was one, probably because of its fluidity of form and its close affinity to the *Landscape*: it was the *Musician* of 26 May 1972. The room's five paintings certainly do exemplify a final style of which there are surely some further examples.

The room is dominated by the amazing *Reclining Nude and Head*, which besides being a very great painting is also a very enigmatic one, most atypically of Picasso, for whom it was a point of honour to make his subject-matter clear. John Richardson, the first writer to insist on the primacy of this painting among late Picassos, affirms that the central structure, 'two huge eyes balanced on a wedge of a nose, balanced on a tiny mouth, balanced in turn on a rudimentary vagina . . . unquestionably stands for Jacqueline', and sees the horizontal structure with its 'vestigial arms and legs and nipples' as a recumbent figure but also, following Jacqueline's interpretation, as a coffin emblazoned with a cross. It seems to me just possible, since the recumbent figure's torso is surely male, that the work is a *Pietà*.

Jacqueline's central and totemic position in this icon as tragic queen, figurehead, sustainer, self-exposer, survivor, is an allegory of her having played, on the evidence of her appearances in the works, a more comprehensive role in Picasso's life than any of his other women, not least because she was part of that life for nearly twenty years, was there when it came to an end — more crucially, even, was there throughout the terrible passage from his being an old man who had retained his youth to being a non-man. Picasso probably didn't become a truly great erotic artist, one who transcends stereotypes and arrives at objectifying his own particular experience, until he started composing his celebrations of the joys of making love to Marie-Thérèse Walter. He was then forty-five, so that all his great erotic art came out of relationships between an ageing man and a young woman. Until Jacqueline's advent the emotional range of those relationships, as shown in the art, tends to be fairly narrow: the swooning raptures of Marie-Thérèse, Dora Maar as Tragic Muse, Françoise Gilot, pastoral deity.

The relationship with Jacqueline is wider and richer and more human, especially in its exchanges of vulnerability. For instance, in the time of his impotence he has to humiliate her in his art as he had no one else, and there are drawings in which it looks as if the humiliation was more than a fantasy — drawings, which do look as if done from life, of her using her fingers to open up her genitals for display as in a hard-porn close-up. The sense of complicity between them recalls, in its total transcendence of shame, the erotic correspondence in 1909 between James and Nora Joyce. Joyce, as Richard Ellman puts it, 'wishes to possess his wife's soul, and have her possess him, in utter nakedness. To know someone else beyond love and hate, beyond vanity and remorse, beyond human possibility almost, is his extravagant desire.' Picasso, in contrast, insists — so many stories confirm it — on a certain distance. Ever the actor-dramatist, he needs to be in control, needs an asymmetrical relationship — father and offspring, god and mortal, artist and model (that perennial theme which for him was the most flexible of metaphors and also only a metaphor, since in reality he hardly ever painted from the model). Above all, Pygmalion and Galatea, the myth implicit in those images of the artist painting the model's body, painting her into existence. And in creating her image,

his interest is not in telling what it may feel like to be her, only in telling what it feels like to have her. The complicity existing between him and her is surely less than the complicity, often at her expense, between him and himself, between himself as artist and himself as audience.

Picasso and Duchamp *1989*

This developed from notes for a lecture which must, I think, have been given in 1978. It was first prepared for publication in 1989 and was published as 'Bicycle Parts' in *Scritti in Honore di Giuliano Briganti*, Milan, Longanesi, 1990. It was then considerably revised and published as 'Bicycle Parts' in the version reprinted here in *Modern Painters*, Vol V, no 4, 1992.

Picasso said that he hoped the sculpture of a bull's head which he made from parts of a bicycle might some day be found somewhere by a cyclist who would turn it back into a saddle and handlebars and that subsequently the reinstated bicycle would be transformed into a sculpture again and then into a bicycle again and so on, back and forth, for an eternity. That remark would mean little if sculptors using found parts almost invariably wanted us to remember that a piece of theirs was both, say, a bull's head and parts of a bicycle, but David Smith's avowal of unconcern that the spectator should be able to see from the finished sculpture where the parts had come from shows that there have been leading exponents of the found part for whom the parts, once transformed into art, are simply art.

Picasso's desire that we do recognise the source of the fragments of reality which he absorbed and transformed suggests that he would have felt the same about the existing art which he absorbed and transformed – that we should be conscious of the prototype and thus of the extravagance of the adaptation. It is like a composer writing a set of variations on an existing tune: if we don't identify the original, part of the meaning is lost. Nothing was more central to Picasso's art than his obsession with metamorphosis, and the efficacy of a metamorphosis depends absolutely on our knowing what the thing was before it was

changed. If we saw Cinderella's coach and six horses and did not realise that they had been a pumpkin and six mice, it would not be the same coach and horses. It is essential to the sense of the story that the meanest things from the kitchen have been turned into grandiose things: if the fairy godmother had turned, say, a Louis Quinze chair and six salukis into a coach and horses, the transformation would be less impressive. And Picasso went further than the fairy godmother. She made her horses out of mice, living beings out of living beings. Picasso wanted to make horses out of pumpkins when he said that it ought to be possible to take a bit of wood and suddenly it's a bird ('on doit pouvoir prendre un bout de bois et que ce soit un oiseau'). It is not just a question of making what is low and rejected into art; it is also a question of bringing dead matter to life.

Picasso's transformation of junk into human and animal images entered his work around 1930. In his early assemblages from junk of the period 1912–16, he didn't attempt to turn pumpkins into horses, only into coaches. He used the bits of wood and cardboard and string to make a representation of something which was also made of wood and string – a violin or a guitar. It is true that most of those constructions can also be read as mask-like images of human heads, as can his modelled sculpture of the same period, *The Absinthe Glass*. Nevertheless, the suggestion of a human image – a suggestion which, after all, frequently occurs in his still lifes of that time on the flat – is secondary. The essential and persistent aim when Picasso put junk together was to manipulate the material so as to bring it on to the plane of art.

When Picasso started doing this in 1912, in collages as well as in constructions, it was one of the great moves in the modern artist's cult of poverty. Throughout the second half of the nineteenth century artists had been concerned to reject the traditional hierarchies of art, such as the idea that noble subjects were better than vulgar subjects. Then, at the turn of the century, there was a rejection of the idea that classical prototypes were superior to all other prototypes; exotic curiosities made by naked savages and collected in museums whose purpose was initially anthropological could now be accepted as art. But, whatever hierarchies had been rejected by 1912 as to subject-matter and as to style, the idea still persisted that the art-object itself was to be made of special materials produced specifically for the pur-

pose of making art. Collage argued against this that art could be made out of the stuff of everyday life. When Cubism turned to collage – and, of course, any synthetic cubist work, even when entirely painted, is conceptually a collage – it was turning away from refinement towards coarseness, away from the hermetic towards the common. Analytical Cubism had erected a delicate structure of transparent planes, one that became increasingly intricate, ethereal, arcane. And the language is a language the stuff of which is high art – an elaboration and systemisation of Cézanne, a constant reminder of Cézanne's late style. But when the constituent parts of the structure become cut-out pieces of newspaper, cigarette packets, labels from bottles, and so forth, high refinement is replaced by the common touch, the solitary contemplation of the Mont Sainte-Victoire by sorties into Paris streets. The cut-out pieces of newspaper may represent a newspaper or they may be used to represent anything but a newspaper: all this is variable and uncertain. What is not uncertain is that the construction is being made out of something in daily use by ordinary people.

At the same time, whereas Analytical Cubism imposes a homogeneity upon everything in the picture, a homogeneity something like that imposed by the brushmarks of, say, Seurat's sketches, collage often uses the strongest possible contrast between the pictorial elements, and this reinforces the idea of abruptness and plain-speaking as against the use of an even, measured tone of voice. Again, in place of Analytical Cubism's exquisite splintering of reality, the fragments are now larger, broader, flat, frontal, bold, forthright. In every way the language is plainer. At the same time, the distinction between the two languages is very much more emphatic with Picasso than it is with Braque. Picasso's Synthetic Cubism began as a way out of late Analytical Cubism, so called Hermetic Cubism, and it went on looking like a reaction against it; whereas Braque, in adopting Synthetic Cubism, somehow made a much smoother transition to it, and his work in that manner preserved quite a lot of the rarefied atmosphere of late Analytical Cubism. With Picasso, however, the change from Analytical to Synthetic was a resounding conversion from a mandarin language to a demotic language. Which does not mean that the works employing that demotic language did not turn out to be even more difficult and obscure than the works which are called hermetic.

*

The time when Picasso was making his first junk sculptures was also the time when Duchamp made his first sculpture from ready-made materials. It was a bicycle wheel placed upside down on a stool. Now, the two objects assembled here are the most basic objects in man's winning dominion over the earth and in distinguishing himself from the beasts of the field: the stool, which enables him to sit down off the ground at a height and a location of his choice; the wheel, which enables him to move himself and his objects around. The stool and the wheel are the origins of civilisation, and Duchamp rendered them both useless. Picasso took junk and turned it into useful objects such as musical instruments; Duchamp took a useful stool and a useful wheel and made them useless. His stool is useless because there is no room to sit on it; his wheel is useless because, although it is still free to turn, it doesn't turn in contact with anything, and of course a wheel is only useful so long as it is in contact with the ground or some further mechanical component. But the dissociation from their normal context which makes the stool and the wheel useless also makes them more visible. One can't look at a stool while one is sitting on it, but if one can't sit on it, one can look at it. Moreover, the wheel raised on the stool can be seen far better than when it's on the ground: the beauty of the movement of the spokes is more visible near eye level, and that level is also an invitation to our fingers to put the wheel in motion. Also, it is made more important, like a statue mounted on a plinth. Duchamp renders the bicycle wheel and the stool useless, but neither more nor less useless than art is. He turns them into things that are there only to be looked at. Where Picasso seems to be saying that bicycle parts can become sculpture through the force of his personal magic, Duchamp seems to be saying that bicycle parts can become sculpture simply by being treated as sculpture.

The bicycle-wheel sculpture was an allegorical antithesis to Duchamp's morality as an artist (or simply his inclinations as an artist): whereas the wheel went round and round, Duchamp, in noble contrast to practically every other professional artist in history, preferred inaction to repetition. At the same time, the piece involved an early instance of a gambit of his which was utterly typical – the separation of entities that are normally connected. The bicycle wheel is separated from the ground: in *The Bride Stripped Bare by her Bachelors,*

Even, the bachelors are separated from the bride. As Robert Lebel puts it, the male and female machines function separately and without any point of contact, man and woman act upon each other from a distance and on separate planes – onanism for two. That is to say, to act upon each other the bride and her bachelors act upon themselves. ('The bachelor', as Duchamp phrased it, 'grinds his own chocolate.')

The composition is reminiscent of Titian's *Assumption of the Virgin*, where the Virgin on a nimbus above is clearly separated from the groping bachelor disciples. The separation can be seen as a paradigm of Duchamp's relationship with his public. He was the bride and we the bachelors from whom he kept his distance. Like the bride, Duchamp was never stripped bare. His audience were left like the masturbating bachelors, looking up at him and fantasising about what he was up to but never coming to grips with him. He liked to observe that audience and how it reacted, and he paid courteous attention to the interpretations it made.

Said the masochist to the sadist: 'Hurt me!' Said the sadist to the masochist: 'No.' When Diaghilev said: 'Etonne-moi, Jean!' Cocteau tried to oblige, but when the art world expected Duchamp to astonish it yet again; Duchamp said no. When we had been talking earnestly for nearly half a century about the implications of his having said no, he surprised us from beyond the grave, with the revelation that he had worked secretly from 1946 to 1966 on a piece as major as 'the large glass': *Etant donnés: 1° la chute d'eau, 2° le gaz d'éclairage*. It is a structure in which an antique wooden door has a pair of peepholes through which we are able to look at a *tableau vivant* realised with remarkable illusionism in a variety of media. What we see through the peepholes is a dilapidated wall with a very large hole in it revealing a landscape in the foreground of which a naked nubile girl is lying on a prickly bed of dead twigs and leaves, her legs spread-eagled, her outstretched hand holding up a lighted gas lamp. She, unlike the Bride, really is stripped bare, stripped to the skin, even on her prominent pubic mound – and the depilation is not that of academic statuary, it serves to provide an uninterrupted view of the display offered by the spread-eagling of the legs. The head, in contrast, is virtually concealed, through being excluded from the limited view we get of the scene. This *Gesamtkunstwerk* includes sound – the murmur of a distant

fountain which apparently issues from a waterfall gushing and shimmering in the sylvan landscape beyond.

As 'the large glass' is Duchamp's most complex and ambitious painting, *Etant donnés* is his most complex and ambitious piece of assemblage. Half-way through the span of its long, secret realisation, Picasso quickly put together his own most complex and ambitious piece of assemblage: *Les Baigneurs*, made in Cannes in the summer of 1956 almost entirely out of bits of wood. Now, *Les Baigneurs* belongs stylistically with a quantity of emphatically frontal wooden constructions looking like ethnographic art which the artist had been making for forty years; it differs from its predecessors only in being far more expansive, with its six over-life-size figures spread across the scene, making large rhetorical gestures and broadly demonstrating principles of construction by presenting sizeable rectangular empty frames (redolent of the studio) among the irregular bits of driftwood (redolent of the beach): it's like many other Picasso assemblages except that it's on a much grander scale. *Etant donnés*, on the other hand, is different in every conceivable way from the bicycle wheel and those other objects put in a place we walk about in: it is an elaborate piece of staging, it is unique, it is immovable, it occupies a place apart and beyond our reach, it can be seen by only one of us at a time.

What completes the analogy with 'the large glass' is that *Etant donnés* too evokes a major masterpiece of the Italian Renaissance. The painting has its affinity with Titian's painting of *The Assumption*; the assemblage has an affinity with sculpture – two separate similar sculptures – by Bernini. Duchamp's presentation of a reclining female figure in a place apart in which she seems to be undergoing, or to have just undergone, some searing crisis calls to mind Bernini's sculptures of St Teresa and the Blessed Lodovica Albertoni, where a woman in a state of ecstasy is shown in a setting within a complicated marble frame. The latter work has the greater resemblance to *Etant donnés* in that the figure is alone, the former in that it includes an element analogous to the flaming gas lamp held aloft – the flaming golden arrow held aloft by an angel. Now, these scenes of Bernini's are designed to be seen from one particular point of view: as Wittkower says of them, 'the carefully contrived framing devices almost force upon the spectator the correct viewing position'. And this is precisely, but without the

'almost', the effect of Duchamp's peepholes. Duchamp's primary motive for having the peepholes, he told his wife, was to ensure that the work should have only one spectator at a time: he hated the thought of a work of art being viewed simultaneously by a mass of people, felt it devalued the experience of looking at it (felt this especially at the time the Metropolitan was showing the *Mona Lisa* – the very icon which he had virtually made his own). But an undeniable result of that strategy is the imposition, as with Bernini, of a viewpoint determined by the artist.

Wittkower sees Bernini's need to do this as a consequence of his insistence on depicting moments of dramatic climax. And in *Etant donnés* too there is a sense of high drama, but with the difference that Duchamp, while revealing the secrets of his protagonist's body, declines to reveal what is happening or has happened to it. Bernini was giving enduring form to events in the lives of popular heroines which were totally known to his audience. They knew that these women in a state of utter abandon were feeling, as one of them wrote, a pain that made her scream aloud but with it such infinite sweetness that she wished the pain to last eternally as the angel thrust the flaming arrow into her body again and again. But in *Etant donnés* the story has to be guessed at. For example, has the figure herself been using the gas lamp in a fashion analogous to the angel's use of the flaming arrow? Duchamp withholds information mainly by his concealment of the protagonist's face, and compounds our frustration by the tantalising way in which that concealment is achieved. It suggests that there is surely a face there, behind the wall; it suggests the possibility of our getting a view of that face through altering our angle of vision so as to see around the corner; it denies that possibility by allowing the scene to be visible only through the peepholes (a reminder of the maddening boyhood experience of looking through the keyhole trying in vain to see one's sister or the maid undressed).

Since the onset of the Romantic movement, artists have made a demand for total freedom. In our time freedom has come to be demanded *of* the artist by his public. The artist's position has become that of someone to whom we say: 'Stand up over there and make a five-minute speech about anything you like and if I'm amused I'll give

you a present.' This approach, at once over-indulgent and un-involved, has been an encouragement to the artist to develop an attitude of not taking responsibility for how he is read. It was an atti-tude totally repugnant to Picasso, who is quoted by Françoise Gilot as saying to Matisse while looking at some Pollock reproductions that it was all very well for Valéry to affirm that he wrote half the poem while the reader wrote the other half, but that he for his part did not want there to be three or four or a thousand possibilities of interpreting a work of his; he wanted there to be one.

Given the modern artist's freedom, Picasso gloried in the possi-bilities it opened for unconfined and unambiguous self-revelation; Duchamp handed on the freedom to the audience, and with it uncer-tainty. The Dionysian and the Apollonian.

Brancusi *1995*

This review article, written early in 1996, was occasioned by *Constantin Brancusi 1876–1957*, the catalogue by Friedrich Teja Bach, Margit Rowell and Ann Temkin of an exhibition at the Philadelphia Museum of Art, 8 October to 31 December 1995, following a showing at the Centre Pompidou, Paris. It was pub-lished under the title 'Pure and Not So Simple' in *The New York Review of Books* dated 4 April 1996. There are some small differences here.

There are several reasons why the artist's studio has become a favoured place for showing art. The cult of genius makes a mecca of the workshop, whether the prophet is alive or dead. The one-man exhibition has become the main vehicle for showing an artist's work, and the studio can be a permanent retrospective exhibition. More and more the content of art has come to be seen as the processes of its own making rather than something outside art, so that the space where the artist has wrestled with his problems becomes like the ground where Jacob wrestled with the angel. And photography, by advertising what studios look like inside, makes the world want to visit them.

Sculptors' studios are especially magnetic because the objects in them are not canvases with hidden faces stacked in racks but objects

out in the open which have a strong presence as they stand there. The most mythic of them is surely the one in a quiet backwater of Montparnasse which Constantin Brancusi occupied from 1928 until he died in 1957, bequeathing its contents to the French nation with the proviso that they be displayed in a reconstruction of the studio which had itself become known as a great work of art. To quote Sidney Geist's admirable monograph: 'It made an impression which, as many writers have attested, was overwhelming, with its white walls and the light falling on precious objects gleaming among rough blocks of wood and stone. It seemed at once a temple and laboratory of art, the site of a confrontation of man-made order and natural chaos.'[1]

Brancusi, one of the large band of important artists who came from abroad to Paris between 1900 and 1925 and stayed, was Romanian (the name is pronounced Brancush), born in 1876 in a small village at the foot of the Carpathians. Leaving home in 1887, he worked as an errand boy and a dishwasher and a waiter and so forth, but within two years was also studying part time and then full time at the arts and crafts school in Craiova and from 1898 at the National School of Fine Arts in Bucharest, winning one prize or grant after another for immensely accomplished academic sculpture.

His journey from Bucharest to Paris is a legend, one of many that have surrounded him. The story of his life, the shape of his personality, were long lost in a mist of myth, a hagiographic cloud, and are still vague in parts. He was certainly a genius, a master craftsman, a charismatic individual and something of a mystic; he was also something of a mystifier – a Munchausen even – as well as a businessman, a ladies' man, an adept social performer and a very controlling person: he was not an innocent or an anchorite and was probably not a saint (whereas Mondrian, to whom he is so often likened, probably was).

It is certain that he arrived in Paris in the summer of 1904. The legend is that the journey was mostly made on foot, in the company of a flute (via Budapest, Vienna, Munich, Rorschach, Zurich, Basle, Alsace, Langres and thence by train), and took more than a year. In 1986, however, a monograph compiled by three writers with special access to the artist's archives – Pontus Hulten, Natalia Dumitresco, Alexandre Istrati – said that Brancusi left Bucharest in May 1904,

worked in Munich 'for a time' and arrived in Paris in July.[2] This has been repeated in subsequent scholarly publications, including the catalogue of the recent exhibition in Paris and Philadelphia (though the French edition[3] says that he *attended* the art school in Munich, the American that he *visited* it). It is open to speculation whether Hulten & Co. were nodding when they wrote 'May 1904' or whether Brancusi was an extremely vigorous walker or whether he managed to take more trains than he said he had or whether he had a knack for hitching lifts on fast carts.

A struggle to find a place for himself in Paris (more dishwashing) was eased in May 1905 by the award of an annual grant for the next three years from the Rumanian ministry of education. He enrolled immediately at the Ecole Nationale des Beaux-Arts, where he worked under Antonin Mercié until early 1907, when Rodin, who had been taking notice of his work, engaged him as an assistant. However, he only stayed a month, wanting to find his own way. In 1906–7 he was producing beautiful sculptures in the manner of Rodin and Medardo Rosso – on the one hand, modelled pieces cast in bronze, notably heads of boys; on the other, carvings in marble of sleeping heads. Needing to distance himself from Rodin, he took up, as other young sculptors were doing at the time, 'direct carving' – going straight to the block of stone or wood without making clay models – and it was in exercising this risky method that in 1907–8 he suddenly produced a stone masterpiece in a chunky modernist style that had lately appeared in carvings by Derain and Picasso: *The Kiss*, the first statement of the first of the themes on which Brancusi made variations over several decades. During the next three or four years he became recognised among the Paris avant-garde as one of its leading figures; the news spread abroad.

In 1909–10 he started on his next major theme, one of those that he was to explore in both marble and polished bronze. It was first incarnate as *The Sleeping Muse*, an ovoid form on its side with slight inflections to hint at the features of a woman's face; years later he reduced the form to an uninflected egg shape in pieces called *Sculpture for the Blind* and *Beginning of the World*. Meanwhile, by 1912 he had embarked on three more of the major themes that he worked in both marble and bronze. One was a stylised head based on the looks of a

young Hungarian painter he knew, *Mademoiselle Pogany*. The second, *Newborn*, was an abstract head of an infant. The third was an upright image of a bird, starting with a series called *Maiastra*, continuing in the slimmer forms of the series called *Bird* and reaching its apogee from 1923 on in the numerous versions of the still more attenuated and streamlined image called *Bird in Space*. The biggest variation in the different versions derived from whether a form was incarnate in marble or in polished bronze. In marble it had a marvellous stillness, in bronze it reflected the room and its passing show, and this made its contours elusive.

While the evolution of the bird theme, which was to be so momentous in his work, was still at an early stage, Brancusi started around 1914 to carve in wood. At the arts and crafts school in Craiova he had specialised in woodwork, making furniture and the like. Now, besides using wood to make bases for his sculptures, he also used it to make sculptures. Their forms were indebted, on the one hand, to African tribal sculpture, which was affecting a lot of people at the time, and, on the other, to an influence peculiar to himself, the memory of Romanian folk art and artefacts. Most of his wood carvings were unique images or short series, but in 1918 he carved the first of a series of *Endless Columns*, zigzagging columns consisting of repeated rhomboids with no pedestal or capital. They came in a variety of heights and thicknesses, sometimes in plaster, once in cast iron. By 1920 Brancusi was working simultaneously and with great mastery in a wide diversity of scales, materials and idioms, some virtually abstract, others patently figurative, some with a rustic roughness, others with a city sleekness, but all of them have his unmistakable flavour of simplicity and purity of form.

The century's second decade, then, was the time when Brancusi established his identity as an artist, as happened with Picasso (born 1881), Braque (1882), Mondrian (1872) and Duchamp (1887). It was also the time – and these things do not necessarily go hand in hand – when he found his market, which was almost entirely American. Ann Temkin's essay in the Philadelphia catalogue, lucidly unfolding the intricate story of 'Brancusi and His American Collectors' and astutely suggesting why most of his customers were American, demonstrates how far his dependence upon them went to shape his life. Every one

of the solo exhibitions he had in his lifetime was held in the United States (he travelled there three times). He never had a dealer in Paris. The need to have a showcase for his work for the benefit of Americans visiting Paris could well have been the main reason for his creating that magical studio, though he would surely have wanted to do so anyway since he was one of those artists who like to have their own work around them and since he cared intensely about how his work was displayed. It was likewise the need to send photographs of new work to clients in America that impelled him to become a terrific photographer of sculpture and thereby immortalise the studio.

After 1920 there were two major themes still to come; both emerged before long. *Fish* appeared in 1922 in a carving in veined marble; there were to be variations in both marble and polished bronze. *Cock* also appeared in 1922, carved in wood, a sort of cross between a *Bird in Space* and – with its zigzagging breast – an *Endless Column*; there were variations in wood and polished bronze and, on a huge scale, three in plaster. After this, the new achievements involved, in one way or another, putting a number of sculptures together.

The creation of the famous studio began in 1928, when Brancusi moved from the studio he had occupied since 1916 to a larger one across the street at 11 Impasse Ronsin. The arrangement of the works, which changed from time to time, had an air of informality that disguised very precise placing and juxtapositions of objects diverse in theme, material and size.

Suddenly, in the mid-1930s, Brancusi was offered two extraordinary commissions for installations – one of them out of doors – to which he responded with formal, symmetrical plans that complemented the aesthetic of the studio, as if following the principles of the French as against the English garden. The outdoor commission came from Romania: a monument to the dead heroes of the 1914 war to be built at Tirgu-Jiu, a small town near the artist's birthplace. He created an ensemble in three parts: a stone gateway based on *The Kiss*; a round table and twelve round stools in stone; and, in cast iron with a yellowish patina, an *Endless Column* a hundred feet high.

The other commission was a request from the Maharajah of Indore for a temple. This was aborted, after Brancusi had made sculptures for it and spent a month at Indore waiting fruitlessly to see his

patron. Such plans for the temple as have survived are mere rough sketches; there is no record of the dimensions. But a plausible projection of the interior was set up in the Philadelphia exhibition (not in Paris because the sculptures were not available in time). The key element was a triangle of three isolated *Birds in Space*: a bird in polished bronze was set against a niche in the centre of the far wall, birds in black marble and white marble against niches in the side walls. The sight seemed an intimation of eternal peace.

Brancusi stayed in the studio, working, throughout the war, and then he stopped working. It was not long after this, in 1947–48, that he let me visit him several times. The first was arranged by a mutual acquaintance; after that, I would telephone to ask if I could come. The first thing he said was prompted by my being English: 'Est-ce que vous connaissez Jim Ede?' The question, which I had to answer in the negative, did not surprise me because I was aware that H. S. Ede, who between the wars had been a curator at the Tate Gallery – the only one who knew anything about contemporary art – owned one or two sculptures by Brancusi. There may have been a hidden reason for the question, one arising from a circumstance of which I was completely ignorant but which has lately become common knowledge. Ede was a close friend of Vera Moore, an Englishwoman and a pianist who was the mother of Brancusi's son John Moore, born in 1934.

The question about Ede was doubtless the only thing he said to me that he didn't say to every other visitor. In fact, it was reassuring, since one didn't want to bother him unduly, that he so obviously had a fixed routine for dealing with us – for example, first conducting one to the nearby polished bronze *Leda* of 1926 and switching on a motor to rotate it. Soon he would leave me alone to wander around. When he talked, he spoke in practised, sometimes published, aphorisms. 'I give you pure joy.' Or: 'Michelangelo, that's just beefsteak,' adding, after a well-judged interval, 'But I don't want to be rude about a chum,' which was guaranteed to produce a sycophantic laugh. He had very few good words to say for any other artist, present or past (I seem to remember trying to sell him on Juan Gris). One day, I brought him, what I thought might give him pleasure, a beautiful photograph of the Temple of Nike Apteros on the Acropolis. His response was to say he wasn't interested in architecture. Such egocentricity seemed disap-

pointing to someone green enough to expect great men to be nice, but, though it disturbed me, I always left the studio feeling at once elevated and chastened – inspired by a resolve that in the future I had to live my life in a more dedicated fashion. This was induced partly by the quiet assurance and authority of his manner, but above all by the feeling that for the last hour or two I had been visiting a holy place and that this long-bearded dandy had created it through unremitting discipline.

From about 1950 his life was blighted by the knowledge that there was no way of preserving the place, since the site was needed for the expansion of a nearby hospital. In the course of 1952 he even received notice to quit; the conflict became a *cause célèbre*. In 1956 a deal was made by which he was allowed to live out his time in the studio and the state got its contents on condition that it housed them in a reconstruction. He lived for one more year. The story of the reconstruction has so far been more disastrous than not. It is told by Germain Viatte with splendid indiscretion in the French edition of the catalogue but not, alas, in the American edition: it is a classic tale of muddle.

No doubt it was naïve of Brancusi to imagine that any reconstruction could work – surprisingly naïve given his lifelong sense of the importance of authenticity and organic uniqueness. He used assistants very sparingly indeed, realising the value of his own handwork; or, again, the fact that he didn't duplicate but made every incarnation of an image something unique. How could a man who had started making furniture in his boyhood come to suppose that reproduction could work? It was obviously because he was desperate over the threats to the studio's existence and wasn't thinking clearly.

Brancusi's photographic records of the studio make it very clear how he liked his sculptures to be seen. Margit Rowell installed the Paris exhibition as if she were trying to show that he got it wrong. Brancusi accepted that it isn't always practicable to make a complete circuit around sculptures rather than a tour through, say, 240 degrees; in the studio he actually turned to advantage the presence of the background wall. Rowell evidently set her heart on putting her groups of sculptures right out in the open: the result was that, when you were looking at a group, you were distracted by the faces and the movement of the people looking from the far side. Rowell also set her heart on

putting the sculptures on their bases on the floor, which is ideal, rather than on the customary protective low platform, which is a compromise: the result was a security risk which she countered with electronic alarms; so every few minutes there was a high-pitched blast going off. 'Any visitor setting off an alarm', warned a leaflet, 'will be asked to leave the exhibition. Please explain the system to your children . . .' Furthermore, Rowell often grouped sculptures in ways that Brancusi, wanting things to be visible individually, rigorously avoided: putting together a lot of pieces in the same material or on the same theme. Worst of all was the lighting: vertical sculptures were lit directly from above, which made them far less visible than their multiple cast shadows.

The Philadelphia installation, by Ann Temkin, was a pleasure, once one had got past the initial spaces, made impossible by low ceilings. The lighting was good, incorporating some daylight, and on the whole the works were related to each other in space with an exquisite rightness. The exhibition actually managed to achieve something of the marvellous calm of the studio. It made me realise that I had to acknowledge what has always been obvious to most people – that Brancusi rather than Picasso made the century's greatest sculptures. Though Picasso created the most significant innovations, Brancusi's finest pieces are more satisfying in that they convey a weightier sense of their own reality as entities in space. By comparison, Picasso's are like images in dreams, with all the tremendous impact that something in a dream can have but with a presence that can suddenly no longer be there.

The success of what was seen in Philadelphia was rooted in scholarly research by both of the curators and several associates. Their supreme achievement was in the hitherto neglected and very important task of bringing the sculptures together with the bases that Brancusi had coupled them with. The catalogue contains a great deal of information, some of which could have been much more clearly organised. It is also well illustrated, with a great many of Brancusi's own black-and-white photographs, which are both beautiful images and indispensable documents, and with colour photographs that don't make the sculptures look too much like costume jewellery. The type used for the text is excessively small for comfort, especially in the American edition, where

the print is paler than in the French: both were printed by the same firm in Barcelona but on different kinds of paper.

Writings about Brancusi during his lifetime don't compare at all well with the literature of the time on Picasso or Matisse. Perhaps writers were frightened by the numinous quality of the work, taking refuge in metaphysical explications of its inner meaning which the artist's own arcane pronouncements tended to encourage and which led nowhere. What was still more offputting was that writers, feeling in awe of a creator inhabiting a higher plane, were forever gushing about the purity of both the work and the man. Well it is, of course, the case that Brancusi's sculpture, at its most simple and refined, can be as pure as anything in Western art since Cycladic sculpture. And it is also the case that his sculpture evolved at a time when the world longed for a certain purity in art and architecture. And not only there. In 1907 Bertrand Russell wrote that mathematics 'possesses not only truth, but supreme beauty, a beauty cold and austere, like that of sculpture, without any appeal to any part of our weaker nature, without the gorgeous trappings of painting or music, yet sublimely pure . . .'[4] This is a highly idealised view of sculpture as a genus, a view that speaks of the art as if Brancusi were its most typical exponent. It seems that Brancusi's sculpture realised an ideal that was widely current.

But there was another sort of purity that was also claimed for it, namely that it was unsullied by contact with other art of the time. Thus Carola Giedion-Welcker wrote in 1937 that Brancusi 'remained aloof from contemporary tendencies'.[5] But, for example, sculptures such as *Princess X* and *Eve*, blatantly phallic images presented as incarnations of femininity, both originating around 1915, were obvious pathfinders for Surrealism, and to pioneer a tendency, even aloofly, is surely a form of closeness to it.

As for the insistence on the purity of the man, it was as if there were a conspiracy to pretend that his personality was free of complications. Written up as a hermit, he was in fact both a loner and companionable. A variant image of simplicity was propagated by revisionist critics from his motherland, who saw him as a Romanian peasant. Ionel Jianou's 1963 monograph[6] was a typical example, debunked by Geist: 'In an effort to clear up what he calls "The

Brancusi Mystery", Mr Jianou early advances the information that Brancusi's art was inspired by Rumanian folk art . . . His "Documents" reproduce a photograph of two bearded peasants in fancy dress . . . two wooden utensils and the church in Brancusi's village. It's a snug little church, and its relation to the art of Brancusi is exactly that of Lincoln's log cabin to the Gettysburg Address.'[7]

Geist's own 1968 monograph demonstrated that Brancusi's art could be loved in a level-headed way, open to how the work actually behaves. It opened up the possibility of writing about Brancusi through looking at the work in all its complexity, as, say, Rosalind Krauss did in 1970,[8] rather than dreaming about it in all its purity. The dreaming is recalled by Ann Temkin: ' . . . following the artist's lead, his admirers looked for and found their reflections in the work's harmonies rather than its tensions, and in its purity rather than its complexity.'

One aspect of that complexity is the topic of a passage from Teja Bach's essay about how the effect of the studio involved 'the calculated grouping of forms, their rhythmic interplay and density of arrangement. In his bases, in the combinations of base and sculpture, and in the constructed sculptural groupings, Brancusi created ensembles in which precious and coarse material, delicate and rough workmanship, curved and rectilinear outline, organic irregularity and stereometric regularity, the used and the resplendently new, were set one against the other.'

This is typical of the rare perceptiveness of Bach's essay – while atypical of its tendency to be verbose – but I think he could have laid more emphasis on how the sculptures relate to the bases, especially as the exhibition was making so much of that relationship. Normally sculpture bases are meant, like bodyguards, to be unobtrusive – smooth mediators between sculpture and setting. Even when they are designed to be conspicuous as decorative elements, they tend to be made to harmonise with the sculpture, to give it moral as well as physical support. But Brancusi made with his own hands distinctive bases to go with his sculptures. And in doing so he tended to set, say, the long subtle curves of an image in smooth marble or polished bronze against a base carved in oak wood with jagged shapes and rough-hewn surfaces. More often than not, then, the base, presents a contrast with the sculpture that is really violent. If sculpture plus base are taken, as

Brancusi insisted, to constitute a work, there's a dialectic in many of his works that is uniquely palpable. These are works about positing, and resolving, extreme and overt conflict. If they give 'pure joy', it is a joy intensified by the surmounting of conflict.

Picasso's remark about finding being preferable to seeking[9] set up a pair of antinomies as suggestive as introvert–extravert. If Picasso is the archetypal finder, who, then, is the seeker? Mondrian, no doubt. Most artists are a bit of both. Brancusi was something special. He was an extreme instance of the seeker, with his indefatigable exploration of a few themes, eschewing duplication to create variations involving the subtlest of differences. But he was also very much a finder, one who around 1915 took some large pieces of discarded wood and put them together as *Arch* and came upon some wooden beams salvaged from a building and with little intervention produced *Bench*. In his handling of his bases he was both seeker and finder: he was perpetually trying out bases in combination with different sculptures until he felt the right match had been found. His activity as an artist was a way of reconciling order and chance, balance and flux, a pursuit of perfection and – despite the urge to control a faith in letting nature have its way.

NOTES

1 Sidney Geist, *Brancusi: A Study of the Sculpture*, New York, Grossman, 1968, pp. 167–8.
2 Pontus Hulten, Natalia Dumitresco, Alexandre Istrati, *Brancusi*, Paris, Flammarion, 1986; New York, Abrams, 1987, p. 64.
3 *Constantin Brancusi 1876–1957*, Paris, Gallimard/Centre Georges Pompidou, 1995, p. 374.
4 'The Study of Mathematics', 1907, *Collected Papers*, vol. 12: *Contemplation and Action 1902–14*, London, George Allen & Unwin, 1985, p. 86.
5 *Modern Plastic Art*, Zurich, Girsberger, 1937, p. 12.
6 *Brancusi*, Paris, Arted; New York, Tudor, 1963.
7 'Brancusi Catalogued', *Arts Magazine*, New York, January 1964, p. 66.
8. 'Brancusi and the Myth of Ideal Form', *Artforum*, New York, January 1970.
9 'In my opinion the search means nothing in painting. To find, is the thing.' 'Picasso Speaks', *The Arts*, New York, May 1923.

Mondrian – II

This was occasioned by a one-man show commemorating the fiftieth anniversary of the artist's death which was held at the Gemeentemuseum, The Hague, the National Gallery of Art, Washington, and the Museum of Modern Art, New York, between December 1994 and January 1996. A first state of the piece, based on seeing the exhibition at The Hague, was written in the summer of 1995 as a contribution to a symposium entitled 'Plastic Made Perfect: Measuring Mondrian' in the October 1995 issue of *Artforum*, in which it was given the title 'Son of Cézanne'. A second state, published here, was completed early in 1996 in the wake of the New York showing.

The transparency and delicacy of the analytical cubist style were largely used by its founders to transform solid, compact, often rather massive objects: clusters of houses; chunky trees; sturdy tables bearing bulky instruments or containers; single human figures shown head-and-shoulders or half- or three-quarter-length – truncated so that they are firmly grounded. That is to say, though late Cézanne was the source of the style, Braque and Picasso evaded many of late Cézanne's key motifs: stretches of land or water or sky; long tapering branches of trees; full-length figures; groups of bathers. Braque and Picasso declined to deal with things like spindly limbs, whether those of trees or human beings; they focused on things that were ample and stable as the Pyramids.

Mondrian's Analytical Cubism began where theirs left off: in *Gray Tree*, usually said to have been painted in 1912 but in the catalogue of the recent commemorative exhibition tentatively ascribed by Joosten and Rudenstine to September 1911; and in *The Sea*, painted in the summer of 1912. The most substantial form in either picture is the slim, pliant trunk of the tree. For the rest, long, slightly curving lines traverse the canvases – in *The Sea* entirely from side to side, in *The Gray Tree* also curving a little towards the upper corners. Those contrasting movements were soon synthesised in a somewhat more abstracted form in *Flowering Appletree*, perhaps the first work in Mondrian's career that could be taken as an overture to what came thereafter.

The Sea is a perfect crystallisation of uninterrupted ebb and flow; the sense of movement outwards from an axis in *Gray Tree* crystallises a tree's life as a paradigm of annual ebb and flow. Process rather than

product is the subject – natural processes and, in particular, those which could have a metaphysical import. There is a metaphysical feel, of course, to all great analytical cubist paintings, because of their mysterious translucence, but with Mondrian's it is reinforced not only by their being more rarefied, more ascetic, but by their themes, which evoke the cycle of life and death and are the stuff of ritual and myth.

Earlier in 1911 Mondrian had completed his most overtly theosophical work, the triptych *Evolution*, with its three hieratic standing figures. *Evolution* had several attributes in common with *Les Demoiselles d'Avignon*, painted four years earlier. One was its attempt to make a big monumental statement. A second was the effort to subjugate the spectator by confronting him with towering idols and a compelling stare. A third was that the artist's friends found the result laughable. Where *Evolution* differed from the *Demoiselles* was that the laughter never turned to amazement.

The whole story of Mondrian is implicit in the configuration that, having failed to produce a religious art out of a study of religious texts, he almost immediately produced a religious art through study of the art of two impeccably secular contemporaries: *The Tree A* of early 1913 (Tate Gallery) comes uniquely close to conveying an atmosphere such as pervades Michelangelo's late drawings of the Crucifixion. In total contrast to the innocence with which Mondrian got embroiled in the irrelevance of *Evolution* was the clear headedness with which he perceived what he could and what he should not take over from Picasso and Braque. The moment of decision was, of course, the crisis of legibility which came to a head in the spring of 1912. Braque and Picasso fought their way out of it by starting to incorporate bits of the real world – actual bits or simulated bits – and gradually abandoning the entire apparatus of Analytical Cubism. Mondrian's decision amounted to a statement that painting, having in the wake of Cézanne's achievement of 'a harmony parallel to nature' established a certain distance from reality, ought not to be letting reality in again through the back door, that it ought to be insisting on its autonomy by becoming less and less referential, more and more musical.

The decision was expounded in 1913 in the series of pictures using an orthogonal grid and a palette of grey and rust and entitled *Tableau* or *Composition*. The rejection of the alternative path into Synthetic

Cubism was dramatised in a related work of the same year, the oval picture in the Stedelijk entitled *Tableau No. 3*. This is virtually a pastiche of Braque's *Man with a Violin* in the Bührle collection painted a year earlier, a classic example of the last days of Analytical Cubism. By the time Mondrian painted his version both Braque and Picasso had produced oval still lifes in the synthetic cubist style. And Mondrian's picture seems to be deliberately echoing its model in that, besides the close resemblances in morphology and composition, it has the same zone down the centre that is more luminous than the rest. In the Braque it is precisely in this luminous zone that the violinist and his instrument are adumbrated, faintly but unmistakably; the corresponding area in the Mondrian is the area that is most immaculately non-figurative.

So much for the negative aspect of Mondrian's choice of direction. The positive aspect is pithily summarised by Yve-Alain Bois in the catalogue of the commemorative show: 'A comparison between the 1912 *Flowering Appletree* and the 1911 *Gray Tree*, whose motif it echoes, reveals a considerable difference between mere curves and curves as potential straight lines. From this new conception of the image in progress flows all of Mondrian's subsequent work. Most importantly, what emerges from it is the idea that a painting is the result of a kind of struggle, a precarious equilibrium that must remain suspended so as to sustain its intensity.' I hope I am not putting words into Bois's mouth when I infer that Mondrian is thereby Cézanne's truest heir.

One of the things that this involves is being a man of destiny, but there are quite a lot of these in the hagiography and mythology of modernist art. Mondrian, though, is a singularly poignant and heroic case. A Mondrian retrospective is not just a procession of great pictures, but a progression which in itself is an aesthetic experience: the trajectory of the man's art becomes as much a thing of beauty as the art. Moreover, whatever its momentum and sense of inevitability, it is still forever able to surprise, and, whatever its overall unity of purpose, it is still rich in contradictions. Given that all this was charted with the highest curatorial intelligence and rigour in the selection and cataloguing and installations of the commemorative exhibition, I cannot remember a more satisfying twentieth-century one-man show.

Those responsible were Angelica Zander Rudenstine, Yve-Alain

Bois, Joop Joosten, Hans Janssen and John Elderfield. One aspect of their rigour was their determination to remove some of the frames that works had been saddled with in order to replace them with frames that the artist might have supplied. But the main thing was that, given their insistence that Mondrian was a *painter*, a painterly painter, and that his surfaces, his handwork, had to be as visible as his design, they made a selection ruthlessly excluding works, however well known, which had been subjected, as so many have, to excessive cleaning or excessive repainting.

Unfortunately, two of the exhibition's three showings lacked the daylight that gives brushwork visibility and resonance. There was daylight at the Gemeentemuseum in The Hague; the artificial light at the National Gallery of Art, Washington, had some daylight mixed with it in a quarter of the galleries; at the Museum of Modern Art, New York, there was only artificial light. A compensation for New York was the presence of both the boogie-woogie pictures, neither of which had been lent for the other showings – *Broadway Boogie Woogie* of 1942–43 and the unfinished *Victory Boogie Woogie* of 1942–44 – paintings radically different in rhythm and mood from anything Mondrian had done before – the artist's last fling.

The love of jazz avowed in their titles could well, I think, have had to do with the fact that jazz is a form of music in which every piece is a set of variations, for Mondrian's artistic output reflected a passion for composing sets of variations. Nevertheless, there is no obvious relationship between paintings of his and the sounds of jazz prior to the boogie-woogie pictures. Here there is an emphatic resemblance between the eight beats to a bar – instead of the usual four – and the broken lines of the paintings. The rhythm of boogie-woogie could even have inspired those paintings, though it seems likelier that the broken lines grew out of the short straight lines which Mondrian had been inserting near the edges of pictures since his arrival in New York in October 1940 – inserting them in new works and also in works he had brought with him, not to their advantage – and that, when he painted a picture using broken lines right across the canvas, he perceived an affinity to the relentless eight beats to a bar and called the picture *Broadway Boogie Woogie*. Either way, the titles must have endeared him to a wider audience. Jazz is normally a minority art, cer-

tainly among whites. Boogie-woogie, like big-band swing, however, had a great popular appeal and success. And there would have been something piquant about the thought that someone as serious and austere as Mondrian was addicted to this popular commodity.

Despite Yve-Alain Bois's brilliant demonstration that *Victory Boogie Woogie* was the climax of Mondrian's development, I must say that for me the boogie woogie pictures were a byway and that the highway was the *New York City* series, of which two were included in the New York showing – No. 1, of 1941–42, and the unfinished No. 3, also of 1941–42 (in which the lines are still embodied in the coloured strips of paper that Mondrian employed in working out his compositions after his arrival in New York). I think that these paintings, with their lines suggestive of high-speed movement across the height or breadth of the canvas, are both more deeply rooted in Mondrian's past – from about 1930 on – and had a greater potential for future development – this through their strange creation of an illusory space, a relatively shallow space, beyond the network of lines. For me these constitute his last great stage (in succession to the works of 1913–17, 1920–22, 1929–30 and 1937–38).

This sort of speculation was encouraged by the New York showing because the excitement it generated was more intellectual than visceral. It was the lighting, of course, that made this so. The difference between electric light and daylight is precisely analogous to the difference between music electrically amplified and heard straight. Electrical amplification or illumination diminishes materiality and the breath of life. Art is left without enough physical resonance to affect the nervous system as it can. The experience at The Hague didn't especially inspire speculation: it was about relating, not about thinking. In front of picture after picture there was a sort of draining, a giving up, of self. The mind felt intent but empty and unfocused. It was the body that was focused. All the energy it contained seemed to be gathered together and channelled towards the rectangle facing it. It was as if taken over by its attention to this separate entity that was a model of completeness.

Cézanne

Entitled 'Notes on Cezanne', this was occasioned by the retrospective exhibition seen at the Grand Palais, Paris, and the Tate Gallery between September 1995 and April 1996. Written around the turn of the year, it was published in the *London Review of Books* for 7 March 1996. It has since been slightly revised.

'Refaire Poussin sur nature'. Why did Cézanne single out Poussin when Rubens was his hero – his avowed and his manifest hero?

One thing that Cézanne and Poussin have in common is that they seem unable to make an image that isn't imbued with gravity. Another is that everything in the picture seems to be in a place ordained for it. But not through a similar process. Poussin is a master manipulator of compositional tactics and strategies, shaping components and fitting them together in an ideal pictorial space with a peerless erudition, inventiveness and cunning; Cézanne tries, against the odds, to work out how depictions of figures and their setting on a flat surface can be organised in a way that makes them an ideal re-creation of figures and their setting in the space of the real world. Again, a Poussin is the performance of an interpretation of the subject reached through deep, prolonged reflection on the psychological content of an event; a figure-composition by the mature Cézanne looks as if the artist had focused entirely on questions of form, leaving the content to look after itself. And then Poussin's act of creation is largely achieved in preparatory drawings; with Cézanne, even more than with Rubens, the act of painting is a continuous revision of intention.

Doing Poussin again from nature, then, couldn't have meant producing an art akin to Poussin's. What Cézanne meant, I think, was 'doing *a* Poussin': he used Poussin's name as a paradigm of Order and Art, antitheses to the chaos of Nature. It was no good saying 'Refaire Rubens sur nature', because Rubens was like a force of Nature. Cézanne invoked the great artificer.

Cézanne's statement to Francis Jourdain that his constant preoccupation had been 'de rendre sensible la distance réelle entre l'oeil et l'objet' obviously relates to the feelings about the dangers of closeness expressed in those early poems sent to Zola in which ravishing beings

with angelic voices dissolve away as he approaches them and a beauty becomes a skeleton as he tries to possess her, feelings expressed in reverse in his phobia about being touched. An anxiety that things should be kept at arm's length could be placated by using the act of painting to ascertain and map precisely where things out there were. But, if everything had to be kept in its proper place, his interest in doing it could be sustained only if things out there were given a right to live, to vibrate, to dance, to threaten to jump out of place, thereby creating a tension between their anarchic force and the opposing force holding them in position.

Writing in 1896–7, the young Bernard Berenson spoke of 'the exquisite modelling of Cézanne, who gives the sky its tactile values as perfectly as Michelangelo has given them to the human figure'.

Michelangelo's is not one of the names commonly brought up in talk about Cézanne, so that Berenson's dashing comparison provokes reflection on whether there aren't other points of resemblance. The most obvious is that Cézanne's love of the Venetians is concentrated above all – his work suggests – on Tintoretto, and Tintoretto's drawing comes straight out of Michelangelo. Another affinity that comes to mind is that Cézanne's frequent practice, in seeking to give plasticity to a head, of dislocating one of its lateral planes and pulling it round so that it widens the frontal view, was fully anticipated by Michelangelo in the British Museum's life-size cartoon of a *sacra conversazione*. More fundamentally, is not the unfinished condition or unfinished look that is such a crucial attribute of Cézanne's painting closely akin to the *nonfinito* in Michelangelo's sculpture? The similarity is that both are about varying the degree to which a form is made to *emerge* from vagueness into clarity. Of course there's the difference that whereas with Michelangelo the form is emerging from the inchoate block of material to which the artist is giving shape, with Cézanne it is emerging from ambiguous brushmarks which the artist himself has put on the canvas or paper. The essential is that the practice has to do with holding definition in reserve. One outcome is that we are brought face to face with the anxiety and drama of creation.

Cézanne's use of the *nonfinito* was in parallel to Michelangelo's, not in imitation of him, as it was with Rodin, who consciously bor-

rowed it for use as a rhetorical device. On the other hand, given that Cézanne is a painterly painter, does it make sense to liken his use of the *nonfinito* to that of Michelangelo, a carver, rather than that of Rodin, a modeller? One reason why it makes sense is that his exemplar was Rubens and Rubens *is* a sort of carver: he gives flesh the inner luminosity of marble.

Controlling how much is to be made clear, the *nonfinito* can be a way of witholding inessential information. In the Philadelphia *Grandes Baigneuses*, it ensures that we cannot identify the entities on the far bank of the river which, with their central position, are the very focal point of the picture. Is that a man standing gazing at the bathers – an Actaeon? Beside him is – what? – a child, a dwarf, a donkey seen from the rear? It doesn't matter. What matters is that the taller form with its pointed head rhymes with the far-away tower and thereby serves the paramount need for the eye to be encouraged to traverse the long distance between background and foreground, and that the shorter form is there to give bulk to this marker. While it is probable that Cézanne would have gone on with this canvas had he lived longer and possible that he would have elaborated these central forms, it is certain that he felt under no pressure to make them identifiable.

Again, in the loosely painted, almost grisaille, medium-size *Baigneuses* of 1902–6 there is a strong suggestion in the central group of four figures standing in the water that they are involved in some sacred happening. If we have to rack our brains to decide what the happening is, that is already a sign that we are abusing the painting by turning it into a puzzle. This painting is expressly not a depiction of a sacred event which happens to be unidentified as yet; it is a painting designed to intimate without help from an explicit narrative that it belongs to a tradition of pictures depicting sacred events.

Cézanne's art tends more than most to render visible its aesthetic. None of its lessons in the nature of painting is more essential than that pictures are meant to be taken as they are, are not there in order to be deciphered.

Modernist artists who have preferred Cézanne to the Renaissance tradition have maintained that his use of colour belongs to a wider and

longer tradition, one for which a painting has to be a fact rather than an illusion. Whatever Cézanne's heritage from Rubens and Tintoretto and Michelangelo, he has deeper affinities with Giotto and Cimbabue.

Cézanne's career is a Hegelian's dream. The thesis and antithesis here are the Dionysian and the Apollonian. An alternative formulation: the I and the eye.

The early unbridled figure-compositions depicting murders, rapes, orgies and the like were realised with the same intense inner need to externalise such visions as impelled him to include sado-masochistic erotic poems in his youthful letters to Zola. Compared with his contemporaneous groups of bathers that do not have narrative content, the fantastic pictures almost seem to have been painted in the way we may have to recount the night's bad dreams over breakfast before we can get on with the day.

His antidote to the *diable au corps*, his path to sublimation, was to dedicate himself to working patiently, sanely, soberly, from nature, a course taken from about 1872 on under the guidance of 'l'humble et colossal Pissarro'. From about 1888, the dialectical process resulted in a marvellous synthesis between the violent and the contemplative.

But what picture would we have had of Cézanne if he had died in 1887? Of course, great artists (Proust apart) rarely do die at around fifty: once they've reached forty, they tend to survive beyond sixty. And these survivors almost all have a fallow period in their middle years during which they rest on their oars and cash in on their early success while gathering energy to launch themselves on fresh enterprises. Had Rembrandt or Matisse, who are classic examples of this, died in the course of those years, the artistic identities they left behind would have been broadly those they did leave, even though they both went on to a glorious late period. If Cézanne had died in 1887, our impression of his artistic identity would have been radically different from what it is. It would have been that of an artist of great and diverse qualities who produced masterpieces but never really got it all together – not quite Frenhofer, but not an artist either who was on the verge of the grand synthesis sustained throughout his last eighteen years.

With Cézanne, works produced under the pressure of aims fraught with internal contradictions and in a state of agonising doubt arrive at a ravishing lyricism.

But he can also create light of an intensity that bores into your eyes the way ice burns your hands.

He had the stubbornness of the hedgehog but also the quickness of the fox. Uniquely, he was a master of the figure-composition and of the portrait and of landscape and of still life. And that is only the beginning of his versatility.

Within each of those domains there is an exceptional range of mood. And an exceptional range of physique. For example, at one end of the gamut of the still lifes is the watercolour of 1902–6 in the Thaw Collection in which a bottle with some red wine left in it and a small blue pot and a cluster of little apples close together on a large stretch of white tablecloth are realised in transparent washes that are so pale and so spare that the work is dominated by an expanse of naked paper transformed into radiant white marble; at the other end is the large oil of c. 1899 in the Musée D'Orsay, densely painted in high-temperature colours, in which a table is laden with a painted jug, a score or more of apples and oranges, each an explosive parcel of energy, scattered about on a white tablecloth loosely draped over the table's edge, while at the rear is a heavy patterned textile pushed and pulled so that it resembles a range of hills, and in this tumultuous prospect those animated spheres seem to be moving towards us as if threatening to spill over the edge of the cliff created by the tablecloth rather as carved reclining figures in the pediment of a Baroque façade seem to be toppling over the edge but immobilised.

The Philadelphia *Grandes Baigneuses* first impresses, like a cathedral, with an immense calm. A feeling of expectancy emerges, perhaps a sense of foreboding. It becomes clear that there are forces thrusting in different directions in each of the groups of figures, forces which in the left-hand group balance out but in the right become violent in their opposition. Nevertheless, from a distance, calm rules. But when we go up to the picture those thrusting forces act on us so that we almost feel we're being torn apart by a pack of dogs. When we retreat

to a distance and look again, we are filled more than ever by feelings of peace and ease and grandeur and also by a growing elation that is engendered by a sense of movement going on within the bow-shaped arcs of the great Gothic arch created by the trunks of the trees. It is a play of smaller bow-shaped arcs created by bathers' arms, arcs which seem to move to and fro across the picture-plane like a swing.

In total contrast with this soaring amplitude of height and depth, the National Gallery version is almost like a frieze in its proportions and like a relief in conception. And this sense of compression in physical depth, together with the lack of room to contain much sky, make it more concentrated in energy and fiercer in emotion. It is thus a perfect foil to the Philadelphia picture, with which it has now been shown together, for the first time since the Salon d'Automne of 1907, at the Grand Palais and the Tate, surviving the tough competition as it has never survived its presentation at the National Gallery with no space in which to breathe.

The high drama engendered in both pictures by the action of the form alone means that these are large-scale gatherings of nude figures which don't require the sort of dramatic interest normally provided in such works by, say, ill-feeling between Diana and Actaeon or Diana and Callisto. In the absence of that sort of drama some commentators use psycho-analytic speculation to tease out hidden stories – unconscious fantasies that could be supposed to have made Cézanne put a figure like this here and one like that there. But there is no real need for such scenarios. Their absence leaves no lack of purpose in the paintings.

In some of the landscapes there's a great silence and emptiness and at the same time a throb, a pulse.

It's like the experience of certain polyphonic music, such as Bach's chorale preludes – an uncanny equation of relentless onward movement and total stillness.

If the groups of bathers of Cézanne's maturity have no need to be seen as images of mythological events, whether of classical or personal origin, the groups of figures portraying individuals need no back-up from actual events. Compare the card players around a table with

Rembrandt's syndics around a table. If we were told that one of the syndics had embezzled his company's funds, this might not add to our aesthetic pleasure when looking at the painting, but we would probably be interested to learn something about the history of any of these characters. We would surely not take that kind of interest in the personal doings and undoings of the card players, for these men are only really alive while Cézanne is painting them.

It's the same thing with the great single portraits of that period, such as the *Madame Cézanne au Fauteuil jaune* of 1893-5 or the *Portrait de Joachim Gasquet* of 1896. The sitter is not projected as a *character*. When that rule is broken, things go wrong, as in *La Vieille au Chapelet*, which the artist abandoned. Not being distracted by the temptation to define character allowed Cézanne to concentrate all his attention on achieving the most precise and complete sensation of a human *presence*, of the way someone in reality appears in space. He achieves it more, I think, than Rembrandt or Velázquez, partly because he was also undistracted by an interest in virtuoso illusionism, partly because he was supreme in dealing with the problem of re-creating the density that people seem to have as we look at them. Rembrandt tends to make them too heavy, Velázquez tends to make them too light. Cézanne gets the weight of their presence right.

'Tout ce que nous voyons, n'est-ce pas, se disperse, s'en va. La nature est toujours la même, mais rien ne demeure d'elle, de ce qui nous apparaît. Notre art doit, lui, donner le frisson de sa durée avec les éléments, l'apparence de tous ses changements. Il doit nous la faire goûter éternelle.' The great paradox – capturing nature's changes while conveying its permanence – reaches its most compelling realisation in the series of *La Montagne Sainte-Victoire vu des Lauves* of 1902–6.

There is a sense of agitation, violence even, in the foreground and middle distance that churns us up as we look. The accumulation of brushmarks – abrupt, hesitant, opaque, transparent, and more disturbing than any hectic expressionist painting – engenders a feeling of nature bursting into growth and with it an intimation of decay and death. The *non finito* is a metaphor for becoming.

There is movement in the paint of the upper stratum too, that of

the mountain and the sky, but here the overall effect is one of calm, partly because this stratum is keeping the lid on the tumult below, partly because the celestial blue and the reassuring shape of the mountain create both a feeling of elevation and an intimation of eternity.

However much Cézanne opens up the sky, however rounded he makes things look, there's a luminous flat wall rising in front of us. That tablet is the first thing we see and the last.

POSTSCRIPT

Picasso and Braque *1997*

This note on the rise of Cubism is a radically revised version, much shortened and with some additions, of a review of *A Life of Picasso: Volume II: 1907–1917* by John Richardson with the collaboration of Marilyn McCully, published under the title 'To be as real as the real thing' in the *Independent on Sunday Review* for 15 December 1996.

Creative partnerships divide into three main categories. There are those where the partners – the Goncourts, say – are doing the same sort of thing for a collaborative work; there are those where the partners – the Gershwins, say – are doing different sorts of things for a collaborative work; and there are those where they are doing the same sort of thing independently in close alliance. A partnership in this last category was responsible for the century's greatest art movement.

The relationship between Picasso and Braque during the time of early and high Cubism makes me think of Dizzy Gillespie and Charlie Parker in the heyday of bebop (though that partnership also entered the first category). It was a relationship in which two young artists who were at once men of genius and great virtuosi and who had totally contrasting temperaments were joined in the creation of a revolutionary style, inspiring each other, guiding each other through a journey in the dark, goading each other with their intense rivalry, loving each other, often disliking and distrusting each other. (A comparison with jazzmen is apposite because a jam session is the paradigm of a situation in which artists are simultaneously supporting and competing with each other.)

Braque's most famous description of the relationship was that they

were like two mountaineers roped together, Picasso's that Braque was 'my wife' – a phrase which, given his notoriety as a male chauvinist pig, is generally taken to be condescending, even dismissive. But John Richardson, in the second volume of *A Life of Picasso*, throws new light on this by reporting a story told him by Dora Maar. 'When Braque was hospitalized in the late 1930s, Picasso rushed off to see him. "The nurse wouldn't let me into his room," he fumed on his return, "she said Madame Braque was with him. She didn't realise that I am Madame Braque."'

As to their honeymoon days, Richardson says that in their 'friendly but deadly game of one-upmanship, it is impossible to say which of the two players had the upper hand.' Nevertheless, there was a pattern by which it was Picasso who tended to urge his colleague to come and work with him. 'Later, Picasso would race ahead on his own. Emotionally, however, he would always need Braque rather more than Braque needed him.' And this seems to have been intensified in their old age, when Braque came to feel increasingly that in getting close to Picasso one risked coming under his domination. In the 1950s, Picasso used to try and get Braque to come and stay at his villa near Cannes 'in the hope that they could work together again . . . Braque failed to show the slightest interest. On his annual visit to the Côte d'Azur, Braque made a point of staying with his dealer, Aimé Maeght. Picasso, who loathed Maeght, was mortified.' However often Braque said no (there are good stories on that theme in Françoise Gilot's *Life with Picasso*), he couldn't stop Picasso from repeating the pattern of their cubist days of borrowing ideas from his work and developing them with more pizzazz: I have pointed out elsewhere that Picasso's first variation, painted in 1957, on Velázquez's *Las Meniñas* is also a variation on Braque's *Studio II* of 1949.

In matters of renown and wealth Picasso far outdid Braque from the start. Whereas Braque is famous among lovers of modern art, Picasso is as famous as Einstein. Yet Picasso was not a much greater painter than Braque. Above all, at the turn of 1912–13, when they were both given formal contracts by Daniel-Henry Kahnweiler, their principal dealer since 1907, there was little or nothing to choose between them as painters. None the less, the amount to be paid for a work by Picasso was somewhat larger than that for a work of the same

size by Braque – according to Richardson's calculations, *five times* larger.

The story of the rise of Cubism is one of the most wonderful chapters in the history of art. There is something deeply moving about the way this pair of artists in their late twenties found themselves subverting six centuries of European painting while seeing themselves – quite rightly – as the successors to a line that stretched from Poussin to Chardin to Corot to Cézanne. Moving and mysterious. I cannot look at a roomful of Picassos and Braques of 1907–14 without marvelling at how Cubism evolved. It continues to amaze me as if it had happened yesterday. The heroic pair moved through uncertainty with certainty, like sleepwalkers crossing narrow bridges over chasms. While nothing if not experimental in approach, they kept on ending up with artefacts that have an unassailable authority. They achieved a perfect combination of intellectual curiosity and instinctive response as they worked away as if under a spell. The mystery isn't quite evoked by Richardson. But perhaps it is impossible for a book to be both a thorough biography and an altogether satisfying critical study.

Nevertheless, Richardson does have one shortcoming in this area that has to be regretted. In 1910, Braque and Picasso brought Cubism to the brink of abstraction. Following in their wake, Mondrian took the plunge into abstraction – thereby preparing the way for a typical art of our time. Braque and Picasso kept their feet on the ground, and it was clearly not from fear of the unknown. What was it that made them insist on retaining the presence of objects in their images and consequently inventing collage – thereby preparing the way for another typical art of our time? Richardson does not, I think, satisfactorily explain their motives. 'If in the end Picasso stopped short of abstraction, it was not a failure of nerve but his conviction that art – his art – should be as real as the real thing. For Picasso, reality (as opposed to realism) is what his painting would always be about. Cubism was a means of enhancing, not dissipating, that reality. He did not want a painting to be an abstraction any more than he wanted it to be a facsimile. He wanted it to constitute a fact, a very specific fact.'

But constituting a fact is not the same as signifying a fact; also, semantically, 'reality . . . is what his painting would always be about' is a dubious formulation. This talk of 'the real' opens a can of worms.

The Cubists' insistence that the image 'simply had to be as real as the real thing' led to the abstractionists' insistence on the reality of the art-object itself. This was why one important group of abstractionists called their work 'concrete art'. This was why an exhibition which came to the Tate in 1969 of paintings and sculptures by Pollock, Newman, Kelly, Noland, Stella, Judd, Andre and others of that ilk was called *The Art of the Real*.

It may be that Braque and Picasso remained faithful to figuration less from an obsession with the real than from their cultivation of every kind of ambiguity. Of course there can be ambiguities in non-figurative art, but figuration brings in so much more to be ambiguous about, and the exploration of those possibilities is as constant a pursuit as any throughout the course of Analytical and of Synthetic Cubism.

But in the end it's probably beside the point to try and fix a rationale for any artist's attachment to figuration. The choice between being figurative and abstract is really so instinctive that it scarcely *is* a choice. Making abstract art is an ascetic activity, a way of testing oneself as to what one can do with limited means: it's like fighting with one hand behind one's back or being a vegetarian cook. Making a figurative art is an inclusive activity, a way of testing oneself as to how many things one can handle simultaneously. Mondrian and Malevich were afraid of having too much to work with. Braque and Picasso were afraid of having too little.

Masson *1996*

This was developed from the untitled preface, published in French, to the catalogue of an exhibition at the Galerie Louise Leiris, Paris, May-July 1996, of *André Masson: Peintures et Oeuvres sur Papier 1919–1927*. Lengthened in the light of the exhibition, it appeared under the title 'Masson before Surrealism' in *Modern Painters*, Autumn 1996.

André Masson was born in 1896 and died in 1987. He had a problematic career, along with most of the other important painters born

between 1885 and 1900. I mean that Duchamp (1887–1968) had done most of his best work by 1923, Chagall (1887–1985) by 1920, de Chirico (1888–1978) by 1919, Ernst (1891–1976) by 1935, Soutine (1893–1943) by 1927, Magritte (1898–1967) by 1934. Masson had done most of his best work as a *painter* by 1928 but was producing marvellous drawings till at least 1970.

His centenary was celebrated at the gallery to which he was under contract from 1922 until his death – the one founded by Daniel-Henry Kahnweiler which became known as the Galerie Louise Leiris – by an exhibition in two parts, both covering the same years: *Paintings and Works on Paper, 1919–1927*, and *Erotic Works, 1919–1927*. The thirty-five erotic works were with one exception drawings, many of them previously unexhibited and unpublished. They are profoundly erotic, because of their particular combination of extravagance and plausibility, also because of their air of being rooted in experience as well as fantasy, and above all because of the feeling they convey of the actors' total absorption in the act. Furthermore, they are various. They can be heterosexual or lesbian, orgiastic or uncomplicated, dreamy or energetic, tense or relaxed, perverse or banal.

They are also remarkable for their graphic virtuosity, here again not least for their variety. For instance, one tiny drawing in pencil on a wood panel, dated 1920, an intertwining of plump legs and buttocks and pudenda, recalls Ingres in the precision of its slowly flowing line and in its conveyance of ample volume with a minimum of modelling. In contrast, there are several fast-flowing pen and wash drawings which call to mind drawings by Rodin. Actually, they surpass them, because they are not subject to the flaw which infects so many sculptors' drawings, that the picture-plane is not smooth, like the surface of a pond, but undulating, like the surface of a sea. From 1923 Masson was also making pen drawings in a style without obvious precedent: the outline is broken up into a series of staccato flicks and jabs which make erogenous zones electrically alive and every surface an erogenous zone.

Though Masson is famous for his massacres, the sado-masochistic element did not enter his work until the end of the period the exhibition covers. There are no knives on show in the erotic scenes typical

of this period – as there are in those of, say, 1930–33. In the early 1920s the most typical erotic scenes present pairs or trios or dozens of naked women smelling, tasting, desiring and devouring one another. The devouring is affectionate, not aggressive or hysterical. There is an amicable, generous atmosphere, in the heterosexual as well as the lesbian scenes. And there's a sense of wonder in the discovery of other people's private parts. The world is filled with a Rubensian appreciation of the flesh and its pleasures.

The one erotic painting was a small gouache done in 1919, *Scène érotique aux marins*, a work which looks very much as if it must have been realised in the wake of seeing a masterpiece on paper of the same year by Picasso: *La Sieste* (Museum of Modern Art, New York). We do not know whether in fact the Picasso was done first or, if it was, that Masson saw it or a reproduction of it before painting the sailors' orgy; the link is proven, though, by the existence of several similar Picasso drawings and several similar Masson drawings of that year together with our knowledge that Picasso's work was a great centre of attention. What is also sure is that Masson was already able to deal with the influence of the most dominant artist on the scene. The Picasso in question is an image basking in erotic satisfaction and in its own formal perfection; the Masson is possessed by a frenzied desire, not eschewing wit, that calls to mind the wild erotic imaginings of Picasso's old age. Masson was a follower of Picasso who sometimes anticipated Picasso. There's an untitled erotic drawing of 1925–26 which foreshadows *Le Charnier* of 1943 (Museum of Modern Art, New York) and thereby also foreshadows the obsession with the closeness of love to death which later became so characteristic of Masson's art.

The combination of amplitude of form and interweaving of forms which make the erotic works effective is no less efficacious for subjects represented in the complementary exhibition – groups of men seated around tables eating and drinking or playing cards or throwing dice, interiors crowded with inorganic and organic forms and forms that could be either. Amplitude and interweaving could be found or could be placed anywhere in the world, for Masson's world was a theatre for metamorphosis. 'It is always the same substance that is in all things, life and death, waking and sleeping, youth and old age. For in chang-

ing, this becomes that, and that, by changing, becomes this again.'
These words from Heraclitus were used long ago by Carolyn
Lanchner as an epigraph to an essay on Masson.

The complementary exhibition told the story of how Masson was
gradually taken over by this obsession with metamorphosis. The final
painting, *L'Homme mort*, 1926, shows the process completed. It pre-
sents certain attributes of Analytical Cubism – the grisaille palette,
and use of a grid as a basis for the composition. But its essential vehi-
cle is line – a curious, very personal line, partly flowing, partly jagged.
The line emphatically has a life of its own: it looks like an enlarged
version of an automatic drawing. Its references to reality are equivo-
cal but unequivocally include a nude human figure and two horses'
heads. It is typical in every way of the sand-paintings of 1926–27
except that, as with a few other similar paintings of the time, no sand
has been added. Such pictures by Masson must have had a crucial
influence in the 1940s on Gorky and de Kooning. Without them,
would *Excavation* have been painted?

Going back to the beginning of the story, in 1922 Masson was
much under the influence of Derain. Part of that influence was a feel-
ing of licence to work in several styles concurrently. A more specific
aspect of it was that in 1922 Masson's paintings were predominantly
woodland scenes which were virtually pastiches of a type of composi-
tion that Derain had invented before the 1914 War and resumed
using after his discharge from the army: clusters and avenues of trees
with pale, slender, serpentine trunks. Masson's versions were not gen-
erally much improved by the introduction of a romantic element
hinting at a rich subterranean life: this doesn't really integrate with
Derain's neo-classicism and the result is something rather Disney-
like.

The concurrent figure-paintings were far more promising. Some
were single figures of seated men, exemplified by a 1922 portrait of
Georges Limbour. Mostly they were the first of the complex compo-
sitions, exemplified by *Le Repas*, 1922, of men sitting around tables
eating and drinking or playing games of chance, conveying a sense of
absorption in what they are doing as fanatical as that of the figures in
the orgies. Another way in which the works that were exhibitable at
the time overlap with the erotic works is that some of the objects on

the tables, such as the pomegranates, suggests parts of the body. Obviously they came to do so more and more as the work became more metamorphic.

The portraits and figures around tables reflect the influence of Derain hardly less than the landscapes – the influence of such works painted shortly before the war as *La Cène*, 1913. They were also surely influenced by recent and current work by Juan Gris, whom Masson became friendly with in 1922. And Gris was the crucial influence on another group of works, one which in my view was clearly Masson's outstanding achievement of 1922 – a number of careful drawings, mostly of still life, sometimes of landscape, in pastel or coloured crayons or pencil, extremely pale and subtly modulated. They are synthetic cubist in manner, tending to focus on a limited view of the scene, presenting a sort of vignette in a sea of white, faint and smoky in colour but crisp in drawing, the image sunk in the grain of the paper. All of this means that, while the composition is synthetic cubist, the paleness calls Analytical Cubism to mind. And this was the style Masson's paintings started to adopt in 1923, in still lifes such as *Mandore et verres* and figures around tables such as *Les Joueurs*. It was a single-handed revival of the most aristocratic of twentieth-century styles, and it gave that style an entirely new life.

There is a compressed energy in these pictures that makes for a very different atmosphere from the serene calm of Picasso and Braque's analytical cubist paintings. The compression comes partly from the multiplicity of the objects packed into the rectangle, but above all from a consequence of this, the insistent rhyming between shapes close to one another: in *Mandore et verres* between the tumblers and then, within the tumblers, between the crinkles in the glass; in *Les Joueurs*, still more emphatically, between the many hands and then, within the hands, between the fingers. In this vigorous and systematic rhyming, which gives the picture a very rapid tempo, there is in fact an echo of Léger's *Les Joueurs* of 1917. But the palette is not Léger's; the palette is Braque's grisaille-and-green.

It's at the turn of 1923–24 that the work becomes metamorphic. It does so in drawings that grow increasingly linear and free and exploratory and improvisatory and are often titled *Dessin automatique*. It does so in paintings such as *La Ville abandonnée*, 1923–24, and *Le*

Torse, 1924. Of course there is ambiguity in Picasso and Braque's Analytical Cubist paintings; of course forms often have a double meaning. But the disparate meanings are alternatives. With Massons of 1924 and after, the identities of the forms seem to shift under our gaze, the forms seem to undergo transformations. And the sense of change enhances the sense of movement. Even some of the landscapes come to life at this stage. Nevertheless, a work such as *L'Étang sous bois*, 1924, still seems to me to be too reminiscent of illustrations to fairy stories.

La Ville abandonnée and its sort are made wonderful by crowded forms cunningly assembled to create miracles of equilibrium and poise, are made mysterious by their metamorphic content but still more by a peculiar luminosity. The luminosity of Picasso and Braque's analytical cubist paintings arises from their crystalline transparency. Masson's grisaille is luminous despite being altogether chalkier and carthier. The chalkiness surely reflects a long attachment to fresco as a medium. When a student at the Ecole des Beaux-Arts in Paris, Masson had chosen to concentrate on fresco painting and in 1914 had got himself a grant to travel in northern Italy studying frescoes. And writing in retrospect of his paintings of around 1924 he was to say that they had the look 'of fresco (sometimes pastel) held over from long habit of painting and drawing only with powdered colours mixed with water or stiffened with glue'.

The echoes here of the great masters of fresco may even have had a relevance to André Breton's enthusiastic espousal of Masson's art. This happened in 1924: in February/March Breton bought a painting from Masson's first one-man show; in December the initial issue of *La Révolution Surréaliste* reproduced two of his automatic drawings. One obvious reason for Breton's admiration and fellow-feeling would have been the fascination with metamorphosis. Another would have been Breton's delight in and nostalgia for Analytical Cubism. But there may also have been a recognition that Masson's art resembled Breton's writing in channelling a modern sensibility, a subversive morality and an obsessive eroticism through a mandarin manner steeped in traditions of high style.

Written in April 1996, these 'Notes on Francis Bacon' appeared in a special issue, in English and French versions, of *Connaissance des Arts* published at the time of the Francis Bacon retrospective at the Centre Georges Pompidou, Paris, which I curated.

Francis Bacon was an old-fashioned militant atheist who always seemed to be looking for pretexts to issue a reminder that God was dead and to bang a few nails into his coffin. Nevertheless, Bacon's paintings – especially the big tryptychs – tend to have a structure and an atmosphere which make them look as if they belonged in churches. Within the tradition of European religious painting God appears, of course, in numerous guises – as creator, as vengeful judge, as merciful father, as the son sacrificed and reborn, as king of the universe, and here as dead and gone. So Bacon's art has a momentous quality that has won him a widely perceived role as something like a successor to Picasso; it's not his formal qualities that have given him this exalted place but his creation of images that are seen as apocalyptic.

He himself said: 'Really, I think of myself as a maker of images. The image matters more than the beauty of the paint . . . I suppose I'm lucky in that images just drop in as if they were handed down to me . . . I always think of myself not so much as a painter but as a medium for accident and chance . . . I think perhaps I am unique in that way, and perhaps it's a vanity to say such a thing, but I don't think I'm gifted; I just think I'm receptive . . .' This extremely sophisticated, intellectually acute man, with a deep realism about life, saw himself as a prophet.

While allowing that 'the image matters more than the beauty of the paint', Bacon felt that painting tended to be pointless if the paint itself were not eloquent. He aimed at the 'complete interlocking of image and paint' so that 'every movement of the brush on the canvas alters the shape and implications of the image'. All sorts of ways of putting paint on and taking it off were used to bring into being something unforeseen; it was a question of 'taking advantage of what happens when you splash the bits down'. Painting became a gamble in which

every gain made had to be risked in the search for further gain. Winning, as always, was largely a question of knowing when to stop. For many years Bacon hardly ever stopped in time.

We walk into a bar or a party and suddenly people are there occupying spaces we might have moved into. They surge up in our field of vision and every movement they make seems to set off vibrations that impinge on us. They are expansive, anarchic presences, and we cannot avoid paying attention to them.

A similar raw immediacy emanates from the figures in Bacon's paintings. And with it a smell of mortality. But also an easy grandeur which suggests that they are demi-gods or kings.

These epic figures are mostly depictions of individuals in Bacon's life – his erotic life or his drinking life. Bacon had something of Picasso's genius for transforming his autobiography into images with a mythic allure and weight.

Was Bacon an Expressionist? He didn't think of himself as one: 'I'm just trying to make images as accurately off my nervous system as I can. I don't even know what half of them mean. I'm not *saying* anything. Whether one's saying anything for other people, I don't know. But I'm not really saying anything, because I'm probably much more concerned with the aesthetic qualities of a work than, perhaps, Munch was. But I've no idea what any artist is trying to say, except the most banal artists.'

At the same time, he was convinced that 'the greatest art always returns you to the vulnerability of the human situation'.

FB: I was thinking about your bedroom – that just to have Holland blinds would be better aesthetically but that curtains make sex more comforting.

DS: Well, I'm sure curtains go very well with sex because they're there so often in pictures of sexual scenes. You yourself used to have curtains in your earliest pictures of having sex but now the backgrounds are starker and the sex seems just as good.

FB: Yes, but in the more recent pictures it's pure sex. You know, I don't really like the billing and cooing of sex; I just like the sex itself.

Do you think that's a homosexual thing?
DS: No. I think it can go right across the board.

His choice of art: Egyptian sculpture. Masaccio. Michelangelo – the drawings above all, perhaps. Raphael. Velázquez. Rembrandt, mainly the portraits. Goya, but not the black paintings. Turner and Constable. Manet. Degas. Van Gogh. Seurat. Picasso, especially where he is closest to Surrealism. Duchamp, especially the *Large Glass*. Some Matisse, especially the *Bathers by a River*, but not wholeheartedly: 'he doesn't have Picasso's brutality of fact'. And Giacometti's drawings, but not the sculpture.

His choice of literature: Aeschylus. Shakespeare. Racine. Aubrey's *Brief Lives*. Boswell's *Johnson*. Saint-Simon. Balzac. Nietzsche. Van Gogh's letters. Freud. Proust. Yeats. Joyce. Pound. Eliot. *Heart of Darkness*. Leiris. Artaud. He liked some of Cocteau but generally had a positive dislike of homosexual writing, such as Auden and Genet.

Bacon was almost the only important artist of his generation anywhere who behaved as if Paris were still the centre of the art world.

Even today Bacon is widely thought of as an artistic leper. People like to say complacently that they are afraid to go near the work. They decline to cope with its 'violence'. Well, of course Bacon's work *is* violent, in the sense that a Matisse or a Newman is violent in the force and incisiveness of its impact: it is aesthetically violent. ('I think that great art is deeply ordered. Even if within the order there may be enormously instinctive and accidental things, nevertheless I think that they come out of a desire for ordering and for returning fact on to the nervous system in a more violent way.') But the main objection that seems to emerge from the muddy controversy about Bacon's violence is that it is something more specialised – that it's a 'morbid' taste for real violence.

There is certainly a very convulsive quality in many of Bacon's figures, and convulsion is a sign of violence. But not necessarily of a horrific violence. Convulsions of sexual pleasure are something most of us undergo as often as we can.

Some peculiarities of Bacon's paintings:

(1) They are intended to be seen through glass – always, not just when they are partly in pastel.

(2) All the extant canvases are upright in format, with two exceptions; all other paintings with a landscape format are triptychs.

(3) There is normally a single mass on a canvas unless it depicts a couple coupling and coalescing into a single mass.

(4) Human beings are always shown on roughly the same scale: the small canvases depict heads and these are about the same size as the heads on the figures which the big canvases depict – about three-quarters life size.

(5) Even when the space is a perspectival stage in the Renaissance tradition, there are often elements such as arrows or dotted lines which are clearly not meant to be read as parts of what is depicted but as diagrammatic signs superimposed upon the image. Another indicator of the work's artificiality is a dichotomy between the handling of figures and that of settings: the figures are realised with highly visible brushmarks, the settings with a flat layer of thin paint.

(6) The paintings have titles like *Study from the Human Body, Study for Portrait, Study for Crouching Nude, Study of a Figure in a Landscape, Study after Velázquez's Portrait of Pope Innocent X.* So there are studies *from*, studies *for*, studies *of*, studies *after*, as if to say that at least some of the works were preliminary sketches for more definitive statements. What is in fact being said is that the artist wishes all his works to be regarded as provisional.

According to a curator's wall text at the Tate, 'Bacon's view of existence strips life of purpose and meaning'. So much for wall texts. Bacon's view of existence was that life was not empty merely because it was bereft of an afterlife and a deity. 'We are born and we die, but in between we give this purposeless existence a meaning by our drives.' The paintings are a huge affirmation that human vulnerability is countered by human vitality. They are a shout of defiance in the face of death.

'And what about the great silent figures of Aeschylus?' he suddenly said one day, apropos of nothing.

The Aeschylean menace and foreboding, the feeling – despite the humanist veneer – of the immanence of higher and decisive powers, are there all of the time.

Bacon – IV *1996*

Revised version, completed in December 1996, of 'Bacon and Matisse', an article inspired by the Pompidou exhibition which was published in *Tate Magazine* for Autumn 1996.

Francis Bacon clearly didn't spend sleepless nights wondering whether Matisse or Picasso was the greater artist. 'I have never had the strong feeling that many people have about Matisse; I've always found him too lyrical and decorative. I think he is less so than usual in some of the late *papiers découpés*, but nevertheless for me there is very little realism in Matisse. I think it's the reason I have always been so much more interested in Picasso. Because Matisse never had the – what can one say? – the brutality of fact which Picasso had. I don't think he ever had the invention of Picasso and I think he turns fact into lyricism. He doesn't have Picasso's brutality of fact.'

In that particular statement of his position, recorded in March 1982, Bacon was more vehement than usual when expressing his preference for Picasso over Matisse: it was as if he had forgotten that he had ever had a positive response to Matisse. This must have been because the conversation had been entirely focused on a problem raised in its opening question: 'Michel Leiris speaks of ways in which your work is a form of realism. What do you think yourself that "realism" means today?' Bacon had got involved in talking about realism in Picasso, so that I must have appeared provocatively gratuitous or casually irrelevant when I suddenly asked: 'And speaking of realism in the way you do, where do you put Matisse's late *papiers découpés*, especially those single nudes, one or two of which you've told me you admired?' A discussion on 'realism' was not an *expected* context in which to talk about Matisse, though I would certainly argue that it was a valid context in which to do so. I would argue too that the marvel-

lous phrase Bacon came out with, 'the brutality of fact', designated a quality that could also be found in Matisse, though in some of the masterpieces of 1907–17 rather than among the *papiers découpés*.

In any case, Bacon did admire Matisse more than any other twentieth-century artist apart from Picasso and Duchamp. He especially admired the *Bathers by a River*, the canvas two-and-a-half metres high and four metres wide started in 1909, probably, and completed in 1916; he often spoke of having seen it in Paris around 1930 when it still belonged to Paul Guillaume. And a number of his pictures could well have been influenced by its wide bands filled with or at least dominated by one colour, the most emphatic of which is a lush black.

The first of them was *Painting*, 1950, belonging to Leeds, which presents a profile view of a standing male nude cut off just below the knees – as if he were standing up in a bath, perhaps taking a shower – a view flanked on either side by black bands with the same sort of width as the one in *Bathers by a River*. This was a crucial work in Bacon's development – only the second painting of a nude that he completed and allowed to survive. The first had been the *Study from the Human Body*, 1949, belonging to Melbourne, which presents a back view, also cut off just below the knees, of a man departing through a pair of curtains. The figure here may well have been the first of the many painted by Bacon which reflect his fascination with a particular Degas, a back view of a nude woman. 'You must know the beautiful Degas pastel in the National Gallery of a woman sponging her back. And you will find at the very top of the spine that the spine almost comes out of the skin altogether. And this gives it such a grip and a twist that you're more conscious of the vulnerability of the rest of the body than if he had drawn the spine naturally up to the neck. He breaks it so that this thing seems to protrude from the flesh.' The length and protrusion of the spine in the 1949 nude is less emphatic than in many later Bacons, but they are present (though not very evident in reproductions).

There is a huge difference between the 1949 and 1950 nudes. To begin, there is a difference of format. Whereas the 1949 picture measures 147 by 134.2 cm, the 1950 picture measures 198.1 by 132.1 cm and was Bacon's first completed and preserved work since the great butcher's shop *Painting* of 1946 (Museum of Modern Art, New York)

to use a canvas of that size. That difference of format clearly influenced everything else: the squarer format – though not all that smaller in terms of centimetres – suited an intimate work, the taller demanded an heroic work.

The 1949 picture is a pure grisaille, dependent on soft nuances of vaporous colour and tone; so the figure is flanked by diaphanous curtains. The 1950 picture presents strong contrasts of colour and tone in its brightly coloured background to the figure and its flanking bands of solid black. And the possible influence upon it of the *Bathers by a River* goes beyond those long black upright rectangles. While the figure, with its heavy musculature and its right arm raised and bent at the elbow, is an obvious homage to Michelangelo, it also resembles the figure with an arm raised on the extreme left of the Matisse. Furthermore, Bacon's figure has a curious shadow beyond it, perhaps a doppelgänger rather than a shadow, for it bends forward as if it has an identity of its own, and the position of the head is not unlike that of the first figure from the right in *Bathers by a River*. There is even a resemblance between the tubular rail in the Bacon and the serpent in the Matisse.

One very conspicuous feature of the Bacon is not matched in the Matisse. This is the red and blue vertically striped wall behind the figure. It is a regular and polychromatic version of the striations which appear, often as folds in curtains, in most of Bacon's pictures of the late 1940s and early 1950s. Such striations generally derive from those which Bacon found so significant in Degas pastels. But the form they take here, with their close proximity and their bright colours, could easily have been borrowed directly from a device that is always occurring in Matisse paintings between 1919 and 1924, though usually with red and white stripes only.

Bathers by a River presents a single wide canvas firmly divided by vertical lines. Every known oil-painting by Bacon that has a horizontal format (other than two small works) is a triptych, meaning that it is unusually wide in proportion to its height and is divided by vertical lines. The verticals in *Bathers by a River* create a series of wide bands the most assertive of which are black or off-white; each band has a figure in front of it. That is to say, Matisse used his vertical lines to separate the figures one from another as Bacon separates figures from

one another by generally placing one figure only in each panel of a triptych. Furthermore, the composition of *Bathers by a River* may well have had a specific influence on the form of two of the greatest triptychs, both of them commemorations of George Dyer, which show the colours of mourning: *Triptych, August 1972* and *Triptych, May–June 1973*. In the first of these the outer panels present a single figure and the central panel a copulating couple (which virtually blend into one figure), in each case on a background of a black rectangle flanked by off-white rectangles; in the second, where the resemblance is even stronger, each panel presents a single figure on a background of a black rectangle flanked by a narrow band of off-white and then a rectangle in Indian red.

A slightly earlier triptych looks as if it had been inspired by another of Matisse's most brilliant translations on to a flat surface of a variety of forms in a space – *The Red Studio* of 1911, where a single colour filling the canvas represents both the walls and the floor of an interior and some of the objects there (mostly paintings and sculptures) are solidly realised while others (mostly furniture) are transparent, depicted by outlines on that ubiquitous ground. In *Triptych – Studies from the Human Body*, 1970, the entire area of the three canvases is a flat orange ground; the figures in the space, and also a bed in the centre panel, are realised solidly; the room's architectural features are depicted by outlines, transparent. And a triptych painted in 1967, *Triptych Inspired by T. S. Eliot's Poem 'Sweeney Agonistes'*, also seems inspired, in its palette and light, both by Bacon's sojourns in Morocco and by what Matisse had taken from Morocco. The central panel especially, a small room like a railway compartment, with a pile of belongings in its surmounted by some bloodied clothing, brings to mind certain Matisse interiors of 1911-13 with a strong sense of foreboding.

Furthermore, certain individual figures in Bacon resemble figures in paintings by Matisse, especially of 1907–17. For example, the man seated on top of a bed in *Study for Figure II*, 1953 and 1955, and the figure which is the first self-portrait, painted in 1956, seem echoes of the seated figures in *Music*, 1909–10, especially the one in the centre, and this resemblance recurs in the figure in the left-hand panel of *Study for Self-Portrait – Triptych*, 1985–86. Again, in *Two Figures in a*

Room, 1959, the crouching male nude seen in profile calls to mind Matisse's *Bathers with a Turtle* of 1908, and so still more emphatically do the nudes in the triptych *Three Figures in a Room* of 1964, especially the one seated on the lavatory. Now, Bacon was famously influenced by Picasso: whenever he made biomorphic forms they were derived from Picasso *personnages*; again and again his treatment of the head is derivative from Picasso. Nevertheless, in Bacon's treatment of the *body* Picasso had much less influence than Matisse as well as Michelangelo and Degas and Muybridge.

There also seems to be a crucial indirect relationship between Bacon and Matisse. It concerns the use of long vertical straight lines, and Barnett Newman is the link. Quite a number of Bacon's paintings from the mid-1960s on suggest that he had looked at Newman, the most striking case being *Study for Self-Portrait – Triptych, 1985–86*, where in each of the panels a pale warm ground is vertically traversed on either side by a pale cool narrow band, a configuration that calls to mind such paintings as *The Voice* of 1950 and *Ninth Station* of 1964. Bacon never had a good word to say for Newman, but he was as capable of being reticent about his sources as he was of being forthcoming about them. Yet it is also possible that, while being aware of Newman's work, he never focused firmly on it: it is possible because Newman's zips were so latent in Matisse's verticals.

That Bacon is a descendant of Matisse as well as of Picasso has become evident through recent experience of seeing the work in monumental spaces that have brought out a commanding grandeur and order and stillness. Without loss of its brutality of fact, it has suddenly seemed to have less in it of Picasso's immediacy and disquiet than of Matisse's serenity beyond pain. It has come to evoke Van Gogh's words, torn from their context, about works that retain their calm even in the catastrophe.

Johns – II 1997

These notes, written between March 1996 and February 1997, were published as 'Shots at a Moving Target' in *Art in America*, April 1997. A few passages are repetitions or rewrites of passages in 'Saluting the Flags' in the catalogue of *Jasper Johns Flags 1955–1994* at the Anthony D'Offay Gallery, London, in the summer of 1996.

Johns's marks articulate matter on a surface so that it becomes an objective correlative of sensations such as, say, looking without focusing, looking fixedly, looking out of windows, looking into darkness, seeing things grow, seeing them sicken, seeing the passing of a day, feeling threatened, feeling nothing, feeling elated, feeling tears prick the back of one's eyes. Marks of varying tempo, weight and direction caress and bruise and elaborate and disrupt and erode the familiar forms of everyday emblems – flags, letters, numbers, etc. – rather as in a Cézanne marks of varying tempo, weight and direction caress and bruise and elaborate and disrupt and erode the familiar forms of everyday objects – apples, ginger-jars, jugs, etc.

Johns and Cézanne both reconcile a free handling of often substantial paint, like Rembrandt's, with a use of severe, often geometric shapes, like Poussin's: it is not a common synthesis. If Johns reaches it, it is surely through consciously following Cézanne's example. He also reaches an elusive Cézannian synthesis unlikely to be attained by trying: the knack of conjoining solemnity and wit. And then the melancholy conveyed by his marks has the stoicism of Cézanne's. (Comparisons are sometimes made between Johns's marks and Guston's of the '50s, but there's a touch of sugar in Guston that makes them different.) Also, Johns's pictures, like Cézanne's, always hurt and unsettle before they can induce calm. And Kirk Varnedoe surely knew he could equally well have been talking about Cézanne when, meditating on the dialectic in Johns's art between creating and concealing, forming and burying, he said 'Johns is in love with conditions of irresolution'. At the same time, there's no irresolution in the risky games both artists play with the picture-plane trusting themselves not to end up losing it.

'Beginning with a flag that has no space around it, that has the same size as the painting, we see that it is not a painting *of* a flag. The roles are reversed: beginning with the flag, a painting was made. Beginning, that is, with structure, the division of the whole into parts corresponding to the parts of a flag, a painting was made which both obscures and clarifies the underlying structure. A precedent is in poetry, the sonnet: by means of language, caesurae, iambic pentameter, license and rhymes to obscure and clarify the grand division of the fourteen lines into eight and six.'

Thus John Cage. It was in one of the earliest versions, *White Flag*, 1955, that the metaphorical implications of simultaneously clarifying and obscuring were most richly realised: forming and melting, tightening and loosening, appearing and disappearing, flowering and decaying, brightness falling from the air. All participles but for one noun, and that's an ethereal one. In other words, I see the work as being about process, not about matter. I don't see the surface as signifying, say, skin or wood but as paint that composes an objective correlative for change. The change has two speeds. In the stars it's *allegro vivace*, agitated movement, flickering and exploding. In the stripes it's *andante*.

In 1957–58 Johns immersed himself in greyness in a series of encaustic paintings such as *Grey Rectangles* and *The*, where the surface is covered all over by slow, gentle, rather haphazard marks contrasting in tone only as far as they must be to be separable and looking as if they might have been made when half-asleep of half-awake or drugged. Their formlessness is corrected by the insertion into the surface of simple geometric shapes placed symmetrically or by a one-word inscription painted in capital letters of a classical mould. Both devices evoke the tomb, and this matches the elegiac atmosphere engendered by the grey. One of the pictures is inscribed and also entitled *Tennyson*. Several have a Tennysonian mood:

> The woods decay, the woods decay and fall,
> The vapours weep their burthen to the ground . . .

When recording an interview with Johns in 1965 I kept trying to attribute certain precise intentions and purposes to him and he

wouldn't have it. 'Intention involves such a small fragment of our consciousness and of our mind and of our life. I think a painting should include more experience than simply intended statement. I personally would like to keep the painting in a state of shunning statement, so that one is left with the fact that one can experience individually as one pleases; that is, not to focus the attention in one way, but to leave the situation as a kind of actual thing, so that the experience of it is variable.' I responded with yet another effort to make something stick: 'In other words, if your painting says something that could be pinned down, what it says is that nothing can be pinned down, that nothing is pure, that nothing is simple.' This false move did have the merit of inviting checkmate: 'I don't like saying that it *says* that. I would like it to *be* that.'

That distinction between saying something and being something corresponds precisely to Wittgenstein's distinction between what can be *said* and what *shows* itself, and the point about art is that it shows rather than says. Johns's sense of the distinction between saying and showing produced a memorable declaration: 'When you begin to work with the idea of suggesting, say, a particular psychological state of affairs, you have eliminated so much from the process of painting that you make an artificial statement which is, I think, not desirable. I think one has to work with everything and accept the kind of statement which results as unavoidable, or as a helpless situation. I think that most art which begins to make a statement fails to make a statement because the methods used are too schematic or too artificial. I think that one wants from painting a sense of life. The final suggestion, the final statement, has to be not a deliberate statement but a helpless statement.'

Shortly after the recording ended, he added: 'To be an artist you have to give up everything, including the desire to be a good artist.'

From the beginning Johns's art was concerned with concentrating attention on visual nuances much as Cage's music concentrates attention on aural nuances, and with Johns as with Cage that attentiveness generates a particular poignancy. Everything depended on the slightest inflections of the paint or wax or the pencil or charcoal or wash, which meant that the marks had to be on a smaller scale

than those which were commonly current. Hence the affinity of the marks in the paintings to those of Cézanne, and of the marks in the drawings to those of Seurat and occasionally of Van Gogh's land-scapes (as in *Flag*, 1958, in Leo Castelli's collection). Johns achieves something of Van Gogh's total translation of life into a script or a complex of scripts.

I said: 'I take it that when you're making art you're often saying to yourself 'It would be interesting to see that.'" He answered: 'Or "it would be interesting to do that", which is not the same.'

Commands to himself to do something often occur in his sketch-book notes. ('Make something, a kind of object, which as it changes or falls apart (dies as it were) or increases in its parts (grows as it were) offers no clue as to what its state or form or nature was at any previous time.') He is one who has always been driven to do things by working on some surface or another with some tool or object or another and/or some medium or another. ('Take a skull. Cover it with paint. Rub it against canvas. Skull against canvas.') While a famously philosophic artist, whose work was a key point of departure for conceptual art, he is anything but a conceptual artist. Just look at a catalogue list of some of his drawings and see how many different techniques and media and original combinations of them are there. Johns is a maker.

It may be that focusing on the making diminishes thinking about what one intends the work to mean, leaves the unconscious with room in which to operate, allows meaning to accrue without interference. As Cézanne said: '. . . if I get at all distracted, if my concentration lapses, above all, if I do too much interpreting . . . if I start thinking while I'm painting, if I intervene, then crash! bang! the whole damn thing falls apart.'

A recent book has made public the results of aggressive research into Johns's life from which it can be concluded that he had a lonely and painful childhood. John Cage's 1964 text included one deadpan biographical paragraph which made it clear without saying so that Johns had had a childhood of a sort that badly needs redeeming later.

Johns's recent work has made public certain documents relating to

his childhood by incorporating into his pictures family photographs and the ground plan of his grandfather's house where he lived for some years. However, there is nothing in the pictures themselves that conveys the personal significance of such material. Johns's work has already contained from the outset far clearer references to his first years inasmuch as so many of his initial themes – flags, targets, numbers, letters, maps, rulers, and a later subject, the puzzle-picture – and then the use of certain techniques – such as rubbing, finger-painting and tracing – belong to the schoolroom and to the nursery; in the light of that paragraph of Cage's, John's activity as an artist has long seemed to have centred on retrieving and resolving his childhood. Nor does he deny it: in 1978 he told an interviewer: 'I certainly believe that everything I do is attached to my childhood . . .' And in 1963, asked why he had done paintings to which he affixed a wire with a fork clamped on, he answered: 'I heard as a child that a man had repaired an aeroplane with chewing gum.'

There's a recent work that goes farther into the past: a series – perhaps a triptych – of untitled paintings each with roughly the same composition and a monochromatic field: from left to right, an oil with a purple ground of 1991–94, an oil with a white ground of 1991; an encaustic with an ochre ground of 1991. The ground is almost bare, with a few emblems scattered around a picture of a picture attached with *trompe l'œil* nails. It is a found image, a drawing by a schizophrenic orphaned young girl published by Bruno Bettelheim as *The Baby Drinking the Mother's Milk from the Breast*. Seeing the triptych (or series) several times without knowing or guessing anything about the drawing, I constantly perceived the bland and immaculate white ground as an ideal image of food – a miraculously smooth and succulent area of icing or ice-cream which was waiting to be licked and licked away. The orphan's drawing and the edible whiteness add up to a symbol of the sucking infant's longing for perfect nourishment; the surrounding emblems include a mouth and two eyes that are also breasts with prominent nipples. Each breast is fenced off by a set of nails with their points outwards.

Assuming that Johns's *Flag*, 1954, was a classic case of a work of art as epigram, and given that an epigram has to be surprising, simple, witty,

subversive, elegant and at best deeply serious, it might be amusing to list some of its predecessors in the first half of the century.

Matisse's *The Red Studio*, 1911
Duchamp's *Bicycle Wheel*, 1913
Picasso's *Absinthe Glass*, 1914
Malevich's *White on White*, 1918
Man Ray's *Gift*, 1921
Magritte's *The Treachery of Images*, 1929
Meret Oppenheim's *Fur Breakfast*, 1936
Picasso's *Bull's Head*, 1942
Duchamp's *Female Fig Leaf*, 1950

As we would expect: first, most of the works are three-dimensional; second, most of them are dada or surrealist. The only pieces which are neither are *The Red Studio*, *White on White* and *Flag*. Each of these is a conceit on the attributes of painting. The inclusion of a structure as complex as the Matisse may be thought questionable if an epigram has to be simple. But the conceit is simple.

The conceit in *Flag* is to represent an object in such a way that its edges coincide with the edges of the canvas. The space between the object and the spectator is squeezed out of existence. To some extent this gambit was anticipated by Magritte, an artist much admired by Johns, in his *Representation* of 1937 – and it was certainly a case of anticipation rather than influence because by 1954 the picture had neither been exhibited outside Brussels nor been reproduced. It is a close-up of a woman's pelvis which was presented on a rectangular canvas until Magritte took a pair of scissors and shaped the canvas to follow the outline of the pelvis and then had a frame made to fit. In the realisation, Magritte aimed at illusion and therefore made his paint invisible so that it could look like flesh and skin, whereas Johns, of course, makes the paint more or less as visible as the image.

The story is 'I dreamt one night that I painted the flag of America. The next day I did it.' This sounds like an episode in the life of a biblical prophet. At least one great painter of our time, Francis Bacon, seems to have seen himself as that: 'I don't think I'm gifted; I just think I'm receptive . . . I think I have this peculiar kind of sensibility as a painter where things are handed to me and I just use them . . . I

suppose I'm lucky in that images just drop in as if they were handed down to me.' Johns might well have felt that images were being handed down to him not only when he first did the flag in 1954 but also when he first did targets and the figure 5 in 1955 and alphabets in 1956 and numbers and all-over grey brushstrokes in 1957 and sculp-metal bulbs and flashlights in 1958 and *o through 9* and polychromatic explosions with superimposed stencilled words in 1959 and painted ale cans in 1960 and the map of the USA in 1961 and the *Skin* draw-ings in 1962. It was as if for those nine years Johns was in a perpetual state of grace. And as if a voice from above then said: 'Jasper, we've done enough for you; you're on your own now.' Suddenly the boy genius had to become a man. Hitherto the struggle had been confined to the realisation of the image; from now on Johns was going to have to hunt the image down. It is true that the legendary passing encounters while out on drives with the prototypes of the paving-stones and the cross-hatching are about finds rather than hunts – but they were still finds, not revelations. (By the way, it was in 1963 that Johns first consented to give a serious interview, as if he were now responsible for what he did.)

The crisis in Johns's history came during the realisation of the *Diver* drawing measuring about seven feet by six – his biggest and best work on paper. He started it in 1962 and before completing it the fol-lowing year interrupted work on it to execute in November–December the *Diver* painting. This too was his biggest piece in its medium yet. The format here is horizontal, slightly higher than the drawing and more than twice as wide. Compositionally it's a five-part polyptych, and it's the centre panel that corresponds with the draw-ing. And whereas the drawing has the same marvellous fusion of the surprising and the inevitable as the flags and the targets and the alpha-bets and the maps, the painting seems inconclusive. It was the first of several large horizontal canvases on which Johns was manifestly reaching to become a different kind of artist: *According to What*, 1964, *Studio*, 1964, *Untitled*, 1964–65 (Stedelijk, Amsterdam), *Eddingsville*, 1965, *Studio II*, 1966, *Harlem Light*, 1967. What seem to me the totally resolved works among these were not included in Kirk Varnedoe's retrospective at the Modern – *Harlem Light* and the first *Studio*, its explosive *trompe l'œil* sunburst of grey on grey next to that

great white slanted door an affirmation that Johns, having worked until 1962 on the scale of de Kooning and Guston, also had it in him to perform on the scale of Pollock and Newman. However, he has not often seemed at home when working on fourteen-footers and upwards.

One arresting thing about the *Diver* is how the scrawls and scribbles lie on the smooth surface of the pair of abutting panels, creating a beautiful tension between the freedom of the artist's gestures and the resistance of that hard dense wooden ground – a ground which in reality is not wood at all but paper mounted on canvas. The band down the middle which is partly lighter in tone is certainly meant to be read as a wooden plank. It is also meant, from the footprints at the top, to represent a diving board. Matching circular vectors traversing the bottom corners indicate the sweep of the diver's arms. Starting at the foot of the vertical band a pair of stylised arms with hands at each end – they look like tribal ritual objects – rise at an angle such that the top pair of the hands is just outside the edges of the band. The lower pair of hands is clearly entering the water. The slightly outstretched upper pair of hands could be a reference to the position of the arms at the beginning of a dive but could also suggest someone in the water crying out for help; they have been interpreted as an allusion to one account of Hart Crane's suicidal dive into the sea. Taken in conjunction with that central vertical band, the arms also hint at a crucifixion. Speculation is encouraged by the work's glowing muted luminosity, and any mystery as to the iconography is far outweighed by the mystery and the drama of the golden and brown *tenebroso* lighting and the play of free, impassioned drawing within a stark structure. It's as if Rembrandt had been at work on a Barnett Newman.

In the retrospective the work was hung near another very freely handled piece similar in size, *Watchman*, the painting in oils with a wax-cast of a leg sitting on a real chair, inverted, attached in the top-right corner. It was made in 1964, while the artist was in Japan, a sombre work that has always seemed to me the finest of those pieces Johns realised at around this time which, basically through long broad brushstrokes and dribbles of paint, evoke Rauschenberg. Whereas *Diver*, while expressly being about a descent, is also suggestive of con-

trary movement, *Watchman* is a conclusive image of descent. If *Diver* looks like a Newman done over by Rembrandt, *Watchman* looks like a Rembrandt done over by Rauschenberg. That is what it looks like; what it is is a Rembrandt done over by Johns. There are so many correspondences in the lighting and the composition – down to the way the chair replaces the Cross and the ladder – that *Watchman* is clearly, knowingly or not – Johns tells me not – a remake of the *Descent from the Cross* in the Hermitage.

It is not surprising that the standard critical assessment of Johns's career resembles that of de Chirico's – that each had a marvellous beginning which made him a major influence while he himself was declining well before he was forty. It is not surprising, because Johns had done everything to activate America's powerful drive to sacrifice her gods while the memory of their apotheosis is still fresh. He has played a double game. On the one hand he has toyed obsessively with the motifs that made him famous, and here he has been subject to the law of diminishing returns. A parade of his *Flags*, say, shows that those realised after the first ten years have mostly been less vibrant or coarser, and this has given good reason to perceive him as a typically fading lyric poet. At the same time he has constantly explored new thematic material. As I see it, these explorations have produced a continuing self-renewal, but the view is widely held that they have been arcane, cerebral and aethetically dry. They certainly tend to seem like that when first encountered, but there can be an efficacious remedy, which is to follow Wittgenstein's advice: 'Don't think. Look.' What is sure is that the very extent of John's bipartite production has not helped his cause. The more an artist makes, the more targets he erects. And even a faithful supporter may feel that there are many individual pieces for which it is difficult to see a *raison d'être* transcending Johns's compulsion to experiment.

On the other hand, the retrospective showed a rare absence of those fallow periods – fallow in quality – that normally appear in retrospectives, even of major masters. The nearest thing to such a period here was the second half of the Sixties, but these years still produced *Voice* and *Voice 2*. Here for once was a retrospective that did not diminish the artist, though I wonder whether the selection could not

have done more to convert unbelievers by being less inclusive. The message for me after a dozen visits was that in the pantheon of painters of the second half of the century it could be Johns who sitteth on the right hand of Newman the Father Almighty. If he does, the iconography is rather apt: Newman's art is immaculate and in charge; Johns's bears the scars of recurrent self-crucifixion.

In the latter part of the retrospective Varnedoe confronted the visitor with a wall bearing a juxtaposition of two 1982 encaustic paintings, one of upright, one of landscape format, both with hanging casts of forearms coloured in harlequin patches – one, *In the Studio*, a dazzling image of daylight; the other, *Perilous Night*, the most turgid thing Johns has ever done, its left side more crazed than the wildest excesses of Albert Pinkham Ryder. They complement each other as if they ought never to be separated. In both of them the forearms convey conflicting intimations of inert objects hanging useless and of living forms lightly touching the wall with their fingertips – in *Perilous Night* so living that as I look I sometimes experience the hallucination that those three arms hanging side by side have detached themselves from the wall and started behaving like mythical snakes.

Johns's tellingly emotive use of casts from parts of the body – above all, here and in the assorted fragments pinned to criss-crossing lengths of wood in the sixteen-foot-wide *Untitled*, 1972, at the Ludwig Museum, Cologne – shows how resourcefully he exploits the fact that low relief is the most poignant form of visual art there is. There's a further dimension in the polychromed fragments in *Untitled*, 1972, fragments that look as if they've been torn away from bodies. They have the lacerating impact that late medieval German polychromed sculpture can have. They are so scary that the wing-nuts and bolts in the carpentry suddenly seem to be thumb-screws. I say this because the atmosphere of the scene suggests that the damage to a body has been inflicted in a martyrdom rather than a battle. This harrowing image is made Johnsian, redeemed from Expressionism, through the alienating visual conceits by which the islands of torn-out flesh are echoed in the flagstones of the two middle panels and both the flagstones and the criss-crossed pieces of wood are echoed in the patches of cross-hatching in the left-hand panel.

In the Studio is curiously Beuysian in atmosphere (see *Show your Wound*, for example), what with its use of varied repetition and its haunting sparseness. What is especially Johnsian about it is how it concentrates attention on nuances in what we are looking at – for example, the differences in their angles to the wall of the yardstick, the cast of a forearm and the pinned sheet of paper bearing a life-size drawing of a forearm. The other variation presented, in the upper and lower versions of a cross-hatch picture pinned to the wall, is between an intact work and one melting away as we look. That melting process appears again in the work which for me is Johns's most amazing piece of the late Eighties, *The Bath*, 1988. I do not know why this picture moves me so profoundly. Perhaps it is about making Beauty and the Beast coalesce. It brings together two of the most gruesome of Johns's reiterated quotations, in the background a monstrous detail from Grünewald's *Temptation of St Anthony*, and pinned to the wall Picasso's grotesque *Woman in Straw Hat* of 1936, treating them in a palette which could have been borrowed from Velázquez's *Rokeby Venus*. And then it incorporates the melting process that makes the Picasso head look as if its nose is dissolving into snot. At the same time, it has the lovely melancholy lyricism of a Medardo Rosso wax head of a child.

Is it because Duchamp has been very fashionable in America while Braque has been underestimated that Johns's affinities to Duchamp have been magnified while those to Braque have gone unnoticed?

Of course Duchamp inspired him in the Sixties even more than he did most of the leading artists of Johns's generation. And of course Duchamp and Johns became rather friendly: they both lived mainly in New York, Duchamp was a mythical figure yet not difficult to meet – kindly and courteously accessible to younger people who had a real interest in knowing him – and it would have been astonishing if he and Johns had not got on extremely well, seeing that both of them had a brilliant, elegant, mordant intelligence and liked to laugh. But it is not certain that Johns learned a lot from Duchamp that he would not have learned from Cage, and they were very different characters despite their shared penchant for taking pleasure in arousing but not satisfying curiosity. Duchamp was more relaxed and dandyish, and while

secretive in many ways, did not have Johns's *pudeur*. Johns said in the early Nineties: 'He has qualities that are foreign to my nature. I think he's more cheerful in his scepticism and more detached.' But even in 1965, at the height of Johns's involvement with Duchamp's thinking, he made it clear what a gulf there was between them when Walter Hopps alluded to Duchamp's professed unconcern with how his art-works looked by comparison with their idea-carrying qualities and asked Johns whether he had ever worked from such a standpoint. 'My idea', said Johns, 'has always been that in painting the way ideas are conveyed is through the way it looks and I see no way to avoid that, and I don't think Duchamp can either.' This links up with the most obvious and perhaps the profoundest difference between them as artists: that Duchamp made as little art as possible and Johns is man-ifestly addicted to the manual labour of art.

As to influence of particular works on particular works, this seems to have been most active in a few minor pieces. In the realm of major works there's a consensus that, when Johns started in 1963-64 to paint large complex horizontal pictures like *According to What*, his paradigm was Duchamp's *Tu'm* of 1918. But on what grounds? Just two or three elements of the iconography. The style has nothing to do with Johns: it is illusionistic; it gives no sense of the presence of the picture plane; the *matière* is transparent. These works by Johns may play games with the addition of real objects to a painted canvas, but their central pre-occupation is the paint on the canvas, worked, layered, varied in texture, self-assertive.

It seems to me that, knowingly or not, Johns's more complex com-positions since the mid-1960s have had a crucial and somewhat increasing resemblance to some of Braque's late *Studios*, the series of eight mostly large canvases painted between 1949 and 1956, and to some of his other late paintings of interiors. Such a resemblance would not be surprising, for Johns has close temperamental affinities to Braque. There's an extreme introversion that creates a formidable dis-tance from others. And there's that artisanal approach to work: this is something not uncommon among French painters, and Matisse for instance certainly had it, though no one perhaps more intensely than Braque, who seems never to have forgotten his beginnings as a house-painter. Among American painters it is rare. Both those shared

attributes are conducive to a shared tendency to nurse a work into existence through an interaction often prolonged for years between idea and realisation. Above all there is even a common atmosphere, present in Braque's *Studios* as it is in Johns's world as Carter Ratcliff so beautifully evokes it: 'Johns neither illuminates life and death nor tells us how he feels about these massive and murky topics. At most, he tinges them with his sensibility. The nature of that tinge is obscure, a matter one cannot even begin to address before withdrawing to an inwardness as private as Johns's own. His art induces us to be like him: entranced by the elusive but somehow always dependable hum of solitude.'

The resemblance in the works was somewhat obscured at first by the strength of the presence in the Johnses of brushmarks powerfully reminiscent of Rauschenberg and de Kooning. It emerges clearly in paintings of 1984 such as *Untitled* in the Broad collection and is most obvious in works of the 1990s such as the two large canvases incorporating the ground plan of a house, especially *Untitled* 1992–94. The common iconographic vocabulary of the relevant works includes a skull, a bowl, a jug, a massive arrow, lettering, balls, stars, a silhouette of a male figure, a picture or pictures within the picture, irregular biomorphic shapes filled by stripes or some other regular pattern. The style is a complicated version of Synthetic Cubism. The composition is divided into compartments, sometimes meshing or overlapping. Shapes often look like pieces of paper partly superimposed on others. There's a ubiquitous dialogue between long straight lines and long serpentine lines. The palette tends to be muted. The paint often varies in thickness and texture between one part of the canvas and another.

It looks unlikely but is probably the case that the resemblance is something of which Johns is unconscious – that when calling certain pictures *The Studio* or *In the Studio* he wasn't thinking at all of Braque's series, that his constant use in the later works of *trompe l'œil* nails is not an allusion to Braque's exploitation of that device in the heyday of Cubism, that any stylistic resemblance derives entirely from an inner affinity reinforced by the inspiration of Cézanne just as it may do when cross-hatch pictures such as *The Dutch Wives* and the *Usuyuki* series seem to be emulating the use of straight lines and a grisaille palette in Braque's late analytical cubist paintings to create a tangible space.

Braque's desire, often avowed, to make space tactile achieved its fullest expression precisely in the late *Studios*, where space appears pleated, melted, folded, bent (to borrow from John Golding's vocabulary). There seem to be hints in certain late works by Johns – especially works on paper – of an interpenetration between mass and space which, as with late Braque, is fluid but somehow stuttering and sometimes suggests the presence of hidden spaces within. Whether Johns has any conscious concern to make space tactile is an open question. He is not one to compose statements, preferring to be interviewed (which puts the ball in someone else's court), and no interviewer has asked a relevant question. There may be a clue embedded in Johns's answer to a questionnaire addressed to artists in 1977 about what artists they admired, when he cited the Cézanne *Bather* at the Modern and said 'it makes looking equivalent to touching'.

INDEX OF ARTISTS